MARY CASSATT

A Catalogue Raisonné of the
Oils, Pastels, Watercolors, and Drawings

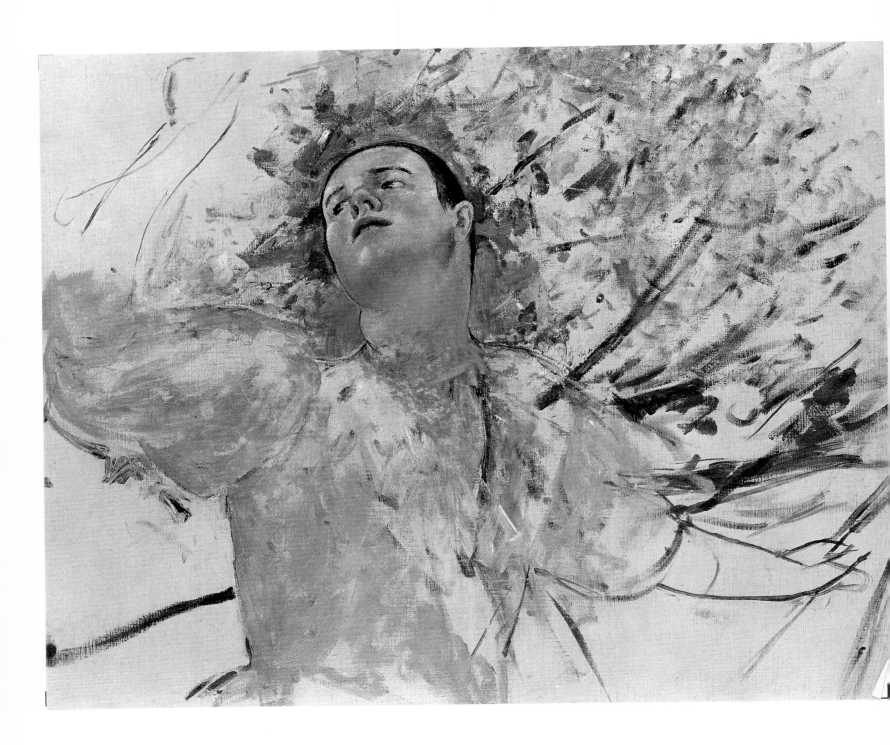

MARY CASSATT

A Catalogue Raisonné of the
Oils, Pastels, Watercolors, and Drawings

Adelyn Dohme Breeskin

SMITHSONIAN INSTITUTION PRESS
CITY OF WASHINGTON 1970

Copyright © 1970 by the Smithsonian Institution

All rights reserved

International Standard Book Number 0-87474-100-9

Library of Congress Catalog Card Number 73-104775

Distributed in the United Kingdom and Europe by
David & Charles (Publishers), Ltd., South Devon House,
Newton Abbot, Devon

Designed by Elizabeth Sur

Type set in England by Stephen Austin and Sons, Limited

Printed in the United States of America by Vinmar Lithographing Company

Color plates printed in Switzerland by the Imprimeries Réunies S.A.,
Lausanne

Frontispiece: Sketch of a Young Woman Picking Fruit, 1892. BrCR 212.

Contents

List of Color Plates

Lydia Reading the Morning Paper (No. 1), 1878. BrCR 51.

The Blue Room, 1878. BrCR 56.

The Nurse, 1878. BrCR 57.

Lydia Leaning on Her Arms, Seated in a Loge, 1879. BrCR 63.

Lydia Crocheting in the Garden at Marly, 1880. BrCR 98.

Susan Comforting the Baby (No. 2), c. 1881. BrCR 112.

Lydia Working at a Tapestry Frame, c. 1881. BrCR 115.

Susan on a Balcony Holding a Dog, 1883. BrCR 125.

Lady at a Tea Table, 1885. BrCR 139.

Emmie and Her Child, 1889. BrCR 156.

The Bath, 1892. BrCR 205.

Sketch of a Young Woman Picking Fruit, 1892. BrCR 212.

Two Sisters, 1896. BrCR 259.

Self-Portrait, c. 1880. BrCR 618.

Portrait of Herbert Jacoby, c. 1905. BrCR 914.

Introduction

As the only American in the great French Impressionist movement, Mary Cassatt holds a unique place in the history of art. When invited by Edgar Degas to join the group in 1877 she accepted with delight, as she later explained; "At last I could work in complete independence, without bothering about the eventual judgment of a jury."[1] Her personality was already distinctive; her special characteristics of style established.

Her indebtedness to Degas was nevertheless considerable since he criticized her efforts constantly during the early, formative years of her career and gave her his own high art standards to uphold. But he in turn owed much to her. Not only did she deeply appreciate his tremendous talents and lend him her criticism and praise, but she gave him a loyalty and a support which once drew from their mutual friend Camille Pissarro, when he was trying to interest his fellow artists in organizing another exhibition, the following remark: "Degas doesn't care, he doesn't have to sell, he will always have Miss Cassatt." Pissarro was correct. It was she who in his old age could not bear to see Degas living alone, neglected. She journeyed south to visit his niece and persuaded her to come to Paris to be with him. Throughout his life she gloried in his art, in his cultivated mind and spirit, in his frankness and biting wit.

Among many things that she learned from the study of his art was the true, lively conception of a subject which she interpreted in her maternity groups, her figure studies, and her portraits. The pose is always relaxed, the attitude natural, the feeling vivid and lively. The arrangement of her compositions is never stiff or static. There is a calmness and a structural clarity about them that is both strong and forceful. There is sometimes an implied movement and, as the critic Huysmans mentioned, "a ruffle of feminine nerves" which passes through her paintings, which is actually a deeply felt reaction to the subject, an active response to its true quality. Her sense of truth is such that a homely subject is portrayed without any alleviation of coarse features or lack of prettiness (in "Woman Holding a Zinnia" (198) for instance).[2] This attribute of honesty and integrity was one which the French mistook for awkwardness and lack of refinement. It was actually much the same thing that Degas insisted upon in portraying his little ballet girls. He showed them also just as they were when offstage, resting, or about to leave a rehearsal. In his work this was not so much resented since theatre subjects were further removed from the daily lives of the French people than were the young women and children with homely features and awkward poses portrayed by Mary Cassatt. She often preferred an unconventional pose, as we find in her early self-portrait (55) where she depicts herself leaning on her arm with her torso slanted on a strong diagonal. The pastel of her sister in a loge leaning forward on both arms (63) and the sprawling pose of the little girl in "The Blue Room" (56) are two good examples of such informality. All three of these works were executed under Degas' direct influence during 1879–80.

Degas and Miss Cassatt both found in Japanese prints many elements to which they responded, such as the asymmetry of composition based on the arabesque. In Mary Cassatt's drypoints this is most strikingly demonstrated, but throughout all of her work we find her preference for the off-center type of composition, with the balance subtly controlled and accents harmoniously placed. The foreshortening of the subject due to a high eye-level was another strong influence. An outstanding example of Miss Cassatt's use of this approach is in "The Bath" (205), her painting at the Art Institute of Chicago. In it the focus of attention is at the low center of the canvas, on the bowl of water toward which both the woman and the child are looking with their faces very much foreshortened. Her use of partial figures cut off by the frame also illustrates the influence of Japanese prints. This is demonstrated in "The Bath," where only three quarters of the pitcher seen at the lower right, and only a portion of the decorated bureau at the upper right are enough to establish them as important elements in the composition.

Her color sense, especially in her use of pastel, was greatly stimulated by Degas' example. Her brilliant use of gorgeous colors created an unfailing luminosity. Until her eyesight weakened she used lively contrasts of color for the most part, and in her backgrounds she usually preferred to intermingle diagonal strokes of contrasting colors. Complementary colors are juxtaposed, warm colors used with cool ones, darker areas with lighter tones, and sometimes—to add an oriental note, as in the background of the portrait of Mrs. Havemeyer (255)—she introduces a few delicate, small flower forms.

Having been so thoroughly coached in her early years directly and effectively by Degas, but also through her study of old masters and her absorption of the works of Manet and Courbet, Miss Cassatt was able to assert a complete style of her own which developed gradually and flourished throughout the 1880s and '90s.

It was only after the turn of the century, and after she returned from her trip to America, that the dividing of her interests resulted in a lessening of her talents. For the most part, she was mercilessly self-critical and did not attempt to push her work before the public. It took time, therefore, for the world to realize the full worth of this remarkable artist, whose honesty of vision was equalled by the brilliance and breadth of her technique, together with the refinement and elegance of taste which distinguishes her works.

During the years leading up to World War I, Miss Cassatt saw a great deal of the American banker, James Stillman, who lived in grand style in Parc Monçeau in Paris. Under her tutelage he became an art collector, and by the time of his death in 1918 he had accumulated 24 of her works as well as some by her fellow Impressionists. He once placed all 24 of her paintings and pastels on exhibition in his home and invited friends to come and enjoy them, whereupon Miss Cassatt wrote to Mrs. Havemeyer that she thought that they looked very well there and that "perhaps they are right who say I will survive."

After Mr. Stillman's death, his son Dr. Edwin Stillman gave 17 or 18 of these works by Miss Cassatt as an anonymous gift to the Metropolitan Museum. The museum, in turn, gave a number of them to various museums throughout the country, which helped to enhance the artist's reputation and to spread her fame.

Among the main American collectors of her work was Mr. Payson Thompson, who also owned all of 24 works by her, not including prints. Most of them were bought directly from the artist and were finally sold at auction in 1928. Other outstanding groups of her works belonged to the Havemeyers, Dikran Kelekian, Albert E. McVitty, Mrs. Montgomery Sears, and various members of the artist's family. Unfortunately, many French collections were scattered after the death of their owners. This occurred in the case of Roger-Marx, George Viau, Ambroise Vollard and others.

In this catalogue raisonné, 943 works are listed. I have traveled three times to Europe to find works by Miss Cassatt in private collections, especially in France, where the artist lived throughout her adult life. It has become increasingly difficult to find them since so many owners now want to remain unknown for one reason or another. I trust that after this volume is published more works will come to light. To date, as catalogued, the large majority of her works are in America. It was a pleasant surprise, however, to find a group of seven works, including four pastel counterproofs, in Belgrade, Yugoslavia. The story of their peregrinations is dramatic. Shortly before Ambroise Vollard's death, which occurred in 1939, he was visited by a Paris dealer of Yugoslavian Jewish birth whose name seems to have been Clomovich, who persuaded Vollard to let him take back to his native country a group of Impressionist works, including seven by Miss Cassatt. He promised to take them to Belgrade where the authorities would be willing to assign a special gallery for them which would bear Vollard's name. Vollard agreed and the Yugoslav, when the Nazis approached Paris, returned to his native

*A photograph of Mary Cassatt
taken in Paris in the early '80s*

Mary Stevenson Cassatt

village where he was routed out by Hitler's men and shot. But he had told his mother that the art works which he had brought were to go to the National Museum at Belgrade. Therefore, at the close of the war, she packed them in crates and started off by train to deliver them to their destination. The train was wrecked en route and the crates of paintings and pastels were stolen. After much searching, they were finally found and delivered to the museum in 1949. Some time ago, I wrote the National Museum in Belgrade to find out whether they had any Cassatts, and the reply came that there were none. The United States ambassador at that time, Mr. C. Burke Elbrick, is art-minded, however, and after hearing indirectly that some of her works were there, I appealed to him. With his persistent help the necessary photographs and data finally came.

In listing the collections through which the various works have passed, there are many gaps in the sequence of owners. Whenever we know that a transfer has been direct we have inserted "to." The last entry is that of the present owner and is italicized (unless it belongs to a dealer, in which case it is not italicized, since ownership is apt to be temporary unless the work is privately owned). Durand-Ruel's file and photograph numbers are included in every case where they are known to me as a clue to authenticity. The Durand-Ruels were Miss Cassatt's dealers throughout her long career in Paris and they kept a full accounting of all her works that passed through their hands. For the same reason the Mathilde X stamp or wax seal is mentioned wherever it appears on a work. This, too, is a means of identifying a work as definitely by the artist. Upon her death, she left to Mathilde Vallet, her companion-housekeeper, everything in her studio, as well as a closetful of things which Mathilde, a thrifty Alsatian, had saved through the years, including many which I feel sure that Miss Cassatt had thrown away.

When her nephew, Gardner Cassatt, went to the artist's home at Mesnil-Theribus to arrange for the sale of her estate, he found a closet packed with works which Mathilde Vallet told him Miss Cassatt had given her. He did not question this. As a result, many works have come on the market which are not up to the artistic standard which Miss Cassatt always maintained. In Mathilde Vallet's 1927 sale, which was entitled "Collection de Mademoiselle X," 91 paintings, pastels, watercolors, and drawings were sold. The catalogue listed each item with measurements in centimeters and there are ten illustrations. In the 1931 sale, entitled "Dessins, Pastels, Peintures, Études par Mary Cassatt," each item was marked either on the recto or verso with the Mathilde X collection stamp, although I have not been able to verify this in some of the photographs. The illustrated catalogue is divided into the various media, with 10 paintings, 13 pastels, 34 watercolors, and 116 drawings. Each one is given a title and catalogue number, but no measurements are given. There are 27 illustrations, but aside from those illustrated it is difficult to identify each item. With the help of a marked copy sent to me by Mr. Charles Durand-Ruel, I was able to record the measurements of at least those items which later passed through Durand-Ruel's hands.

Most of the titles given have been improvised by the author, since Miss Cassatt very seldom titled her works. Those that have been given were usually made up by the galleries exhibiting her work. The most obvious title was often the one chosen, such as "Mère et enfant." Since there are so many of them with this ambiguous designation, I have taken the liberty of retitling many to facilitate identification. Fortunately the names of some of the actual models who posed have been found and used wherever possible.

The measurements given of the various works must be considered merely approximate. In most cases, they were sent to me or were found on a photograph of the work.

Many times they were measured within the frame, in which case the word "sight" should have been added, but often was not. The measurements are given first in inches with height preceding width, then in centimeters. To make the two types of measurements absolutely accurate has proved difficult. In the case of a number of preparatory drawings for prints the dates of the drawings and those of the prints vary. In every case the date given to the drawing should stand and that of the prints which followed will be adjusted in the forthcoming second edition of *The Graphic Work of Mary Cassatt.*

The compilation of the catalogue has been the work of many years. When Durand-Ruel closed their New York branch gallery in 1950, I was able, with the help of Mr. William Davidson at M. Knoedler & Co., Inc., to obtain five thick volumes of photographs of Miss Cassatt's works which had passed through Durand-Ruel's hands. These photographs formed the basis of this catalogue. The question of when to call a catalogue raisonné finished must bother all authors who attempt them. One could go on throughout a lifetime and still have unresolved questions as to ownership, provenance, and many other problems. It seemed wiser to call a halt finally, knowing that at some later date supplementary information will have to be published.

The question of authenticity is a major problem. Miss Cassatt's signature is one that can be easily forged, and she was not apt to sign her name until she was about to sell or give away a work. Many of the large group of works sent to her family were never signed, and there are many other instances in which she either did not sign or else did so long after the work was completed. I have therefore included many unsigned works and have left out quite a number bearing her signature. The only criterion has been her particular artistic handwriting which, of course, developed gradually. The dating in most instances is approximate since she dated very few works. I have attempted to make the sequence in the catalogue, however, as chronologically correct as possible. Works on which information was received too late for them to be incorporated into the body of the catalogue have been put into an addenda section at the end of the book.

I am deeply indebted to many people for much help in the compilation of the catalogue. My deepest thanks go to Mrs. Horace Peters, who has stood by me as an alter ego, attending to many of the pesky details of organizing the necessary information and hunting down the whereabouts of owners and works. For the endless typing which the work demanded I am most indebted to Stephanie Belt and Tina Weiner. Research was also done by Christie Kayser, Marjorie Hoffer, and Joyce Keener. Georgia Rhoades has been a most thoughtful and efficient editor. I am also most appreciative of the help given by William Walker, the librarian of the National Collection of Fine Arts and National Portrait Gallery, and his excellent staff. I owe special thanks to Henry Gardiner formerly of the Philadelphia Museum of Art for answers to a number of questions as well as to Robert Schmit of Paris, who sent me photographs after contacting French owners of Miss Cassatt's work. I am also deeply indebted to M. Pierre Bisset of Paris, who turned over to me countless sketches which he made of Miss Cassatt's works and a very full bibliography and running text on the artist's life and work.

Dr. David Scott, Director of the National Collection of Fine Arts, 1964–1969, has been a most generous patron to whom I am deeply grateful for his interest and encouragement. Through the generosity of Mr. Lester Avnet the inclusion of many more color illustrations has been made possible. Mrs. Shirley Schlesinger was equally generous in helping with travel funds. To these and to many more kind people who have encouraged me in this work I extend my grateful thanks.

Notes 1 John Rewald, "The History of Impressionism," New York, The Museum of Modern
Art, 1946, p. 320.

2 Numbers in parentheses throughout the Introduction, Commentary, and Bio-
graphical Chronology are the catalogue numbers in this volume of the works in
question.

Commentary

One hundred years ago our country was very barren soil artistically speaking. Consequently, when Mary Cassatt in her early twenties decided to become an artist, she was forced to go to Europe to pursue her high ambition. She had already attended one of the very few established art schools in our country, the Pennsylvania Academy of the Fine Arts, and found the courses altogether uninspiring. Therefore, during the year of 1866 she embarked for France. She stayed in Paris with family friends and haunted the Louvre and other museums, studying the works of old masters and thus learning about art at its source.

Her schooling in Philadelphia had commenced with drawing from casts and still-life groups. After two or three years of this, she had been allowed to copy oil paintings hanging in the Academy. One in particular of which she copied a portion was "The Deliverance of Leyden" by Witkamp, a contemporary Dutch academician of no particular standing. She soon became convinced, however, that copying great paintings was the best way to learn the art of painting. In her later years she would show young aspiring students from America who came to visit her the only one of her copies which seems to have survived, "Copy after Frans Hals" (25), and tell them that in such works she gradually mastered the technique of painting.

After a few years abroad she began sending her paintings home to Philadelphia to be sold by a local framer and art dealer. Others she must have sold in France or else given them to friends. There are only a handful that have so far come to light from those first years of study abroad. To begin with, there is a rough sketch of the bent head of a fellow student (1), dashed off with a degree of spirited verve, though lacking any real assurance. Then there are two early pastels (2, 3) of a little brother and sister, one a sentimental tribute to companionship in loneliness, followed by an amateurish attempt at portraiture that was definitely made just to please. In comparison with the artist's later brilliant use of the pastel medium and her complete absence of sentimentality, these two very early works give an indication of how far she needed to progress.

After two years or so in Europe, she went on a sketching trip to the Haute Savoie region of France with Miss Gordon, a Philadelphia friend. Some sketches (4, 6, 7, 8) have survived from that trip which demonstrate a newfound interest in light and a breadth of treatment which anticipated her allegiance to Impressionism.

When news reached Philadelphia of the siege of Paris in the Franco-Prussian War of 1870, her parents insisted upon her coming home. It was just before leaving that she painted "Young Woman Standing by Railings" (9), a naive work of charm and sincerity. She brought back with her a number of canvases which she hoped to sell, for her father had insisted that if she wanted to continue her studies she must pay her own way —for studio, models, and materials. She took a number of her works with her on a trip to Chicago. She arrived there in time to be caught in the great fire of 1871, in which, unfortunately, these paintings were destroyed. The over-ambitious portrait of her nephew Eddie (12), however, was done during the year or so that she remained with her family in Philadelphia, as well as the very interesting and much more successful double sketch of her father and of Mrs. Currey (11).

Without doubt the budding artist in her was more than eager to return to Europe. Consequently, by 1872 she left this country and went at once to Parma, Italy, to study the works of Correggio and Parmigianino. "The Bacchante" (15), and the "Early Portrait" (16) which she inscribed to Carlo Raimondi, from whom she rented studio space while in Parma, both reflect her study of these two masters whom she continued to revere throughout her life. As late as 1913 she wrote that she hoped to go back to Italy to study Parmigianino's works again and to show what El Greco owed to him. She stayed for about eight months in Parma, working diligently. It is probable that she

took some lessons in printmaking from Raimondi, since he taught engraving and etching at the local Academy, techniques which she later used with remarkable aptitude. "The Bacchante" shows a close adherence to the youthful fresco style of Correggio in the convent of San Paolo, especially in her use of decorative vine leaves in the model's hair and the active pose of the figure. "The Mandolin Player" (17) is very much more somber and calm, but its softened contours derive also from those Parma studies.

From Rome she then sent off to the Paris Salon of 1872 the painting "On the Balcony During the Carnival" (18) about which her brother Aleck wrote as follows: "She [Mary] is in high spirits as her picture has been accepted for the annual exhibition in Paris . . . and not only has it been accepted but it has been hung on the 'line.' . . . Mary's art name is 'Mary Stevenson' under which name I suppose she expects to become famous, poor child."[1] In the light of such remarks one can surmise how difficult it was to make her family take her art seriously. Actually, they were never fully to appreciate her talents. Already in this Salon painting she showed marked ability. It is an academic painting, but of its kind altogether professional. The "Roman Girl" (19) which followed it is of a more blond palette, a courageous step away from the "brown sauce" to which the juries of the Salon were partial.

While in Spain, her attention was focused first on Velasquez, but before long Rubens delighted her even more with his warm flesh tones and brilliant use of color. In two important paintings executed while there, she responded to his influence and advanced in stature to new heights, first in "Torero and Young Girl" (22), accepted in the Salon of 1873, and with much more spirited results in the "Toreador" (23), a handsome canvas executed with true artistry—a Spanish idyll of marked significance in her development.

In order to further her study of Rubens she went next to Antwerp and also came under the spell of the Frans Hals painting of the "Meeting of the Officers of the Cluveniers-Doelen" at Haarlem, which she proceeded to copy (25), not slavishly line-for-line, but as a pentrating, yet summary, sketch, setting down the full flavor and character of the work without dwelling on any unimportant details. The original Hals painting measures $71\frac{3}{4} \times 104\frac{1}{8}$ inches. This copy is only about one-sixteenth that size, yet it captures all the color, composition, and quality of the original. One cannot help wishing that more of her copies had survived. Among her drawings there are a few small sketches marked as copies which date from this period, but there must have been many more which have disappeared together with numerous copies done on canvas.

Her mother came to visit her while she was in Antwerp in 1873 and a portrait (27) done of her there is a fine character study with the features strongly modeled and sensitively defined. The artist next proceeded to Paris, having probably talked over her plans with her mother, letting her know that she had, by that time, decided to stay in Europe and to settle there quite permanently.

It is of interest, I think, at this point, to divide her work at that time into canvases done for exhibition and less pretentious work done to sell to dealers. Having settled in Paris, she was visited by a friend from Philadelphia, a Mrs. Mitchell, who was eager and willing to act as her agent and to take her works back to be sold in the United States. Mrs. Mitchell also arranged for them to be shown in exhibitions at the National Academy of Design in New York and at the Pennsylvania Academy of the Fine Arts. There, in 1876, Miss Cassatt was represented by one or two portraits and by "A Musical Party" (29), a picture of sufficient quality to have attracted her Philadelphia dealer, Teubner, who wanted to keep it for himself. It went back to France, however, and has recently been given to the Petit Palais, where it can very well represent one of the early successful steps in her career.

Among the small paintings of 1874 she executed eight (30–35, 46–47) or more on

wood panels varying in size from quite small to medium size. The best of them is the "Portrait of Mme. Cortier" (35), which she sent to the Salon of 1874, where Degas saw it and remarked to a friend, Joseph Tourney: "It is true. There is someone who feels as I do."[2] It is indeed a fine portrait, glowing with warm, lively color and with vivid characterization.

In spite of her steady advancement, her family was convinced that she needed more instruction and persuaded her to study under a well-known teacher, Charles Chaplin. Eva Gonzales, Manet's only pupil, had worked under him and may have recommended him to Miss Cassatt. She allowed herself to be persuaded to attend his classes for a short time, but they proved very uncongenial to her, especially his painting of semi-nude models whose translucent, roseate flesh tones were extremely artificial, not in a class with those of her favored realist painter, Courbet. "Red-haired Nude, Seated" (37) was evidently painted while she was there. As though deliberately defying the academic studio routine, Miss Cassatt began to pose her models outdoors (39–43), and may have asked for Chaplin's criticism of some of them. She sent a seated three-quarter length model, painted in bright light and entitled "The Young Bride" (44), to the Salon of 1875, only to have it refused. She sensed that the reason for its rejection was its blond color; she toned it down with a dark background and it was accepted the following year. After one more attempt, she realized that her chosen art approach did not conform to the dictates of the Salon and decided not to exhibit there any longer.

Within the year she produced such splendid works that she was already an Impressionist by the time Degas and Tourney visited her in 1877 and asked her to join the group at that time called the Independents. She later told her friend Mrs. H. O. Havemeyer that ever since her arrival in Paris she had studied Degas' works in art shop windows, absorbing all that she could of his art, and to her biographer Achille Segard she said, "I had already recognized who were my true masters. I admired Manet, Courbet, and Degas. I hated conventional art. I began to live."[3]

In many of her early works, the influence of Courbet can be seen in her strict adherence to realism. In "A Musical Party" (29) the man in the background even resembles the handsome young Courbet. Most of all she admired that artist's insistence on contemporary subject matter, treating it objectively and truthfully. She, too, wanted to be of her own time and to portray it honestly, with deep insight and conviction. In later years she presented two of Courbet's paintings to the Pennsylvania, later Philadelphia, Museum of Art. She had sold a Cézanne to buy one of them and felt that she then had the greater work of art. At the time the Museum had no examples by Courbet and she considered it all-important that they should have him well represented.

Miss Cassatt's relationship with Edouard Manet was more personal, since they lived near each other, had mutual friends, and met from time to time during his later years until his death in 1883. Like Manet, she was an Impressionist only in the high key and luminosity of her color and in her insistence on the importance of light as it plays on objects. Three-dimensional form was important to both of them as well as contemporary subject matter. Her admiration for his painting can best be demonstrated by the many fine examples of his works which she was responsible for sending to our country, especially to the Havemeyer Collection now at the Metropolitan Museum.

She first met Mrs. H. O. Havemeyer as a young girl named Louisine Elder who was attending a fashionable boarding school in Paris run by an Italian friend of Miss Cassatt. She befriended this young girl, took her to exhibitions, and influenced her to buy the first of Degas' works to come to America. There were at the time at least two other American girls staying at the school, one of whom was Mary Ellison of Philadelphia. Miss Cassatt used her as a model on at least three different occasions. The portrait of

her embroidering (48) is an especially handsome painting done in 1877. Together with the portrait of the artist's father (49) and the charming painting, the "Reader" (50), this may very well have been among the canvases shown to Degas when he came to invite Miss Cassatt to join his group. There must have been an immediate rapport established between them, but just how close it was we may never know, since the extent of their relationship is hidden in mystery. The fact that she burned all of his letters to her before she died is significant. From the time they first met until he died in 1917, a span of 40 years, they managed to maintain a close friendship that was taken for granted by all who knew them. But their relationship changed constantly due to his vitriolic temperament. There were long periods during which their estrangement could be terminated only by mutual friends who would manage to bring them together again. Credit for their continued intimacy, in spite of such difficulties, must be given to Miss Cassatt, who used great self-control and tact in dealing with Degas' cantankerous nature. She recognized his superiority and had profound respect for his genius but at the same time maintained her own pride and personality. When working on her Chicago mural in 1891, she wrote to Mrs. Potter Palmer: "I have been half a dozen times on the point of asking Degas to come and see my work but if he happens to be in the mood he would demolish me so completely that I could never pick myself up in time to finish for the exhibition."[4] And yet she was a self-assured woman, stubborn and determined, indomitable and forceful. She knew only too well that the cost to her in self-control and strain was great, but it was as nothing compared to the value of knowing his genius, even though she had to admit that he was a disenchanted pessimist. She once said: "He dissolves one so that you feel after being with him: 'Oh, why try, since nothing can be done about it.' "[5] She, on the other hand, had a vibrant, optimistic disposition which must have contrasted acutely with his. Nevertheless, they had much in common. They belonged to the same social class and both were exceptionally cultivated, with high ideals and similar tastes. Also, both were intellectually attuned and felt that drawing was all-important to art. They were both urban painters, preferring portraits and figure painting to landscape, and they shared an uncompromising objectivity. It has been suggested that he was able to talk to her as he couldn't to a French-woman. His mother was a Creole from New Orleans, and this may have added to his sympathy for and understanding of the thoroughly American woman, Mary Cassatt. In 1872 he made a trip to New Orleans and wrote about it: "Everything attracts me here. I look at everything."[6]

Within a year after they first met Degas was giving her criticisms of her work, and we know that he actually worked on one of the most remarkable of her paintings, usually called "The Blue Room" (56). She wrote to Ambroise Vollard years later telling him that Degas not only liked the painting very much but actually had painted on it. The light coming through the two French doors onto the floor and the very bold shape made by the various upholstered furniture pieces as they cut off a fuller view of the floor are most likely his share in the work. The child lounging in the big chair is surely all hers.

Degas' plan to publish a journal in 1879 to which he and Miss Cassatt, as well as some others, were to contribute prints, certainly helped to cement their friendship. Even though the journal was never published, it served to accustom them to being constantly together and created the opportunity for mutual criticism.

From the year 1878 came her self-portrait (55) done in gouache which Mrs. Have-meyer later owned. It is done in the Impressionist manner, light-filled, informal, colorful, a work of great charm. Then followed a group of paintings and pastels of her sister and other models seated in a loge at the opera or the theater.

They are among her very best works linked with Impressionism. Her use of pure color in the pastel medium is comparable to the technique of Degas and Manet and I feel quite sure that she learned it from Degas. We know that he blew steam on a pastel work after sketching the outlines. In this way, he changed the pastel particles into a paste which he worked with brushes of various hardness. If the water vaporized on the pastel instead of forming a paste, he would obtain a wash which he could spread with a brush. Naturally, he was careful not to have the steam cover all of the work. In some places he kept the original paste and thus produced variegated effects in harmony with the various elements of the composition. In the later '90s he began blowing a layer of fixative on a first sketch made in pastel. Then he would work on it again; each time spreading another coat of fixative. In this way, the color notations were superimposed on one another. This method was surely used by Miss Cassatt. Degas also mixed oil paint diluted with turpentine with pastel, pastel with distemper on canvas, pastel with gouache—this last used mostly on fans. Miss Cassatt seems to have made one fan, but it has never been found. In a few of her early works, however, she used oil, pastel, and gouache in different combinations. Degas, and probably she too, used a fixative made for him by Chialiva, an artist of Italian origin who lived in Paris and painted mostly animal studies.[7]

The years between 1879 and 1882 were very happy times for Miss Cassatt. We can surmise this from the many delightfully bright, happy paintings and pastels of that period, including the different vivid renderings of young women at the opera, of which there are eight altogether, four in pastel. An oil of 1879, "Lydia in a Loge, Wearing a Pearl Necklace" (64), was in the fourth (and her first) Impressionist exhibition. It is fresh and luminous and depicts the effects of artificial light on flesh tones brilliantly. This figure is beautifully modeled with an ease of pose and warmth of glowing color which is entrancing and gay. In preparation for it, we find the pastel of "Lydia Leaning on Her Arms Seated in a Loge" (63), a delightful study, equally luminous and animated. To the Impressionist show of 1880 she sent a pastel of an auburn-haired young beauty (72) (seen in just head and shoulder length) holding an open fan. Gauguin also exhibited in that show and he liked this work so much that he asked Miss Cassatt for it, possibly in an exchange. When Gauguin's wife left him and went back to Copenhagen the picture went with her and she sold it. It later appeared in Berlin where it remained until 1930, and then came to the United States where it has remained in a private collection. It was possibly after studying this delightful work that Gauguin became convinced, and accordingly stated in comparing Berthe Morisot and Mary Cassatt, that Miss Cassatt had as much charm but more force. Huysman wrote about this same 1880 pastel: "In spite of her personality which is still not completely free, Miss Cassatt has nevertheless a curiosity, a special attraction, for a flutter of feminine nerves passes through her painting which is more poised, more calm, more able than that of Mme. Morizot, a pupil of Manet."[8]

The Boston Museum's "A Woman in Black at the Opera" (73) is another very strong work, also painted in 1880 together with the "Young Woman Buttoning Her White Glove" (74). From two years later comes "The Young Ladies in a Loge" (121). In the foreground is a blonde girl said to be the daughter of Miss Cassatt's friend, the poet Stéphane Mallarmé, and behind the large open fan is Mary Ellison once again.

Much other spirited work was done then by the rapidly developing artist. During these crucial years, Degas wrote to his friend Henri Rouart: "The Cassatts have come back from Marly; Mlle. is installed in a studio on the street level which seems to me is not very healthy. What she did in the country looks very well in studio light. It is much more firm and more noble than what she did last year."[9]

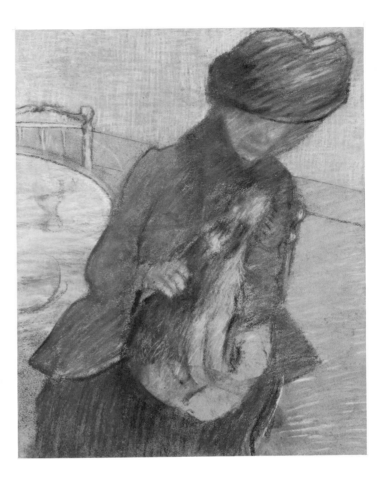

The works that gained such praise from this most severe critic certainly included the painting of "Lydia Crocheting in the Garden at Marly" (98), one of her strongest works of these early years. The color is especially distinguished, with the soft blues of the gown contrasted with the rich dark crimson of the coleuses in the flower bed behind Lydia and the handsome white accents of her bonnet. It is indeed an outstanding example of Miss Cassatt's kind of Impressionism, which never fractured the form nor used color in dots and dashes in the manner of some of her fellow artists.

"Five O'Clock Tea" (78) is another important work from these prolific years when she had not only the privilege of Degas' serious criticism but also that of his close friendship and deep admiration. The "Woman and Child Driving" (69) of 1879 shows his influence in many fascinating details. The partial view of the horse and gig, the groom whose humorous face is somewhat caricatured, and the intricate details of the harness, reins, and whip all reflect his teaching.

It was in 1880 that Miss Cassatt started her studies of mothers and children. "A Mother about to Wash Her Sleepy Child" (90), now at the Los Angeles County Museum of Art, is said to be the first on this theme, but there is also a charming pastel called "A Goodnight Hug" (88) done about the same time. During this year her nephews and nieces visited her for the first time, and from them came the stimulus to depict the very close and intimate relationship between mother and child which she had to observe second hand, having no children of her own. To be able to express the relationship without any sentimentality, with straightforward and unadulterated directness, was a gift which Degas, I feel sure, urged her to perfect; and perfect it she did. Just as Degas used his family and friends as subjects for portraiture, so did she. Having them at hand saved her time and effort so that she could concentrate on other aspects of her art. One very appealing work is "Lydia Working at a Tapestry Frame" (115), the last portrait of her sister, done about 1881. She died the following year after a long and painful illness.

There are many portraits from this early period which are noteworthy, including "Susan on a Balcony Holding a Dog" (125). It is a beautifully painted canvas, full of luminous color and Impressionist light, and is among the finest of her works, marking her steady progress. It leads on to the portrait of her mother entitled "Reading *Le*

Figaro" (128) of 1883 in which, once again, her use of creamy whites is exceptionally lovely. This portrait of her mother reading is in my opinion as handsome a work as she ever achieved. The painting of the whites of the dress and those of the newspaper is very subtle and varied in tone, and the composition is quite bold, with the angle of the paper acutely accented in its reflection in the mirror. Miss Cassatt, like Manet, was fascinated by the spatial dynamism of the mirror image, and mirror reflections are to be found in her work throughout her career.

Contrasting with the blond tonality of these two portraits is "Young Woman in Black" (129), which shows an allegiance to Manet as well as to Degas. The broad brush work of the costume is more like Manet, but the horizontal bands behind the head, the cutting off of the fan on the wall, and the pattern of the cretonne-covered armchair—even the use of the veil through which the features are seen—these are closer to Degas, who a year or so before had made a pastel sketch of Miss Cassatt seated by a table with a dog on her lap. In it she wears a heavier veil through which her features are seen somewhat blurred.

Although five years and more were to pass before Cassatt went a number of times with Degas and other friends to see the Japanese Exhibition at the École des Beaux-Arts, she seems already, between 1883 and 1885, to have become aware of certain phases of Japanese art which she accepted as valid and of special interest to her. We first find her use of the flattening of planes and emphasis on strongly linear contours in her great portrait of her cousin, Mrs. Riddle, which is now known as "Lady at the Tea Table" (139). The simply described dark shape of her gown is contrasted with the brilliantly sparkling blue Canton china across the foreground. The long-fingered hand holding the teapot is balanced by the lace ends of her cap and the strong line of her dark hair. The features are delicately suggested with very little three-dimensional form. Nevertheless, the individual character is set down with a directness and simplicity which marks the portrait as a "speaking likeness" as well as a powerful figure study.

At this point, Miss Cassatt seemed to assert a preference for the arabesque. We find it in many of the drypoints in which she concentrated on the heads and let the bodies of her models taper off into a graceful S-curve or a diagonal. In the painting "Girl Arranging Her Hair" (146) we see this tendency enter through the pose of the figure

with the left elbow high, the dark line of the head and the braid of hair ending in the hand holding the braid and the lower arm, forming a continuous S-curve. It is offset by the tilt of the head and the long line of the gown at the right. The solidly modeled figure contrasts with the decoratively conceived background of wallpaper, interestingly detailed bamboo chair and mirror frame, and washstand appurtenances. After a serious quarrel with Degas over the meaning of the word "style," Cassatt painted this picture to prove that she knew what style meant. She not only won her point, but Degas took the painting and kept it throughout his lifetime.

The last portrait of Miss Cassatt's mother (162) was painted about 1889. It is a noble work done with great insight and deep appreciation. The simple black shape of the gown held in by the whites of the shawl supports the beautifully rendered head resting on the well-formed hand. The character of this aging woman, who had for a long time been ailing with heart trouble and had only a few more years to live, is vividly described. The broadly sketched background, full of quick, nervous strokes, contrasts with the serene quietude of the figure.

Throughout these years of steady development Miss Cassatt painted many more mothers with their children. She preferred the simple peasant people who had the complete care of their babies rather than the more worldly women who delegated most of the child's care to nursemaids. When painting these more detached mothers she portrayed the relationship as it was. "Mme. H. de Fleury and her Child" (175) is an example, and also "Portrait of a Frenchwoman and Her Son" (479) of 1906. In the pastel called "At the Window" (179), it is definitely a nurse bringing the baby from his bath, whereas in "Emmie and Her Child" (156) the relationship is that of a country mother and her little girl. Equally delightful works in pastel are one which is now bequeathed to the Louvre (154) and another in which the contrast of pattern and flat color is even more definitely inspired by the Japanese (219). Added to this strong influence one can sense her solid draftsmanship, skillful interpretation of flesh and costumes, profound sentiment, and true gestures.

By 1890 Miss Cassatt had departed from an Impressionist approach in order to place greater emphasis on form and design. Her color became more focused and was used more for accents in specific areas. Little or no tumultuous action is to be found in her work as a whole. There is a sense of calm restraint and dignity, which to the more demonstrative

French people suggested aloofness and to the average viewer of that era appeared as lacking the preferred sentimentality. Interspersed with dozens of variations on the maternal theme we find not only portraits but also some very charming figure studies of young women. In summing up Miss Cassatt's complete works there are more pastels than oils and more portraits and figure studies of women than there are of mothers and children. It is only because of her unique approach to the maternity theme that she is known primarily as a painter of mothers and children.

In 1892 she concentrated for long months on her mural (213) for the World's Columbian Exposition at Chicago. It was to decorate the south tympanum in the Woman's Building, and the theme assigned to her was "Modern Woman." Mrs. Mary Fairchild MacMonnies was given the theme of "Primitive Woman" for the north tympanum. Miss Cassatt divided her composition into three parts separated by wide floral borders, interrupted by circles in which naked babies were pictured tossing fruit (215). She wrote that she went to the East for this idea of the border, but surely it derived from Correggio as well. For the large central area she chose as her subject "Young Women Plucking the Fruits of Knowledge and Science" (214). The fruit trees extend far back over a broad green meadow and the young women and children are seen under the trees busily collecting apples and cherries. The left panel, "Young Girls Pursuing Fame" (213), is more symbolic since fame is shown as a nude girl high in the air pursued by a group of three girls with outstretched arms who run forward followed by quacking ducks. The right-hand panel (213) is devoted to the arts of music and dancing. There are two seated figures, one with a banjo, one singing, while a third figure stands before them holding up her wide skirt, dancing. This mural was not well received and was evidently destroyed or, in any case, lost after the close of the exposition. It surely deserved much better treatment. Miss Cassatt, in describing it in a letter to Mrs. Potter Palmer, who had chosen her for the commission, wrote: "I have tried to make the general effect as bright, as gay, as amusing as possible. The occasion is one of rejoicing, a great National fête. I reserved all of the seriousness for the execution, for the drawing and painting. My ideal would have been one of those admirable old tapestries, brilliant yet soft."[10] Only one sketch (212) connected with the mural has so far come to light, and it is indeed bright and gay—a lovely, sun-filled study for the left-hand figure in the central group, pulling down a branch of the apple tree.

About a year before starting the mural Miss Cassatt had created a group of ten color prints which were then shown in her first one-man exhibition at Durand-Ruel in Paris in 1891. They were done, so she wrote, "with the intention of attempting an imitation of Japanese methods. Of course I abandoned that somewhat after the first plate and tried more for atmosphere."[11] In all of them linear delineation is of primary importance, offset by broad, flat patterns. The viewpoint is often from an unusually high level. Her absorption of such Japanese influences was so thoroughly studied and so completely understood that they became a part of her own artistic expression. We find them used throughout the Chicago mural as well. The figures stand out against the background with their contours sharply defined. The patterns of dresses, whether floral or striped, are flattened for decorative effect and the viewpoint is from above as though seen from a high ladder. She never was a landscape painter, but she depicted the sunny orchard with unusual skill while keeping the two side panels much flatter. The coloring was vivid throughout since that seemed necessary in order to be entirely visible from such a height. The mural was actually placed 40 feet above the floor where it must have been difficult to see it at all. The central section, however, was shown to the Durand-Ruel brothers before it left Paris and it received much praise from them.

Connected with the mural, but not actually a sketch for it, is "Nude Baby Reaching for an Apple" (216). The artist was at this time at the very height of her powers, having

mastered the art of drawing as few of her peers had managed or cared to do. She gloried in the success of such sunny, happy works as this beautiful, healthy, sturdy baby on his mother's arm reaching up to pick some of the abundant fruit which fills the upper background of the picture. The same baby is seen in an exotic and decorative pastel entitled "In the Garden" (221), which is covered with a variety of orientally inspired patterns, except for the two startling, dark areas of the child's black-stockinged legs and feet and the mother's very full upper sleeve. The most significant painting related to her unique color prints, however, is "The Bath" (205) in the Art Institute of Chicago. Here we find the full gamut of her very subtle transference of Japanese print qualities achieving a rich blend of patterns, color contrasts, flattening of spaces, harmonious rhythms, and overall beauty of design and subject that sums up her most successful absorption of Japanese methods.

Wintering in Antibes in 1893–94, after the extensive days of very hard work necessary for both the color prints and the mural, Miss Cassatt was glad to relax. She then produced "The Boating Party" (230), one of her largest canvases aside from the mural. It, too, is full of air and sun and brilliantly contrasts the dark solid back of the oarsman with the light-filled figures of the mother and child against the bright blue water. Without doubt she was guided to this subject by the Manet painting of 1874 called "In a Boat," which she knew well and persuaded the Havemeyers to buy for their collection.

"Summertime" (240) is another delightful work depicting a boating party filled with sunshine with bright accents of ducks in the water, whereas "In the Park" (239) features a nurse and child in a sunny outdoors scene with bright flower beds behind them. There are also from this year a number of splendid portraits; one of a distant cousin, young Margaret Sloane (220); one of her nephew, Gardner, called "The Sailor Boy" (208); one of Mrs. Havemeyer with her daughter Electra (248); and then the "Little Infanta" of her niece, also called "Ellen Mary Cassatt in a White Coat" (258). This last was done in oils; and three others are pastels. She used the two media interchangeably and was able to get equally solid, finished works from either medium. This was true also among her maternity subjects. "The Peasant Mother and Child" (232) and "Woman from Martinique and her Child" (223) are both pastels, both solidly constructed, but whereas the former is well finished and completely articulated throughout, the latter is much more of a sketch with sections drawn only in outline. We find among her pastels everything from a very slight sketch to a very finished work, whereas among her oils, with few exceptions, they are thoroughly completed works. A few of the exceptions, however, are worth noting since there is a short-hand eloquence about them that makes them outstanding. This is true of the "Study of Mrs. Clement B. Newbold" (288) and "Sleeping Baby at Mother's Breast" (310).

During the closing years of the century the artist continued to concentrate unremittingly on her work until the end of 1898. She produced at least thirteen subjects of mothers and children in the year 1897 alone, twelve of them in pastel, only one in oil. She was preparing for a journey home to America and had decided to take only her pastels with her. Typical of the group of pastels from the year before her journey is "Two Sisters" (259), and especially alluring is the oil called "Breakfast in Bed" (275), with its interesting arrangement of arms and legs against the brilliant white of the sheet and pillow and the bright green of the bed and stand. The well-rounded forms of the limbs are achieved with close, parallel brush strokes which follow the form and stress its solidity with remarkable force.

The trip home was very exciting for the artist. The last time she had seen her native country was in 1872. One reason for such a long interim was her dread of the ocean since it made her really ill. Another reason was her conviction that an artist needed to

work in a fixed environment and not change it very often, and a third was the fact that until her mother died in 1895 her parents as ailing, old people, needed her near them. With the success of the Durand-Ruel exhibitions behind her—two in Paris and one in New York—and no close family ties to keep her any longer rooted to Paris and its environs, she crossed the dreaded ocean late in the autumn of 1898 and came home to see her many relatives and good friends. She first went to stay with her brother Gardner and his family. She felt more at home there than with her older brother Alexander since his wife and the artist had never been on friendly terms. While at the Gardner Cassatts' home outside of Philadelphia she made more charming likenesses of the children, Ellen Mary and young Gardner (286, 287, 302). Next she went to Boston to do portraits of the Hammond children, one of the daughter Frances (295), and another of the two little boys together (294). While at work on the latter she happened upon the older boy going out onto the Boston Common with his nurse. He was dressed in a green coat and tricorn hat, and Miss Cassatt was so delighted with his appearance that she did a pastel (293) of him alone and presented it to his parents. She visited other friends, including the Whittemore family, and did various pastel portraits. Among them the one of "A Grand Lady (Mrs. John Howard Whittemore)" (297) stands out, as well as the "Grandmother and Grandson" (296).

Back in Paris again during the spring of 1899 her good friends, who were also her dealers, Messrs. Charles, Joseph, and Georges Durand-Ruel, arranged to have her do a portrait of their sister Mme. Aude and her two little girls (307). This proved to be a very strong, well-integrated work in pastel. It again contains evidence of her fine drafts- manship, her emphasis on strong contours and outlines, her concentration on the indi- vidual portraits, and her well-organized composition. Close to it in date and general approach is "Mrs. Meerson and Her Daughter" (308), which is another successful group portrait done with consummate skill.

She soon returned to her more customary maternal subjects, introducing a number of nursing mothers. Among them is a sketch of a baby alone who has fallen asleep while nursing (310). It is a sketch done with freedom and dash, a delightful impression, both truthful and full of instantaneous perception.

After 1900 a lighter touch appeared in her work. There was a rhythmic ease born partly of confidence but also reflecting less of the essence of her character and her strong personality. She seemed then to prefer working with somewhat older children and later remarked: "It is not worthwhile to waste one's time over little children under three who are spoiled and absolutely refuse to allow themselves to be amused and are very cross, like most spoiled children. It is not a good age, too young and too old, for babies held in the arms pose very well."[12] Among the older children she now chose Jules, a young boy of six or seven years, of whom she did more than five studies. One of him called "The Oval Mirror" (338) brought forth praise from Degas, who went over all of the details of the picture with her and expressed great admiration for it and then, as if regretting what he had said in praising it, relentlessly added that it was a little Jesus with his English nurse. Of greater interest, in my opinion, is "The Garden Lecture" (343), although even here one begins to feel a lack of complete concentration. The faces are modeled with care but the hands are not, although they are an important element in the composition. Of more consistent quality is "Mother and Daughter, Both Wearing Large Hats" (345) which is colorful and very well composed.

It was in 1901 that Miss Cassatt joined Mr. and Mrs. Havemeyer for a trip to Italy and Spain to gather art for the Havemeyer's collection. She was ambitious to see great art of the present and the past reach American collections, and this diverted her from giving full attention to her own work. Consequently her art suffered. It is rather amazing

that in spite of this dividing of her interests the artist was able to complete so many canvases and pastels. Those many studies of little blonde Sara date mostly from that year (at least 25, interspersed with other studies posed with a mother and baby). Of these the culminating one is the pastel "After the Bath" (384) in the Cleveland Museum of Art. In 1902 when she was in her late fifties, she produced "The Caress" (393) which she considered her most important painting of the first years of this century. It was Durand-Ruel who sent it to the Pennsylvania Academy for their 73rd annual exhibition where it was awarded the Lippincott Prize, which she refused. She wrote of her refusal as follows: "I was one of the original 'Independents'[13] who founded a society where there was to be no jury, no medals, no awards. This was in protest against the government salons, and amongst the artists were Monet, Degas, Pissarro, Mme. Morisot, Sisley and I. This was in 1879, and since then we none of us have sent to any official exhibitions and have stuck to the original tenets. You see therefore that it is impossible for me to accept what has been flatteringly offered to me."[14]

The model used in "The Caress" (393) was Reine Lefebvre, who figured in many compositions both in oil and pastel during 1902 and 1903. The quick sketch of her head (395) is to me among Cassatt's most delightful sketches. Of many renderings of a little dark-haired girl, Margot Lux, the best is in "Young Mother Sewing" (415), a sunny painting in which the artist seems to recall the approach that she used in painting her mural. Somewhat less successful, but nevertheless charming, is a study of Margot usually entitled "Spring" (424). In 1903 the artist used another little blonde model about sixteen times, mostly alone, seated, wearing various bonnets and dresses. Typical of them is "Simone in a White Bonnet Seated with Clasped Hands (No. 3)" (441).

At some time during the early 1900s the dealer Ambroise Vollard approached Miss Cassatt offering to purchase some of the many pastels of these little girls if she would allow him to have counterproofs made of them which she would then finish. She evidently agreed to do so and the story of the counterproofs is a very interesting one. As far as I can ascertain they first appeared on the American market in the 1950s. After seeing a few and being puzzled by them, I learned from Henri Petiet in Paris that Ambroise Vollard did buy a group of at least 13 pastels and then persuaded the artist to allow him to have counterproofs made of them. This was done by the Paris lithographic printer Clot. He ran them through his press with a sheet of somewhat dampened paper over them so that some of the pastel came off onto the dampened sheet. Miss Cassatt's pastel technique was very much like Degas'. The pastel was applied very thickly with some parts steamed to make it penetrate farther into the paper. Consequently, the pastel was sufficiently thick so that even when some was taken off onto another sheet there was still plenty of it left. However, as M. Petiet told the story to me, Ambroise Vollard then persuaded Miss Cassatt to rework both the original, in case too much pastel was then missing from parts of it, and the counterproof which, of course, was the mirror image of the original. Four of the 13 counterproofs have found their way to the National Museum in Belgrade, Yugoslavia, and they were seemingly never reworked thoroughly. In all four cases Miss Cassatt's original signature at the lower right appears on the counterproofs in reverse at the left. The four originals have had finishing touches added, however, darkening of shadows on the hair, detailing of costumes, darkening of eyes, adding of enclosing lines, etc. In the case of "Nicolle and Her Mother" (326) much more extensive shading was added to the background of the original.

If it is true that Vollard persuaded Miss Cassatt to do all of the rework on both the originals and the counterproofs, then both are originals and the signatures which were added were added by her. In all cases so far studied, however, the first original is the

better of the two, with richer and more varied color and fewer rough, crude lines. It is easy to identify the counterproofs as such since Miss Cassatt was entirely a right-handed artist. Her lines of shading usually went from upper right to lower left. Repeated lines of shading from upper left to lower right therefore signify a counterproof.

The group of pastels from which the counterproofs were made are dated between 1889 and 1903. Just when the counterproofs were made we cannot determine. M. Petiet thinks that it was shortly after 1900, but since the counterproofing of all of them was done probably at the same time it must have occurred at some date after 1903 when the last of the originals was completed. We know that the artist sold a lot of her work to Vollard in 1906 and that may very well be the date for the counterproofs. It has seemed better, however, not to try to assign even an approximate date to them.

At the same time that these counterproofs were made, Vollard also had some counterproofs made of pastels by Renoir and Degas. It has been suggested that the idea was eventually to lithograph the counterproofs but, at least in the case of the Cassatts, this was never done. The 13 counterproofs are numbered as follows: 270, 313, 327, 365, 374, 376, 382, 427, 429, 439, 446, 449, 459.

Following this duplication of her pastels—mostly of little girls for which there was beginning to be a demand—the artist turned to more serious painting. The oil sketch of her niece, Ellen Mary (467), was done in 1905 as well as studies of her mother as a young girl (468, 469), evidently inspired by a daguerreotype. It must have intrigued her to take such a dated work of another era and make of it a contemporary study. Then, too, she had a new challenge in an invitation to do murals for the woman's lounge of the Harrisburg, Pennsylvania, statehouse, which was in the process of being built. She decided to do a group of tondo paintings to be hung over the doorways. We know that she completed two of them (471, 472), but she never carried out this assignment since she heard that there was much graft connected with the entire building and therefore would have nothing more to do with it.

The paintings of mothers and children continued, together with some portraits of friends. In 1908 she did a series of a mother with two children, one of which is still in the Cassatt family (502); another is in the White House collection at Washington (501). Among the portraits there are some of a neighbor's little girl about whom the artist wrote to Mrs. Havemeyer in October 1910: "I am just finishing a little portrait [584] of my neighbor's little girl. He already has one in pastels of her [552] and another with her mother and little brother [554]. He does so love this child who is very pretty and a nice child and begged me to paint her this time. If all sitters were like her it would not be hard."[15]

She also did some portraits of Dikran Kelekian's son and daughter (511, 512, 570). He was a good friend whom she saw again in Egypt when she went there with her brother Gardner and his family in 1911. She respected Kelekian as a very knowledgeable connoisseur of Near Eastern Art and bought some handsome Persian manuscripts from him; he in turn owned some of her finest early paintings. He wrote about her in 1939: "She was very discerning and I had the most profound respect for her, because I have never seen an artist with such a comprehensive knowledge of the art of all periods, combined with such an exquisite taste. We did not always agree, of course, for she had no use for Lautrec and others whose work I love to have, but it was not her eyes that were at fault; I think that she really objected only to his subject matter since she was really still a little bit a 19th-century American Lady."[16]

In about 1908 her painting technique seemed to change somewhat and she applied her paint more thickly. This is evident in "Mother and Child in a Boat" (524) and with some of the seven studies in preparation for it. It is less apparent in the oil studies

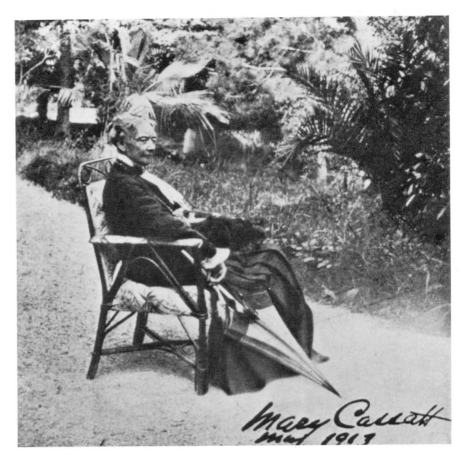

A photograph of Miss Cassatt, 1913, taken in her garden at Chateau de Beaufresne, Mesnil-Theribus, Oise

of the series of the model Françoise, of which there are fourteen (525–38) altogether in oil and pastel. But in many of the later oils there is a lack of precision in drawing and a roughness of brush work that weakens them considerably. This is true of "Mother and Child Smiling at Each Other" (506–08) and even more so of the painting of "Two Mothers and Their Nude Children in a Boat" (580) of 1910. Miss Cassatt was by then 66 years old. She had always been very strong physically, with much vitality and no visible sign of aging. It was said of her that her physique was as rugged as her will was strong. She was tall, thin, very aristocratic and usually dressed in black, as we see her in the photograph taken for Segard's biography in 1912. But after the disastrous trip to Egypt, as a result of which her brother Gardner died, she had a discouraging and barren time for almost two years. She was ill and depressed and did no work at all during a part of 1911 and 1912. She was also losing her eyesight. It was then that her biographer, Achille Segard, visited her while working on his book, and thought that her days of active work were over. In 1913, however, she made what can be considered a valiant effort to resume her career. The work which she accomplished in 1913 and 1914 is all in pastel. Because of her blurred vision, due to cataracts which became inoperable, her sense of color dimmed. The colors became increasingly harsh and strident, which hampers the quality in every case, and yet she thought that they were her very best works. Two of them went into the Havemeyer collection and are now at the Metropolitan Museum (599, 600). After this last spurt of work she stopped entirely but lived on alone throughout World War I, staying mostly at Grasse on the Riviera. Her loyal companion-maid, Mathilde Vallet, a German Alsatian, was interned for some time, although Miss Cassatt had ferreted her away to Northern Italy at the start of the war. During the last years of her life Mathilde was her mainstay, having been off and on in her service for over 40 years. Upon the artist's death in 1926 she left all the art works in her studio to this faithful companion.

Aside from Miss Cassatt's work in painting and pastel, her watercolors and drawings must also be considered, although neither of these media seems to have been as sympathetic to her as painting, pastel, or printmaking. Among the watercolors so far found, the early self-portrait (618) is a vivid work as revealing in its way as the gouache of the same year. Many of the sketches of mothers and children are mere notes for possible

compositions. Two of them (622, 623), carried farther than most, are studies for the painting in the Cincinnati Art Museum (153). Another group, including nine sketches (637–46), were all done in preparation for the White House painting (501) or for "Children Playing with a Dog" (502), owned in the Cassatt family. Included are sketches of individual heads of the mother and of the little girl as well as both of them together, and finally of the group of three. Of the model Françoise there are eleven studies (652–62), the most interesting being the two studies of her sewing. In the three sketches (679–81) for the Petit Palais painting of "Two Mothers and Their Nude Children in a Boat," the interest is centered on the broadly treated mapping of the composition.

Miss Cassatt's drawings stand as a fascinating survey of her entire career. Starting with her first hesitant attempts they continue to grow constantly more assured and in some cases attain a fine degree of brilliancy, as in the study (818) for "Young Women Picking Fruit" and the study (777) for the baby in "The Family." For the most part they are working drawings for works in other media, especially for prints. Many were used for getting a drawing onto a plate covered with soft ground, usually a tallow ground. Over this grounded plate was spread a sheet of drawing paper on which the artist had sketched a design, then the design was redrawn and the firm pressure of the pencil caused the soft ground to adhere to the back, or verso, of the paper so that it pulled away from the metal plate when the paper was lifted off. The soft ground thus adhering to the paper is a brown color which can be seen on the back of many of Miss Cassatt's drawings, and in some cases the color even shows on the top or recto side of the paper in spots (see 716 and 717).

In many of these working drawings the paper has been folded around a copper plate. In those cases the measurements have been taken to the edges of the folds. In some instances the soft-ground prints, usually used with aquatint, exist and can be compared with the drawings; but with many others no prints have been found so far that relate to the drawings. We may conclude, therefore, that after setting the drawing onto the plate the artist decided not to finish the print. Many of these working drawings are in the collection of Henri Petiet, who obtained them from Ambroise Vollard, who, in turn, received them from the artist. Most of them date from the 1880s, during her most interesting formative years.

Another group of the soft-ground drawings (800–16, 820) was used in the formation of Miss Cassatt's great series of color prints, ten of which were done for her first Durand-Ruel one-man show of 1891. For some of them there are two or more preparatory sketches before the drawing that was used to put the soft-ground lines onto the plate. These are all strong drawings, full of vitality and a quality of line that is absolutely sure and decisive. They were done when she was at the height of her powers, and they are masterworks, as are the great color prints of which they were a part. The finest of the entire group of color prints was "The Toilette," and it is strange that for that print no drawings have so far been found. It was in connection with this print that Degas is supposed to have remarked that he would not admit that a woman could draw that well. There are also no sketches with color notations for any of the series of color prints. This means either that she destroyed them, that they have been lost, or that she never made any, which is quite possible since, with her remarkable visual memory, she could easily have envisioned the color areas and retained the color composition in her mind.

For some of her later drypoints there are also preparatory drawings which were used to place the design onto the copper plate. On the backs of these we sometimes find blue tracing-paper marks. There are not as many portrait sketches among her drawings as one might expect. Aside from those of her mother, her father, and of young Robert we

find very few. Worth studying, however, are the three drawings (855–57) of Mme. Ley Fontvielle, a spiritualist medium. The first of these is a very lively quick sketch. The second is a working drawing for a drypoint, and the third a more finished drawing, done very carefully, and which, without doubt, was a good likeness. The three drawings of Katharine Kelso Cassatt as a young girl (911–13) are also of special interest. They are studies for the painting which the artist did in 1905.

There are three drawings (923–25) for the White House painting of the "Mother Looking Down, Embracing Both of Her Children" as well as the nine watercolor sketches, which indicates that the artist concentrated on that painting, considering it a milestone in her career. The drawings, however, show the weaknesses which became constantly more pronounced until in the last drawings of 1913 it is easy to see why she was forced by her lack of eyesight to stop working entirely within the ensuing year.

She lived through the remaining twelve years of her long life interesting herself in politics, advising young art students and insisting proudly in spite of her deep appreciation of France and its rich traditions that she was American, thoroughly American.

Notes

1 Julia Carson, 1966, p. 9.

2 Christian Brinton, "A Glance in Retrospect," catalogue of an exhibition, "Mary Cassatt" (The Union, Haverford College, 1939).

3 Achille Segard, 1913, p. 8.

4 Julia Carson, 1966, p. 98.

5 Br., p. 15.

6 From a letter by Degas written from New Orleans in 1873. "Lettres de Degas," in *Bulletin de l'art ancien et moderne*, June, 1931, p. 317.

7 Denis Rouart, *Degas à la recherche de sa technique*, Paris, Floury, 1945, p. 22.

8 Frederick A. Sweet, 1966, p. 51.

9 Ibid., p. 57.

10 Julia Carson, 1966, p. 97.

11 Unpublished letter to Mr. Weitenkampf, 18 May 1906, New York Public Library.

12 Unpublished letter to Mrs. H. O. Havemeyer, 8 March 1909, owned in the Havemeyer family.

13 Both Degas and Cassatt wanted to call their struggling group of advanced painters the Independents rather than the Impressionists, but the latter title, introduced in scorn, has continued to be used to describe them.

14 Julia Carson, 1966, p. 132.

15 Unpublished letter to Mrs. H. O. Havemeyer, 24 October 1910, owned in the Havemeyer family.

16 *Art News Annual*, 1939, vol. 37, no. 2 (1939), p. 68.

Biographical Chronology

1844 Born 22 May at Allegheny City, Pennsylvania (now a part of Pittsburgh), second daughter of Mr. and Mrs. Robert Simpson Cassatt.

1851–58 With her family in Paris, Heidelberg, and Darmstadt. Her brother Robbie needed the help of specialists for a disease of the knee joint, and the oldest child, Alexander, wanted the superior schooling for his future engineering career. Mary, in turn, learned both French and German at an early age.

1855 Robbie died at Darmstadt.

1858–68 With her family in Philadelphia.

1861–65 Studied at the Pennsylvania Academy of the Fine Arts.

1866–67 With her mother to Europe.

1868–70 To France to study in the museums. She took sketching trips, including one to the Haute-Savoie region in 1869.

1870–71 To Philadelphia to be with her family during the Franco–Prussian War.

1872 To Parma, Italy, where she concentrated on the study of the paintings of Correggio and Parmagianino. Also studied graphic techniques with Carlo Raimondi. Sent her first painting, "On the Balcony During the Carnival" (18) to the Paris Salon.

1873 Studied at the Prado, Madrid, and at Seville, from where she sent a second painting to the Salon ("Torero and Young Girl") (22). Then on to Belgium and Holland and to Paris again.

1874 Sent her third painting, "Portrait of Mme. Cortier" (35), to the Paris Salon from Rome. Her first two Salon paintings sent for exhibition at the National Academy of Design in New York.

1875 Persuaded by her family to go to the studio of Charles Chaplin. She found his instruction antipathetic and soon left.

1877 Her parents and her sister, Lydia, came to Paris to live with her. Degas invited her to join the group then called "The Independents."

1879 Sent her first light-filled paintings to the exhibition of the Society of American Artists— probably the first impressionist paintings shown in America. Showed "Lydia in a Loge, wearing a Pearl Necklace" (64) and "The Cup of Tea" (65) at the Fourth Impressionist Exhibition.

1880 Showed the pastel later belonging to Gauguin (72) at the Fifth Impressionist Exhibition. Her older brother Alexander brought his family for a long visit, and she charmed his children into posing for her. They all spent the summer at Marly-le-Roi in a villa next to that of Edouard Manet.

1881 Showed the portrait of her sister "Lydia Crocheting in the Garden at Marly" (98) at the Sixth Impressionist Exhibition.

1882 Following Degas' lead she would not show her work in the Seventh Impressionist Exhibition. Her sister Lydia died.

1883 Her brother Gardner brought his bride to visit the family in Paris. Three of her works were exhibited at Dowdeswell's in London in an exhibition by members of the Impressionist group.

1884 To Spain with her mother.

1886	Showed "Girl Arranging her Hair" (146) in the Eighth and last Impressionist Exhibition.
1887	The family moved to the apartment and studio at 10 rue Marignan which she kept for the rest of her life.
1890	She visited the great Japanese print exhibition at the École des Beaux-Arts in Paris with Degas and other friends.
1890–91	She rented the Chateau Bachivillers on the Oise for the summer and fall. She set up her etching press there and worked on the set of ten color prints.
1891	In April she had her first one-man show at Galerie Durand-Ruel, Paris. It included the set of ten color prints as well as two oils and two pastels. They were "The Quiet Time" (151), "Baby's First Caress" (189), "Hélène of Septeuil" (185) and one other mother and child subject. Her father died on 9 December.
1892	Mrs. Potter Palmer commissioned her to do a large mural for the World Columbian Exposition at Chicago. She completed it at Chateau Bachivillers.
1893	In November–December she had a much larger, more comprehensive one-man exhibition at Galerie Durand-Ruel, Paris, including 16 oils, 14 pastels, the series of ten color prints with four more added, as well as the set of 12 drypoints, 38 other drypoints, and one lithograph. She bought the Chateau Beaufresne at Mesnil-Theribus, Oise, 27 miles from Paris. It was her summer home for the rest of her life.
1895	In April her mother died. Durand-Ruel organized a Cassatt exhibition in New York, with 26 paintings, 9 pastels, 1 gouache, and 18 prints.
1898–99	Her first visit to America since settling in Paris in 1874. She visited her family and many friends.
1901	Accompanied the Havemeyers to Italy and Spain and encouraged them to buy El Grecos, Manets, and other great paintings that were later given to the Metropolitan Museum.
1903	One-man exhibition at Durand-Ruel, New York, with 15 paintings, 10 pastels.
1904	A short trip to America. Guest of honor at the opening of the annual American exhibition at the Art Institute of Chicago. Made a Chevalier of the Legion of Honor.
1905	Competed for a mural for the new capitol at Harrisburg, Pennsylvania, but withdrew upon hearing of graft there. Death of her brother Alexander, formerly president of the Pennsylvania Railroad.
1907–08	Six works shown at Manchester, England, in a group show of French Impressionists.
1908–09	Last visit to America.
1910–11	To Egypt with the Gardner Cassatts. Death of Gardner.
1911–12	First operation for cataracts of both eyes.
1914	Awarded Gold Medal of Honor by the Pennsylvania Academy of the Fine Arts. Stopped painting due to progressive blindness. During World War I she spent most of her time in Grasse on the Riviera where she often visited the aging Renoir.
1926	Died at Chateau Beaufresne on 14 June.

Abbreviations

†	No photograph available.
Br	Breeskin, Adelyn D. *The Graphic Work of Mary Cassatt: A Catalogue Raisonné*. New York: H. Bittner, 1948.
BrCR	Breeskin, Adelyn D. *Mary Cassatt: A Catalogue Raisonné of the Oils, Pastels, Watercolors, and Drawings*. Washington, D.C.: Smithsonian Institution Press, 1970.
Margaret Breuning, 1944	Breuning, Margaret. *Mary Cassatt*. New York: Hyperion Press, 1944.
Julia Carson, 1966	Carson, Julia M. H. *Mary Cassatt*. New York: David McKay, 1966.
Achille Segard, 1913	Segard, Achille. *Un peintre des enfants et des mères—Mary Cassatt*. Paris: Librarie Ollendorf, 1913.
Frederick A. Sweet, 1966	Sweet, Frederick A. *Miss Mary Cassatt: Impressionist from Pennsylvania*. Norman: University of Oklahoma Press, 1966.
Edith Valerio, 1930	Valerio, Edith. *Mary Cassatt*. Paris: Crès et Cie, 1930.
Forbes Watson, 1932	Watson, Forbes. *Mary Cassatt*. American Artists Series. New York: Whitney Museum of American Art, 1932.

Oils and Pastels

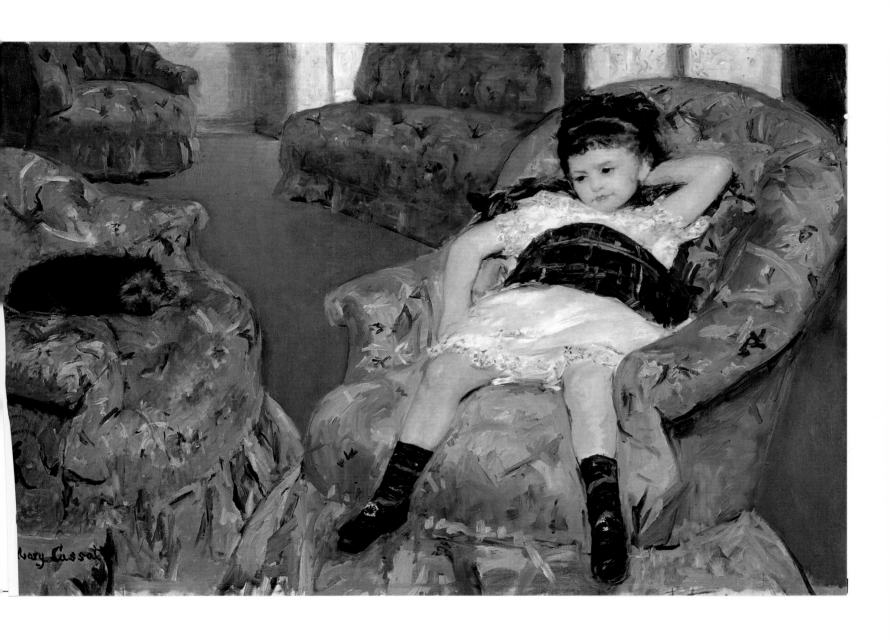

The Blue Room, 1878. BrCR 56.

1
Bent Head and Torso of a Woman Looking Down c. 1868
Oil on canvas, 11¾ × 9 in., 30 × 23 cm.
Unsigned

Description: A slight sketch of the head and torso of a woman looking down. She wears a dark blouse, her hair is drawn up over her ears, and she has bangs. The background behind her face is dark.

Collections: Kurt A. Baer, Larchmont, New York.

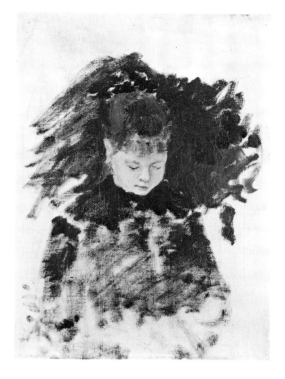

2
Two Children at the Window c. 1868
Pastel on paper, 28 × 20 in., 71 × 51 cm.
Unsigned

Description: Two little children—a boy and girl— stand looking out of an open window with their backs to the spectator. The girl wears a white dress and red cap, the fair-haired boy a pale blue suit.

Collections: Acquired from the artist by Lady Elsie de Wolfe Mendl, who gave it to *Anne Hunter- O'Connor,* London.

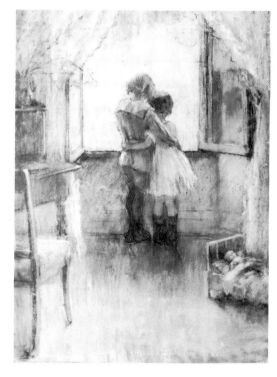

3
Brother and Sister c. 1868
Pastel on gray paper stretched onto canvas, 14 × 18 in., 35.5 × 45.5 cm.
Signed lower left corner: *Mary Cassatt*

Description: The boy at the right has dark, bobbed hair with bangs and wears a green jacket with revers, open at the neck. His little sister leans her head against his shoulder. Her reddish-blond hair is parted on the side and drawn across her forehead. She wears a wide, ruffled bertha on her high-necked dress. The background is in shades of blue.

Collections: Wilfred H. Stein, Geneva, Switzerland; bought at auction in Lausanne in 1960 from the estate of an English lady who lived near Montreux.

4
Little Savoyard Child on the Arm of Her Mother c. 1869

Oil on plywood, 21 × 16 in., 53.2 × 40.5 cm.
Signed at lower right and also at lower left: *M. C.*

Description: Unfinished oil sketch with light patches in the background behind parts of the figures. The child holds something in both hands. She wears a big bib, a dark dress, and dark shoes; the mother wears a fringed shawl, a dark apron, and a kind of bandeau back on her head. The mother looks at the child on her left arm. The child, in full face, looks forward.

Note: According to the former owner, William H. Holston, a member of the firm of Durand-Ruel for over 20 years, he bought this painting from the family of an aunt of Miss Cassatt in 1928. Also called "Blond Italian Child on the Arm of Her Nurse." Miss Cassatt wrote to her future sister-in-law, Lois, in August 1869 from the Haute-Savoie region near Bauges, where she and Miss Gordon, a friend, were painting: "The Savoyards are a most civil people and talk a sort of mixture of French and Italian very hard to understand."

Collections: University of Georgia, Eva Underhill Holbrook Collection, Athens, Georgia.

Exhibitions: Renaissance Galleries, Philadelphia.

5
Young Woman Wearing a Ruff c. 1869

Oil on canvas, 32 × 25 in., 81.2 × 63.3 cm.
Signed at lower left: *M. S. Cassatt*

Description: A smiling young woman looks forward from a rosy background. She is seen in half-length, wearing a costume with a wide white ruff and playing a mandolin. Her wavy hair is parted in the middle, and her lips are parted as if she were singing.

Collections: Samuel T. Freeman & Co., Philadelphia, sold at auction 26 Feb. 1931 (cat. 145, illus.); present location unknown.

Exhibitions: Society of American Artists, New York, second annual exhibition, 1879, and the Pennsylvania Academy of the Fine Arts, Philadelphia, 50th annual exhibition, 1879.

6
Two Women, One Sketching c. 1869

Oil on canvas, 30 × 21¼ in., 76 × 54 cm.
Unsigned

Description: Outdoor sketch of two women. The one sits on a bench in the foreground looking down, while the other at a distance stands sketching at an easel; behind her is a fence. She wears a bright pink blouse; the seated woman has a vermilion scarf beside her on the bench.

Note: In a letter home from the Haute-Savoie region where she was sketching with her friend, Miss Gordon, Mary Cassatt wrote: "The place is all that we could desire as regards scenery but could be vastly improved as regards accommodations; however, as the costumes and surroundings are good for painters we have concluded to put up with all discomforts for a time."

Collections: Laura Julia Sterette McAdoo, Paris, 1904–1911; Anderson C. Bouchelle, New Smyrna Beach, Florida; sold at Parke-Bernet, New York, March 1967; *Mr. and Mrs. Philip Berman,* Allentown, Pennsylvania.

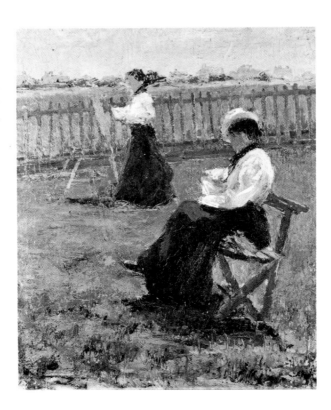

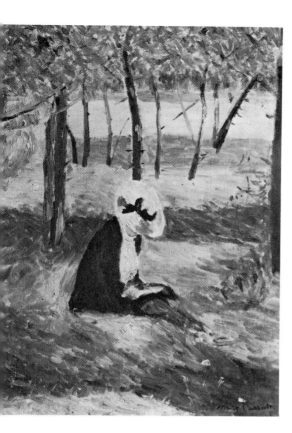

7
Young Woman in a Hat Seated on the Ground under Trees c. 1869
Oil on canvas, 13 × 9½ in., 33 × 24 cm.
Signed lower right: *Mary Cassatt*

Description: On the ground under a copse of slender trees sits a young woman wearing a dark jacket and skirt and a large, round, light hat trimmed with dark ribbon.

Note: Also called "Jeune fille dans un jardin." This is the type of small painting which the artist sent home to be sold by the local gilder, framer, art shop salesman, Teubner.

Collections: George Bernheim, Paris; Gimpel Fils, London; Mrs. R. Peto, London; E. V. Thaw & Co. Inc., New York.

Exhibitions: Galerie Charpentier, Paris, "Scènes et figures parisiennes" (cat. 3), 1943; Gimpel Fils, London, "Collector's Choice IV" (cat. 3), 1954; City Art Gallery, Plymouth, England, "French Impressionists from the Peto Collection" (cat. 13), 1960.

8
Two Women Seated by a Woodland Stream
c. 1869
Oil on canvas, 9½ × 13 in., 24 × 33 cm.
Unsigned

Description: Two women, seen from the rear and wearing light blouses and dark skirts, are seated under trees by a stream. One of them is blond, the other has darker hair.

Note: Also called "Deux femmes assises auprès de l'eau."

Collections: Collection Dain, Paris.

9
Young Woman Standing by Railings
c. 1870
Oil on canvas, 17½ × 14½ in., 44.4 × 36.8 cm.
Unsigned

Description: Full-length view of a young woman leaning on the railings of an upper balcony in Paris. She wears a dark costume with a bustle. In the background are roofs with chimney pots. An aspidistra plant in a pot is in the left foreground.

Collections: Sold at Christie's, London, 20 Feb. 1959, and again 20 May 1960; *D. S. Culven*, London, England.

10
Baby Boy Wearing a Bib c. 1870
Oil on canvas, 24¼ × 20¾ in., 62 × 52.6 cm.
Signed toward lower right: *Mary Cassatt*

Description: Head and shoulders of a dark-eyed baby gazing toward the spectator. Brilliant green background.

Note: Painted in Philadelphia.

Collections: Mrs. Nickolas Muray, New York.

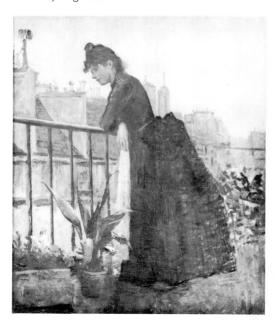

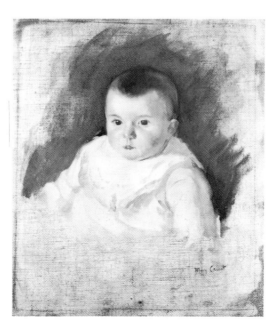

11
Portrait of Mrs. Currey; Sketch of Mr. Cassatt c. 1871
Oil on canvas, 32 × 27 in., 81.2 × 68.4 cm.
Unsigned

Description: Head and shoulders of a young Negro woman wearing a white kerchief on her head. She looks at the spectator. Her left hand rests on a light object. Below and upside down is a canceled sketch of Miss Cassatt's father. Both sketches were painted in Philadelphia.

Note: When James E. Lewis was an art student in Philadelphia, he lived with Mr. and Mrs. Currey, who, when he needed frames for his student works, told him to go to the attic and take any he found there. He brought down this painting and asked Mrs. Currey what it was. She told him that in her youth she had worked for the Cassatt family. They had a daughter who came home after studying painting in Paris and asked Mrs. Currey to pose for her and then gave her the sketch. Mrs. Currey then gave the sketch to Mr. Lewis.

Collections: Given by the artist to Mrs. Currey, Philadelphia, 1871–72; to James E. Lewis, Baltimore, Maryland; to Hirschl & Adler, New York, 1966–67; to *W. Myron Owen*, New Bedford, Massachusetts, 1967.

Reproductions: Selections from the Collection of Hirschl & Adler Galleries, vol. 8 (cat. 7), 1966–67; Hirschl & Adler, *American Painting for Public and Private Collections,* vol. 9 (cat. 89), 1967–68.

12
Portrait of Eddy Cassatt 1872
Oil on canvas, 58¼ × 43¼ in., 148 × 110 cm.
Signed below center at left: *Eddy/from/Aunt Mary*

Description: Full-length formal portrait of little Eddy wearing a dark red velvet suit with white lace collar, cuffs, and ruffles at the knees, a wide sash at the waist, and a velvet hat over his long curls.

Note: Mrs. Thayer, the mother of Mrs. Iselin, wrote that her father was born in 1869 and that she thought he was between 4 and 6 years old when this was painted in Philadelphia. He was actually 3 years old, though he does appear to be older.

Collections: Mrs. C. Oliver Iselin III, granddaughter of the subject.

Exhibitions: Pennsylvania Academy of the Fine Arts, Philadelphia, 47th annual exhibition, 1876; Philadelphia Museum of Art, 1960 (called "Eddy in Red Velvet").

13
The Sombre One 1872
Oil on canvas, 18 × 15 in., 46 × 38 cm.
Signed upper right: *Mary Cassatt*

Description: Head and shoulders of a sober-faced woman who looks forward, as though thinking. Her black hair is cut in thick bangs across her forehead, and her simple high-necked dress is entirely black. The background is dark green.

Collections: Retained by the artist after being sent to the Paris Salon of 1872. After World War I in a private collection at Nice; acquired by a Central European collector in 1927; Kennedy Gallery, New York, 1968.

Exhibitions: Paris Salon, 1872.

14

Smiling Young Woman in a Hat with Turned Up Brim 1872

Oil on canvas, 21 × 18 in., 53.2 × 45.6 cm.
Signed at lower left: *M. S. Cassatt Paris 1872*

Description: Young brunette woman wears a hat with an upturned brim, showing much of her parted black hair beneath it. The hat is trimmed with a bow toward the right under the brim. Her dress has a round bertha with a wide ruffle at the neck.

Collections: Samuel T. Freeman & Co., Philadelphia, sold at auction 26 Feb. 1931 (cat. 153, illus.) to Baruch Feldman, Philadelphia; present location unknown.

Exhibitions: Pennsylvania Academy of the Fine Arts, Philadelphia, 50th annual exhibition, 1879.

15

The Bacchante 1872

Oil on canvas, 24½ × 20 in., 62 × 50.7 cm.
Signed lower left: *Mary S. Cassatt/Parma/1872*

Description: Half-length figure of a young girl wearing a golden yellow blouse and blue scarf, with coins hung about her shoulders, playing cymbals. Her long dark hair is wreathed in vine leaves.

Note: Also called "The Bajadere (Hindu Dancing Girl)."

Collections: J. W. Lockwood, Philadelphia; *Pennsylvania Academy of the Fine Arts*, Philadelphia.

Exhibitions: Pennsylvania Academy of the Fine Arts, Philadelphia, "Choice Paintings Loaned from Private Galleries of Philadelphia" (cat. 343), 1877 (J. W. Lockwood is listed as owner; Cassatt's address given as Philadelphia); American Art Association, Inc., New York, 29 Jan. 1926 (cat. 162, illus.).

16

Early Portrait 1872

Oil on canvas, 23 × 20 in., 58.4 × 50.7 cm.
Signed lower left corner: *Mary Stevenson Cassatt/ à mon ami C. Raimondi*

Description: A young woman looks toward the right, her head and shoulders seen in three-quarter view. Her neck and chest are bare. Her hair is dark and parted but rather short. She wears a rose dress, draped in pleats from her shoulders, over a lighter underblouse. Deep wine red background.

Note: This was formerly called a self-portrait but is definitely not one.

Collections: Gift from the artist to Carlo Raimondi, 1872; Raimondi family; R. M. C. Livingston sale (cat. 72, illus.), Parke-Bernet, New York, 23 May 1951; to J. W. Young; to Robert Badenhof; his gift to *Dayton Art Institute*, 1955.

Exhibitions: Pennsylvania Academy of the Fine Arts, Philadelphia, Peale House Gallery (cat. 14), 1955; Pennsylvania Academy of the Fine Arts, Philadelphia, 1965.

17
The Mandolin Player c. 1872

Oil on canvas, 36¼ × 29 in., 92 × 73.5 cm.
Signed lower left: *Mary Stevenson*

Description: A dark-haired Italian girl in a white blouse, red sash, and dark blue skirt sits playing the mandolin before a dark background.

Collections: Sent by the artist to Teubner in Philadelphia; to G. H. Sherwood; to *Anthony D. Cassatt.*

Exhibitions: Society of American Artists, New York, second annual exhibition, 1879; Pennsylvania Academy of the Fine Arts, Philadelphia, 50th annual exhibition, 1879; Philadelphia Museum of Art, 1960.

18
On the Balcony During the Carnival 1872

Oil on canvas, 39¾ × 32½ in., 101 × 82.5 cm.
Signed lower left corner: *M. S. C./1872, à Seville*

Description: Two young women and a man seen on a balcony. The woman at the left leans forward, resting her right arm on the green balcony railing. The woman at the right converses with the man wearing a wide-brimmed hat who stands behind and rests his left hand on the wall at the right. She has a pink flower in her hair and wears a colorful, embroidered shawl.

Note: Also called "Jeunes femmes jetant des bonbons un jour de Carnaval." Sweet calls it "A Balcony at Seville" and "Pendant le Carnaval," and William Walton in *Scribner's Magazine*, March 1896, called it "A Spanish Scene in Old Seville."

Collections: Philadelphia Museum of Art, Wilstach Collection.

Exhibitions: Paris Salon, 1872 (cat. 1433, illus. p. 217) (called "Pendant le Carnaval"; Cassatt gave her name as Mary Stevenson); National Academy of Design, New York, 49th annual exhibition, 1874; Pennsylvania Museum of Art, Philadelphia, "Cassatt Memorial Exhibition" (cat. 22), 1927; Art Institute of Chicago and Metropolitan Museum of Art, New York, "Sargent, Whistler and Mary Cassatt" (cat. 2, illus.), 1954; Philadelphia Museum of Art, 1960.

Reproductions: Scribner's Magazine, vol. 19 (March 1896), p. 355; *International Studio*, vol. 35 (1908), p. xxxvii; Elizabeth Luther Cary, *Artists Past and Present*, New York, 1909, facing p. 32; *American Magazine of Art*, vol. 18 (June 1927), p. 309; Frank Jewett Mather, *The Pageant of America: The American Spirit in Art*, New Haven, 1927, fig. 235, p. 146; *Art and Archaeology*, vol. 23 (June 1929), p. 283.

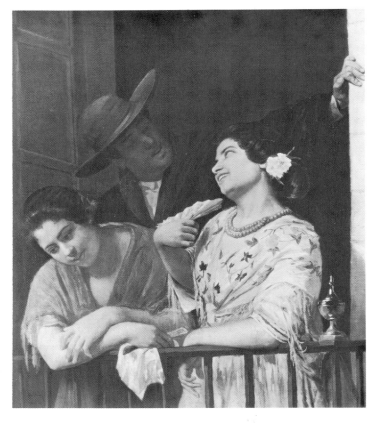

19
Roman Girl c. 1872

Oil on canvas, 27¼ × 22½ in., 69 × 57 cm.
Signed lower left corner: *M. S. Cassatt*

Description: Head and shoulders of an Italian model seen in profile to left. On the back of her head she wears a lace shawl that falls down her back to the foreground of the picture. She holds a mandolin. The background is flecked shades of pinkish tan.

Collections: Sold at Parke-Bernet, New York, 1951 (cat. 289); Christie's, London, 1966 (cat. 9); Gulf American Gallery, Miami, Florida, 1967; to **Andrew Crispo, New York, 1968; to A.C.A. Gallery, New York, 1970.**

Exhibitions: Society of American Artists, New York, second annual exhibition, 1879; Pennsylvania Academy of the Fine Arts, Philadelphia, 50th annual exhibition, 1879.

20
Peasant Woman Peeling an Orange c. 1873
Oil on canvas, 21⅛ × 18 in., 53.5 × 45.7 cm.
No signature visible

Description: An Italian woman looks directly forward, her dark head tilted to left. Her bare elbows rest on a table as she peels an orange, using both hands. She wears an embroidered shawl and earrings.

Note: This is the type of early painting that the artist sent back for sale at Teubner's in Philadelphia.

Collections: Samuel T. Freeman & Co., Philadelphia, sold at auction 26 Feb. 1931 (cat. 135, illus.); present location unknown.

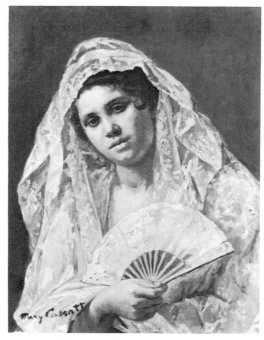

21
Spanish Dancer Wearing a Lace Mantilla
1873
Oil on canvas, 25½ × 19½ in., 65 × 49.5 cm.
Signed on the light sleeve at lower left: *Mary Cassatt.* Signed in dark background in lower left corner: *1873 à Seville*

Description: A full-faced young woman holds a fan in her right hand. Over her dark hair she wears a pale white mantilla with pink ribbons showing under it. Her fan has pink and blue decoration on a white ground. Dark green-gray background.

Note: Also called "Spanish Dancer," "L'Espagnole à l'éventail," and "Femme à l'éventail, une mantille sur la tête." Durand-Ruel A#11096.

Collections: From the artist to Mathilde Vallet, 1927; Mathilde X sale, Paris, 1927; to Lévy, Paris; to Hugo Perls, New York; Parke-Bernet sale (cat. 76), 3 Feb. 1954; to Hirschl & Adler (cat. 8515); to Mrs. Max Dreyfus, who presented it to the *National Collection of Fine Arts*, Washington, D.C., 1967.

Exhibitions: Galerie A.-M. Reitlinger, Paris, 1927 (cat. 57); Hirschl & Adler, New York, "A Salute to the Whitney, 250 Years of American Art 1690–1940" (cat. 33), 1966.

Reproductions: Harper's New Monthly Magazine, vol. 58 (March 1879), p. 495; S. G. W. Benjamin, *Art in America*, New York, 1880, p. 208; *Selections from the Collection of Hirschl & Adler Galleries*, vol. 4 (cat. 10), 1962–63.

22
Torero and Young Girl 1873
Oil on canvas, 39¾ × 33½ in., 101 × 85 cm.
Signed lower right: *Mary S. Cassatt/Seville/1873*

Description: A girl with a rose in her black hair holds a large glass goblet toward a toreador in full regalia. Her face is in shadow. Her striped dress is partly covered by a lace shoulder scarf and a large embroidered Spanish shawl that hangs down from her left shoulder and is caught up under her right hand on her hip.

Note: Also called "Scène espagnole" and "Torero à qui une jeune fille offre un verre d'eau"; Sweet calls it "Offering the Panal to the Bullfighter" (panal is a sweet drink).

Collections: M. Knoedler & Co., New York; to *Sterling and Francine Clark Art Institute*, Williamstown, Massachusetts.

Exhibitions: Paris Salon, 1873 (cat. 1372); National Academy of Design, New York, 49th annual exhibition, 1874 (her address listed as Rome, Italy); Durand-Ruel, New York, 1895 (cat. 22) (called "Scène espagnole").

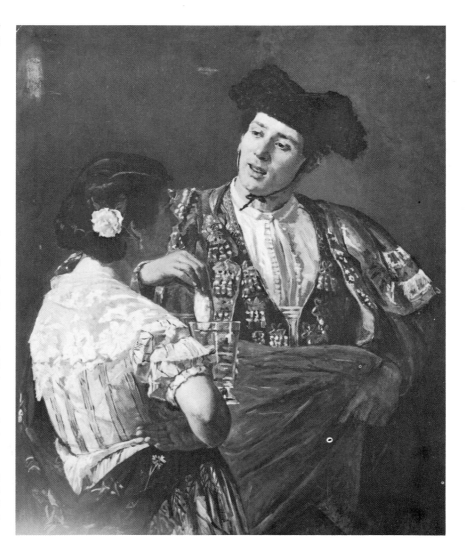

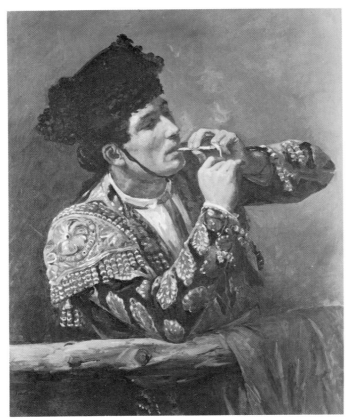

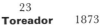
23
Toreador 1873
Oil on canvas, 32¼ × 25¼ in., 82 × 64 cm.
Signed lower left corner: *M. S. C./Seville/1873*

Description: A half-length view of a toreador in his elaborately embroidered jacket and black hat with chin strap. He rests his right elbow on a fence rail half covered by his cape while he lights the cigarette in his left hand. The cool and sparkling blue and silver of his jacket is contrasted with the red tie and cape.

Note: Also called "Torero."

Collections: Sold by the artist to John Ruderman; to Mr. and Mrs. Lewis Padawar; to *Mrs. Sterling Morton*, Chicago, Illinois, 1959.

Exhibitions: Pennsylvania Academy of the Fine Arts, Philadelphia, 1878 (called "Spanish Matador"); Federation of Jewish Philanthropies, Waldorf-Astoria, New York, "Sixty-eight Great Paintings" (cat. 9), 1957.

Reproductions: Frederick A. Sweet, 1966, color pl. 1, fol. p. 76; *Selections from the Collection of Hirschl & Adler Galleries*, vol. 1 (cat. 12, color), 1959.

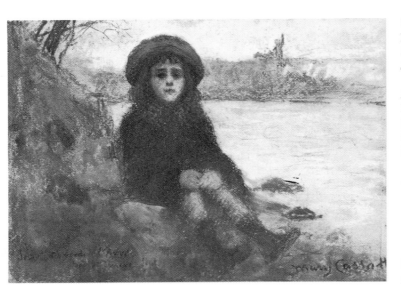

24
Little Girl Sitting by the River 1873
Pastel on paper, 8⅛ × 10¼ in., 21.5 × 26.5 cm.
Signed lower left: *Souvenir des bords de l'Arve/*[?]
Sept. Signed lower right: *Mary Cassatt*

Description: A little girl in a dark hat and coat and high dark boots sits on a rock by the river. A high bank rises at left with a few tree trunks indicated in the upper left corner. The child looks forward, her hands folded before her.

Note: The Arve River is in the neighborhood of Geneva. Mary Cassatt must have stopped there on her way either to or back from Rome, where she spent a part of the winter of 1873–74. Durand-Ruel 12682-L14427.

Collections: C. P. Bondu; to Mr. Martin, 1947; to *private collection*, Paris, 1969.

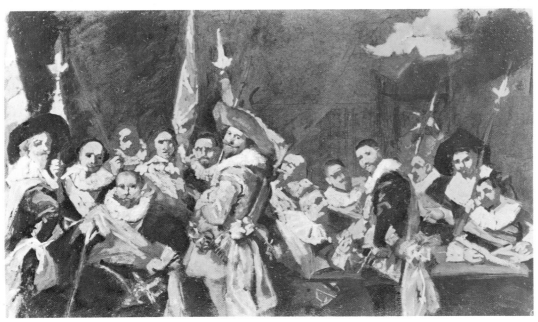

25
Copy after Frans Hals c. 1873
Oil on canvas, 18¼ × 28½ in., 46.3 × 72.3 cm.
Unsigned

Description: Copy of Frans Hals' painting in Haarlem entitled "Meeting of the Officers of the Cluveniers-Doelen, 1633."

Note: In later years Mary Cassatt was proud of this copy and would show it to young art students, assuring them that such an exercise was essential for their development.

Collections: Mrs. Percy C. Madeira, Jr., Berwyn, Pennsylvania.

Exhibitions: Baltimore Museum of Art, 1941–42 (cat. 1); Art Institute of Chicago and Metropolitan Museum of Art, New York, "Sargent, Whistler and Mary Cassatt" (cat. 1), 1954; Philadelphia Museum of Art, 1960; M. Knoedler & Co., New York, 1966 (cat. 1, illus.).

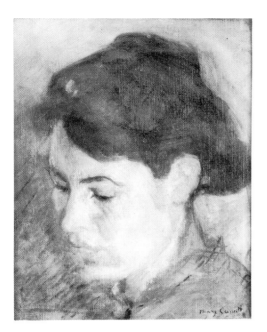

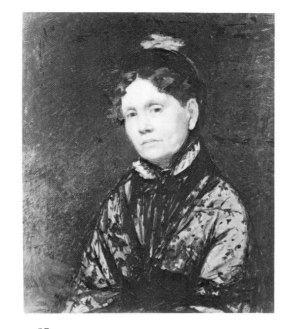

26
Contemplation c. 1873
Oil on canvas, 14¼ × 11½ in., 36 × 29 cm.
Signed lower right: *Mary Cassatt*

Description: Head only of a young woman looking down toward left, seen in three-quarter view (or closer to profile). Her dark hair is softly brushed over her ear and loosely puffed out in back with a knot on top. There is a slight indication of a plaid pattern at the neck of her blouse. Her eyebrows are clearly and sharply defined.

Collections: Private collection, Paris.

27
Miss Cassatt's Mother in a Lacy Blouse
1873
Oil on canvas, 24½ × 22½ in., 62.4 × 57.4 cm.
Signed lower left: *M. S. Cassatt/Antwerp/1873*

Description: Half-length portrait of Miss Cassatt's mother, Mrs. Robert S. Cassatt. Her wavy auburn hair is parted in the middle and drawn back behind her ears. She wears a black bonnet trimmed with a red flower. The background is dark brown and black.

Note: Mary Cassatt progressed from Spain to the Netherlands to study the works of Rubens in Antwerp and Frans Hals in Haarlem. Her mother joined her there and sat for this early portrait.

Collections: Estate of Mrs. Horace Binney Hare.

Exhibitions: Pennsylvania Academy of the Fine Arts, Philadelphia, 50th annual exhibition, 1879 (called "Portrait of a Lady"); Durand-Ruel, New York, 1895 (cat. 34); Pennsylvania Museum of Art, Philadelphia, Cassatt memorial exhibition (cat. 25), 1927; Philadelphia Museum of Art, 1960; M. Knoedler & Co., New York, 1966 (cat. 3, illus.).

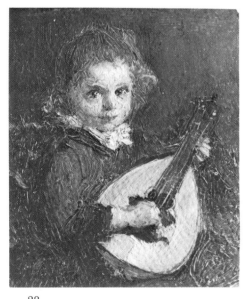

28
Little Girl Playing a Mandolin c. 1874
Oil on wood panel, 7½ × 5¼ in., 19 × 13.4 cm.
Signed lower right (in red): *Mary Cassatt*

Description: The little girl is seated, turned somewhat to the right. She has dark curly hair and wears a dark blouse with white at the collar. Dark background.

Collections: Private collection, Buenos Aires; to Adams-Davidson Galleries, Washington, D.C., 1967; to Maxwell Galleries, San Francisco; to *Mr. and Mrs. J. Ralph Stone*, Santa Rosa, California.

29
A Musical Party 1874
Oil on canvas, 38 × 26 in., 96.4 × 66 cm.
Signed and dated at upper left: *M. S. Cassatt/1874*

Description: At the lower right sits a young woman wearing a pearl necklace and a rose-pink décolleté gown. Her hair is auburn. She holds a mandolin and looks up at a brunette with bangs and with a red rose tucked in her hair. She wears a light blue dress covered with a wide white lace fichu and holds sheet music in her right hand while she rests her left on the shoulder of the first young woman and leans over her. Behind them, at upper right, stands a young man (resembling the young Courbet) who bends over the shoulder of the brunette to read the music. The background is dark maroon.

Note: Also called "La partie de musique" and "The Music Lesson."

Collections: Petit Palais, Paris, 1966, gift of M. et Mme. René Mayer.

Exhibitions: Pennsylvania Academy of the Fine Arts, Philadelphia, 47th annual exhibition, 1876; Department of Fine Arts of the Massachusetts Charitable Mechanic Association, Boston, 13th exhibition, 1878.

30

[*After this* catalogue raisonné *went into production, painting number 30—Summer Siesta, circa 1874—was found to be not by Mary Cassatt but by J. J. Tissot, a close friend and protégé of Degas.*]

32

Peasant Girl c. 1874

Oil on wood panel, 12¾ × 9 in., 32.6 × 23 cm. Unsigned. Label on back of panel reads: Mary Cassatt/given to Alfred Q. Collins by Miss Cassatt in 1878 and by him given to Walter Gay.

Description: Half-length view of a girl turned somewhat to right. She wears a multicolored dress with a blue and white shawl or kerchief. Her eyes and hair are brown. Background is brown.

Note: Collins and Gay were Boston painters who studied with Bonnat about 1878. Both were born in 1856.

Collections: Gift of the artist to Alfred Q. Collins, 1878; to Walter Gay; to *Museum of Fine Arts*, Boston, 1927, gift of Mr. Gay.

31

Small Profile Head of a Girl c. 1874

Oil on wood panel, c. 13¾ × 10½ in., 35 × 26.7 cm. Unsigned

Description: Blond young woman in profile to left gazes slightly upward, reverently. She wears a black veil over her head. Seen against a dark background.

Collections: Gift from the artist to Alfred Q. Collins, 1878; inherited by Mrs. Collins' brother, Forbes Watson; Parke-Bernet, New York, sale #2001 (cat. 114), 30 Nov. 1960; to Mr. and Mrs. Alfred Reyn, New York; to Andrew Crispo, New York, 1968; to the Samanthe Gallery, New York, 1968; to *Mrs. Everett D. Reese*, Columbus, Ohio.

33

Head of a Young Girl c. 1874

Oil on wood panel, 7½ × 5¼ in., 19 × 13.2 cm. Unsigned

Description: Portrait head of a young girl with large hazel eyes. Her dark hair is drawn back tightly above the ear and tied with a big dark crimson bow at the neck. The background is dove gray.

Collections: William Rolfe, Jr., and Q. Q. Thorndike; Steven Juvelis, who gave it to the Newark Museum, 1964–65; returned in 1968 to *Steven Juvelis*, Marblehead, Massachusetts.

34

The Scottish Nurse c. 1874

Oil on wood panel, 13 × 10 in., 33 × 25.3 cm.
Signed lower left: *Mary Cassatt*. On verso inscribed:
"La Nourrice Ecossaise." Again signed on verso:
Mary Cassatt

Description: Head and shoulders of a young woman
wearing a plaid tam-o'-shanter.

Collections: Austin L. Adams, Washington, Con-
necticut.

35

Portrait of Mme. Cortier 1874

Oil on wood panel, 19 × 15¾ in., 48.2 × 40 cm.
Signed upper left corner: *M. S. Cassatt/Rome/1874*

Description: Head and shoulders of an older
woman, smiling and looking forward. She wears
long drop earrings and a dark dress with narrow
white ruching at the neck. Her wavy hair is parted
in the middle, and her complexion is ruddy and
alive.

Note: Also known as "Ida"; sent to the Salon and
favorably commented on by Degas, who re-
marked when seeing it there, "C'est vrai. Voilà
quelqu'un qui sent comme moi." (It is true.
There is someone who feels as I do.) It has at
times been called Mme. Cordier. Durand-Ruel
7768-L11457.

Collections: Galerie Charpentier sale (cat. 40),
Paris, 16 June 1959; Parke-Bernet sale, New York,
May 1965 (called Mme. Cordier); Christie & Co.
(cat. 10), London, 23 June 1965, to Mrs. M.
Lowell Harmon; A. C. A. Heritage Gallery, June
1968; to Andrew Crispo, New York; to Maxwell
Galleries, San Francisco.

Exhibitions: Paris Salon, 1874 (cat. 326); Durand-
Ruel, Paris, 1908 (cat. 4); McClee's Gallery,
Philadelphia, 1930 (cat. 5); Haverford College,
1939 (cat. 10, illus.); Wildenstein, New York, 1947
(cat. 1); Marlborough Fine Art Ltd., London,
1953 (cat. 1, illus.).

Reproductions: Edith Valerio, 1930, pl. 1; *Illustrated
London News*, 11 July 1953, p. 73.

36

**Little Girl with White Ruffled Yoke to Her
Dress** c. 1875

Oil on canvas, 15¾ × 12½ in., 40 × 37 cm.
Unsigned

Description: Head and shoulders of a little girl
looking to left in three-quarter view. Her auburn
hair with bangs is held back by a black velvet
band, and her dark dress has a wide, white ruffled
yoke. The background is reddish brown.

Collections: Mr. M. A., Beirut, Lebanon.

37

Red-haired Nude, Seated c. 1875

Oil on canvas, 39½ × 27 in., 100 × 68.3 cm.
Signed lower left: *Mary Cassatt*

Description: Nude model is seated on the floor with
her knees bent to left and lower limbs hidden. Her
Titian red hair is arranged in a loose knot, softly
waved around her face. She looks off to the right.
Background of rich golds, with a hint of blue and
green landscape at left.

Note: Probably painted in the studio of Charles
Chaplin where Mary Cassatt studied for a very
short time after settling permanently in Paris.
A certificate by M. Jean Cailac dated Paris,

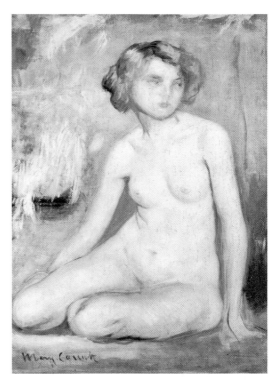

December 1948, was given to purchaser in 1951.

Collections: Hôtel Drouot sale, Paris (cat. 25), 3
April 1943; Parke-Bernet, New York, Pepsi-Cola
sale #286 (cat. 1244), 1951; to De Braux, Phila-
delphia, who presented it to the Baltimore Museum
of Art, 1957; to Harold Diamond, New York,
1964; to *Barry Taper,* Los Angeles, California, 1968.

Exhibitions: Dallas Museum of Fine Arts, 1949;
Museum of the University of Oklahoma, Norman,
1950; Wichita (Kans.) Museum of Art, 1950.

Reproductions: Art News, vol. 50 (April 1951), p. 14;
World Collector's Annuary, vol. 3, pl. 62.

38

Portrait of a Young Girl with Long Hair
c. 1875
Pastel on paper, 27 × 21 in., 68.4 × 53 cm.
Signed upper right: *Mary Cassatt*

Description: Half-length of a young girl turned left with folded arms, her right hand half visible tucked within her left arm. Her dark hair is cut in thick bangs over her forehead, drawn back in a bow at the back, and falls down her back to her waist. She wears a blue dress with puffed upper sleeves, a bustle, and a white lace yoke. The background is mottled light green, pinkish gray, and tan.

Collections: Fitzhugh and J. Hall McCardell collection, London; to Lefevre Gallery, London; to *Richard Herner*, London.

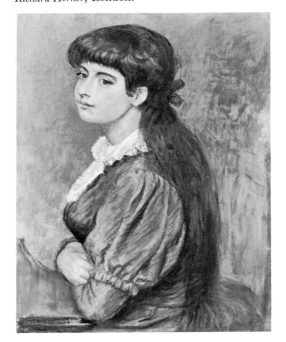

39

Head and Shoulders of a Blond Baby Against Foliage c. 1875
Oil on canvas, 13½ × 12¼ in., 34.4 × 31 cm.
Signed lower right: *M. Cassatt*

Description: A nude baby with a very small nose looks somewhat to left. His straight hair is cut in a short bob just over his ears and his bangs are parted over his forehead. The background is covered with thick greenery.

Note: Also called "Bébé blond."

Collections: From the artist to Mathilde Vallet, 1927; Mathilde X sale, Paris, 1931; present location unknown.

Exhibitions: Galerie A.-M. Reitlinger, Paris, 1931 (cat. 3, illus.).

Reproductions: "Une retrospective de Mary Cassatt," *Art et décoration* (July 1931), p. 3.

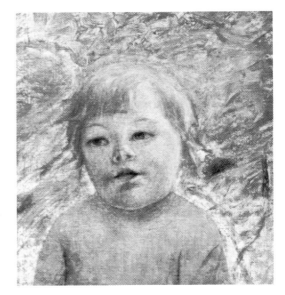

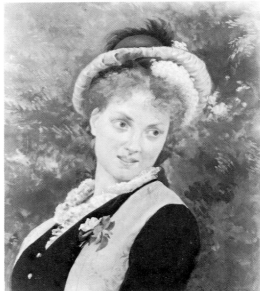

40

Young Woman with Red Hair Before a Woods c. 1875
Oil on canvas, 23½ × 19 in., 59.5 × 48 cm.
Signed at lower right: *M. Cassatt*

Description: A pretty young woman is seen turned toward left and looking to right. She wears a poke bonnet of silk with flowers tucked under the brim. Her hair is frizzed with divided bangs. Over her black velvet bodice is a figured satin vest with white, full ruching at the throat. A rose is pinned to the vest, and the bodice shows three buttons. Behind her is full shrubbery of a woods.

Note: Hirschl & Adler no. 6346-D.

Collections: Bought from the artist by Henri Rouart, whose grandson, Oliver Rouart, sold it to M. Knoedler & Co.; to Gimpel Fils, London, 1959; to Hirschl & Adler, New York; present location unknown.

Reproductions: *Burlington Magazine* (Dec. 1959), suppl. 8, p. 101.

41

A Boy and a Girl in the Woods c. 1875
Oil on canvas, 17¾ × 21¾ in., 45.2 × 55.5 cm.
Unsigned

Description: At the left a young boy's head and shoulders are seen before a sunny background. He looks slightly to left. At the right is a girl with long, dark hair seen in lost profile left. Both are seen in shadow before brightly sunlit foliage.

Collections: Charles Walter Brown collection, Providence, Rhode Island; to Chapellier Gallery, New York, 1967.

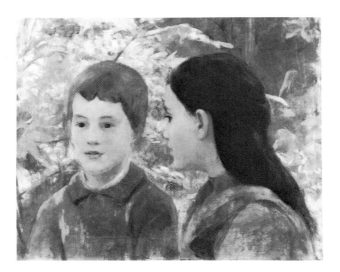

42
Picking Flowers in a Field c. 1875

Oil on wood panel, 10 $\frac{7}{16}$ × 13 $\frac{7}{16}$ in., 26.5 × 34.5 cm.
Signed lower right: *Mary Cassatt*

Description: Two women and a child are shown in a broad, open field. One woman in the middle distance is walking forward; the other bends over as she picks flowers. The child in the foreground stoops to pick flowers also.

Collections: Mr. and Mrs. William Coxe Wright, St. David's, Pennsylvania.

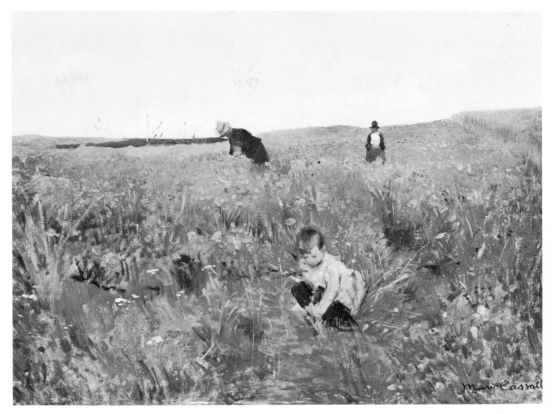

43
Head of a Young Girl with Blue Eyes, Outdoors c. 1875

Oil on canvas, 17$\frac{1}{2}$ × 13$\frac{1}{2}$ in., 44.5 × 34.3 cm.
Unsigned

Description: Head and shoulders of a young girl with gray-blue eyes turned slightly to right, seen against green foliage. Her light brown hair is parted in the middle with a few curly strands over her temples. A white ruffle details the high neck of her blouse.

Collections: George Chapellier, New York; Ira Spanierman, in sale at Parke-Bernet, Spring, 1970.

44
The Young Bride c. 1875

Oil on canvas, 34$\frac{5}{8}$ × 27$\frac{1}{4}$ in., 88 × 69.3 cm.
Signed upper right: *Mary Stevenson/Paris.* At upper left: *M. C.* A partial signature at bottom left.

Description: A blond young woman seen in three-quarter length is seated facing toward left, looking down at her knitting. The ball of wool rests on a taboret at the left. Her dress is of heavy ribbed silk with the low, square neckline outlined in lace. The wide angel sleeve is rounded at bottom. Dark background.

Note: Also called "La jeune mariée." Martha Gansloser was a maid of Miss Cassatt, who gave

the painting to her as a present when she married Mr. Röhrich.

Collections: Gift from the artist to Martha Gansloser Röhrich; to Karl Loevenich, her nephew; to the Max Kade Foundation, given to the *Montclair* (N.J.) *Art Museum*, 1958.

Exhibitions: Possibly Paris Salon, 1876; Hirschl & Adler, New York, "Montclair in Manhattan" (cat. 42, p. 67, illus.), 1961.

Reproductions: Art Quarterly, vol. 21, no. 1 (Spring 1958), p. 90.

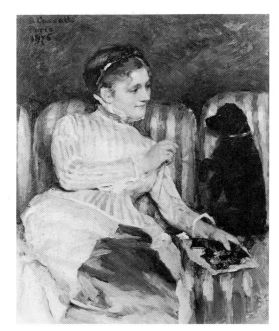

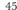
45
Young Woman on Striped Sofa with Her Black Dog 1875
Oil on wood panel, 13¾ × 10¾ in., 35.3 × 27.6 cm.
Signed upper left corner: *M. S. Cassatt/Paris/1875*

Description: A young woman, with a filet in her hair, wears a tight-fitting, high-necked, striped blouse and a skirt with darker satin front panel. In her right hand she holds up a needle and thread, while her gros point embroidery is held in her left hand resting on the sofa. Her dog sits up begging as she smiles at him on the right. The sofa is striped in yellow and red.

Note: A certificate of sale, dated 3 June 1958 and including the provenance of the painting, was given to Pierre Adler by the owner, Gaston Inglebach.

Collections: From the artist to Mme. Paul Ingelbach through her sister, Mme. E. Vogt-Hélène; to her son, Gaston Ingelbach, Paris, 1908; to Pierre Adler, 1958; to Mrs. Peter I. B. Lavan, who presented it in 1961 to the *Fogg Art Museum*, Cambridge, Massachusetts.

46
Young Girl with a Portfolio of Pictures
c. 1876
Oil on canvas mounted on panel, 8⅞ × 7⅞ in., 22.6 × 20 cm.
Signed lower right: *M. Cassatt*

Description: A little girl sits engrossed in a large portfolio of pictures. She holds up one side of the portfolio with her left hand and holds a picture in her right. Her hair is drawn up off her ears and falls down her back. Her old-fashioned, long-sleeved dress has ruffles on the skirt and down the front. The background is dark.

Collections: J. J. Haverty collection, Atlanta, Georgia; given in 1949 to the *High Museum of Art*, Atlanta.

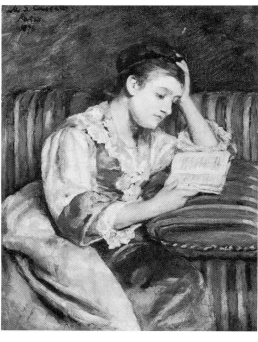

47
Mrs. Duffee Seated on a Striped Sofa, Reading 1876
Oil on wood panel, 13¾ × 10½ in., 35 × 27 cm.
Signed upper left corner: *M. S. Cassatt/Paris/1876*

Description: A woman with auburn hair, tied with black ribbon, wears a brilliant blue dress with pink and white striped sleeves. The sofa on which she sits reading a book is covered with striped red and yellow silk. Dark, warm gray background.

Note: Also called "Young Woman Reading."

Collections: Francis Harold Duffee, 1894; American Art Galleries, New York, Mrs. I. N. Seligman sale (cat. 167, illus.), 1928; to E. D. Levinson, Cedarhurst, New York; to Wildenstein, New York; to J. T. Spaulding, 1934; bequeathed by him in 1948 to the *Museum of Fine Arts*, Boston.

Exhibitions: Museum of Fine Arts, Boston, John Taylor Spaulding Collection (cat. 7), 1948; Munson-Williams-Proctor Institute, Utica, N.Y., "Expatriates" (cat. 17), 1953; Art Institute of Chicago and Metropolitan Museum of Art, New York, "Sargent, Whistler and Mary Cassatt" (cat. 3, illus.), 1954; Mt. Holyoke College, South Hadley, Mass., "French and American Impressionism," 1956.

Reproductions: Art Digest, vol. 22, no. 38 (1 June 1948), p. 12.

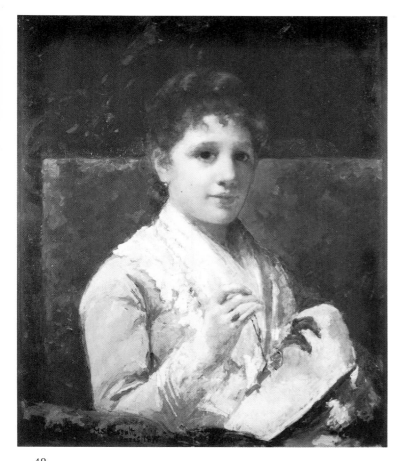

49

**Portrait of Miss Cassatt's Father
(Robert Simpson Cassatt)** 1877
Oil on canvas, 26½ × 22⅛ in., 67.5 × 56.3 cm.
Unsigned

48

Miss Mary Ellison Embroidering 1877
Oil on canvas, 29¼ × 23½ in., 74.3 × 59.7 cm.
Signed toward lower left: *M. S. Cassatt/Paris 1877*

Description: Young Miss Ellison is seen in half-length looking at spectator. She sits embroidering, holding the gros point embroidery piece in her left hand (hidden) and the needle and thread in her right. She has dark hair and eyes and wears a blouse with a wide fichu trimmed with lace.

Note: Mary Ellison was staying at Madame Del Sarte's pension for young ladies in Paris with three friends, who went often to Miss Cassatt's studio. Miss Ellison's father, at her request, commissioned this portrait.

Collections: Rodman D. Ellison, to his daughter (the sitter) who became Mrs. William H. Walbaum; to *private collection*, Villanova, Pennsylvania.

Exhibitions: Durand-Ruel, New York, 1895 (cat. 20) (called "Portrait"); Pennsylvania Museum of Art, Philadelphia, "Cassatt Memorial Exhibition" (cat. 36), 1927; Carnegie Institute, Pittsburgh, 1928; Santa Barbara Museum of Art, "Impressionism and Its Influence on American Art" (cat. 7), 1954; Philadelphia Museum of Art, 1960.

Reproductions: American Magazine of Art, vol. 18 (June 1927), p. 305; *Art and Archaeology*, vol. 23, no. 6 (June 1927), p. 283; *The Arts*, vol. 11, no. 6 (June 1927), p. 295.

Description: Head and shoulders of Mr. Cassatt wearing a dark jacket, high collar, and wide tie. His white hair is parted on his right and falls over his ears. His mustache and long, narrow beard are also white. The background is dark red.

Note: A sketch for this portrait was started while the artist was in Philadelphia in 1870–71. It can be seen upside down on the canvas of "Portrait of Mrs. Currey" (BrCR 11).

Collections: Anthony D. Cassatt.

Exhibitions: Pennsylvania Academy of the Fine Arts, Philadelphia, 1876 (called "Portrait of a Gentleman"); Durand-Ruel, New York, 1895 (cat. 27) (called "Portrait of Mr. C."); Pennsylvania Museum of Art, Philadelphia, 1927 (cat. 24); Baltimore Museum of Art, 1941–42 (cat. 2); Wildenstein, New York, 1947 (cat. 2); Philadelphia Museum of Art, 1960.

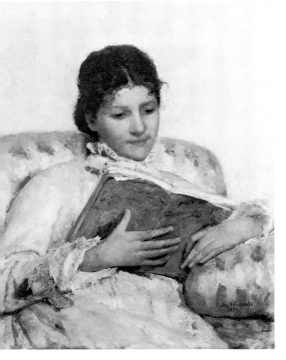

50

The Reader 1877
Oil on canvas, 32 × 25½ in., 81.4 × 65 cm.
Signed lower left and lower right: *M. S. Cassatt/1877*

Description: Half-length of a seated young woman holding a large, brown book with both hands. She wears a soft, white dress with ruffles and light blue bows at her throat and at her wrists.

Note: Also called "Femme assise, habillée en blanc."

Collections: Mrs. Ralph J. Hines; Henrico Schlieper,

Hamburg, 1925; Miguel Bechelli, Buenos Aires; Sotheby & Co., London, 1962 (cat. 86); Hirschl & Adler, New York; to *Electra B. McDowell*, New York.

Exhibitions: M. Knoedler & Co., New York, 1966 (cat. 4, illus.).

Reproductions: Atlantida (April 1938); *Art Journal*, vol. 22, no. 1 (Fall 1962), p. 31; *Selections from the Collection of Hirschl & Adler Galleries*, vol. 2 (cat. 34, color, also on cover).

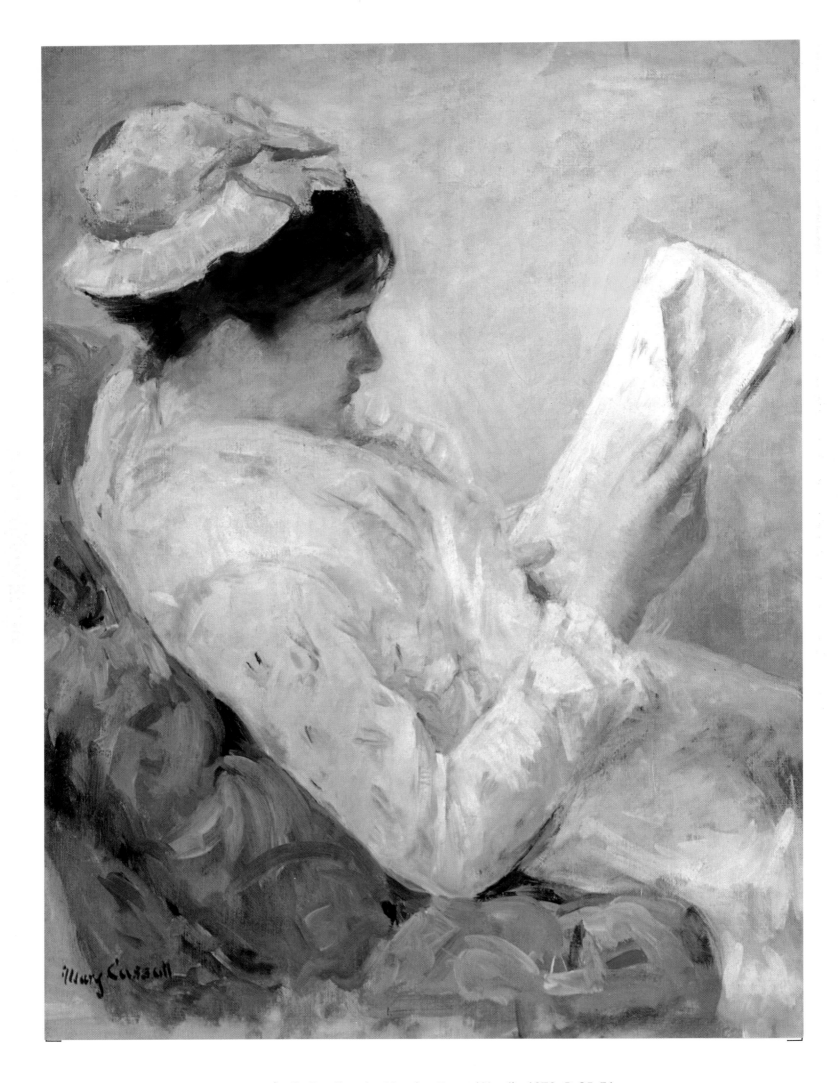

Lydia Reading the Morning Paper (No. 1), 1878. BrCR 51.

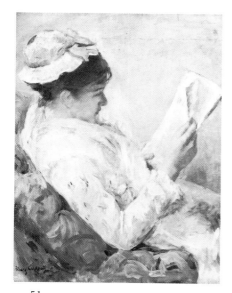

51
Lydia Reading the Morning Paper (No. 1)
1878
Oil on canvas, 31 × 23¼ in., 78.6 × 59 cm.
Signed lower left: *Mary Cassatt*

Description: A young woman, seated in a chair upholstered in bright green with red flecks, leans back and looks down at a newspaper held in both hands. She wears a white dress with blue dots, a fichu, and a pink ribboned, ruffled boudoir cap on her hair.

Note: Durand-Ruel 5551-L8233.

Collections: From the artist to D. G. Kelekian (It hung in his Paris apartment for 43 years. He called it "one of her earliest paintings."); Kelekian & Co. to *Joslyn Art Museum*, Omaha, Nebraska, 1943.

Exhibitions: Baltimore Museum of Art, 1941–42 (cat. 3); Wildenstein, New York, 1947 (cat. 11, illus., p. 26); Santa Barbara Museum of Art, "Impressionism and Its Influence on American Art" (cat. 8, illus.), 1954; Santa Barbara Museum of Art, "Illusion and Reality in Contemporary American Art," 1956; Toledo Museum of Art, Seattle Art Museum, Dallas Museum of Fine Arts, and Carnegie Institute, Pittsburgh, 1957; Oklahoma Art Center, Oklahoma City, 1958; Davenport (Iowa) Municipal Art Gallery, 1963; Portland (Ore.) Art Museum, "75 Masterpieces," 1967.

Reproductions: Dictionary of American Biography, vol. 3 (1929), p. 567; *Art News*, vol. 42 (1–14 Nov. 1943), p. 19.

52
Lydia Reading the Morning Paper (No. 2)
1878
Oil on canvas, 32 × 25½ in., 81 × 64.6 cm.
Signed lower left: *Mary Cassatt*

Description: A young woman, seated in an upholstered armchair, leans back and looks at a newspaper held in both hands. She wears a light dress trimmed with a fichu and a boudoir cap on her dark hair. Behind her is a wide window through which greenery and a part of an iron grille are seen.

Note: Also called "La liseuse"; Durand-Ruel A#5551-16052.

Collections: From the artist to the Durand-Ruel family; to Sam Salz, New York; to Clare Boothe Luce, New York; to Marlborough-Gerson Galleries, New York; to *Norton Simon Foundation*, Fullerton, California.

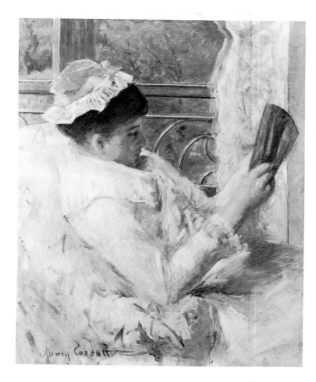

53
Madame Bérard's Baby in a Striped Armchair c. 1878
Pastel on paper, 25¾ × 36¼ in., 65.3 × 92 cm.; later cut down to 25 × 26½ in., 63.3 × 67 cm.
Signed lower right: *Mary Cassatt*

Description: A baby in a very long dress and a cap sits up in a big chair or chaise longue which is covered in a very bright, striped material.

Note: Also called "Enfant sur un fauteuil (Mlle. Bérard)" and "Mlle. Lucie Bérard"; Durand-Ruel 8311-L10995.

Collections: Clément Rouart collection, Paris; Galerie Charpentier sale, Paris, 4 April 1957; O'Hana Galleries, London; Findlay Galleries, Palm Beach; Stephan Hahn, New York, 1967; Wally F. Galleries, New York, 1968; to *Wally Findlay* (his private collection).

Exhibitions: Marlborough Fine Art Ltd., London, April 1967.

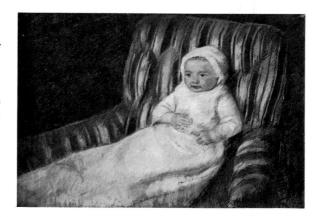

54
Portrait of Madame X Dressed for the Matinée 1878
Oil on canvas, 39½ × 31¾ in., 100 × 81 cm.
Signed lower left: *Mary Cassatt*

Description: A young woman, handsomely dressed in a black costume with a tan satin toque trimmed with a gray plume, holds opera glasses in her gloved hand which rests on a sienna-red striped pillow. Her dark hair is parted, with a curl on her forehead.

Note: "Une Americaine, belle-sœur d'un frère de M. C." according to a French authority. This must be either Lois Cassatt's sister, Harriet Buchanan, or a sister of Jennie Carter. Authenticated by Jacques Dubourg, Charles Durand-Ruel, and Paul Ebstein, Paris, 1960; Durand-Ruel L8620.

Collections: From the artist to Ambroise Vollard; Palais Galleries sale, Paris, 5 Dec. 1960, from Mme. R. G. Lanvin; to E. V. Thaw & Co., Inc., New York.

Exhibitions: Kunsthaus, Zurich, "Portraits de femmes" (cat. 435).

Reproductions: Camille Mauclair, *L'impressionisme*, Librarie de l'art ancien et moderne, Paris, 1904, fol. p. 208; Edith Valerio, 1930, pl. 2.

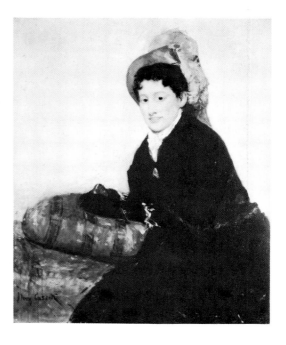

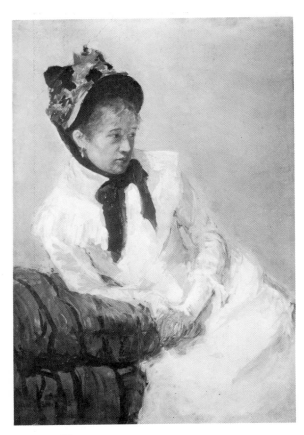

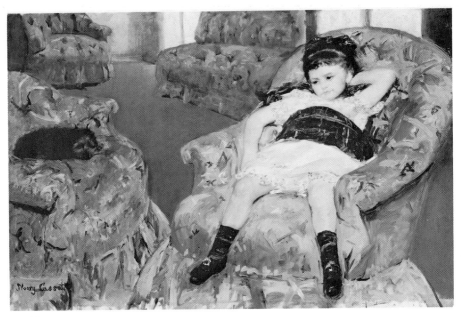

55
Portrait of the Artist 1878

Gouache, 23½ × 17½ in., 59.5 × 44.3 cm.
Signed lower left: *Mary Cassatt*

Description: The artist is seen leaning on her right elbow against a dull green cushion striped with brownish red. She wears a white gown with a wide ruffled yoke, and a poke bonnet trimmed with red flowers and with long crimson streamers tied under her chin. The background is light green to tan.

Collections: From the artist to Mrs. H. O. Havemeyer; American Art Association, New York, Havemeyer Estate sale (cat. 74), 1930; to *Mr. and Mrs. Richman Proskauer*, New York.

Exhibitions: Durand-Ruel, New York, 1895 (cat. 35, on loan) (called "Jeune femme assise"); Art Institute of Chicago, 1926–27 (cat. 33); Pennsylvania Museum of Art, Philadelphia, 1927 (cat. 23); Carnegie Institute, Pittsburgh, 1928 (cat. 28); Art Institute of Chicago, "Art Masterpieces in a Century of Progress Fine Arts Exhibition" (cat. 29, illus.), 1934; Brooklyn Institute of Arts and Sciences, "Leaders of American Impressionism: Mary Cassatt, Childe Hassam, J. H. Twachtman, J. Alden Weir" (cat. 19), 1937; Haverford College, 1939 (illus.); Wildenstein, New York, 1947 (cat. 3); Art Institute of Chicago and Metropolitan Museum of Art, New York, "Sargent, Whistler and Mary Cassatt" (cat. 4, illus.), 1954; M. Knoedler & Co., New York, 1966 (cat. 5, frontispiece).

Reproductions: The Arts, vol. 11, no. 6 (June 1927), p. 290; *Art News*, vol. 28 (22 March 1930), p. 30; *The Arts*, vol. 16 (May 1930), p. 594; Forbes Watson, 1932, p. 23; *Life*, vol. 12 (19 Jan. 1942), p. 54; Frederick A. Sweet, "Assembling an International Exhibition," *Art Institute of Chicago Quarterly*, vol. 48, no. 1 (Feb. 1954), p. 3; *Life*, vol. 36 (17 May 1954), pp. 92, 98; *Art Quarterly*, vol. 21, no. 2 (Summer 1958), pp. 202–15; Julia Carson, 1966, p. 94.

56
The Blue Room 1878

Oil on canvas, 35 × 51 in., 89 × 130 cm.
Signed lower left: *Mary Cassatt*

Description: A little girl with black hair and dark blue eyes sprawls in a big chair upholstered in blue with pink and white floral designs on it. She wears a white dress, a tartan sash (dark blue with green, red, and yellow stripes), and tartan socks. The floor is gray and the curtains white. Two other upholstered chairs and a settee are shown toward the left, the spaces between them forming a most unusual design.

Note: Also called "Enfant dans le salon bleu." Letter from Mary Cassatt to Vollard c. 1900: "Sir, I wanted to return to your place yesterday to talk to you about the portrait of the little girl in the blue armchair. I did it in '78 or '79. It was the portrait of a child of a friend of Mr. Degas. I had done the child in the armchair and he found it good and advised me on the background and he even worked on it. I sent it to the American section of the big exposition '79 [actually '78]. They refused it. As Mr. Degas had found it to be good, I was furious, all the more so since he had worked on it. At that time this appeared new and the jury consisted of three people of which one was a pharmacist!" (Ambroise Vollard, *Recollections of a Picture Dealer*, Boston, 1936.)

Collections: From the artist to Ambroise Vollard, Paris; to Hector Brame, Paris; to *Mr. and Mrs. Paul Mellon*, Upperville, Virginia, 1963.

Exhibitions: Ambroise Vollard Galerie, Paris, 1908 (cat. 38); exposition d'art moderne à l'Hôtel de la Revue, Paris, "Les Arts," 1912; Renaissance Galerie, Paris, 1928 (cat. 27); National Gallery of Art, Washington, D.C., French paintings, 25th anniversary exhibition (cat. 121, illus. p. 135), 1966.

Reproductions: Les arts, vol. 2 (Aug. 1912), p. xv; Charles L. Borgmeyer, *Master Impressionists*, Chicago, 1913, p. 249; Arsène Alexandre, *La renaissance*, vol. 1 (July 1928), p. 278; *Apollo*, vol. 8 (July 1928), p. 33; André Michel, *Histoire de l'art*, Paris, 1929, p. 1155; Frederick A. Sweet, 1966, fig. 8, fol. p. 44; *Washington Star*, Sunday Magazine Section (16 March 1966) (color).

Color plate, page 27.

57
The Nurse 1878

Oil on canvas, 28⅞ × 36¼ in., 73.6 × 92.6 cm.
Signed lower left: *Mary Cassatt*

Description: A nurse wearing a blue dress with a red bow, a white apron, and a cap sits on a bench in a flower-bordered garden. To her right is a perambulator in which a baby is sleeping; on her left, stooping down, is a little boy in a hat.

Collections: Charles Haviland, third sale, Paris, 12 July 1922; to M. Knoedler & Co., London; to E. G. Byng, 1925; to *Mr. and Mrs. A. Varick Stout*, Greenwich, Connecticut.

Exhibitions: Durand-Ruel, New York, 1895 (cat. 19, on loan); M. Knoedler & Co., London, "19th-century French Painters" (cat. 4), 1923; Minneapolis Institute of Arts, 1930 (cat. 4); New Britain (Conn.) Institute, 1943 (cat. 53); M. Knoedler & Co., New York, "Impressionist Treasures" (cat. 1, illus.), 1966.

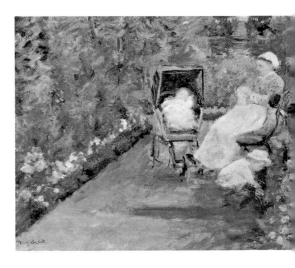

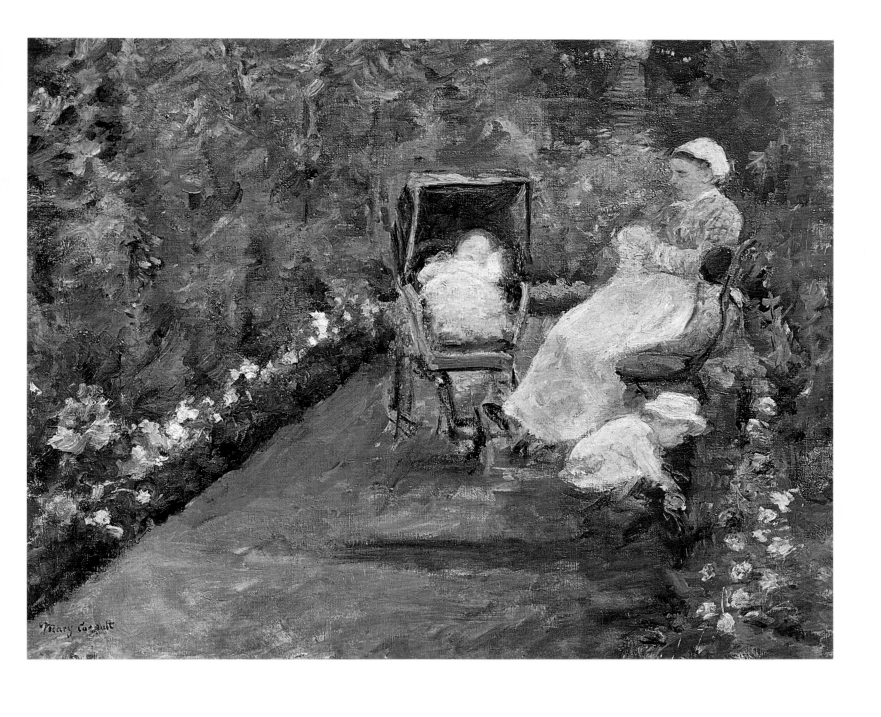

The Nurse, 1878. BrCR 57.

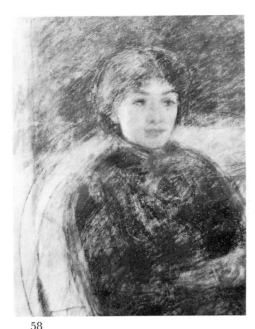

58

Portrait of a Woman in a Dark Dress
c. 1879
Pastel on paper, 25½ × 20 in., 64.5 × 51 cm.
Unsigned. Mathilde X collection stamp at lower
left.

Description: Half-length view of a young woman
seated in a big upholstered armchair by a window
(unseen). Her hair is softly parted with some bangs
and drawn low on her neck. Her dress is dark with
a suggestion of a bow at the neck. Her hands are
folded at her waist.

Note: Durand-Ruel 19848-13921, called "Portrait
de femme."

Collections: From the artist to Mathilde Vallet,
1927; Mathilde X sale, Paris, 1931; Durand-
Ruel, Paris, 1966.

Exhibitions: Galerie A.-M. Reitlinger, Paris, 1931
(cat. 18).

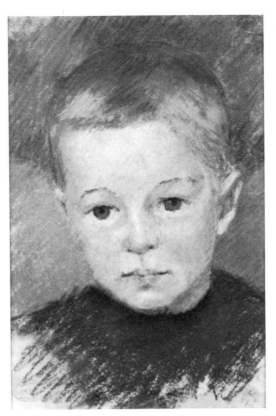

59

French Peasant Boy c. 1879
Pastel on tan paper, 9 × 6 in. (sight), 23 × 15.3 cm.
Unsigned. Mathilde X collection stamp at lower
left corner.

Description: Head of a young boy with blond,
short-cropped hair and dark blue eyes. He wears
a dark brown smock. The background is two shades
of green. The work was done outdoors, and the
flesh tones of the face have many blue shadows as
well as lavender and pink flecks.

Collections: From the artist to Mathilde Vallet,
1927; Mathilde X sale, Paris, 1931; to Le Garrec;
Estate of Christine Biddle Scull, Villanova, Penn-
sylvania.

Exhibitions: Galerie A.-M. Reitlinger, Paris, 1931.

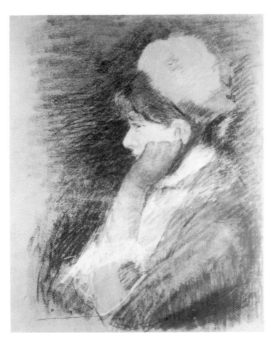

60

**Young Woman Gazing to Left, Resting Her
Head on Her Gloved Hand** 1879
Pastel on paper, 22⅜ × 17⅞ in., 57 × 45.5 cm.
No signature visible

Description: A young woman is seen in half-length
and in profile with the lower part of her face
hidden by her gloved left hand. She wears a small
toque of a light color, against a darker back-
ground.

Note: Also called "Dans la loge."

Collections: Ambroise Vollard, Paris; Edouard
Jonas, Paris; *Carole Slatkin,* New York.

Reproductions: Art in America, vol. 53 (Aug. 1965),
p. 6.

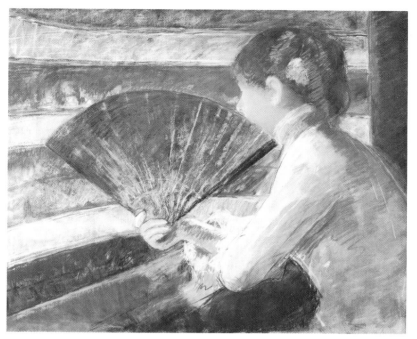

61
Young Woman in a Loge Holding a Wide-open Fan 1879

Pastel on paper, $26\frac{1}{4} \times 32\frac{1}{2}$ in., 66.5×82.4 cm.
Signed left center: *Mary Cassatt*

Description: A young woman, seen in profile left and holding a wide-open fan, rests her elbows on the loge railing and gazes out into the theater. In her auburn hair, behind her ear, are a red and a white flower. Her dress is light yellow. The lime green fan with an orange-red pattern which she holds in her gloved right hand hides the lower part of her face. Three tiers of loges seen in background.

Note: Also called "La loge," "Femme à l'éventail," and "Femme dans une loge."

Collections: Edgar Degas, 1893; Degas sale (cat. 102), Paris, 26, 27 March 1918; Mrs. Q. A. Shaw McKean; her daughter, *Margaret Sargent McKean* (on loan to Museum of Fine Arts, Boston, 1950–68; to be willed to Philadelphia Museum of Art).

Exhibitions: Durand-Ruel, Paris, 1893 (cat. 30); Fogg Art Museum, Cambridge, Mass., 1935; Baltimore Museum of Art, 1941–42 (cat. 5) (called "In the Loge"); Pennsylvania Academy of the Fine Arts, Philadelphia, Peale House Gallery (cat. 10), 1955; Philadelphia Museum of Art, 1960.

62
In the Box c. 1879

Oil on canvas, 17×24 in., 43×61 cm.
Unsigned

Description: The heads and shoulders of two young women are shown. The lady at left holds opera glasses up to her eyes with both gloved hands. The young woman on the right, blond with a pink flower in her hair, wears a round low-necked, salmon-pink dress. She holds a large, open fan, turning her face away so that only her nose and eyelashes show.

Note: Also called "Au balcon." Mrs. Cassatt wrote to Aleck Cassatt in November 1883: "Annie [Mrs. Thomas A. Scott] went to Durand-Ruel's the other day and bought a picture by Mary, perhaps you remember it—Two Young Girls at the Theatre."

Collections: From the artist to Durand-Ruel; Mrs. Thomas A. Scott; *Mr. and Mrs. Edgar Scott,* Villanova, Pennsylvania.

Exhibitions: Brooklyn Institute of Arts and Sciences, "Leaders of American Impressionism: Mary Cassatt, Childe Hassam, J. H. Twachtman, and J. Alden Weir," 1937 (cat. 20); Haverford College, 1939 (cat. 7); Carnegie Institute, Pittsburgh, 1940 (cat. 200); Art Institute of Chicago and Metropolitan Museum of Art, New York, "Sargent, Whistler and Mary Cassatt," 1954 (cat. 6, illus.); Philadelphia Museum of Art, 1960; M. Knoedler & Co., New York, 1966 (cat. 7, illus.).

Reproductions: Forma, vol. 2, no. 20 (1907), p. 299; Mentor, vol. 2 (16 March 1914), p. 2; The Arts, vol. 11, no. 6 (June 1927), p. 289; Forbes Watson, 1932, p. 39; Life, vol. 36 (17 May 1954), fol. p. 98; Frederick A. Sweet, 1966, fig. 9, fol. p. 108.

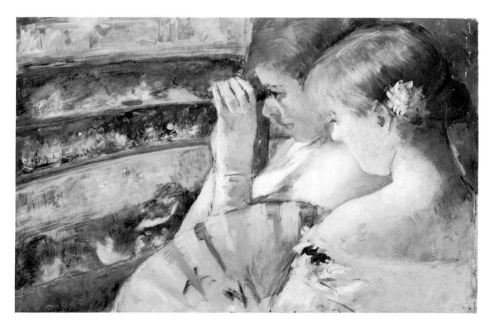

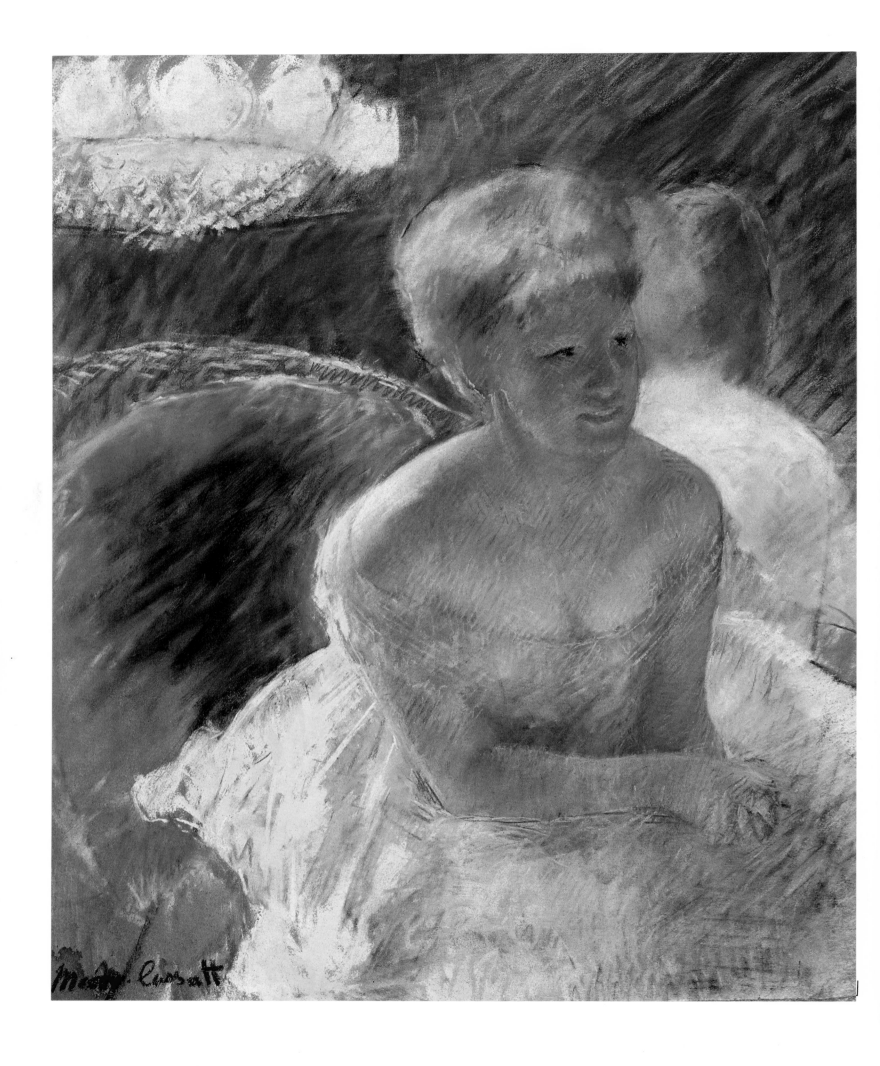

Lydia Leaning on Her Arms, Seated in a Loge, 1879. BrCR 63.

63

Lydia Leaning on Her Arms, Seated in a Loge c. 1879

Pastel on paper, 21⅝ × 17¾ in., 55 × 45 cm.
Signed lower left: *Mary Cassatt*

Description: A smiling young woman in a décolleté evening gown leans forward on her elbows with her hands clasped together. Behind her at upper left is a chandelier. Her reflection is suggested in a mirror at the right. (The pose resembles that of Degas' portrait of Mary Cassatt executed at about the same time.)

Collections: The Michel family, Paris; Arthur Tooth & Sons, London; to Aquavella Galleries, Inc., New York, 1969; to *Eleanor Dorance Ingersoll*, Newport, Rhode Island.

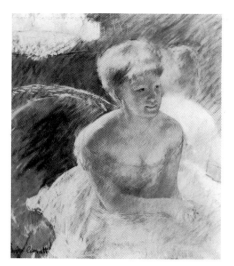

64

Lydia in a Loge, Wearing a Pearl Necklace 1879

Oil on canvas, 31⅝ × 23 in., 80.2 × 58.2 cm.
Signed lower left corner: *Mary Cassatt*

Description: A handsome young woman with orange-red hair and a pink décolleté evening gown wears a choker string of pearls and holds a fan in her gloved right hand. She smiles as she looks off to the right. Other loges with people fill the background.

Note: Also called "The Sister of the Artist in a Loge," "La loge de théâtre," "Jeune femme dans une loge," "Au théâtre," "Dans la loge," and "Lady in a Loge at the Opera."

Collections: Alexis Rouart, Paris; to Marcel Midy, Paris, until March 1967; *Mr. and Mrs. William Coxe Wright*, St. Davids, Pennsylvania.

Exhibitions: Fourth Impressionist Exhibition, Paris, 1879; Durand-Ruel, Paris, 1893 (cat. 4) (called "Au théâtre"); Durand-Ruel, New York, 1895 (cat. 5); Durand-Ruel, New York, 1903 (cat. 1); Durand-Ruel, Paris, 1908 (cat. 8); Galerie Charpentier, Paris, "Scènes et figures parisiennes" (cat. 45), 1943; Galerie Charpentier, Paris, "Cent portraits de femmes" (cat. 121), 1950; The Art Institute of Chicago and Metropolitan Museum of Art, New York, "Sargent, Whistler and Mary Cassatt" (cat. 7, illus.), 1954; Centre Culturel Américain, Paris, 1959 (cat. 2, illus.).

Reproductions: Elizabeth Luther Cary, *Artists Past and Present*, New York, 1909, frontispiece; *L'art et les artistes*, vol. 12 (Nov. 1910), p. 74; Achille Segard, 1913, fol. p. 4; *Les arts*, vol. 12 (June 1913), p. 31; André Michel, *Histoire de l'art*, Paris, 1929, p. 1154; *Art News*, vol. 28 (28 Dec. 1929), p. 3; *Art Digest*, vol. 4 (1 Jan. 1930), p. 18; *Vogue*, vol. 75 (15 Feb. 1930), p. 81; *Art News*, vol. 31 (5 Nov. 1932), p. 8; *Studio* (Feb. 1935), p. 102; *Time* (11 Jan. 1954), p. 56; Frederick A. Sweet, "Assembling an International Exhibition," *Art Institute of Chicago Quarterly*, vol. 48, no. 1 (Feb. 1954), p. 4; *Art News*, vol. 53 (3 April 1954), p. 20; *Studio*, vol. 159, no. 803 (March 1960), p. 95; Frederick A. Sweet, 1966, color pl. 2, fol. p. 76; Julia Carson, 1966, p. 28.

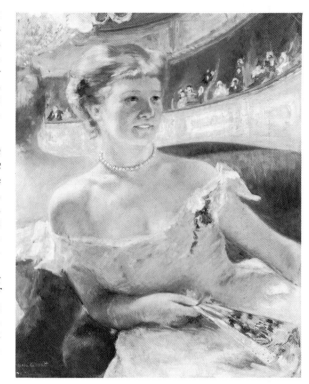

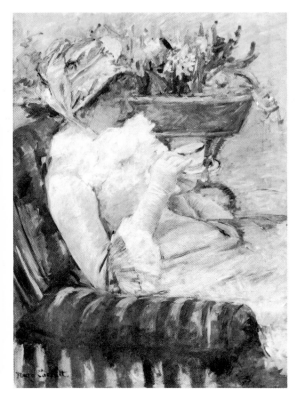

65

The Cup of Tea 1879

Oil on canvas, 36⅜ × 25¾ in., 92.3 × 65.3 cm.
Signed lower left: *Mary Cassatt*

Description: Miss Cassatt's sister Lydia is seated in a broadly striped armchair. She wears a handsome shell pink costume with a pink poke bonnet tied under her chin. In her left hand she holds a saucer and with her right hand lifts a cup. In the background is a wicker flower stand filled with white hyacinths.

Note: Durand-Ruel 511-L1283.

Collections: From the artist to the James Stillman collection, Paris; *Metropolitan Museum of Art*, New York, 1922, anonymous gift (acc. no. 22.16.17).

Exhibitions: Fourth and 6th Impressionist Exhibitions, Paris, 1879, 1881; Durand-Ruel, Paris, 1893 (cat. 8); Durand-Ruel, Paris, 1908 (cat. 12); Pennsylvania Museum of Art, Philadelphia, 1927 (cat. 5); Baltimore Museum of Art, 1941–42 (cat. 4); Wildenstein, New York, 1947 (cat. 4); Lotus Club, New York, 1948; Barnard College, New York, 1949–50; Winnipeg Art Museum, 1951; Art Institute of Chicago, 1951; Pasadena Art Institute, 1951 (cat. 13); Munson-Williams-Proctor Institute, Utica, N.Y., 1953; Art Institute of Chicago and Metropolitan Museum of Art, New York, "Sargent, Whistler and Mary Cassatt" (cat. 5, illus.), 1954; Pennsylvania Academy of the Fine Arts, Philadelphia, 150th anniversary exhibition, 1955; U.S.I.A. traveling exhibition, 1955; Cosmopolitan Club, New York, 1958; Metropolitan Museum of Art, New York, "Three Centuries of American Painting," 1965; Parrish Art Museum, Southampton, N.Y., 1967 (cat. 9, illus.).

Reproductions: Achille Segard, 1913, facing p. 4; *Bulletin, Metropolitan Museum of Art*, vol. 17, no. 3 (March 1922), p. 56; Catherine B. Ely and Frederick F. Sherman, *Modern Tendency in American Painting*, New York, 1925, facing p. 4; Frederick A. Sweet, "America's Greatest Woman Painter: Mary Cassatt," *Bulletin, Metropolitan Museum of Art*, n.s. vol. 16, no. 1 (Summer 1957), p. 11; *Vogue*, no. 123 (15 Feb. 1954), p. 102; *Time*, vol. 63 (11 Jan. 1954), pp. 56–9 (color); Roland J. McKinney, *Famous American Painters*, New York, 1955; *Information et documents*, no. 72 (15 Sept. 1957); Frederick A. Sweet, 1966, fig. 10, fol. p. 108; *Apollo*, n.s. vol. 85, no. 61 (March 1967), p. 219.

66
Mr. Moyse Dreyfus 1879

Pastel on tan paper, 31½ × 25 in., 80 × 63.3 cm.
Signed toward lower left: *Mary Cassatt*

Description: Half-length study of a man seated in an armchair upholstered in chintz. He holds a book in his right hand, his left resting on his leg. He wears glasses and is somewhat bald, with blond mustache and beard. His dark coat contrasts with the light background. His eyes smile at the observer.

Note: The paper split down the middle during World War II. It has since been restored.

Collections: Petit Palais, Paris, 1917, gift of Mme. Moyse Dreyfus in memory of her husband (ref. Inventory of the Municipal Collections, no. D. 1020, Palais de Beaux-Arts de la Ville de Paris, 1927, cat. 106).

Exhibitions: Fourth Impressionist Exhibition, Paris, 1879 (together with "Lydia in a Loge, Wearing a Pearl Necklace" [BrCR 64]).

67
Portrait of Marcellin Desboutin c. 1879

Oil on canvas, 18 × 14⅞ in., 45.7 × 37.7 cm.
Signed upper left: *Mary Cassatt*

Description: Head and shoulders of a man with mustache and rounded beard. A long pipe is in his mouth and a large beret on his head. Dark background with some lighter area above shoulder at right against which the pipe is silhouetted.

Note: Durand-Ruel A#12395.

Collections: George Viau; first George Viau sale, Paris (cat. 10), 4 March 1907; to Mr. Bauer, Paris; Hirschl & Adler, New York, 1967; to *private collection*, New Canaan, Connecticut.

Reproductions: Burlington Magazine, vol. 108, supp. 8 (Dec. 1966), pl. 41; *Connoisseur*, vol. 164, no. 662 (April 1967), p. iii (color).

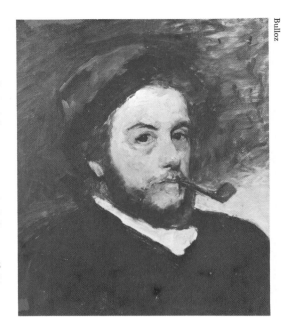

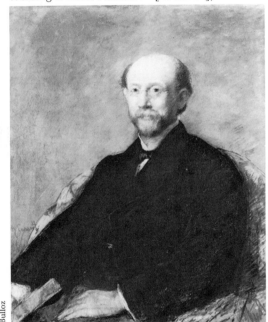

68
Portrait of a Young Girl in a White Hat
1879

Oil on canvas, 17¾ × 15 in., 45 × 38 cm.
Signed center left: *Mary Cassatt/1879*

Description: Head and shoulders of a young girl wearing a small, white feathered hat. Her long, dark brown hair falls down her back. She wears delicate earrings and a black velvet gown with a white stiff collar and a large bow with gold fringe. The background is dark brown.

Collections: Private collection, Paris.

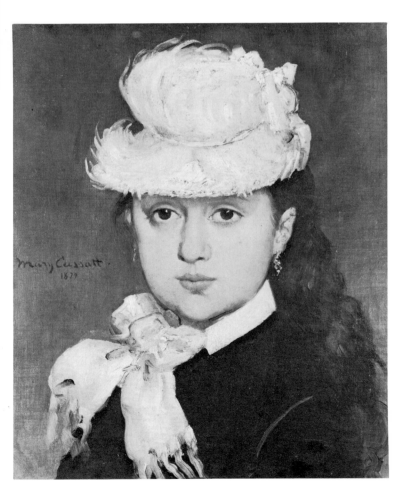

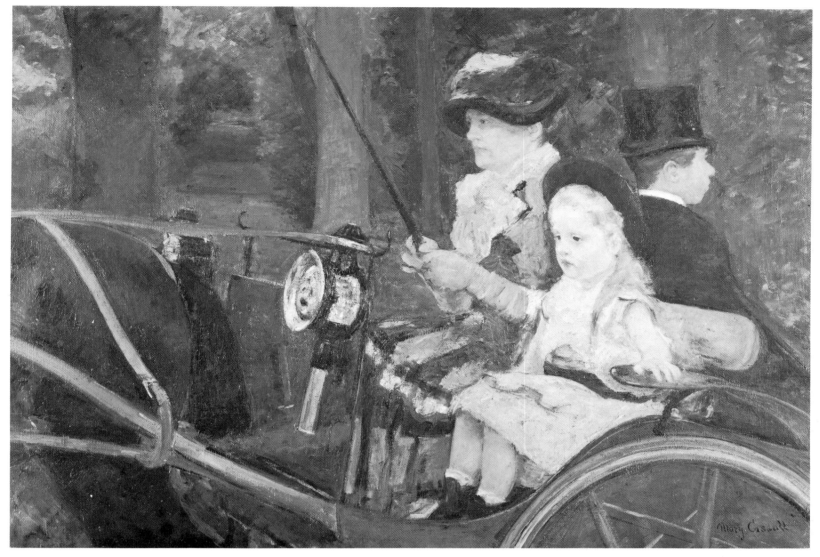

69
Woman and Child Driving　　1879
Oil on canvas, 35¼ × 51½ in., 89.3 × 130.8 cm.
Signed lower right: *Mary Cassatt*

Description: Mary Cassatt's sister Lydia is seen holding the reins and whip as she drives a horse and buggy. Next to her sits a little girl and behind them, facing to right, is a groom. Lydia and the child are seen in profile and near profile to left. Lydia wears a black poke bonnet trimmed in reddish brown and white, a white jabot, and tan gloves. The child has blond hair and wears a black hat, black shoes, and a pink and white dress. She is Odile Fèvre, a niece of Degas, daughter of his sister Marguerite. (Mrs. Cassatt wrote to her grandson Robert Cassatt about it in a letter dated 18 December 1879.)

Collections: The Cassatt family; Alexander J. Cassatt; to the *Philadelphia Museum of Art*, Wilstach Collection.

Exhibitions: Durand-Ruel, New York, 1895 (cat. 28, on loan) (called "En voiture"); Pennsylvania Museum of Art, Philadelphia, Wilstach Collection (cat. 55), 1922; Pennsylvania Museum of Art, Philadelphia, 1927 (cat. 40, illus.); Philadelphia Museum of Art, "Life in Philadelphia Exhibition" (cat. 12), 1940; Tate Gallery, London, "American Painting" (cat. 40), 1946; Wildenstein, New York, 1947 (cat. 7); Art Institute of Chicago and Metropolitan Museum of Art, New York, "Sargent, Whistler and Mary Cassatt" (cat. 8), 1954; Philadelphia Museum of Art, 1960; M. Knoedler & Co., New York, 1966 (cat. 6); Baltimore Museum of Art, "From El Greco to Pollock: Early

and Late Works" (illus. p. 70), 1968.

Reproductions: Pennsylvania Museum of Art Bulletin, vol. 22 (22 May 1927), p. 380; *American Magazine of Art*, vol. 18 (June 1927), p. 305; *The Arts*, vol. 11, no. 6 (June 1927), p. 297; Forbes Watson, 1932, p. 37; *Pennsylvania Museum of Art Bulletin*, vol. 33 (March 1938), p. 13; *Pennsylvania Museum of Art Bulletin*, no. 177 (June 1938), fol. p. 3; *Philadelphia Museum of Art Bulletin*, vol. 35 (May 1940), p. 49; *Philadelphia Museum of Art Bulletin*, vol. 37 (May 1942), p. 1 (detail); John Walker, *Paintings from America*, New York, 1943, pl. 76; Margaret Breuning, 1944, p. 29; *Ladies Home Journal*, vol. 64 (July 1947), p. 41 (color); Francis H. Taylor, *Fifty Centuries of Art*, New York, 1954 [p. 179]; Frederick A. Sweet, 1966, color pl. 4, fol. p. 76.

A Visitor in Hat and Coat Holding a Small Dog c. 1879
Oil on canvas, 14 × 10¾ in., 35 × 27.5 cm.
Signed lower left: *M. S. Cassatt*

Description: A woman in a dark hat and coat sits turned toward the right in an armchair upholstered in a chintz fabric. She holds a small, fluffy dog and looks down at it.

Collections: Bernheim-Jeune, Paris; *private collection*, Paris.

70
Lydia Feeding Oats to Bichette, the Pony
1879
Oil on canvas, 38 × 28 in., 96.5 × 71 cm.
Unsigned

Description: Lydia stands at left wearing a long coat and a light, flower-trimmed hat tied with a dark bow under her chin. Her right hand is extended to feed the pony. The pony is much darker than the background.

Note: Two years later, in a letter of 16 December 1881 Mrs. Cassatt wrote to her grandson Robert: "Your Aunt Mary is so fond of all sorts of animals that she cannot bear to part with ones she loves. You would laugh to hear her talk to Bichette the pony. She painted a picture of her head and your Aunt Lydia standing beside her giving her some oats from her hand." (Frederick A. Sweet, 1966, p. 64.)

Collections: Estate of Mrs. Horace Binney Hare.

Exhibitions: Haverford College, 1939 (cat. 25); Philadelphia Museum of Art, 1960.

72
Young Lady in a Loge Gazing to Right
c. 1880
Pastel and gouache, 25½ × 21½ in., 64.6 × 54.5 cm.
Signed at center left, vertically: *M. Cassatt*

Description: Head and shoulders of a young woman with auburn hair, holding a wide-open, decorated fan. Her hair is massed behind in a large knot and is held by a narrow black band. She wears a pink dress, and the background of loges is mostly in shades of yellow.

Note: Durand-Ruel A≠L. D. 13469-10753.

Collections: Paul Gauguin; to Edward Brandes, Copenhagen; to Dr. Alfred Gold, Berlin; sold 1935 to *private collection*, Fairhaven, Massachusetts.

Exhibitions: Fifth Impressionist Exhibition, Paris, 1880; Durand-Ruel, Paris, 1893 (cat. 30); Durand-Ruel, Paris, 1928; "35 Paintings Selected from Exhibitions at Dr. Alfred Gold's Gallery," Berlin, 1930.

73
A Woman in Black at the Opera 1880
Oil on canvas, 32 × 26 in., 81 × 66 cm.
Signed lower left corner: *Mary Cassatt*

Description: A woman wearing a black costume
with white collar and cuffs holds a closed fan in her
left hand while looking through the opera glasses
in her right. Her black poke bonnet is tied with a
bow under her chin. The background includes two
tiers of loges.

Note: Also called "La loge (à l'opéra)," "Dans la
loge," and "At the Opera." Durand-Ruel
A.488-N.Y.1166.

Collections: Mme. Martin et Camentron, 1893;
Durand-Ruel, Paris; Durand-Ruel, New York;
Museum of Fine Arts, Boston, purchased, 1910,
through the Charles Henry Hayden Fund.

Exhibitions: Society of American Artists, New York,
1881; Durand-Ruel, Paris, 1893 (cat. 13); St.
Botolph Club, Boston, 1909 (cat. 24); Art Institute
of Chicago, 39th annual exhibition, 1926; Car-
negie Institute, Pittsburgh, 1928; Smith College,
1928 (cat. 9); Museum of Fine Arts, Boston,
"Selected Oil and Tempera Paintings and 3
Pastels," 1932; Art Institute of Chicago, "A Cen-
tury of Progress," 1933; Wadsworth Atheneum,
Hartford, 1935; Brooklyn Institute of Arts and
Sciences, "Leaders of American Impressionism:
Mary Cassatt, Childe Hassam, J. H. Twachtman,
and J. Alden Weir" (cat. 31, illus.), 1937; Jacques
Seligman & Co., New York, "The Stage," 1939;
Baltimore Museum of Art, 1941–42 (cat. 7);
Wildenstein, New York, 1947 (cat. 5); Carnegie
Institute, Pittsburgh, Munson-Williams-Proctor
Institute, Utica, N.Y., Virginia Museum of Fine
Arts, Richmond, Baltimore Museum of Art,
Currier Gallery of Art, Manchester, N.H.,
"American Classics of the 19th Century" (cat. 76),
1957; Baltimore Museum of Art, 1962 (cat. 101,
illus.); Better Living Center, New York World's
Fair, "Four Centuries of American Masterpieces"
(cat. 10, illus.), 1964.

Reproductions: Scrip, vol. 2 (March 1907), facing
p. 193; *Fine Arts Journal*, vol. 28 (April 1913),
p. 226; Charles L. Borgmeyer, *Master Impressionists*,
Chicago, 1913, p. 160; *Catalogue of Paintings*,
Museum of Fine Arts, Boston, 1921, p. 178, cat.
565; Suzanne La Follette, *Art in America*, New
York & London, 1929, facing p. 218; Forbes
Watson, 1932, p. 29; *London Studio*, vol. 9 (Feb.
1935), p. 102; *Art News*, vol. 37, no. 28, pt. II
(8 April 1939), p. 1; *Apollo*, vol. 29, no. 174 (June
1939), p. 297; Sheldon Cheney, *Story of Modern
Art*, 1941, p. 337; Margaret Breuning, 1944, p. 37;
French Impressionists, 1944, p. 93; *Gazette des
beaux arts*, s6, vol. 29 (April 1946), p. 233; *Art
News*, vol. 46, pt. I (Nov. 1947), p. 18; Jean
Leymarie, *Impressionism: Biographical and Critical
Study*, Lausanne, 1955, p. 69 (color); Forbes
Watson, "Mary Cassatt," *Carnegie Magazine*, vol.
31(Oct. 1957), p. 259; Frederick A. Sweet, 1966,
fig. 11, fol. p. 108; Julia Carson, 1966, p. 29.

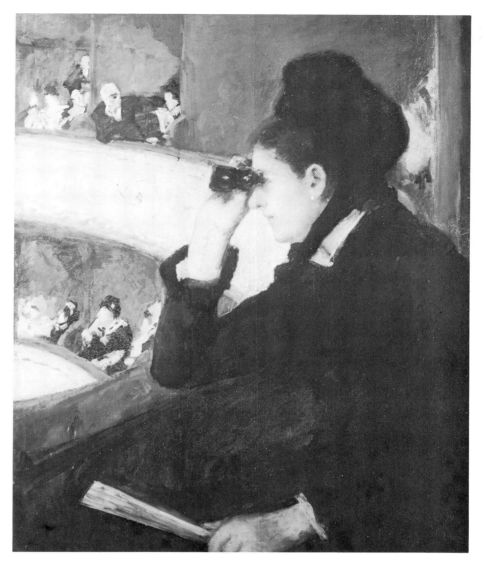

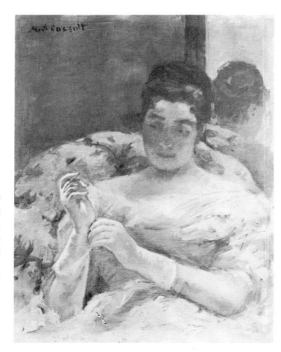

74
Young Woman Buttoning Her White Glove
1880
Oil on canvas, 13¾ × 10¾ in., 34.2 × 27.2 cm.
Signed upper left: *M. S. Cassatt, 1880*

Description: A young woman with dark hair,
sitting in a round-backed chair covered in a floral
pattern, buttons her glove on her right hand with
her gloved left hand. She wears a yellow evening
gown with round décolletage. Her head is reflected
in a mirror in the right background.

Note: Also called "Femme mettant ses gants" and
"La femme au gant." Durand-Ruel 7007-
L9610.

Collections: Bought from the artist by Alexis Rouart,
1893–1911; Dikran Kelekian, 1911–22; Mr. and
Mrs. Otto Spaeth, 1922–63; Knud Abildgaard,
1963 (destroyed in a fire in his house during the
summer of 1968).

Exhibitions: Durand-Ruel, Paris, 1893 (cat. 6);
Guildhall, Easthampton, N.Y., "Historic Survey of
American Paintings," 1951; Princeton University
Art Gallery, "The Spaeth Collection," 1952;
Columbus (Ohio) Gallery of Fine Arts, "The
Spaeth Collection," 1955.

Reproductions: Art in America, vol. 51 (April 1963),
p. 9; *Burlington Magazine*, vol. 105 (April 1963),
p. xi.

Elsie and Robert Cassatt 1880

Oil on tan millboard, 25 × 21 in., 63.3 × 53.2 cm.
Unsigned

Description: A sketch. The two faces are well developed as are Elsie's black cap and the collar of her black coat. The background features many scraggly brush strokes in green, red, brown, etc., with more of the background left bare.

Collections: The family of the artist; *the children of Mrs. William Potter Wear*, Cecilton, Maryland.

Exhibitions: Philadelphia Museum of Art, 1960.

75

Sketch of a Young Girl Holding a Loose Bouquet c. 1880

Oil on canvas, 23¾ × 18⅛ in., 60.2 × 46 cm.
Signed at lower left: *M. C.*

Description: A sketch of a young girl with dark hair and eyes. In front of her is a large mass resembling a loosely arranged bouquet with straggly ends.

Note: Also called "Femme aux fleurs." M. Knoedler and Co. no. A7117.

Collections: Mr. & Mrs. Alfred Zantzinger, Villanova, Pennsylvania.

77

Mrs. Cassatt Reading to Her Grandchildren
1880

Oil on canvas, 22 × 39½ in., 55.7 × 100 cm.
Signed lower left corner: *Mary Cassatt*

Description: Mrs. Cassatt sits facing left, seen in profile, wearing glasses and reading aloud to three children. The boy, Robert, sits facing her in profile to right. The two girls, on either side of Mrs. Cassatt, are Katharine and Elsie. Robert wears a blue plaid blouse. The book is red. Through the windows is green foliage.

Note: Similar in composition to prints Br 58 and 59. Also called "Bible Reading."

Collections: From the artist to her brother Alexander J. Cassatt; to his son Robert Kelso Cassatt; to his son *Anthony D. Cassatt*.

Exhibitions: Sixth Impressionist Exhibition, Paris, 1881; Carnegie Institute, Pittsburgh, 1928 (cat. 8); Haverford College, 1939 (cat. 3); Baltimore Museum of Art, 1941–42 (cat. 8); Philadelphia Museum of Art, 1960.

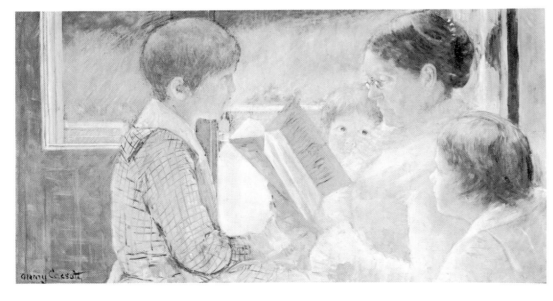

78

Five O'Clock Tea 1880

Oil on canvas, 25½ × 36½ in., 64.7 × 92.7 cm.
Signed lower left corner: *Mary Cassatt*

Description: Lydia Cassatt, wearing light brown, is
seated at the left on a couch upholstered in a rose
floral pattern. Next to her sits her guest, wearing a
poke bonnet and dark blue costume with gray hat
and lemon yellow gloves. She drinks from a tea
cup in her right hand, while she holds her saucer
in her left. At the right is a large tea tray with
service. At extreme upper right is a part of a
mantelpiece and across the rest of background
wallpaper striped in rose and gray.

Note: The tea service, still in the Cassatt family
and marked "M.S. 1813," was made for Miss
Cassatt's grandmother Mary Stevenson, after
whom Miss Cassatt was named. Also called "Le
thé," "Five o'clock" (in Durand-Ruel's 1893
exhibition), and "Le Tasse de Thé."

Collections: Henri Rouart, purchased from the 6th
Impressionist Exhibition, 1881, and retained by
him until 1912; first Henri Rouart sale (cat. 91),
Paris, 9, 10, 11, Dec. 1912; to Dikran Kelekian;
Kelekian sale, New York, 31 Jan. 1922; to
Museum of Fine Arts, Boston, acquired through the
Maria Hopkins Fund.

Exhibitions: Fifth Impressionist Exhibition, Paris,
1880; 6th Impressionist Exhibition, Paris, 1881
(cat. 4); Durand-Ruel, Paris, 1893 (cat. 5);
Durand-Ruel, New York, 1895 (cat. 8); Durand-
Ruel, Paris, 1908 (cat. 7); Baltimore Museum of
Art, 1941–42 (cat. 6, illus.); Wellesley College,
1947; Wildenstein, New York, 1947 (cat. 4);
Milwaukee Art Institute, 1948 (cat. 4); Art
Institute of Chicago and Metropolitan Museum of
Art, New York, "Sargent, Whistler and Mary

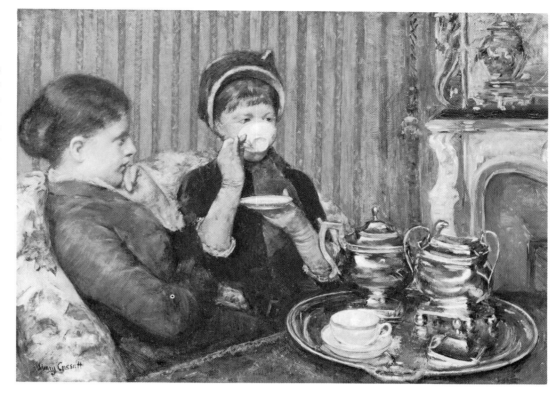

Cassatt" (cat. 9, illus.); Society of Fine Arts,
Palm Beach, "Sargent and Cassatt," 1959;
American Academy of Arts and Letters, New York,
"Change of Sky," 1960; Baltimore Museum of
Art, "Manet, Degas, Berthe Morisot and Mary
Cassatt" (cat. 102, illus.), 1962; M. Knoedler and
Co., New York, 1966 (cat. 8).

Reproductions: Charles L. Borgmeyer, *The Master
Impressionists*, Chicago, 1913, p. 160; Achille
Segard, Paris, 1913, facing p. 13; *International
Studio*, vol. 54 (Nov. 1914), p. 6; Edith Valerio,
1930, pl. 7; *Art News*, vol. 40, (1–14 Jan. 1942),
p. 18; *Museum of Fine Arts Bulletin*, Boston, vol. 40,
no. 240 (Aug. 1942), p. 63; Margaret Breuning,
1944, p. 17; Germain Bazin, *History of Modern
Painting*, New York, 1951; *Time*, vol. 63 (11 Jan.
1954), p. 56 (color); Alexander Eliot, *300 Years
of American Painting*, New York, 1957, p. 124;
Frederick A. Sweet, 1966, color pl. 3, facing p. 77;
Julia Carson, New York, 1966, p. 40; *Arts*, vol. 40,
no. 7 (May 1966), p. 60.

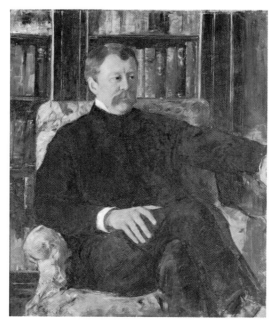

79

Portrait of Mr. Alexander J. Cassatt 1880

Oil on canvas, 40 × 32 in., 101.3 × 81 cm.
Signed lower left: *Mary Cassatt*

Description: Miss Cassatt's brother, seen in three-
quarter view, sits in a chintz-covered armchair
with his right leg crossed over his left, his right
hand resting on his leg. His hair and mustache are
reddish, and he wears a dark suit. Behind him is a
bookcase filled with books.

Note: Painted at Marly-le-roi.

Collections: From the artist to the sitter; to his son
Robert Kelso Cassatt; to his son *Anthony D.
Cassatt*.

Exhibitions: Pennsylvania Museum of Art, Phil-
adelphia, 1927; Haverford College, 1939 (cat. 20);
Baltimore Museum of Art, 1941–42 (cat. 15);
Philadelphia Museum of Art, 1960.

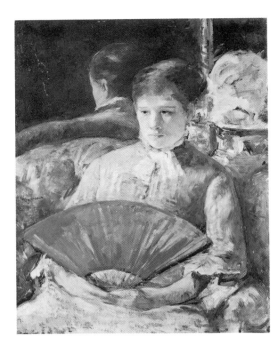

80
Miss Mary Ellison c. 1880
Oil on canvas, 33¾ × 25¾ in., 85.7 × 65.2 cm.
Signed center left: *Mary Cassatt*

Description: A young woman sits in an upholstered armchair before a mirror which shows the reflection of her head. She wears a green dress with a ruffle and jabot at the throat. On her lap she holds a large, open fan with both hands.

Note: Also called "Woman with a Fan." The daughter of the sitter wrote to the author a comparison of the two paintings of Mary Ellison: "The portrait in Washington is a dreamy young girl, the one I have [BrCr 48] is the vital, enthusiastic one which is to me much more my mother but I can see my mother in another mood in the one in Washington." Durand-Ruel A948-NY1343; National Gallery of Art 1759.

Collections: Durand-Ruel, Paris and New York; *National Gallery of Art*, Washington, D.C., Chester Dale Collection.

Exhibitions: Durand-Ruel, Paris, 1893 (cat. 10); Durand-Ruel, New York, 1895 (cat. 2); Cincinnati Art Museum, annual exhibition (cat. 11), 1901; Cincinnati Art Museum, annual exhibition (cat. 1), 1903; Durand-Ruel, New York, 1903 (cat. 2); Cincinnati Art Museum, annual exhibition, 1906; St. Botolph Club, Boston, 1909; Corcoran Gallery of Art, Washington, D.C., "Masters of the Modern French School," 1911; Corcoran Gallery of Art, Washington, D.C., "5th Biennial" (cat. 77), 1914–15; Carnegie Institute, Pittsburgh, Cleveland Museum of Art, Cincinnati Art Museum, William Rockhill Nelson Gallery, Kansas City, Mo., City Art Museum of St. Louis, "Paintings by Six American Women Painters," 1917–18; Durand-Ruel, New York, 1924 (cat. 2); Albright Art Gallery, Buffalo, "Selected Paintings by American Artists," 1926; Art Institute of Chicago, 1926–27; Pennsylvania Museum of Art, Philadelphia, 1927 (cat. 36); Durand-Ruel, "Before Manet to Modigliani" (cat. 42), 1929.

Reproductions: Elizabeth Luther Cary, *Artists Past and Present*, New York, 1909, facing p. 34; *Arts*, vol. 3 (June 1923), p. 432; *Pennsylvania Museum of Art Bulletin*, vol. 22 (May 1927), p. 376; *American Magazine of Art*, vol. 18 (June 1927), p. 306; *Art and Archeology*, vol. 23 (June 1927), p. 283; Forbes Watson, 1932, p. 25; Margaret Breuning, 1944, p. 43.

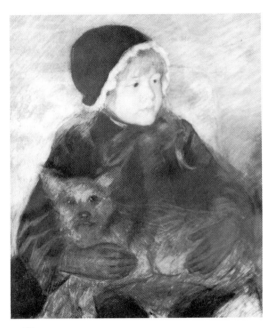

81
Elsie Cassatt Holding a Big Dog c. 1880
Pastel on paper on board, 25 × 20½ in.,
63.5 × 52 cm.
Unsigned

Description: Elsie sits in an upholstered chair holding a big dog on her lap. She looks off to the right, whereas the dog looks alertly at the spectator. Elsie wears a tight-fitting black cap edged with white ruching and tied under her chin with a big dark bow. Her coat is dark and her two gloved hands are prominently placed as she holds the dog.

Collections: From the artist to her brother Alexander; to the sitter; within the family; private collection, Philadelphia, Pennsylvania.

Exhibitions: Haverford College, 1939 (cat. 22); Philadelphia Museum of Art, 1960.

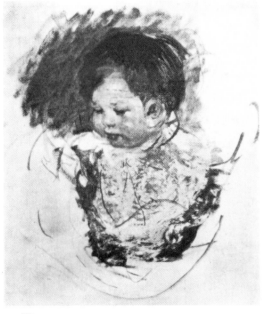

82
Baby Boy in a Bib, Looking Down c. 1880
Oil on canvas, 18¼ × 15½ in., 46.2 × 39.2 cm.
Unsigned

Description: Head of a brown-haired baby looking down to the left. His hair is full and cut short, parted on the side. Behind his head at left and above is a dark shadow. The foreground is sketchy.

Collections: Payson Thompson; American Art Association, New York, Payson Thompson sale (cat. 75, illus.), 12 Jan. 1928; present location unknown.

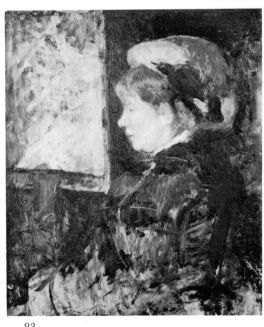

83
The Visitor, Profile Left c. 1880
Gouache on canvas, 28 × 22¾ in., 71 × 57.5 cm.
Signed upper left corner: *Mary Cassatt*

Description: A seated woman is seen wearing a light greenish toque trimmed with what looks like a deeper green bird. Her blouse is deep green and a rich dark blue. Her hair is reddish gold.

Note: Also called "Woman in Profile" and "Portrait de femme de profil." Authenticated by J. Dubourg, Charles Durand-Ruel, and Paul Ebstein. Durand-Ruel, N.Y. A1277-4709.

Collections: Dikran G. Kelekian; Kelekian sale (cat. 135), New York, 31 Jan. 1922; M. & Ph. Rheims sale, Paris, 29 Nov. 1962; probably *private collection, France.*

Exhibitions: Wildenstein, New York, 1947 (cat. 6).

84
Woman by a Window Feeding Her Dog

c. 1880

Oil, gouache, and pastel, 24 × 16 in., 61 × 40.5 cm.
Signed lower right: *Mary Cassatt*

Description: A seated young woman seen in profile
to right has her hands raised together over her lap
—evidently with food in them, which draws the
attention of her dog who pricks up his ears. Behind
them are two large panes of a window. The woman
wears a dark dress with a white bow at the throat.

Note: Also called "Femme assise jouant avec un
chien devant une fenêtre." Durand-Ruel 10453,
D13159.

Collections: From the artist to Mathilde Vallet,
1927; Mathilde X sale, Paris, 1927; bought by
Durand-Ruel, Paris; **Acquavella Galleries, New
York;** *private collection*, Gladwyne, Pennsylvania.

Exhibitions: Galerie A.-M. Reitlinger, Paris, 1927
(cat. 60, illus.); City Art Museum of St. Louis,
1933–34 (cat. 7); Durand-Ruel, New York, 1935
(cat. 17).

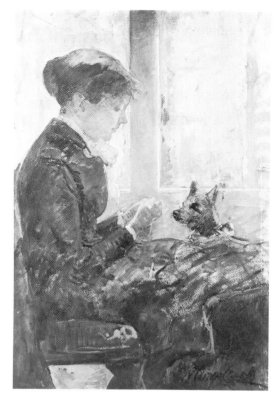

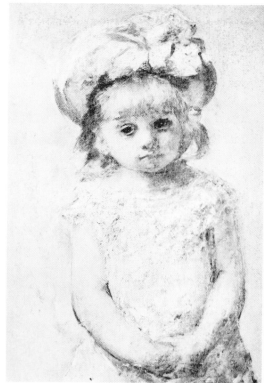

85
Portrait of Little Marthe Laurent 1880

Oil on canvas, 24¾ × 16⅛ in., 63 × 41 cm.
Unsigned

Description: A little blond girl seen in half-length
with her hands clasped before her. She wears a
large white hat and a white dress.

Note: Mlle. Laurent was a grandchild of Marie
Dorval who lived at 13 Avenue Trudaine (today
no. 27) where Miss Cassatt also lived for a time.
Marthe played with Miss Cassatt's two nieces,
Kate and Elsie, when they came to visit her in
1880.

Note: Also called "Le chapeau blanc." The idea
for this portrait evidently came from her recol-
lection of the portrait of young Titus by
Rembrandt, now in the Norton Simon collec-
tion.

Collections: Private collection, Paris.

Exhibitions: Centre Culturel Americain, Paris,
1959–60 (cat. pl. 1) (called "Le chapeau blanc").

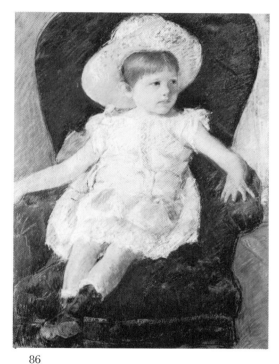

86
Portrait of Elsie Cassatt 1880

Pastel on paper, 35 × 25 in., 88.8 × 63.3 cm.
Unsigned

Description: The artist's niece sits in a large chair
upholstered in royal blue, her arms resting on its
arms. She wears a white dress with a light pink
sash and a large white hat with some light green
on it. Her high shoes are dark brown. Under her
hat her short reddish blond hair is slightly parted,
with bangs.

Collections: From the artist to her family; *Elsie
Foster Stockwell,* Cambridge, Massachusetts.

Exhibitions: Pennsylvania Museum of Art, Phil-
adelphia, 1927 (cat. 32); M. Knoedler & Co.,
New York, 1966 (cat. 15, illus.).

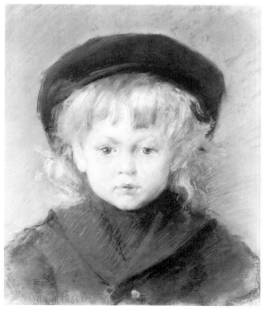

87
Portrait of Katharine Cassatt 1880

Pastel, 17⅝ × 14¾ in., 44.7 × 37.3 cm.
Signed toward lower left: *Mary Cassatt*

Description: Head and shoulders of a little girl
wearing a dark blue beret on the back of her head.
Her blond hair is cut in bangs and is somewhat
curly behind the ears. Her dark blue coat is
fastened with a brass button. The background is
greenish blue.

Note: Also called "Portrait d'enfant."

Collections: Henri Rouart; Rouart sale, Paris, 16
Dec. 1912 to Elaine Dondi; Galerie Pétridès,
Paris; to *Mr. and Mrs. Raymond A. Young,* Okla-
homa City, Oklahoma.

Exhibitions: Durand-Ruel, New York, 1895 (cat.
24, on loan) (called "Portrait d'enfant"); Pennsyl-
vania Museum of Art, Philadelphia, 1927 (cat. 32).

88

A Goodnight Hug 1880

Pastel on paper, 16½ × 24 in., 42 × 61 cm.
Signed lower right: *Mary Cassatt*

Description: Head and shoulders of a mother kissing her child who embraces her. She has dark hair and wears a dark, striped blouse. The background is striped, flowered wallpaper.

Note: Possibly in 6th Impressionist Exhibition, 1881; Huysmans wrote of one "Mother who kissed her baby on the cheek" by Cassatt. Also called "Caresse Maternelle." Durand-Ruel 9158-L11711.

Collections: Durand-Ruel, Paris; Mrs. C. J. Lawrence, New York; to Marlborough Fine Art Ltd., London; *Estates of Stephen R. and Audrey B. Currier*, New York.

Exhibitions: Durand-Ruel, Paris, 1900; St. Botolph Club, Boston, 1909 (cat. 25); City Art Museum of St. Louis, 1933–34 (cat. 13); Marlborough Fine Art Ltd., London, 1953 (cat. 16) (called "Caresse Maternelle").

Reproductions: Edith Valerio, 1930, pl. 3.

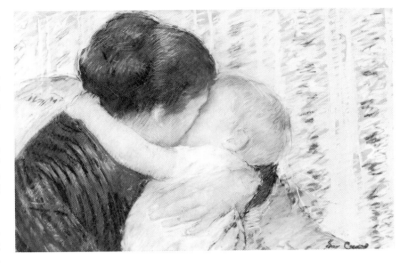

89

Mother Feeding Her Child with a Spoon

c. 1880

Crayon and pastel on light brown paper, 26 × 20½ or 23½ × 18 in., 66 × 52 cm. or 59.5 × 45.5 cm.
Signed upper right: *Mary Cassatt*

Description: The mother, with hair parted in the middle, looks down at her child seated on her lap whom she is feeding with a spoon. The blond child looks at the spoon and touches it with his right hand. His left arm hangs over his mother's left hand. There are a few touches of pastel on the mother's nose and on the spoon.

Collections: Galerie P. Naves, Paris; Jimmy McHugh, Los Angeles; Parke-Bernet, New York, Albert E. McVitty sale (cat. 79, illus.), 15 Dec. 1949. Present location unknown.

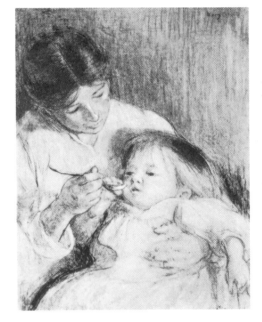

90

Mother about to Wash Her Sleepy Child

1880

Oil on canvas, 39½ × 25¾ in., 100 × 65 cm.
Signed lower left: *Mary Cassatt/1880*

Description: A baby in a white shift sprawls on his mother's lap. The mother, dressed in gray, is in a striped chair against a wallpaper background.

Note: Also called "La toilette de l'enfant" and "The Bath." This is often considered Miss Cassatt's first professional painting of the mother and child theme. Durand-Ruel 627-L8636.

Collections: Mr. and Mrs. A. A. Pope; Mrs. John Riddle, 1940; M. Knoedler & Co., New York; to Mrs. Fred Hathaway Bixby, 1946, who bequeathed it to *The Los Angeles County Museum of Art.*

Exhibitions: Fifth Impressionist Exhibition, Paris, 1880; Durand-Ruel, New York, 1895 (cat. 9); St. Botolph Club, Boston, 1909 (cat. 20).

Reproductions: Les modes, vol. 4 (Feb. 1904), p. 4; *La revue de l'art ancien et moderne,* vol. 23 (March 1908), p. 175; Achille Segard, 1913, facing p. 12; *Gazette des beaux arts,* s6, vol. 61 (Feb. 1963), sup. no. 1129, p. 43.

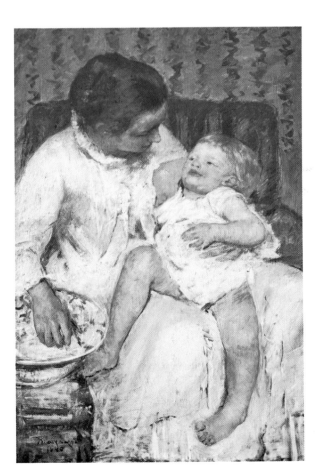

91

Landscape with a Suggestion of Figures on the Grass c. 1880

Pastel on paper, 19⅝ × 24¾ in., 50 × 63 cm.
Signed lower left (faintly): *Mary Cassatt*

Description: Many trees surrounding a broad meadow in the center of which seated and reclining figures are suggested slightly.

Collections: Ambroise Vollard; M. Clomovich; *National Museum*, Belgrade, Yugoslavia, since 1949 (inventory no. 350).

92

In the Meadow (No. 1) c. 1880
Gouache and oil on canvas, 24 × 32½ in.,
61 × 82.3 cm.
Signed lower right: *Mary Cassatt*

Description: Three ladies are seated on the grass in
a meadow, with three lines of low shrubbery
behind them. The middle one wears a large straw
hat: the others are bareheaded.

Collections: Durand-Ruel, Paris; to Ambroise
Vollard; George Charpentier sale (cat. 2, illus.),
Paris, 12 May 1950; present location unknown.

93

In the Meadow (No. 2) 1880
Oil on canvas, 21⅜ × 25⅝ in., 54 × 65 cm.
Signed lower right: *Mary Cassatt*

Description: Two women and a child are seen sitting
on the grass in a meadow with trees behind them.
The woman on the right wears a hat. The one at
the left has blond hair and wears a white-collared
dress.

Note: Also called "Dans la prairie." Durand-Ruel
A752, 1385.

Collections: Mme. Martin et Camentron; Durand-
Ruel, Paris, Jan. 1894; to Durand-Ruel, New
York, 1895; *B. E. Bensinger,* Chicago, Illinois, 1969.

Exhibitions: Durand-Ruel, Paris, 1893 (cat. 12);
Durand-Ruel, New York, 1895 (cat. 10); Durand-
Ruel, New York, 1903 (cat. 4); St. Botolph Club,
Boston, 1909 (cat. 21); Durand-Ruel, New York,
1920 (cat. 4); Durand-Ruel, New York, 1926 (cat.
10); Pennsylvania Museum of Art, Philadelphia,
1927 (cat. 9); Carnegie Institute, Pittsburgh, 1928
(cat. 12); McClees Gallery, Philadelphia, 1931
(cat. 6); Brooklyn Museum, 1932 (cat. 10); City
Art Museum of St. Louis, 1933–34 (cat. 8).

94

Lydia Reading in a Garden 1880
Oil on canvas, 35½ × 25⅝ in., 90 × 65 cm.
Signed at lower left: *Mary Cassatt*

Description: Lydia, wearing a soft white dress
patterned with outlined polka dots, is seated in a
wicker chair. Her dark hair is brushed back into a
bun. Behind her, against shrubbery, is a bright
clump of richly blooming roses that give a brilliant
color note in contrast to the delicate whites and
grays of her dress.

Note: Also called "Femme lisant" and "Woman
Reading in a Garden" (Art Institute of Chicago).
Durand-Ruel A816-NY2707.

Collections: Art Institute of Chicago, gift of Mrs.
Albert J. Beveridge in memory of her aunt,
Delia Spencer Field.

Exhibitions: Durand-Ruel, New York, 1903 (cat.
10); St. Botolph Club, Boston, 1909 (cat. 23);
Corcoran Gallery of Art, Washington, D.C., 5th
Biennial (cat. 73), 1914–15; Pan-Pacific Inter-
national Exposition, San Francisco, 1915; Wor-
cester (Mass.) Art Museum, "Exhibition of Paint-
ings by Modern French Masters" (cat. 1), 1917;
Durand-Ruel, New York, 1920 (cat. 8); Carnegie
Institute, Pittsburgh, 1928 (cat. 7); Durand-Ruel,
Paris, 1940 (cat. 199); Carnegie Institute, Pitts-
burgh, "Survey of American Painting" (cat. 199),
1940; Pasadena Art Institute, 1951 (cat. 1);
Durand-Ruel, Paris, 1954 (cat. 10); Art Institute
of Chicago and Metropolitan Museum of Art,
New York, "Sargent, Whistler and Mary Cassatt"
(cat. 10, illus.), 1954.

Reproductions: Art Institute of Chicago Bulletin, vol.
32 (April 1938), illus. (cover and p. 57); *Art
Institute of Chicago Report,* vol. 33, no. 3 (1938),
pp. 1 and 182; *Art News,* vol. 36 (28 May 1938),
p. 20; *Art Digest,* vol. 15 (1 Nov. 1940), p. 7;
Magazine of Art, vol. 33 (Nov. 1940), p. 622; *Art
News,* vol. 42 (1 Nov. 1943), p. 19; Margaret
Breuning, 1944, p. 20.

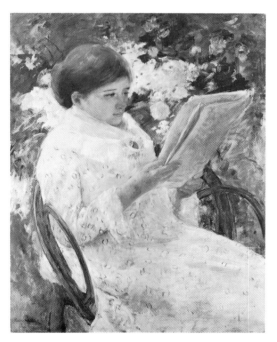

95

**Lydia Seated in the Garden with a Dog on
Her Lap** c. 1880
Oil on canvas, c. 12 × 18 in., 30.5 × 45.8 cm.
Signed lower right: *M. C.*

Description: Lydia, wearing a gray-blue coat and a
straw hat trimmed with black ribbon, is seated on a
folding chair in a garden, surrounded by thick
foliage and flowers. She is seen from the rear,
turned away from the spectator. On her lap can
be seen the head of a griffon dog.

Collections: Estate of Mrs. Horace Binney Hare.

Exhibitions: Haverford College, 1939 (cat. 14);
Pennsylvania Academy of the Fine Arts, Philadel-
phia, Peale House Gallery (cat. 27), 1955.

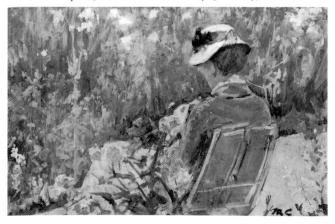

Bulloz

96
Profile Portrait of Lydia Cassatt 1880
Oil on canvas, 36¼ × 25½ in., 93 × 65 cm.
Signed lower right: *Mary Cassatt*

Description: The artist's sister, seen in profile to the left, wears a poke bonnet lined in red with black top and long streamers tied under the chin. Her multi-colored coat or wrap is mostly in warm tones of red, and her gloves are tan. She holds an umbrella in her right hand and is seated on a green slatted bench. A green woods is in the background.

Note: Ch. Léger, *Courbet et son temps*, Paris, 1948, p. 196: "Mlle. Cassatt . . . se sentant décliner, prévint Théodore Duret de son désir de faire un don à un musée. Mr. Henri Lapouze fit, sur le champ une visite à Mlle. Cassatt. C'est ainsi que le Petit Palais s'est enrichi des œuvres délicates de l'artiste americaine."

Collections: Petit Palais, Paris, gift of the artist, 1922.

Exhibitions: Petit Palais, "Un siècle d'art francais 1850–1950" (cat. 396), 1953.

97
Lydia Cassatt in a Green Bonnet and a Coat
c. 1880
Oil on canvas, 23⅞ × 19⅜ in., 60.8 × 49.3 cm.
Signed lower right: *Mary Cassatt*

Description: Half-length of the artist's sister wearing a green poke bonnet trimmed with ribbon and tied under her chin, but without a large bow. Her coat hangs loosely from her shoulders.

Note: Also called "Jeune fille au chapeau vert."

Collections: Ambroise Vollard and Fabiani, Paris; Ernest Duveen, London; to Gimpel Fils, London, 1955; to Philip J. Goldberg, London; Sotheby sales, London, 7 June 1960 and 1 July 1964; to Stephen Hahn Gallery, New York.

Exhibitions: Gimpel Fils, "Collector's Choice" (cat. 1), spring 1955.

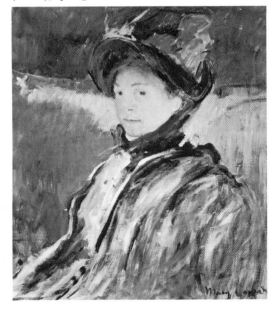

98
Lydia Crocheting in the Garden at Marly
1880
Oil on canvas, 26 × 37 in., 66 × 94 cm.
Signed lower left: *Mary Cassatt*

Description: The artist's sister sits in a chair on a garden path. She wears a blue dress and a frilly white bonnet with pink ribbons tied under her chin. The flowers bordering the path behind her include a low row of plants with mulberry colored leaves and a higher row with green stems and small, salmon pink blossoms.

Note: Also called "En brodant" and "Lydia Knitting in the Garden at Marly." Durand-Ruel 435-L2574.

Collections: From the artist to her brother Alexander J. Cassatt; to his son Robert Kelso Cassatt; to a nephew, Gardner Cassatt; to *Mrs. Gardner Cassatt*, Villanova, Pennsylvania. It is willed to the Metropolitan Museum of Art, New York.

Exhibitions: Sixth Impressionist Exhibition, Paris, 1881 (cat. 2); Durand-Ruel, 1893 (cat. 7); Durand-Ruel, New York, 1895 (cat. 18) (called "Dame Tricotant"); Pennsylvania Academy of the Fine Arts, Philadelphia, 111th anniversary exhibition (cat. 134, p. 32, illus.), 1916; Pennsylvania Museum of Art, Philadelphia, 1927 (cat. 27); City Art Museum of St. Louis, 1933–34 (cat. 2); Haverford College, 1939 (cat. 4); Carnegie Institute, Pittsburgh, 1940 (cat. 202, illus.); Baltimore Museum of Art, 1941–42 (cat. 9); Portraits, Inc., New York, "Portraits of American Women" (cat. 14), 1945; Wildenstein, New York, 1947 (cat. 8); Pennsylvania Academy of the Fine Arts, Philadelphia, Peale House Gallery (cat. 12), 1955; Philadelphia Museum of Art, 1960; Baltimore Museum of Art, "Manet, Degas, Berthe Morisot and Mary Cassatt" (cat. 105, illus.), 1962; M. Knoedler & Co., New York, 1966 (cat. 10).

Reproductions: Achille Segard, 1913, facing p. 16; André Mellerio, "Mary Cassatt," *L'art et les artistes*, vol. 12 (Nov. 1910), p. 69; *Town & Country*, vol. 71 (20 Feb. 1916), p. 35; *The Arts*, vol. 11, no. 6 (June 1927), p. 296; *Art News*, vol. 64, no. 10 (Feb. 1966), p. 13.

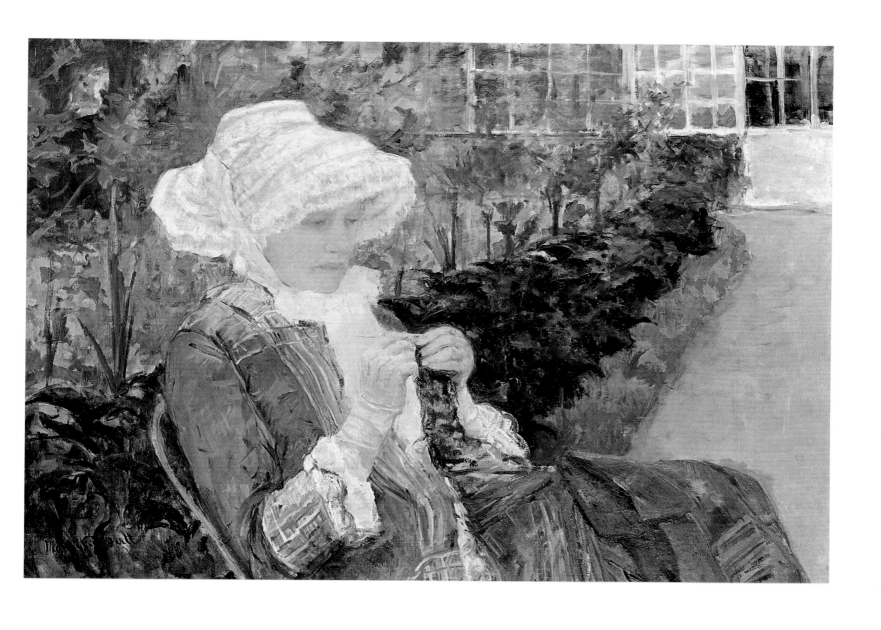

Lydia Crocheting in the Garden at Marly, 1880. BrCR 98.

99
Portrait Sketch of Little Madeleine Fèvre
1880
Pastel on paper, 22½ × 17 in., 57 × 43 cm.
Unsigned

Description: Half-length of a little girl wearing a dark gray straw bonnet tied under her chin. Her sleeveless white dress has a wide pink sash, and her yellow hair hangs down her back.

Note: Madeleine, born in Paris in 1876, was the niece of Edgar Degas, her parents being Henri and Marguerite Degas Fèvre. She became a nun and was known as Mère Marie Louise. She died at Nice, 3 June 1960.

Collections: Albert Martinez, Cannes, France (inheritor of the Fèvre and Degas estates); *private collection*, Houston, Texas.

Exhibitions: Durand-Ruel, New York, 1895 (cat. 24).

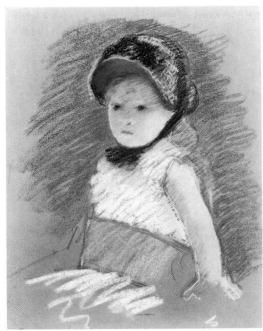

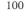

100
Slight Sketch of a Young Woman with a Baby on Her Lap c. 1880
Pastel on paper, 16 × 12½ in., 40.7 × 31.7 cm.
Unsigned. Mathilde X stamp at lower right

Description: Full-length view of stylish young woman in a dark suit and light hat holding a baby on her lap. The baby is just suggested in white.

Collections: Sir V. Naylor-Leyland, London.

101
Woman Seated on a Green Bench c. 1881
Pastel on paper, 17 × 23¼ in. (sight), 43 × 59 cm.
Unsigned

Description: At the left end of a green slatted bench sits a woman who leans forward and looks down as she works at some sewing. She wears a black dress with white around the neck and her hair is light brown.

Collections: Mrs. Gardner Cassatt, Villanova, Pennsylvania.

102
Lydia Seated on a Porch, Crocheting 1881
Gouache, 15 × 24 in., 38 × 61 cm.
Signed lower left: *Mary Cassatt*

Description: A young woman in a large white hat and long white dress sits on a green slatted bench. Before her is a wide view with a pond, greenery, and buildings, seen through a light green iron railing.

Note: Also called "Woman on Park Bench" and "La Serre." Durand-Ruel 8882, L11520.

Collections: From the artist to Durand-Ruel, Paris; to Mrs. Montgomery Sears, Boston; to Mrs. E. N. Graham (Elizabeth Arden), New York; *Lansing W. Thoms*, St. Louis.

Exhibitions: Durand-Ruel, Paris, 1924 (cat. 31); Art Institute of Chicago, "A Century of Progress," 1933–34; Springfield Museum of Fine Arts, Springfield, Mass., opening exhibition (cat. 100), 1933; Society of the Four Arts, Palm Beach, Fla., "The French Impressionists" (cat. 4), 1946; M. Knoedler & Co., New York, 1966 (cat. 9).

Reproductions: Arts, vol. 11, no. 6 (June 1927), p. 296; *City Art Museum of St. Louis Bulletin*, vol. 44, no. 4 (1961), p. 33.

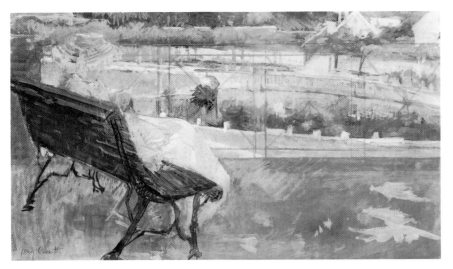

103
Little Girl in a Red Beret c. 1881
Oil on canvas, 23 × 27 in., 58.5 × 69 cm.
Signed and inscribed at lower right (illegible in photograph)

Description: Head and shoulders of a little girl wearing a big red beret and a coat with a wide collar. Both arms are extended toward the lower right. The background is covered with foliage.

Note: Also called "Le béret rouge."

Collections: From the artist to Mathilde Vallet, 1927; Mathilde X sale, Paris, 1931; present location unknown.

Exhibitions: Galerie A.-M. Reitlinger, Paris, 1931 (cat. 2, illus.).

104
Little Girl in a Large Red Hat c. 1881
Oil on canvas, 16½ × 14 in., 42 × 35.6 cm.
Signed lower left: *Mary Cassatt*

Description: A little girl with big dark eyes wears a large red hat which is tied under the chin with a bow with long ends. Her coat is brown and the background green.

Note: Also called "Fillette au chapeau rouge."

Collections: Senator Antonio Santamarina, Buenos Aires.

Exhibitions: Museo Nacional de Bellas Artes, Buenos Aires, "Escuela Francesca" (cat. 8), 1933; idem, "El impresionismo Frances en las colecciones Argentinas" (cat. 15), 1962.

Reproductions: Antonio Santamarina, "My Pleasure in Collecting," *Magazine of Art*, vol. 35 (Feb. 1942), p. 53; *La Colección Antonio Santamarina*, London, 1965, p. 47 (color).

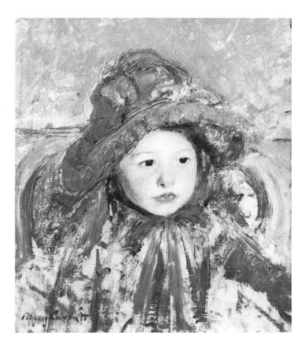

105
Susan in a Toque Trimmed with Two Roses
c. 1881
Oil on canvas, 25½ × 21⅛ in., 64.7 × 53.5 cm.
Unsigned

Description: Half-length view of a young woman wearing a dark, fur-collared coat and a dark toque trimmed with two roses toward the right. Behind her is greenery and the trunk of a tree just left of her toque.

Note: Also called "La jeune femme à la toque."

Collections: Durand-Ruel, Paris; Galerie Charpentier sale, 1–2 April 1954; to *Mme. Ader*, Paris.

Exhibitions: Durand-Ruel, Paris, 1908 (cat. 16); Galerie Charpentier, 1954 (cat. 62, illus.).

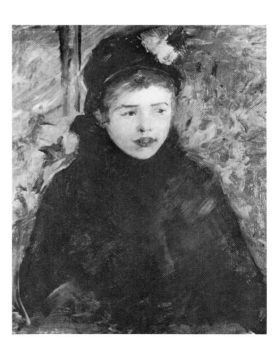

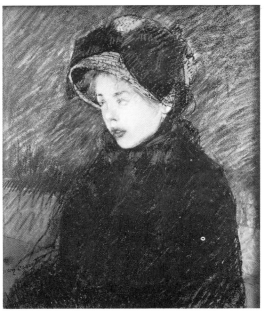

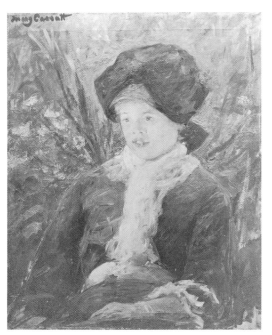

Susan Seated in a Garden c. 1881
Oil on canvas, 25½ × 19½ in., 64.7 × 49.4 cm.
Signed upper left corner: *Mary Cassatt*

Description: A young woman, blond with blue eyes, is seen in half-length, seated before a verdant background, looking off toward left. She wears a dark poke bonnet and dark dress with a lighter scarf.

Note: Durand-Ruel 7969, L10703.

Collections: From the artist to Durand-Ruel, Paris; to Leon Tual, 22 Jan. 1891 (cat. 11); Marcel Guiot, until 1914; to Durand-Ruel, Paris, July 1914 to the present time.

Exhibitions: Joslyn Art Museum, Omaha, Nebraska, "Mary Cassatt among the Impressionists" (cat. 8), 1969.

106
Susan in a Straw Bonnet, Gazing Left
c. 1881
Pastel, 24⅛ × 20⅛ in., 61 × 51 cm.
Signed toward lower left: *Mary Cassatt*

Description: A young woman wears a dark coat and a straw bonnet trimmed with a large bow in front and tied under her chin with another bow. She is blond with large blue eyes, a small nose, and full lips, seen in half profile against a green background.

Note: Called "Portrait of a Young Girl" by Art Institute of Chicago.

Collections: George Bernheim sale, Paris, 11 Jan. 1923; *Art Institute of Chicago*, gift of Kate L. Brewster.

108
Susan Seated Outdoors Wearing a Purple Hat c. 1881
Oil on canvas, 27½ × 34½ in., 69.7 × 87.5 cm.
Signed lower left corner: *Mary Cassatt*

Description: Three-quarter length figure of a woman, seated in a straight chair with her gray gloved hands folded in her lap, is seen in a garden before a border of shrubbery. She wears a poke bonnet, tilted forward, which is trimmed with a wide band of purple gauze, a dress and cape of dark green, and a blue neckerchief.

Note: Also called "Jeune fille dans un parc," "Au jardin," and "Girl in a Purple Hat." Hirschl & Adler no. 3922.

Collections: Lazare Weiller; Hôtel Drouot sale (cat. 14), 29 Nov. 1901; Montmartin collection sale, Paris; to Ambroise Vollard; to Chrétien de Gallia; Parke-Bernet sale (cat. 1052), March 1949; to Hirschl & Adler, New York; to *Mr. and Mrs. Nathan Cummings*, New York.

Exhibitions: Baltimore Museum of Art, "Manet, Degas, Berthe Morisot and Mary Cassatt" (cat. 103), 1962; Minneapolis Institute of Arts, "Paintings from the Cummings Collection," 1965.

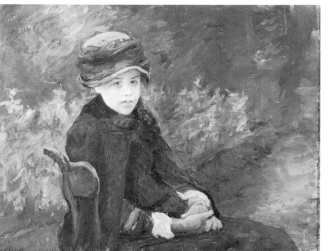

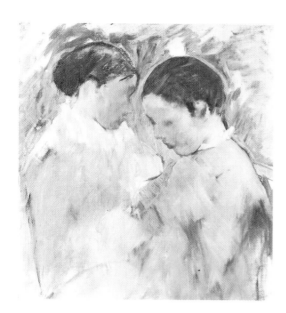

109

Unfinished Sketch of Two Young Women Outdoors c. 1881
Oil on canvas, 21½ × 19 in., 54.6 × 48.2 cm.
Unsigned

Description: Against a greenish background two young women with dark hair are seen facing each other. The one on the right wears a tight-fitting dress with a white ruffle at the neck and looks down at something which she holds in her hands. The one on the left is in profile to right, somewhat behind the other.

Collections: Lefevre Gallery, London, 1966; to *private collection*, New York.

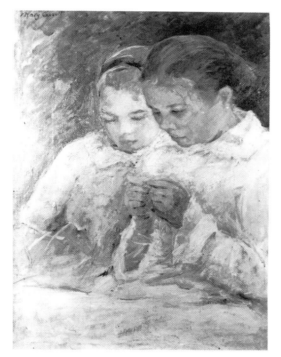

110

Two Young Women: One Threading a Needle
1881
Oil on canvas, 23½ × 16⅞ in., 59.8 × 43 cm.
Signed upper left corner: *Mary Cassatt*

Description: Against a dark greenish background two young women in light colored dresses sit looking down toward left. The one on the right is threading a needle with her face in shadow. Her dark hair is pulled back into a bun with an ear showing. The other young woman has a dark ribbon holding back her hair. A slightly sketched book suggests that she is reading.

Note: Also called "Les dentellières" and "Deux jeunes filles travaillant." Durand-Ruel 6274 & L11383 & 17365.

Collections: George Viau collection, Paris, until 1907; Galerie Matthiesen, Berlin, 1927; *Mme. Lehmann-Lefranc*, Paris.

Exhibitions: Durand-Ruel, Paris, 1893 (cat. 16); Durand-Ruel, Paris, 1908 (cat. 9).

111

Susan Comforting the Baby (No. 1)
c. 1881
Oil on canvas, 17⅛ × 23 in., 43.5 × 58.5 cm.
Signed lower right: *Mary Cassatt*

Description: Bust length of a young woman, in an ivory white dress striped in blue, talking to a baby who holds her left hand to her ear. The baby wears a white dress trimmed in blue and holds a scarlet toy in her right hand. The background is of varied green foliage extending from the right.

Note: Also called "Two Heads."

Collections: Durand-Ruel; J. Howard Whittmore; Parke-Bernet sale, 19 May, 1948; to Frederick W. Schumacher; *Columbus (Ohio) Gallery of Fine Arts*, gift of Mr. Schumacher.

Exhibitions: Baltimore Museum of Art, 1941–42 (cat. 11); Carnegie Institute, Pittsburgh, Munson-Williams-Proctor Institute, Utica, N.Y., Virginia Museum of Fine Arts, Richmond, Baltimore Museum of Art, Currier Gallery of Art, Manchester, N.H., "American Classics of the 19th Century" (cat. 72), 1957.

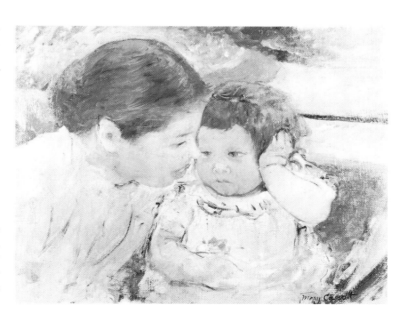

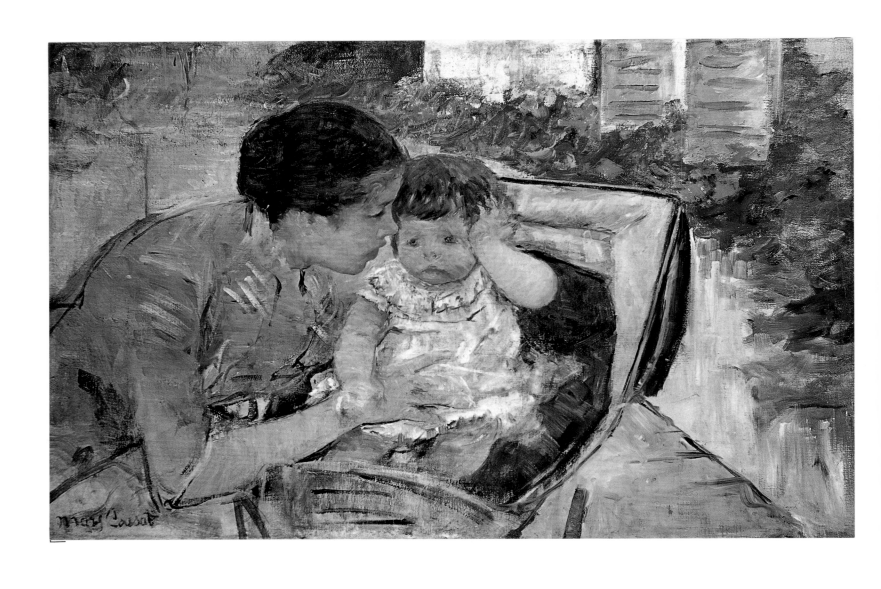

Susan Comforting the Baby (No. 2), c. 1881. BrCR 112.

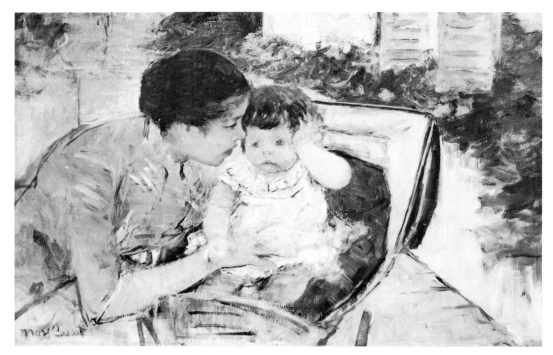

112
Susan Comforting the Baby (No. 2)
c. 1881
Oil on canvas, 25 × 38½ in., 63.5 × 97.8 cm.
Signed lower left corner: *Mary Cassatt*

Description: Half-length of young woman with brown hair leaning over a baby who holds her left hand to her ear. The baby sits in her carriage with pillows, wearing a white dress trimmed in blue. Susan's dress is gray. Behind them is a window box with bright red flowers and a shuttered window.

Collections: Ambroise Vollard, Paris; to *Mr. and Mrs. John A. Beck*, Houston, Texas.

Exhibitions: Ambroise Vollard, Paris, 1912; Exposition d'Art Moderne à l'Hôtel de la Revue, "Les arts, Paris," 1912; M. Knoedler & Co., New York, 1933 (cat. 2).

Reproductions: Les arts, vol. 11 (Aug. 1912), p. xv; Arsène Alexandre, "Portraits . . . à Picasso," *La renaissance de l'art* (July 1928), p. 269; *Apollo*, vol. 18 (Nov. 1933), p. 340; *Studio* (Jan. 1934), p. 27.

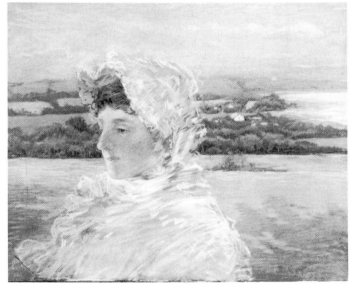

113
Landscape with Profile Portrait of a Woman
c. 1881
Pastel on paper, 18 × 22 in., 45.6 × 55.8 cm.
Signed lower right: *Cassatt*

Description: Head and shoulders of a young woman, in profile to left, wearing a white ruffled bonnet and a white shoulder cape. Her dark hair shows under her bonnet. Behind her is a broad expanse of sunny landscape with a meadow in middle ground and houses beyond in the woods. A lake or river is at right.

Note: Mrs. Peter dates it c. 1881 "when Miss Cassatt was working near Pissarro."

Collections: Jacob Rosenberg and Frank X. Kelly, New York; Kende Art Gallery sale, New York, 3 Dec. 1952; to *Marion Mason Peter*, Lake Forest, Illinois.

114
Interior with a French Screen c. 1881
Oil on canvas, 17 × 22½ in., 43 × 57 cm.
Signed lower right corner: *Mary Cassatt*

Description: A woman in profile to left and wearing a white dress is seated in a room with light coming from a window at the right. She is reading. Behind her is a potted plant. In the background is a high, three-ply French blue screen with glass in the upper sections.

Collections: Mrs. *Percy C. Madeira*, Berwyn, Pennsylvania.

Exhibitions: Haverford College, 1939 (cat. 11); Baltimore Museum of Art, 1941–42 (cat. 10); Philadelphia Museum of Art, 1960; M. Knoedler & Co., New York, 1966 (cat. 12); Parrish Art Museum, Southampton, N.Y., 1967 (cat. I, illus.).

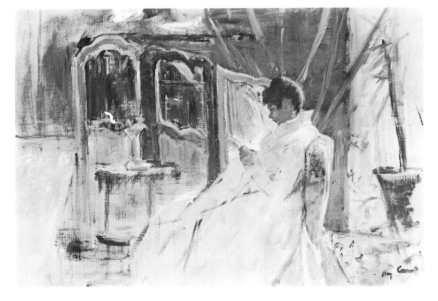

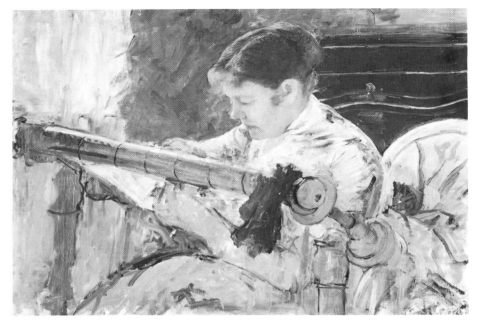

115
Lydia Working at a Tapestry Frame
c. 1881
Oil on canvas, 25¾ × 36¼ in., 65.5 × 92 cm.
Signed lower right corner: *Mary Cassatt*

Description: Lydia is seated behind a large tapestry frame. Her dress is pink with a pattern of rose-salmon flowers and dull green leaves. Her hair is auburn. There is a green and rose chintz drapery to left.

Collections: From the artist to Durand-Ruel, Paris, 1893; to Ambroise Vollard, Paris; to Mr. Barnsdale, New York; to Harry Brahms, New York; to *Flint (Michigan) Institute of Arts*, 1967, gift of the Whiting Foundation.

Exhibitions: M. Knoedler & Co., New York, 1966 (cat. 11).

Reproductions: Frederick A. Sweet, 1966, fig. 12, facing p. 109.

116
Head of Robert, Aged Nine (No. 1) 1882
Pastel on beige paper, 11 × 11 in., 28 × 28 cm.
Signed lower left corner: *Cassatt*

Description: Head of Miss Cassatt's nephew Robert Kelso Cassatt with his golden brown hair in bangs over his forehead. He wears an Eton collar, has a retroussé nose, and his eyes are blue. The background is blue with streaks of pink.

Note: Robert was born in 1873. Also called: "Jeune garçon au col blanc."

Collections: From the artist to Mathilde Vallet, 1927; Mathilde X sale, Paris, 1927; Charles Slatkin Gallery, New York; to *Mr. and Mrs. Bernard Lande*, Montreal, Canada.

Exhibitions: Galerie A.-M. Reitlinger, Paris, 1927 (cat. 8).

118
Robert and His Sailboat 1882
Pastel on paper, c. 28 × 24 in., 71 × 61 cm.
Unsigned

Description: Robert sits in a chair and leans forward to touch the bow of a large toy sailboat. His hair is blond, and he wears a white shirt with a blue bow tie. The interior of the boat is orange.

Collections: the Cassatt family; to *Anthony D. Cassatt*, New York.

Exhibitions: Philadelphia Museum of Art, 1960.

117
Head of Robert, Aged Nine (No. 2) 1882
Pastel on tan paper, 13 × 11¼ in., 33 × 28.5 cm.
Unsigned

Description: Head of Robert seen in three-quarter view to right looking down. His golden brown hair is brushed over his forehead. Just the edge of his white collar is shown.

Note: Also called "Jeune garçon aux yeux bleus."

Collections: From the artist to Mathilde Vallet, 1927; Mathilde X sale, Paris, 1927; to Chester Dale; Parke-Bernet sale, 5 Jan. 1946; to *Murray Laub*, Minneapolis.

Exhibitions: Galerie A.-M. Reitlinger, Paris, 1927 (cat. 25).

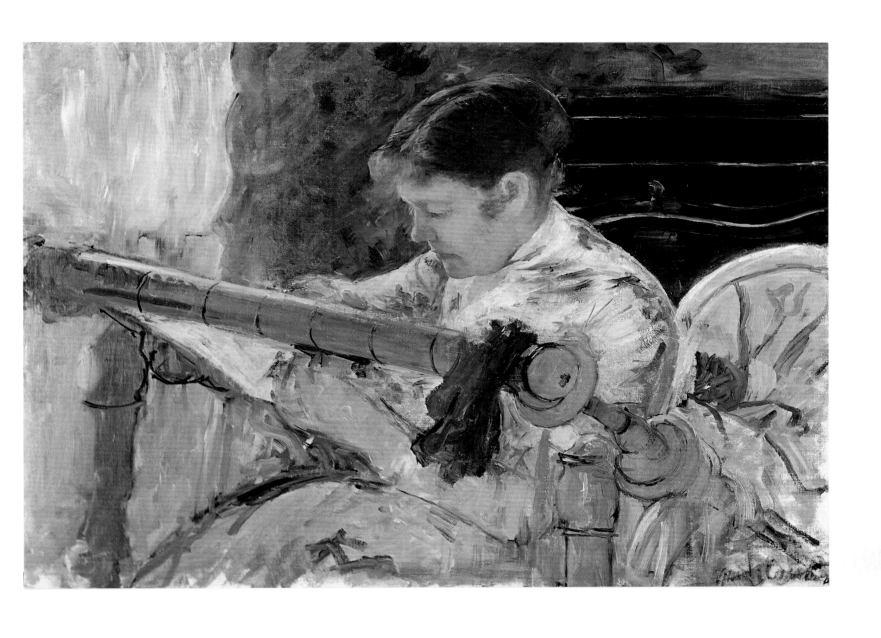

Lydia Working at a Tapestry Frame, c. 1881. BrCR 115.

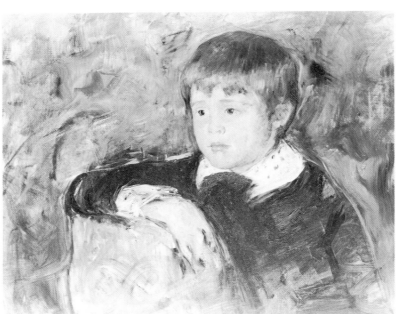

Master Robert Kelso Cassatt c. 1882
Oil on canvas, $19 \times 22\frac{3}{4}$ in., 48×58 cm.
Unsigned

Description: Robert is seated with his right arm resting on the back of a chair upholstered in light reddish brown. He wears a dark suit with a white collar with blue dots. The background is multi-colored—maroon, dark blue, etc.

Collections: Mr. and Mrs. Alexander J. Cassatt, Cecilton, Maryland.

Exhibitions: Pennsylvania Museum of Art, Philadelphia, 1927 (cat. 35); M. Knoedler & Co., New York, 1966 (cat. 13, illus.).

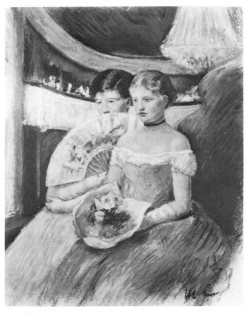

120
Sketch for "Two Young Ladies in a Loge"
1882
Pastel on paper, $11\frac{1}{2} \times 8\frac{3}{4}$ in., 29×22 cm.
Signed lower right: *M. C.*

Description: Two young women in evening dresses are seated in an opera box. One holds a wide-open fan, the other a bouquet of flowers.

Note: This sketch for the painting in the Chester Dale collection (BrCR 121) also relates to the soft-ground and aquatint print (Br 18).

Collections: Cincinnati Art Museum, bequest of Mary Hanna.

Exhibitions: Cincinnati Art Museum, 1933 (lent by Miss Mary Hanna); Cincinnati Print and Drawing Circle, "10th Annual Exhibition of Drawings, Pastels and Watercolors," 1933.

Reproductions: Art News, vol. 31 (5 Nov. 1932), p. 8; Emily Poole, "Loan Exhibition of Drawings, Pastels and Watercolors," *Cincinnati Art Museum Bulletin,* vol. 4 (1933), p. 51; Margaret Breuning, 1944, p. 48; *French Impressionists,* 1944, p. 51.

121
Two Young Ladies in a Loge 1882
Oil on canvas, $31\frac{1}{2} \times 25\frac{1}{4}$ in., 80×64 cm.
Signed lower right corner: *Mary Cassatt*

Description: Two young ladies are seated in a loge. The blond at right wears an off-shoulder décolleté evening dress with a black ribbon at her throat. She holds a bouquet wrapped in paper. Her companion holds a large open fan which conceals the lower part of her face. The background shows tiers of loges.

Note: Also called "The Opera Box" and "La Loge." The blond young lady is the daughter of Miss Cassatt's friend, Stéphane Mallarmé; the brunette is Miss Mary Ellison. Durand-Ruel 3159-L3725; National Gallery of Art no. 1760.

Collections: Baron Herzog, Budapest; to Marczell von Nemes, Budapest; von Nemes sale (cat. 84), Paris, 18 June 1913; to Chester Dale, New York; to *The National Gallery of Art,* Washington, D.C., Chester Dale Collection.

Exhibitions: Städl. Kunsthalle, Dusseldorf, Gemälde aus der Sammlung von Nemes, (cat. 103), 1912; Museum of French Art, New York, "Portraits of Women: Romanticism to Surrealism," 1931; Museum of Modern Art, New York, "American Painting and Sculpture, 1862–1932" (cat. 14), 1933; Union League Club, New York, 1937.

Reproductions: Les arts, vol. 12 (June 1913), p. 31; *Art News,* vol. 28 (28 Dec. 1929), p. 3; *Art Digest,* vol. 4 (30 Jan. 1930), p. 18; *Art News,* vol. 35 (23 Jan. 1937), p. 1; *Cahiers d'art,* no. 1–2 (1938), p. 55; Katheryn D. Lee and K. T. Burchwood, *Art Now and Then,* New York, 1949, p. 157; *Art News,* vol. 51 (Dec. 1952), p. 14; Albert Châtelet, *Impressionist Painting,* New York, 1962; John Walker, *The National Gallery,* New York, 1963, p. 328.

122
Portrait of a Young Woman in a Red Dress
c. 1882
Pastel on tan paper, 16 × 12 in., 40.5 × 30.5 cm.
Signed lower right: *Mary Cassatt*

Description: Head and shoulders of a young woman
with gray-blue eyes and auburn hair parted in the
middle. Her red dress has a high collar with a
ruffle at the neck. A gold brooch is on the front of
the collar.

Collections: Michael J. Kutza, Jr., Chicago.

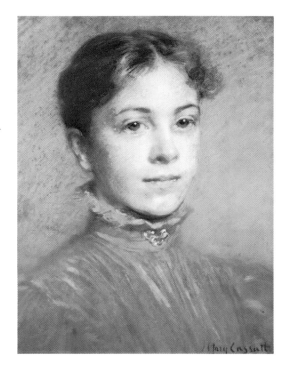

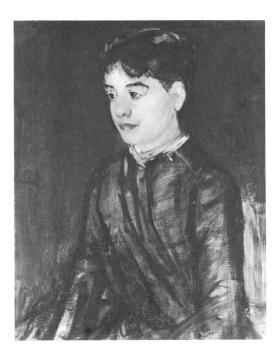

123
Young Woman in Black Looking to Left
c. 1882
Oil on canvas, 23⅝ × 17¾ in., 60 × 45 cm.
Unsigned

Description: Half-length of a seated young woman
turned halfway toward left. Her hair and eyes are
dark. She wears a high-necked, long-sleeved black
dress with folds on the blouse from the shoulder at
left to the waist under her left arm. Her collar is
white and the background dark.

Note: Also called "Woman in Black" and "Femme
brune."

Collections: From the artist to Mathilde Vallet,
1927; Mathilde X sale, Paris, 1931; to Mr. and
Mrs. Buell Hammett, Santa Barbara, California,
1944; to Theodore Schempp, 1946; to the *City Art
Museum of St. Louis.*

Exhibitions: Galerie A.-M. Reitlinger, Paris, 1931
(cat. 4, illus.); Baltimore Museum of Art, "Manet,
Degas, Berthe Morisot and Mary Cassatt" (cat.
106, illus.), 1962.

Reproductions: Margaret Breuning, 1944, p. 41.

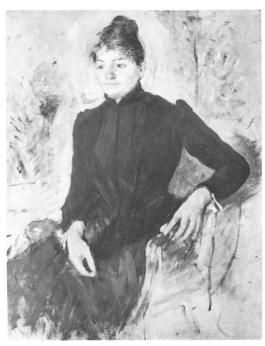

124
**Portrait of Woman in Black Seated in an
Armchair** c. 1882
Oil on canvas, 40 × 29¼ in., 100.6 × 74 cm.
Unsigned

Description: A woman in a severe black dress sits in
a French armchair, her left hand resting on its
arm, and looks somewhat toward left. Her hair is
piled high on her head, and she wears bangs. The
background is quite mottled.

Collections: Mr. Riesener; to Roland, Browse, and
Delbanco, London; to the *Museum of the City of
Birmingham,* England.

Exhibitions: Thomas Agnew & Sons, London,
"Pictures from Birmingham" (cat. 71), 1957;
Royal Academy, London, "Primitives to Picasso"
(cat. 248), 1962.

Reproductions: Illustrated London News, vol. 230 (6
April 1957), p. 551.

125
Susan on a Balcony Holding a Dog 1883
Oil on canvas, 39½ × 25½ in., 100.3 × 64.7 cm.
Signed lower right: *Mary Cassatt*

Description: A young woman, with a large, fluffy pink bonnet tied under her chin and wearing a white dress with tan gloves, sits in a chair on a balcony with an iron railing. She looks to left. On her lap is a black and tan dog. In the background are city buildings and green trees.

Note: Also called "Woman with a Dog" and "La femme au chien." The artist's pet dog seen here was named "Battie." Durand-Ruel 3156-L5611.

Collections: Purchased from the artist through Durand-Ruel, 1909, by the *Corcoran Gallery of Art*, Washington, D.C.

Exhibitions: Durand-Ruel, New York, 1903 (cat. 9); Corcoran Gallery of Art, Washington, D.C., 2nd Biennial (cat. 252, illus.), 1908–09; Durand-Ruel, New York, 1935 (cat. 17); Carnegie Institute, Pittsburgh, 1940 (cat. 201); Baltimore Museum of Art, 1941–42 (cat. 18); Baltimore Museum of Art, "Manet, Degas, Berthe Morisot and Mary Cassatt" (cat. 104, illus.), 1962.

Reproductions: Art News, vol. 29 (26 Oct. 1940), p. 15; Margaret Breuning, 1944, p. 16; *Life*, vol. 40 (23 Jan. 1956), p. 67 (color); *Art in America*, no. 4 (Winter 1958–59), p. 87; *Arts*, no. 33 (May 1959), pp. 11 and 40 (color); *Arts*, no. 40 (Sept. 1966), p. 41 (color).

126
Portrait of Alexander J. Cassatt 1883
Oil on canvas, 25½ × 35¾ in., 64.5 × 90.7 cm.
Unsigned

Description: A half-length view of the artist's brother wearing a black jacket. His hair is brown, his mustache more reddish. The background is varied with a turquoise green section to right of his ruddy face.

Collections: Mr. and Mrs. Alexander J. Cassatt, Cecilton, Maryland.

Exhibitions: McClees Gallery, Philadelphia, 1931 (cat. 4); Philadelphia Museum of Art, 1960; M. Knoedler & Co., New York, 1966 (cat. 18).

127
Mrs. Alexander J. Cassatt in a Blue Evening Gown Seated at a Tapestry Frame c. 1883
Pastel on paper, 32 × 25 in., 81.3 × 63.5 cm.
Unsigned

Description: Three-quarter length view of the sister-in-law of the artist. Her right hand rests on a large tapestry frame, as though about to push the needle through it with the thimble on her middle finger. Her blue evening gown has a bow on the right shoulder and one above the left elbow.

Note: This is the only portrait of her sister-in-law done by Miss Cassatt. They were not fond of each other.

Collections: Mrs. John B. Thayer, Rosemont, Pennsylvania.

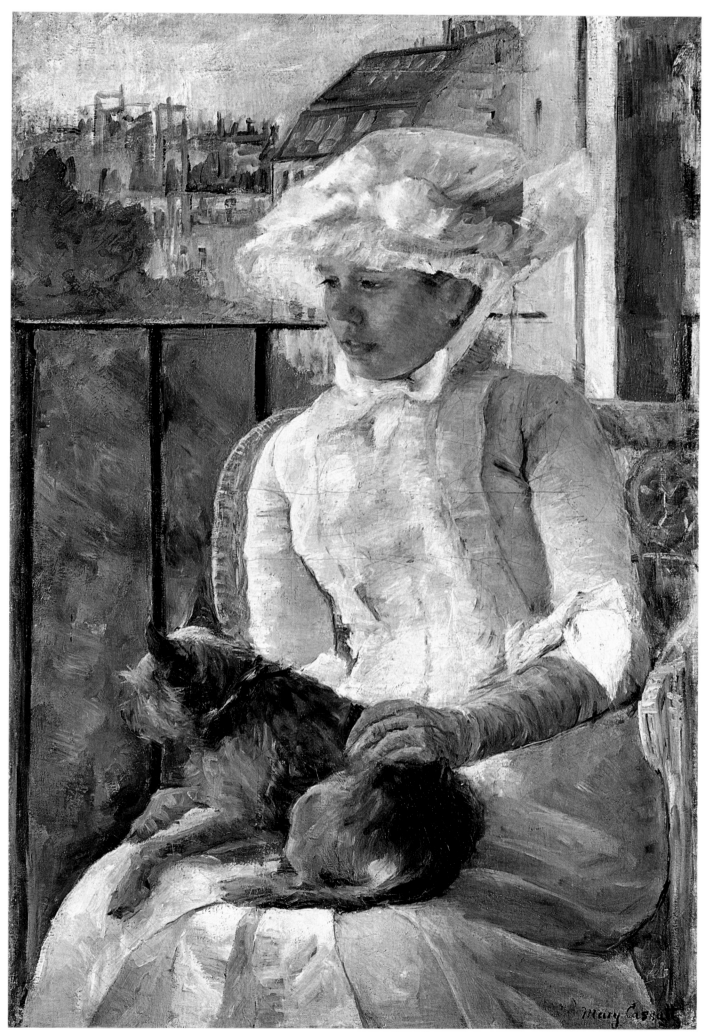

Susan on a Balcony Holding a Dog, 1883. BrCR 125.

128
Reading "Le Figaro" 1883

Oil on canvas, 41 × 33 in., 104 × 83.7 cm.
Signed lower right: *Mary Cassatt*

Description: Mrs. Robert Simpson Cassatt, the artist's mother, is seen wearing a white dress trimmed with small ruffles around the neck, down the entire front, and at the cuffs. Her dark hair is drawn back simply over her ears. She is seated in a large patterned armchair. She wears eye glasses and reads a folded newspaper held with both hands. In the background at left is the reflection of the newspaper in a mirror. The painting of the white dress is brilliantly done.

Note: Also called "La lecture du Figaro."

Collections: Mr. and Mrs. William Potter Wear (Cassatt family); *Katharine Stewart de Spoelberch*, Haverford, Pennsylvania (Cassatt family).

Exhibitions: Haverford College, 1939 (cat. 5, illus.); Wildenstein, New York, 1947 (cat. 12, illus.); Art Institute of Chicago and Metropolitan Museum of Art, New York, "Sargent, Whistler and Mary Cassatt" (cat. 11, illus.), 1954; Pennsylvania Academy of the Fine Arts, Philadelphia, Peale House Gallery (cat. 21), 1955; Philadelphia Museum of Art, 1960; Baltimore Museum of Art, "Manet, Degas, Berthe Morisot and Mary Cassatt" (cat. 107, illus.), 1962.

Reproductions: Kunstwerk, vol. 16 (July 1962), p. 73; *Connoisseur*, vol. 151 (Sept. 1962), p. 66; Frederick A. Sweet, 1966, color plate V, fol. p. 156; Julia Carson, 1966, p. 42.

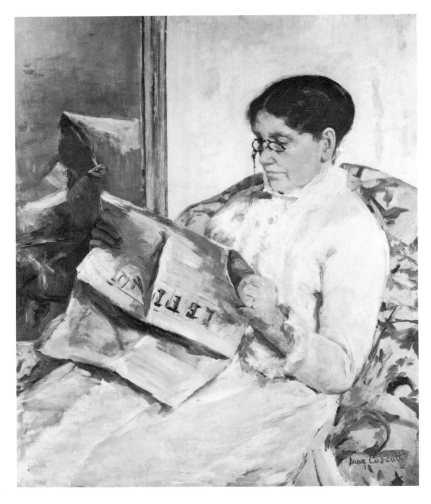

129
Young Woman in Black 1883

Oil on canvas, 31¾ × 25½ in., 80.6 × 64.6 cm.
Signed lower right: *Mary Cassatt*

Description: A young woman in a black costume, a black hat trimmed with bird wings, a thin black nose veil, and black gloves, holds a black jet bag in her lap. At her throat is a small pink bow. She sits in an armchair upholstered in a rose and green patterned chintz. Behind her on a wall is part of a framed fan.

Note: Durand-Ruel 10082-L.D. 12859.

Collections: From the artist to Durand-Ruel, Paris; to Durand-Ruel, New York; to the *Peabody Institute*, Baltimore, purchased 1942.

Exhibitions: Durand-Ruel, New York, 1924 (cat. 1) (called "Jeune femme en noir"); Durand-Ruel, New York, "Exhibition of Works by Cassatt and Morisot" (cat. 11), 1939; Los Angeles County Museum, "Development of Impressionism" (cat. 5), 1940; Baltimore Museum of Art, 1941–42 (cat. 13); Wildenstein, New York, 1947 (cat. 9); Art Institute of Chicago and Metropolitan Museum of Art, New York, "Sargent, Whistler and Mary Cassatt" (cat. 12), 1954; Baltimore Museum of Art, "Manet, Degas, Berthe Morisot and Mary Cassatt" (cat. 109, illus.), 1962; M. Knoedler & Co., New York, 1966 (cat. 14, illus.).

Reproductions: Art Digest, vol. 14 (15 Nov. 1939), p. 19; *Art News*, vol. 38 (4 Nov. 1939), p. 9; *Magazine of Art*, vol. 32 (Dec. 1939), p. 732; *Art News* vol. 61, no. 2 (April 1962), p. 30.

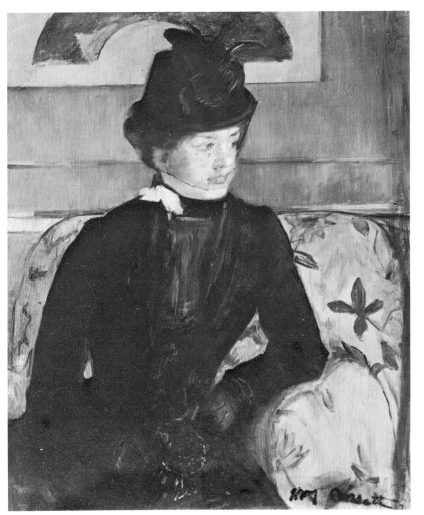

130

Two Women Sewing on the Beach c. 1884

Oil on canvas, 7⅛ × 10¾ in., 18 × 27.3 cm.
Unsigned

Description: Two peasant women are seated on the sand sewing on large pieces of material, possibly sails. The older woman at the left, closer to the foreground, wears a dark blue gown with a heavy dark purple shawl over her head and shoulders. The other woman, also in dark blue, is bareheaded. The sand in the center foreground is reddish.

Collections: Baroness Cacacci and Wallace G. Anderson, San Francisco; to *private collection*, 1962, Tacoma, Washington.

131

Two Children at the Seashore 1884

Oil on canvas, 38½ × 29¼ in., 97.6 × 74 cm.
Signed lower right: *Mary Cassatt*

Description: Two small children are playing in the sand. The one at the left has a bucket and shovel. She wears a white pinafore over a dark dress and dark shoes and stockings. The other child, her face unseen, wears a large hat with a red ribbon and bow. She, too, wears a pinafore over a dark dress. Behind them is the ocean with a sailboat to right and a small yacht to left.

Note: Also called "Enfants jouant sur la plage," "Enfants au bord de la mer," and "Marine."

Durand-Ruel 1786-L5139.

Collections: Durand-Ruel, Paris; *Estate of Mrs. Mellon Bruce*, New York.

Exhibitions: Durand-Ruel, New York, 1895 (cat. 7) (called "Marine"); Manchester, England, 1907, organized by Durand-Ruel, Paris (cat. 71); Durand-Ruel, Paris, 1908 (cat. 13); National Gallery of Art, Washington, 1966 (cat. 20, color illus.).

Reproductions: *Harper's Bazaar*, vol. 45 (Nov. 1911), p. 490; *Apollo*, n.s. vol. 83, no. 52 (June 1966), p. 433, pl. 11 (color).

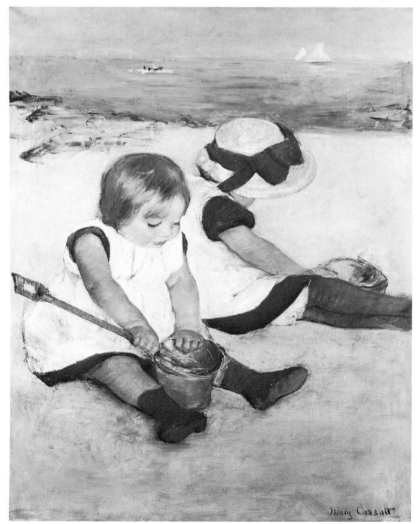

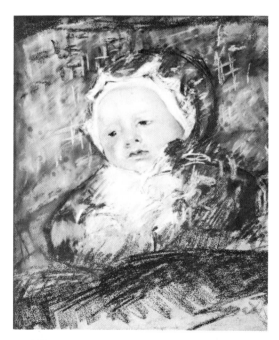

132

Baby in Blue in His Carriage c. 1884

Pastel on cardboard, 17¼ × 16⅞ in., 43.6 × 43 cm.
Signed lower right: *Cassatt*

Description: A baby in blue cap and coat lies back in his carriage against a plaid pillow with a dark blue cover in foreground to his waist.

Note: Also called "Enfant en bleu."

Collections: In George Viau sale, Paris, 21–22 March 1907 (cat. 100); bought back by M. Viau who sold it in 1910 to *Sidney Brown*, Baden, Switzerland.

Exhibitions: Durand-Ruel, Paris, 1893 (cat. 21) "à M. Viau").

133 †

Baby in Her Carriage at the Seashore
c. 1884
Oil on canvas, 12 × 20 in., 30.3 × 50.7 cm.
Unsigned. Mathilde X collection stamp

Note: Also called "Bébé dans sa voiture au bord de la mer."

Collections: From the artist to Mathilde Vallet, 1927; Mathilde X sale, Paris, 1927; to Galerie d'Art, Paris; present location unknown.

Exhibitions: Galerie A.-M. Reitlinger, Paris, 1927 (cat. 64).

134

Sketch of a Young Boy c. 1884
Pastel, 17½ × 13½ in., 44.4 × 34.2 cm.
Signed lower left: *Mary Cassatt*

Description: Head of a brown-haired boy with ruddy complexion against a yellowish-green background with orange touches.

Note: Called "Young Boy" in Parke-Bernet sale, 1953.

Collections: Galerie Percier, Paris; James Sauter, etc., sale (cat. 88, illus.), Parke-Bernet, 8 April 1953; present location unknown.

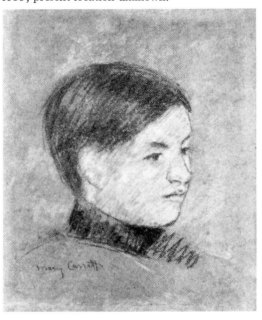

135

Sketch of Alexander J. Cassatt c. 1884
Pastel on paper, 15 × 11½ in., 38 × 29 cm.
Unsigned. Mathilde X collection stamp on verso

Description: Sketch of head of Alexander J. Cassatt turned left in three-quarter view looking down. A study for the portrait of him with his son Robert in the Philadelphia Museum of Art (BrCR 136).

Collections: From the artist to Mathilde Vallet, 1927; Mathilde X sale, Paris, 1927; *Adolfo Costa du Rels,* Bolivian Ambassador to UNESCO, Paris.

Exhibitions: Galerie A.-M. Reitlinger, Paris, 1927 (cat. 19) (called "Tête d'homme/Etude pastel").

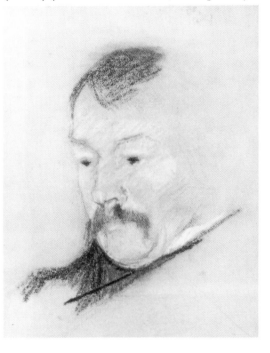

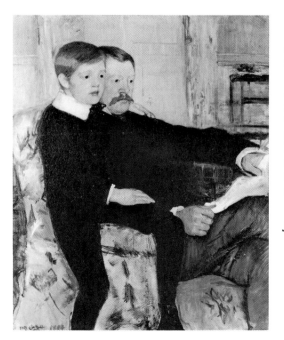

136

Portrait of Mr. Alexander J. Cassatt and His Son Robert Kelso 1884
Oil on canvas, 39½ × 32 in., 100 × 81.2 cm.
Signed lower left: *Mary Cassatt 1884*

Description: Young Robert is seated on the arm of a chair upholstered in a large-patterned chintz with his right hand resting on his left leg, his left arm around his father's neck. He wears a dark Eton suit with a white collar and bow tie, dark stockings and shoes. His father and he both look to right. Mr. Cassatt, whose hair and mustache are reddish, holds a paper in his hands.

Note: At the end of 1884 Alexander Cassatt and young Robert came over to Paris for a visit. Aleck wrote home to his wife: "Mary has commenced portraits of Robert and me together, Rob sitting on the arm of my chair. I hope it will be a success this time. I don't mind the posing as I want to spend several hours a day with Mother anyhow and Rob will not have to pose

very much or long at a time." (Frederick A. Sweet, 1966, p. 92.)

Collections: From the artist to the Cassatt family in Philadelphia; Parke-Bernet sale, 15 April 1959; to Mr. and Mrs. William Coxe Wright who presented it to the *Philadelphia Museum of Art.*

Exhibitions: Pennsylvania Museum of Art, Philadelphia, 1927 (cat. 28); Baltimore Museum of Art, 1941–42 (cat. 14); Pennsylvania Academy of the Fine Arts, Philadelphia, 150th anniversary exhibition, 1955; Philadelphia Museum of Art, 1960; City Art Museum of St. Louis, "200 Years of American Painting" (p. 24, illus.), 1964.

Reproductions: The Arts, vol. 11, no. 6 (June 1927), p. 292; *Philadelphia Museum of Art Bulletin* 54, no. 262 (Summer 1959), p. 84; *Art News,* vol. 58, no. 6 (5) (Sept. 1959), p. 45; *City Art Museum of St. Louis Bulletin* 48, nos. 1–2 (1964), p. 24; Frederick A. Sweet, 1966, fig. 14, fol. p. 108.

137

Mr. Robert S. Cassatt on Horseback 1885

Pastel on paper, 36 × 28 in., 91.5 × 71 cm.
Signed lower left: *Mary Cassatt*

Description: Full view of a brown horse turned away toward right. Mr. Cassatt is mounted, wearing a gray suit and hat. Behind him is an allée of green trees.

Note: During the summer at Louveciennes, Mary Cassatt acquired for herself from an army officer a new riding horse, a twelve-year-old trooper. Mr. Cassatt wrote: "The horse is a good size for Mame, carries well, is showy even and has unmistakable signs of blood. I ride him a good deal as Mame does not in her rides give him enough exercise." (Frederick A. Sweet, 1966, p. 69.)

Collections: Mrs. Percy C. Madeira, Berwyn, Pennsylvania.

Exhibitions: Philadelphia Museum of Art, 1960; M. Knoedler & Co., New York, 1966 (cat. 17, illus.); Parrish Art Museum, Southampton, N.Y., 1967 (cat. 14, illus.).

138

Mathilde and Robert c. 1885

Oil on canvas, 28¾ × 24 in., 73 × 61 cm.
Unsigned

Description: Mathilde sits outdoors, wearing a mauve dress shot with white and a white, lace yoke. Her dark hair is drawn up in a soft pompadour. The boy with her, seen in half-length, wears a dark suit. She looks off toward right; he looks at the spectator while she draws his head to her breast. Behind them is a fruit tree, a smaller tree without leaves, and, upper right, a lake or river.

Note: Also called "Femme tenant un jeune garçon serré contre elle: au fond, un lac." Mrs. Cassatt wrote to her granddaughter Katharine: "Your Aunt Mary had a little thing only two and a half years old to pose for her. . . . I wish Robbie would do half as well. I tell him that when he begins to paint from life himself, he will have a great remorse when he remembers how he teased his poor Aunt wriggling about like a flea." (Frederick A. Sweet, 1966, p. 94.) Here Mathilde seems to be trying to keep him from wriggling.

Collections: From the artist to Mathilde Vallet, 1927; Mathilde X sale, Paris, 1931; Simonson Gallery, Paris; to Felix Fuld, 1931; bequeathed to the *Newark Museum*, 1944.

Exhibitions: Galerie A.-M. Reitlinger, Paris, 1927 (cat. 54); National Academy of Design, New York, 1931; Brooklyn Institute of Arts and Sciences, "Leaders of American Impressionism: Mary Cassatt, Childe Hassam, J. H. Twachtman, and J. Alden Weir" (cat. 32), 1937; Newark Museum, "Changing Tastes in Painting and Sculpture" (cat. 1), 1945–46; Carnegie Institute, Pittsburgh, Munson-Williams-Proctor Institute, Utica, N.Y., William Rockhill Nelson Gallery of Art, Kansas City, Mo., Virginia Museum of Fine Arts, Richmond, Baltimore Museum of Art, Currier Gallery of Art, Manchester, N.H., "American Classics of the 19th Century" (cat. 73), 1957.

Reproductions: American Magazine of Art, vol. 24 (April 1932), p. 297.

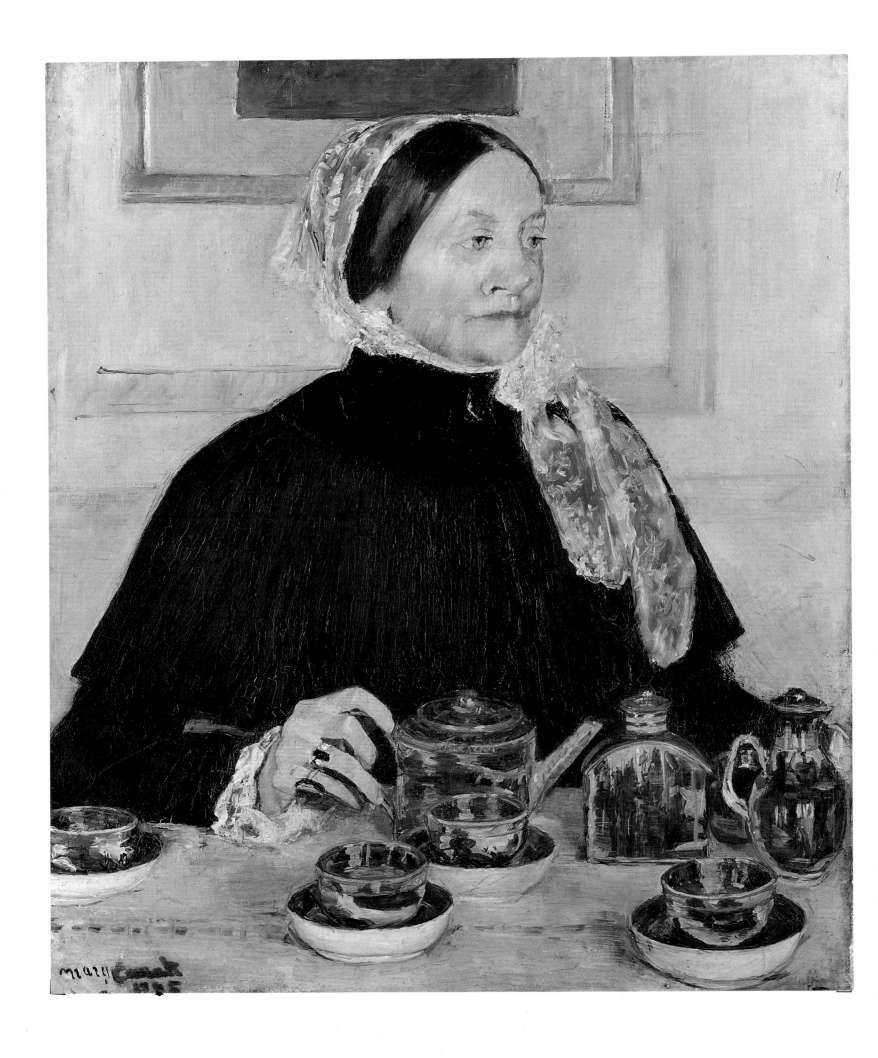

Lady at a Tea Table, 1885. BrCR 139.

139
Lady at the Tea Table 1883–85
Oil on canvas, 29 × 24 in., 73.4 × 61 cm.
Signed lower left: *Mary Cassatt/1885*

Description: An elderly woman is seated behind a table set with a white cloth and a blue and white Canton china tea service with gold edges. She wears a deep blue caped dress and a lace cap on her head with long white lace ends tied at the right. Her blue eyes look to right. The background is light blue.

Note: This is a portrait of Mrs. Robert Moore Riddle (Mary Johnston Dickinson), a first cousin of Mrs. Robert S. Cassatt. It was begun in 1883 but finished two years later. Mrs. Cassatt wrote home to Philadelphia: "As they are not very artistic in their likes and dislikes of pictures and as a likeness is a hard thing to make to please the nearest friends, I don't know what the results will be. Annie ought to like it in one respect for both Degas and Raffaëlli said it was 'la distinction même'." (Frederick A. Sweet, 1966, p. 86.) The family were not pleased with it and Mary Cassatt was terribly disappointed. She put it away in a closet where it remained for years until Mrs. Havemeyer found it and insisted on its being exhibited in 1914.

Collections: Gift of the artist to the *Metropolitan Museum of Art*, New York, 1923.

Exhibitions: Durand-Ruel, Paris, 1914 (cat. 8) (called "Portrait"); M. Knoedler & Co., New York, "Masterpieces by Old and Modern Painters," 1915; Metropolitan Museum of Art, New York, 1918–20; Pennsylvania Academy of the Fine Arts, Philadelphia, 1920; Pennsylvania Museum of Art, Philadelphia, 1927 (cat. 11); Carnegie Institute, Pittsburgh, 1928 (cat. 13); Albright Art Gallery, Buffalo, 22nd annual exhibition, 1928; Baltimore Museum of Art, 1941–42 (cat. 16, illus.); Wildenstein, New York, 1947 (cat. 15, illus.); Art Institute of Chicago and Metropolitan Museum of Art, New York, "Sargent, Whistler and Mary Cassatt" (cat. 14, illus.), 1954; Baltimore Museum of Art, "Manet, Degas, Berthe Morisot and Mary Cassatt" (cat. 110, illus.), 1962.

Reproductions: Town and Country, vol. 70 (10 April 1915), p. 31; *Arts and Decoration,* vol. 5 (May 1915), p. 282; *Arts,* vol. 10 (Aug. 1926), p. 109; *Literary Digest,* vol. 90 (10 July 1926), p. 29; Edith R. Abbot, *The Great Painters,* New York, 1927, p. 86b, fol. p. 388; *Arts,* vol. 15 (Jan. 1929), cover; Walker and James, *Great American Paintings,* no. 74, 1943, p. 21; *French Impressionists,* 1944, p. 105 (color); *Magazine of Art,* vol. 39, no. 7 (Nov. 1946), p. 306; *Metropolitan Museum of Art Bulletin,* n.s. vol. 7 (Dec. 1948), p. 117; *Metropolitan Museum of Art Bulletin,* no. 12 (1954), p. 183; *Life* (28 March 1955), p. 74; *Arts,* vol. 31 (May 1957), p. 12; Charles McCurdy, *Modern Art: A Pictorial Anthology,* New York, 1958, p. 150; *Art in America,* vol. 47, no. 2 (Summer 1959), p. 49; idem, vol. 53 (Aug. 1965), p. 64 (color); Margaret Breuning, 1944, p. 14 (color); Frederick A. Sweet, 1966, fig. 13, fol. p. 108.

140
Study of One of the Little Sisters c. 1885
Pastel on paper, 19 × 13¾ in., 48.4 × 35 cm.
Unsigned

Description: Head of a little girl looking toward left. Her hair is straight and hangs on either side just to her shoulders. There are a few straggly bangs. A single line at right and two at left indicate her shoulders.

Collections: Mrs. Oscar Hammerstein, New York.

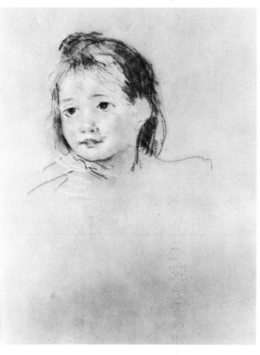

141
Two Little Sisters c. 1885
Oil on canvas, 12½ × 16 in., 31.6 × 40.5 cm.
Signed lower right: *Mary Cassatt*

Description: Heads and shoulders of two little girls seen from above. Both have light brown hair, dark eyes, and wear white dresses. The older child at the left has her hair brushed back from her forehead. The background is dappled green.

Collections: Galerie Hervé, Paris, 1958; to *Mr. and Mrs. Robert B. Mayer,* Winnetka, Illinois.

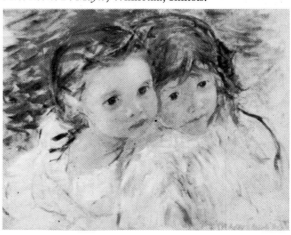

142
The Little Sisters c. 1885
Oil on canvas, 19 × 22½ in., 48.2 × 57 cm.
Signed lower right: *Mary Cassatt*

Description: Two little girls with reddish-brown hair sit on the grass and both look up to the right. Their white dresses are not detailed but have bright blue shadows. Green grass covers the background.

Collections: Ambroise Vollard, Paris; *Glasgow Art Gallery and Museum*, Scotland, presented, 1953, by the Trustees of the Hamilton Bequest.

Exhibitions: Belfast Museum and Art Gallery, "19th and 20th Century French Paintings" (cat. 2), 1958–59.

Reproductions: Apollo, vol. 58 (Aug. 1953), p. 40; *Scottish Art Review*, vol. 4, no. 4 (1953), p. 18; *Glasgow Art Gallery Bulletin*, no. 59 (1953), p. 8; *The Artist*, vol. 47, no. 4 (1954), p. 8 (color); *Apollo*, vol. 57 (1958), p. 40; François Mathey, *Les impressionists et leur temps*, Paris, 1959, p. 113.

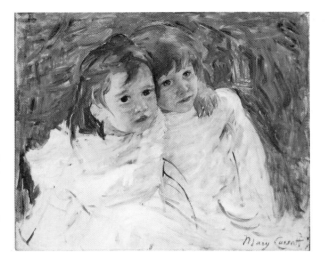

143
Little Girl in a Big Straw Hat and a Pinafore
c. 1886
Oil on canvas, 25½ × 19¼ in., 64.7 × 49 cm.
Signed lower right corner: *Mary Cassatt*

Description: Three-quarter length of a little girl with blond hair wearing a large, round, yellow straw hat trimmed in black and white ribbon, a white short-sleeved dress, and a plain, high-necked lilac pinafore or apron. The background is grayish tan.

Collections: Ambroise Vollard; by descent to Chrétien de Gallia, Paris; Edward Speelman, Zurich, to *Mr. and Mrs. Paul Mellon*, Upperville, Virginia, 1965.

Exhibitions: National Gallery of Art, Washington, D.C., 1966 (cat. 118).

Reproductions: Julia Carson, 1966, p. 102.

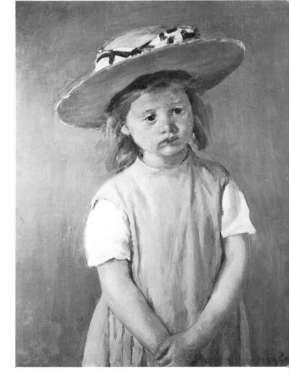

144
Young Woman Sewing in a Garden c. 1886
Oil on canvas, c. 36 × 25½ in., 91.5 × 64.7 cm.
Signed extreme lower left: *Mary Cassatt*

Description: A young woman wearing a light blue dress and with brown hair, parted in the middle, is seated in a garden with bright red geraniums on either side of her. She looks down at some sewing held in both hands.

Note: Also called "Jeune fille travaillant" or "Femme cousant."

Collections: From the artist to Antonin Personnaz; to *Musée du Louvre*, Paris, Antonin Personnaz Collection, 1937.

Exhibitions: Eighth Impressionist Exhibition, 1886 (cat. 8); Durand-Ruel, Paris, 1893 (cat. 14); Musée du Louvre, "Les impressionistes, leurs précurseurs et leurs contemporains" (cat. 29), 1948.

Reproductions: Louvre catalogue, 1958 (cat. 241); Julia Carson, 1966, p. 171.

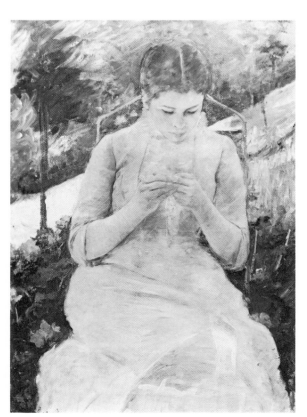

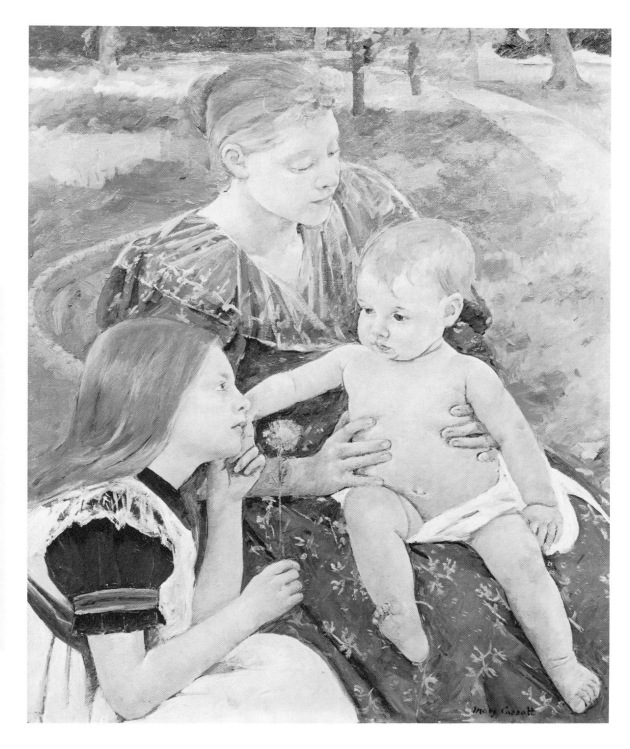

145
The Family c. 1886
Oil on canvas, 32 × 26 in., 81.2 × 66 cm.
Signed lower right: *Mary Cassatt*

Description: A mother, little girl, and baby form a
triangular composition. They are seen in a park
with a path under trees in the background. The
mother, seated in a wicker chair, holds her baby
on her lap with both hands under his arms. He
wears just a diaper. The little girl is at lower left,
seen in profile to right, wearing a short, puff-
sleeved dress with a white pinafore. Her long,
straight hair falls down her back. The mother
wears a flowered dress with a wide, thin lace
collar.

Note: Also called "Family Group" and "Mater-
nité." Durand-Ruel 506-L.2860.

Collections: From the artist to Durand-Ruel,
Paris; to Robert K. Cassatt; to Mr. and Mrs.
H. O. Havemeyer; American Art Association,

New York, Havemeyer Estate sale, 1930; to the
Chrysler Art Museum, Provincetown, Massachusetts,
1969.

Exhibitions: American Art Association, 1886,
through National Academy of Design, New York,
to Marlborough Fine Art Ltd., London, 1886
(cat. 27); Carnegie Institute, Pittsburgh, 1887;
Durand-Ruel, Paris, 1893 (cat. 3); Durand-Ruel,
New York, 1895 (cat. 36); Durand-Ruel, New
York, 1911; Pennsylvania Museum of Art,
Philadelphia, 1927 (cat. 6); Carnegie Institute,
Pittsburgh, 1928 (cat. 5); Brooklyn Institute of
Arts and Sciences, "Leaders of American Im-
pressionism: Mary Cassatt, Childe Hassam, J. H.
Twachtman and J. Alden Weir," 1937; Jeu de
Paume, 1938 (cat. 13); Montclair (N.J.) Art
Museum, 1938 (cat. 12); Washington Gallery of
the Museum of Modern Art, "Six Centuries of
Child Portraiture," 1938; Haverford College, 1939
(cat. 13); Durand-Ruel, New York, "Morisot and
Mary Cassatt" (cat. 7), 1939; Baltimore Museum

of Art, 1941–42 (cat. 17); Wildenstein, New York,
1947 (cat. 16); Marlborough Fine Art Ltd.,
London, 1953 (cat. 2, illus.); Dayton Art Institute,
"21 French Paintings, 1789–1929" (French Collec-
tion of Walter P. Chrysler, Jr.) (cat. 70), 1960.

Reproductions: Scribner's Magazine, vol. 19 (March
1896), p. 357; Vittorio Pica, "Artisti contempo-
ranei Berthe Morisot e Mary Cassatt," *Emporium*,
vol. 26 (July 1907), p. 15; *Craftsman*, vol. 19
(March 1911), p. 544; Edmond Joseph, *Diction-
aire biographique des artistes contemporains*, Paris,
1930, vol. 1, p. 249; Arsène Alexandre, "La
collection Havemeyer et Mary Cassatt," *La
renaissance*, vol. 13 (Feb. 1930), p. 52; *Art News*,
vol. 28, pt. 1 (22 March 1930), p. 30; *Art
News*, vol. 36 (26 Feb. 1938), p. 16; *Life* (3
May 1943), p. 68; Margaret Breuning, 1944,
p. 15; *Milwaukee Gallery Notes*, vol. 21 (Oct. 1948),
p. 3; *Illustrated London News*, vol. 223 (11 June
1953), p. 73; *Art News*, vol. 52 (Sept. 1953), p. 54;
Pictures on Exhibit, vol. 21 (Nov. 1957), p. 25.

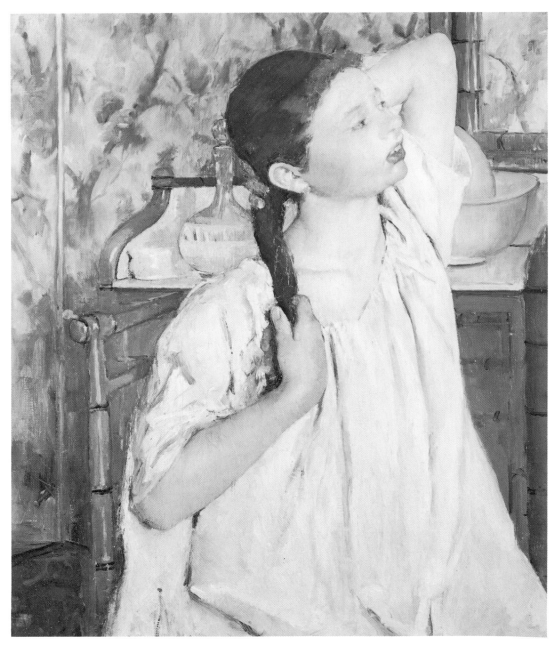

Girl Arranging Her Hair 1886

Oil on canvas, 29½ × 24½ in., 75 × 62.2 cm.
Signed lower left: *Mary Cassatt*

Description: A young girl seen in half-length sits in a chair looking off to the right. She wears a plain chemise and holds the braid of her brown hair at the nape of her neck. Behind her is a washstand with washbowl and pitcher against a flowered wallpaper.

Note: Also called "Fillette se coiffant," "La fille à sa toilette," "The Morning Toilet," and "La toilette." National Gallery of Art no. 1761.

Collections: Edgar Degas, 1886–1918; Degas sale, Paris, 6–7 March 1918; to Mr. and Mrs. H. O. Havemeyer; American Art Association, New York, Havemeyer Estate sale, 1930; to Chester Dale; to *National Gallery of Art*, Washington, D.C., Chester Dale Collection.

Exhibitions: Eighth Impressionist Exhibition, Paris, 1886; Durand-Ruel, Paris, 1893 (cat. 17); Durand-Ruel, Paris, 1908 (cat. 1); Pennsylvania Academy of the Fine Arts, Philadelphia, 1920; Art Institute of Chicago, 1926–27 (cat. 4); Pennsylvania Museum of Art, Philadelphia, 1927 (cat. 7); Carnegie Institute, Pittsburgh, 1928 (cat. 2); Museum of French Art, New York, "Degas and His Tradition," 1931; Museum of Modern Art, New York, "American Painting and Sculpture, 1862–1932" (cat. 13, illus.), 1932–33; Art Institute of Chicago, "A Century of Progress" (cat. 438, illus.), 1933; Baltimore Museum of Art, "A Survey of American Painting," 1934, cat. p. 25; Tate Gallery, London, "American Painting," 1946.

Reproductions: Achille Segard, 1913, fol. p. 20; *The Arts*, vol. 11 (June 1927), p. 294; *Studio* (July 1927), p. 150; *Art News*, vol. 29 (21 March 1931), p. 25; *Social Calendar*, vol. 20 (6 April 1931), p. 6; *Art News*, vol. 31 (3 June 1933), p. 3; *Fine Arts*, vol. 20 (June 1933), p. 42; Holger Cahill and Alfred H. Barr, Jr., eds., *Art in America in Modern Times*, 1934, p. 30; Margaret Breuning, 1944, frontispiece (color); *French Impressionists*, 1944, p. 82 (color); *Gazette des beaux arts*, series 6, vol. 30 (Oct. 1946), p. 333; John Hadfield, *A Book of Joy*, London, 1962, fol. p. 59; John Walker, *The National Gallery*, Washington, D.C. 1963, p. 328; Julia Carson, 1966, p. 63; Frederick A. Sweet, 1966, fig. 15, fol. p. 108.

Portrait of an Elderly Lady in a Bonnet: Red Background c. 1887

Oil on canvas, 31⅝ × 25½ in., 80.5 × 64.8 cm.
Unsigned. Mathilde X Collection seal on verso

Description: The lady sits on a high-backed settee, looking off to left. She wears a dark gown and gray gloves. Her bonnet perched on top of her gray hair is decorated with a spray of pink flowers and is tied under her chin with a bow. Above the patterned back of the settee the lower sections of pictures on the wall are shown.

Note: Also called "Etude de femme âgée en chapeau: fond rouge."

Collections: From the artist to Mathilde Vallet, 1927; Mathilde X sale, Paris, 1927; *private collection*, United States.

Exhibitions: Galerie A.-M. Reitlinger, Paris, 1927 (cat. 53).

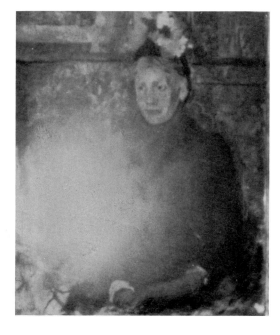

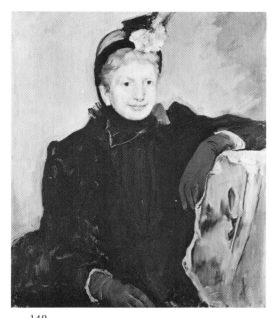

148
Portrait of an Elderly Lady c. 1887
Oil on canvas, 28⅝ × 23¾ in., 72.5 × 60.3 cm.
Unsigned

Description: An elderly gray-haired lady wearing a small bonnet trimmed with one big pink rose sits looking forward with her left arm resting on the back of an upholstered chair. She wears brown gloves and a variegated silk costume.

Note: Also called "Etude de femme âgée: chapeau à fleur rose." National Gallery of Art no. 1671.

Collections: From the artist to Mathilde Vallet, 1927; Mathilde X sale, Paris, 1927; to Chester Dale; to the *National Gallery of Art*, Washington, D. C., Chester Dale Collection.

Exhibitions: Galerie A.-M. Reitlinger, Paris, 1927 (cat. 63); Albright Art Gallery, Buffalo, 1928; Museum of French Art, New York, "100 Years of French Portraits," 1928; Brooklyn Museum, "American Impressionists and Other Artists, 1800–1900" (cat. 14), 1932; City Art Museum of St. Louis, 1933–34 (cat. 6).

Reproductions: Art News, vol. 27 (27 April 1929), p. 47; *Brooklyn Museum Quarterly,* vol. 19 (April 1932), p. 55; Forbes Watson, 1932, p. 27.

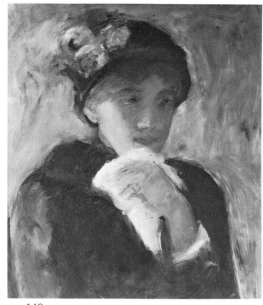

149
A Young Woman Holding a Handkerchief to Her Chin c. 1887
Oil on canvas, 21½ × 18¾ in., 54.6 × 47.6 cm.
Signed below, at center: *Mary Cassatt*

Description: A young woman wears a dark suit and a dark hat trimmed with three large pink roses at left. Her face is in shadow as she looks toward right. Mottled blue background.

Note: Also called "La femme au mouchoir."

Collections: From the artist to Ambroise Vollard; Mr. Martin, Paris; *private collection,* New York.

Exhibitions: Credit Municipal Sale, Paris, 1950.

Reproductions: Art Quarterly, vol. 24, no. 1 (Spring 1961), p. 109.

150
Portrait of Alexander J. Cassatt c. 1887
Pastel on paper, 35½ × 27¾ in., 90 × 70.5 cm.
Unsigned

Description: The artist's brother sits behind a table covered with a raspberry-rose cloth. On it is a paperbacked book and another object. His right hand rests on the table. He wears a black jacket and a gray cravat. His hair is dark, mustache reddish. The background is pink.

Collections: Mr. and Mrs. Alexander J. Cassatt, Cecilton, Maryland.

Exhibitions: M. Knoedler & Co., New York, 1966 (cat. 33).

Reproductions: Julia Carson, 1966, p. 139.

151
The Quiet Time 1888

Oil on canvas, 18¼ × 15⅝ in., 46 × 39 cm.
Signed lower right: *Mary Cassatt*

Description: Bust-length figure of a young woman in
blue, her brown hair drawn tightly back. She
holds her baby, who wears a white dress. The
child's head rests on her mother's shoulder and
one chubby hand is raised to the mother's neck.
Vague landscape background.

Note: Also called "Mother and Child" in Have-
meyer collection catalogue. Painted at Septeuil,
near Nantes.

Collections: From the artist to Durand-Ruel, Paris,
1890; to Durand-Ruel, New York, 1895; to Mrs.
H. O. Havemeyer, 1895; to her daughter, Electra
H. Webb; present location unknown.

Exhibitions: Durand-Ruel, Paris, 1891 (cat. 1);
Durand-Ruel, Paris, 1893 (cat. 11); Museum of
Fine Arts, Boston, 1909 (cat. 3); M. Knoedler &
Co., New York, "Masterpieces by Old and
Modern Painters" (cat. 48), 1915; Art Institute of
Chicago, 1926 (cat. 4); Pennsylvania Museum
of Art, Philadelphia, 1927 (cat. 15); Art Institute
of Chicago, 1934 (cat. 437).

Reproductions: Art Amateur, vol. 39 (May 1898),
p. 131; Achille Segard, 1913, fol. p. 20; Arsène
Alexandre, "La collection Havemeyer et Mary
Cassatt," *La renaissance,* vol. 13 (Feb. 1930), p. 54.

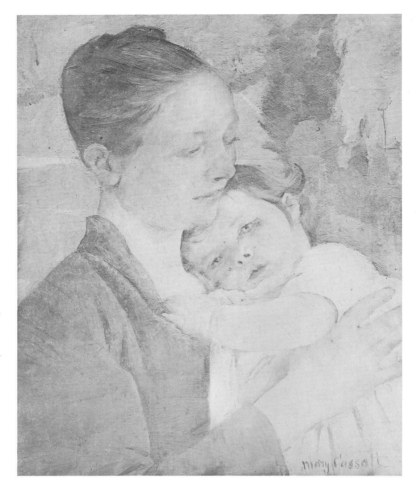

152
Mother's Goodnight Kiss 1888

Pastel on paper, 33 × 29 in., 84 × 73.8 cm.
Signed upper left corner: *Mary Cassatt*

Description: Half-length of a mother holding her
sleepy baby on her left arm. The mother wears a
brown striped dress with a pale yellow yoke; the
baby wears a dark blue dress piped in white. She
has her left hand up to her mouth and rests her
head against the chair back while her mother
kisses her on the forehead.

Note: Called "Mother and Child" by Art Institute
of Chicago.

Collections: From the artist to Mrs. Potter Palmer;
to the *Art Institute of Chicago,* Potter Palmer Collec-
tion.

Exhibitions: Art Institute of Chicago, 1926–27;
Art Institute of Chicago, 1934 (cat. 435); Marl-
borough Fine Art Ltd., London, 1953 (cat. 9).

Reproductions: Margaret Breuning, 1944, p. 21.

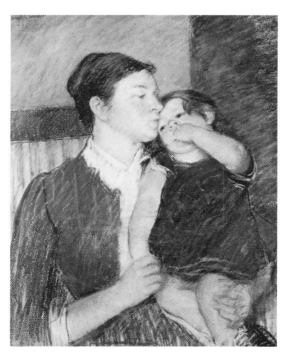

153

Baby in Dark Blue Suit, Looking Over His Mother's Shoulder 1889

Oil on canvas, 29 × 23½ in., 73.7 × 59.8 cm.
Signed lower right: *Mary Cassatt*

Description: A baby in a dark suit with white piping has a finger of his left hand in his mouth as he looks over his mother's shoulder. His mother wears a tight-fitting dove-gray dress with a bustle. Interestingly detailed background with rose chintz at upper right, blue and white detail at left.

Note: Also called "Enfant en costume bleu et jeune femme" and "Bébé en costume bleu, dans les bras d'une jeune femme." Durand-Ruel 10456-L.D.13160.

Collections: From the artist to Mathilde Vallet, 1927; to Durand-Ruel, Paris, 1927; to *Cincinnati Art Museum*.

Exhibitions: Art Institute of Chicago, 1934 (cat. 436, illus.); Durand-Ruel, New York, 1935 (cat. 8); Art Gallery of Toronto, 1940; Santa Barbara Museum of Art, 1941; Fine Arts Gallery of San Diego, 1941; Museum of Modern Art, New York, "Art in Progress" (illus. p. 19), 1944; Birmingham (Ala.) Museum of Art, Dayton Art Institute, Columbus (Ohio) Gallery of Fine Arts, "America and Impressionism," 1951; Art Institute of Chicago and Metropolitan Museum of Art, New York, "Sargent, Whistler and Mary Cassatt" (cat. 15), 1954; Society of Four Arts, Palm Beach, "John Singer Sargent and Mary Cassatt" (cat. 41, illus.), 1959.

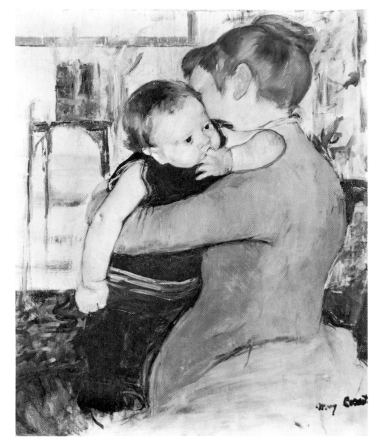

Reproductions: Figaro Artistique (28 April 1927), p. 438; *Art News,* vol. 27 (17 Nov. 1928), p. 3; *American Magazine of Art,* vol. 20 (Jan. 1929), p. 42; *Edith Valerio,* 1930, pl. 21; *Margaret Breuning,* 1944, p. 27; *Cincinnati Art Museum Bulletin* (May 1951), p. 2 (color); *Art Digest,* vol. 28 (15 Jan. 1954), pp. 6–7; *Cincinnati Art Museum Bulletin,* n.s. vol. 2 (Oct. 1952), p. 41.

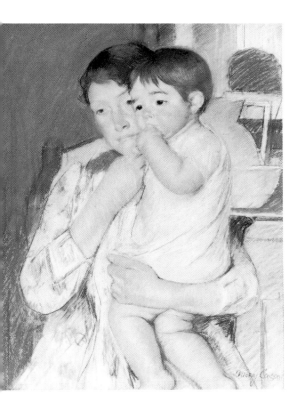

154

Baby on His Mother's Arm, Sucking His Finger 1889

Pastel on paper, 25 × 19 in., 63.5 × 48.2 cm.
Signed lower right: *Mary Cassatt*

Description: The baby is held on his mother's arm. She wears a flowered dress and looks left, her face partly obscured by his. Behind them is a washstand with bowl and pitcher and a mirror in which her dark hair is reflected.

Note: Also called "Maternité," "Jeune mère," "Jeune femme tenant un enfant dans ses bras," and "Avant la toilette." Durand-Ruel 6253-D.11385.

Collections: From the artist to Henri Rouart; 2nd Rouart sale, 16 Dec. 1912 (cat. 14); to *Pierre Hugot*, Paris, who will bequeath it to the Louvre.

Exhibitions: Durand-Ruel, Paris, 1893 (cat. 23); Durand-Ruel, New York, 1895 (cat. 11); Durand-Ruel, Paris, 1908 (cat. 30); Manzi Joyant Galerie, Paris, 1913; Durand-Ruel, Paris, 1932 (illus. p. 12).

Reproductions: L'art et les artistes, vol. 12 (Nov. 1910), p. 71; *International Studio,* vol. 33 (Nov. 1913), p. 70; *Studio,* vol. 60 (Oct. 1913), p. 70; *Beaux Arts,* vol. 9 (March 1931), p. 9; *Le bulletin de l'art ancien et moderne, revue de l'art,* vol. 59 (April 1931), p. 186.

155

Sketch of "Emmie and Her Child" 1889

Pastel on paper, 16½ × 20 in., 42 × 51 cm.
Unsigned

Description: Bust length figure of a woman in blue with tightly dressed chestnut hair piled high on her head, holding closely to her a fair-haired child dressed in white whose head, drawn with fine foreshortening, rests upon the woman's shoulder. The child's right hand is raised to caress her mother's face. Sketchy green background.

Collections: From the artist to Payson Thompson; American Art Association, New York, Payson Thompson sale, 12 Jan. 1928 (cat. 79, illus.); present location unknown.

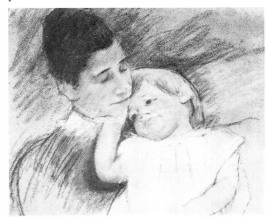

156

Emmie and Her Child 1889

Oil on canvas, 35⅜ × 25⅜ in., 90 × 64.5 cm.
Signed lower left: *Mary Cassatt*

Description: A young mother, holding her child on her lap and clasping her with both arms, is seen in three-quarter length seated before a washstand with a white bowl and pitcher. The mother's dress has a bright pattern of pink and red roses on white ground; the child wears a white chemise. The child's hair is blond, the mother's dark.

Note: Also called "Maternité."

Collections: From the artist to Durand-Ruel, Paris, 1899; to George Viau; George Viau sale (cat. 9, illus.), Paris, 4 March 1907; to Mrs. Montgomery Sears; to her daughter, Mrs. J. Cameron Bradley; to M. Knoedler & Co., New York, 1953; to Roland P. Murdock; presented to the *Wichita Art Museum*, Roland P. Murdock Collection.

Exhibitions: Durand-Ruel, New York, 1895 (cat. 16); Durand-Ruel, Paris, 1908 (cat. 11); Art Institute of Chicago, 1926–27; Carnegie Institute, Pittsburgh, 1928; Institute of Modern Art, Boston, 1937; Museum of Fine Arts, Boston, 1938; Museum of Fine Arts, Boston, "Art in New England" (cat. 8), 1939; Art Institute of Chicago and Metropolitan Museum of Art, New York, "Sargent, Whistler and Mary Cassatt" (cat. 17, color illus.), 1954; Alabama Polytechnic Institute, Auburn, "Community Art from Midwest Collections" (cat. 17), 1954; Des Moines (Iowa) Art Center, 1955; Wildenstein, New York, "The American Vision" (cat. 20), 1957.

Reproductions: Vittorio Pica, "Artisti contemporanei, Berthe Morisot e Mary Cassatt," *Emporium*, vol. 26 (July 1907), color cover; *Time*, vol. 62, no. 5 (12 Oct. 1953), p. 93 (color); *Life* (17 May 1954), pp. 92–98; *Arts*, vol. 30 (July 1956), p. 13 (color); Alexander Eliot, **300 Years of American Painting**, New York, 1957, p. 124; Frederick A. Sweet, 1966, fig. 16, fol. p. 108; Julia Carson, 1966, p. 86.

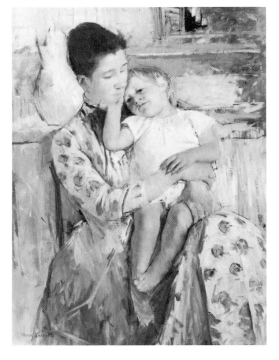

157

The Long Gloves 1889

Pastel on tan paper, 25½ × 21 in., 65 × 53.5 cm.
Signed lower right: *Mary Cassatt*

Description: A young, auburn-haired woman in evening dress pulls on her long white glove with her right hand. She looks down at the glove. Shadows of bright green-blue on her right arm.

Collections: Mrs. Percy C. Madeira, Berwyn, Pennsylvania.

Exhibitions: Baltimore Museum of Art, 1941–42 (cat. 19); Wildenstein, New York, 1947 (cat. 18, illus.); Art Institute of Chicago and Metropolitan Museum of Art, New York, "Sargent, Whistler and Mary Cassatt" (cat. 13), 1954; Philadelphia Museum of Art, 1960; Baltimore Museum of Art, 1962 (cat. 111); M. Knoedler & Co., New York, 1966 (cat. 19).

Reproductions: Art News, vol. 46 (20 Nov. 1947), p. 18.

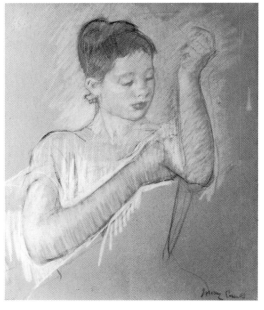

158

Mimi as a Brunette c. 1889

Pastel, 23½ × 19½ in., 59.8 × 49.5 cm.
Signed toward lower right: *Mary Cassatt*

Description: A young woman with dark reddish hair with blond lights is seated behind a bamboo table. She wears a low-necked old-rose and pink evening gown with a bow on her right shoulder. Hiding her left shoulder is a bouquet of pink and pale golden yellow flowers in a vase on the table. The table top is in orange tones. Her fan has touches of green. Deep aerial blue background.

Note: Also called "Femme en corsage rose tenant un éventail" and "Jeune femme en toilette de bal." Durand-Ruel 10672, L.D. 13366.

Collections: George Viau; 2nd George Viau sale (cat. 99), 1907; to Dikran Kelekian, Paris; Kelekian Estate sale (cat. 66), Paris, 1922; American Art Association, New York, M. H. L. Warner/Gerry sale (cat. 160), 1928; to *Mr. Taneyhill.*

Reproductions: Vittorio Pica, "Artisti contemporanei, Berthe Morisot e Mary Cassatt," *Emporium*, vol. 26 (July 1907), p. 13.

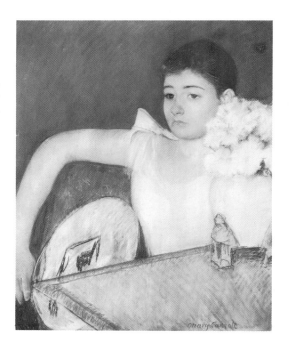

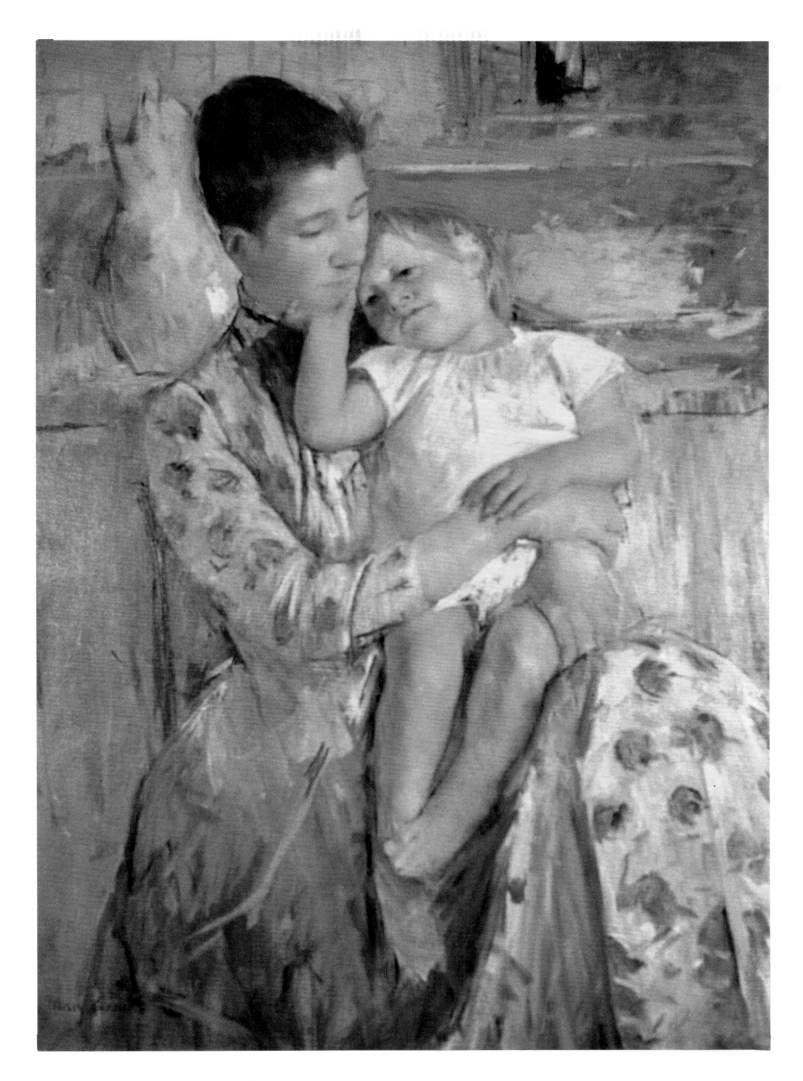

Emmie and Her Child, 1889. BrCR 156.

159

Sketch of the Bonnet c. 1889

Oil on canvas, 25¾ × 19¾ in., 65.6 × 50.2 cm.
Signed lower right: *Mary Cassatt*

Description: Half-length study of a young woman trying on a bonnet. With her left hand she holds the bonnet strings under her chin while in her right hand she holds up a hand mirror to see her image. Her head and the bonnet are well developed, whereas her arms and hands are barely outlined.

Note: Also called "Lady with Gloves."

Collections: Private collection, Paris.

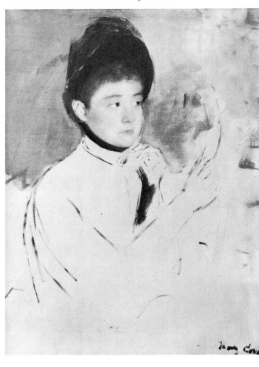

161

Head of Mrs. Robert S. Cassatt c. 1889

Pastel on paper, 15 × 14 in., 38 × 35.5 cm.
Unsigned. Mathilde X collection stamp on verso

Description: Study for the three-quarter length oil portrait. She looks to right, seen in three-quarter view with her dark hair parted. The pose of the shoulders is in outline only.

Note: Also called "La mère de l'artiste; étude de tête."

Collections: From the artist to Mathilde Vallet, 1927; Mathilde X sale, Paris, 1927; to Mr. Stoneborough, London; present location unknown.

Exhibitions: Galerie A.-M. Reitlinger, Paris, 1927 (cat. 65, illus.).

Reproductions: Figaro Artistique (24 March 1927), p. 375.

160

The Bonnet c. 1889

Oil on canvas, 16¼ × 9¾ in., 41.3 × 25 cm.
Unsigned

Description: Head of a young woman wearing a poke bonnet with black velvet underbrim and a black ribbon under her chin. Her dark eyes look to right. Her hair shows a fringe of bangs and her right ear shows.

Note: Also called "Woman's Head" and "Woman Wearing a Bonnet." Related to drypoint BR 137 and BrCR 159.

Collections: In the Cassatt family until 1939 when Albert E. McVitty bought it from Eugenia Cassatt Davis; Parke-Bernet, New York, A. E. McVitty sale, 15 Dec. 1949; to *Robert S. Pirie,* Boston.

Exhibitions: Baltimore Museum of Art, 1936 (cat. 6); Brooklyn Museum, 1937 (cat. 27, illus.); Haverford College, 1939 (cat. 17); New Jersey State Museum, Trenton, 1939 (cat. 5); Baltimore Museum of Art, 1941–42 (cat. 20); Wildenstein, New York, 1947 (cat. 19).

162

Portrait of Mrs. Robert S. Cassatt c. 1889

Oil on canvas, 38 × 27 in., 96.5 × 68.6 cm.
Unsigned

Description: The artist's mother is seated wearing a black dress with a white ruching and pin at the neck and a cream colored shawl which covers her right arm. Her right hand rests on her lap and holds a handkerchief, while her left hand with forefinger extended rests on her cheek. Behind her to the right is a plant on a stand, toward the left a picture or mirror. The background is lavender-gray.

Collections: From the artist to her brother, Alexander J. Cassatt; to his daughter, Mrs. W. Plunkett Stewart; to *Mrs. Gardner Cassatt*, Villanova, Pennsylvania.

Exhibitions: Durand-Ruel, New York, 1895 (cat. 34); Durand-Ruel, Paris, 1908 (cat. 4); St. Botolph Club, Boston, 1909 (cat. 10); Pennsylvania Museum of Art, Philadelphia, 1927 (cat. 26, illus.); Carnegie Institute, Pittsburgh, 1928 (cat. 24); City Art Museum of St. Louis, 1933–34 (cat. 4); Art Institute of Chicago, "A Century of Progress, Exhibition of Paintings and Sculpture" (cat. 438, illus.), 1934; Brooklyn Museum, 1937 (cat. 23); Haverford College, 1939 (cat. 2, illus.); Wildenstein, New York, 1947 (cat. 10, illus.); Pennsylvania Academy of the Fine Arts, Philadelphia, Peale House Gallery (cat. 40), 1955; Philadelphia Museum of Art, 1960; Baltimore Museum of Art, "Manet, Degas, Berthe Morisot and Mary Cassatt" (cat. 108), 1962; M. Knoedler & Co., New York, 1966 (cat. 16).

Reproductions: Bulletin de l'art ancien et moderne, no. 739 (June 1927), p. 207; *Pennsylvania Museum of Art Bulletin,* vol. 22 (May 1927), p. 372; Forbes Watson, "Philadelphia Pays Tribute to Mary Cassatt," *Arts,* vol. 11, no. 6 (June 1927), p. 288; *American Magazine of Art,* vol. 18 (June 1927), p. 310; Forbes Watson, 1932, p. 33; *Art Institute of Chicago Bulletin,* vol. 27 (Dec. 1933), p. 118; *Art Institute of Chicago Bulletin,* vol. 28 (April–May 1934), p. 39; *Carnegie Magazine,* vol. 9 (Feb. 1936), p. 268.

163

Still Life of Tulips and Stock c. 1889

Oil on canvas, 20 × 16 in., 50.8 × 40.7 cm.
Signed lower right: *Mary Cassatt,* and on vase: *MC*

Description: Five pale pink floppy tulips and four or five sprays of stock in a vase against a dark red background at the left and bluish-green background at the right.

Collection: Mrs. Harry Brahms, New York.

164

Lilacs in a Window c. 1889

Oil on canvas, 24¼ × 20 in., 61.6 × 51 cm.
Signed lower left: *Mary Cassatt*

Description: A large bunch of lilacs in a vase, seen against a window shown at an acute angle.

Collections: Moyse Dreyfus, Paris; to Galerie Robert Schmit; Parke-Bernet sale, New York, 18 Nov. 1965 (lot 99); to William A. Rudd, Cincinnati, Ohio; *Mrs. Marshall Field, Sr.,* New York.

165
Child Drinking Milk from a Bowl c. 1890
Pastel, 16½ × 14½ in., 42 × 37 cm.
Signed lower right: *M. C.*

Description: A child in profile to left bends his head
to drink from a white bowl. A large-handled
spoon between his fingers extends to the left. His
hair is soft red-brown, his blouse white with blue-
green shading. Background is dark green.

Collections: H. Leonard Simmons; acquired by the
father of Mrs. Butler c. 1935; to Mrs. George A.
Butler, New York; to Kennedy & Co., New York,
1968; to *Mr. and Mrs. Richard S. DuPont*, New York.

Exhibitions: M. Knoedler & Co., New York, 1966
(cat. 2, illus.).

166
Head of a Little Girl with Curly Hair
c. 1890
Pastel on paper, 15¾ × 15 in., 40 × 38 cm.
Unsigned

Description: Head and shoulders of a little girl with
very thick curly hair, one strand hanging over her
cheek. She looks to right and wears a dark apron
over a dress with light sleeves.

Collections: Collection Dain, Paris.

168
**Head of a Woman with Bangs, Wearing a
Toque (No. 2)** c. 1890
Pastel on paper, 17½ × 12½ in., 44.5 × 31.8 cm.
Unsigned

Description: Front view of head and shoulders of a
young woman. She has dark eyes, blond hair, and
wears a simple toque with a brown bow at left.
Her high collar is white and her gray coat has
pointed revers. The background is in shades of
yellow.

Collections: Mme. Brière, Paris, 1951; *Dr. and Mrs.
T. Edward Hanley*, Bradford, Pennsylvania.

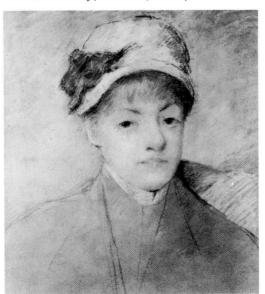

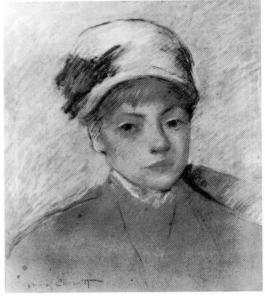

167
**Head of a Woman with Bangs, Wearing a
Toque (No. 1)** c. 1890
Pastel on paper, 16¾ × 13¾ in., 42.7 × 35 cm.
Signed lower left: *Mary Cassatt*

Description: Front view of head and shoulders of a
young woman. She has dark eyes, blond hair, and
wears a simple toque with a brown bow at the
left. Her high collar is white and her jacket is
gray. In this version the two revers are only
slightly indicated. The features are less defined
and the face seems smaller. The background is in
shades of yellow.

Collections: Lefevre Gallery, London; to Mrs. R.
Peto, London; to Mr. and Mrs. Lester Avnet, New
York, 1968; to Trosby, Palm Beach, Florida,
1969; to *Mrs. Alphonse A. Juvilier*, Palm Beach.

Exhibitions: Arts Council of Great Britain, "French
Paintings from Mr. Peto's Collection," 1951–52;
Plymouth City Art Gallery, England, "French
Paintings from Mr. Peto's Collection," 1960.

169
Half-length of a Young Woman in a Toque
c. 1890
Pastel on gray paper, 23¼ × 19 in., 59 × 48.4 cm.
Unsigned

Description: A young woman with pale red-gold hair in a toque and a dark jacket with a white collar. Her hat is white with some gray and sprigs of vivid prussian blue mixed with white. Light yellow background with outline of old-rose chair-back.

Collections: Lucien Pissarro, London; Georges Petit Galerie, Paris, Pissarro sale (cat. 60), 1928; to Marcel Bernheim, Paris; to *Mrs. R. Peto,* London.

Exhibitions: Arts Council of Great Britain, "French Paintings from Mr. Peto's Collection," 1951–52; Plymouth City Art Gallery, England, "French Paintings from Mr. Peto's Collection," 1960.

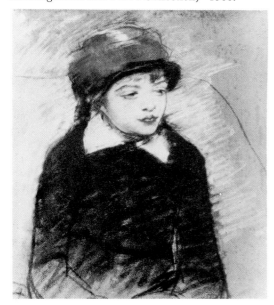

170
Sketch of Mathilde in a Dark Hat c. 1890
Pastel on gray paper, 18½ × 14½ in., 47 × 37 cm.
Unsigned

Description: Head and shoulders of a woman with dark hair under a simple dark hat held on by a blue maline veil. She looks to left.

Collections: Baltimore Museum of Art, Saidie A. May Collection, sold 1958; to Miller Galleries, New York, 1958; to *Canajoharie (N.Y.) Library and Art Gallery.*

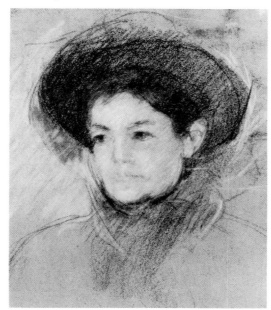

171
Portrait of Mrs. William Harrison c. 1890
Oil on canvas, 30 × 20 in., 76.2 × 51 cm.
Unsigned

Description: Seated woman, hands in lap, in half-length, wearing a light colored, striped shirt-waist dress with a dark bow at the collar and a dark belt, also with a bow. Her dark hair is pulled tightly behind her ears, close to her head.

Collections: George S. Ireland, Jr., Chicago; to Wildenstein, New York; to *N. B. Woolworth,* New York.

Exhibitions: Munson-Williams-Proctor Institute, Utica, N.Y., Baltimore Museum of Art, Dallas Museum of Art, Colorado Springs Fine Arts Center, "Portraiture: The 19th and 20th Centuries" (cat. 9), 1957.

Reproductions: Dallas News, 30 June 1957.

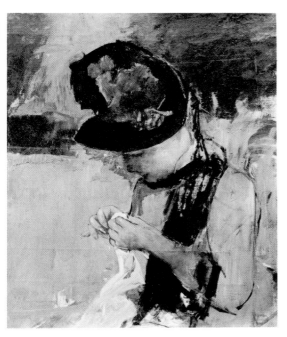

172
Woman in a Black and Green Bonnet, Sewing c. 1890
Oil on canvas, 24 × 19¾ in., 61 × 50.3 cm.
Unsigned. Mathilde X collection stamp at lower right corner

Description: A young woman wearing a green poke bonnet trimmed with ribbon and flowers sits outdoors sewing on a piece of white material. Her dress is pale green and the background is also green with a darker green area at the upper right.

Note: Called "Young Woman Sewing" by Art Institute of Chicago.

Collections: From the artist to Mathilde Vallet, 1927; Mathilde X sale, Paris, 1931; *Art Institute of Chicago,* Charles H. and Mary F. S. Worcester Collection.

Exhibitions: Galerie A.-M. Reitlinger, Paris, 1931 (cat. 7); Baltimore Museum of Art, 1941–42 (cat. 12).

173

Young Woman in a Black and Green Bonnet, Looking Down c. 1890

Pastel on paper, 25½ × 20½ in., 65 × 52 cm.
Signed in lower right corner: *Mary Cassatt*

Description: Half-length of a young woman wearing a black poke bonnet trimmed with green ribbon and tulle. Her light écru dress has a slight pattern. Rose and mauve background.

Note: Also called "Jeune femme accoudée" and "Femme au chapeau."

Collections: From the artist to Mathilde Vallet, 1927; Mathilde X sale, Paris, 1927; to Chester Dale; sold Parke-Bernet, New York; to Mrs. Potter Palmer, Chicago; Parke-Bernet, New York, Palmer sale, 16 March 1944; *The Art Museum, Princeton University* (on loan to the donor, Mrs. Christian Aall).

Exhibitions: Galerie A.-M. Reitlinger, Paris, 1927.

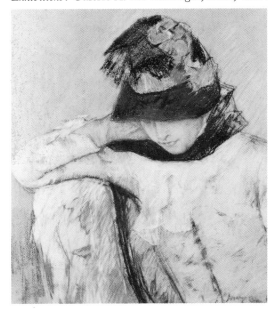

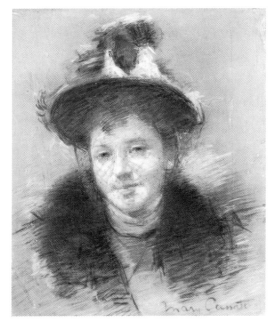

174

Woman Arranging Her Veil c. 1890

Pastel on tan paper, 25½ × 21½ in., 64.8 × 54.6 cm.
Signed toward lower right: *Mary Cassatt*

Description: Bust-length pastel of a young woman with red hair in a black poke bonnet trimmed with flowers and leaves. A soft veil from the back of the hat encircles her neck. The background is partly shaded in yellows and orange.

Note: Also called "The Black Hat."

Collections: In the Cassatt family; sold by Eugenia Cassatt Davis to Lisa Norris Elkins; bequeathed by her to the *Philadelphia Museum of Art.*

Exhibitions: Haverford College, 1939 (cat. 29, illus.) (called "Le Chapeau"); Baltimore Museum of Art, 1941–42 (cat. 21) (called "The Hat"); Wildenstein, New York, 1947 (cat. 20, illus.) (called "The Black Hat"); Philadelphia Museum of Art, "Masterpieces of Philadelphia Private Collections," 1947; Art Institute of Chicago and Metropolitan Museum of Art, New York, "Sargent, Whistler and Mary Cassatt" 1954 (cat. 16) (called "Woman Arranging Her Veil"), 1954; Philadelphia Museum of Art, 1960.

Reproductions: Art News, vol. 46 (July 1947), p. 14; *Art News* vol. 53 (April 1954), p. 20; *Arts,* vol. 34, no. 9 (June 1960), p. 17.

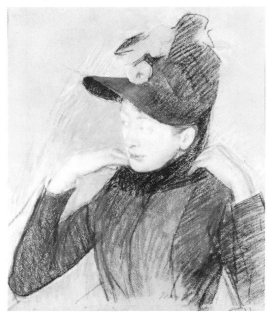

176

Portrait of a Woman in a Plumed Hat and Veil c. 1890

Pastel on paper, 21¾ × 17½ in., 55.3 × 44.5 cm.
Signed lower right: *Mary Cassatt*

Description: Head and shoulders of a woman facing forward, observing the spectator. She wears a hat with high trimming, partly light blue, and a veil

175

Madame H. de Fleury and Her Child 1890

Oil on canvas, 29 × 23½ in., 73.6 × 59.7 cm.
Signed lower right: *Mary Cassatt*

Description: Mme. de Fleury leans her head on her right arm with her elbow on a small table at left on which is a vase of flowers. She wears a dark dress with a white yoke ruffled at the neck and a large brooch at the throat. Her child sits on her lap and leans against her, looking at the spectator.

Note: Mme. de Fleury was a friend of the artist and of Degas and a sister-in-law of the sculptor Bartholomé. In April 1890, Degas wrote to Bartholomé: "Dinner at the Fleury's on Saturday with Mlle. Cassatt. Japanese exhibition at the Beaux-Arts." (Frederick A. Sweet, 1966, p. 116.) Durand-Ruel 10085 L.D. 12861.

Collections: From the artist to Durand-Ruel, Paris; to *Mr. and Mrs. Ogden Phipps,* Roslyn, New York.

Exhibitions: Durand-Ruel, New York, 1895 (cat. 25); Durand-Ruel, Paris, 1924 (cat. 14); Haverford College, 1939 (cat. 8, illus.).

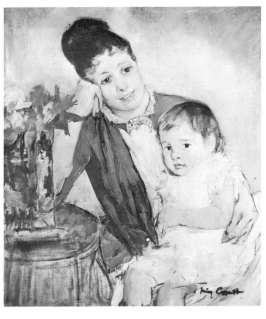

with criss-cross pattern. Around her neck is a dark fur piece. She has very red lips, pink cheeks, and auburn hair. The background is tan.

Note: Also called "Femme à voilette."

Collections: Mrs. V. Watney, England; sold Sotheby's, 31 March 1965 (lot 1); to *Daniel Maggin,* New York.

177
Portrait of a Young Girl in a Black, Plumed Hat c. 1890

Pastel on paper, 24 × 18 in., 61 × 45.7 cm.
Signed lower right: *Mary Cassatt*

Description: A bust-length study of a young girl with light eyes wearing a round black hat topped with high plumes. Her hair is dark. She wears a turquoise blue velvet costume with a high neck. The puff-sleeved jacket is bordered with dark fur, forming a zigzag line at lower right. Her neck scarf is also turquoise blue. Gray background.

Note: Also called "Buste de jeune fille, chapeau noir." Durand-Ruel 8784-LD11926.

Collections: From the artist to Durand-Ruel, Paris; to Mme. Jean d'Alayer, Paris; to Sam Salz, New York; to *Mr. and Mrs. Paul Mellon*, Upperville, Virginia.

Exhibitions: Marlborough Fine Art Ltd., London, 1953 (cat. 10); National Gallery of Art, Washington, D.C., 1966 (cat. 119).

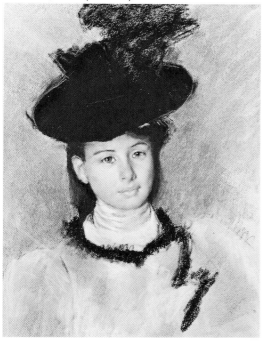

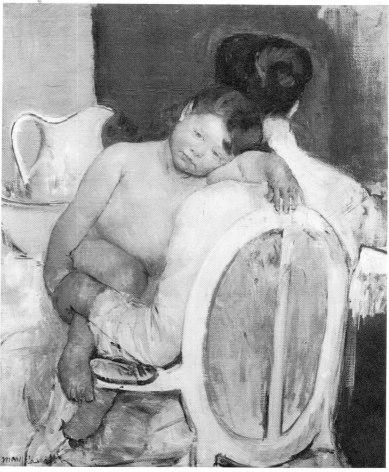

178
Baby with His Hand on the Back of a Chair
c. 1890

Oil on canvas, 31¾ × 25½ in., 80.7 × 65 cm.
Signed lower left: *Mary Cassatt*

Description: A mother, seated in an oval-backed white chair, wears a white dress. The background is dark gray with a lighter bluish-gray behind the light pink pitcher on the washstand. The baby gazes at the spectator.

Note: Also called "Femme assise, vue de dos et enfant" and "Femme assise, vue de dos, tenant un enfant dans ses bras." Durand-Ruel 7929, L 10603.

Collections: Museos de Bellas Artes y de Arte Moderno, Bilbao, Spain.

Reproductions: Edith Valerio, 1930, pl. 17.

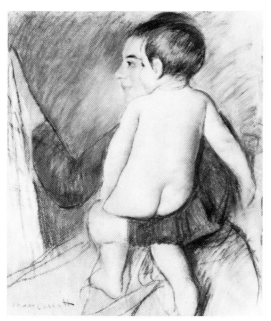

179
At the Window c. 1890

Pastel and charcoal on gray paper, 29¾ × 24½ in., 75.4 × 62.3 cm.
Signed lower left, in charcoal: *Mary Cassatt*

Description: A nurse, holding a nude baby in her left arm, stands near a curtained window at left. She wears a dark blue blouse streaked with black and a gray skirt with pink and blue highlights. She is about to pull the curtain aside. The background is lavender gray.

Collections: *Musée du Louvre*, Paris (called "Récupération").

Exhibitions: Musée du Louvre, Paris, "Les impressionistes, leurs précurseurs et leurs contemporains" (cat. 30), 1948; Musée du Louvre, Paris, "Pastels et miniatures du XIXᵉ siecle. 37ᵉ exhibition du cabinet des dessins," 1966.

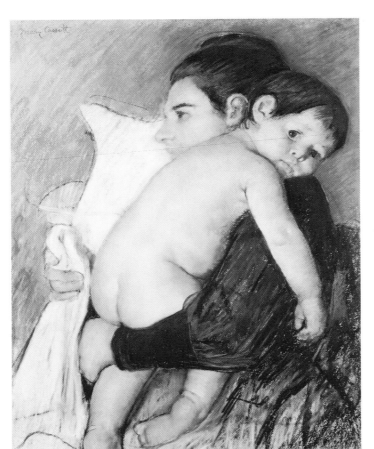

Maternity, with Baby Observing Spectator
c. 1890
Pastel on paper, 23¾ × 18 in., 60.3 × 45.7 cm.
Signed upper left corner: *Mary Cassatt*

Description: Lower part of the mother's face in profile to left is hidden behind her nude baby whom she holds on her left arm, his head on her shoulder, as he looks at the spectator. His right arm hangs down toward right. The mother holds a towel in her right hand.

Collections: Théodore Haviland collection, Paris; C. de Pourtales, Paris; Parke-Bernet sale, New York, 3 April 1968; to Michael F. Drinkhouse, New York; to *H. Wendell Cherry*, Louisville, Kentucky.

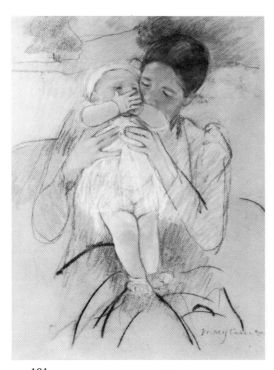

181
Baby Bill Standing on His Mother's Lap
c. 1890
Pastel on paper, 31¾ × 23¾ in., 80.6 × 60.3 cm.
Signed lower right: *Mary Cassatt*

Description: A baby wearing a thin dress and little round cap stands on his mother's lap and holds both hands over his mouth. His mother holds him up with her hands under his arms. His left arm hides her mouth. She has dark hair and sits in a landscape.

Collections: From the artist to Ambroise Vollard; Vollard & Fabiani, Paris; to *Thomas J. Gannon*, New York.

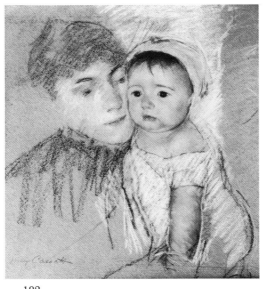

182
Baby Bill in Cap and Shift, Held by His Nurse
c. 1890
Pastel on paper, 16⅞ × 15⅛ in., 43 × 38.4 cm.
Signed lower left: *Mary Cassatt*

Description: Head and shoulders of a fat baby with dark eyes and hair held on his nurse's arm. He faces toward left. He wears a small, tight-fitting cap under which his straight dark hair is brushed forward in wisps over his forehead. His white shift falls off his shoulder. The nurse's hair and dress are both sketched lightly.

Collections: Private collection, Paris.

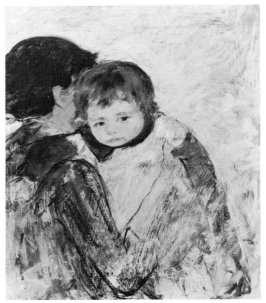

183
Hélène Is Restless c. 1890
Oil on canvas, 25½ × 20¾ in., 64.8 × 52.8 cm.
Unsigned

Description: A slight sketch of a baby held up by her mother, with a nervous feeling to the drawing of the pose. The mother's dress is blue-green and rose. The baby wears a blue dress and rose pinafore. Light absinthe yellow background.

Note: Also called "Femme tenant sur ses genoux un enfant au tablier rose."

Collections: From the artist to Mathilde Vallet, 1927; Mathilde X sale, Paris, 1927; to Chester Dale; to Mrs. Potter Palmer; Parke-Bernet, New York, Palmer sale, 16 March 1944; to N. H. Kimball, Basil Dighton, Inc.; to *Margaret Payson*, Portland, Maine.

Exhibitions: Galerie A.-M. Reitlinger, Paris, 1927 (cat. 56).

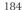

184
Hélène of Septeuil, with a Parrot c. 1890
Pastel on paper, 26½ × 20½ in., 67.3 × 52 cm.
Signed lower right: *Mary Cassatt*

Description: At left a parrot sits on a perch close to the shoulder of a mother. Her head is half hidden by the parrot as she looks at her child whom she holds. The dark-eyed baby, Hélène, wears a white bib and a large hat over a small cap tied under her chin.

Collections: From the artist to Ambroise Vollard, Paris; to *Mr. and Mrs. Leo M. Rogers*, New York.

Exhibitions: Baltimore Museum of Art, "Manet, Degas, Berthe Morisot and Mary Cassatt" (cat. 112), 1962.

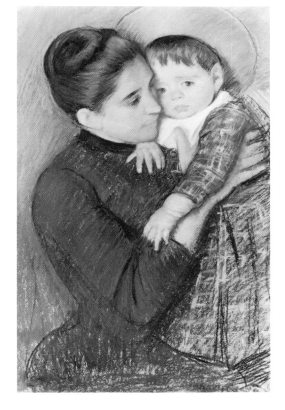

185
Hélène of Septeuil c. 1890
Pastel, 25 × 16 in., 63.5 × 40.6 cm.
Signed lower right: *Mary Cassatt*

Description: A very finished pastel of a three-quarter length view of a seated mother wearing a dark brown, tight-fitting dress with a high collar. Her dark hair is in a bun on top of her head. Hélène wears a big, round straw hat under which her bangs show, and a long, bright red and blue plaid dress with a white bib. The background is green.

Note: Related to drypoint of the same title (Br134).

Collections: From the artist to Durand-Ruel; to Paul Gallimard, 1893; to Bernheim-Jeune, Paris; Demotte Gallery, New York; to Victor Spark, New York, 1930; sold, 17 Nov. 1948, to *University of Connecticut Museum of Art*, Louise Crombie Beach Collection.

Exhibitions: Durand-Ruel, Paris, 1893 (cat. 22) (called "Après le promenade").

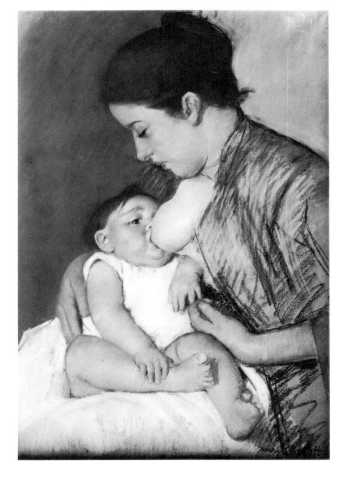

186
Maternité c. 1890
Pastel on paper, 27⅛ × 17⅝ in., 69 × 44.8 cm.
Signed lower right: *Mary Cassatt*

Description: A mother in profile to left looks down at her fat infant who nurses at her right breast. Her dark hair is drawn into a large high knot. Her lavender (or plum over blue) robe is open. The baby looks at the spectator and holds his right ankle with his right hand. The background is divided—at left it is mauve brown, at right bluish-gray.

Note: Durand-Ruel 6252.

Collections: From the artist to Olivier Sainsère; *private collection*, Paris.

Exhibitions: Durand-Ruel, Paris, 1908 (cat. 34).

Reproductions: L'art et les artistes, vol. 12 (Nov. 1910), p. 71; *Gazette des beaux arts*, vol. 9 (March 1931), p. 9.

187
**Mathilde Holding a Baby Who Reaches Out
to Right** 1890
Pastel on paper, 28¾ × 23½ in., 73 × 60 cm.
Signed lower right: *Mary Cassatt*

Description: Mathilde sits on a wicker settee hold-
ing a baby on her left arm. She wears a gray
blouse with white stripes; her brown hair is parted
in the middle and drawn back over her ears; she
looks to right. The blond baby also looks to right
as he stretches out his right arm. The baby wears
a bright blue dress and red-brown stockings.
Mathilde's skirt is a lighter blue. Background is a
green slope with a bank of trees at left.

Note: Durand-Ruel 11514-NY4441.

Collections: From the artist to Dr. Paulin, a friend
of Degas, 1890; Galerie Georges Petit, Paris,
Paulin-Nijhoff sale (cat. 38), 22 May 1919; to
Durand-Ruel, Paris; to Durand-Ruel, New York,
April 1920; to a Swiss collector, 1948; to the
International Galleries, Chicago, 1964; to *Mr. and
Mrs. Robert S. Johnson*, Chicago.

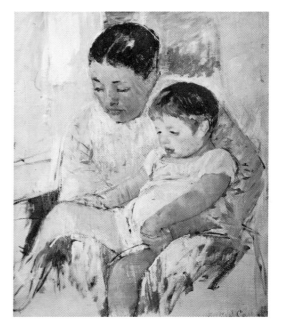
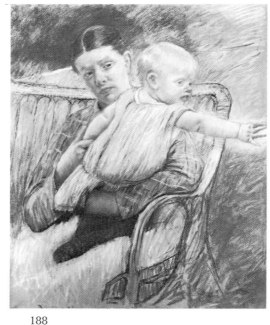

188
Jenny and Her Sleepy Child c. 1891
Oil on canvas, 28¾ × 23½ in., 73 × 60 cm.
Signed lower right: *Mary Cassatt*

Description: Sketch of a baby sprawled on his
mother's lap, his bare right leg over her knee to
left. He wears a white chemise with short sleeves.
The mother has dark hair, parted in the middle.
The pattern on her dress is scarcely indicated. She
holds the baby's left hand within hers.

Note: Durand-Ruel a1923.NY5720.

Collections: From the artist to Ambroise Vollard;
sold from his estate to Lilienfeld Galleries, New
York; to Durand-Ruel, New York, 1948; to
Marlborough Fine Art Ltd., London; to *private
collection*, New York.

Exhibitions: Marlborough Fine Art Ltd., London,
1953 (cat. 8, illus.).

Reproductions: Illustrated London News, vol. 223 (11
June 1953), p. 73.

189
Baby's First Caress 1891
Pastel, 30 × 24 in., 76.2 × 61 cm.
Signed upper left corner: *Mary Cassatt*

Description: Three-quarter length figure of a young
woman in a flowered white dress, seated, with a
nude baby in her lap, her left hand holding the
child's raised foot. She looks lovingly down at him
and rests her face against the hand which he lifts
to caress her.

Note: Also called "La caresse." Durand-Ruel 512-
L805.

Collections: From the artist to Durand-Ruel, Paris,
1891; to Durand-Ruel, New York, 1895; to Mrs.
H. O. Havemeyer, 1895; to Mrs. J. Watson Webb,
her daughter; to the Macbeth Gallery, New York;
to the *New Britain Museum of American Art*, 1948
(Harriet Russell Stanley Memorial Fund).

Exhibitions: Durand-Ruel, Paris, 1891 (cat. 2);
Durand-Ruel, Paris, 1893 (cat. 25); Durand-Ruel,
New York, 1895 (cat. 26); St. Botolph Club,
Boston, 1909 (cat. 17); M. Knoedler & Co., New
York, "French Masterpieces of the Late 19th
Century" (cat. 1), 1915; Durand-Ruel, Paris, 1924
(cat. 30); Philadelphia Museum of Art, 1927 (cat.
22); Baltimore Museum of Art, 1941–42 (cat. 22).

Reproductions: Georges Lecomte, *L'art impressioniste
d'après la collection privée de M. Durand-Ruel*, Paris,
1892, p. 129; *La revue de l'art ancien et moderne*, vol.
14 (Dec. 1903), p. 507; Achille Segard, 1913, fol.
p. 32; *Arts and Decoration*, vol. 3 (June 1913), p. 267;
Gazette des beaux arts, vol. 8 (May 1930), p. 17;
Forbes Watson, 1932, p. 40; *La renaissance*, vol. 13
(Feb. 1930), p. 55; *Art Digest*, vol. 22, no. 4 (15
Nov. 1947), p. 24.

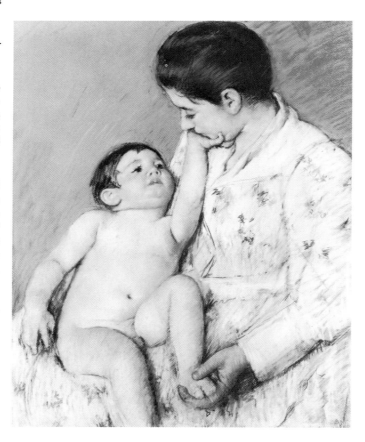

190 †
The Stocking c. 1891
Pastel on paper, 30¾ × 22½ in., 78 × 57 cm.
Signed lower right: *Mary Cassatt*

Description: A child on his mother's lap reaches off to right with extended left arm while the mother puts on his stocking. The mother's dress is white.

Note: Also called "Les soins maternelle" and "Le lever de l'enfant."

Collections: M. Manzi, Paris; Manzi sale (cat. 119), March 1919; to Graat and Madoulé; present location unknown.

Exhibitions: Durand-Ruel, Paris, 1893 (cat. 29).

191
Baby on Mother's Arm c. 1891
Oil on canvas, 25 × 20 in., 63.5 × 51 cm.
Signed lower left: *to Adolph Borie/Mary Cassatt*

Description: A baby is held on his mother's left arm, her face partly covered by his head. Her dark hair contrasts with his light brown hair. Her black dress is accented just at the neck. The picture is unfinished, the rest of the pose in outline only.

Collections: Peter Borie (Adolph's son), New York.

Exhibitions: Pennsylvania Museum of Art, Philadelphia, May 1927; McClees Gallery, Philadelphia, 1931 (cat. 7).

192
Bathing the Young Heir c. 1891
Oil on canvas, 28¾ × 23⅜ in., 73 × 59.4 cm.
Signed lower left: *Mary Cassatt*

Description: Half-length of a young woman dipping her hand in a basin of water at extreme left, preparing to bathe a fat, blond baby whom she holds on her lap. She wears a black, long-sleeved blouse and has dark hair.

Collections: From the artist to Ambroise Vollard; sold from his estate to the Graham Gallery, New York; to *Mrs. Percy Uris*, Brookville, New York.

Reproductions: Art in America, vol. 50, no. 2 (Summer 1962), p. 6.

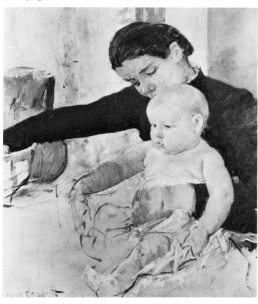

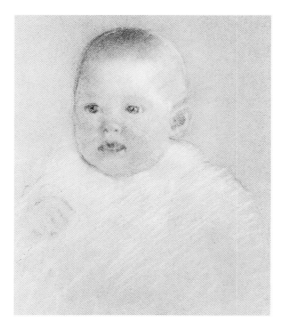

193
Head of a Baby c. 1891
Pastel on paper, 14 × 12 in., 35.5 × 30.5 cm.
Unsigned

Description: The baby has a very pink head, blue eyes, blond hair, and wears a white dress with accents of pale blue and light green.

Collections: Given by the artist to Mrs. George Agassiz (Mabel Simkins) about 1891; to her niece Mrs. Richard Story, South Hamilton, Massachusetts, who presented it to the *Museum of Fine Arts*, Boston, in 1962 in memory of her mother, Mrs. Bayard Thayer.

194
Baby's Head Covering Mother's Face
c. 1891
Pastel on paper, 12½ × 11½ in., 32 × 29.3 cm.
Unsigned

Description: Head and shoulders of a chubby nude baby. His hair is dark. The mother's entire features are hidden by his head. The background is sky blue.

Collections: From the artist to Payson Thompson; American Art Association, New York, Payson Thompson sale (cat. 7, illus.), 12 Jan. 1928; present location unknown.

195
The Child's Caress c. 1891
Oil on canvas, 26 × 21 in., 66 × 53.4 cm.
Signed upper right corner: *Mary Cassatt*

Description: Three-quarter length view of a mother wearing a white dress with a striped pattern in dark blue. The little child on her lap wears a light blue dress. Her right foot in a dark shoe shows below the mother's right wrist. Background richly covered with plum fruit in greenery.

Note: Similar in composition to drypoint Br140 in reverse. Also called "Mère et enfant" and "La caresse maternelle." Durand-Ruel 327-L935.

Collections: Sir William Van Horne, Montreal, Canada; sold 1946; Dalzell Hatfield Galleries, Los Angeles, 1953; to *Honolulu Academy of Arts*, given in memory of Miss Wilhelmina Tenney.

Exhibitions: Los Angeles County Museum, "Pan American Exhibition of Oil Paintings," 1926; Pennsylvania Museum of Art, Philadelphia, 1927 (cat. 14); Art Association of Montreal, 1933; Dalzell Hatfield Galleries, "Modern French Masterpieces," 1953.

196
Celeste in a Brown Hat c. 1891
Oil on canvas, 29 × 23½ in., 73.6 × 60 cm.
Signed lower right: *Mary Cassatt*

Description: A young woman seated on a slatted bench rests her right arm on its back while holding her hand to her face with her little finger touching her lip. She wears a large brown straw hat trimmed with flowers, a dark jacket, and a light, high-necked dress with a striped and dotted pattern. The background is dark foliage.

Note: Also called "Jeune fille en chapeau marron"

(with sometimes "au jardin" added). There is a drypoint (Br168) that relates to it. Durand-Ruel 10086-LD12857.

Collections: Mrs. H. Huddleston Rogers; to *private collection*, New York.

Exhibitions: Durand-Ruel, New York, "Paintings by Berthe Morisot and Mary Cassatt" (cat. 8), 1939; Wildenstein, New York, 1947 (cat. 14, illus.); John Herron Art Institute, Indianapolis, "Chase Centennial Exhibition," 1949.

197
Young Women Picking Fruit 1891

Oil on canvas, 52 × 36 in., 132 × 91.5 cm.
Signed lower right: *Mary Cassatt*

Description: A young woman is seated wearing a lavender dress patterned with sprigs of flowers and a large hat trimmed with wings. Her companion, who stands at center, wears a light dress with ruffles at the elbows. She has reddish hair. Behind them across a lawn is a tree and a border of blossoming plants.

Note: Painted at Bachivillers. Durand-Ruel 525-L2462.

Collections: Carnegie Institute, Pittsburgh, purchased, 1922, from Durand-Ruel, New York, through the Patrons Art Fund.

Exhibitions: Durand-Ruel, Paris, 1893 (cat. 9); Durand-Ruel, New York, 1895 (cat. 3); Carnegie Institute, Pittsburgh, "4th Pittsburgh International Exhibition" (cat. 33, illus.), 1899–1900; Durand-Ruel, New York, 1903 (cat. 3); Atkins Museum of Fine Arts, Kansas City, Mo., "Exhibition of Paintings by French Impressionists" (cat. 7), 1915; Art Association, Dallas, Texas, "1st Annual Exhibition of Contemporary International Art," 1919; Durand-Ruel, New York, 1920 (cat. 18); Carnegie Institute, Pittsburgh, "Exhibition of Art and Science in Gardens" (cat. 26), 1922; Art Gallery of Toronto, Canada, 1926 (cat. 27); California Palace of the Legion of Honor, San Francisco, "1st Exhibition of Selected Paintings by American Artists" (cat. 27), 1927; Carnegie Institute, Pittsburgh, "Mary Cassatt Memorial Exhibition" (cat. 48), 1928; Durand-Ruel, New York, 1935 (cat. 10); Cleveland Museum of Art, 20th anniversary exhibition (cat. 350), 1936; Carnegie Institute, Pittsburgh, 1940 (cat. 7); M. H. de Young Memorial Museum, San Francisco, 1940; Dayton Art Institute and Columbus (Ohio) Gallery of Fine Arts, 1951–52; Munson-Williams-Proctor Institute, Utica, N.Y., 1953; Art Institute of Chicago and the Metropolitan Museum of Art, New York, "Sargent, Whistler and Mary Cassatt" (cat. 18), 1954; Pennsylvania Academy of the Fine Arts, Philadelphia, 1955; Grand Rapids (Mich.) Art Gallery, 1955; Detroit Institute of Arts, Munson-Williams-Proctor Institute, Utica, N.Y., Virginia Museum of Fine Arts, Richmond, Baltimore Museum of Art, Currier Art Gallery, Manchester, N.H., "American Classics of the 19th Century" (cat. 75), 1957; Society of the Four Arts, Palm Beach, "Paintings by Sargent and Mary Cassatt," 1959; Columbia (S.C.) Museum of Art, 1960 (cat. 6); Art Gallery of Toronto, Winnipeg Art Gallery Association, Vancouver Art Gallery, and Whitney Museum of American Art, New York, 1961 (no. 8, illus.); Minneapolis Art Institute, 1964.

Reproductions: Brush and Pencil, vol. 5 (Dec. 1899), p. 135; *Art and Archeology,* vol. 14 (Nov.–Dec. 1922), p. 319; *Carnegie Magazine,* vol. 1 (March 1928), p. 12; *Carnegie Magazine,* vol. 13 (Feb. 1940), p. 278; Homer St. Gaudens, *The American Artist and His Times,* New York, 1941, p. 189; *Carnegie Magazine,* vol. 23, no. 4 (Nov. 1949), pp. 134–35; Frederick A. Sweet, 1966, pl. 17, fol. p. 204; E. P. Richardson, *Painting in America,* New York, 1966, p. 288.

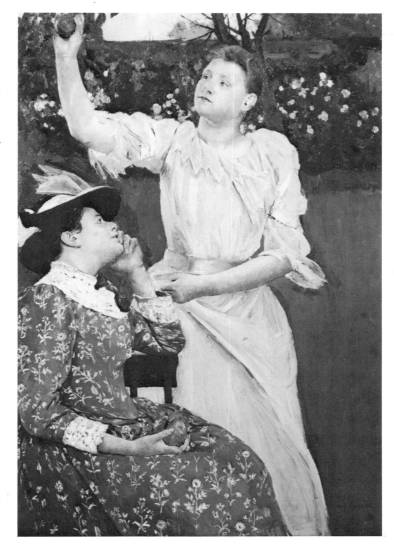

198
Woman Holding a Zinnia 1891

Oil on canvas, 28¾ × 23¾ in., 73 × 60.5 cm.
Signed lower right: *Mary Cassatt*

Description: An auburn-haired young woman sits on a green park bench, her left arm resting over the top rail. In her right hand she holds out a red zinnia. Her costume is elaborately designed with braided borders and a belt run under pleats down the front. Behind her is a deep lawn with forest trees beyond.

Collections: From the artist to Durand-Ruel, Paris; to Chester Dale, New York; to the *National Gallery of Art,* Washington, D.C., Chester Dale Collection.

Exhibitions: Durand-Ruel, Paris, 1893 (cat. 15) (called "Reverie"); Durand-Ruel, New York, 1895 (cat. 12); Durand-Ruel, New York, 1920 (cat. 15); Concord Art Association, 6th annual exhibition (cat. 15), Town Hall, Concord, Mass., 1922; Durand-Ruel, New York, 1924 (cat. 17); Durand-Ruel, New York, 1926 (cat. 9) (called "Femme assise"); Art Institute of Chicago, "Memorial Exhibition of Works of Mary Cassatt," 1926–27; American-Scandinavian Foundation and Allied Societies Exhibition, Stockholm, Sweden, Neue Glyptotek, Copenhagen, Kunst-Verein, Munich, 1930; Brooklyn Museum, 1932 (cat. 15); City Art Museum of St. Louis, 1933–34 (cat. 5).

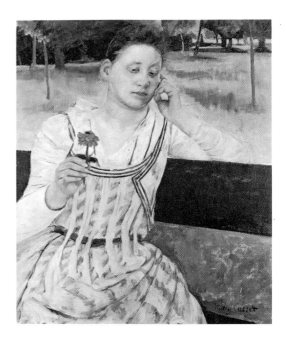

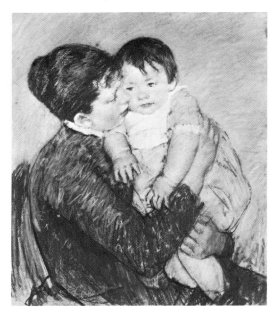

199
Agatha and Her Child c. 1891
Pastel on paper mounted on canvas, 26 × 21 in.,
66 × 53.3 cm.
Signed lower left in light pastel: *Mary Cassatt*

Description: A young mother with dark auburn
hair wears a dark blue dress with white ruching at
the collar. The child, whom she holds in her left
arm, wears a light pink dress and a white bib. The
background is gray.

Note: Also called "Sollicitude maternelle."
Durand-Ruel 513, L997.

Collections: From the artist to Durand-Ruel, Paris,
1891; to Durand-Ruel, New York, 1895; to E.
Arnhold, 1906; M. Knoedler & Co., New York,
1947; to the *Butler Institute of American Art*, Youngs-
town, Ohio.

Exhibitions: Durand-Ruel, Paris, 1893 (cat. 27).

Reproductions: Achille Segard, 1913, fol. p. 40;
Edith Valerio, 1930, pl. 4.

200
Head of Adele (No. 1) c. 1892
Pastel on paper, 21¾ × 19 in., 55.3 × 48.3 cm.
Signed lower right: *Mary Cassatt*

Description: Head of a young girl who smiles
slightly as she looks at the spectator. Her long dark
hair, falling onto her shoulders, is tied back with
a bow. A long diagonal line crosses her chest from
the end of her hair on the left down to the signature
on the right, which identifies this version.

Collections: M. Knoedler & Co., Paris, 1924, to
private collection, New York.

Exhibitions: St. Paul (Minn.) Art Center, 1965 and
1967.

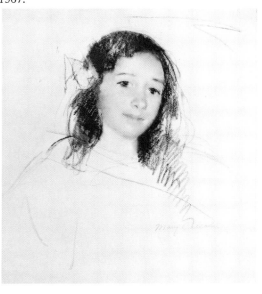

201
Head of Adele (No. 2) c. 1892
Pastel on paper, 18 × 16 in., 46 × 41 cm.
Signed lower right: *Mary Cassatt*

Description: Head of a young girl who smiles as
she looks at the spectator. Her long dark hair,
falling onto her shoulders, is tied back with a bow.
One long line running from the side of her head at
the right and out downward identifies this sketch.

Collections: Mr. Frederick W. Richmond, New York.

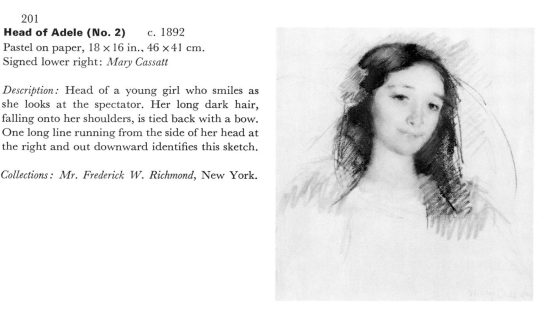

202
Head of Adele (No. 3) 1892
Pastel on paper, laid down on canvas, 18 × 17¼ in.,
45.6 × 43.5 cm.
Signed upper right: *Mary Cassatt/1892*

Description: A young girl with long dark hair fall-
ing forward below her shoulders looks off toward
the right with a slight smile. Only her face and
hair are shaded. There are a few lines of a high
chair back behind her head and a few more lines
to indicate her shoulders, otherwise no further
development.

Collections: The Israel Museum, Jerusalem, gift of
Mrs. Irving S. Norry.

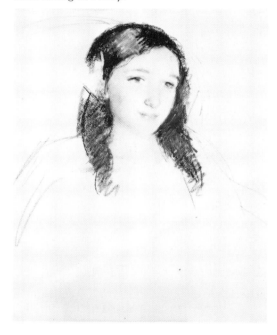

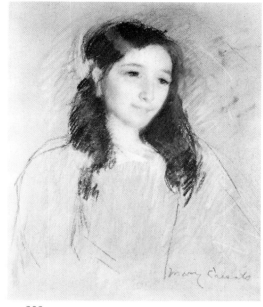

203
Head of Adele (No. 4) c. 1892
Pastel on paper, 24 × 19 in., 61 × 48 cm.
Signed lower right: *Mary Cassatt*

Description: A young girl with long dark hair fall-
ing below her shoulders looks off toward the right
with less of a smile than in the other three versions.
She is seen in half-length with her bodice suggested
in bare outlines. There is shading over her dress
and also on the background.

Collection: Hirschl & Adler, 1954, to *Mr. and Mrs.
George L. Armour*, New York.

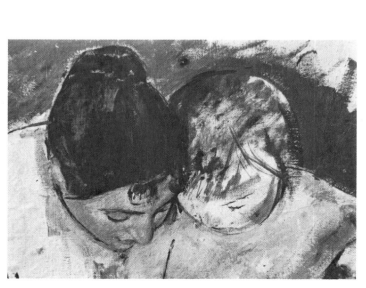

204
Study for "The Bath" (Heads Only) 1892
Oil on canvas, 27 × 35 in., 68.6 × 89 cm.
Unsigned. Mathilde X collection stamp at lower
left.

Description: Mother and child's dark heads, both
looking down, very much foreshortened. The
mother's head is well developed with her dark hair
fixed simply with a bun at the top and some bangs
on her forehead. The little girl is only barely
suggested. The background is shaded.

Note: Also called "Mère et enfant: têtes baissées."

Collections: From the artist to Mathilde Vallet,
1927; Mathilde X sale, Paris, 1927; *private collec-
tion*, Paris.

Exhibitions: Galerie A.-M. Reitlinger, Paris, 1927
(cat. 76, illus.).

205
The Bath 1892
Oil on canvas, 39½ × 26 in., 100.3 × 66 cm.
Signed lower left: *Mary Cassatt*

Description: A mother with a child on her lap, seen from above, holds the child's right foot in a bowl of water with her right hand. She wears a dress with broad stripes of moss green, pink-lavender, and white. Her hair is black and the child's dark brown. The child is wrapped in a towel. A green bureau with pink, painted flowers is at the upper right section of background. A large pitcher in lower right foreground.

Note: Also called "La toilette" and "La toilette de l'enfant."

Collections: The Art Institute of Chicago, purchased 1933, through the Robert A. Waller Fund.

Exhibitions: Durand-Ruel, Paris, 1893 (cat. 1); Durand-Ruel, New York, 1895 (cat. 21); Pennsylvania Museum of Art, Philadelphia, 67th annual exhibition, 1898 (illus.); Cincinnati Art Museum, annual, 1900 (cat. 13, illus.); Durand-Ruel, New York, 1903 (cat. 6); Pennsylvania Academy of the Fine Arts, Philadelphia, 1905 (illus.); Art Institute of Chicago, 1927 (cat. 29); Pennsylvania Museum of Art, Philadelphia, 1927 (cat. 2); Art Institute of Chicago, 1932 (cat. 145); Art Institute of Chicago, "A Century of Progress" (cat. 439), 1933; Art Institute of Chicago, "A Century of Progress" (cat. 440), 1934; Durand-Ruel, New York, 1935 (cat. 14); Brooklyn Museum, 1937 (cat. 22); Cleveland Museum of Art, 1937 (cat. 27); Museum of Modern Art, New York, "Art in Our Time" (cat. 48, illus.), 1939; Santa Barbara Museum of Art, 1941; Baltimore Museum of Art, 1941–42 (cat. 25, illus.); Wilden-

stein, New York, 1947 (cat. 25); Art Institute of Chicago and Metropolitan Museum of Art, New York, "Sargent, Whistler and Mary Cassatt" (cat. 19, illus.), 1954; Detroit Institute of Arts, "Painting in America, the Story of 450 Years," 1957; M. Knoedler & Co., New York, 1966 (cat. 21).

Reproductions: *Brush and Pencil*, vol. 6 (July 1900), p. 183; *L'art decoratif*, vol. 4 (Aug. 1902), p. 185; *Brush and Pencil*, vol. 15 (March 1905), p. 165; Sadakichi Hartmann, *History of American Art*, vol. 2, Boston, 1909, p. 189; Achille Segard, 1913, fol. p. 52; *Survey*, vol. 57 (1 Dec. 1926), p. 272; Edith Valerio, 1930, pl. 5; *A Guide to the Paintings in the Permanent Collection*, Art Institute of Chicago, 1932, p. 115; Forbes Watson, 1932, p. 43; C. J. Bulliet, *Art Masterpieces in a Century of Progress*, Chicago, 1933, (pl. 47); *Art Institute of Chicago Bulletin*, vol. 27 (Dec. 1933), p. 118; C. J. Bulliet and Jessica MacDonald, *Paintings, an Introduction to Art*, Chicago, 1934, pl. 12; *Magazine of Art*, vol. 34 (June 1941), p. 295; *Apollo*, vol. 34 (Sept. 1941), p. 56; *Art Digest*, vol. 16 (15 Dec. 1941), pp. 8–9; *Pictures on Exhibit*, vol. 5 (Dec. 1941), p. 2; *Life*, vol. 12 (19 Jan. 1942), p. 55; Margaret Breuning, 1944, p. 39; *Emporium*, vol. 101 (Jan. 1945), p. 33; *Emporium*, vol. 107 (Feb. 1948), p. 88; French Impressionists, 1944, p. 89; Olive L. Riley, *Your Art Heritage*, New York, 1952, p. 249; *Art Institute of Chicago Quarterly*, vol. 48 (Feb. 1954), pp. 4–8; Sarah Newmeyer, *Enjoying Modern Art*, New York, 1955, pl. 14; William H. Pierson and Martha Davidson, *Arts of the U.S.: A Pictorial Survey*, New York, 1960, p. 300; Daniel M. Mendelowitz, *A History of American Art*, New York, 1960, p. 451; James T. Flexner, *The Pocket History of American Painting*, New York, 1962, pl. 26; *American Artist*, vol. 26 (Jan. 1962), p. 54; Frederick A. Sweet, 1966, color pl. VI, fol. p. 156; Julia Carson, 1966, p. 89.

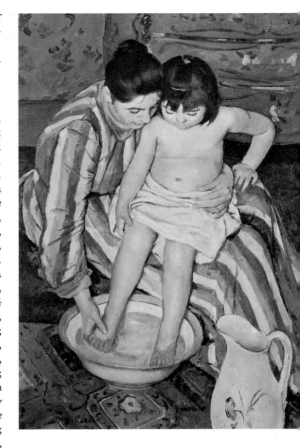

206
The Church at Jouilly c. 1892
Oil on canvas, 21½ × 25½ in., 54.7 × 65 cm.
Signed lower right: *Mary Cassatt*

Description: In the middle of a green field stands a peasant woman wearing a dark blue dress with a white apron and carrying a basket. Beyond her toward the right is a small tree, then a wall, beyond which rises a large church in the midst of houses.

Collections: From the artist to her brother, Gardner Cassatt; to his daughter, Mrs. Horace B. Hare; to a grandniece of the artist, Philadelphia.

Exhibitions: Philadelphia Museum of Art, 1960; M. Knoedler & Co., New York, 1966 (cat. 23).

207 †
The Church at Presles c. 1892
Oil on canvas, 28¾ × 23½ in., 73 × 59.5 cm.
Unsigned. Mathilde X collection stamp on verso

Note: No description available.

Collections: From the artist to Mathilde Vallet, 1927; Mathilde X sale, Paris, 1927; Hotel Drouot sale (cat. 71), 29 Oct. 1927, "composant la collection de M.R.P."; present location unknown.

Exhibitions: Galerie A.-M. Reitlinger, Paris, 1927 (cat. 55).

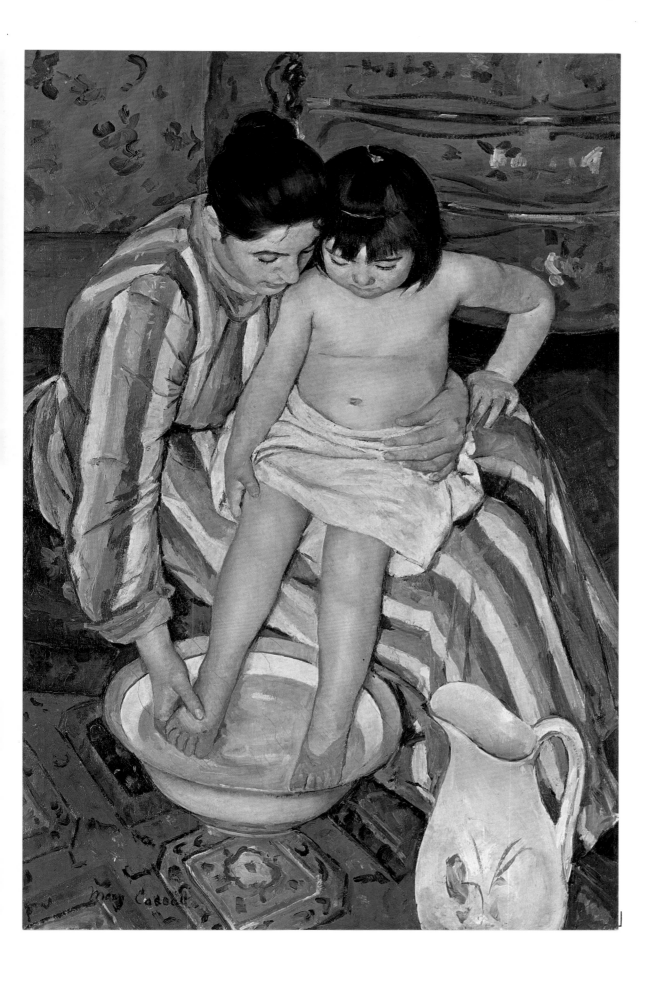

The Bath, 1892. BrCR 205.

The Sailor Boy: Gardner Cassatt 1892

Pastel on tan paper, 28 × 23 in., 71 × 58.3 cm.
Signed in light pastel at lower left: *Mary Cassatt/
Paris 1892*

Description: The young Gardner, seen in half-length, turns his head and looks to left. His blond hair is brushed toward right. He wears a dark blue sailor suit with white braid on the large collar, the cuffs, and around the neck. There are four buttons on the jacket. Background is taupe or fawn gray.

Note: Mrs. Madeira, the artist's niece, told that in order to get his alert attention Miss Cassatt had a rooster brought in and let him watch feathers being pulled out of its tail.

Collections: Mrs. Gardner Cassatt, Villanova, Pennsylvania.

Exhibitions: Pennsylvania Museum of Art, Philadelphia, 1927 (cat. 33, illus.); Haverford College, 1939 (cat. 19, illus.); Wildenstein, New York, 1947 (cat. 13); Pennsylvania Academy of the Fine Arts, Philadelphia, Peale House Gallery (cat. 35), 1955; Philadelphia Museum of Art, 1960; M. Knoedler & Co., 1966 (cat. 22, illus.); Parrish Art Museum, Southampton, N.Y., 1967 (cat. 15).

Reproductions: Pennsylvania Museum of Art Bulletin, vol. 22 (May 1927), cover; *American Magazine of Art*, vol. 18 (June 1927), p. 307; *Philadelphia Museum of Art Bulletin*, vol. 60 (Fall 1964), pp. 283–84.

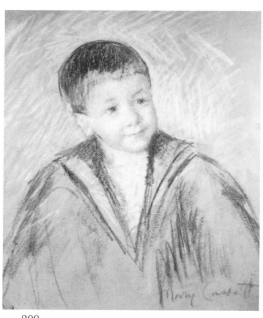

209
Sketch of Master St. Pierre c. 1892
Pastel on paper, 22 × 18 in., 56 × 46 cm.
Signed lower right: *Mary Cassatt*

Description: Head and shoulders of a small boy dressed in a navy blue sailor suit. He has short brown hair and blue eyes and looks smilingly to the right. Light blue background.

Note: The full name of the sitter is M. de la Motte St. Pierre.

Collections: Sold Parke-Bernet, New York, 19 Jan. 1950 (cat. 71, illus.), from a private collection in New York; to *Mr. and Mrs. Nat Bass*, New York.

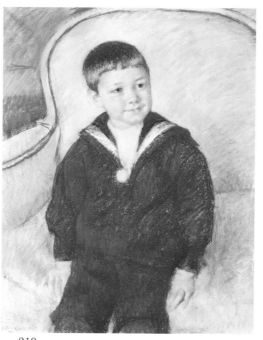

210
Portrait of Master St. Pierre as a Young Boy c. 1892
Pastel on white paper, 29½ × 22½ in., 75 × 57 cm.
Signed lower left: *Mary Cassatt*

Description: A young boy sits forward in a large chair upholstered in a light color, his dark blue sailor suit contrasting strongly with it. He smiles slightly as he looks off to right. His hands rest on the seat of the chair at either side close to him. He is seen in three-quarter view to the knees. His hair is cut with short bangs.

Collections: Mr. and Mrs. Lester Francis Avnet, Great Neck, New York.

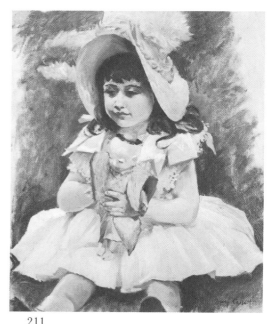

211
Little Girl with a Japanese Doll c. 1892
Oil on canvas, 23 × 19 in., 58.5 × 48.2 cm.
Signed lower right: *Mary Cassatt*

Description: A little girl is seated outdoors wearing a yellow straw hat trimmed in candy-striped ribbon and an orange-pink pompon. She has dark brown hair and eyes. The background is mostly green. She holds a Japanese doll.

Note: Also called "Fillette à la poupée japonaise."

Collections: Sold at Sotheby & Co., London, 23 Oct. 1963; Hotel Rameau, Versailles, Vente des Florabis, 2 or 3 June 1965; to *Grégoire Georges Schick collection*, Paris.

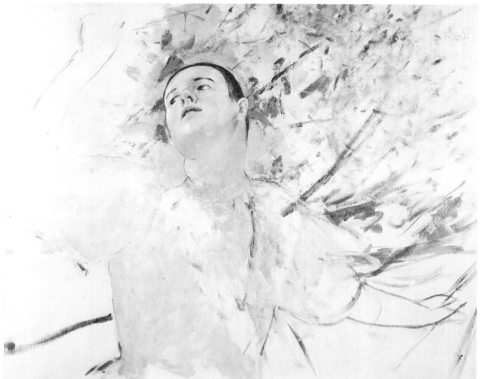

212
Sketch of a Young Woman Picking Fruit
1892
Oil on canvas, 23½ × 28¾ in., 60 × 73 cm.
Unsigned

Description: A half-length figure of a young woman in a tight-fitting bodice with her head tilted back. She reaches with her right hand to pick fruit from a tree while she holds onto a branch with her left. Her sparse black hair is silhouetted against a patch of bright blue sky. The rest of the background is composed of leaves and branches. Her full-sleeved gown is pink.

Note: This is a sketch for part of BrCR 213.

Collections: Private collection, London.

Reproductions: Art & Archaeology, vol. 14 (Nov.–Dec. 1922), p. 319.

Color plate: frontispiece.

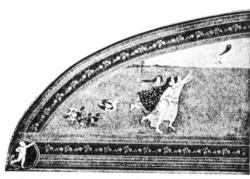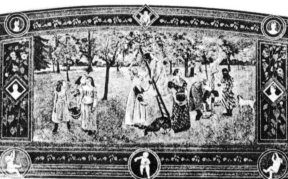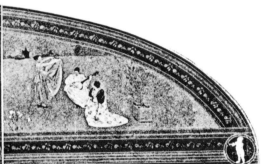

213
Mural of "Modern Woman" 1892
Oil on canvas, measurements and signature unrecorded. However, the height at center, including the borders, is about 12½ feet.

Description: A very large, long tympanum, outlined in garlands of flowers, in three sections. The central section (described in BrCR 214) contains about 12 figures, a dog and turkeys. In the right section there are just three figures within a meadow with a potted tree at right. The center figure is seated facing forward, playing a banjo. At right, farther forward, another seated figure is in left profile, as though listening. At left, a third figure in right profile stands holding her very wide skirt in both hands as high as her shoulders. She is

dancing. At the left is the third section of the tympanum, with a very strange design of a group of three young girls running away from a group of ducks. The girls' arms are raised as though pointing up to a nude figure flying off, in the air, her long dark hair falling over her back. Behind the three figures in the foreground is a wide meadow. There are seven lunettes accenting the borders of the entire mural and three diamond-shaped ones at the center top and center sides. These contain figures of babies and heads of young women.

Note: Executed at Bachivillers, where the artist built a vast glass-roofed studio for this gigantic undertaking. She had the ground excavated so the canvas could be lowered into it when she

wanted to work on the upper part.

Exhibitions: Decoration for the South Tympanum, Woman's Building, World's Columbian Exposition, Chicago, 1893 (since lost).

Reproductions: "Outsider's View of the Women's Exhibit," *Cosmopolitan,* vol. 15, no. 5 (Sept. 1893), p. 560; *Art and Handicraft in the Woman's Building* (official edition), Paris and New York, 1894, p. 25; Pauline King, *American Mural Painting,* Boston, 1902, p. 89 (center section); *Metropolitan Museum of Art Bulletin,* n.s. vol. 7 (Dec. 1948), p. 110 (entire mural); John D. Kysela, S.J., "Mary Cassatt's Mystery Mural and the World's Fair of 1893," *Art Quarterly,* vol. 29, no. 2 (1966), p. 135.

214
Detail from the Central Section, Mural of "Modern Woman" ("Gathering Fruit")
1892
Oil on canvas
Signed at right but not visible in detail: *Mary Cassatt*

Description: A woman in a salmon pink striped dress stands on a ladder and leans far down to place an apple in the hand of a little girl in a long, cream colored dress with dark blue short sleeves and orange ribbons. Behind her stands a woman in a white dress who reaches up to pull down a branch of the apple tree. At the right is a third woman wearing a purplish brown dress with a pattern of sprigs of leaves. It is trimmed with a white bertha and ruffles on the puffed sleeves and also with an elaborate ribbon sash and bow. She holds a large basket of cherries. Two turkeys are shown in the center foreground. The background, with other smaller figures, shows an extensive fruit orchard. [The following is not visible in the reproduced detail.] At the right a group of three figures and a dog. One woman bends to the ground to lift a basket of fruit while another, behind her, reaches up to pull down a branch and a younger girl, seen from the rear, looks on. At the left of center is a third group of three women walking forward. The two in front carry a basket of fruit between them while one of them looks back at the third figure who carries a basket on her hip.

Note: Also called "Jeunes filles cueillant des fruits." See BrCR 213 for further data.

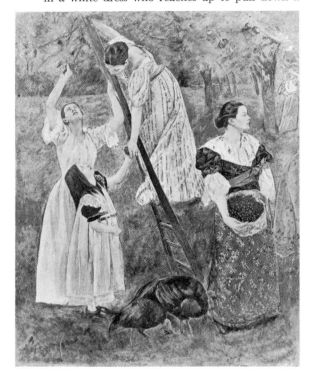

215
Roundel from the Border of the Mural of "Modern Woman" c. 1892
Oil on canvas, measurements and signature unrecorded

Description: A nude baby sits looking off to left, holding a red apple in each hand. His left foot rests on the border of the roundel at lower right.

Note: This roundel was at the lower center of the floriated border. See BrCR 213 for further data.

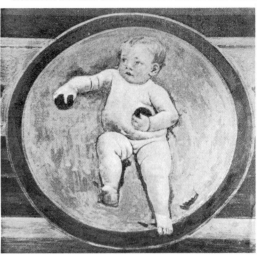

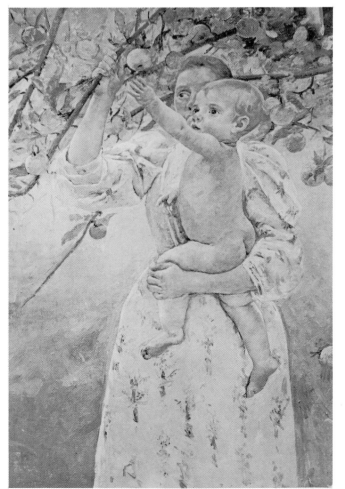

216
Nude Baby Reaching for an Apple 1893
Oil on canvas, 39 × 25½ in., 100 × 65 cm.
Signed at left: *Mary Cassatt*

Description: A nude baby is held on his mother's left arm. She stands under the branches of an apple tree and pulls down a branch within reach of her baby who reaches up with his left arm to grasp an apple. The mother wears a pink dress patterned with sprigs of flowers.

Note: Also called "Enfant cueillant un pomme" or "Enfant cueillant un fruit." Durand-Ruel 508; L2862 or NY3384.

Collections: From the artist to Durand-Ruel, 1893; to James Stillman, Paris, 1910; to Dr. E. G. Stillman, New York; to Mrs. *Blaine Durham*, Hume, Virginia.

Exhibitions: Durand-Ruel, Paris, 1893 (cat. 2); Durand-Ruel, New York, 1895 (cat. 4); Durand-Ruel, Paris, 1908 (cat. 14).

Reproductions: Scribner's Magazine, vol. 19 (March 1896), frontispiece; Achille Segard, 1913, fol. p. 36; *Ladies' Home Journal*, vol. 44 (Nov. 1927), p. 24 (color).

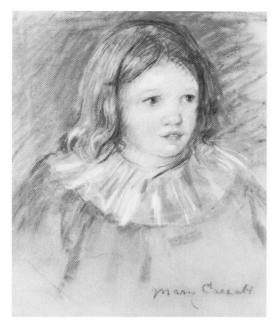

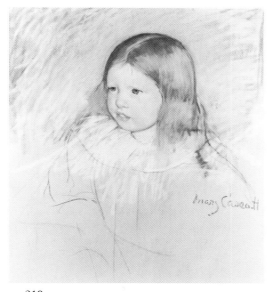

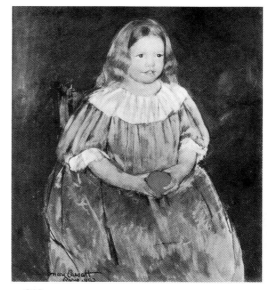

217
Sketch of Margaret Sloane, Looking Right
c. 1893

Pastel on paper, 16 × 13 in. (sight), 40.5 × 33 cm.
Signed toward lower right: *Mary Cassatt*

Description: Head and shoulders of a little girl who wears a ruffled, round white collar on her dress. Her hair is parted in the middle but without more than a slight suggestion of a ribbon on it.

Collections: Wildenstein, New York, 1967–68; to *Laura May Ripley*, Grand Rapids, Michigan, to be bequeathed to the Grand Rapids Art Museum.

218
Sketch of Margaret Sloane, Looking Left
1893

Pastel on paper, 20¼ × 17¾ in., 51.5 × 45 cm.
Signed toward lower right: *Mary Cassatt*

Description: Head and shoulders of a little girl. She looks to left, seen in three-quarter view. Her long straight hair is parted in the middle. The round ruffle of her dress is indicated.

Collections: Galerie Charpentier sale, Paris, 9–10 June 1953; idem, 1 June 1954 (cat. 2); to Arthur Tooth & Sons, London; to *Mr. and Mrs. Leo M. Rogers*, New York.

Exhibitions: Charles Slatkin Gallery, New York, "French Master Drawings, XVI–XX Centuries," 1959.

219
Portrait of Margaret Milligan Sloane (No. 1)
1893

Pastel on paper, 31½ × 25½ in., 80 × 64.6 cm.
Signed lower left: *Mary Cassatt/Paris 1893*

Description: A little girl, with yellow hair falling onto her shoulders and parted in the middle with a narrow band holding it back, sits in a straight-backed chair facing somewhat to right and looking to right. Her long dress is a greenish blue with a round bertha. She holds an orange with both hands. The background is dark and undetailed.

Note: Also called "Child," "Girl with an Orange," and "Peggy."

Collections: Benson Bennett Sloan, Jr., New York.

Exhibitions: Haverford College, 1939 (cat. 23, illus.).

Reproductions: Harper's Weekly, vol. 39, no. 2030 (16 Nov. 1893), p. 1091.

220
Portrait of Margaret Milligan Sloane (No. 2)
1893

Pastel on gray paper, 32 × 26 in., 81.5 × 66 cm.
Signed lower left: *Mary Cassatt*

Description: A seated little girl with silky yellow hair falling onto her shoulders caught with a red band of ribbon. Her long dress is a pale greenish-blue. She holds an orange with both hands. Behind her and to left is a chest of drawers on which stands a Chinese vase with strong blue accents. Background to right has green strokes over rich brown.

Note: Also called "Girl with an Orange." Durand-Ruel 510-L2864.

Collections: From the artist to Durand-Ruel; to Frank Thomson, Philadelphia; to his daughter, Anne Thomson, Philadelphia; Mrs. Richard Berridge, London (greatniece of Frank Thomson); to a *private collection*, England.

Exhibitions: Durand-Ruel, Paris, 1893 (cat. 18); Durand-Ruel, New York, 1895 (cat. 6); Durand-Ruel, New York, 1903 (cat. 17); Durand-Ruel, New York, 1920 (cat. 24); Philadelphia Museum of Art, 1926 (cat. 193).

Reproductions: Scribner's Magazine, vol. 19 (March 1896), p. 358; Les Modes, vol. 4 (Feb. 1904), p. 7; La Renaissance, vol. 13 (Feb. 1930), p. 55; Edith Valerio, 1930, pl. 6.

221
In the Garden 1893

Pastel on tan oatmeal paper, 28¾ × 23⅝ in., 73 × 60 cm.
Signed lower right: *Mary Cassatt*

Description: A baby stands on his mother's lap and looks to right. His black stockings and shoes are clearly outlined against the mother's light, broadly patterned, flowered dress with great dark blue puffed sleeves. The baby's dress is more delicately patterned. They are placed against a richly floriated background.

Collections: Durand-Ruel, New York; bought by Etta Cone out of the 1941–42 Baltimore Museum of Art Exhibition; *Baltimore Museum of Art,* Cone Collection.

Exhibitions: Durand-Ruel, Paris, 1893 (cat. 19); Durand-Ruel, New York, 1895 (cat. 13); Durand-Ruel, New York, 1903 (cat. 16); Durand-Ruel, New York, 1920 (cat. 17); Durand-Ruel, New York, 1926 (cat. 3); Pennsylvania Museum of Art, Philadelphia, 1927 (cat. 10); City Art Museum of St. Louis, 1933–34 (cat. 10); Baltimore Museum of Art, 1936 (cat. 1); Baltimore Museum of Art, 1941–42 (cat. 23, illus.); Wildenstein, New York, 1947 (cat. 22, illus.); Art Institute of Chicago and Metropolitan Museum of Art, New York, "Sargent, Whistler and Mary Cassatt" (cat. 20, illus.), 1954; Baltimore Museum of Art, "Manet, Degas, Berthe Morisot and Mary Cassatt" (cat. 114), 1962; M. Knoedler & Co., New York, 1966 (cat. 24).

Reproductions: Scribner's Magazine, vol. 19 (March 1896), p. 359; *Literary Digest,* vol. 90 (10 July 1926), p. 28; *Art News,* vol. 33 (27 April 1935), p. 8; *Art News,* vol. 40 (1 Jan. 1942), p. 18; Margaret Breuning, 1944, p. 28; Frederick A. Sweet, 1966, pl. 18, fol. p. 204.

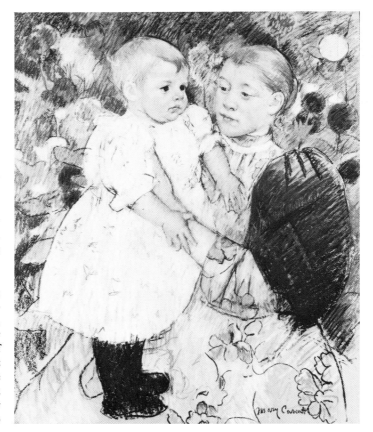

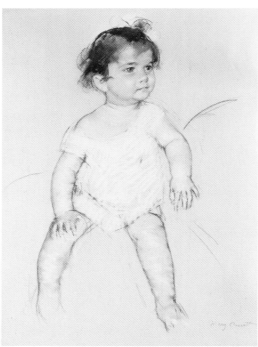

222
Little Girl in Her Chemise, on a Bed
c. 1893

Pastel on pinkish tan paper, 24½ × 17⅞ in., 62.2 × 45.5 cm. (sight)
Signed lower right: *Mary Cassatt*

Description: A baby with short, curly auburn hair has one curl standing up from her head. She looks off to right. She wears a white chemise which falls off her right shoulder. Her legs and feet are bare. Her right hand rests on her right knee, her left rests on the bed, which is indicated by a few lines. Her large eyes are hazel.

Collections: Albert Pra; Pra sale, Paris, 17 June 1938 (lot 1); to *Mr. and Mrs. Fritz Lugt,* Paris.

Exhibitions: Durand-Ruel, New York, 1895 (cat. 30); Centre Culturel Américain, Paris, 1959 (cat. 12).

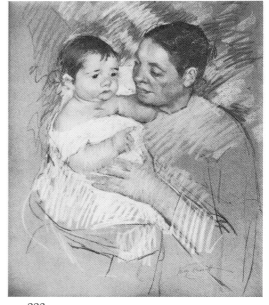

223
Woman from Martinique and Her Child
1893

Pastel on brown paper, 25½ × 21¼ in., 64.8 × 54 cm.
Signed lower right: *Mary Cassatt*

Description: A dark-skinned woman with black hair looks at her child whom she holds on her right arm. Her left hand rests on the child's stomach. The child looks toward right and holds his left hand under his chin.

Note: Also called "Maternité." Durand-Ruel 8771; L11507.

Collections: Dr. Peyrot, Paris, 1893; Galerie Georges Petit, 1919; Durand-Ruel, Paris; to Durand-Ruel, New York, 1920; present location unknown.

Exhibitions: Durand-Ruel, Paris, 1893 (cat. 28).

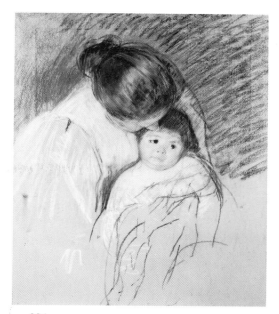

224

Sketch of a Mother Looking Down at Thomas c. 1893

Pastel on brown paper, 27 × 22½ in., 68.5 × 57 cm.
Signed upper right: *Mary Cassatt*

Description: Head, shoulders, and left arm of the child are indicated. As the mother bends over the child we see only the top of her head, her dark hair in a bun at the back, her shoulders, and the leg-of-mutton sleeve of her orange blouse. The child, facing the spectator but with eyes toward the right, has short dark hair with bangs. Bright blue background.

Note: Durand-Ruel 6601-L.9161.

Collections: From the artist to Durand-Ruel, Paris, 1909; to Mrs. Montgomery Sears, 1910; to her daughter, Mrs. J. Cameron Bradley, Boston; to *Mr. and Mrs. Morris Sprayregen*, New York.

Exhibitions: M. Knoedler & Co., New York, "Masterpieces by Old and Modern Painters" (cat. 51), 1915.

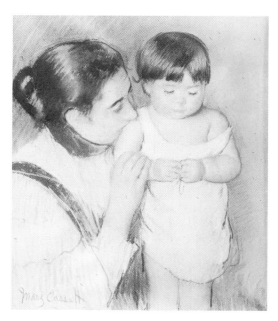

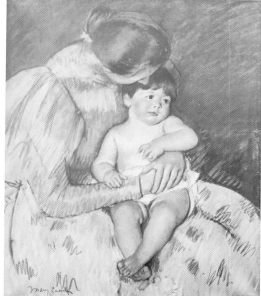

225

Mother Looking Down at Thomas 1893

Pastel on paper, 31⅞ × 25½ in., 81 × 65 cm.
Signed lower left: *Mary Cassatt*

Description: Thomas, wearing only a diaper, sits on his mother's lap with crossed legs and his left hand on his chest. He looks off to right. His mother encloses him with her arms, her hands clasped under his left arm. She lowers her head over his so that only the top of her head is seen. She wears a dress with a yellow and orange bodice with a large puffed sleeve and a skirt of pale pink with dark greenish and fawn colored spots on it. Dark blue background.

Note: Also called "Sollicitude Maternelle." Durand-Ruel 635; L3212. Reference: Catalogue of the Museum of Modern Western Art, 1928, n. 221, in Russian; Catalogue of the State Pushkin Museum of Fine Arts, Moscow, p. 96 (cat. 3429).

Collections: From the artist to Durand-Ruel; S. I. Shchukin, Moscow; Museum of National History, Moscow, 1922; *Museum of Modern Western Art*, Moscow, since 1922.

Exhibitions: Durand-Ruel, New York, 1895 (cat. 17).

Reproductions: Scribner's Magazine, vol. 19 (March 1896), p. 353; *L'art decoratif*, vol. 4 (Aug. 1902), p. 182; *Les Modes*, vol. 4 (Feb. 1904), p. 9.

227

Young Thomas and His Mother 1893

Pastel on cardboard, 24 × 20 in., 61 × 51 cm.
Signed lower left: *Mary Cassatt*

Description: Thomas stands, wearing a white shift which hangs off his left shoulder. He looks down at an object which he holds in both of his hands. He is seen in three-quarter length whereas his mother is in half-length, her right hand on his arm as she kisses his upper arm and looks at him. His mother wears a white blouse trimmed in dark green velvet.

Note: Durand-Ruel 632-L3213.

Collections: Durand-Ruel, Paris, New York; *Pennsylvania Academy of the Fine Arts*, Philadelphia.

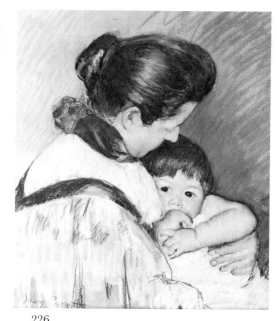

226

Sleepy Thomas Sucking His Thumb 1893

Pastel on paper, 21 × 17½ in., 53.3 × 44.5 cm.
Signed lower left: *Mary Cassatt*

Description: Mother in one-quarter view looks down at her baby who observes the spectator. Her hair is drawn back and held in a bun at the back. She wears a dress with a green velvet collar, a white yoke edged in velvet, and a circular flounce forming the sleeve with an indistinct pattern. Young Thomas sucks his thumb and holds his right arm with his left hand.

Note: Durand-Ruel 636-L3211.

Collections: From the artist to Durand-Ruel; to Lady Waterloo, England; to Marlborough Fine Art Ltd., London, 1953; to *Bührli Museum*, Zurich, Switzerland (E. G. Bührli Foundation).

Exhibitions: Durand-Ruel, New York, 1895 (cat. 23); Manchester, England, organized by Durand-Ruel, Paris, "Impressionists" (cat. 72), Dec. 1907–Jan. 1908.

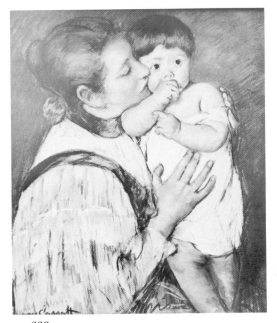

228
Thomas Standing, Sucking His Thumb
1893
Pastel on paper, $23\frac{1}{2} \times 19$ in., 59.7×48.2 cm.
Signed lower left: *Mary Cassatt*

Description: Thomas stands on his mother's lap, seen in three-quarter length wearing a shift that has slipped off his left shoulder. He looks off to right as he sucks his right thumb. His mother clasps him with both hands as she kisses him on his right cheek. She is seen in profile to right. Her brown hair is drawn back in a bun at the back. She wears a green dress with white yoke and a voluminous sleeve. The background is a warm reddish brown.

Note: Durand-Ruel 624-L3187.

Collections: C. J. Lawrence, 1904; to J. Howard Whittemore; *Harris Whittemore, Jr.,* Naugatuck, Connecticut.

Exhibitions: Durand-Ruel, New York, 1895 (cat. 23); Baltimore Museum of Art, 1947 (cat. 24, color illus.).

Reproductions: Emporium, vol. 26 (July 1907), p. 14; *Good Housekeeping*, vol. 50 (Feb. 1910), p. 140; *Arts and Decoration*, vol. 3, no. 8 (July 1913), p. 266; Charles L. Borgmeyer, *Master Impressionists*, Chicago, 1913, p. 126; *La Renaissance*, vol. 13 (Feb. 1930), p. 52; Edith Valerio, 1930, pl. 9.

229 †
Thomas Kissed by His Mother 1893
Pastel on paper, 33×29 in., 84×73.5 cm.
Signed upper left corner: *Mary Cassatt*

Description: The baby wears a cap. The mother's gown is mauve and pink.

Collections: From the artist to Mrs. Potter Palmer, Chicago; to *Mrs. Brooke Howe*, New York.

Exhibitions: Art Institute of Chicago, 1926–27 (cat. 4); Art Institute of Chicago, "A Century of Progress" (cat. 435), 1934.

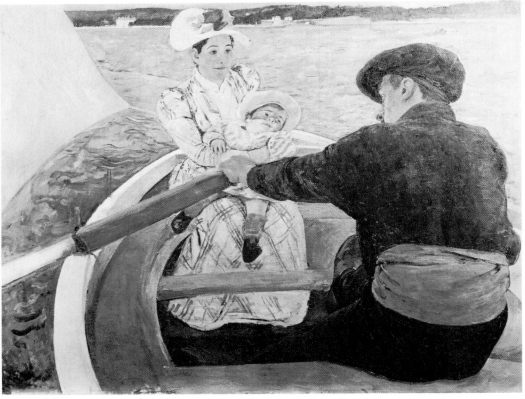

230
The Boating Party (Near Antibes) 1893
Oil on canvas, $35\frac{1}{2} \times 46$ in., 90×117 cm.
Unsigned

Description: A woman in a light plaid dress sits facing the spectator with a small child on her lap. She wears a white hat turned up in back and looks at the oarsman, whose back dominates the right side of the picture. He wears a dark blue suit and beret, a dark blue sash showing at his waist. His left arm, extended toward center, holds the oar. Bright blue water surrounds the boat with a far shore line visible.

Note: In 1914 she wrote to Durand-Ruel from Grasse: "About the painting, 'La Barque,' I do not want to sell it; I have already promised it to my family. It was done at Antibes 20 years ago —the year when my niece came into the world." Also called "La partie en bateau," "La barque," and "Les canotiers" or "En canot." Durand-Ruel 692-L8633; National Gallery of Art no. 1758.

Collections: In possession of the artist until at least 1914; Durand-Ruel, New York; to Chester Dale, New York; to the *National Gallery of Art*, Washington, D. C., Chester Dale Collection.

Exhibitions: Durand-Ruel, New York, 1895 (cat. 1); Carnegie Institute, Pittsburgh, Cleveland Museum of Art, Cincinnati Art Museum, Atkins Museum, Kansas City, City Art Museum of St. Louis, "Paintings by Six American Women Painters" (cat. 1), 1917–18; Durand-Ruel, New York, 1920 (cat. 16); Durand-Ruel, New York, 1926 (cat. 11); Art Institute of Chicago, 1926–27; Pennsylvania Museum of Art, Philadelphia, 1927 (cat. 3); Carnegie Institute, Pittsburgh, 1928 (cat. 11); Official Art Exhibition of the California-Pacific International Exhibition, Palace of Fine Arts, San Diego, 1936 (p. 50, illus.); Tate Gallery, London, 1946; National Gallery of Art, Washington, D. C., "Eighteenth- and Nineteenth-Century Paintings and Sculpture of the French School in the Chester Dale Collection" (p. 85, illus.), 1965.

Reproductions: Broadway Magazine, vol. 18 (Aug. 1907), p. 585; Achille Segard, 1913, fol. p. 36; *Art Institute of Chicago Bulletin*, vol. 20 (Dec. 1926), p. 126; Edouard-Joseph, *Dictionnaire biographique des artistes contemporains*, Paris, 1930, vol. 1, p. 249; Forbes Watson, 1932, p. 41; *Art News*, vol. 29 (9 May 1931), p. 9; *Art News*, vol. 34 (13 June 1936), p. 19; *Magazine of Art*, vol. 35 (1940), p. 180; *Burlington Magazine*, vol. 88 (Sept. 1946), p. 215; *Life*, vol. 36 (17 May 1954), p. 98; Frederick A. Sweet, 1966, color pl. VII, fol. p. 156.

231

Sketch of "Peasant Mother and Child" 1894

Pastel on gray paper, $27\frac{1}{4} \times 20\frac{1}{4}$ in., 69×52 cm.
Signed lower right: *Mary Cassatt*

Description: A mother in a light, full-sleeved blouse looks at her child who stands up, wearing a long dress with gathers down the front. He is held by his mother with her left hand.

Collections: From the artist to Ambroise Vollard, Paris; to Mr. Clomovich, Yugoslavia; to the *National Museum*, Belgrade, Yugoslavia, 1949 (no. 348).

232

Peasant Mother and Child 1894

Pastel on paper, $26\frac{1}{2} \times 19\frac{3}{4}$ in., 67.3×50.3 cm.
Signed lower left: *Mary Cassatt*

Description: A mother, wearing a dark, changeable green and brown dress with a large puffed sleeve, with her hair drawn back in a bun, looks to left in one-quarter view at her child, who stands up wearing a long, olive green dress gathered into a yoke. His dark eyes look off to left, and his hair is cut with bangs over his forehead. Rose-lilac background.

Note: This is similar to color print Br 159. Durand-Ruel 626-L3202.

Collections: From the artist to Durand-Ruel, Paris, 1894; to Durand-Ruel, New York; to C. J. Lawrence, 1895; to Adolph Lewisohn, New York; sold at Parke-Bernet, New York, 16 May 1939; present location unknown.

Exhibitions: Durand-Ruel, New York, 1895 (cat. 14); Musée National du Luxembourg, Paris, "Exposition d'artistes de l'école américaine" (cat. 58), 1919; Smith College Museum of Art, Northampton, Mass., 1928 (cat. 3).

Reproductions: Scribners Magazine, vol. 19 (March 1896), p. 353; *L'art decoratif*, vol. 4 (Aug. 1902), p. 178; Camille Mauclair, *L'impressionisme*, Paris, 1904; *Good Housekeeping*, vol. 50 (Feb. 1910), p. 140; *Harper's Bazaar*, vol. 45 (Nov. 1911), p. 490; *World Today*, vol. 21 (Jan. 1912), p. 1660; *Les arts*, vol. 11 (Dec. 1912), p. 26; *Arts & Decoration*, vol. 3 (June 1913), p. 267; Achille Segard, 1913, fol. p. 64; *Good Housekeeping*, vol. 58 (Feb. 1914), p. 158; *La revue de l'art*, vol. 36 (Nov. 1919), fol. p. 200; *International Studio*, vol. 78 (March 1924), p. 485; *Survey*, vol. 57 (1 Dec. 1926), p. 271; *Arts*, vol. 10 (July 1926), p. 3; *Emporium*, vol. 26 (July 1927), p. 14; *Art News*, vol. 26 (24 Dec. 1927), p. 7; *La Renaissance*, vol. 13 (Feb. 1930), p. 52; *Arts & Decoration*, vol. 33 (May 1930), p. 55; *Burlington Magazine*, vol. 104 (July 1962), p. 73.

233

On the Water c. 1894

Oil on canvas, $23\frac{3}{4} \times 28\frac{3}{4}$ in., 60.4×73 cm.
Unsigned. Mathilde X collection stamp on verso

Description: Two women and a child are in a boat on the water with some ducks swimming around them. The woman on the left, wearing a deep pink dress, extends her right arm over the water as though dropping food to the one dark duck approaching. The other woman, in an orange-yellow dress, holds the standing child, both seen frontally as they watch the duck approach.

Note: Also called "Promenade sur l'eau."

Collections: From the artist to Mathilde Vallet, 1927; Mathilde X collection sale, Paris, 1931; *Art Institute of Chicago*, Charles H. and Mary F. S. Worcester Collection.

Exhibitions: Galerie A.-M. Reitlinger, Paris, 1931 (cat. 6, illus.); Baltimore Museum of Art, 1941–42 (cat. 26).

234
Young Woman Reflecting c. 1894
Pastel on tan paper, 24 × 19¼ in. (sight),
61 × 49 cm.
Signed lower right: *Mary Cassatt*

Description: Head and shoulders of a young woman
in a simple, high-necked dark blue blouse looking
down in profile to left. Her hair is auburn, drawn
back into a knot. The background is red with some
green and a large dark spot behind her profile.

Note: Also called "Profile de femme." Durand-
Ruel 16684.

Collections: Girardin collection, Paris; to Durand-
Ruel, Paris; Hôtel Drouot, Paris, Bellier sale (cat.
17, illus.), 10 May 1950; Galerie Charpentier sale
(cat. 125), Paris, 15–16 Dec. 1958; to Madame M.
Rheims, Paris; to the *George Waechter Memorial
Foundation*, Geneva, Switzerland.

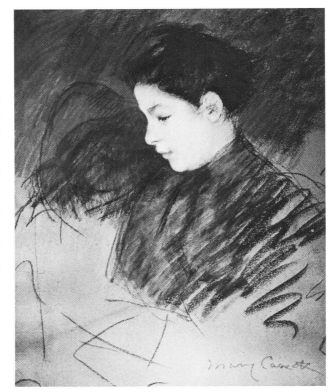

235
The Pensive Reader c. 1894
Pastel on paper, 32 × 27 in., 81 × 68.5 cm.
Signed lower left: *Mary Cassatt*

Description: A young girl with fair hair cut in
bangs is dressed in a plain blue linen smock show-
ing rose-colored sleeves. She rests her cheek on her
left hand and looks down at a book on the table
before her. Tan background.

Note: Also called "Jeune fille lisant."

Collections: Yamanaka and Co., New York; to
Tadamasa Hayashi, Tokyo and Paris, 1913 (cat.
82); to Charles V. Wheeler; to American Art
Association, New York, Charles V. Wheeler,
Franklin Murphy, and Emma Rockefeller Mc-
Alpin sale (cat. 37, illus.), 1 Nov. 1935; present
location unknown.

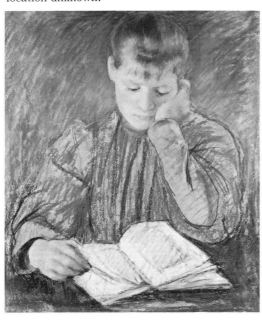

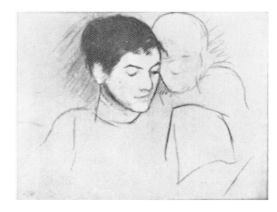

236
Sketch for "The Banjo Lesson" 1894
Pastel on paper, 17¾ × 17⅞ in., 45 × 48 cm.
Unsigned. Mathilde X collection stamp at lower
left

Description: Head of a girl looking down toward
right with dark hair and a puffed sleeve. There is a
suggestion of another girl's head looking over her
left shoulder.

Note: Also called "Esquisse" and "Deux têtes."
Durand-Ruel 19850 A-13920.

Collections: From the artist to Mathilde Vallet,
1927; Mathilde X sale, Paris, 1931; present loca-
tion unknown.

Exhibitions: Galerie A.-M. Reitlinger, Paris, 1931
(cat. 13, illus.).

Reproductions: Art et Décorations, vol. 60, supp. 3 (5
June 1931).

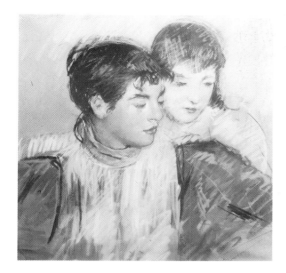

237
Study for "The Banjo Lesson" 1894
Pastel on paper, 17½ × 17½ in., 44.5 × 44.5 cm.
Signed lower right: *M. C.*

Description: Bust-length study of a young woman wearing a blue blouse with a white yoke and a yellow velvet ribbon around her neck. Behind her is a younger girl with brown hair, dressed in light pink. Shaded green background with some brown flecks.

Note: Also called "Mother and Daughter" and "Two Sisters." Durand-Ruel A1374-NY5040.

Collections: From the artist to Payson Thompson; American Art Association, New York, Payson Thompson sale, 12 Jan. 1928; *Museum of Fine Arts*, Boston, Charles Henry Hayden Fund.

Exhibitions: Durand-Ruel, New York, 1917 (cat. 6); Durand-Ruel, New York, 1923 (cat. 3); Durand-Ruel, New York, 1924 (cat. 22); Durand-Ruel, New York, 1926 (cat. 7); Museum of Fine Arts, Boston, 1932.

Reproductions: *The Arts*, vol. 1 (4 Dec. 1920), p. 33; *Art Digest*, vol. 6, no. 16 (15 May 1932), p. 15; *Bulletin of the Museum of Fine Arts*, Boston, vol. 30 (Dec. 1932), p. 81; Margaret Breuning, 1944, p. 34; *French Impressionists*, 1944, p. 99.

238
The Banjo Lesson 1894
Pastel on paper, 28 × 22½ in., 71 × 57.2 cm.
Signed lower right: *Mary Cassatt*

Description: Three-quarter length view of a young woman playing the banjo which she holds on her lap, plucking it with her right hand, her left fingering the frets. She has very dark hair with bangs, a blue dress with highlights of apricot color and a white yoke. Behind her, looking down at the hand on the frets, is a younger girl. Background divided between green and light apricot.

Note: Similar to color print Br 156. Durand-Ruel A1346-NY4969.

Collections: Mrs. Montgomery Sears; to Mrs. J. Cameron Bradley; to *Virginia Museum of Fine Arts*, Richmond, 1958.

Exhibitions: Carnegie Institute, Pittsburgh, 1928 (cat. 32); Carnegie Institute, Pittsburgh, 1941; Museum of Fine Arts, Boston, 1958; Baltimore Museum of Art, "Manet, Degas, Berthe Morisot and Mary Cassatt" (cat. 115), 1962; University Art Gallery, University of New Mexico, Albuquerque, "Impressionism in America," 1965; M. Knoedler & Co., New York, 1966 (cat. 26).

Reproductions: Edith Valerio, 1932, pl. 15; *Art Quarterly*, vol. 21, no. 4 (Winter 1958), p. 430; *Gazette des beaux-arts*, s6, vol. 55, no. 144 (Jan. 1960), supp. p. 42; *Christian Science Monitor* (29 July 1961), p. 8.

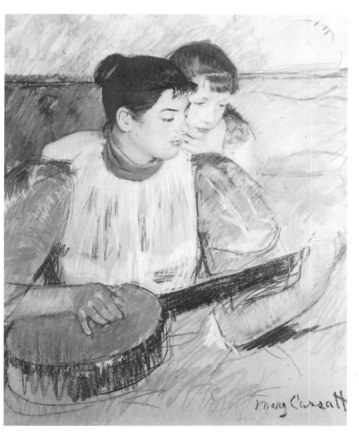

239
In the Park c. 1894
Oil on canvas, 29½ × 37½ in., 75 × 95.2 cm.
Signed lower right: *Mary Cassatt*

Description: Young woman in a polka dotted blouse sits on a park bench with her left arm resting on its top rail. She has very dark hair and is seen in profile to left as she looks down toward the ground. Leaning against her, with her right hand on the knee of the woman, stands a little girl with blond hair. She wears a dark red dress which falls off her right shoulder. A large flower bed with blooming flowers behind them.

Collections: From the artist to Ambroise Vollard; to Chrétien de Gallia; to Hirschl & Adler; to *private collection*, New Canaan, Connecticut.

Exhibitions: Durand-Ruel, Paris, 1924 (cat. 6).

Reproductions: *Connoisseur*, vol. 143 (June 1959), p. LXXIII; *Selections from the Collection of Hirschl & Adler Galleries*, vol. 5 (cat. 7, color illus.), 1963–64.

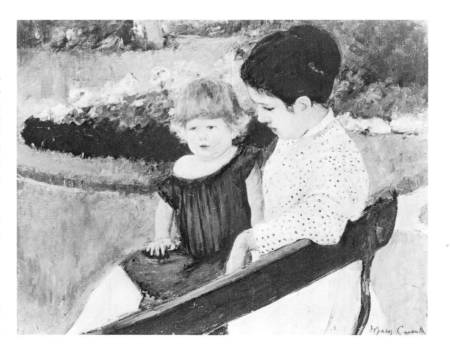

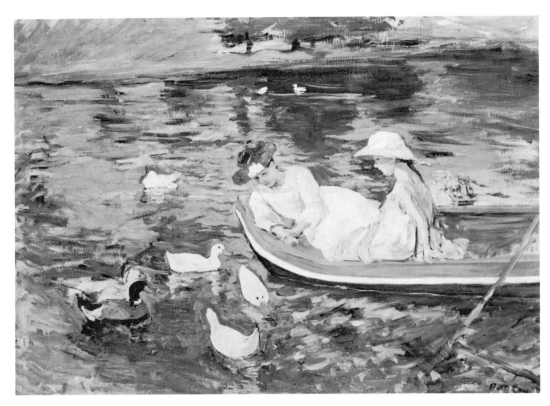

Summertime 1894
Oil on canvas, 29 × 38 in., 73.6 × 96.5 cm.
Signed at lower right corner: *Mary Cassatt*

Description: A young woman and a girl in a boat observe five ducks in the water alongside. The woman wears a brown hat and a pink dress. The girl has a light straw hat and a lavender dress. The blue water has many colored reflections. Green shore in background and more ducks in distance.

Collections: Huntington Hartford collection, New York.

Exhibitions: Baltimore Museum of Art, "Manet, Degas, Berthe Morisot and Mary Cassatt" (cat. 116), 1962; M. Knoedler & Co., New York, 1966 (cat. 25); Parrish Art Museum, Southampton, N.Y., 1967 (cat. 2).

241
Madame and Her Maid c. 1894
Pastel on paper, 20 × 29 in., 51 × 73.6 cm.
Signed lower right: *Mary Cassatt*

Description: Head and shoulders of a lovely young woman in profile to left. Behind her, beyond a square-backed settee on which she evidently sits, is her maid, somewhat older with coarse features. She wears a dark dress with wide sleeves. Background has suggestion of floral pattern at left.

Collections: Mrs. F. J. Gould, Cannes, France.

Reproductions: Illustrated London News (23 Nov. 1957).

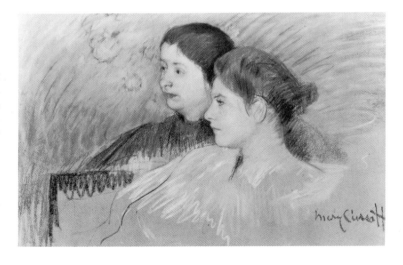

242
Smiling Mother with Sober-Faced Child
c. 1894
Pastel on paper, 32 × 25½ in., 81.2 × 64.8 cm.
Unsigned
Description: A smiling, dark-haired mother looks at the spectator. Her V-necked dress has wide, puffed sleeves. Before her on the right is the head of her child looking somewhat left. Her hair is blond, drawn back into a bandeau and then falling down, hiding her ears.

Collections: Private collection, Paris; *Mr. and Mrs. Michael Orman*, Miami, Florida.

Reproductions: Art Quarterly, vol. 26, no. 4 (Winter 1963), p. 508.

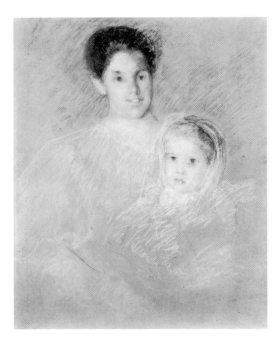

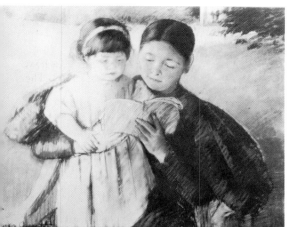

243
The Child's Picture Book 1895
Pastel on paper, 23½ × 28¾ in., 59.8 × 73 cm.
Signed lower left: *Mary Cassatt/'95*

Description: A stylishly dressed mother wears a blue dress with huge puffed sleeves. She sits in a chair on the grass and holds her standing child on her lap. In her left hand she holds a picture book, with her right she clasps her child at the waist. The little girl wears a mauve dress and has a ribbon around her hair, which is red-gold. The mother's hair is darker. The mother's blue gown shows a shimmer of green and yellow. In the background is a brilliant green sunny lawn, partly in transparent shade. The base of a red house seen in the background.

Note: Also called "The Reading Lesson," "Woman Teaching a Small Girl to Read," "Nurse Reading to a Little Girl," and "La lecture." Durand-Ruel 6257.

Collections: Dikran Kelekian, Paris; Kelekian sale, New York, 31 Jan. 1922; to *Mrs. Hope Williams Reed*, New York (a part interest given to Metropolitan Museum of Art, 1965).

Exhibitions: Carnegie Institute, Pittsburgh, 1928 (cat. 36) (called "The Reading Lesson").

Reproductions: Arts, vol. 2, no. 5 (Feb. 1922), p. 336; *Art News*, vol. 25, no. 19 (12 Feb. 1927), p. 6; Rilla Evelyn Jackman, *American Arts*, New York, 1928, pl. lxxiv.

244
Bust of Mary Dickinson Scott in Evening Dress c. 1895
Oil on canvas, 18 × 15 in., 45.8 × 38 cm.
Unsigned

Description: A young woman with dark auburn hair and dark eyes looks to left in three-quarter view. Her straight hair is parted and drawn behind her ear. Her evening dress with some rose flecks has a soft chiffon edge. The background is black.

Note: Mr. Barrows, whose wife is the daughter of the sitter, wrote to the author in 1968: "It is rumored that Mrs. Scott was not satisfied with this portrait and did not accept it. Therefore it remained for years in the artist's possession. After Miss Scott married Mr. Clement Newbold, another portrait was done which was accepted and stayed in the Newbold family. The sketch for it came to Mrs. Barrows." See BrCR 288 and 289.

Collections: From the artist to Ambroise Vollard, Paris; to Chrétien de Gallia; to Stephen Hahn, New York; to *Mrs. Donald B. Barrows and Mr. S. D. Colhoun*, Bryn Mawr, Pennsylvania.

245
Study of a Young Woman's Head 1895
Pastel on paper, 16 × 16 in., 40.6 × 40.6 cm.
Unsigned. Mathilde X collection stamp at lower right corner

Description: Head and shoulders of a young woman seen in three-quarter view left who looks at the spectator. Her dark hair is in a pompadour. The suggestion of a white blouse has a high collar. Shading in background close to the head with two dark spots at upper right.

Note: Also called "Tête de jeune femme."

Collections: From the artist to Mathilde Vallet, 1927; Mathilde X sale, Paris, 1931; *private collection*, Paris.

Exhibitions: Galerie A.-M. Reitlinger, Paris, 1931 (cat. 12, illus.); Centre Culturel Américain, Paris, 1959–60 (cat. 8).

246
Profile of a Woman Wearing a Red Jabot 1895
Pastel on paper, 26 × 17½ in., 66 × 44.5 cm.
Unsigned. Mathilde X collection stamp on verso

Description: Half-length portrait of a woman with dark hair wearing a dark blue dress with black velvet standing collar lined with ruching. A large red jabot cascades down the front of her dress.

Note: Also called "Portrait de femme," "Étude de femme," "Étude de femme, corsage à bouffant rouge, 1895." Durand-Ruel 10447-LD13162.

Collections: From the artist to Mathilde Vallet, 1927; Mathilde X sales, Paris, 1927, 1931; to Durand-Ruel, Paris; Palais Galeria sale, Paris, 27 March 1962; to Hirschl & Adler, New York; to *Mrs. Dunbar W. Bostwick*, Shelburne, Vermont.

Exhibitions: Galerie A.-M. Reitlinger, Paris, 1927 (cat. 82), and 1931 (cat. 18); Palais Galeria, Paris, March 1962.

247
Young Woman with Auburn Hair in a Pink Blouse 1895

Pastel on tan paper, 21¾ × 17¼ in., 55 × 44 cm.
Signed lower right: *Mary Cassatt*

Description: Half-length study of a pensive young woman with auburn hair, piled high on her head in a pompadour. She wears a delicately tinted rose pink blouse with sky blue highlights and a black ribbon around her neck. Verdant landscape background.

Note: Also called "Jeune femme au corsage rose

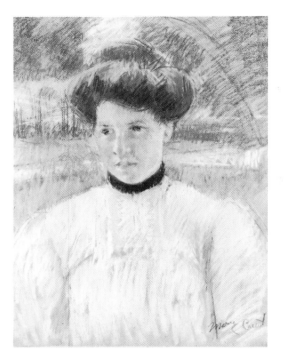

clair." Durand-Ruel 11081-LD12870.

Collections: From the artist to Durand-Ruel, 1924; to Durand-Ruel, New York; Marlborough Fine Art Ltd., London, 1953; Parke-Bernet, New York, Hotchkiss sale, 26 April 1961; to *Mr. A. Murray.*

Exhibitions: Durand-Ruel, Paris, 1924 (cat. 23); Marlborough Fine Art Ltd., London, 1953 (cat. 13).

Reproductions: Arts, vol. 35 (April 1961), p. 9.

248
Portrait of Mrs. Havemeyer and Her Daughter Electra 1895

Pastel, 24 × 30½ in., 61 × 77.5 cm.
Signed upper right: *Mary Cassatt/Vichy '95*

Description: Mrs. Havemeyer wears a tan silk dress with a white yoke trimmed with blue bows at the throat and on the chest. Electra wears a pink and white striped dress. Her hair is brown. Mrs. Havemeyer's hair is black. They are seated on a settee upholstered in rose-red. The background is in varying shades of dark brown.

Note: Durand-Ruel 707.

Collections: Electra B. McDowell, New York.

Exhibitions: Durand-Ruel, New York, 1895 (cat. 31); Art Institute of Chicago and Metropolitan Museum of Art, New York, "Sargent, Whistler and Mary Cassatt" (cat. 21, illus.), 1954.

Reproductions: Art News, vol. 50 (Feb. 1952), p. 38; *Art News,* vol. 52 (Jan. 1954), p. 35; *Metropolitan Museum of Art Bulletin,* vol. 20, no. 1 (Summer 1961), p. 18; *Apollo* (April 1966), p. 303; Frederick A. Sweet, 1966, pl. 19, fol. p. 204; Julia Carson, 1966, p. 108.

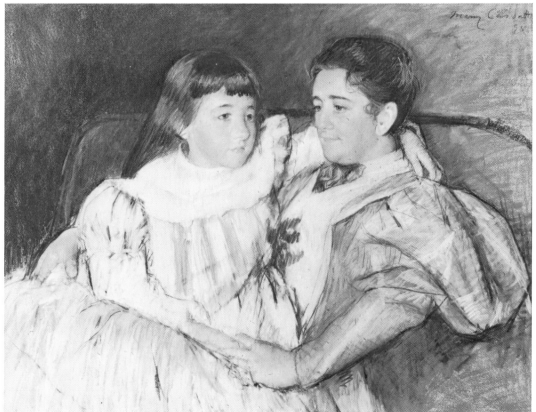

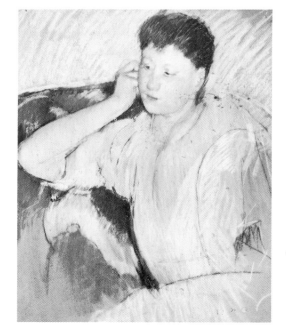

249
Clarissa, Turned Left, with Her Hand to Her Ear 1895

Pastel on paper, 25½ × 20 in., 64.6 × 50.7 cm.
Signed lower right: *M. C.*

Description: Seated on a high backed sofa upholstered in a large, strongly patterned material, Clarissa leans her elbow on it as she raises her right hand to her ear and looks down toward the left. She wears a light colored dress with a round neck and puffed sleeve.

Note: Also called "Study of a Seated Young Woman." Durand-Ruel A1376-NY5042.

Collections: From the artist to Payson Thompson; American Art Association, New York, Payson Thompson sale (cat. 86, illus.), 12 Jan. 1928; Sotheby and Co. sale, London, 1 July 1964; to Stephen Hahn (lot 66, no. A5765); to *L. W. Frolich,* New York.

Reproductions: Art News, vol. 26, no. 12 (24 Dec. 1927), p. 8.

250

Clarissa, Turned Right, with Her Hand to Her Ear 1895

Pastel on paper, 26 × 20 in., 66 × 51 cm.
Signed lower left: *Mary Cassatt*

Description: Seated on a high backed sofa upholstered in a large patterned material, Clarissa raises her right hand to her ear and looks to right. In her left hand she holds an open fan. She wears a light colored dress with a round neck and short, puffed sleeves.

Note: Also called "Femme à l'éventail." Durand-Ruel A1278-NY4708.

Collections: Roger-Marx, Paris; to Mr. Moline, 1899; to Dikran G. Kelekian, Paris; Kelekian sale, 4 Nov. 1913 (cat. 120); *Mrs. Mark C. Steinberg*, St. Louis, Missouri.

Exhibitions: Durand-Ruel, New York, 1924 (cat. 6); Durand-Ruel, New York, 1926 (cat. 1); Marlborough Fine Art Ltd., London, 1953 (cat. 12).

Reproductions: Connoisseur, vol. 154 (Dec. 1963), p. 262.

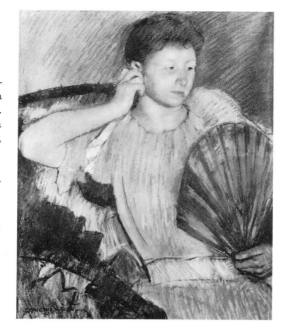

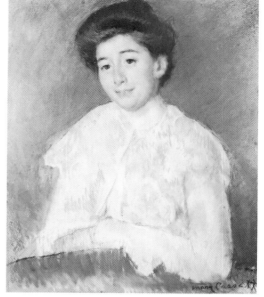

251

Portrait of a Smiling Woman in a Pink Blouse c. 1895

Pastel on paper, 24 × 20 in., 61 × 51 cm.
Signed lower right: *Mary Cassatt*

Description: Half-length portrait of a woman smiling. She turns slightly to the left with her eyes observing the spectator enigmatically. She wears a bright pink blouse with a deep lace bertha, and her arms are folded upon the back of a green sofa. Green background.

Collections: American Art Association, New York, Commodore Elbridge T. Gerry Estate sale (cat. illus.), 2–3 Feb. 1928; to H. L. Warner; to the Kende Gallery, 1949; to Himan Brown, New York, 1953; present location unknown.

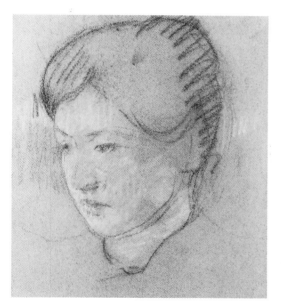

252

Head of a Young Woman, Three-Quarter View to Left c. 1895

Pastel on paper, 12½ × 11¾ in., 32 × 30 cm.
Unsigned

Description: Outline sketch of a young woman's head, heightened with flesh tones on face and neck. She looks to left.

Note: Possibly the same model as in BrCR 251. Also called "Étude de jeune femme." Durand-Ruel 10445-LD13154.

Collections: From the artist to Mathilde Vallet, 1927; Mathilde X collection sale, Paris, 1927; to Durand-Ruel, Paris; present location unknown.

Exhibitions: Galerie A.-M. Reitlinger, Paris, 1927 (cat. 26).

253

Portrait of a Lady in a Blue Dress c. 1896

Pastel on very light tan paper, 30 × 22 in., 76.2 × 56 cm.
Unsigned

Description: A woman in a brilliant blue dress is seated with her hands linked together and arms resting on a pink pillow at lower left. She has brown hair, blue eyes, a white yoke to her dress, and puffed sleeves. The background is of variegated yellow and green.

Collections: From the artist to Charles A. Walker, Lexington and Brookline, Massachusetts; to Leon Walker, his son; to *T. Gilbert Brouillette*, Falmouth, Massachusetts, 1940.

Exhibitions: Oklahoma Art Center, Oklahoma City, 1965 (cat. 28).

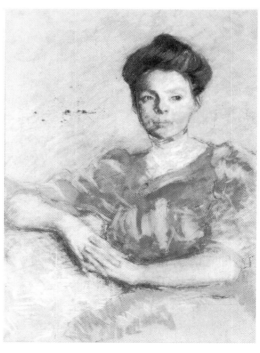

254

Portrait of Hermione c. 1896
Pastel on tan paper, 18¼ × 14⅞ in., 46 × 38 cm.
Signed at right in yoke of dress: *Mary Cassatt*

Description: Head and shoulders of a little girl
looking at the spectator. Her dark auburn hair
curls around her ears. A round yoke of her coat or
dress is indicated in blue; under it is a scarf with
a big white bow at her throat. Bright emerald
green background.

Note: Also called "Head of a Girl," "Portrait of
 Young Girl," and "Portrait of a Little Girl."

Collections: Pasadena Art Museum, bequest of
Josephine P. Everett, 1938.

Exhibitions: New Jersey State Museum, Trenton,
1939 (cat. 8) (called "Head of a Girl"); Pasadena
Art Museum, "Mary Cassatt and her Parisian
Friends" (cat. 12, illus.), 1951.

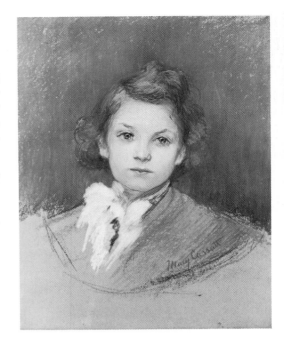

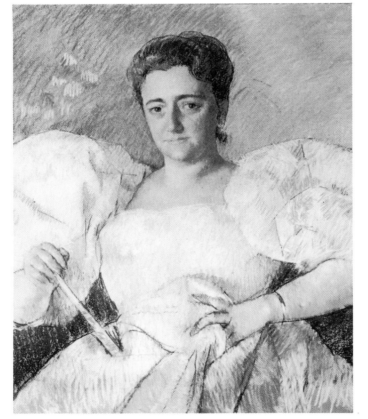

255

Portrait of Mrs. H. O. Havemeyer 1896
Pastel, 29 × 24 in., 73.6 × 61 cm.
Unsigned

Description: Mrs. Havemeyer wears a white even-
ing gown, with large puffed sleeves, which has an
indefinite figured pattern. Her dark hair has
touches of gray. The yellow background has
shades of green mixed with it and a suggestion of
very light pink blossoms at the left.

Collections: Electra Havemeyer Webb; to Mrs.
Dunbar W. Bostwick, her daughter; to *J. Watson
Webb, Jr.*, Shelburne, Vermont.

Exhibitions: M. Knoedler & Co., New York, 1966
(cat. 29).

Reproductions: Metropolitan Museum of Art Bulletin,
n.s. vol. 20, no. 1 (Summer 1961), p. 28; *Apollo,*
n.s. vol. 83, no. 50 (April 1966), p. 303.

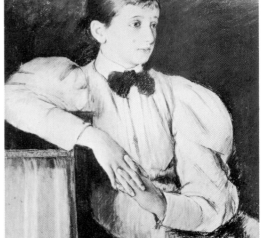

256

Portrait of Adaline Havemeyer Frelinghuysen
1896
Pastel on paper, 28¼ × 21⅝ in., 71.7 × 55 cm.
Signed upper right corner: *Mary Cassatt*

Description: A young girl in a shirtwaist with tre-
mendous sleeves sits with her hands linked together
and her right arm resting on the back of a chair
next to her. Her hair is smoothed back behind her

ear with some bangs showing. She looks off to the
right. Dark background.

Note: Durand-Ruel 706.

Collections: Harry O. H. Frelinghuysen, Far Hills,
New Jersey, from his mother, the sitter.

Exhibitions: Parrish Art Museum, Southampton,
New York, 1967 (cat. 20).

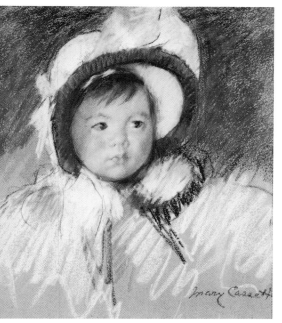

257
Ellen Mary Cassatt as a Baby c. 1896
Pastel on paper, 18 × 14 in., 45.8 × 35.6 cm.
Signed lower right: *Mary Cassatt*

Description: Head of Ellen Mary wearing a white
bonnet bound in brown fur, with fur also outlining
part of the white coat collar on the right. She
looks to right. Her dark hair under her bonnet is
brushed down over her forehead. The background
is grayish green.

Note: Ellen Mary Cassatt, later Mrs. H. B. Hare,
is the daughter of J. Gardner Cassatt, the artist's
brother, and his wife who was Eugenia Carter
of Virginia. Also called "The White Bonnet."
Durand-Ruel 985-L4516.

Collections: Estate of Mrs. Horace Binney Hare,
Radnor, Pennsylvania.

Exhibitions: Pennsylvania Museum of Art, Phil-
adelphia, 1927 (cat. 29); Haverford College, 1939
(cat. 25); Art Institute of Chicago and Metro-
politan Museum of Art, New York, "Sargent,
Whistler and Mary Cassatt" (cat. 22), 1954;
Philadelphia Museum of Art, 1960 (called "Head
of Ellen Mary").

Reproductions: Good Housekeeping, vol. 50 (Feb.
1910), p. 140; *Arts & Decoration,* vol. 3, no. 8 (June
1913), p. 265.

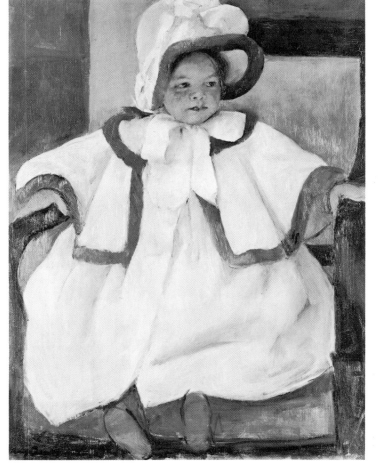

258
Ellen Mary Cassatt in a White Coat c. 1896
Oil on canvas, 32 × 24 in., 81.3 × 61 cm.
Signed lower left: *Mary Cassatt*

Description: Ellen Mary sits in a big, square-
backed chair upholstered in golden yellow with
her hands resting on each of the arms. She looks
soberly to right. She wears a big white bonnet
edged with brown fur. The same fur outlines the
cape and the collar of the long white coat.

Note: Also called 'The Little Infanta."

Collections: Estate of Mrs. Horace Binney Hare,
Radnor, Pennsylvania.

Exhibitions: Pennsylvania Museum of Art, Phil-
adelphia, 1927 (cat. 30); City Art Museum of St.
Louis, 1933–34 (cat. 1); Haverford College, 1939
(cat. 9); Wildenstein, New York, "The Child
Through Four Centuries" (cat. 40), 1945;
Wildenstein, New York, 1947 (cat. 23, illus.);
Carnegie Institute, Pittsburgh, "French Paintings
1100–1900" (cat. 111), 1951; Pennsylvania
Academy of the Fine Arts, Philadelphia, Peale
House Gallery (cat. 20), 1955; Philadelphia
Museum of Art, 1960 (called "The White Coat");
M. Knoedler & Co., New York, 1966 (cat. 27).

Reproductions: Pennsylvania Museum of Art Bulletin,
vol. 22 (May 1927), p. 375; *American Magazine of
Art,* vol. 18 (June 1927), p. 311; *Art News,* vol. 44
(1 March 1945), p. 15.

259
Two Sisters 1896
Pastel, 14¾ × 21 in., 37.4 × 53.5 cm.
Signed upper left: *Mary Cassatt*

Description: Heads and shoulders of two auburn-
haired young women. The one at left is seen in
profile to right, facing a strong light, and wears a
rose and white gown; the other looks toward her
companion above an open, rose-colored fan.
Light green shaded background.

Collections: Mrs. J. Cameron Bradley; Parke-
Bernet sale, New York, 11 Dec. 1947 (cat. 166,
illus.); Albert Otten; Edward A. Bragaline; *Mr.
and Mrs. Lester Francis Avnet*, Great Neck, New
York.

Exhibitions: Pasadena Art Institute, "Mary Cassatt
and Her Parisian Friends" (cat. 16), 1951.

Reproductions: Artist, vol. 47 (3 June 1954), p. 80;
Art Quarterly, vol. 27, no. 4 (1964), p. 542.

260
The Conversation 1896
Pastel on paper, 25⅝ × 31⅞ in., 65 × 81 cm.
Signed lower left: *Mary Cassatt*

Description: Two dark-haired women sit facing
each other as though talking together. The one on
the right faces the spectator. She has her left arm
raised to touch her hair. The one on the left is seen
in lost profile to right—just her cheek is visible.
Both wear light dresses.

Note: Also called "Les deux sœurs." Durand-Ruel
845-L3982.

Collections: From the artist to Durand-Ruel, 1896;
to Durand-Ruel, New York, 1898; to Mrs. C. A.
Griscom, 1898; American Art Association, New
York, Clement A. Griscom sale, 26 Feb. 1914;
Durand-Ruel, 1914–62; M. & Ph. Rheims sale,
Paris, 11 Dec. 1962; present location unknown.

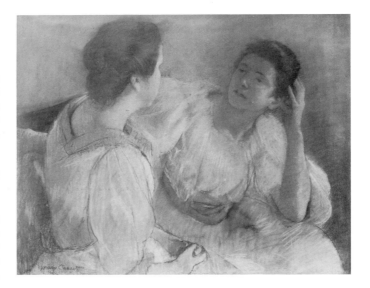

Exhibitions: Durand-Ruel, New York, 1920 (cat.
23); Durand-Ruel, New York, 1924 (cat. 22);
Durand-Ruel, New York, 1926 (cat. 7); Carnegie
Institute, Pittsburgh, 1928 (cat. 40); McClees
Galleries, Philadelphia, 1931 (cat. 20); City Art
Museum of St. Louis, 1933–34 (cat. 14); Durand-
Ruel, New York, 1935 (cat. 15); Baltimore
Museum of Art, 1941–42 (cat. 35); Wildenstein,
New York, 1947 (cat. 30, illus.) (called "The Two
Sisters").

Reproductions: L'Art Décoratif, vol. 4 (Aug. 1902),
p. 180.

261
**Young Woman Fastening Her Sister's
Dress** c. 1896
Pastel, 29 × 23¾ in., 73.7 × 60.4 cm.
Signed upper right corner: *Mary Cassatt*

Description: Three-quarter length view of two
young women, one of them wearing a pink evening
dress trimmed with white shirring at the square
décolletage. Behind her, at left, is her sister, seen
in right profile. She looks down as she fastens the
pink evening dress. The background is blue.

Note: Also called "The Sisters."

Collections: From the artist to Ambroise Vollard,
Paris; to Paul Pétridès, Paris; to Charles E.
Slatkin Galleries, New York; to Mr. and Mrs.
Samuel Sair, Winnipeg, Canada; Parke-Bernet
sale (cat. illus.), New York, 9 Dec. 1959; *Jacques A.
Gerard*, New York.

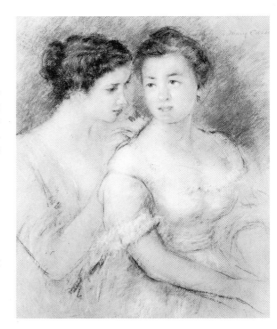

Exhibitions: Charles E. Slatkin Galleries, New York,
"Drawings by Old and Modern Masters" (color
illus. pl. 27), 1960.

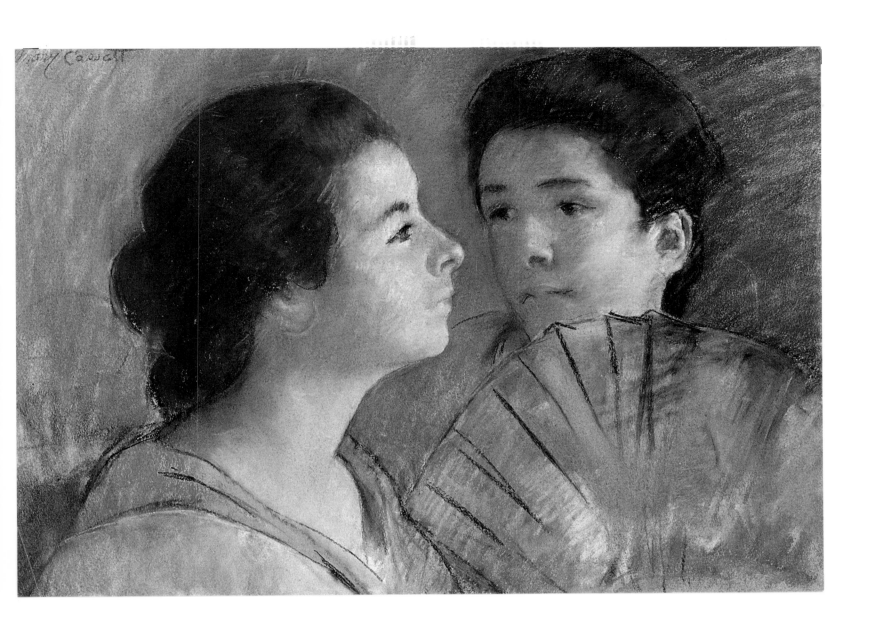

Two Sisters, 1896. BrCR 259.

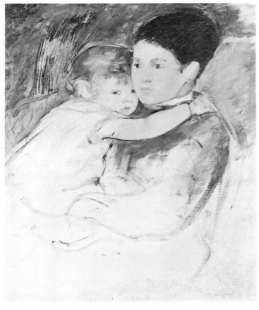

262

A Caress for Grandmother c. 1896

Oil on canvas, 15 × 21¼ in., 38 × 54 cm.
Signed lower right: *Mary Cassatt*

Description: Head and shoulders of two figures on the grass under trees. Little Marie is held by her grandmother whose left arm embraces her, while her right hand holds the child's left arm as Marie raises it to pat her grandmother's cheek. She looks at her grandmother, her head back and her long curly reddish hair falling down her back. The grandmother wears a lavender print dress with a white yoke.

Note: Also called "Caresse maternelle." Durand-Ruel 817-L3905.

Collections: From the artist to Durand-Ruel, Paris, 1896; to Durand-Ruel, New York, 1896; to C. J. Lawrence, 1897; American Art Association, New York, C. J. Lawrence sale (cat. 64), 20 Jan. 1910;

Durand-Ruel, New York, 1920; to *Aaron E. Carpenter*, 1942.

Exhibitions: Museum of History, Science and Art, Los Angeles, 1st Pan-American Exposition, 1925–26; Pennsylvania Museum of Art, Philadelphia, 1927 (cat. 14); Brooklyn Museum, 1937 (cat. 24); Durand-Ruel, New York, "Exhibition of Paintings by Berthe Morisot and Mary Cassatt" (cat. 10), 1939.

Reproductions: *Craftsman*, vol. 19 (March 1911), p. 542; Achille Segard, 1913, fol. p. 68; *Touchstone Magazine*, vol. 7 (July 1920), p. 266; *Pennsylvania Museum of Art Bulletin*, vol. 22 (May 1927), p. 381; *Parnassus*, vol. 1, no. 6 (Oct. 1929), p. 24; *Pennsylvania Museum of Art Bulletin*, vol. 25 (May 1930), p. 20; Forbes Watson, 1932, p. 45; Michel-Louis Conil, "Mary Cassatt," *Informations et Documents* (15 May 1958), cat. 86.

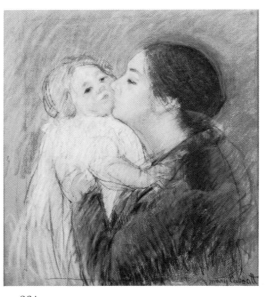

263

Sketch of Anne and Her Nurse c. 1897

Oil on canvas, 27½ × 23 in., 70 × 58.5 cm.
Unsigned

Description: A blond, curly-headed baby in a white dress clasps her nurse's shoulder with her right hand and looks at the spectator. The nurse's hair is black. The background is mottled green.

Collections: Mrs. Percy C. Madeira, Jr., Berwyn, Pennsylvania.

Exhibitions: National Gallery of Ireland, Dublin, 1968.

264

A Kiss for Baby Anne (No. 1) c. 1897

Pastel, 25¼ × 20¾ in., 64 × 52.8 cm.
Signed lower right: *Mary Cassatt*

Description: Sketch of a mother seen in profile to left kissing her baby whom she holds up to her face. The baby looks slightly to right, her right hand resting on the mother's shoulder. Dark background.

Collections: From the artist to Mrs. Potter Palmer, Chicago; to Mrs. C. J. Blair, Chicago; to Elizabeth Arden (Mrs. E. N. Graham); to her niece, *Patricia Graham Young*, New York.

Reproductions: Arsène Alexandre, "La collection Havemeyer et Miss Cassatt," *La Renaissance*, vol. 13 (Feb. 1930), p. 54.

265

Sketch of Woman's Head in Profile to Left (No. 1) c. 1897

Pastel on gray paper, 10¾ × 10¾ in., 27.3 × 27.3 cm.
Unsigned

Description: Head of a handsome woman's profile to left. Her hair is drawn back over her ear to a knot in back. The hair is shaded dark with lighter highlight rubbed out. Flesh color pastel on face and neck very light. Her right eye can barely be seen.

Collections: City Art Museum of St. Louis (no. 44.34).

Reproductions: *Bulletin of City Art Museum of St. Louis*, vol. 19, no. 4 (Oct. 1934); Margaret Breuning, 1944, p. 9.

266 †
Sketch of Woman's Head in Profile to Left (No. 2) c. 1897

Pastel on paper, 24 × 19⅝ in., 61 × 50 cm.
Signed lower right: *Mary Cassatt*

Description: Head and shoulders of a woman in profile to left. She looks down toward lower left. Her dark hair is brushed up onto the top of her head. Shaded background.

Collections: Hôtel Drouot sale, Paris, 10 May 1950 (cat. 17); Galerie Charpentier sale, Paris, 15–16 Dec. 1958 (cat. 215); present location unknown.

267
A Kiss for Baby Anne (No. 2) c. 1897

Pastel, 21½ × 17¾ in., 54.5 × 45 cm.
Signed upper left: *Mary Cassatt*

Description: Same general composition as in first version but much more finished and more detailed. The mother's lovely profile allows her right eye to show slightly. Her bright blue dress has embroidered collar and cuffs, and her hair is black. The baby's hair is in blond ringlets. The mother's wedding ring shows at left. The background is gray.

Note: Hirschl & Adler no. 5737-D. Durand-Ruel 10017-LR2

Collections: From the artist to Durand-Ruel, Paris; to J. Boyer, Paris; to Mrs. H. B. Tuttle, New York; to *Mrs. Abram Eisenberg*, Baltimore, Maryland, on loan to the Baltimore Museum of Art.

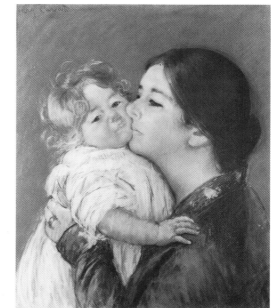

268
A Kiss for Baby Anne (No. 3) 1897

Pastel, 17 × 25½ in., 43 × 64.6 cm.
Signed lower right: *Mary Cassatt*

Description: The mother bends back her head to kiss her bare-shouldered baby on the left cheek. She supports the baby's back with her right hand and holds her right hand with her left. The baby looks slightly to right.

Note: Also called "Le Baiser." Durand-Ruel 982-L4514.

Collections: From the artist to Durand-Ruel, 1897; to Durand-Ruel, New York, 1898; to Miss E. S. Hamilton, Dec. 1905; present location unknown.

Exhibitions: Durand-Ruel, New York, 1903 (cat. 20); Smith College Museum of Art, Northampton, Mass., 1928 (cat. 1).

Reproductions: Les Modes, vol. 4 (Feb. 1904), p. 4; *Good Housekeeping*, vol. 50, no. 2 (Feb. 1910), p. 144; Edith Valerio, 1930, pl. 10.

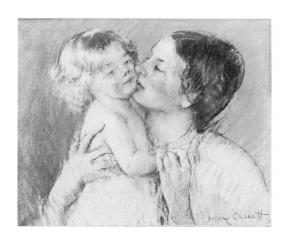

269
A Kiss for Baby Anne (No. 4) c. 1897

Pastel on paper, 23⅝ × 19⅝ in., 60 × 50 cm.
Signed lower left: *Mary Cassatt*

Description: Half-length of a mother seated, kissing her nude baby on the neck as she turns her head left, blocking most of the mother's lower face from view. Both of the baby's feet show partly below the mother's left arm on which she holds the baby. Her left hand is on her mother's shoulder.

Note: Two versions of this pastel are included. One (left) is a rotogravure taken before the counterproof was made. The other (right) is a photograph taken after the counterproof was made. In the latter the position of the lower left sleeve has been changed and many other details have been weakened due to losses of pastel as a result of pulling the counterproof. Also, the signature at lower left was erased and a new signature was placed at lower right.

Collections: Georges Petit Gallery, Paris, 1907; Findlay Gallery, New York, June 1959; Sotheby & Co., London, 6 Dec. 1963; to Lady Baillie, London; to *private collection*, Paris.

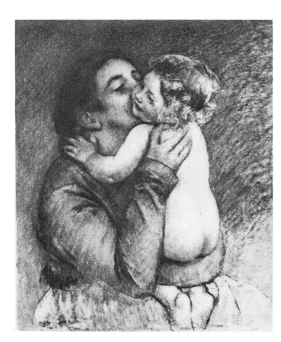

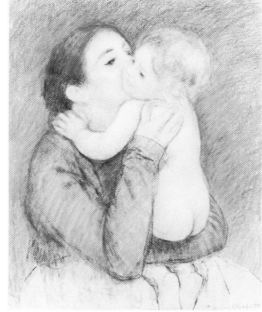

270
A Kiss for Baby Anne (No. 4) (Counterproof)
Pastel on paper, 23¼ × 18⅝ in., 59 × 47.3 cm.
Signed lower right: *Mary Cassatt*

Description: A very pale sketch in reverse of no. 4.
A mother holds up her nude baby whose right
hand rests on the mother's left shoulder. The baby's
face half covers her mother's face. She wears a blue
bodice and an orange-yellow skirt, and has brown
hair whereas the baby is blond. The background
is light green.

Collections: Arthur Tooth & Sons, Ltd., London,
1957; to Sotheby & Co., London, 1963; to
Wildenstein, New York, 1965; to *Mr. and Mrs.
Norman I. Schafler*, New York.

Exhibitions: Arthur Tooth & Sons, Ltd., London,
"Recent Acquisitions, XII" (cat. 26), 1957.

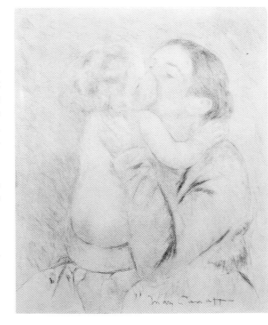

271
Anne, with Her Mother, Seated on the Grass
1897
Pastel on paper, 25½ × 31½ in., 65 × 80 cm.
Signed lower right: *Mary Cassatt*

Description: A golden blond, curly-haired baby sits
on the grass at left wearing a white dress. She
looks down and with her right hand touches the
hand of her mother which is extended over her
lap. The mother wears a lovely blue blouse with
puffed sleeves tapering to tight ruffled cuffs. The
skirt is white with pink flecks in a figured material.
The background is a dappled green.

Note: Also called "Mère jouant avec son enfant."
Durand-Ruel 1137-L4856.

Collections: From the artist to James Stillman,
Paris; to the *Metropolitan Museum of Art*, New York,
anonymous gift, 1922.

Exhibitions: Durand-Ruel, Paris, 1908 (cat. 43);
Manchester, England, organized by Durand-Ruel,
Paris, 1907–08 (cat. 73); Baltimore Museum of
Art, 1941–42 (cat. 27); Wildenstein, New York,
1947 (cat. 26); Brearley School, New York, 1956.

Reproductions: Good Housekeeping, vol. 50 (Feb.
1910), p. 143; Achille Segard, 1913, fol. p. 72;
Edith Valerio, 1930, pl. 11; *Art Digest*, vol. 22 (15
Nov. 1947), cover.

272
Three Women Admiring a Child 1897
Pastel, 25½ × 31½ in., 65 × 80 cm.
Signed lower left: *Mary Cassatt*

Description: A smiling young woman at right
greets a little blond girl, holding both of her hands
as they look at each other. The little girl is held by
a woman at left seen in quarter view wearing a
print blouse with a black neck band. Between the
child and the woman greeting her is another woman
with dark hair and eyes.

Note: Also called "Femmes et enfant." Durand-
Ruel 972-L4456.

Collections: Detroit Institute of Arts, gift of Edward
Chandler Walker, 1908.

Exhibitions: Durand-Ruel, New York, 1903 (cat.
18); Wildenstein, New York, 1947 (cat. 33, illus.).

Reproductions: L'Art Décoratif, vol. 4 (Aug. 1902),
fol. p. 184; *Detroit Institute of Arts Bulletin*, vol. 3
(Jan. 1909), p. 1; Camille Mauclair, *The French
Impressionists (1860–1900)*, New York, 1903, p. 157;
Fine Arts Journal, vol. 25 (Aug. 1911), p. 69; Charles
L. Borgmeyer, *Master Impressionists*, Chicago, 1913,
p. 159; Detroit Institute of Arts, *Paintings in the
Permanent Collection*, 1930 (cat. 275); Margaret
Breuning, 1944, p. 32.

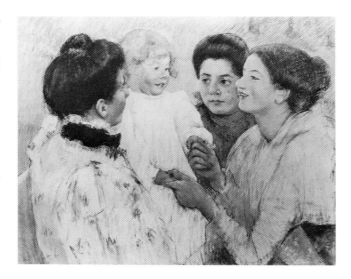

273
Adoration 1897
Pastel on paper, 28 × 20½ in., 71 × 52 cm.
Unsigned

Description: A nude baby looks up at one woman
who kisses his hand as she bends over him, only the
top of her head and foreshortened features showing
besides her hand. His mother on the left has her
arms around him and also looks down adoringly
at him.

Note: Also called "La sortie du bain." Durand-
Ruel 1107-L9269.

Collections: From the artist to Durand-Ruel, Paris,
1898; to Durand-Ruel, New York, 1899; to
Durand-Ruel, Paris, 1910; to Durand-Ruel, New
York, 1926–67; Wildenstein, New York, 1967;
to *Mr. and Mrs. Morris Newberger*, Dallas, Texas.

Exhibitions: Musée National du Luxembourg,
Paris, "L'école américaine" (cat. 58), 1919; Art
Institute of Chicago, "Memorial Collection of
Works by Mary Cassatt" (cat. 3), 1926–27; Penn-
sylvania Museum of Art, Philadelphia, 1927 (cat.
1); Baltimore Museum of Art, 1941–42 (cat. 28);
Philadelphia Print Club, 1942; Durand-Ruel,
New York, "A Selection of Paintings," 1948.

Reproductions: *L'art décoratif*, vol. 4 (Aug. 1902),
p. 177; Achille Segard, 1913, fol. p. 84; *La revue
de l'art*, vol. 36 (Nov. 1919), p. 200; *Cleveland
Museum of Art Bulletin*, vol. 7 (Dec. 1920), frontis-
piece; *Arts & Decoration*, vol. 20 (Feb. 1924),
cover; *Pennsylvania Museum of Art Bulletin*, vol. 22
(May 1927), p. 379; Herbert B. Tschudy, *Water-
colors, Paintings, Pastels and Drawings in the Permanent
Collection of the Brooklyn Museum*, New York, 1932,
p. 183; *Art News*, vol. 38 (4 May 1940), p. 17.

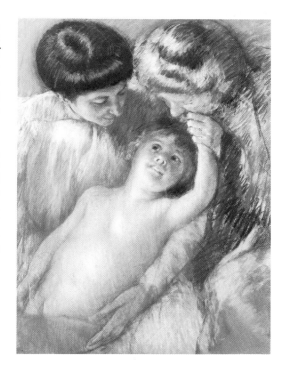

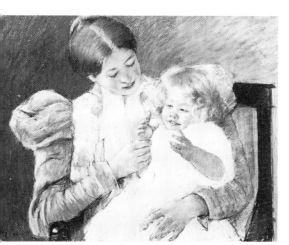

274
Patty-cake 1897
Pastel on paper, 23¾ × 28¼ in., 60.4 × 71.7 cm.
Signed lower left: *Mary Cassatt*

Description: A little girl with curly blond hair
smiles as her mother helps her to clasp her hands
together. The mother holds the child's wrist and
looks down with eyelids lowered. The mother wears
a bright blue dress with puffed sleeves and a white
yoke; her hair is parted in the middle. The adult
model is Renée Chauvet.

Note: Durand-Ruel 973-L4457.

Collections: From the artist to Durand-Ruel, Paris,
1897; to Durand-Ruel, New York, 1898; to John
G. Lowe, Dayton, Ohio, 1935; to *private collection*,
Denver, Colorado.

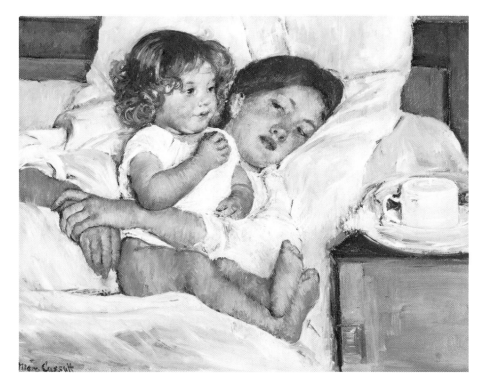

275
Breakfast in Bed 1897
Oil on canvas, 25⅝ × 29 in., 65 × 73.6 cm.
Signed lower left: *Mary Cassatt*

Description: A baby girl sits on her mother's bed in
her nightgown, her bare legs uncovered. She looks
off to right. Her mother lies next to her and en-
closes her in her arms with her hands clasped at
left. She looks at her child through half-closed eyes.
At right is a breakfast tray with a cup and saucer
resting on top of an apple green stand.

Note: Durand-Ruel 984-L4517.

Collections: Mrs. Chauncey Blair; to Mrs. William
F. Borland, Chicago; to M. Knoedler & Co., New
York, 1967; to *Dr. John J. McDonough*, Youngs-
town, Ohio.

Exhibitions: M. Knoedler & Co., New York, 1966
(cat. 28).

Reproductions: *Art Amateur*, vol. 38 (May 1898),
p. 133; *Delineator*, vol. 74 (Aug. 1909), p. 121;
Craftsman, vol. 19 (March 1911), p. 541; *Touchstone
Magazine*, vol. 7 (July 1920), p. 264.

276
The Barefooted Child 1897
Pastel on paper, 28½ × 20¾ in., 72.4 × 53 cm.
Signed lower left: *Mary Cassatt*

Description: A mother holds up her baby with both
hands encircling the baby's waist. The child's face
is foreshortened as she leans back and looks off to
right smiling. She wears a white dress to her knees,
exposing bare legs and feet. The mother looks to
right over the baby's shoulder. Dark background.

Note: Durand-Ruel 848-L4081.

Collections: From the artist to A. A. Pope; *Bowdoin
College Museum of Art*, Brunswick, Maine, given by
Mrs. Murray S. Danforth in memory of her hus-
band.

Exhibitions: Cincinnati Art Museum, "27th
Annual of American Art," 1920; Durand-Ruel,
New York, 1926 (cat. 5).

Reproductions: Fine Arts Journal, vol. 27 (Aug. 1912),
p. 494; *Fine Arts Journal*, vol. 28 (June 1913),
p. 354; *Arts & Decoration* (July 1917), p. 445.

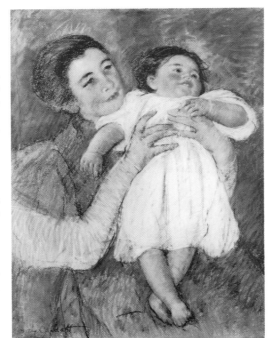

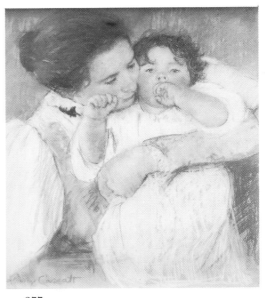

277
**Little Anne Sucking Her Finger, Embraced
by Her Mother** 1897
Pastel on beige paper, 21¾ × 17 in., 55.3 × 43.2 cm.
Signed lower left: *Mary Cassatt*

Description: A mother embraces a baby with her
left arm and bends her head so that she presses her
cheek against the baby's. Her face is foreshortened.
The mother wears a white blouse with a black
ribbon at the ruffled high neck. Over the blouse
she wears a variegated rose-colored sleeveless
jumper. The baby wears a white gown with blue
shadows. Both have brown hair. The background
is green.

Note: Dur 859-L4079. Musée du Louvre inventory
RF2051.

Collections: Jeu de Paume (Musée du Louvre, cabinet
des dessins), gift of the artist, 1897, to the Musée du
Luxembourg.

Exhibitions: Orangerie, Paris, "Pastels français"
(cat. 114), 1949; Musée du Louvre, Paris,
"Catalogue Impressionistes" (cat. 28), 1958;
Centre Culturel Américain, Paris, 1959 (cat. 7);
Musée du Louvre, "Pastels et miniatures du XIXᵉ
siècle," 37ième exhibition du cabinet des dessins,
Paris, 1966.

Reproductions: Charles L. Borgmeyer, *Master
Impressionists*, Chicago, 1913. p. 224.

278
Marie Looking Up at Her Mother 1897
Pastel on paper, 31½ × 26¼ in., 80 × 66.7 cm.
Signed lower left: *Mary Cassatt*

Description: A little girl stands in front of her
mother and leans back against her, her left hand
up to her cheek, her right resting on her mother's
arm. Her mother holds her within her arms with
clasped hands. The mother's face is foreshortened
as she looks down at her daughter and smiles. Her
dress is white with green shadows, the child's is
pinkish white. The background is salmon color,
with some green pattern.

Note: Also called "Nurse and Child." Durand-
Ruel 858-L4080.

Collections: Metropolitan Museum of Art, gift of Mrs.
Ralph J. Hines, 1960 (60.181).

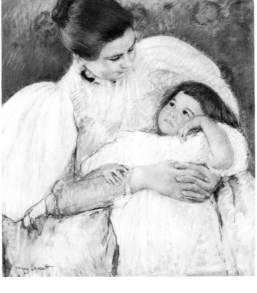

279
Pensive Marie Kissed by Her Mother 1897
Pastel on paper, 22 × 17 in., 56 × 43 cm.
Signed lower left: *Mary Cassatt*

Description: Half-length of a little girl looking to
left while her mother, seen in quarter view, kisses
her left cheek. The mother's straight brown hair is
drawn back in a bun; Marie's auburn curls are
tied up with a ribbon. The mother wears a yellow
dress while the child wears a gray on white print.
Background is green.

Note: Also called "Baiser Maternel." Durand-Ruel
815-L3906.

Collections: Philadelphia Museum of Art, bequest of
Anne Hinchman, 1952.

Exhibitions: Philadelphia Museum of Art, 1960.

Reproductions: Good Housekeeping, vol. 50, no. 2 (Feb.
1910), p. 139.

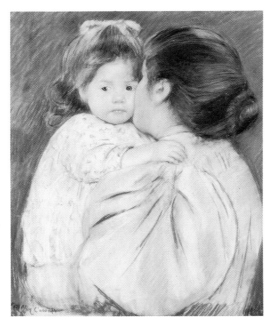

280
Two Little Girls c. 1897

Pastel on paper, 25 × 20¾ in., 63.5 × 53 cm.
Signed upper right: *Mary Cassatt*

Description: Two little girls seated one behind the other, one brunette, one blond. The brunette wears a brownish red dress, the blond is in pale yellow. The brunette on the right clasps her hands in her lap. The blond smiles slightly as they both look to left. Greenish gray background.

Note: Also called "Young Girls."

Collections: Gustave Mirbeau; to Maurice Le-

clanché; Hôtel Drouot, Leclanché sale (cat. 7), 6 Nov. 1924; to M. Knoedler & Co., New York; to *Herron Museum of Art*, Indianapolis.

Exhibitions: M. Knoedler & Co., New York, 1966 (cat. 32).

Reproductions: 41st Annual Report for the Year 1925, John Herron Art Institute, Indianapolis, p. 39; *John Herron Art Institute Bulletin,* vol. 12 (April–May 1925), p. 29; *Art News,* vol. 23 (13 June 1925), p. 2; *John Herron Art Institute Bulletin,* vol. 18 (Sept. 1932), p. 49; Margaret Breuning, 1944, p. 24; Julia Carson, 1966, p. 47.

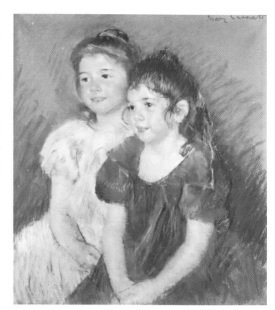

281
The Cup of Chocolate 1898

Pastel, 21⅜ × 28¾ in., 54.3 × 73 cm.
Signed lower right: *Mary Cassatt*

Description: Bust-length view of a young woman seen looking to right as she stirs her cup of chocolate with a spoon held in her right hand, her left holding the saucer up to her chest. Her hair is parted in the middle. Her dress has puffed sleeves narrowing to tight cuffs at the wrists.

Note: Also called "La tasse de thé." Durand-Ruel 983-L4515.

Collections: From the artist to Durand-Ruel, Paris, 1897; to Durand-Ruel, New York, 1898–1942; present location unknown.

Exhibitions: Durand-Ruel, New York, 1903 (cat. 21); American Watercolor Society, New York, 44th annual exhibition (cat. 102), 1911; Durand-Ruel, New York, 1926 (cat. 2); Baltimore Museum of Art, 1941–42 (cat. 29).

Reproductions: Harpers Weekly, vol. 55 (20 May 1911), p. 24.

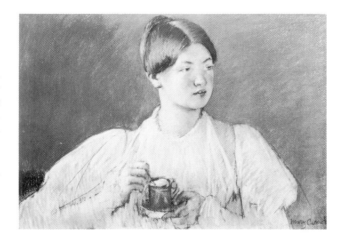

282
Mother Giving a Drink to Her Child 1898

Pastel on paper, 25½ × 32 in., 65 × 81.3 cm.
Signed lower left: *Mary Cassatt*

Description: A child with short straight blond hair helps to hold a large glass to his mouth. The mother also holds it in her right hand. She is seen behind a table enclosing the lower left section of the picture. On the table is a large glass water carafe and a plate. She looks down to right at her child who wears a yellow dress with orange dots; the mother's is light green. The background is gray.

Note: Also called "Mother Feeding Her Child." Durand-Ruel 842-L3981.

Collections: James Stillman collection, Paris; to the *Metropolitan Museum of Art,* anonymous gift, 1922 (22.16.22).

Reproductions: Art Amateur, vol. 38, no. 6 (May 1898), p. 130; *Century,* vol. 57, n.s. 35 (March 1899), p. 741; *L'art décoratif,* vol. 4 (Aug. 1902), frontispiece; *Good Housekeeping,* vol. 50 (Feb. 1910), p. 142; Achille Segard, 1913, fol. p. 84; Edouard-Joseph, *Dictionnaire biographique des artistes contemporains,* Paris, 1930, vol. 1, p. 248.

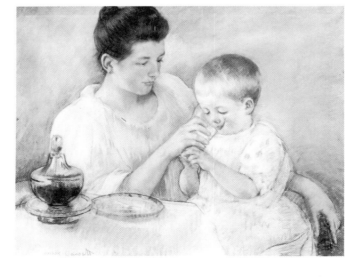

283
Mother Looking Down at Her Blond Baby Boy c. 1898
Pastel on paper, 22½ × 16 in., 57 × 40.6 cm.
Signed lower right: *Mary Cassatt*

Description: Head and shoulders of mother and baby (both well developed and finished likenesses). The mother's dark hair is in a pompadour, her dark eyes observing her child. He is seen in profile to left, his blond hair cut short. The mother's left hand rests on his left shoulder.

Collections: Hôtel Drouot, Leclanché sale (cat. 8, illus.), 11 June, 1924; to M. Fouquet; *Denver Art Museum*, Charles Bayly, Jr. collection.

Reproductions: Art Collectors' Quarterly, "Accessions of American and Canadian Museums from October–December 1952" (Summer 1953), p. 150.

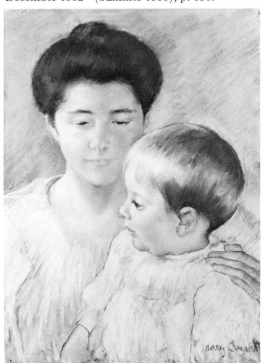

284
Heads of Leontine and a Friend c. 1898
Pastel on paper, 13 × 17¾ in., 33 × 45 cm.
Unsigned. Mathilde X collection stamp at lower left corner

Description: Sketched at the right is the head of a young woman wearing a fluffy pink hat, tilted forward. At left is the front view of a young woman with dark hair and no hat.

Note: Also called "Deux têtes de femmes" and "Femme, chapeau esquissé et jeune fille; deux têtes."

Collections: From the artist to Mathilde Vallet, 1927; Mathilde X collection sales, Paris, 1927, 1931; present location unknown.

Exhibitions: Galerie A.-M. Reitlinger, Paris, 1927 (cat. 15), and 1931 (cat. 14, illus.).

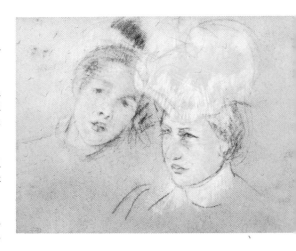

285
Leontine in a Pink Fluffy Hat 1898
Pastel, 15 × 9¾ in., 38 × 25 cm.
Unsigned

Description: Sketch of Mme. Leontine Richez-Constantin who states in the 1960 Parke-Bernet catalogue that she sat for her portrait at Miss Cassatt's estate at Mesnil-Theribus (Oise) in 1898. Just her head is shown, her blue eyes looking to half-right. She wears her auburn hair piled high under a fluff of pink hat tilted somewhat forward. Blue and green background.

Note: Also called "Portrait of a Young Woman."

Collections: Parke-Bernet sale (cat. illus.), New York, 16 March 1960; to *Mr. DeCordoba*.

286
Ellen Mary Cassatt, Aged Four c. 1898
Pastel on tan paper, 12 × 14½ in., 30.5 × 37 cm.
Unsigned

Description: Head and shoulders of a little girl with blue eyes and brown hair. Only the head is developed, the rest is sketchy. A bright green upholstered mahogany chairback is behind her.

Collections: Mrs. Gardner Cassatt, Villanova, Pennsylvania.

Exhibitions: Haverford College, 1939 (cat. 28); Pennsylvania Academy of the Fine Arts, Philadelphia, Peale House Gallery (cat. 1), 1955; Parrish Art Museum, Southampton, N.Y., 1967 (cat. 16).

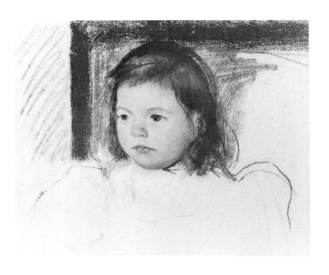

287
The Pink Sash (Ellen Mary Cassatt)
c. 1898
Pastel on paper, 24 × 20 in., 61 × 51 cm.
Unsigned

Description: A little girl sits in a big chair with a square back, her left arm resting on the arm of the chair. She looks off to the left. Her hair curls onto her shoulders and is held to one side by a small ribbon bow. Her white dress has a wide ruffle from the neck over the shoulders and a wide pink sash.

Collections: Estate of Mrs. Horace Binney Hare, Philadelphia, Pennsylvania.

Exhibitions: Pennsylvania Museum of Art, Philadelphia, 1927 (cat. 31, illus.); Haverford College, 1939 (cat. 24, illus.); Philadelphia Museum of Art, 1960.

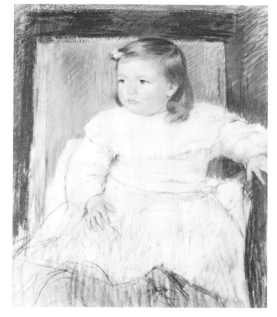

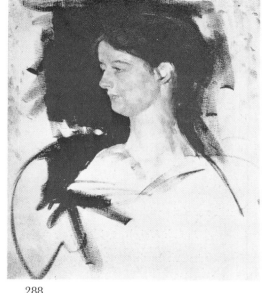

288
Study of Mrs. Clement B. Newbold 1898
Oil on canvas, 24 × 21 in., 61 × 53.4 cm.
Unsigned

Description: Finely modeled head in profile to left. Mrs. Newbold has blue eyes and dark hair. Dark, sketchy background.

Collections: From the artist to Payson Thompson; American Art Association, New York, Payson Thompson sale, (cat. 84, illus.), 12 Jan. 1928; *Mrs. Donald B. Barrows,* Bryn Mawr, Pennsylvania.

Exhibitions: Carnegie Institute, Pittsburgh, 1928 (cat. 29).

289
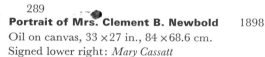
Portrait of Mrs. Clement B. Newbold 1898
Oil on canvas, 33 × 27 in., 84 × 68.6 cm.
Signed lower right: *Mary Cassatt*

Description: Three-quarter length view of a lady with light brown hair drawn back simply over her ears. Her right hand rests on her hip, her left holds a handkerchief in her lap. She wears a dark green velvet waist with large, wide puffed sleeves, tapering to the wrists, and a light, dotted skirt.

Note: The sitter was formerly Miss Mary Scott, a cousin of the artist. Durand-Ruel 630.

Collections: Clement B. Newbold, Jr., Philadelphia, Pennsylvania.

Exhibitions: Durand-Ruel, New York, 1895 (cat. 33) (called "Portrait de Miss S"); Pennsylvania Museum of Art, Philadelphia, 1927 (cat. 37); Philadelphia Museum of Art, 1960.

Reproductions: Arts, vol. 11, no. 6 (June 1927), p. 293.

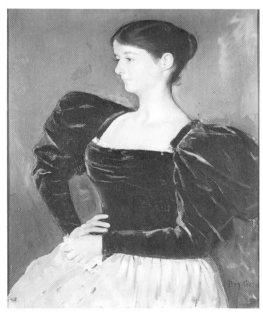

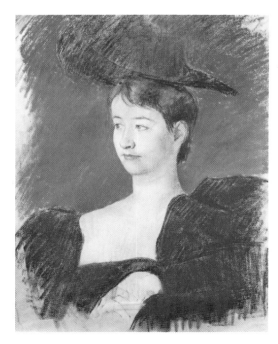

290
Portrait of a Young Woman in Green
c. 1898
Pastel on paper, 22⅞ × 18½ in., 58 × 47 cm.
Signed upper right: *Mary Cassatt*

Description: Head, shoulders, and suggestion of folded hands of a young woman wearing a formal gown with a square décolletage and wide upper sleeves. Her hair is cut short and parted with a few bangs. Her plumed hat is perched high on her head. The background is in tones of brown.

Collections: Paul Pétridès, Paris.

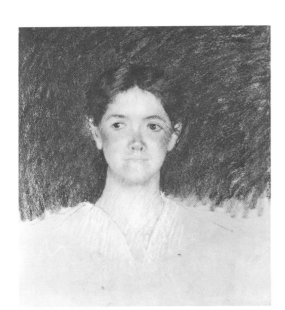

291
Portrait of Mary Say Lawrence 1898
Pastel on paper, 20 × 17 in., 51 × 43 cm.
Unsigned

Description: Young Miss Lawrence is seen facing the spectator, looking to left. Head and shoulders only. Her dark hair is parted in the middle, ears showing. Her dress with V-neck is white and blue. Background is brown.

Note: Mr. Benjamin Webster, her son, wrote to the author in 1965 that it was done in New York by Miss Cassatt in 1897, but it must have been 1898 since that was the time she came on her extensive visit home to America. Durand-Ruel A1970-NY9623.

Collections: Cyrus J. Lawrence, the sitter's father; Benjamin L. Webster, son of the sitter; Mrs. John Ogg Ross, New York.

292
Head of Master Hammond c. 1898
Pastel on paper, 20 × 19½ in., 51 × 49.6 cm.
Unsigned

Description: Head of a young boy in a black tricorn hat and a green coat with a shoulder cape. He looks off to the left, his dark eyes sharp. The background is rose color flecked with yellow and blue.

Note: Miss Cassatt described how, when visiting the Hammonds in Boston to do the portraits of the children, she spotted the little boy out walking with his nurse in this costume and wanted at once to make a sketch of him in it. (Frederick A. Sweet, 1966, p. 150.)

Collections: Phoenix Art Museum, gift, 1964, from the collection of Mr. and Mrs. Donald D. Harrington.

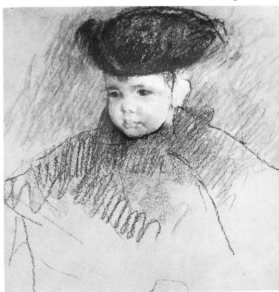

293
Gardiner Green Hammond, Jr. 1898
Pastel on tan paper, 27 × 21 in., 68.5 × 53.3 cm.
Signed lower left: *Mary Cassatt*

Description: Half-length portrait of a small boy wearing a black tricorn hat and a bottle green coat with two small shoulder capes. He looks off to left, his hands hitched into the belt of his coat. His eyes are brown, his short hair reddish brown. The background is of tawny shades of reddish brown and green.

Collections: Mr. George Fiske Hammond, Santa Barbara, California.

Reproductions: Margaret Breuning, 1944, p. 22.

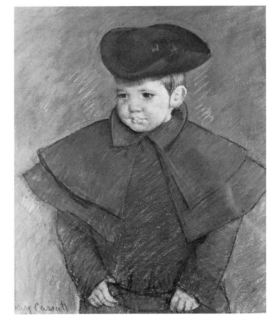

294
Portrait of Gardiner G. Hammond and George Fiske Hammond 1898
Pastel on tan paper, 20 × 24½ in., 51 × 62 cm.
Signed lower left: *M. Cassatt*

Description: Young Gardiner stands at right with his right arm around his little brother's shoulder. He looks toward left, his brown eyes serious. His brown hair, brushed forward, is cut short. He wears a white apron over a bluish white yoke. His little brother wears a simple white dress. He looks toward the right. His bare arms and both hands show. The background is in shades of blue.

Collections: George Fiske Hammond, Santa Barbara, California.

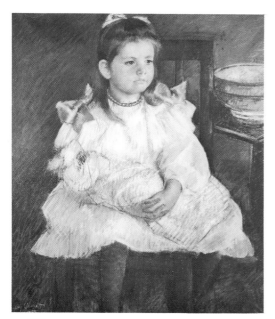

295
Portrait of Frances L. Hammond as a Child
1898
Pastel, 30½ × 25 in., 77.5 × 63.5 cm.
Signed lower left corner: *Mary Cassatt/1898*

Description: Young Frances, looking to right, sits on a straight, wooden chair holding a doll wrapped in a blanket in her arms. She wears a white dress with large bows on the shoulders and a bow on her hair as well. A large bowl rests on the stand beside her.

Collections: Private collection, Santa Barbara, California.

Exhibitions: Fogg Art Museum, Cambridge, Mass., 1943.

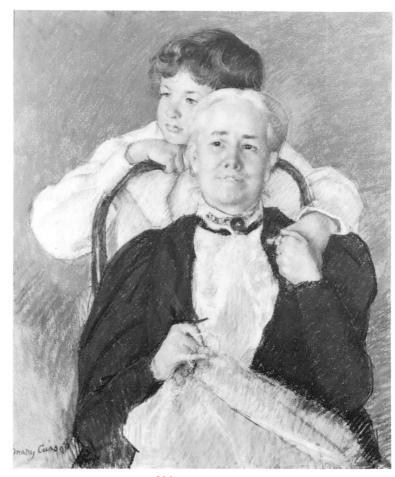

296
Grandmother and Grandson c. 1899
Pastel, 28 × 23 in., 71 × 58.5 cm.
Signed lower left: *Mary Cassatt*

Description: The grandmother is seated on a bentwood chair, smiling and looking slightly to left. She holds her sewing in her right hand, the light blue material forming a triangle in foreground. She wears a black dress with a white jabot. Her left hand is raised to clasp that of her young grandson who stands behind her and leans his head on the chair back. The background is gray.

Collections: Private collection, Greenwich, Connecticut.

297
**Portrait of a Grand Lady
(Mrs. John Howard Whittemore)** 1898
Pastel, 28 × 23 in., 71 × 58 cm.
Signed lower left: *Mary Cassatt*

Description: The lady is seated, looking off to left, her left hand raised with forefinger held along her cheek. Her gray hair is brushed back with a few curls over her forehead. She wears a gray dress with a white yoke trimmed in lace and a gray ribbon sash. Dark background.

Collections: Private collection, Middlebury, Connecticut.

Exhibitions: Baltimore Museum of Art, 1941–42 (cat. 32); Wildenstein, New York, 1947 (cat. 28); Art Institute of Chicago and Metropolitan Museum of Art, New York, "Sargent, Whistler and Mary Cassatt" (cat. 23, illus.), 1954; Baltimore Museum of Art, "Manet, Degas, Berthe Morisot and Mary Cassatt" (cat. 117), 1962.

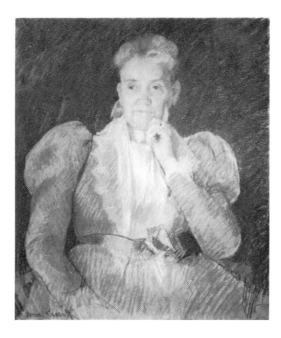

298
Mrs. Harris Whittemore and Baby Helen
c. 1898
Pastel on paper, 23 × 19 in., 58.5 × 48.3 cm.
Signed lower left: *Mary Cassatt*

Description: A blond baby with short hair is held up by her mother, whose dark hair and eyes form a contrast. The baby's right hand rests on the mother's cheek, the left one shows prominently on her long white dress. The mother's dress has a high neck and large sleeves.

Collections: Austin L. Adams, Jr., Los Angeles, California.

Exhibitions: Baltimore Museum of Art, 1941–42 (cat. 33).

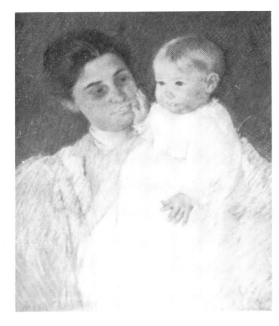

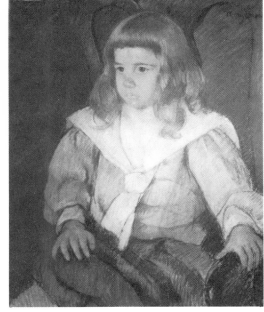

299
Boy with Golden Curls
(Harris Whittemore, Jr.) 1898
Pastel, 21½ × 19½ in., 54.7 × 49.6 cm.
Signed upper right: *Mary Cassatt*

Description: Young Harris sits in a chair, his left hand resting on its rounded arm. He looks to left, his golden curls falling over the broad white collar of his blue suit.

Collections: Harris Whittemore, Jr., Naugatuck, Connecticut.

Exhibitions: Baltimore Museum of Art, 1941–42 (cat. 34); Wildenstein, New York, 1947 (cat. 29, illus.).

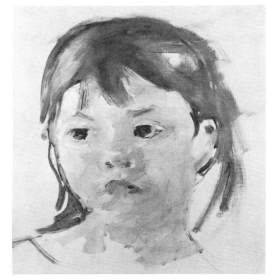

300
Sketch of Ellen Mary Cassatt c. 1899
Oil on canvas, 8¾ × 8 in., 22.5 × 20.5 cm.
Unsigned

Description: Head of Ellen Mary done very rapidly with broad strokes of the brush. Her dark hair has some stray bangs across the forehead and hangs back over her shoulder at left, with a few ends hanging away from her head at right.

Collections: From the artist to the Haviland family; *private collection,* Paris.

301
Ellen Mary with Bows in Her Hair c. 1899
Oil on canvas, 17¼ × 22 in., 44 × 56 cm.
Signed lower right: *Mary Cassatt*

Description: Head and shoulders of Ellen Mary looking to right, seen in three-quarter view. Her dark hair is parted in the middle and tied back with two yellow bows as it hangs down her back. She wears a white dress with a high neck. The background is grayish-green.

Note: Also called "Little Girl in a White Dress."

Collections: Estate of Mrs. Horace Binney Hare, Philadelphia, Pennsylvania.

Exhibitions: Haverford College, 1939 (cat. 15).

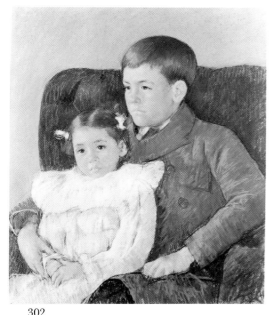

302
Gardner and Ellen Mary Cassatt 1899
Pastel on paper, 25 × 18¾ in., 63.5 × 48 cm.
Signed lower right corner: *Mary Cassatt*

Description: The sister is seated on her brother's
lap in a large chair upholstered in blue-green. He
holds her right wrist with his right hand while he
looks to left. She looks at the spectator. She wears
a pink dress with a white ruffled yoke and little
white ribbons tying back her parted hair. His suit
is dove gray, his hair light brown, and his tie blue.
The background is bright green.

Collections: Mrs. Gardner Cassatt, Villanova, Penn-
sylvania.

Exhibitions: Pennsylvania Academy of the Fine
Arts, Peale House Gallery (cat. 45), 1955;
Philadelphia Museum of Art, 1960; M. Knoedler
& Co., New York, 1966 (cat. 31); Parrish Art
Museum, Southampton, N.Y., 1967 (cat. 17).

Reproductions: *Apollo*, n.s. vol. 83 (April 1966),
pp. 303–04.

303
Ellen with Bows in Her Hair, Looking Left
1899
Pastel on paper, 22 × 17¼ in., 56 × 44 cm.
Signed lower right: *Mary Cassatt*

Description: A little girl with dark hair and eyes
looking to left. She wears two bows in her hair,
which is parted in the middle and cut rather short.
The face and hair are developed, the dress sketched
lightly, showing a wide bertha extending over the
shoulders. Arms are indicated but not hands.

Note: Also called "Buste d'enfant." Durand-Ruel
4049-L7070.

Collections: Mme. Veuve Diaz, May 1902;
Durand-Ruel, New York, 1903; Charles H. Foced,
1904; present location unknown.

Exhibitions: Durand-Ruel, New York, 1903 (cat.
24).

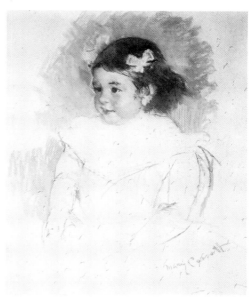

304
Ellen with Bows in Her Hair, Looking Right
1899
Pastel on paper, 23 × 17¼ in., 58.5 × 44 cm.
Signed center right: *Mary Cassatt*

Description: Head and shoulders of a little girl with
dark hair and eyes looking to right. She wears
two bows and flowers in her hair, which is parted
in the middle and curls over her ears. She wears
a high-necked, light blue dress with a round
bertha. Gray background.

Note: Durand-Ruel 9159-LD12093

Collections: Durand-Ruel, New York; to *Mr. and
Mrs. Albert L. Reeves, Jr.*, Hillsborough, California,
purchased through Effie Seachrist, Kansas City,
Missouri, c. 1920.

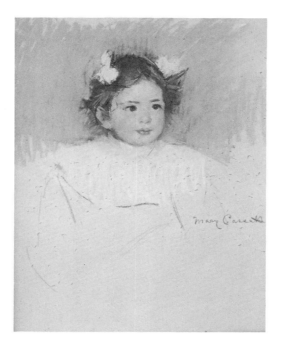

305
Ellen Seated Holding an Apple 1899
Pastel on paper, 22 × 17¼ in., 56 × 44 cm.
Signed lower right: *Mary Cassatt*

Description: Three-quarter length view of a little
girl with dark hair and eyes looking to left. She
wears pink bows in her brown, parted, short hair
and a light blue dress with a ruffled yoke. She
holds a red apple with both hands in her lap
Neutral greenish tan background.

Note: Durand-Ruel 4048-L7074.

Collections: Cyrus J. Lawrence, 1903; to Richard
H. Lawrence; American Art Association sale,
New York, 28–29 Jan. 1926 (cat. 170); to *private
collection*, Denver, Colorado.

Exhibitions: Durand-Ruel, New York, 1903 (cat.
25); M. Knoedler & Co., London, "Nineteenth
Century French Painting" (cat. 21), 1928.

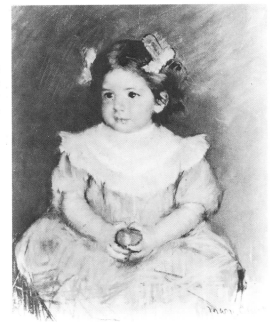

306
**Portrait of Adaline Havemeyer in a
White Hat** c. 1899
Pastel on paper, 25½ × 21 in., 64.7 × 53.3 cm.
(sight)
Signed upper right: *Mary Cassatt*

Description: Half-length portrait of Adaline (later
Mrs. Frelinghuysen) wearing a fluffy white hat
with pink overtones against a greenish-blue back-
ground. Her dress is also white with some pink
shadows.

Collections: From the artist to Mrs. H. O. Have-
meyer; to her daughter, Adaline Havemeyer
Frelinghuysen; to her daughter, Mrs. Emmet; to
her brother, *Peter H. B. Frelinghuysen*, Morristown,
New Jersey.

Exhibitions: Parrish Art Museum, Southampton,
N.Y., 1967 (cat. 20).

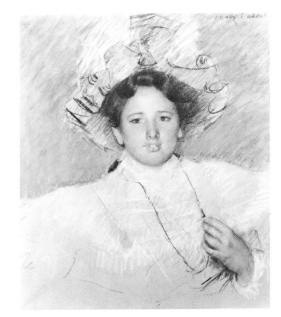

307
**Portrait of Mme. A. F. Aude and Her
Two Daughters** 1899
Pastel on gray paper, 21⅜ × 31⅞ in., 54.4 × 81 cm.
Signed lower right: *Mary Cassatt*

Description: Bust-length view of Mme. Aude look-
ing at spectator with her younger daughter seated
in front of her to the right and the older one stand-
ing to the left with her right arm over her mother's
chest to embrace her. Both children look to the
right. They both have long dark hair tied with a
small bow. Background dark.

Note: Mme. Aude was the sister of Joseph, Charles,
and Georges Durand-Ruel. The older daughter,
Madeline, became the Comtesse de Brecey; the
younger, Thérèse, the Vicomtesse de Montfort.
Durand-Ruel 10450-LD13146.

Collections: Durand-Ruel, Paris.

Exhibitions: Galerie Charpentier, Paris, "La Vie
Familiale" (cat. 35), 1944; Art Institute of
Chicago and Metropolitan Museum of Art, New
York, "Sargent, Whistler and Mary Cassatt" (cat.
24, illus.), 1954; Centre Culturel Américain,
Paris, 1959 (cat. 9).

Reproductions: Frederick A. Sweet, 1966, pl. 20,
fol. p. 204; Julia Carson, 1966, p. 100.

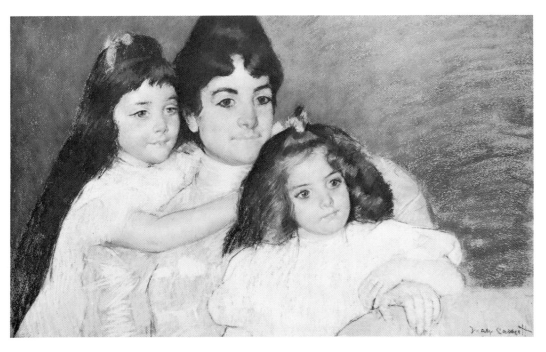

308
Madame Meerson and Her Daughter
c. 1899
Pastel, 23½ × 28¾ in., 60 × 73 cm.
Signed upper left: *Mary Cassatt*

Description: Mme. Meerson is seated looking slightly to left. She is seen to the waist, wearing a striped dress. Her auburn hair, with soft fringe on her forehead, is piled high on her head. Her much more brunette daughter has her left arm around her mother's neck with her hand falling over mother's shoulder. She looks at the spectator, her long dark curls falling forward over her dress. The background is shaded rose color.

Note: Durand-Ruel 9062-L11668.

Collections: Mme. Meerson, Paris; to Maurice Delacre; Delacre sale, Paris, 15 Dec. 1941 (cat. A); Parke-Bernet sale, 13 April 1949; to Dr. Morris H. Saffron; to Hirschl & Adler, 1968; **to Reynolda House, Inc., Winston-Salem, North Carolina.**

Exhibitions: Newark Museum, 1964; Metropolitan Museum of Art, New York, 1967.

Reproductions: *Arts*, vol. 42 (May 1968), p. 49; *Art News*, vol. 67, no. 7 (Nov. 1968), p. 51.

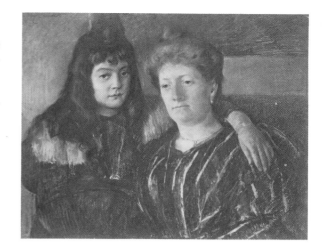

309
Young Girl in a Park Landscape 1899
Oil on canvas, 29 × 24⅛ in., 73.7 × 61.3 cm.
Signed lower left: *Mary Cassatt*

Description: A young girl is seated on a slope with a broad park landscape and winding river in background. She wears a ruffled lace hat with black ribbon and bow on it. Her light pink dress with ruching at the neck has elaborate black puffs on the sleeves. In her left hand she holds a long piece of grass to her mouth.

Note: Also called "Jeune fille dans un parc" and "Portrait of a Young Girl." D-R 1631.

Collections: From the artist to James Stillman, Paris; to the *Metropolitan Museum of Art*, New York, anonymous gift, 1922.

Exhibitions: Smith College, Northampton, Mass.,

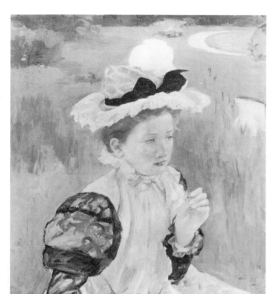

1928 (cat. 5); Baltimore Museum of Art, 1941–42 (cat. 31); Metropolitan Museum of Art, New York, 1950 (cat. 2); IBM Gallery, New York, "Realism: An American Heritage," 1963; Metropolitan Museum of Art, New York, "Three Centuries of American Painting," 1965; M. Knoedler & Co., New York, 1966 (cat. 30); M. H. de Young Memorial Museum, San Francisco, "American Paintings from the Metropolitan Museum of Art" (cat. 101), 1966; Parrish Art Museum, Southampton, N.Y. (cat. 10, illus.).

Reproductions: Gustave Geffroy, *Les modes*, vol. 4 (Feb. 1904), p. 10; Achille Segard, 1913, opp. p. 92; André Mellerio, *L'art et les artistes*, vol. 12 (Nov. 1910), p. 70; *Bulletin: Metropolitan Museum of Art*, New York, vol. 17 (March 1922), p. 57; *Art News*, vol. 49 (June 1950), p. 36; *Emporium*, vol. 113, no. 673 (Jan. 1951), p. 39; *Washington Evening Star*, 2 June 1969.

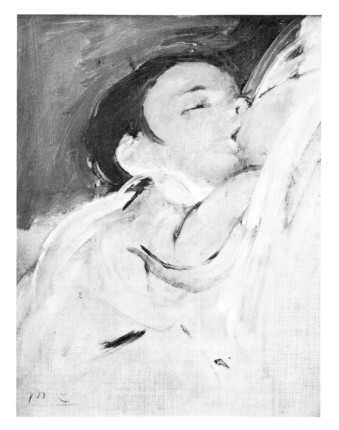

310
Sleeping Baby at Mother's Breast c. 1899
Oil on canvas, 9 3/16 × 7⅛ in., 24 × 18 cm.
Signed lower left: *M. C.*

Description: Baby's mouth is slightly open as he falls asleep at his mother's breast. His head and arm and a part of her breast form the entire composition against a green background. There are light pink strokes giving rhythmic strength to the sketch, with some deep red strokes close to the green background.

Collections: Mr. and Mrs. Georges E. Seligmann, New York; present location unknown.

311
Mother Louise, Nursing Her Baby 1899
Pastel, 28½ × 21 in., 72.4 × 53.4 cm.
Signed lower left: *Mary Cassatt*

Description: A baby nursing at his mother's breast
has his eyes open and looks up at his mother. His
left hand rests on the mother's breast. His bare
right foot is seen under mother's right arm as she
rests her hand on his other leg. She has dark hair
and wears a black satin blouse with long sleeves
and a dark skirt.

Note: Edith Valerio wrote: "It was in 1899 that
Mary Cassatt gave the full measure of her art
in a pastel entitled 'Mother Nursing Her Child';
a veritable chef d'œuvre in its execution and its
sentiment" (p. 9). The model is Louise Fissier
of Fresneaux, Mont Chevreuil. Durand-Ruel
1285-L5154.

Collections: From the artist to Mme. d'Alayer de
Costemore d'Art, April 1899; to *Collection d'Alayer*,
France.

Exhibitions: Manchester, England (organized by
Durand-Ruel, Paris), 1907 (cat. 69); Durand-
Ruel, Paris, 1908 (cat. 44).

Reproductions: L'art decoratif, vol. 4 (Aug. 1902),
p. 179; *Les modes*, vol. 4 (Feb. 1904), p. 5; André
Mellerio, *L'art et les artistes*, vol. 12 (Nov. 1910),
p. 70; Achille Segard, 1913, fol. p. 88; *Good
Housekeeping Magazine*, vol. 58 (Feb. 1914), p. 152;
Edith Valerio, 1930, pl. 12; *La renaissance*, vol. 13
(Feb. 1930), pp. 55–56; Forbes Watson, 1932,
p. 35.

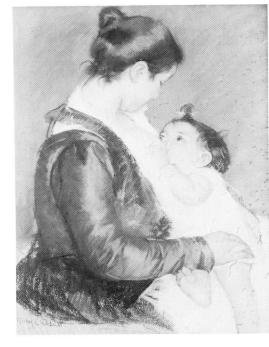

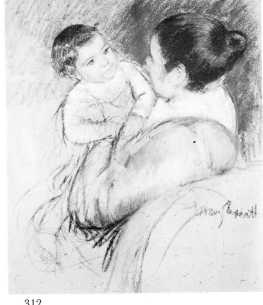

312
**Mother Louise Holding up Her
Blue-eyed Child** c. 1899
Pastel on gray cardboard, 27 × 22 in.,
68.7 × 56 cm.
Signed toward lower right: *Mary Cassatt*

Description: A mother wearing a bright orange
blouse with a white yoke edged at the neck with
pink sits on a chair upholstered in blue, her face
in only one-quarter view, her black hair in a high
bun at the back. She holds up her baby who looks
to right, her left hand on her mother's breast.
She has short dark hair and very blue eyes and
wears a white dress. Background is variegated
blue-green.

Collections: In Hôtel Drouot sale, Paris, 10 March
1944 (cat. 13); Galerie Charpentier sale, 17 June
1958; to de Poplavsky; to Fred A. Van Braam,
Holland; Parke-Bernet sale, New York, Oct.
1968; to Beilen Gallery, New York.

Exhibitions: Durand-Ruel, Paris, 1924 (cat. 5).

Reproductions: Burlington Magazine, vol. 110 (April
1968), p. x.

313
**Mother Louise Holding up Her
Blue-eyed Child (Counterproof)**
Pastel on paper, 33 × 25¼ in., 81 × 64 cm.
Signed in reverse at left: *Mary Cassatt*

Description: Reverse of BrCR 312.

Note: Without any retouching or finishing.
National Museum, Belgrade, inventory 349.

Collections: From the artist to Ambroise Vollard,
Paris; to Mr. Clomovich, Yugoslavia; to the
National Museum, Belgrade, Yugoslavia, acquired
1949.

314
Mother Rose Nursing Her Child c. 1900
Pastel on tan paper, 28¼ × 22¾ in., 71.7 × 57.7 cm.
Signed lower right: *Mary Cassatt*

Description: A mother with dark brown pompa-
doured hair looks down at her baby, with her face
foreshortened to left. The baby, with his round,
bald head toward lower left, is nursing at her
breast. She holds his right arm with her left hand.
She wears an emerald green gown and sits on a
chair upholstered in orange. The background is a
darker green.

Note: Hirschl & Adler 3432-D. Durand-Ruel
13919.

Collections: Mrs. Montgomery Sears; to Elizabeth
Taylor (the actress); to M. Knoedler & Co., New
York (c. 1957); to Mrs. Dunbar W. Bostwick,
who presented it to *Shelburne Museum*, Vermont,
collection of Electra Havemeyer Webb fund.

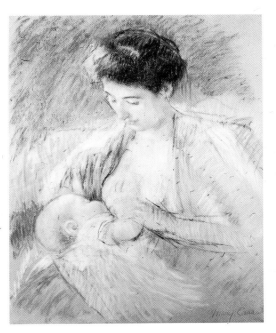

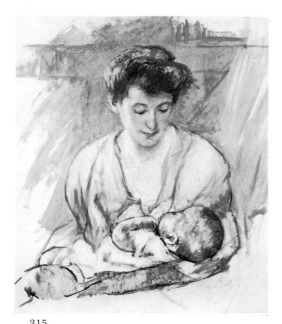

315

**Mother Rose Looking Down at Her
Sleeping Baby** c. 1900

Oil on canvas, 28 × 23 in., 71 × 58.5 cm.
Unsigned. Mathilde X collection stamp toward
lower right

Description: A sketch of a mother looking down at
her child asleep on her lap. The baby's left arm
is bent with his hand under his chin. His head
rests on her left arm. The mother's hair is brown,
her dress tan, with an edge of sienna. A pink
curtain of the baby's crib at right. The rest of the
background is grayish blue.

Note: Also called "Maternité," "Le repos," and
"Jeune femme tenant sur ses genoux un bébé
couché."

Collections: From the artist to Mathilde Vallet,
1927; Mathilde X sale, Paris, 1931; *Mr. and Mrs.
Neville Blond*, London.

Exhibitions: Galerie A.-M. Reitlinger, Paris, 1931
(**cat.** 5, illus.).

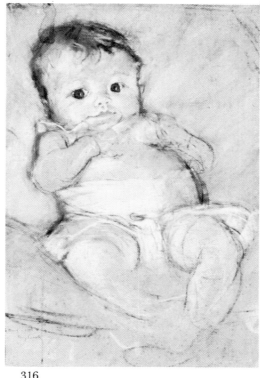

316

Nancy Lying on a Pillow 1900

Pastel on paper, 7 × 5 in., 18 × 12.7 cm.
Signed lower left: *To Nancy 1900/Mary Cassatt*

Description: An infant lies contentedly on a big
pillow wearing only a bellyband and diaper. Her
two hands rest on her chest; her legs are bent and
her feet (not fully described) together. She has
dark hair and looks at the spectator with big dark
eyes.

Collections: Private collection, Hollywood, Florida.

Reproductions: Connoisseur, vol. 158 (April 1965),
p. xxxiv.

317

Slight Sketch of Baby Nursing c. 1900

Pastel on tan paper, 27 × 17½ in., 68.6 × 44.5 cm.
Unsigned. Mathilde X collection stamp at lower
right

Description: A summary sketch of a dark-haired
baby nursing at the breast, facing right. Its
right arm and both legs are unfinished and are
heightened with bright pink pastel.

Collections: From the artist to Mathilde Vallet,
1927; Mathilde X sale, Paris, 1931; present
location unknown.

Exhibitions: Galerie A.-M. Reitlinger, Paris, 1931
(cat. 15, illus.).

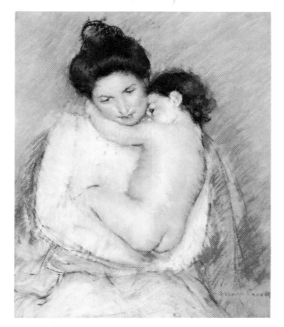

318

Sleepy Nicolle c. 1900

Pastel, 28 × 23 in., 71 × 58.5 cm.
Signed lower right: *Mary Cassatt*

Description: A sleepy nude child leans her head
on her mother's left shoulder so that only her eye
and eyebrow are in view. Her left arm encircles
her mother's neck as the mother leans her cheek
against it. The child's curly hair is dark auburn;
the mother's black hair is piled high. She gazes
toward the floor and looks as though rocking her
child to a lullaby. The mother's dress is white,
outlined on either side with an orange scarf. The
background is light blue.

Note: Also called "Mother Holding Child."

Collections: From the artist to Ambroise Vollard,
Paris; to E. and A. Silberman Galleries, New
York; to Dr. John Jay Ireland, Chicago; be-
queathed to the *Art Institute of Chicago*, 1968.

Exhibitions: Art Institute of Chicago and Metro-
politan Museum of Art, New York, "Sargent,
Whistler and Mary Cassatt" (cat. 25, illus.), 1954.

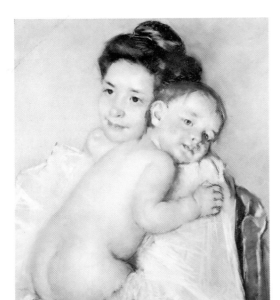

319
Mother Berthe Holding Her Nude Baby
1900
Pastel, 22⅝ × 17⅛ in., 57.5 × 43.5 cm.
Signed lower right corner: *Mary Cassatt*

Description: A mother holds her nude baby with his head on her left shoulder facing to right and looking at the spectator. Her right hand is shown supporting him at lower left. She looks off to left. Her hair is dark and she wears a filmy, ruffled gown. A wooden chairback is seen at right.

Note: Also called "The Young Mother." Durand-Ruel A6271.

Collections: Albert Pra, Paris; Hôtel Drouot, Paris, Pra sale, 17 June 1938 (cat. 3); to M. Knoedler & Co., New York; to Mme. Mayer, Paris; to *Dr. Chester J. Robertson*, Pelham, New York.

Exhibitions: Durand-Ruel, New York, 1924 (cat. 12); M. Knoedler & Co., New York, "Pictures of Children," 1941; Baltimore Museum of Art, 1941–42 (cat. 40).

Reproductions: Achille Segard, 1913, fol. p. 108.

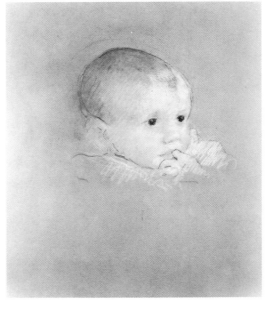

320
Head of a Baby with Finger in Mouth
c. 1900
Pastel on blue paper, 18 × 14½ in., 45.7 × 36.7 cm.
Unsigned. Mathilde X collection stamp at lower left

Description: A baby looks off to right with thumb or finger in mouth. Head well-shaped with very little hair.

Collections: From the artist to Mathilde Vallet, 1927; Mathilde X sale, Paris, 1931; *Miss Carole Slatkin*, New York.

Exhibitions: Galerie Jacques Dubourg, Paris, 1961 (illus.).

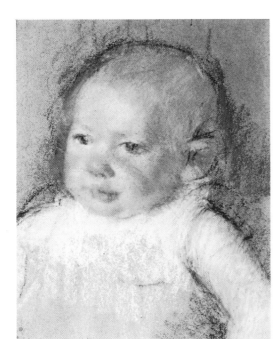

321
Baby Charles 1900
Pastel, 12½ × 9¼ in., 32 × 23.5 cm.
Unsigned

Description: A baby's head developed above a white bib. His blue eyes look to left. There is dark accenting around the outlines of head, arm, ear, and also on the eyes.

Collections: From the artist to Payson Thompson; American Art Association, New York, Thompson sale, 12 Jan. 1928 (cat. 70); to John Levy and L. C. Rosenbaum, Albuquerque, New Mexico; to *Joseph Hirshhorn Foundation*, New York.

322
Baby Charles Looking Over His Mother's Shoulder (No. 1) c. 1900
Pastel, 21¼ × 25½ in., 54 × 65 cm.
Signed lower right: *Mary Cassatt*

Description: The mother is seen from the rear, her light brown hair brushed up with a knot on top, ear showing. She wears an orange dress with V-neck in back. The blue-eyed baby looks to left with a rather sober expression. Many outlines reinforced.

Note: Also called "Young Woman with Baby in Her Arms" and "Jeune femme de profil, un enfant dans les bras, ce dernier vu de face." Durand-Ruel 10451-LD13158.

Collections: From the artist to Mathilde Vallet, 1905; Mathilde X sale, Paris, 1927; to Durand-Ruel, Paris; to Durand-Ruel, New York; in a Swiss collection, 1948–62; International Galleries, Chicago; to *Mrs. Samuel E. Johnson*, Chicago.

Exhibitions: Gallerie A.-M. Reitlinger, Paris, 1927 (cat. 59).

Reproductions: Connoisseur, vol. 160 (Nov. 1965), p. lxxviii.

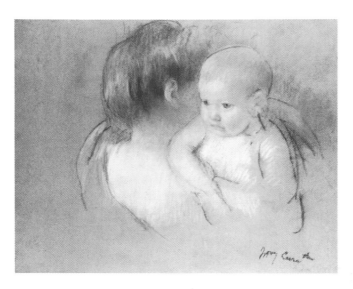

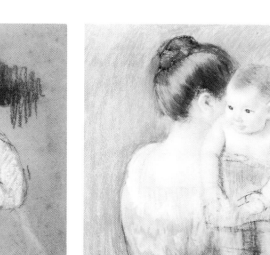

324
Baby Charles Looking Over His Mother's Shoulder (No. 2) c. 1900
Pastel on paper, 28 × 23⅝ in., 71 × 60 cm.
Signed lower left, with some added words erased: *Mary Cassatt*

Description: Half-length view of the mother's back, her hair brushed up to a knot on top, showing an ear. Her happy-looking baby hangs both of his arms over her right arm with which she clasps him. She wears a low-necked gown of soft material with a lavender ground, with salmon and blue flowers and a white lace fichu. The baby wears a bright blue necklace. His hair is light brown, the mother's is darker. The background is greenish-gray.

Collections: Private collection, Paris.

323
Baby Charles: Head and Arms 1900
Pastel on dark tannish-gray cardboard, 23 × 18 in., 58.5 × 45.7 cm.
Signed and inscribed lower right: *To my friend/Elizabeth Nourse/Mary Cassatt*

Description: The baby is shown alone, looking left, his right arm hanging down, his left one bent. He has dark short hair.

Collections: Mr. and Mrs. Henry Fletcher Kenny, Cincinnati, Ohio.

325
Baby Charles Looking Over His Mother's Shoulder (No. 3) c. 1900
Oil on canvas, 28 × 20⅞ in., 71 × 53 cm.
Signed lower left: *Mary Cassatt*

Description: The baby has a bright, happy expression as he looks to left over his mother's shoulder, resting his arms on her shoulder with his little hands crossed. The mother, seen from the rear, wears a bright orange-red gown with a low V-neck in back. Her face is reflected in the oval mirror at the upper right corner of the canvas.

Note: Also called "The Mirror."

Collections: Cyrus J. Lawrence; American Art Association, New York, C. J. Lawrence sale (cat. 66), 1910; to Alexander Morten; American Art Association, New York, Ingles, Morten, Lawrence collections sale, 29 Jan. 1919; to the *Brooklyn Museum* (Carl H. De Silver Fund).

Exhibitions: Art Gallery of Toronto, 1932; Brooklyn Institute of Arts & Sciences, "Leaders of American Impressionism: Mary Cassatt, Childe Hassam, J. H. Twachtman, and J. Alden Weir" (cat. 34), 1937; Baltimore Museum of Art, 1941–42 (cat. 60); Wildenstein, New York, 1947 (cat. 31); Pasadena Art Institute, 1951 (cat. 4); Parrish Art Museum, Southampton, N.Y., 1967 (cat. 3).

Reproductions: Gustave Geffroy, *Les modes*, vol. 4 (Feb. 1904), pp. 4–11; André Mellerio, *L'art et les artistes*, vol. 12 (Nov. 1910), p. 71; Achille Segard, fol. p. 92; Bernard S. Myers, *Lessons in Art Appreciation*, 1937 (cat. 1, p. 5); Margaret Breuning, 1944, p. 33.

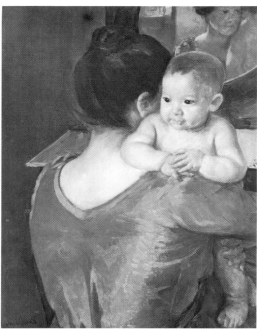

326
Nicolle and Her Mother c. 1900
Pastel on paper, 25⅛ × 20¾ in., 64 × 53 cm.
Signed lower right: *Mary Cassatt*

Description: A baby leans forward on her mother's lap to hold her leg with her right hand. She looks off to left. She has auburn hair and dark eyes. Her mother looks soberly toward the right, dressed in a light pink dress, her black hair in a high pompadour.

Note: Hirschl & Adler 4542.

Collections: Sidney Levyne, Baltimore, Maryland; Mrs. Dunbar Bostwick, Shelburne, Vermont; *Des Moines Art Center*, 1966.

Reproductions: Apollo, n.s. vol. 81 (March 1965), p. xcvi; *Art Quarterly*, vol. 29, no. 3 (1966), p. 312; *Gazette der beaux arts*, s6, vol. 69 (Feb. 1967), p. 101.

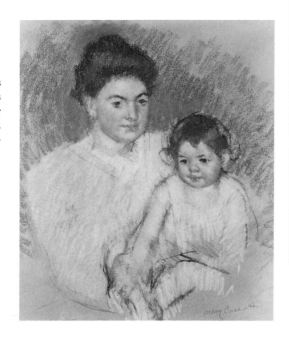

327
Nicolle and Her Mother (Counterproof)
Pastel on paper, 30¾ × 23⅜ in., 78.2 × 59.5 cm.
Signed in reverse, lower left: *Mary Cassatt*

Description: Reverse of BrCR 326.

Note: National Museum, Belgrade, inventory 347.

Collections: From the artist to Ambroise Vollard,
Paris; to Mr. Clomovich, Yugoslavia; to the
National Museum, Belgrade, Yugoslavia, acquired
1949.

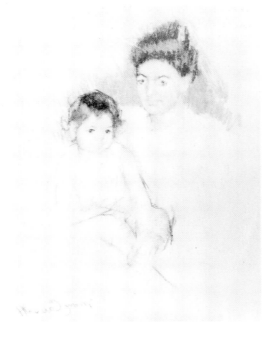

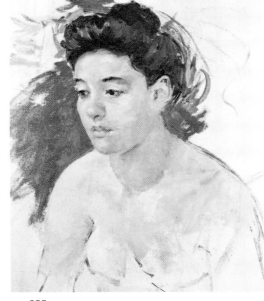

328
Sketch of Antoinette (No. 1) c. 1901
Oil on canvas, 19½ × 16 in., 49.6 × 40.7 cm.
Unsigned. Mathilde X collection stamp on verso

Description: A study of the head and shoulders of
a woman, with a suggestion of nude breasts. The
head is carefully developed against a dark back-
ground at the left. Her hair and eyes are black.
She looks to the left.

Note: Also called "Buste de femme" and "Jeune
femme le buste découvert." Durand-Ruel
11152-L13536.

Collections: From the artist to Mathilde Vallet,
1927; Mathilde X sale, Paris, 1927; to M.
Zambaux; to Mr. Müller; to Durand-Ruel, Paris,
1934; to *Mme. Belval*, Paris, 1941.

Exhibitions: Galerie A.-M. Reitlinger, 1927 (cat.
74).

329
Sketch of Antoinette (No. 2) c. 1901
Oil on canvas, 24½ × 21 in., 62.3 × 53.5 cm.
Unsigned

Description: Head and shoulders of a young woman
turned toward left and looking to left. Her features
are well developed, with a dark background close
to her right cheek. Her hair is just summarily
sketched. (The sketch was at one time set in an
oval frame, cutting off many dashing strokes in
background and lower foreground.)

Note: Also called "Study of a Head" (in Payson
Thompson sale catalogue). Hirschl & Adler
1332.

Collections: From the artist to Payson Thompson;
American Art Association, New York, Thompson
sale, 12 Jan. 1928 (cat. 88, illus.); Sessler collec-
tion, Philadelphia; to Harris Masterson; present
location unknown.

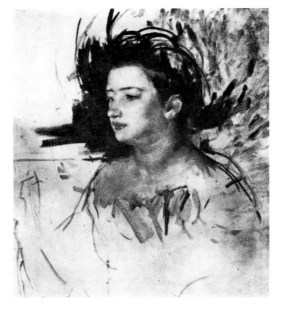

330
Head of Jules 1901
Oil on canvas, 13¼ × 10¼ in., 33.7 × 26 cm.
Signed above head toward left: *Mary Cassatt*

Description: Head and shoulders of a small boy
looking somewhat down to right. His hair is dark,
his shoulders bare. Plain background.

Note: Sotheby & Co., London, A5937 & A5662.

Collections: Mrs. Edward Hutton, Westbury, New
York; sold Sotheby & Co., London, 1 July 1964
(called "Buste d'enfant"); to Edgardo Acosta
Gallery Ltd., Beverly Hills, California.

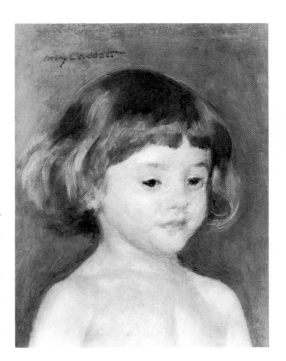

331

Jules Standing after His Bath c. 1901

Oil on canvas, 25½ × 20 in., 65 × 51 cm.
Signed lower left: *Mary Cassatt*

Description: Three-quarter length figure of a boy
with a large towel draped around him standing
somewhat to right facing spectator. Plain blue-
green background.

Note: Also called "Petite fille sortant du bain."
Sotheby & Co., London, A6514.

Collections: Senator Antonio Santamarina, Buenos
Aires; sold Sotheby & Co., London, 29 Nov.
1964; to Mr. Raynor (lot 140); to Gulf American
Corporation, Rosen Brothers, Miami, Florida.

Reproductions: Burlington Magazine, vol. 106 (Oct.
1964), p. vi.

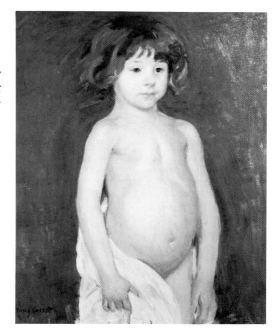

332

Jules Dried by His Mother 1901

Oil on canvas, 36¼ × 28¾ in., 92 × 73 cm.
Signed lower left: *Mary Cassatt*

Description: Jules, with dark, disheveled hair, stands
by his mother while she dries him with a large
white towel. His arms are at his sides with his
right hand touching that of his mother. She looks
up at him. Her dark hair is fixed in a pompadour.
She wears a light dress cut with a low V-neckline.

Note: Also called "La sortie du bain" and "Après
le bain." Durand-Ruel 1629-L 6194.

Collections: From the artist to Durand-Ruel, Paris,
1901; to Durand-Ruel, New York, 1913; to
Gertrude Whittemore, 1921; to *private collection,*
Middlebury, Connecticut.

Exhibitions: Durand-Ruel, New York, 1903 (cat.
11); St. Botolph's Club, Boston, 1909 (cat. 18);
M. Knoedler & Co., New York, 1915 (cat. 45);
Albright Art Gallery, Buffalo, 1917; Corcoran
Gallery of Art, Washington, D. C., 7th biennial,
1919–20 (cat. 65); Durand-Ruel, New York 1920
(cat. 12); Durand-Ruel, New York, 1924 (cat. 7);
Durand-Ruel, New York, 1926 (cat. 6); Penn-
sylvania Museum of Art, Philadelphia, 1927
(cat. 1).

Reproductions: Good Housekeeping Magazine, vol. 50
(Feb. 1910), p. 145; *Bulletin, Albright Art Gallery,*
Buffalo, 1917, p. 45; *Literary Digest,* vol. 90 (10
July 1926), p. 26; *Survey,* vol. 57 (1 Dec. 1926),
p. 273; *La renaissance,* vol. 13 (Feb. 1930), p. 53.

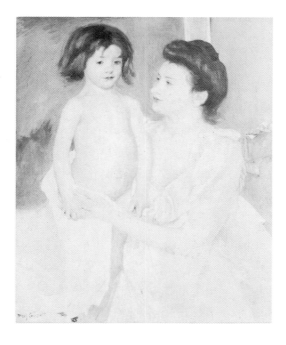

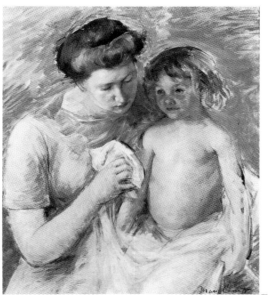

333

Jules Being Dried after His Bath 1901

Oil on canvas, 28¾ × 23½ in., 73 × 60 cm.
Signed lower right: *Mary Cassatt*

Description: Jules sits on his mother's lap at right
and looks off to left, his face in shadow. His
mother leans over, her head foreshortened, to dry
him with a large towel which covers his lower
limbs. She holds the towel in her right hand. This
is a broadly treated sketch.

Note: Durand-Ruel 7904-D10571.

Collections: From the artist to Durand-Ruel, 1914;
to *Mme. Jean Pierre,* Paris, 1941.

Exhibitions: Concord Art Association, Concord,
Mass., 7th annual exhibition of paintings and
sculpture, 1923 (cat. 9).

334

Jules Standing by His Mother c. 1901

Oil on canvas, 25¼ × 23½ in., 64 × 59.7 cm.
Signed lower right: *Mary Cassatt*

Description: Half-length view of Jules, nude, turned to left and looking off to left, with his mother, who wears a dark gray robe embroidered in pink and green with a white scarf around her neck. Her face is foreshortened as she looks down to dry her son with a towel, which is just suggested. The background is variegated green and ochre.

Note: Also called "Après le bain."

Collections: Mr. and Mrs. Harry L. Seay, Jr., Tulsa, Oklahoma.

Exhibitions: St. Botolph's Club, Boston, 1909 (cat. 15); Corcoran Gallery of Art, Washington, D. C., 6th biennial (called "After the Bath"), 1916–17 (cat. 236); Durand-Ruel, New York, 1920 (cat. 10); Carnegie Institute, Pittsburgh, 1928 (cat. 1); Smith College, Northampton, Mass., 1928 (cat. 6); Philbrook Art Center, Tulsa, Oklahoma, "Tulsa Collects" (cat. 22, illus.), 1966.

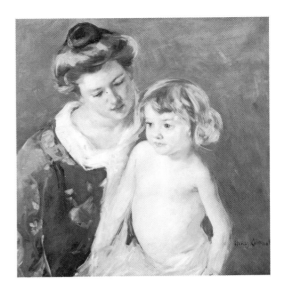

335

Sketch for "The Sun Bath" c. 1901

Oil on canvas, 14¾ × 22½ in., 37.6 × 57 cm.
Signed lower right corner: *M. C.*

Description: A nude child sits on a white sheet spread on the grass. He is at center of canvas. Next to him reclines his mother, her head resting on her elbow at left. The mother wears a pale green dress. Behind them is greenery.

Collections: E. & A. Silberman Gallery, New York, about 1952; to Max Miller, Miami, Florida; on loan to Lowe Gallery, Miami, Florida, 1954; to M. Knoedler & Co., New York; to *Mr. and Mrs. Kenneth A. Ives,* New York, 1961.

Exhibitions: Parrish Art Museum, Southampton, N.Y., 1967 (cat. 4).

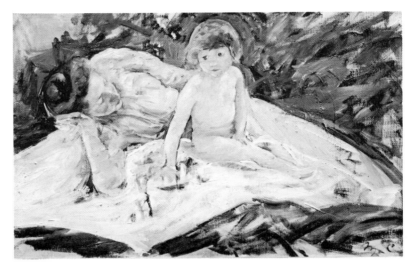

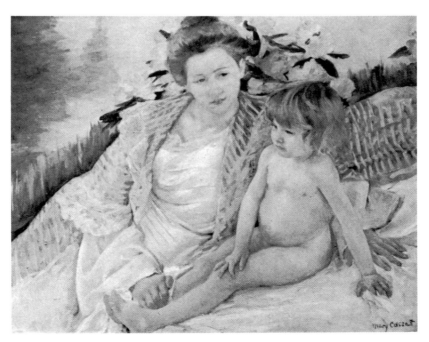

336

The Sun Bath 1901

Oil on canvas, 28¾ × 36¼ in., 73 × 92 cm.
Unsigned

Description: A nude child sits on a sheet spread on the ground, his legs extended to left; his left hand is spread out on the ground, as is his mother's behind him. His right hand rests on his left knee. He looks off to the left. His mother looks at him. Behind her is a clump of lavender magnolia blossoms and leaves.

Note: Also called "Le lever de bébé" and "After the Bath."

Collections: From the artist to Durand-Ruel, 1901; present location unknown.

Exhibitions: Durand-Ruel, New York, 1903 (cat. 8); New Jersey State Museum, Trenton, 1939 (cat. 4); Baltimore Museum of Art, 1941–42 (cat. 36).

337

The Sun Bath, with Three Figures c. 1901

Oil on canvas, 25¾ × 36¼ in., 65.5 × 92 cm.
Signed lower right: *Mary Cassatt*

Description: A nude child is seated outdoors, in profile to right, looking at two women who observe him. The right-hand woman is seen in profile left while the other is shown in three-quarter view left. The background shows the dark green of trees.

Collections: Pétridès Gallery, Paris, c. 1953; to *Mr. and Mrs. George Zauderer*, New York.

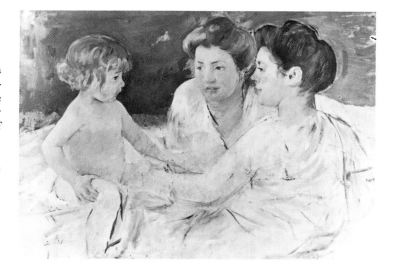

338

The Oval Mirror 1901

Oil on canvas, 32⅛ × 25⅞ in., 81.7 × 66 cm.
Signed lower left faintly: *Mary Cassatt*

Description: A nude boy stands by his mother facing forward and looking off to the left. He has his left arm around her neck. Her right arm encircles his back at the waist while she holds his right hand within hers. She is in profile to left. His blond head is framed by a dark oval mirror behind them. Her gown is white with a blue and white striped overdress.

Note: Like drypoint Br 205 (in reverse). This was the painting which Degas praised, saying it was like an infant Jesus with "his English nurse." Also called "The Florentine Madonna" and "Mother and Boy." Durand-Ruel 1284-L5155.

Collections: From the artist to Mr. and Mrs. H. O. Havemeyer, New York; to the *Metropolitan Museum of Art*, New York, H. O. Havemeyer Collection, 1929.

Exhibitions: St. Botolph's Club, Boston, 1909 (cat. 17); M. Knoedler & Co., New York, "Masterpieces by Old and Modern Painters" (cat. 46), 1915; Art Institute of Chicago, 1926; Pennsylvania Museum of Art, Philadelphia, 1927 (cat. 20); Metropolitan Museum of Art, New York, Havemeyer Collection (cat. 2, illus.), 1930; Society of the Four Arts, Palm Beach, 1959; Cornell University, Ithaca, N.Y., 1965.

Reproductions: Vittorio Pica, "Artisti Contemporanei—Berthe Morisot e Mary Cassatt," *Emporium*, vol. 26, no. 3 (July 1907), p. 16; *Gazette des beaux arts*, s6, vol. 25 (May 1944), p. 303; *Art in America*, vol. 46, no. 2 (Summer 1958), p. 100.

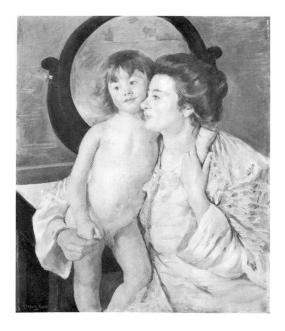

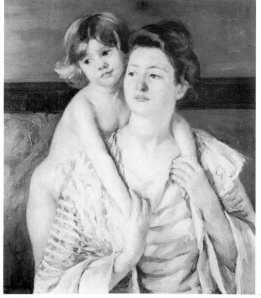

339

Antoinette Holding Her Child by Both Hands
1901

Oil on canvas, 28¾ × 23¾ in., 73 × 60 cm.
Signed: *Mary Cassatt*

Description: A nude child stands behind his mother, reaching both arms forward over her shoulders so that she can hold his hands. Both gaze off to the left. The mother wears a light gown with sky blue and white stripes and dots on the full sleeves. A raspberry couch behind them and gray wall above.

Note: Also called "Mère jouant avec son enfant." Durand-Ruel 1421-L5511.

Collections: Alfred Atmore Pope, Farmington, Connecticut; to Mrs. John Riddle, Connecticut; to Mrs. J. Lee Johnson III, Fort Worth, Texas; to *Karen Carter Lindley*, Fort Worth, Texas.

Exhibitions: Wadsworth Atheneum, Hartford, Conn., for some years before 1946 on indefinite loan; Person Hall Art Gallery, University of North Carolina, Chapel Hill, 1946 (cat. 21); Wildenstein, New York, 1947 (cat. 44); M. Knoedler & Co., New York, 1966 (cat. 35).

Reproductions: Good Housekeeping Magazine, vol. 50 (Feb. 1910), p. 143; Edith Valerio, 1930, pl. 11.

340

Looking at a Picture Book (No. 1) c. 1901

Pastel on paper, 14 × 19 in., 35.5 × 48.2 cm.
Signed lower right: *M. C.*

Description: Heads of woman and a child with blond hair in a white frock; both glance downwards. Shaded blue, green, and yellow background. No indication of book. The child is at left, the mother's head behind the child's left shoulder.

Collections: From the artist to Payson Thompson; American Art Association, New York, Thompson sale, 12 Jan. 1928 (cat. 77); present location unknown.

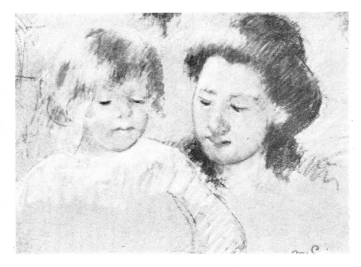

341

Looking at a Picture Book (No. 2) c. 1901

Pastel on paper, 18 × 25 in., 45.5 × 63.3 cm.
Signed upper right: *Mary Cassatt*

Description: A child's head and shoulders in center of picture. She is seen full face, looking down at a book held by her mother, whose face hides the child's left shoulder. The mother is seen in three-quarter view to left. Her hands holding the book are very roughly indicated. She wears a violet colored dress with a black collar.

Note: Also called "Mother and Child Reading" and "La lecture."

Collections: From the artist to Roger-Marx, Paris; Roger-Marx estate sale, Paris, 11–12 May 1914 (cat. 101); sold Sotheby & Co., London, 24 Nov. 1964 (cat. 27, illus.); to O'Hana Gallery, London; to Acquavella, New York; to *private collection*, Philadelphia, Pennsylvania.

Exhibitions: Durand-Ruel, Paris, 1908 (cat. 33); Carnegie Institute, Pittsburgh, 1928 (cat. 37).

Reproductions: Achille Segard, 1913, fol. p. 68.

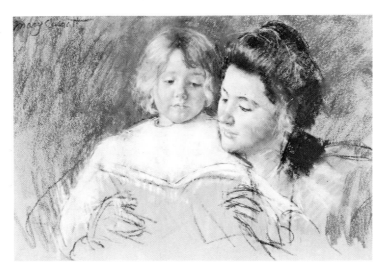

342

Baby Getting up from His Nap 1901

Oil on canvas, 36⅛ × 29 in., 91.7 × 73.7 cm.
Signed lower left on tray: *Mary Cassatt*

Description: A nude baby sits on a bed with a green headboard with his arm around his mother's neck while she dries his feet with a towel. She wears a yellow and orange negligée and looks downward. The child looks brightly to the left. In the left foreground is a large tray on which a silver pitcher, some fruit, etc., are seen. The mother sits in a chair upholstered in a striped and patterned red and green material.

Note: Also called "Le lever de bébé," "Morning Bath," and "Baby Arises." Durand-Ruel 1422-L5510.

Collections: Metropolitan Museum of Art, New York, George A. Hearn Fund, 1907.

Exhibitions: Art Institute of Chicago, annual, 1900; Carnegie Institute, Pittsburgh, 5th annual exhibition (cat. 33, illus.), 1900–01; Durand-Ruel, New York, 1903 (cat. 7); Cleveland Museum of Art, annual, 1906; Cincinnati Museum of Art, 13th annual exhibition of American art (cat., illus.), 1906; Carnegie Institute, Pittsburgh, "Exhibition of Paintings by French Impressionists" (cat. 19, illus.), 1908; Metropolitan Museum of Art, New York, "George A. Hearn Gift to the Metropolitan Museum of Art and Arthur Hoppock Hearn Memorial Fund," 1913 (cat. 79, illus.); Cincinnati Museum of Art, 20th annual exhibition of American painting, 1913; Pennsylvania Academy of Fine Arts, Philadelphia, 110th anniversary exhibition, 1915; Baltimore Museum of Art, 1941–42 (cat. 48); Saginaw Museum, Saginaw, Mich., "American Paintings from Colonial Times until Today" (cat. 7), 1948; Parrish Museum, Southampton, N.Y., 1967 (cat. 8).

Reproductions: Brush & Pencil, vol. 7 (Feb. 1901), p. 260; Camille Mauclair, *L'art decoratif*, vol. iv (Aug. 1902), p. 184; *International Studio*, vol. 29 (Aug. 1906), p. 54; *American Art News*, vol. 5 (9 Feb. 1907), p. 5; *Bulletin, Metropolitan Museum of Art*, vol. 4 (March 1909), p. 54; *American Art News*, vol. 7 (30 Jan. 1909), p. 1; *Good Housekeeping Magazine*, vol. 50 (Feb. 1910), p. 145; Camille Mauclair, *The French Impressionists (1860–1900)*, Paris, 1911, p. 155; Charles L. Borgmeyer, *The Master Impressionists*, Chicago, 1913; *Mentor*, vol. 2, no. 1 (16 March 1914), fol. p. 208; Lorinda M. Bryant, *American Pictures and Their Painters*, New York, 1917, p. 413; *Literary Digest*, vol. 90 (10 July 1926), p. 26; Samuel Isham, *History of American Painting*, New York, 1927, p. 413; Eugen Neuhaus, *History and Ideals of American Art*, Palo Alto, 1934; *Life*, vol. 12 (19 Jan. 1942), p. 56; Herman Joel Wechsler, *French Impressionists and Their Circle*, 1953; *Life*, vol. 36 (17 May 1954), p. 99.

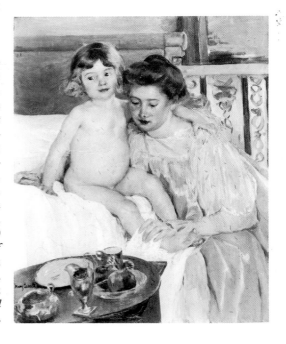

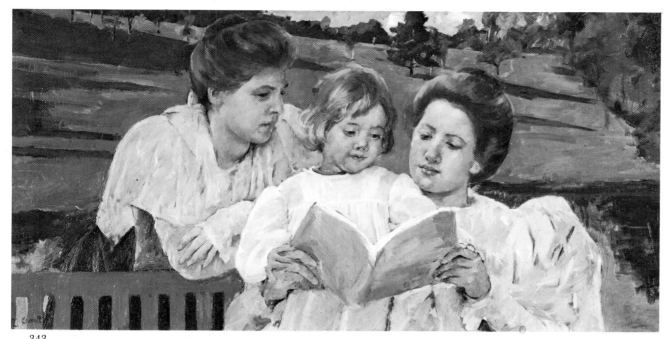

343

The Garden Lecture 1901
Oil on canvas, 22 × 44 in., 56 × 111.7 cm.
Signed lower left corner: *Mary Cassatt*

Description: Half-length view of a blond child looking down at a picture book held up by a woman seated at one end of a long wooden bench. She holds the book with both hands and the child places her hands over those of her mother. Behind the bench to the left, resting her arms on the back of it, another woman leans, also looking at the book.

Note: Also called "Le livre d'images," "Family Group, Reading," and "Il libro illustrato." Durand-Ruel 1121-L4817.

Collections: Mr. and Mrs. H. O. Havemeyer (cat. 433 in Havemeyer sale); to Mrs. J. Watson Webb; to the *Philadelphia Museum of Art.*

Exhibitions: City Art Museum of St. Louis, "11th Annual Exhibition of Selected Paintings by American Artists," 1916; Baltimore Museum of Art, 1941–42 (cat. 55); Wildenstein, New York, 1947 (cat. 43); Durand-Ruel, New York, 1951 (cat. 5); Pasadena Art Institute, 1951 (cat. 5); Philadelphia Museum of Art, 1960; M. Knoedler & Co., New York, 1966 (cat. 39, illus.); Parrish Art Museum, Southampton, N.Y., 1967 (cat. 6, illus.).

Reproductions: *L'art decoratif*, vol. 4 (Aug. 1904), p. 181; *Emporium*, vol. 26 (July 1907), p. 13; *Current Opinion*, vol. 82 (June 1917), p. 427; *La renaissance*, vol. 13 (Feb. 1930), p. 52.

344
Mother Combing Her Child's Hair c. 1901
Pastel, 25 3/16 × 31 1/2 in., 64 × 80 cm.
Signed lower left: *Mary Cassatt*

Description: A mother sits in a wooden chair upholstered in striped material, with her little girl on her lap. With her left hand she holds the child's head up while she combs her blond hair. Their reflections are seen in a mirror at left, the mother's reflection in profile.

Note: Also called "La toilette de bébé." Durand-Ruel 1122-L4818.

Collections: Mary T. Cockroft, purchased 1946; to the *Brooklyn Museum.*

Exhibitions: Durand-Ruel, New York, 1903 (cat. 22); Baltimore Museum of Art, 1941–42 (cat. 30); Wildenstein, New York, 1947 (cat. 27, illus.).

Reproductions: *Women Painters of the World*, ed. Walter Shaw Sparrow, London, 1905, p. 157; *Delineator*, vol. 74 (Aug. 1909), p. 122; *Good Housekeeping Magazine*, vol. 50 (Feb. 1910), p. 142; *Les arts*, vol. 11 (Aug. 1912), p. 15; Edouard-Joseph, *Dictionnaire biographique des artistes contemporains*, Paris, 1930, vol. 1, p. 250; *Catalogue of Watercolors, Paintings, Pastels and Drawings in the Permanent Collection of the Brooklyn Museum*, 1932, p. 183.

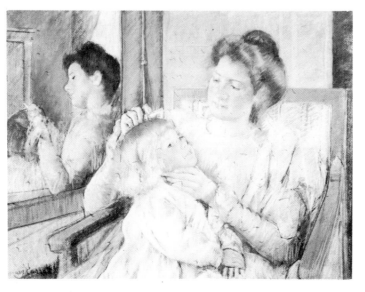

Mother and Daughter, Both Wearing Large Hats 1901
Oil on canvas, $31\frac{7}{8} \times 25\frac{5}{8}$ in., 81×65 cm.
Signed lower right: *Mary Cassatt*

Description: A mother sits outdoors in a flowered hat and a light blue dress with her little girl leaning against her. The mother holds the child's left hand in hers. The child wears a large straw hat outlined in black velvet ribbon with a big bow over her left eye. The mother's skirt is pink and her hat is trimmed with red nasturtiums.

Note: Also called "Fillette au grand chapeau." Durand-Ruel A1334-NY2895.

Collections: From the artist to Durand-Ruel; to the Newhouse Gallery, New York; to *Mrs. J. Lee Johnson III*, Fort Worth, Texas.

Exhibitions: Durand-Ruel, New York, 1903 (cat. 12); St. Botolph's Club, Boston, 1909 (cat. 4); Cincinnati Art Museum, 21st annual, 1914 (cat. 3, illus.); Albright Art Gallery, Buffalo, "14th Annual of Selected Paintings by American Artists" (illus. p. 48), 1920; Durand-Ruel, New York, 1920 (cat. 20); Durand-Ruel, New York, 1924 (cat. 5); Durand-Ruel, New York, 1926 (cat. 4); Corcoran Gallery of Art, Washington, D. C., 10th biennial, 1926 (cat. 113); Pennsylvania Museum of Art, Philadelphia, 1927 (cat. 13); McClees Gallery, Philadelphia, 1931 (cat. 12); Union League Club, New York, "Forty Years of American Painting," 1932; Museum of Modern Art, New York, "American Painting and Sculpture 1862–1932" (cat. 12), 1932–33; Durand-Ruel, New York, 1935 (cat. 4); Brooklyn Museum, 1937 (cat. 25, illus.); Arden Gallery, New York, "Portraits of Children in Paintings and Sculpture" (cat. 23), 1937; Brooklyn Institute of Arts and Sciences, "Leaders of American Impressionism: Mary Cassatt, Childe Hassam, J. H. Twachtman and J. Alden Weir," 1937; Baltimore Museum of Art, "200 Years of American Painting" (cat. 10, illus.), 1938; New York World's Fair, 1940 (cat. 320); Wildenstein, New York, 1947 (cat. 32, illus.); M. Knoedler & Co., New York, 1966 (cat. 34).

Reproductions: All the Arts, vol. 4 (June 1921), p. 79; *Arts*, vol. 17 (Nov. 1930), p. 108; Edith Valerio, 1930, pl. 8; *Vogue* (1 May 1936), frontispiece (color); Margaret Breuning, 1944, p. 26 (color); Francis E. Hyslop, Jr., "Berthe Morisot and Mary Cassatt," *College Art Journal*, vol. 8, no. 3 (Spring 1954), pp. 179–84; Frederick A. Sweet, 1966, pl. 21, fol. p. 204.

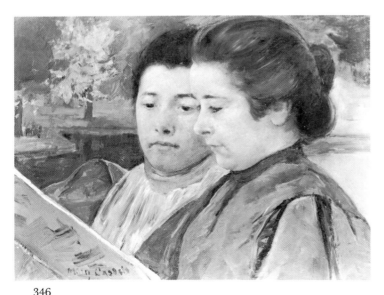

346
Two Women Reading 1901
Oil on canvas, $15 \times 19\frac{1}{4}$ in., 38×49 cm.
Signed on back of book at lower left: *Mary Cassatt*

Description: Head and shoulders of two young women in a lovely park with a wide stream flowing by and one yellow tree toward left. The brown-haired young woman at right wears a dark blue dress; the one at left, with blue-black hair, wears a lighter grayish blue dress with a white gathered yoke and an orange band around her neck. The large book is brick red.

Note: Also called "La lecture" and "Reading." Durand-Ruel 844-L3985.

Collections: From the artist to Durand-Ruel, Paris; to William A. Cargill, Scotland; sold Sotheby & Co., London, 6 Nov. 1963; to Hirschl & Adler; to *William Hobson Green*, River Forest, Illinois.

Exhibitions: Corcoran Gallery of Art, Washington, D. C., 3rd biennial, 1910–11 (cat. 63); Durand-Ruel, New York, 1926 (cat. 12); Durand-Ruel, Paris, 1933 (cat. 11); City Art Museum of St. Louis, 1933–34 (cat. 11); Durand-Ruel, New York, "Berthe Morisot and Mary Cassatt" (cat. 9), 1939; Marlborough Fine Art Ltd., London, 1953 (cat. 3).

Reproductions: Arts, vol. 37 (May 1963), p. 12; *Selections from the Collection of Hirschl & Adler Gallery*, vol. 5, 1963–64 (cat. 6, color).

347
Mother Combing Sara's Hair (No. 1)
c. 1901
Pastel on tan paper, 19 × 25 in., 48.3 × 63.5 cm.
Signed lower right corner: *M. C.*

Description: A mother with black hair sits with
back to spectator combing or brushing back her
daughter's hair. Sara looks at her mother with
very prominent black eyes. In this version Sara's
hand does not show. Background behind her
mother is brilliant orange-red. To the right of
Sara's head it is bright cerulean blue. The mother's
dress is green and tan, Sara's pink (in touches).

Note: Durand-Ruel 6258-D11388.

Collections: From the artist to Payson Thompson;
American Art Association, New York, Thompson
sale, 12 Jan. 1928 (cat. 87); to Charles Sessler,
Philadelphia; *Mr. and Mrs. C. C. G. Chaplin*, Bryn
Mawr, Pennsylvania.

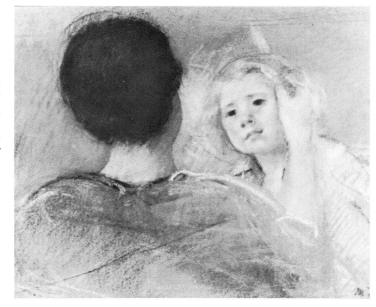

348
Mother Combing Sara's Hair (No. 2)
c. 1901
Pastel, 18 × 23¾ in., 46 × 61 cm.
Signed lower left: *Mary Cassatt*

Description: A mother with black hair sits with her
back to the spectator, combing or brushing back
her daughter's hair. Sara looks at her mother, her
left hand holding her mother's right wrist. The
mother's dress is green and tan, Sara's pink.

Note: Also called "Maternité." Durand-Ruel
A6280.

Collections: From the artist to Durand-Ruel, Paris;
to Ambroise Vollard, Paris; to Sotheby & Co.,
London; to *Mr. and Mrs. Melvin Gelman*, Washington, D. C., 1965.

Exhibitions: Durand-Ruel, Paris, 1908 (cat. 41).

Reproductions: Julia Carson, 1966, p. 71.

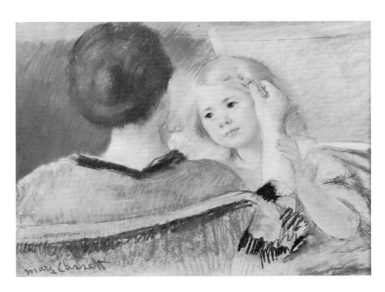

349
Sara in a Red Dress c. 1901
Pastel, 15¾ × 17¾ in., 40 × 45 cm.
Unsigned. Mathilde X collection stamp on verso

Description: Sara sits in a chair with her right arm
resting on its arm. She looks off to left. She wears
a round-necked red dress with short sleeves. Her
blond hair is parted on the side and drawn over
toward the right. Her eyes are dark brown or
black.

Note: Also called "Fillette blonde aux yeux noirs,
corsage rouge." Durand-Ruel 10454-LD13161.

Collections: From the artist to Mathilde Vallet,
1927; in Mathilde X sale, Paris, 1927; to Durand-
Ruel, Paris.

Exhibitions: Galerie A.-M. Reitlinger, Paris, 1927
(cat. 67, illus.).

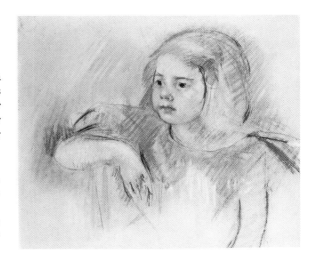

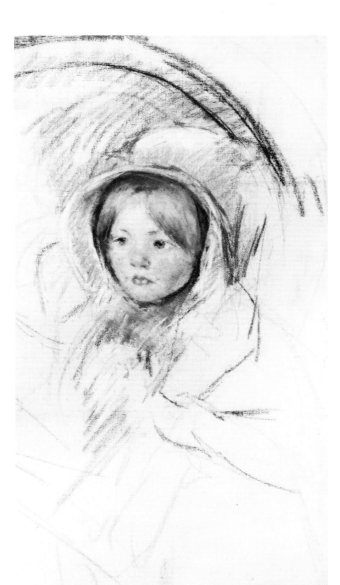

350
Sketch of "Sara in a Green Bonnet" c. 1901
Pastel on canvas, 25 × 13¼ in., 62.8 × 33.4 cm.
Signed lower right: *Mary Cassatt*

Description: Head of a little girl wearing a green bonnet, looking off to the left. She has very pink cheeks and straight blond hair parted in the middle. Her left hand holds the lapel of her coat. Behind her are the outlines of a big, high-backed chair.

Collections: From the artist to Albert E. McVitty; Parke-Bernet, McVitty sale, 15 Dec. 1949 (cat. 47); to *Irene Mayer Selznick*, New York.

Exhibitions: Carnegie Institute, Pittsburgh, 1928 (cat. 10); Baltimore Museum of Art, 1936 (cat. 2); Brooklyn Museum, 1937 (cat. 26); New Jersey State Museum, Trenton, 1939 (cat. 10); Haverford College, 1939 (cat. 27); Baltimore Museum of Art, 1941–42 (cat. 44, illus.); Wildenstein, New York, 1947 (cat. 42).

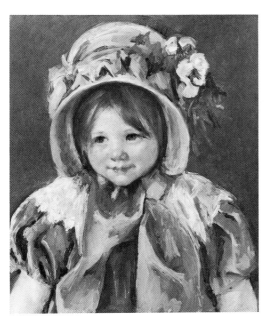

351
Sara in a Green Bonnet c. 1901
Oil on canvas, 16⅜ × 13½ in., 42 × 34 cm.
Signed upper right: *Mary Cassatt*

Description: Head and shoulders of a little girl wearing a large white poke bonnet, decorated with green ribbon and flowers. Her straight blond hair is divided over her forehead. Her rust-colored dress has a white lace collar and short puffed sleeves. The background is green.

Note: Also called "La fillette au chapeau vert." According to the National Collection of Fine Arts files, the little model was a granddaughter of one of the former presidents of the French Republic, Emile Loubet. Durand-Ruel 10703-LD13431.

Collections: Felix Doistau, Paris; Doistau sale, Paris, 18–19 June 1928 (cat. 1); to M. Knoedler & Co., New York; to the Milch Gallery, New York; to John Gellatly, New York; to the *National Collection of Fine Arts*, Washington, D. C., John Gellatly Collection.

Exhibitions: M. Knoedler & Co., New York, 1966 (cat. 36).

Reproductions: Edith Valerio, 1930, pl. 22; *Catalogue of American and European Paintings in the Gellatly Collection*, Smithsonian Institution, Washington, D. C., 1933 (cat. 11, p. 6); *Art & Archeology*, vol. 35 (May 1934), p. 118; *Art News*, vol. 34 (25 Jan. 1936), p. 12; Margaret Breuning, 1944, p. 13 (called "Young Girl in Green Bonnet"); *Pictures on Exhibit* (March 1945) (color); *The Art Gallery*, vol. 9, no. 5 (Feb. 1966), cover (color).

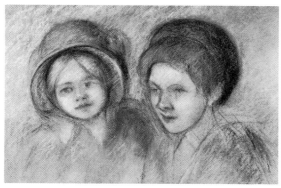

352
Two Heads: Woman with a Child in a Stiff Bonnet c. 1901
Charcoal and pastel on tan paper, 15 × 23¼ in., 38 × 59 cm.
Unsigned. Mathilde X wax seal on verso

Description: Sara, with straight hair parted in the middle under her round, stiff bonnet, is at the left. At right is a young woman with a retroussé nose and dark hair drawn back with a band to form two puffs. Both look to left.

Collections: From the artist to Mathilde Vallet, 1927; Mathilde X sale, Paris, 1927; to Achille Segard, Paris; to Alain Tarica, Paris; to Harold Diamond, New York; to *Mr. and Mrs. Ernest Shiftan*, Scarsdale, New York.

Exhibitions: Galerie A.-M. Reitlinger, Paris, 1927 (cat. 81).

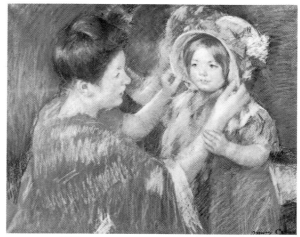

353
Mother Adjusting Her Child's Bonnet
c. 1901
Pastel on paper, 23¾ × 29 in., 60 × 73.4 cm.
Signed lower right: *Mary Cassatt*

Description: A little girl stands at right wearing a large light bonnet trimmed with bright blue-green ribbons. She looks at her mother at left, seen in profile to right, who holds the bonnet with both hands to adjust it. She has reddish hair and wears a raspberry red shawl which covers her shoulders and upper arms.

Note: Also called "Mère mettant chapeau à son enfant," "Maman coiffant sa fillette," and "Mother and Little Girl" (Art Institute of Chicago).

Collections: Mme. S. Mayer, Paris; to Ambroise Vollard, Paris; *Art Institute of Chicago*, Charles H. and Mary F. S. Worcester Collection.

Exhibitions: Durand-Ruel, Paris, 1908 (cat. 38); *Les arts*, Paris, "Art moderne à l'hôtel de la revue," 1912.

Reproductions: Arts, vol. 11, 1912, pl. 15.

354
Head of Sara Looking to Right 1901
Oil on canvas, 16¼ × 13¾ in., 41.3 × 33.5 cm.
Unsigned

Description: Young Sara with her blond straight hair tied at left with a bow looks to the right. Head only, against a background painted in brown tones in the technique of a sepia drawing.

Note: Also called "Portrait Study."

Collections: Vladimir Raykas, Galerie Zak, Paris; sold Parke-Bernet, New York, 16 March 1950; present location unknown.

355
Mother with Left Hand Holding Sara's Chin
c. 1901
Oil and pastel on canvas, 32¾ × 26¾ in., 83 × 68 cm.
Unsigned

Description: A woman with dark, pompadoured hair is seated at right wearing a décolleté evening gown. With her left hand she holds Sara's chin as though to turn her head toward her. Sara faces forward and looks somewhat to left. She wears a short-sleeved dress.

Collections: From the artist to Ambroise Vollard, Paris; to *Mrs. Neville Blond*, London.

Exhibitions: Wildenstein, London, "Loan Exhibition of French Impressionists and Some Other Contemporaries" (cat. 61, illus.), 1963.

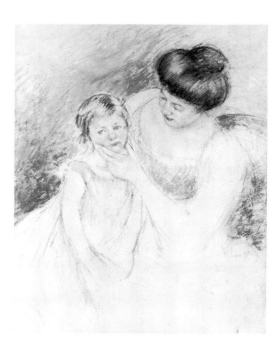

356
Sara Looking Down at a Dog c. 1901
Pastel, 22½ × 16¼ in., 57 × 41 cm. (sight)
Signed lower left: *Mary Cassatt*

Description: A little girl seated on a backless settee
looks down at a tannish-brown dog with a red
collar who is very summarily indicated. Her
brownish-blond hair is drawn to the left side, and
she wears a short-sleeved, round-necked blue dress.
Her right arm and hand hang down at left; her
left arm is mostly hidden by the dog. The end
of the settee curves upward at right. Background
is gray.

Collections: Mary E. Johnson, Glendale, Ohio.

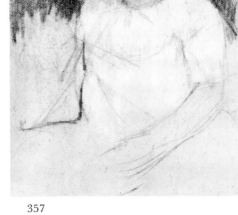

357
Sara Looking to Right c. 1901
Pastel, 24 × 17½ in., 61 × 44.5 cm.
Unsigned

Description: A little girl, with straight hair caught
up at left with a blue bow, looks to right, her head
tilted somewhat to left. Her left arm is sketched
summarily with her hand in her lap. Background
is dark green at left, suggesting foliage.

Note: Related to print Br 195. Durand-Ruel
A1375-NY5041.

Collections: From the artist to Payson Thompson;
American Art Association, New York, Thompson
sale, 12 Jan. 1928 (cat. 83, illus.); to Durand-Ruel,
New York, 1928; present location unknown.

Exhibitions: Marlborough Fine Art Ltd., London,
1953 (cat. 18).

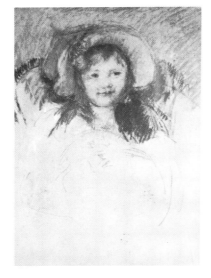

358
**Sara in a Bonnet with a Plum Hanging Down
at Left (No. 1)** c. 1901
Pastel on paper, 24 × 17 in., 61 × 43.2 cm.
Unsigned. Mathilde X collection stamp on verso

Description: Head and shoulders of Sara with dark
hair and eyes. She looks somewhat to right, wear-
ing a yellow straw bonnet with the suggestion of a
plum hanging from the brim toward left. The col-
lar of her coat is green. She sits in a round-backed
Victorian chair. The background is red.

Collections: From the artist to Mathilde Vallet,
1927; Mathilde X sale, Paris, 1927; to Stone-
borough, Paris; to Kraushaar Galleries, New
York; present location unknown.

Exhibitions: Galerie A.-M. Reitlinger, Paris, 1927
(cat. 70, illus.); Kraushaar Galleries, New York,
"Pastels and Watercolors by American Artists,"
1937.

Reproductions: Art News, vol. 35 (29 May 1937),
p. 16.

359
**Sara in a Bonnet with a Plum Hanging Down
at Left (No. 2)** c. 1901
Pastel on paper, 17 × 15 in., 43 × 38 cm.
Signed lower right: *Mary Cassatt*

Description: Head and shoulders of little blond girl
wearing a big bonnet trimmed with a green plum
hanging down from the brim at left. Suggestion
of loose streamers hanging straight down over her
dark coat. She looks at the spectator.

Collections: Stephen Hahn, New York; *David B.
Findlay*, New Canaan, Connecticut.

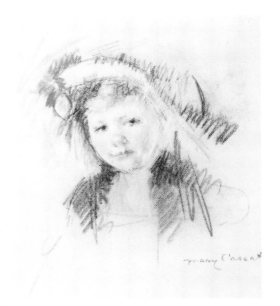

360
Head of Sara in a Bonnet Looking to Left
c. 1901
Pastel on gray paper, 18¼ × 15¼ in., 46.3 × 38.6 cm.
Signed lower right: *Mary Cassatt*

Description: Head of Sara with straight blond hair brushed over to left. She wears a big brown bonnet trimmed at right with a pink rose. The bonnet is tied under her chin with dark ribbons. Her eyes are blue.

Collections: J. J. Honeyman, London, 1957; to Arthur Tooth & Sons, London, 1958; to William A. Cargill, Carruth, Scotland; sold Sotheby & Co., London, 11 June 1963; to *private collection*, London, England.

Reproductions: Burlington Magazine, vol. 99 (8 Dec. 1957), suppl. 8.

361
Sara in a Bonnet with a Plum Hanging Down at Left (No. 3) c. 1901
Pastel on paper, 20⅛ × 15¾ in., 51 × 40 cm.
Signed upper right: *Mary Cassatt*

Description: Head of little girl wearing a big bonnet trimmed with a green plum hanging down from the brim at left. Suggestion of loose dark streamers on her shoulders. She looks to left. Outline of top of round-backed chair behind her.

Collections: Private collection, Paris.

362
Sara, with Bonnet Streamers Loose, Feeding Her Dog c. 1901
Pastel, 22¾ × 16⅞ in., 58 × 43 cm.
Signed lower right: *Mary Cassatt*

Description: A little girl wearing a poke bonnet over her blond hair looks down at her dog, her untied streamers hanging over her shoulders. Only the back of the dog's head shows, together with his collar.

Note: Purchased by the present owner's father in the 1920s from the John Levy Gallery, New York.

Collections: DeWitt W. Balch, Cincinnati, Ohio.

Reproductions: Bulletin de la vie artistique, vol. 7 (1 July 1926), p. 205.

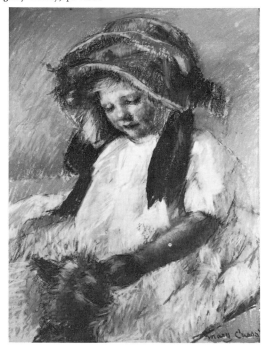

363
Sara with Her Dog, in an Armchair, Wearing a Bonnet with a Plum Ornament
1901
Pastel on paper, 23⅝ × 17¾ in., 60 × 45 cm.
Signed upper right: *Mary Cassatt*

Description: Sara is seated in a Victorian round-backed chair, holding her griffon dog. She looks somewhat to the right, wearing a bonnet with a plum ornament and dark streamers untied falling over her shoulders.

Collections: Private collection, Paris.

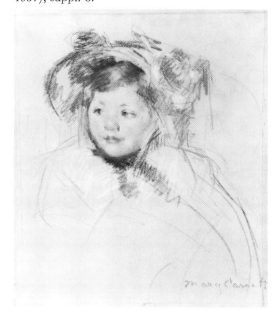

364
Sara, in a Bonnet with Streamers Loose, and Her Dog c. 1901
Pastel on paper, 22½ × 17 in., 57 × 43 cm.
Signed lower right: *Mary Cassatt*

Description: A little girl, wearing a big bonnet with a plum hanging down at left, sits holding her tan, long-haired dog with both arms around him. The dark velvet streamers of her bonnet fall forward over her chest. She looks down at her dog while the dog looks alertly at the spectator.

Collections: Ambroise Vollard, Paris; Hôtel Drouot sale, 27 April 1929 (no. 73); present location unknown.

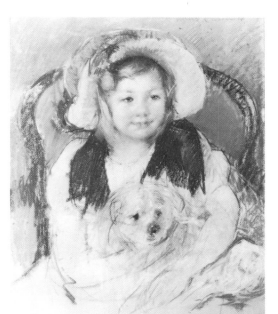

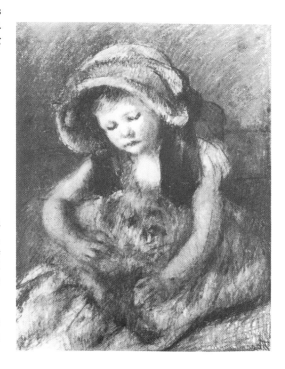

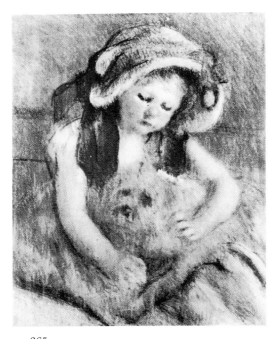

365

Sara, in a Bonnet with Streamers Loose, and Her Dog (Counterproof)

Pastel on paper, 21⅛ × 17⅛ in., 53.5 × 43.5 cm.
Unsigned

Description: Reverse of BrCR 364.

Collections: From the artist to Ambroise Vollard, Paris; Hôtel Drouot sale, 31 May 1956 (cat. 2); present location unknown.

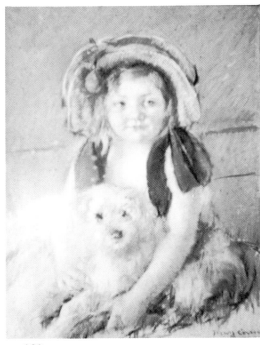

366

Sara with Her Dog c. 1901

Pastel on paper, 26 × 22 in., 66 × 56 cm.
Signed lower right: *Mary Cassatt*

Description: Sara sits facing forward but turned toward left, holding her griffon dog with one hand on each of his front legs. She wears a straw bonnet trimmed with a plum hanging down at front left, a blue dress, and dark green velvet streamers loose over her shoulders. The background is grayish-blue.

Collections: Private collection, Paris.

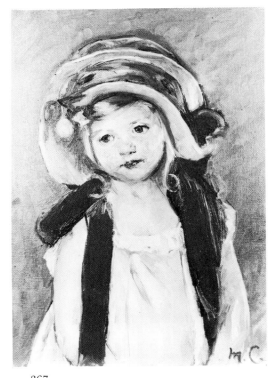

367

Sara in a Very Big Bonnet with a Plum Hanging at Left c. 1901

Oil on canvas, 18⅛ × 14⅛ in., 46 × 36 cm.
Signed at lower right: *M. C.*

Description: Little Sara wears a big bonnet with a plum hanging over the brim. She looks left and wears a low, round-necked sleeveless dress. The wide dark streamers of her bonnet hang forward over her shoulders, with one big loop over her shoulder at left.

Collections: Private collection, Paris.

368

Sara in a Round-Brimmed Bonnet, Holding Her Dog c. 1901

Pastel, 23 × 18 in., 58.5 × 45.7 cm.
Signed at right center: *Mary Cassatt*

Description: Sara sits in an armchair upholstered in rose color with her dog on her lap. Both face forward but Sara looks to the right. She wears a round poke bonnet tied under the chin with a dark bow. It is trimmed with feathers and a cluster of blue flowers under the brim.

Note: Related to drypoint Br 197.

Collections: From the artist to Payson Thompson; American Art Association, New York, Thompson sale, 12 Jan. 1928 (cat. 82, illus.); to *private collection*, Flint, Michigan.

Reproductions: International Studio, vol. 89 (Jan. 1928), p. 368.

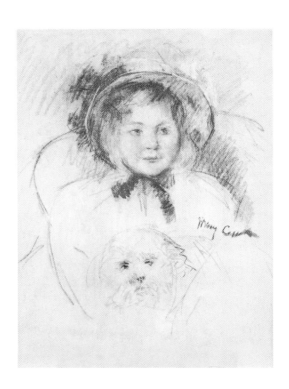

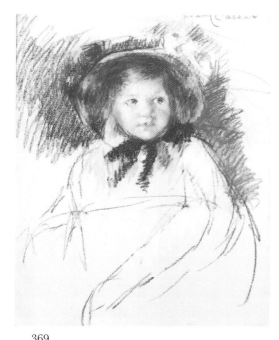

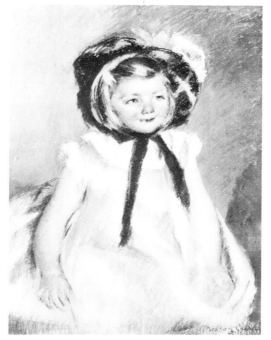

Sara in a Blue Dress c. 1901
Pastel on paper, 19¾ × 17 in., 50 × 43 cm.
Signed lower right: *Mary Cassatt*

Description: Three-quarter length portrait of a small blond girl smiling as she gazes to the right. Her dark bonnet has a large rose at upper right, and her blue dress has tiny cap sleeves.

Note: Also called "Fillette à la robe bleue."

Collections: Galerie Georges Petit; Jacques Seligman sale, Paris, 18 May 1925 (cat. 18); present location unknown.

Reproductions: Arts, vol. 11 (1912), p. xv; Charles L. Borgmeyer, *The Master Impressionists*, Chicago, 1913, p. 251.

369
Sara in a Dark Bonnet Tied under Her Chin
c. 1901
Pastel on paper, 21¼ × 16½ in., 54 × 42 cm.
Signed upper right: *Mary Cassatt*

Description: This is a sketch related to the pastel (BrCr 366) but without the dog. Instead there are some lines below the shoulders where the dog could be placed. Dark background on either side of head; no chair indicated. The hat has flowers suggested above the brim at right. A black bow under her chin.

Collections: From the artist to Ambroise Vollard; to Mme. Ader, Paris, 1957; to *A. Max Weitzenhoffer, Jr.*, Oklahoma City, Oklahoma.

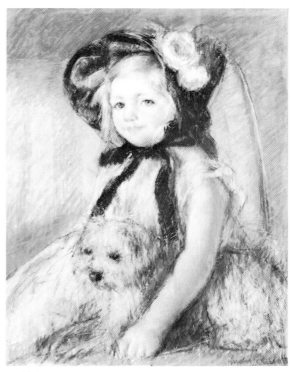

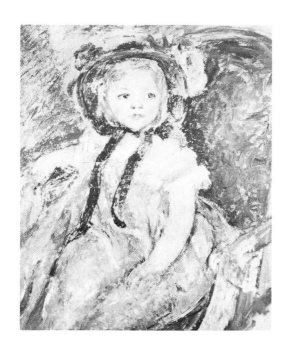

371
Sara in a Dark Bonnet with Right Hand on Arm of Chair c. 1901
Oil on canvas, 26½ × 21¾ in., 67 × 55 cm.
Unsigned

Description: A little girl seen in three-quarter length is seated in a high round-backed armchair wearing a dark bonnet trimmed with a dark flower at the left and two pink roses at right. Long dark streamers tie the bonnet under her chin and hang down to her waist on her short-sleeved light blue dress. She looks to the right.

Collections: Hôtel Rameau sale, Paris, 1962 (cat. 75); to *Mme. Bloche*, Paris.

372
Sara in a Dark Bonnet Holding Her Dog
c. 1901
Pastel, 27⅝ × 21¾ in., 70 × 55 cm.
Signed lower right: *Mary Cassatt*

Description: A little blond girl sits on a striped settee wearing a dark bonnet trimmed with two big roses and tied under the chin with a dark bow. Her little dog lies at her side.

Collections: From the artist to Ambroise Vollard; to Van Dombrowsky, Milan, Italy; present location unknown.

Exhibitions: Durand-Ruel, Paris, 1908 (cat. 40).

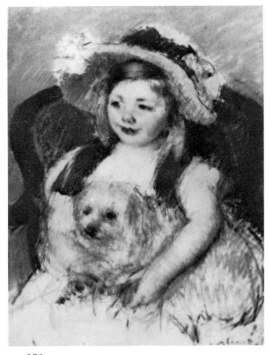

373
Smiling Sara in a Big Hat Holding Her Dog (No. 1) c. 1901
Pastel, 22½ × 17 in., 57 × 43 cm.
Signed lower right: *Mary Cassatt*

Description: A little girl sits in a Victorian armchair holding her dog with both arms. She looks to the left and smiles.

Collections: Ambroise Vollard, Paris; to Sacha Guitry, Paris; Hôtel Drouot, Guitry sale, 27 April 1929 (cat. 73); to Gaston Lévy; to Adelaide M. deGroot; to the *Metropolitan Museum of Art*, New York.

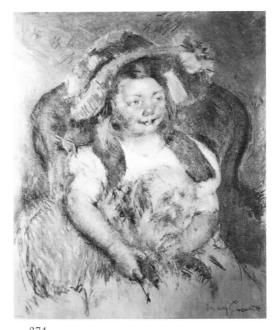
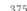

374
Smiling Sara in a Big Hat Holding Her Dog (No. 1) (Counterproof)
Pastel, 21¾ × 17 in., 55 × 43 cm.
Signed lower right: *Mary Cassatt*

Description: A little girl (with heavier features than in BrCR 373) sits in a Victorian armchair holding both forelegs of her dog with her two hands. She and the dog both look to the right.

Note: This counterproof has been reworked considerably, changing its entire quality.

Collections: Ambroise Vollard, Paris; *Mr. and Mrs. Meyer Potamkin*, Philadelphia, Pennsylvania.

375
Smiling Sara in a Big Hat Holding Her Dog (No. 2) c. 1901
Pastel, 25½ × 19½ in., 64.7 × 49.5 cm.
Signed lower right: *Mary Cassatt*

Description: A little girl holds her dog on her lap with both arms. She wears a big straw hat trimmed with pink roses. Her straight blond hair falls onto her shoulders. She looks toward the right while the dog looks at the spectator. She wears a low-necked salmon-orange dress. The background is teal blue.

Note: Due to the taking of the counterproof there were many losses to this original version, which then required rework throughout except for the modeling of the face. When asked by the Wadsworth Atheneum about the date of this pastel, Miss Cassatt wrote that she had often used this little girl as a model but could not date the work exactly. Durand-Ruel 9326-L11857.

Collections: Ambroise Vollard, Paris; Durand-Ruel, New York; to *Wadsworth Atheneum*, Hartford, Connecticut, J. J. Goodwin fund, 1923.

Exhibitions: Phillips Academy, Andover, Mass., 1932; Avery Museum, Wadsworth Atheneum, "Paintings by Women," 1938; Slater Memorial Museum, Norwich, Conn., "American Paintings," 1954.

Reproductions: Les arts, no. 128 (Aug. 1912), pl. xv; Charles L. Borgmeyer, *The Master Impressionists*, Chicago, 1913, p. 251; *Bulletin, Wadsworth Atheneum* (June 1923), p. 2 and cover; Edith Valerio, 1930, pl. 16.

376
Smiling Sara in a Big Hat Holding Her Dog (No. 2) (Counterproof)
Pastel, 21½ × 17 in., 54.6 × 43 cm.
Signed lower left: *Mary Cassatt*

Description: Reverse of BrCr 375.

Collections: From the artist to Ambroise Vollard, Paris; to Arthur Tooth & Sons, London; to William Findlay Galleries, Chicago; to *Mr. and Mrs. Raymond A. Young*, Oklahoma City, Oklahoma.

Reproductions: Herman J. Wechsler, *French Impressionists and Their Circle*, New York, Harry N. Abrams, 1959, pl. 7.

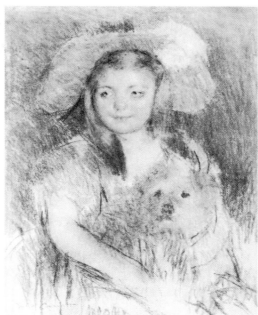

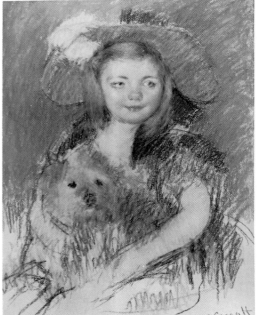

377
Sara in a Large Flowered Hat, Looking Right, Holding Her Dog c. 1901

Pastel on paper, 27⅝ × 21⅝ in., 70 × 55 cm.
Signed lower right: *Mary Cassatt*

Description: Little Sara is seated in a Victorian chair before a window looking to the right. Her straight blond hair falls forward under a large hat fastened beneath her chin with a bow and streamers and trimmed with flowers on both sides. Her arms are bare below tiny puffed sleeves. She holds her dog under her left arm. An upright post at left has a diamond-shaped detail.

Note: Also called "Petite fille au chien." Durand-Ruel 6279-L11390.

Collections: Georges Viau, 1908; present location unknown.

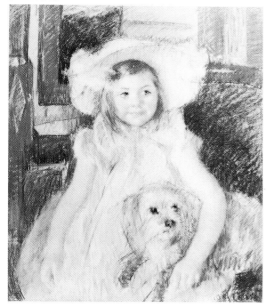

378
Smiling Sara in a Hat Trimmed with a Pansy
c. 1901

Oil on canvas, 26½ × 22½ in., 67 × 57 cm.
Signed lower left corner: *Mary Cassatt*

Description: A little girl with long blond straight hair faces forward holding a gray griffon dog on her lap. She gazes to the left. Her large hat, trimmed with lace insets, has a pansy tucked under the brim. Her pink dress has short puffed sleeves. The background is blue.

Note: Also called "Fillette au chien griffon." Durand-Ruel 5752-L137.

Collections: From the artist to Durand-Ruel, 1906; to Colis P. Huntington, 1907 or 1908; to General E. C. Young, 1935; to *Scripps College*, Claremont, California, General and Mrs. Edward Clinton Young Collection of American Art.

Exhibitions: Durand-Ruel, Paris, 1908 (cat. 5); Durand-Ruel, New York, 1920 (cat. 2); Durand-Ruel, New York, 1935 (cat. 7); Los Angeles County Fair, Pamona, California, "Masters of Art from 1790 to 1950" (cat. 11), 1950; Pasadena Art Institute, "Mary Cassatt and her Parisian Friends" (cat. 11), 1951.

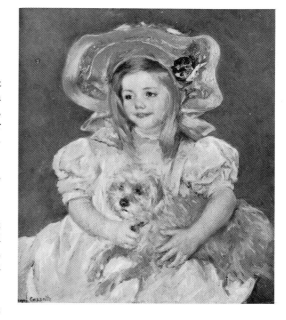

379
Sara Handing a Toy to the Baby c. 1901

Oil on canvas, 32½ × 26 in., 82.5 × 66 cm.
Signed lower right corner: *Mary Cassatt*

Description: Little Sara in an orange-yellow dress with a wide lace bertha stands at the left. Her mother is seated at right in a wooden chair, upholstered in greenish blue, of which the back-support is visible. The baby's right hand reaches over to rest on the top of the chair. The nude baby, held on the mother's left arm, reaches with his left hand to grasp the toy offered by his sister. The mother's dress is white, the background blue.

Note: Also called "Le lever du bébé," "La toilette de l'enfant" and "Mère et deux enfants." Durand-Ruel 3916-L6914.

Collections: From the artist to Alfred Atmore Pope; to the *Hill–Stead Museum*, Farmington, Connecticut.

Exhibitions: Durand-Ruel, New York, 1903 (cat. 14); St. Botolph's Club, Boston, 1909 (cat. 6).

Reproductions: Brush & Pencil, vol. 15 (March 1905), p. 165; *La revue de l'art ancien et moderne*, vol. 23 (March 1908), p. 175.

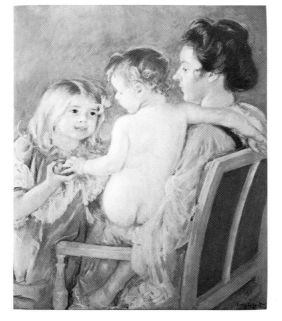

380
The Reading Lesson c. 1901

Oil on canvas, 24½ × 31 in., 62 × 79 cm.
Signed lower right corner: *Mary Cassatt*

Description: A mother, in profile, seated in a chair, and her child, standing beside her, are looking at a book. The blond child wears an orange dress; the mother is brunette.

Note: Also called "La leçon de lecture." Durand-Ruel 3918-L6915.

Collections: From the artist to Durand-Ruel, Paris; to Durand-Ruel, New York; to Gertrude Whittemore; to *Harris Whittemore, Jr.*, Naugatuck, Connecticut.

Exhibitions: St. Botolph's Club, Boston, 1909 (cat. 1); Cincinnati Museum of Art, 1911 (illus.); Cincinnati Museum of Art, 1912 (illus.); Baltimore Museum of Art, 1941–42 (cat. 51).

Reproductions: Camille Mauclair, *L'impressionisme*, Paris, 1904; *La renaissance de l'art*, vol. 13 (Feb. 1930), pp. 51–56.

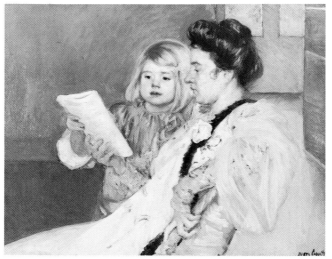

381
Mother, Sara, and the Baby c. 1901
Pastel, 36 × 29½ in., 91.4 × 75 cm.
Signed lower right: *Mary Cassatt*

Description: The mother, with dark hair piled on top of her head, wearing a white dress, sits on a chair over which has been thrown a rose and gold fabric. She holds a nude child with red-gold hair on her knee. A little blond girl in a bright orange dress stands on the far side. There is a bureau of dark wood with an oval mirror in left background.

Note: Durand-Ruel A6260.

Collections: From the artist to Ambroise Vollard, Paris, 1908; to Dalzell Hatfield, Los Angeles; to *Hal Wallis*, California.

Exhibitions: Durand-Ruel, Paris, 1908 (cat. 39); Baltimore Museum of Art, 1941–42 (cat. 33).

382
Mother, Sara, and the Baby (Counterproof)
Pastel on paper, 34 × 28 in., 86.3 × 71 cm.
Signed lower left: *Mary Cassatt*

Description: Reverse of BrCr 381.

Collections: From the artist to Ambrose Vollard; to E. and A. Silberman Galleries, New York; present location unknown.

Reproductions: Art News, vol. 51 (Dec. 1952), p. 53.

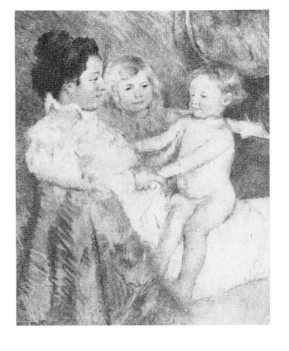

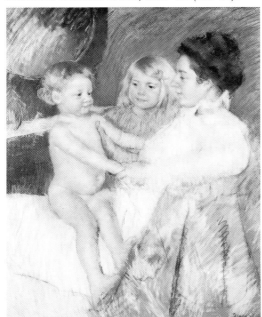

383
Sketch of Sara for "After the Bath" c. 1901
Pastel on gray paper, 14¼ × 11 in., 27 × 35 cm.
Signed toward lower right: *Mary Cassatt*

Description: Sara, with blond shoulder-length hair, is seen looking up to the left. She wears an orange-red dress. This is a preparatory sketch for BrCR 384.

Collections: George Gastine, Los Angeles, California; to *Gene Kelly*, Beverly Hills, California.

384
After the Bath c. 1901
Pastel, 25¾ × 39¼ in., 66 × 100 cm.
Signed lower left: *Mary Cassatt*

Description: The mother sits with her baby at left and Sara at the right. Sara leans her arm over her mother's shoulder and holds the baby's arm at the wrist. The baby looks at her as though amused. The mother looks to left, her dark hair parted. She wears a costume with a jacket edged in black.

Note: Also called "La sortie du bain" and "After the Bath." Durand-Ruel 3644-L6728.

Collections: Cleveland Museum of Art, gift of J. H. Wade, 1920.

Exhibitions: Art Institute of Chicago, "28th Annual Exhibition of American Painting and Sculpture," 1915–16; Dallas Art Association, "2nd Annual Exhibition of American and European Art," 1921; Cleveland Museum of Art, 1937 (cat. 26); Art Institute of Chicago and Metropolitan Museum of Art, New York, "Sargent, Whistler and Mary Cassatt" (cat. 26, illus.), 1954; Cleveland Museum of Art, "The International Language," 1956.

Reproductions: Fine Arts Journal, vol. 33 (Dec. 1915), p. 528; *Bulletin, Cleveland Museum of Art*, vol. 7, no. 10 (Dec. 1920), frontispiece; Frederic A. Whiting, "The Cleveland Museum of Art," *Art and Archeology*, vol. 16 (Nov. 1923), p. 192; *Arts and Decoration*, vol. 20 (Feb. 1924), cover; *American Art Student*, vol. 8 (Sept. 1924), p. 23; *Bulletin, Cleveland Museum of Art*, vol. 13 (April 1926), p. 77; *Art News*, vol. 25 (30 Oct. 1926), p. 8; Margaret Breuning, 1944, p. 23 (color); Edward Alden Jewell and Aimée Crane, *French Impressionists*, New York, 1944, p. 131 (color); G. F. Hartlaub, *Impressionists in France*, Milan, 1955, p. 40 (color); *Ladies' Home Journal* (May 1956), p. 87 (color); *Handbook, Cleveland Museum of Art*, 1958 (cat. 546); W. H. Pierson, Jr., and Margaret Davidson, *Arts of the United States: A Pictorial Survey*, New York, 1960, pl. 2548; Frederick A. Sweet, 1966, color pl. 8, fol. p. 156.

385
Sara Seated, Leaning on Her Left Hand
c. 1901

Oil on canvas, $28\frac{3}{4} \times 21\frac{1}{4}$ in., 73×54 cm.
Signed lower right: *Mary Cassatt*

Description: Three-quarter length view of Sara seated on a bench leaning on her left hand, wearing an orange dress with a wide, light sash and a wide collar edged in points, outlined in white. It falls off her left shoulder. She wears a stiff, rounded, white bonnet tied under her chin with a long bow. Plain neutral background.

Note: Also called "Petite fille assise" or "Enfant blonde." Durand-Ruel 6275-11397.

Collections: M. Guyotin, Paris; to Durand-Ruel, Paris; present location unknown.

Exhibitions: Durand-Ruel, Paris, 1908 (cat. 10).

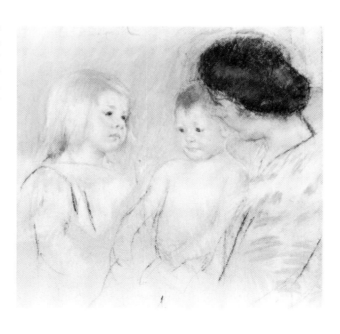

386
Children Playing with Their Mother 1901
Pastel, $24\frac{3}{4} \times 31$ in., 63×78.7 cm.
Signed lower left: *Mary Cassatt*

Description: Sara in an awkward pose rests her left hand on the floor and looks up at her mother holding up her baby. Sara wears a dress with a big collar with points over her shoulders. It hangs off her left shoulder. Her mother at left holds the baby in front of her. He has his two hands up to his mouth.

Note: Durand-Ruel 3833-L6729.

Collections: From the artist to Durand-Ruel, Paris, 1901; to Durand-Ruel, New York, 1901; to J. D. Maguire, 1926; present location unknown.

Exhibitions: Durand-Ruel, New York, 1903 (cat. 23); Durand-Ruel, New York, 1920 (cat. 21); Durand-Ruel, New York, 1924 (cat. 18).

Reproductions: Sketch Book, vol. 5 (July 1906), p. 395; *Current Literature*, vol. 46 (Feb. 1909), p. 168; *Delineator*, vol. 74 (Aug. 1909), p. 121; Edith Valerio, 1930, pl. 13.

387
Sara and Her Mother with the Baby (No. 1)
c. 1901

Pastel, $22\frac{3}{4} \times 23\frac{5}{8}$ in., 57.7×60 cm.
Signed lower right: *Mary Cassatt*

Description: Sara turned in three-quarter view to right looks at her mother seen in lost profile to left, the back of her head of dark hair showing prominently at upper right. On her lap is the nude baby with reddish hair. He looks somewhat down toward left. Sara wears an orange and white dress. Her mother's gown is turquoise blue.

Note: Also called "En famille."

Collections: Durand-Ruel, Paris; to Galerie Fisher, Lucerne; private collection, Germany; Newhouse Gallery, New York; *Mrs. Burton Carter*, Fort Worth, Texas.

Exhibitions: Carnegie Institute, Pittsburgh, 1928 (cat. 47); Virginia Museum of Fine Arts, Richmond, 1950.

Reproductions: Pictures on Exhibit, vol. 13, no. 2 (Nov. 1950), p. 41.

388
Sara and Her Mother with the Baby (No. 2)
c. 1901
Oil on canvas, 29⅛ × 36⅝ in., 74 × 93 cm.
Signed lower right: *Mary Cassatt*

Description: Sara, turned to right, looks at the
nude baby, in profile to left, on her mother's lap.
He looks down at his left hand. The mother, also
in profile to left, supports him with her left hand
under his arm.

Collections: Private collection, Paris.

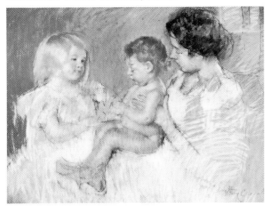

389 †
Sara and Her Mother with the Baby (No. 3)
c. 1901
Pastel, 25 × 31½ in., 63.5 × 80 cm.
Signed twice at lower right: *Mary Cassatt*

Description: Sara turned right looks at the nude
baby on her mother's lap. He looks down at what
he has in his hand. The mother, in profile to left,
supports him with her left hand under his arm.
Sara's dress is pink.

Note: Also called "Maternité," "L'heureuse
mère," and "En famille."

Collections: Hôtel Drouot, Paris, Marcel Bénard
sale, 23–24 Feb. 1931 (cat. 6); to Mr. Loeb; to
George Bernheim; Galerie Charpentier, Paris,
Bernheim sale, 7 June 1935 (cat. 1); to *private
collection*, Denver, Colorado.

390
Sara and Her Mother Admiring the Baby
c. 1901
Pastel on paper, 16¼ × 21⅞ in., 41.2 × 55.5 cm.
Signed lower right: *Mary Cassatt*

Description: Sara tilts her head to left as she holds
out her right arm to help to embrace the baby in
the center of the composition. The mother at the
right is seen in profile to the left. Her hair is dark,
as is the baby's. Sara's is blond.

Note: Durand-Ruel A1382-NY-D8327.

Collections: Private collection, Buffalo, New York.

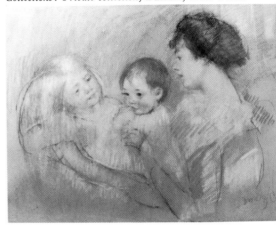

391
Mother and Sara Admiring the Baby 1901
Oil on canvas, 36 × 29 in., 91.5 × 73.7 cm.
Signed lower left: *Mary Cassatt*

Description: A dark-haired mother in a kimono
looks down at her baby seated on her lap in pro-
file to right. He has his finger in his mouth and
his bare feet are crossed. At the right stands his
sister, whose left hand is stretched out toward
him. She is blond and wears a flowered dress with
short, puffed sleeves.

Note: Also called "Jeune mère et ses deux enfants."
Durand-Ruel 4212-L7169.

Collections: C. C. Gibson, Piedmont, California;
to *Mrs. Alexander Albert*, San Francisco.

Exhibitions: Corcoran Gallery of Art, Washington,
D. C., 1921–22 (cat. 10); Cincinnati Art Museum,
1925 (cat. 18); San Francisco Museum of Art, 1935
(cat. 2); University of California at Los Angeles,
and California Palace of the Legion of Honor,
San Francisco, "California Collects" (cat. 37),
1958.

Reproductions: American Art Annual, vol. 5 (1905–06),
fol. p. 108; Walter Shaw Sparrow, *Women Painters
of the World*, London, 1905, p. 327; Margaret
Breuning, 1944, p. 42; Edward Alden Jewell and
Aimée Crane, *French Impressionists*, New York,
1944, p. 128.

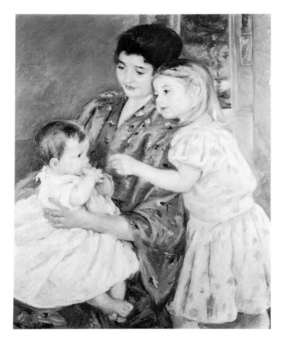

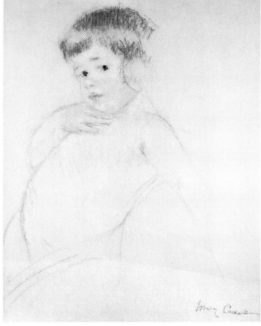

392
Study of the Baby for "The Caress" c. 1902
Pastel on paper, 23½ × 18½ in., 59.7 × 47 cm.
Signed lower right: *Mary Cassatt*

Description: The baby, shown in three-quarter
length, stands as though leaning against some
support at the right, his left arm extended, his
right hand raised and held under his chin. His
hair is reddish with gold highlights, his eyes are
blue-black. The body is sketched in black with
some light blue accents.

Collections: Mr. and Mrs. Danny Kaye, Beverly
Hills, California.

Exhibitions: Baltimore Museum of Art, 1936
(cat. 4).

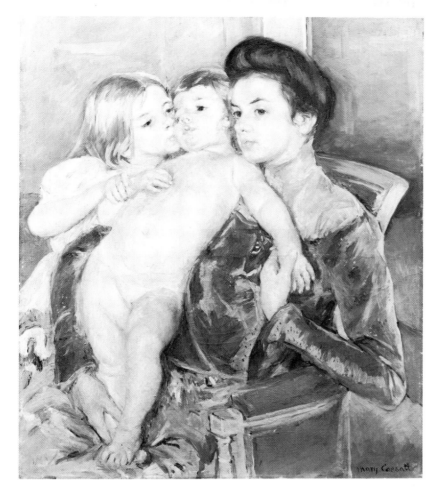

393
The Caress 1902

Oil on canvas, 32 × 26¾ in., 81.3 × 67.7 cm.
Signed lower right: *Mary Cassatt*

Description: A mother sits in a French armchair upholstered in green velvet. She wears a green gown with a yoke and a high, boned collar. On her lap stands her nude baby, leaning back against her. A little girl at left kisses the baby's cheek.

Note: Also called "Caresse enfantine" and "Caresse maternelle." Durand-Ruel 4722-L7282.

Collections: From the artist to Durand-Ruel; to James Stillman, Paris; to William T. Evans; to the *National Collection of Fine Arts,* Washington, D.C., 1911, gift of Mr. Evans.

Exhibitions: Durand-Ruel, New York, 1903 (cat. 13); Cincinnati Art Museum, 11th annual exhibition of American art, 1904 (cat. 1); Pennsylvania Museum of Art, Philadelphia, 1904 (cat. 2); Pennsylvania Academy of the Fine Arts, Philadelphia, 73rd annual exhibition, 1904 (awarded the Lippincott Prize, which the artist refused); Art Institute of Chicago, 17th annual exhibition, 1904 (awarded the Norman Wait Harris Prize of $500, which the artist refused); Albright Art Gallery, Buffalo, 1907; Durand-Ruel, Paris, 1908 (cat. 3); Art Institute of Chicago, "Half a Century of American Art" (cat. 2), 1939; Pushkin Museum, Moscow, 1960; Baltimore Museum of Art, "Manet, Degas, Berthe Morisot and Mary Cassatt" (cat. 118), 1962.

Reproductions: International Studio, vol. 22 (March 1904), p. 234; *Collector & Art Critic,* vol. 3 (15 March 1905), p. 36; *Notes, Fine Arts Academy, Buffalo,* vol. 3 (Dec. 1907), p. 114; Achille Segard, 1913, fol. p. 96; Rilla Evelyn Jackman, *American Arts,* New York, 1928, pl. 73, fol. p. 168; Margaret Breuning, 1944, p. 12; *Art in America,* vol. 53 (June 1965), p. 80; *Time* (3 Jan. 1969), p. 46 (color).

394
Quick Sketch of Reine's Head c. 1902

Pastel on paper, 14 × 16¾ in., 35.5 × 42.5 cm.
Unsigned. Mathilde X collection stamp on verso

Description: Head only of Reine. A preparatory sketch for BrCR 399. Drawn in crayon with highlights in pastel on her nose and cheek at right.

Collections: From the artist to Mathilde Vallet, 1927; Mathilde X sale, Paris, 1927; *private collection,* Paris.

Exhibitions: Galerie A.-M. Reitlinger, Paris, 1927 (cat. 22).

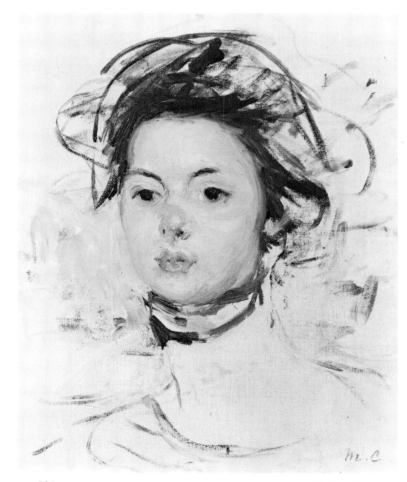

395
Sketch of Head of Reine Lefebvre c. 1902

Oil on canvas, 16 × 13 in., 40.7 × 33 cm.
Signed lower right: *M. C.*

Description: Very free sketch of the head of this model done in preparation for BrCR 406.

Collections: Captain Peter Moore; to Lord Berners, Rome; to M. Knoedler & Co., New York; to *Mr. and Mrs. Raymond A. French,* Locust Valley, New York.

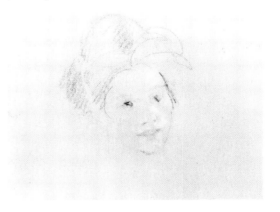

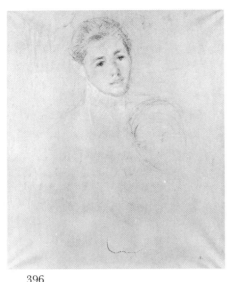

396
Sketch of Reine's Head with Outline of Child's Head Below c. 1902
Pastel on paper, 28¾ × 23½ in., 73 × 59.6 cm.
Unsigned

Note: Durand-Ruel 18655.

Collections: Adolfo Costa du Rels, Bolivian ambassador to UNESCO, Paris, France, 1963.

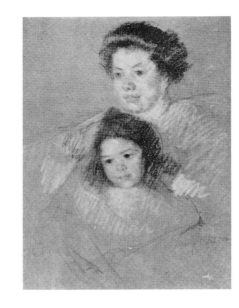

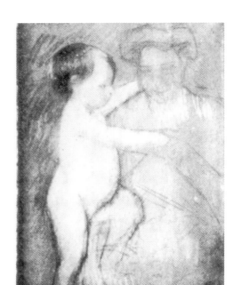

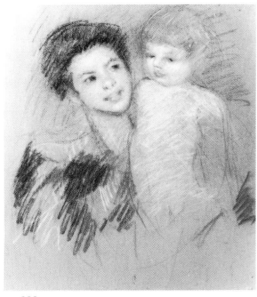

399
Reine Holding up a Blond Child c. 1902
Pastel on tan paper, 25 × 20½ in., 63.5 × 52 cm. (sight)
Unsigned

Description: Reine, wearing a green dress, holds up a blond, nude child whose figure is unfinished. Reine smiles as she looks up at the child.

Collections: Mrs. Gardner Cassatt, Villanova, Pennsylvania.

400
Sketch of Reine with Nude Child in Her Arms
c. 1902
Pastel on gray paper, 28 × 20½ in., 71 × 52 cm.
Signed lower right, poorly: *Mary Cassatt*

Description: Reine's head is well developed, the child's somewhat blurred and its body in three-quarter length undefined. Very pronounced dark lines enclosing both figures. Mother's dress and background in shades of blue. This is a study for BrCR 406.

Collections: Dr. Louis Moinson, Grasse, France; Dr. John J. McDonough, Youngstown, Ohio; M. Knoedler & Co., New York, 1968.

397
Heads of Reine and of Margot c. 1902
Pastel on paper, 25 × 19¼ in., 63.5 × 49 cm.
Signed lower right: *Mary Cassatt*

Description: Heads only of Reine above and to the right of Margot against a delicate green background. Reine looks down toward little Margot. Margot looks to the left.

Collections: From the artist to Mathilde Vallet, 1927; Mathilde X sale, Paris, 1931; sold, Hôtel Drouot, Paris, 29 May 1952, by Mme. Étienne Ader (cat. 89, illus.); present location unknown.

Exhibitions: Galerie A.-M. Reitlinger, Paris, 1931 (cat. 22).

Reproductions: Connoisseur, vol. 166 (Oct. 1967), (color).

398
Nude Baby Beside Her Mother c. 1902
Pastel on paper, not measured
Unsigned. Mathilde X collection stamp at lower right

Description: A nude baby in profile to right stands with her left leg bent and left arm around her mother's shoulder. Her right hand is held by her mother who is facing forward, summarily sketched. The background is shaded darker at left with baby's hair still darker.

Note: Also called "Bébé nu dans les bras de sa mère."

Collections: From the artist to Mathilde Vallet, Paris, 1927; Mathilde X sale, Paris, 1931; present location unknown.

Exhibitions: Galerie A.-M. Reitlinger, Paris, 1931 (no. 11, illus.).

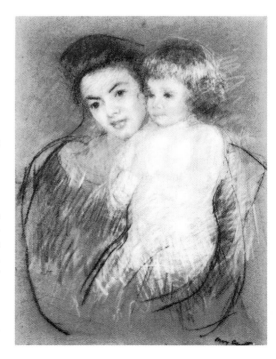

401
**Sketch of Reine with a Nude Baby
Leaning against Her** c. 1902
Pastel on gray paper, 25¼ × 21 in., 64 × 53 cm.
Unsigned

Description: Reine, with very dark eyes and
pompadoured black hair, looks slightly to left,
with her nude baby's head, in profile, resting on
her shoulder. To her left, at her neck, is an area
colored a lovely bright pink or rose. This is a
study for BrCR 406.

Note: Also called "Mother and Nude Child."
Durand-Ruel A1378-NY5044.

Collections: From the artist to Payson Thompson;
American Art Association, New York, Thompson
sale, 12 Jan. 1928 (cat. 90); to Mrs. O. G. Bitler;
to *Mrs. David Marman*, Kansas City, Missouri,
1967.

Exhibitions: Art Institute of Chicago, "A Century
of Progress," 1934; Nelson Gallery and Atkins
Museum of Fine Arts, "Kansas City Collects,"
1965.

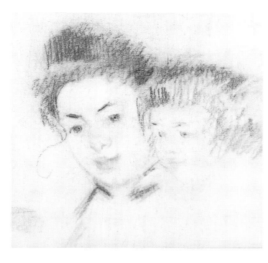

402
Sketch of Reine and Child c. 1902
Pastel on light tan paper, 13 × 15 in., 33 × 38 cm.
Unsigned. Mathilde X collection stamp on verso

Description: Heads only of Reine and a child.
Both look down toward the left. Reine has large
brown eyes and auburn hair, the child gray eyes
and blond hair. Reine's collar and part of her
jabot are of red ribbon.

Collections: From the artist to Mathilde Vallet,
1927; Mathilde X sale, Paris, 1927 (cat. 2)
(called "Femme et enfant, deux têtes"); *M. Costa
du Rels*, Bolivian ambassador to UNESCO, Paris,
1950.

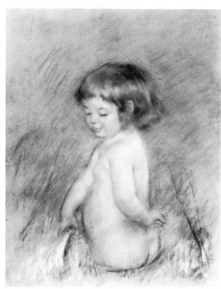

403
Little Eve c. 1902
Pastel on tan paper, 29 × 21½ in., 73.7 × 54.5 cm.
Signed lower right: *Mary Cassatt*

Description: A nude baby in three-quarter view
sits facing left, with body and head turned away.
Her left arm reaches behind her back, her right
hand holds a white cover. She looks down toward
left, her dark lashes covering her eyes. Her reddish
blond hair is bobbed.

Collections: Ambroise Vollard, Paris; *Charles and
Emma Frye Art Museum*, Seattle, Washington.

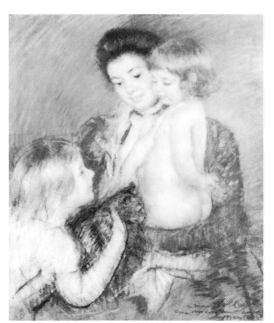

404
**Reine Lefebvre with Blond Baby and
Sara Holding a Cat** c. 1902
Pastel on paper, 31½ × 25¼ in., 80 × 64 cm.
Signed and inscribed lower right: *à Mons. Vollard/
avec mes compliments/Mary Cassatt*

Description: Reine, wearing a magenta-crimson
dress, holds her nude blond baby on her left arm
as they both look down at Sara, who holds a gray
tiger cat. Sara's dress is light yellow. The back-
ground is yellow, with green flecks above, fading
into gray lower down.

Note: Also called "Maternité."

Collections: Ambroise Vollard, Paris; to Paul
Rosenberg & Co., New York; from his estate to
Mr. and Mrs. Sidney Rabb, Boston, Massachusetts.

Exhibitions: The Poses Institute of Fine Arts,
Brandeis University, "Boston Collects Modern
Art" (cat. 13, illus.), 1964.

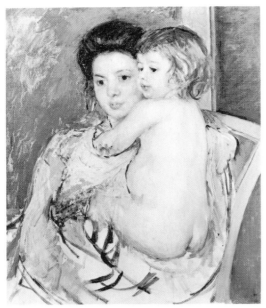

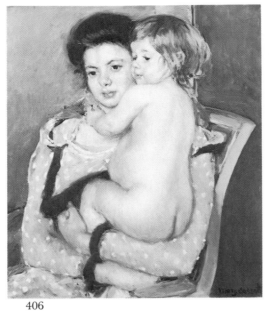

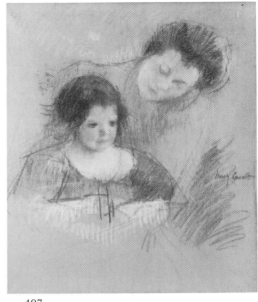

405

Study of Reine Lefebvre Holding a Nude Baby c. 1902

Oil on canvas, 26⅜ × 22⅜ in., 67 × 57 cm.
Unsigned

Description: A study for the oil (BrCR 406) without the details of mother's costume or the finishing of the baby's arm and hand.

Collections: Ambroise Vollard, Paris; *private collection*, Paris.

408

Reine Lefebvre and Margot before a Window
1902

Oil on canvas, 24 × 32 in., 61 × 81.2 cm.
Signed lower right: *Mary Cassatt*

Description: Half-length of a young mother in a soft green taffeta dress looking down at her child, who wears a ruby red velvet dress. Both have their hands clasped together, the mother's arms encircling her child. Behind them is a large conservatory window and beyond a green lawn and trees.

Note: Also called "Mère et enfant devant un vitrage et fond de parc."

Collections: Durand-Ruel, New York; to J. Howard Whittemore, Naugatuck, Connecticut; to Mr. and Mrs. Nicolas de Koenigsberg, New York; to Max Miller, Miami, Florida; to *private collection*, Houston, Texas, 1960.

Exhibitions: Durand-Ruel, Paris, 1908 (cat. 18); Armory Show, New York, 1913; Cincinnati Art Museum, 20th annual exhibition of American art, 1913; Pennsylvania Museum of Art, Philadelphia, annual, 1915; Baltimore Museum of Art, 1941–42 (cat. 46); The Mattatuck Historical Society, Waterbury, Conn., 1941 (cat. 1); Wildenstein, New York, 1947 (cat. 37, illus.); M. Knoedler & Co., New York, 1966 (cat. 38).

Reproductions: Achille Segard, 1913, fol. p. 112; Lorinda Munson Bryant, *American Pictures & Their Painters*, New York, 1917, fig. 160, fol. p. 207; *Life*, vol. 12 (19 Jan. 1942), p. 56 (color); *Art News*, vol. 64, no. 10 (Feb. 1966), p. 13.

406

Reine Lefebvre Holding a Nude Baby 1902

Oil on canvas, 26⅛ × 22½ in., 68.2 × 57.2 cm.
Signed lower right: *Mary Cassatt*

Description: Reine, wearing an orange robe with lighter dots, and bordered in brown fur, looks to left as she sits holding her nude baby in both of her arms. The chair back is shown at right.

Note: Also called "After the Bath." Durand-Ruel 4721-L7283.

Collections: Worcester Art Museum, purchased 1909.

Exhibitions: Corcoran Gallery of Art, Washington, 1st biennial, 1907 (cat. 219, illus.); Worcester Art Museum, 12th annual summer exhibition, 1909; Worcester Art Museum, 15th annual summer exhibition, 1912 (cat. 7); Baltimore Museum of Art, 1941–42 (cat. 39); Wildenstein, New York, 1947 (cat. 35, illus.); Cincinnati Art Museum and Dayton Art Institute, 1957.

Reproductions: *Studio*, vol. 21, no. 121 (March 1907), p. x; *Worcester Art Museum Bulletin*, vol. 1, no. 1 (1910), p. 4; Achille Segard, 1913, fol. p. 108; *Touchstone Magazine*, vol. 7 (July 1920), p. 265; *Worcester Art Museum Catalogue*, 1922, p. 169; Rilla Evelyn Jackman, *American Arts*, Chicago, 1928, pl. 73, fol. p. 168.

407

Reine Leaning Over Margot's Shoulder
c. 1902

Pastel on paper, 26 × 22 in., 66 × 56 cm. (sight)
Signed center right: *Mary Cassatt*

Description: Head and shoulders of Reine and of little Margot, who wears a round-necked, puffed-sleeved, dark red dress. Her dark hair is rather short. Reine, in a green blouse, looks down at Margot from over her left shoulder.

Collections: Mrs. Percy C. Madeira, Berwyn, Pennsylvania.

Exhibitions: Philadelphia Museum of Art, 1960; Parrish Art Museum, Southampton, N.Y., 1967 (cat. 18).

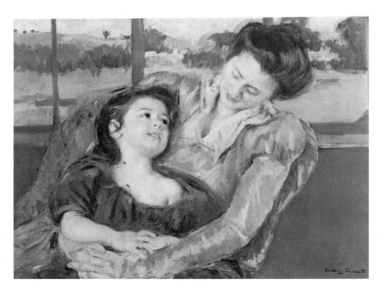

409

Sketch of Jeanette c. 1902
Pastel on paper, 18 × 14½ in., 45.7 × 37 cm.
Signed toward lower right: *Mary Cassatt*

Description: Head and shoulders of a very little girl with dark hair and eyes, wearing a bonnet with long tie ends. She looks to right. Blue shading on upper lip and lower chin and lining the bonnet.

Note: Durand-Ruel A1833-NY5531.

Collections: George Gard de Sylva, Los Angeles; to Mrs. Allen Kander, Washington, D. C.; to Hirschl & Adler, New York; to *Morgan State College*, Baltimore, gift of Mr. and Mrs. J. M. Kaplan, New York.

Reproductions: Selections from the Collection of Hirschl & Adler Galleries, vol. 2, 1960 (cat. 4); *Museum News* (June 1965), p. 34.

410

Nude Dark-Eyed Little Girl with Mother in Patterned Wrapper c. 1902
Pastel on paper, not measured
Unsigned

Description: Head and shoulders of a mother with her nude dark-eyed little girl, who rests her right hand on her mother's left shoulder. The child looks at the spectator, the mother somewhat down, her head slightly forward. The child rests her cheek on her mother's.

Collections: Provenance and present location unknown.

411

Sketch of Woman in Light Green Wrapper Holding Her Child c. 1902
Pastel, c. 27 × 23 in., 68.6 × 58.4 cm.
Signed lower right: *Mary Cassatt*

Description: A mother, seen in profile to left, holds her nude child, who rests her right arm on her mother's chest. Both look to left and have dark hair. Darker background at left.

Collections: Present location unknown.

412

Woman in an Orange Wrapper Holding Her Nude Baby 1902
Pastel on gray paper, 28⅜ × 20⅞ in., 72 × 53 cm.
Signed lower right: *Mary Cassatt*

Description: A dark-haired mother, in a bright orange negligée with a green and blue pattern, holds her nude brunette daughter. The mother is in profile facing left, while the little girl stands on

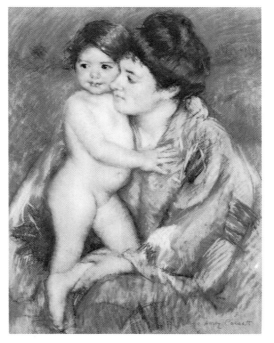

her lap, facing front, with her eyes directed left. The daughter's right arm rests below her mother's shoulder, and her left hand appears at the back of her mother's neck. The background is blue above, shading into a bright green with a strip of red across the picture at shoulder height.

Note: Durand-Ruel 10671-LD13377.

Collections: From the artist to Durand-Ruel, Paris; to M. Manaud, Paris; to Albert E. McVitty, Princeton, New Jersey; to Sidney Schoenberg; to *private collection*, New York.

Exhibitions: Pennsylvania Museum of Art, Philadelphia, "Mary Cassatt Memorial Exhibition," 1927; Brooklyn Institute of Arts and Science, "Leaders of American Impressionism: Mary Cassatt, Childe Hassam, J. H. Twachtman and J. Alden Weir," 1937; New Jersey State Museum, Trenton, 1939 (cat. 9); Baltimore Museum of Art, 1941–42 (cat. 38); Philadelphia Museum of Art, 1960.

Reproductions: Edith Valerio, 1930, cover; Adolph Basler and Charles Kunstler, *Modern French Painting: The Post-Impressionists from Monet to Bonnard*, New York, 1931, pl. 30.

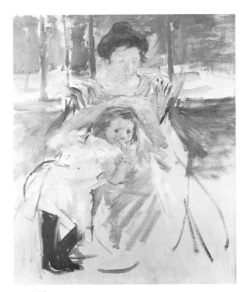

413
Sketch for "Young Mother Sewing" 1902
Oil on canvas, 17½ × 14¾ in., 44.5 × 37.5 cm.
Unsigned. Mathilde X seal on stretcher

Description: A seated young woman sews while her
little girl leans against her knees with her hand to
her mouth and looks at the spectator. Behind
them, through wide open windows, is seen a
brown lawn with trees and in the distance,
greenery. The little girl wears black stockings and
shoes and is seen in full length.

Note: Also called "Femme et enfant dans un
paysage." Durand-Ruel 10455-LD13153.

Collections: From the artist to Mathilde Vallet,
1927; in Mathilde X sale, Paris, 1927; to Durand-
Ruel, Paris; to Oliver B. James; to *Mrs. Lawrence
Pool*, Alpine, New Jersey, 1945, inherited from her
father, Mr. James.

Exhibitions: Galerie A.-M. Reitlinger, Paris, 1927
(cat. 21).

415
Young Mother Sewing 1902
Oil on canvas, 36⅜ × 29 in., 92.3 × 73.7 cm.
Signed lower right: *Mary Cassatt*

Description: Before a wide window opening onto a
lawn with trees a young woman sits sewing. She
wears a black and white striped dress and a light
blue apron. A little girl in white leans against her
knees. At left is a blue and white vase of orange
flowers on a bureau.

Note: Durand-Ruel 9458.

Collections: Metropolitan Museum of Art, New York,
bequest of Mrs. H. O. Havemeyer, 1929.

Exhibitions: St. Botolph's Club, Boston, 1909 (cat.
13); M. Knoedler & Co., New York, "Master-
pieces of Old and Modern Painters" (cat. 47),
1915; Pennsylvania Academy of the Fine Arts,
Philadelphia, 1920; Metropolitan Museum of
Art, New York, "H. O. Havemeyer Collection"
(cat. 3), 1930; Baltimore Museum of Art, 1941–42

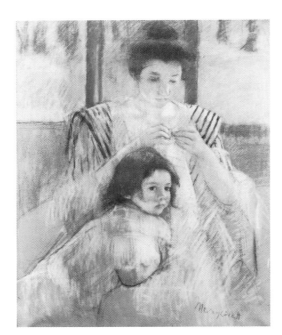

414
Study for "Young Mother Sewing" 1902
Pastel on tan board, 36¼ × 29⅛ in., 92 × 74 cm.
Signed lower right: *Mary Cassatt*

Description: Before a wide window divided in
three segments, looking out onto a lawn and
trees, a young mother sits sewing. She wears a
black and white striped dress. A little girl leans
against her knees and looks almost at the spec-
tator, very soberly. Her hands do not show. There
is no bureau at the left and no vase of flowers, as
in the finished oil (BrCR 415).

Collections: Private collection, Paris.

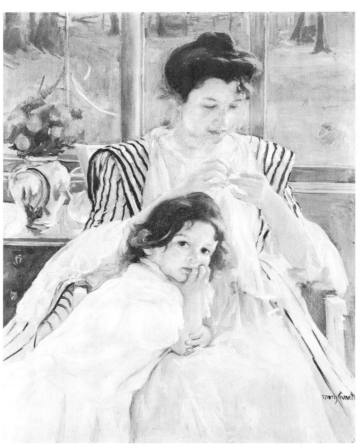

(cat. 41); Museum of Modern Art, New York,
"Children's Festival of Modern Art," 1943; Mint
Museum, Charlotte, N.C., 1946; Newark Museum,
1946; Fairleigh Dickinson College, 1946; Society
of Fine Arts, Palm Beach, 1950; Pasadena Art
Institute, 1951 (cat. 6); Vancouver Art Gallery,
1955; Brearley School, New York, 1956; Metro-
politan Museum of Art, New York, "Three
Centuries of American Painting," 1965; Parrish
Art Museum, Southampton, N.Y., 1967 (cat. 11,
illus., color).

Reproductions: Gustave Geffroy, "Mary Cassatt:
une peintre de l'enfance," *Les modes,* vol. 4 (Feb.
1904), pp. 4–11; Arsène Alexandre, "La collection
Havemeyer et Mary Cassatt," *La Renaissance,* vol.
13 (Feb. 1930), p. 56; *Arts,* vol. 16 (March 1930),
p. 476; *Arts & Decoration,* vol. 33 (May 1930),
p. 55; *H. O. Havemeyer Collection Catalogue,* 1931
(privately printed), fol. p. 173; *Literary Digest,*
vol. 112 (March 1932), cover; Forbes Watson,
1932, p. 31; *Life,* vol. 12 (19 Jan. 1942), p. 56;
Margaret Breuning, 1944, p. 31.

416

**Sketch for "Margot Embracing Her Mother"
(No. 1)** c. 1902
Pastel on paper, 19 × 24⅞ in., 48 × 63 cm.
Signed lower right: *Mary Cassatt*

Description: Head and shoulders of Reine and
Margot. Reine faces toward left. Margot, leaning
her head against Reine's cheek, looks at the
spectator. Margot's right arm is bent with the
suggestion of her hand on Reine's chest. The
puffed sleeve of her dress is dark red.

Collections: The Newhouse Galleries, New York;
present location unknown.

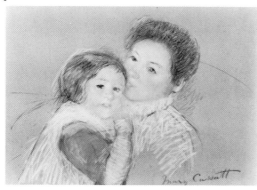

417 †

**Sketch for "Margot Embracing Her Mother"
(No. 2)** c. 1902
Pastel on paper, 19½ × 25 in., 49.4 × 63.3 cm.
Signed lower right: *Mary Cassatt*

Description: Bust-length sketch of a young mother
kissing her child on the cheek while the child
embraces her and looks at the spectator. Both
mother and child have dark hair and the child
wears a white pinafore with a dark red, short
sleeve.

Collections: Hôtel Drouot sale, Paris, 6 March 1927
(cat. 7); Gaston Levy sale, Hôtel Drouot, Paris,
17 Nov. 1932 (cat. 8); to Georges Bernheim,
Paris; present location unknown.

418

Margot Embracing Her Mother 1902
Oil on canvas, 36¼ × 28¾ in., 92 × 73 cm.
Signed lower right corner: *Mary Cassatt*

Description: The mother is seated on a broad, gold-
colored sofa with a mahogany frame. She clasps
her child around her knees as the child kneels on
her lap and hugs her mother. The child's dress is
crimson over which she wears a thin white
pinafore. The mother's dress is lavender. The wall
behind them is bluish gray and there is greenery
seen through the window at upper right.

Note: Also called "Caresse maternelle." Durand-
Ruel 4942-L7506.

Collections: J. M. Longyear; in his estate sale to
Miss Aimée Lamb; *Boston Museum of Fine Arts*,
Boston, Massachusetts.

Exhibitions: City Art Gallery, Manchester, Eng-
land, organized by Durand-Ruel, Paris, "Exhi-
bition of Impressionists" (cat. 68, illus.), 1907–08;
Durand-Ruel, Paris, 1908 (cat. 17); Royal
Academy of Arts, Berlin, "Exhibition of American
Art," 1910 (illus.); Worcester Art Museum, 14th
annual summer exhibition (cat. 8), 1911; Museum
of Fine Arts, Boston, "Paintings, Drawings,
Prints from Private Collections in New England"
(cat. 8), 1939; Baltimore Museum of Art, 1941–42
(cat. 37); Wildenstein, New York, 1947 (cat. 34).

Reproductions: Craftsman, vol. 18 (June 1910),
p. 302; *Magazine of Art*, vol. 32 (Sept. 1939),
p. 531.

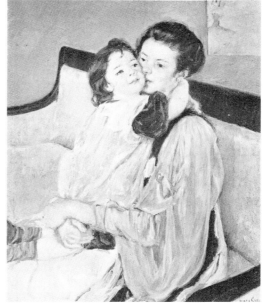

419

Margot's Face c. 1902
Pastel on tan paper, 11⅝ × 9¼ in., 29.6 × 23.5 cm.
Unsigned. Mathilde X collection stamp on verso

Description: Face of little Margot in three-quarter
view to left. Some dark hair on the top of her head
is indicated. No ear is drawn. One line for her
neck toward right and two lines at left for her
shoulder.

Collections: From the artist to Mathilde Vallet,
1927; Mathilde X sale, Paris, 1927; *private collec-
tion*, Paris.

Exhibitions: Galerie A.-M. Reitlinger, Paris, 1927
(cat. 37).

420

Head of Margot c. 1902
Pastel on paper, 8¼ × 6⅞ in., 21 × 17.5 cm.
Unsigned

Description: Head only of Margot with dark hair
and dark eyes, wearing a stiff round bonnet. She
looks slightly to the right.

Note: Also called "Enfant aux yeux bruns."

Collections: From the artist to Mathilde Vallet,
1927; Mathilde X sale, Paris, 1927; to Mr. Stone-
borough, Paris; to Guy Mayer, New York; to
Boston Public Library, Albert H. Wiggin Collection.

Exhibitions: Galerie A.-M. Reitlinger, Paris, 1927
(cat. 66, illus.).

Reproductions: Figaro artistique (24 March 1927),
p. 375.

421

Head of Margot in a Big Hat Looking to Left

c. 1902

Pastel on gray-beige paper, 18 × 12½ in.,
45.5 × 31.5 cm.
Unsigned. Mathilde X wax seal on verso

Description: Head and shoulders of a little girl
wearing a large gray hat with one touch of deep
pink that matches the deep pink of her dress,
heightened with orange. Her face and low neck
are of rosy pink flesh tones with blue-green
shadows. Eyes and hair are brown. There is a
lack of firm definition that results in an im-
pressionistic sketch.

Note: Also called "Fillette, corsage rouge."

Collections: From the artist to Mathilde Vallet,
1927; Mathilde X sale, Paris, 1927; *Harry Rubin*,
New York.

Exhibitions: Galerie A.-M. Reitlinger, Paris, 1927
(cat. 73).

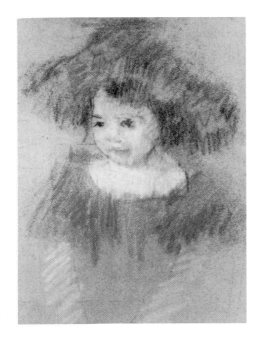

422

**Sketch of Head of Margot in a Bonnet
Looking to Right** c. 1902

Pastel on paper, 14¼ × 11 in., 36.5 × 28 cm.
Unsigned

Description: Head of a little girl with dark eyes and
hair. She wears a big straw bonnet tied with a big
bow under her chin. She looks off to the right. Her
face is longer than in the more finished version
(BrCR 423).

Collections: Private collection, Paris.

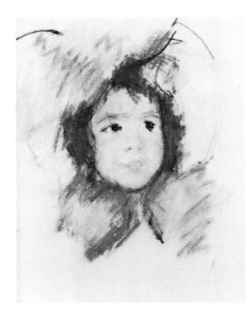

423

Head of Margot Looking to Right c. 1902

Pastel on paper mounted on board, 19½ × 15½ in.,
49.5 × 39.4 cm.
Signed within oval at lower right and also at top
left: *Mary Cassatt*

Description: Head of a little girl wearing a big
straw hat trimmed in blue under which her very
dark hair shows. Her eyes are equally dark. Her
coat is blue.

Note: The pastel is mounted formally in an oval
frame, therefore signed twice, since first sig-
nature was under the frame at upper left. On
the back is a label of Pottier, Emballeur, 14, rue
Gaillon, Paris, with the name Vollard written
in ink and a number "V.D. 96." On the present
backing of the frame is a hand-written label:
"This picture bought in Paris by Mr. Fox, the
Head of the Art Gallery at Indianapolis for
George E. Hume."

Collections: Ambroise Vollard, Paris; George E.
Hume, Indianapolis, Indiana, 1910; to *William M.
Hume*, San Francisco, California.

Exhibitions: According to the present owner, it has
been exhibited in Philadelphia, Louisville, and
Indianapolis.

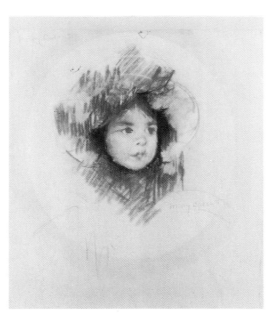

424

Spring: Margot Standing in a Garden 1902

Oil on canvas, 26¾ × 22 in., 68 × 56 cm.
Signed lower left: *Mary Cassatt*

Description: A little girl stands on the grass looking
to right, a garden in the background. She wears a
large, black, floppy hat with a pink rose on it.
Her currant-red puffed sleeved dress and white
pinafore have slipped off her left shoulder. She
holds up the front of her apron with both hands.
She has brown eyes and auburn hair.

Note: Also called "Fillette dans un jardin" and
"Bimbra nel jiardini." Durand-Ruel 4944-
L7508.

Collections: From the artist to Durand-Ruel, 1903;
to G. Kohn, Paris, 1909; Mrs. C. J. Lawrence,
New York; present location unknown.

Exhibitions: Durand-Ruel, Paris, 1908 (cat. 19);
St. Botolph's Club, Boston, 1909 (cat. 9); Durand-
Ruel, New York, 1924 (cat. 9) (called "Enfant
dans un jardin"); McClees Galleries, Philadelphia,
1931 (cat. 16).

Reproductions: Walter Shaw Sparrow, *Women
Painters of the World*, New York, 1905, p. 327;
Vittorio Pica, "Artisti Contemporanes: Berthe
Morisot e Mary Cassatt," *Emporium*, vol. 26
(1907), p. 17; *Good Housekeeping Magazine*, vol.
58 (Feb. 1914), p. 155; *Allies in Art*, London,
1917, pl. 29 (color); *Emporium*, vol. 101 (Jan.
1945), p. 33.

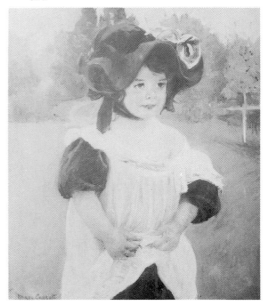

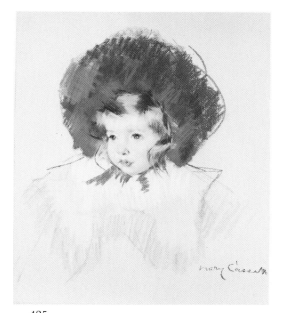

425

Portrait of Margot in a Large Red Bonnet
c. 1902
Pastel on light blue paper, 20¾ × 17⅛ in.,
52.5 × 43.5 cm.
Signed lower right: *Mary Cassatt*

Description: A little girl in a large, bright red
bonnet looks to left. Her hair is brown, her eyes
blue. Her coat or dress is pink with a white yoke.
The background is light green.

Note: Also called "Portrait of a Child, Red Hat,"
"Child with Red Hat," and "Enfant à la toque
rouge." Clark Institute inventory 674.

Collections: Mme. A. de Duel de Salyerne; to La
Jeunesse Collection, Paris; *Sterling and Francine
Clark Art Institute*, Williamstown, Massachusetts,
1935.

Exhibitions: Galerie Vollard, Paris, 1908 (cat. 8);
Sterling and Francine Clark Art Institute,
Williamstown, Mass., "Miscellaneous 19th Cen-
tury Artists" (suppl., 1958, pl. 8).

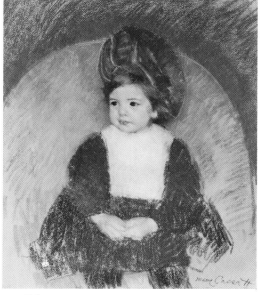

426

**Margot in a Dark Red Costume Seated on a
Round-Backed Chair** c. 1902
Pastel on paper, 25 × 21½ in., 63.5 × 54.6 cm.
Signed lower right: *Mary Cassatt*

Description: Margot wears an unusually high,
bright red and green beret, the top of which
extends above the rounded back of the mustard
yellow chair in which she sits. Her dark burgundy-
red dress has a deep, square, white yoke. She holds
her hands together in her lap. Her knees show
below the hem of her dress and her stockings are
black. The background is a medium deep olive
green.

Note: Also called "La Petite."

Collections: Ambroise Vollard, Paris; to Laing
Galleries, Toronto; *George N. Richard*, New York.

Reproductions: Art News, vol. 53 (Sept. 1954), p. 56.

427

**Margot in a Dark Red Costume Seated on a
Round-Backed Chair (Counterproof)**
Pastel on paper, 23¾ × 20 in., 60.2 × 51 cm.
Signed lower right: *Mary Cassatt*

Description: The colors of Margot's costume in
this counterproof are lighter than in the original
pastel (BrCR 426). Instead of dark red the color
is more like pink. The features are somewhat
coarsened and the entire figure is less well articu-
lated.

Note: Also called "La petite dans une bergère
jaune" or "Petite fille assise dans une bergère
jaune."

Collections: Mary E. P. B. Hines, New York;
Van Diemen-Lillienfeld Gallery, New York;
Sotheby & Co., sale, London, 4 July 1962 (cat.
87, illus.); Mrs. J. A. Curran, London; present
location unknown.

Exhibitions: Sotheby & Co., London and Paris,
1954 (cat. 9).

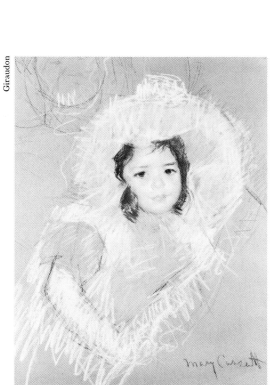

Giraudon

428

Study of Margot in a Fluffy Hat c. 1902
Pastel on gray paper, 23¼ × 17¾ in., 59 × 44 cm.
Signed lower right: *Mary Cassatt*

Description: Little Margot, with her dark brown
hair outlined by her very large fluffy bonnet,
looks at the spectator as she leans against some-
thing at the right. The pose is summarily sketched,
her face is well developed. Her bonnet is white
with light blue shading and with touches of green
outlining it at right. Her right arm is shown with a
short, orange, puffed sleeve. The face of her
mother is barely indicated at top left.

Note: Also called "Buste de fillette" and "Petite
fille au grand chapeau."

Collections: Ambroise Vollard, Paris; Roger-Marx,
Paris; Roger-Marx sale, Hôtel Drouot, Paris, 12
May 1914 (cat. 103); to *Musée du Petit Palais*,
Paris.

Exhibitions: Musée du Petit Palais, "Un siècle
d'art français, 1850–1950," 1953.

430
Reine Lefebvre and Margot c. 1902
Pastel on paper, 31¾ × 25¾ in., 80.6 × 65.5 cm.
Signed lower left corner: *Mary Cassatt*

Description: Reine Lefebvre is seated leaning her right arm along the curved end of a sofa. Margot leans against her, wearing a big, lacy bonnet trimmed with a bunch of white daisies at top. She rests her left arm against that of Reine and looks slightly toward the right. Her dark hair frames her face. Reine's dress is pink with white tulle; Margot's dress is a strong yellow.

Note: Durand-Ruel 10702-D13432.

Collections: Felix Doistau; in Doistau sale, Paris, 18 June 1928 (cat. 6); to Durand-Ruel, New York; to Mrs. A. L. Adams, Jr., Los Angeles, California, 1921; to *Armand Hammer*, Los Angeles, California.

Reproductions: Revue de l'art (Nov. 1928); *Bulletin de l'art ancien et moderne*, vol. 54 (Nov. 1928), p. 357.

429
**Study of Margot in a Fluffy Hat
(Counterproof)**
Pastel on paper, 30½ × 28 in., 77.5 × 71 cm.
Signed in reverse, lower left: *Mary Cassatt*

Description: Margot, wearing a big, fluffy bonnet is shown at the lower left looking at the spectator. Her dark hair frames her face. Only her left arm is drawn, with a dark, short, puffed sleeve. An outline of a woman's head and shoulder at upper right.

Note: Also called "Petite fille."

Collections: From the artist to Ambroise Vollard, Paris; to Mr. Clomovich, Yugoslavia; to the *National Museum*, Belgrade, Yugoslavia, 1949 (inventory no. 344).

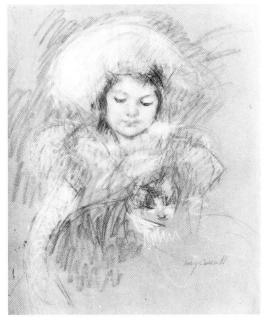

431
Margot Holding a Cat c. 1902
Pastel on paper, 28½ × 21⅛ in., 72.2 × 54 cm.
Signed lower right: *Mary Cassatt*

Description: Margot wears a large white hat and a party dress with puffed, short sleeves. She looks down at a cat which she holds with her right arm supporting its back.

Collections: Ambroise Vollard, Paris; to Mr. Clomovich, Yugoslavia; to the *National Museum*, Belgrade, Yugoslavia, 1949 (inventory no. 345).

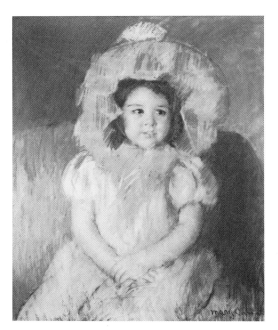

432
Margot in White 1902
Pastel on paper, 24⅞ × 20½ in., 63 × 52 cm.
Signed lower right: *Mary Cassatt*

Description: A little girl sits demurely forward on an upholstered couch with her hands folded in her lap. She looks off to right. She wears a big floppy hat with just one lighter detail of flowers above. Both hat and puffed sleeved dress are white.

Note: Durand-Ruel A6269.

Collections: Alexis Rouart, Paris; 4th Rouart estate sale, Paris, 19 May 1911 (cat. 198, illus.); to Durand-Ruel, Paris; to James Stillman, Paris; *Phyllis Bartlett Pollard*, New York (presented to her father by a member of the Stillman family in 1922).

Exhibitions: Durand-Ruel, Paris, 1908 (cat. 31).

Reproductions: L'art et les artistes, vol. 12 (Nov. 1910), p. 73.

433
Margot in an Orange Dress 1902
Pastel on paper, 28⅝ × 23⅝ in., 72.7 × 60 cm.
Signed lower right: *Mary Cassatt*

Description: The child sits in a dark green up-holstered chair with her right arm resting on its top. She wears a big fluffy white bonnet topped with flowers and tied in a large bow under her chin. Her orange dress is trimmed with a lace bertha. The background is gray.

Note: Also called "Fillette assise dans un fauteuil." Durand-Ruel 5066-L7606.

Collections: From the artist to James Stillman, Paris; *Metropolitan Museum of Art*, New York anonymous gift, 1922.

Exhibitions: Durand-Ruel, Paris, 1908 (cat. 27).

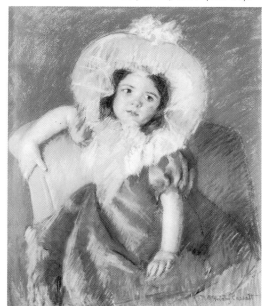

434
Margot in Blue 1902
Pastel on paper, mounted on canvas, 24 × 19⅝ in., 61 × 50 cm.
Signed lower right: *Mary Cassatt*

Description: Margot sits demurely in a chair with her hands folded in her lap. Her big floppy hat is decorated with three flowers at the top. Her long-sleeved blue coat is very full, with a shoulder cape edged with narrow plaiting.

Note: Durand-Ruel 5067-L7610.

Collections: Alexis Rouart, Paris; 3rd Rouart estate sale, 8–9–10 May 1911 (cat. 198); Galerie Georges Petit, Paris, Monsieur J. S. sale, 18 May 1925 (cat. 18); to the *Walters Art Gallery*, Baltimore, Maryland.

Exhibitions: City Art Gallery, Manchester, England, organized by Durand-Ruel, Paris, "Exhibition of Impressionists," 1907–08 (cat. 70); Durand-Ruel, Paris, 1908 (cat. 45); "D'art moderne à l'Hôtel de la Revue," Paris, 1912; Baltimore Museum of Art, 1941–42 (cat. 42); Wildenstein, New York, 1947 (cat. 38, illus.).

Reproductions: *Les arts*, vol. 11 (Aug. 1912), p. xv; E. S. King and Marvin C. Ross, *Catalogue of the American Works of Art*, Walters Art Gallery, Baltimore, 1956, p. 16.

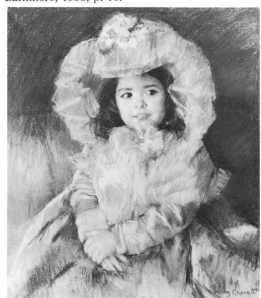

435
Simone in a Round-Backed Upholstered Chair c. 1903
Pastel on paper, 19¾ × 17⅜ in., 50 × 44 cm.
Signed center right: *Mary Cassatt*

Description: A little girl sits in a big, round-backed, greenish-blue armchair looking to left. Only her head and shoulders are shown, with the suggestion of her right hand on the chair arm. She has ash blond hair and dark eyes.

Collections: Lilienfeld Gallery, New York; to Schweitzer Gallery, New York.

Exhibitions: Hopkins Art Center, Dartmouth College, "Impressionism," 1962; University Art Gallery, University of New Mexico, Albuquerque, and M. H. de Young Memorial Museum, San Francisco, "Impressionism in America," 1965; Schweitzer Gallery, New York, "Sung and Unsung," 1965.

Reproductions: *Art Quarterly*, vol. 25, no. 1 (Spring 1962), p. 87.

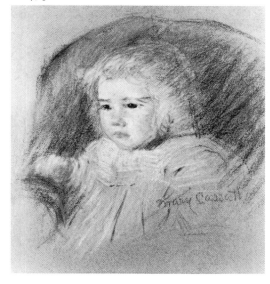

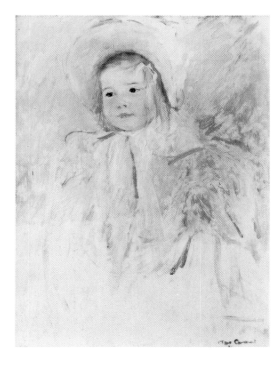

436
Simone in a Blue Bonnet (No. 1) c. 1903
Oil on canvas, 26 × 19½ in., 66 × 49.5 cm.
Signed lower right: *Mary Cassatt*

Description: Simone is dressed in red. Her hair is tied with a narrow pink ribbon, and she wears a deep blue bonnet which ties in a bow under her chin. The top of the bonnet just reaches the top of the canvas. Background green and gray.

Collections: From the artist to Payson Thompson;

American Art Association, New York, Thompson sale, 12 Jan. 1928 (cat. 93, illus.); *Fine Arts Gallery of San Diego*, California, bequest of Mrs. Henry A. Everett, 1938.

Exhibitions: Pasadena Art Institute, "Mary Cassatt and Her Parisian Friends" (cat. 14), 1951.

Reproductions: Edith Valerio, 1930, pl. 18; Margaret Breuning, 1944, p. 17 (detail only).

437
Simone in a Blue Bonnet (No. 2) c. 1903
Oil on canvas, 22¾ × 16½ in., 58 × 42 cm.
Signed lower right: *Mary Cassatt*

Description: A child in a bonnet looks to the left. The strings of the bonnet are tied in a bow with long streamers under her chin, and a bow of ribbon trimming it is featured in highlights at upper right. The top of the bonnet is well below the top of the canvas.

Note: Also called "L'enfant blonde." Durand-Ruel 10362-LD13068.

Collections: Pierre Decourcelle, Paris; Hôtel Drouot sale, Paris, 16 June 1926 (cat. 18); to Durand-Ruel, New York; to *Mrs. W. J. Brace*, Kansas City, Missouri.

Exhibitions: Galerie Vollard, Paris, 1908 (cat. 5); Durand-Ruel, New York, 1924 (cat. 15); Nelson Gallery and Atkins Museum of Fine Arts, "Kansas City Collects," 1965 (cat. 24, illus.).

438
Simone in a White Bonnet Seated with Clasped Hands (No. 1) c. 1903
Pastel on paper, 30½ × 25¼ in., 77.4 × 64.2 cm.
Signed lower right: *Mary Cassatt*

Description: The head only is developed; the arms are crudely sketched with no hands showing. Her bonnet is elaborately tied under her chin. Her hair is darker and more curly than in other pastels of this model. A shaded background is above the curved line of the sofa on either side of her head.

Collections: Ambroise Vollard, Paris; present location unknown.

Exhibitions: Galerie Vollard, Paris, 1908 (cat. 6).

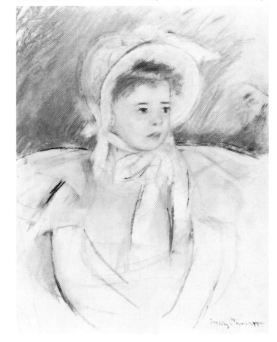

439
Simone in a White Bonnet Seated with Clasped Hands (No. 1) (Counterproof)
Pastel on paper, 20¾ × 17 in., 52.7 × 43 cm.
Signed lower right: *Mary Cassatt*

Description: Reverse of BrCR 438 (except signature).

Note: The bows on the bonnet and many other details are less well defined than in the original version. Also called "Fillette au chapeau blanc."

Collections: Ambroise Vollard, Paris; Findlay Associates, New York (sale cat. 2391); Parke-Bernet sale, New York, lot 48, 8–9 Dec. 1965; to Mrs. W. H. Jarvis, Jr., Temple, Texas; to *private collection*, Kalamazoo, Michigan.

Exhibitions: Sartor Galleries, Dallas, 1958 (cat. 7, illus.).

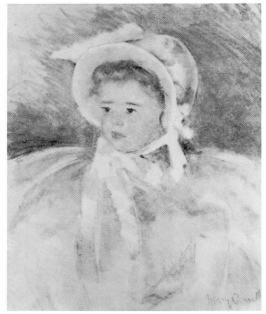

440
Simone in a White Bonnet Seated with Clasped Hands (No. 2) c. 1903
Pastel on tan oatmeal paper, 25½ × 16½ in., 65 × 42 cm.
Signed toward lower right: *M. C.*

Description: Simone sits on the end of a sofa with her hands clasped in her lap. They extend almost to the bottom of the paper. She wears a white bonnet and a white dress with short, puffed sleeves. She looks to right. Green background.

Collections: From the artist to Payson Thompson; American Art Association, New York, Thompson sale, 12 Jan. 1928 (cat. 85, illus.); to Albert E.

McVitty; to *Mrs. Dale H. Dorn*, San Antonio, Texas.

Exhibitions: Carnegie Institute, Pittsburgh, 1928 (cat. 4); Art Institute of Chicago, "Century of Progress," 1934; Brooklyn Institute of Arts and Sciences, "Leaders of American Impressionism: Mary Cassatt, Childe Hassam, J. H. Twachtman, and J. Alden Weir" (cat. 28), 1937; New Jersey State Museum, Trenton, 1939 (cat. 7); Haverford College, 1939 (cat. 26); Marion Koogler McNay Art Institute, San Antonio, Texas, "American Art in San Antonio Collections" (cat. 5), 1958.

Reproductions: Art Digest, vol. 12 (15 Oct. 1937), p. 8.

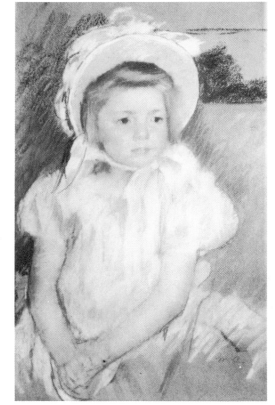

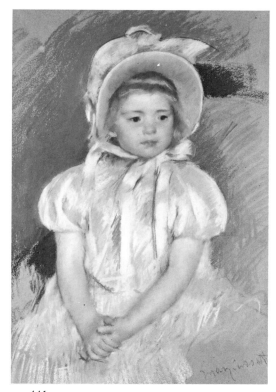

441
Simone in a White Bonnet Seated with Clasped Hands (No. 3) 1903
Pastel on paper, 28¼ × 19⅝ in., 71.7 × 49.8 cm.
Signed lower right: *Mary Cassatt*

Description: Simone sits on the end of a sofa with her hands clasped in her lap. She wears a white bonnet and a white dress with short, puffed sleeves. She looks to the right. Her hands are about four inches above the bottom of the picture.

Note: Also called "L'enfant blonde." Durand-Ruel A6272.

Collections: Alexis Rouart, Paris, 1908; to Albert Pra; Pra sale, Paris, 17 June 1938 (cat. 2, illus.); to *Reed Erickson,* Baton Rouge, Louisiana.

Reproductions: Art News, vol. 46, sec. 2 (Nov. 1947), p. 73 (detail).

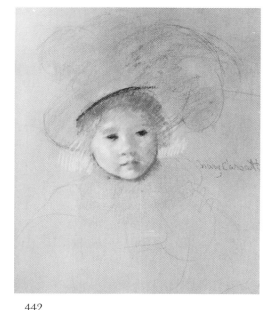

442
Head of Simone in a Large Plumed Hat, Looking Right c. 1903
Pastel on paper, 22½ × 18½ in., 57 × 47 cm.
Signed at center right: *Mary Cassatt*

Description: A summary sketch of Simone with face very well developed and eyes very dark. Only a slight indication of a plumed hat and a bow under her chin. She looks toward the right.

Collections: Frederic J. Oppenheimer, San Antonio, Texas.

443
Head of Simone in a Large Plumed Hat, Looking Left c. 1903
Pastel on paper, 17 × 18¼ in., 43 × 45 cm.
Signed lower left: *Mary Cassatt*

Description: Head of a little blond girl with straight, bobbed hair seen under a large plumed hat tied under her chin. Shaded background.

Note: Durand-Ruel 2898-L6242.

Collections: Hôtel Drouot sale, March 1901 (cat. 63); to Durand-Ruel, Paris; to Mrs. Montgomery Sears, Boston; to M. Knoedler & Co., New York; to *Mrs. Henry W. Breyer,* Bryn Mawr, Pennsylvania.

Reproductions: Good Housekeeping Magazine, vol. 50 (Feb. 1910), pp. 141, 144.

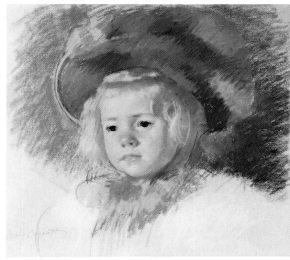

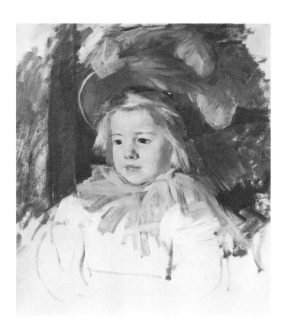

444
Simone in a Large Plumed Hat, Looking Left, a Dark Pilaster in the Background c. 1903
Oil on canvas, 28 × 25 in., 71 × 63.5 cm.
Unsigned

Description: A little blond girl looks to left, wearing a large, high blue hat with plumes falling over the brim and a big bow under her chin. There is a dark background with a strong upright post or pilaster at left.

Note: Hirschl & Adler 5264-D.

Collections: Joseph Katz, Baltimore, Maryland; *Museum of Art, Rhode Island School of Design,* gift of Mrs. Danforth, 1964 or 1965.

Reproductions: Gazette des beaux arts, s.6, vol. 67 (Feb. 1966), suppl. p. 68.

445 †

Simone in a Plumed Hat, Turned Left,
a Pilaster in the Background c. 1903
Pastel on paper, 24 × 19¾ in., 61 × 50.2 cm.
Unsigned

Description: A little blond girl wearing a big
plumed hat sits in a chair resting her left arm on
its arm in the foreground. The upright vertical
lines of a pilaster are in the background at left.

Collections: From the artist to Ambroise Vollard,
Paris; *A. Chester Beatty, Jr.*, London, England,
1954.

446

Simone in a Plumed Hat, Turned Left,
a Pilaster in the Background (Counterproof)
Pastel on paper, 24½ × 20 in., 62.2 × 50.7 cm.
Unsigned

Description: Reverse of BrCR 445. The details of
the hat are blurred.

Collections: From the artist to Ambroise Vollard,
Paris; present location unknown.

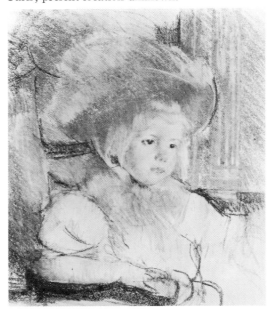

447

Simone in an Armchair with Both Hands
Resting on the Chair Arm c. 1903
Pastel on paper, 27 × 20 in., 68.3 × 50.5 cm.
Signed lower right: *Mary Cassatt*

Description: A little girl sits in an armchair facing
left, looking slightly to left. She wears a hat tipped
back on her head, showing her ash blond hair,
with a big bow under her chin. There are a num-
ber of rough awkward lines reinforcing the pastel.

Collections: Private collection, Paris.

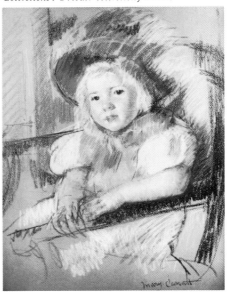

448

Simone in a Large Plumed Hat, Seated,
Holding a Griffon Dog c. 1903
Pastel on paper, 23⅝ × 17¾ in., 60 × 45 cm.
Signed lower right: *Mary Cassatt*

Description: A little girl sits in a chair with a dark
wooden frame, one arm of which is seen at lower
right. She is turned toward the left. She holds a
light-colored griffon dog and wears a large
plumed hat tied with a bow at her chin.

Note: After the counterproof of this pastel was
taken some rework was done, such as the dark
line within the rim of the hat at left and the
dark shading of it toward the right, also the out-
lining of her hand and arm.

Collections: Ambroise Vollard, Paris; *private col-
lection*, Paris.

Exhibitions: "D'art moderne à l'Hôtel de la
Revue," Paris, 1912.

Reproductions: Les arts, vol. 11 (Aug. 1912), p. xv.

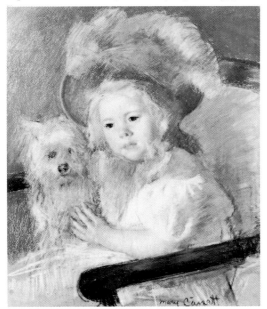

449

Simone in a Large Plumed Hat, Seated,
Holding a Griffon Dog (Counterproof)
Pastel on paper, 29 × 22¾ in., 73.6 × 57.8 cm.
Signed faintly, in reverse, toward lower left: *Mary
Cassatt*

Description: Reverse of BrCR 448.

Note: Very little, if any, rework was done on this
counterproof. There is, therefore, a lack of
definition of the forms.

Collections: From the artist to Ambroise Vollard,
Paris; to Mr. Clomovich, Yugoslavia; to the
National Museum, Belgrade, Yugoslavia, 1949
(inventory no. 346).

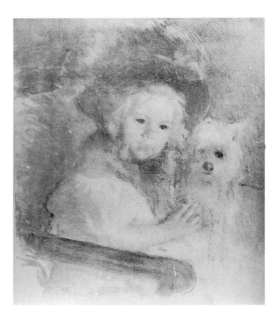

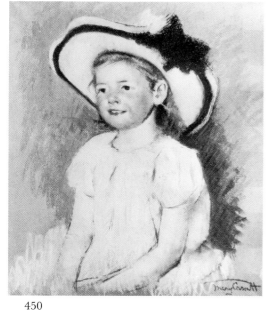

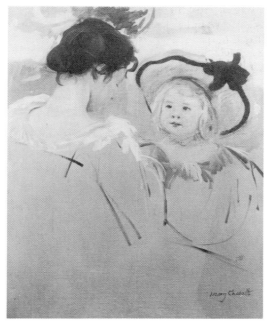

Simone Talking to Her Mother c. 1904

Oil on canvas, 31⅞ × 25⅝ in., 81 × 65 cm.
Signed lower right: *Mary Cassatt*

Description: Head and shoulders of a mother seen from the rear, her dark head looking down with few features in view. Her little girl is before her looking up at her, wearing a big straw hat outlined in black velvet ribbon with a big bow toward right and a pink dress. Heads and shoulders only. Lower half of canvas left undeveloped in flat, gray tone. Greens in background and one brown area above the mother's head.

Note: Durand-Ruel 7930-L10602.

Collections: Madeline Dreyfus-Bruhl, Paris, *Dr. and Mrs. A. K. Chapman*, Rochester, New York.

Exhibitions: Centre Culturel Américain, Paris, 1959–60 (no. 3).

Reproductions: Edith Valerio, 1930, pl. 7.

450

Simone Wearing a Big Hat Outlined in Black Ribbon c. 1904

Pastel on paper, 23⅝ × 19 in., 60 × 48 cm.
Signed lower right: *Mary Cassatt*

Description: A little girl seated facing left smiles as she looks left. She wears a big yellow hat trimmed on the underbrim with black ribbon and a pom-pon toward right. Her white dress, tinted in yellow, has short, puffed sleeves, and her hands (not visible) are in her lap.

Collections: Galerie Georges Petit, Paris, Jacques Seligmann sale, 18 May 1925; present location unknown.

Exhibitions: "D'art moderne à l'Hôtel de la Revue," Paris, 1912.

Reproductions: *Les arts*, vol. 11 (Aug. 1912), p. xv.

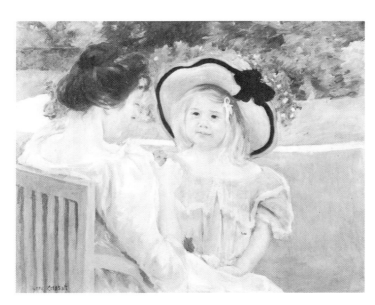

452

Simone and Her Mother in the Garden
1904

Oil on canvas, 24⅜ × 32⅝ in., 62 × 83 cm.
Signed lower left: *Mary Cassatt*

Description: A little girl stands before her mother, smiling at her. She wears a big straw hat, outlined in black velvet ribbon with a large bow of it toward right. She wears a bright pink dress trimmed in white and has a pink bow in her hair. The mother is dressed in white and sits in a blue, slatted chair. Behind them is a lovely garden with blooming flowers.

Note: Also called "Au jardin." Durand-Ruel 3917-L6916.

Collections: C. J. Lawrence sale, New York, 21 Jan. 1910; to James Stillman, Paris; to the Metropolitan Museum of Art, New York, 1922; to *Detroit Institute of Arts*, gift of Edward Chandler Walker.

Exhibitions: Durand-Ruel, New York, 1924 (cat. 3); Kalamazoo Art Center, Kalamazoo, Mich., "Paintings by American Masters," 1966 (illus.).

Reproductions: *Forma*, vol. 2, no. 21 (1907), p. 339; *Current Literature*, vol. 46 (Feb. 1909), p. 169; *Good Housekeeping*, vol. 58 (Feb. 1914), p. 155; *Bulletin, Detroit Institute of Arts*, vol. 3 (April 1922), p. 66; *Arts*, vol. 3 (April 1923), p. 289; *Paintings in the Permanent Collection*, Detroit Institute of Arts, 1930, no. 276; *College Art Bulletin*, vol. 13, no. 3 (1954), pp. 179–84.

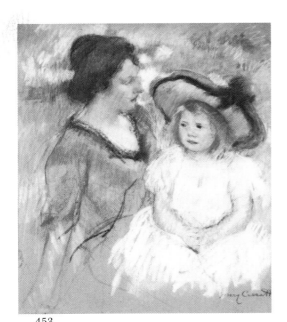

453

Simone Seated on the Grass Next to Her Mother c. 1904
Pastel on paper, $28\frac{1}{2} \times 23\frac{1}{2}$ in., 72.5×59.7 cm.
Signed lower right: *Mary Cassatt*

Description: A little girl seated at right is wearing a big hat outlined on the underbrim with black velvet ribbon with a bow of it at right. She wears a light dress with short, puffed sleeves. Her mother, at left, is seen in profile to right wearing a dress with a low V-neck.

Note: M. Knoedler & Co., New York, no. CA3433.

Collections: Dr. and Mrs. A. K. Chapman, Rochester, New York.

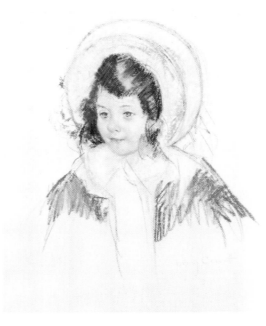

454

Sara Wearing a Bonnet and Coat c. 1904
Pastel on paper, $20\frac{1}{4} \times 17\frac{3}{8}$ in., 51.4×44.2 cm.
Signed lower right: *Mary Cassatt*

Description: This pastel is related to the lithograph (Br 198) and is a study for it, but Sara has no bow on her hair and there are no long ends of hair hanging forward over her coat collar. The composition is otherwise much the same.

Collections: Private collection, Paris.

455

Sara in a Green Coat c. 1904
Pastel on paper, $24 \times 19\frac{3}{4}$ in., 61×50 cm.
Signed lower right: *Mary Cassatt*

Description: A little girl sits in half length, looking left, her face in three-quarter view. She wears a stiff, pink poke bonnet with her hair and hair ribbon showing under it. Her green coat has a cape collar edged in white scallops and a tremendous pink bow under her chin. The background is gray.

Note: Durand-Ruel 6649-L9194.

Collections: James Stillman, Paris; *Metropolitan Museum of Art,* New York, anonymous gift, 1922.

Exhibitions: Baltimore Museum of Art, 1941–42 (cat. 43).

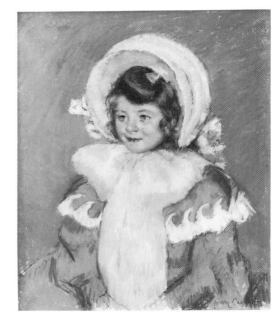

456

Dorothy in a Very Large Bonnet and a Dark Coat c. 1904
Pastel on paper, 23×17 in., 58.3×43 cm.
Signed lower right: *Mary Cassatt*

Description: A little girl with fat pink cheeks sits with her left arm resting on the arm of an upholstered chair. She wears a high fluffy white bonnet faced with light blue, under which her brown curls show. The bonnet is tied under her chin and the front of her dark blue coat is light. Apple green chair and background.

Note: Related to drypoint "The Velvet Sleeve" (Br 194). Durand-Ruel 8773-L11314.

Collections: William Thornton Kemper, Kansas City, Missouri.

Exhibitions: Nelson Gallery and Atkins Museum of Fine Arts, Kansas City, "Kansas City Collects" (cat. 22, illus.), 1965.

457
Head of Simone in a Green Bonnet with Wavy Brim (No. 1) c. 1904
Pastel, 24½ × 18½ in., 62 × 47 cm.
Signed at center right: *Mary Cassatt*

Description: Head only of a little blond girl in a strange floppy hat with ribbon under her chin. She looks to right.

Note: Durand-Ruel 10452-LD13157.

Collections: From the artist to Mathilde Vallet, 1927; Mathilde X sale, Paris, 1927; to Durand-Ruel, Paris; to Chester H. Johnson Gallery, 1929; to *B. Mont*, New York, 1951.

Exhibitions: Galerie A.-M. Reitlinger, Paris, 1927 (cat. 58).

458
Head of Simone in a Green Bonnet with Wavy Brim (No. 2) c. 1904
Pastel on light brown paper, 16 × 17¾ in., 37 × 43 cm.
Signed upper right: *Mary Cassatt*

Description: A little blond girl is seen looking to right. Her dark green hat dips at right. Head and shoulders only.

Collections: From the artist to Ambroise Vollard, Paris; Galerie Charpentier sale, Paris, 27 April 1951; to Hirschl & Adler, New York; to *City Art Museum of St. Louis*, gift of Mr. and Mrs. John E. Simon, 1957.

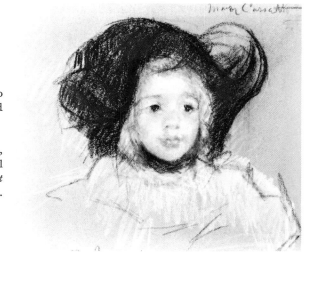

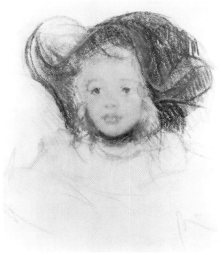

459
Head of Simone in a Green Bonnet with Wavy Brim (No. 2) (Counterproof)
Pastel, 19¼ × 15⅜ in., 49 × 39 cm.
Signed lower right: *Mary Cassatt*

Description: Reverse of BrCR 458.

Collections: *Private collection*, London.

Exhibitions: Arthur Tooth & Sons, London, 1956 (cat. 17).

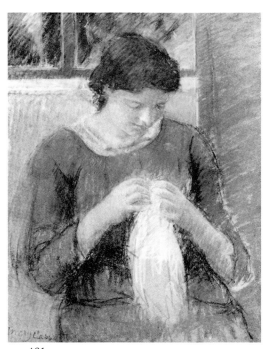

461
Sewing in the Conservatory c. 1905
Pastel on tan paper, 28 × 20 in., 71 × 51 cm.
Signed lower left corner: *Mary Cassatt*

Description: A young woman in a teal blue dress with a white collar sits before a double window. Her hair is dark auburn. She is seen in half-length sewing with both hands. She looks down at the material, her face foreshortened. The wall at the right is tan. The wall behind the figure is white with blue border. Green trees are seen through the windows.

Note: Also called "Girl Knitting," "Femme tricotant," and "Jeune femme brodant."

Collections: From the artist to Ambroise Vollard, Paris; Martin Fabiani, Paris; to Mlle. Fouque et Mlle. Deschryvère, 1945; to the International Gallery, Chicago, 1965; to *Mrs. Samuel E. Johnson*, Chicago, Illinois.

Reproductions: Galerie Charpentier, Paris, 10 Dec. 1959 sale catalogue, pl. 2; *Journal de l'amateur d'art* (10 Feb. 1960), p. 20; Galerie Motte, Geneva, 25 April 1961 sale catalogue (cat. 244), pl. 7; *Tribune de Genève* (May 1961), p. 2.

460
Head of Simone in a Green Bonnet with Wavy Brim (No. 3) c. 1904
Pastel, 23½ × 17¼ in., 59.5 × 43.7 cm.
Signed right center: *Mary Cassatt*

Description: Head and shoulders of a somewhat younger child than in first and second versions, with darker hair. A suggestion of a wide coat collar is outlined. She looks to right, framed in a bluish-green hat with wavy, floppy brim tied with a broad ribbon beneath her chin.

Collections: From the artist to Payson Thompson; American Art Association, New York, Thompson sale, 12 Jan. 1928 (cat. 81, illus.); present location unknown.

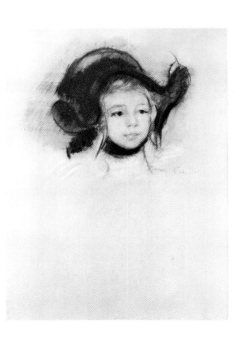

462

Woman in Raspberry Pink Costume Holding a White Dog c. 1905

Pastel on gray paper mounted on canvas, 29 × 23¾ in., 73.7 × 60.3 cm.

Signed lower right: *Mary Cassatt*

Description: Half-length sketch of a woman wearing a black plumed hat and a raspberry pink costume with two short shoulder capes and a flat bow at the throat. Before her is a small white dog. Both look to left.

Collections: Galerie L'Art Moderne, Paris; to Charles Laughton and Elsa Lanchester, California; Parke-Bernet sale, New York, 20 Oct. 1966 (cat. 91, color illus.); to *Joseph H. Hirshhorn Collection*, New York.

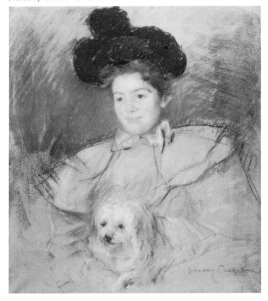

463

Woman in a Black Hat and a Raspberry Pink Costume c. 1905

Pastel on tan paper, 32 × 25½ in., 81.3 × 64.7 cm.

Signed lower left (twice): *Mary Cassatt*

Description: Three-quarter length study of a seated blond woman with dark eyes, turned left and looking left. She wears a large black plumed hat and a raspberry pink coat dress with two short shoulder capes and three big, blue buttons. The background is bright yellow.

Collections: Mrs. Cheever Cowdin, New York.

Exhibitions: M. Knoedler & Co., New York, 1966.

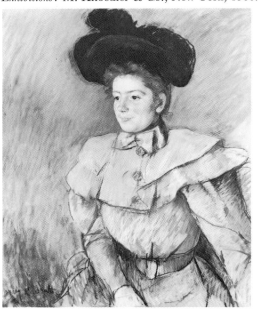

464 †

Study of a Young Girl's Head c. 1905

Pastel on gray paper, 14 × 16¾ in., 35.7 × 42.8 cm. Unsigned. Mathilde X collection stamp on verso

Description: Head of a girl looking up to the right. Her face is highlighted at the right with white or pink pastel. Sketchy lines of a high hat with some shading.

Collections: From the artist to Mathilde Vallet, 1927; Mathilde X sale, Paris, 1927; *private collection*, Paris.

Exhibitions: Galerie A.-M. Reitlinger, Paris, 1927 (cat. 22).

465

Woman in a Blue and Red Hat c. 1905

Oil on canvas, 25⅝ × 19⅝ in., 65 × 50 cm. Unsigned

Description: Head and shoulders of a young woman with very dark hair wearing a hat with high trimming. She looks off to left, seen in three-quarter view against a background of lawn and trees. The square back of a chair is indicated at left at shoulder height.

Note: Durand-Ruel 19012.

Collections: Ambroise Vollard, Paris; *private collection*, Paris.

466

Sketch of "Ellen Mary Cassatt in a Big Blue Hat" c. 1905

Oil on canvas, 24 × 22 in., 61 × 56 cm. Unsigned

Description: Head of Miss Cassatt's niece wearing a very large blue hat. Her dark hair is parted over the forehead. The hat is only summarily treated.

Collections: Mrs. Percy C. Madeira, Berwyn, Pennsylvania.

Exhibitions: McClees Galleries, Philadelphia, 1931 (cat. 12); Philadelphia Museum of Art, 1960; Parrish Art Museum, Southampton, N.Y., 1967 (cat. 12).

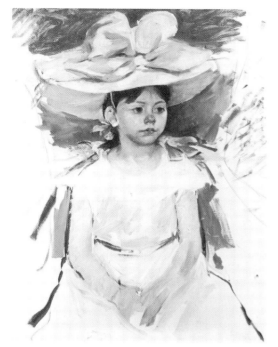

467
Ellen Mary Cassatt in a Big Blue Hat
c. 1905
Oil on canvas, 32 × 24 in., 81 × 60.8 cm.
Unsigned

Description: Ellen Mary is seated, wearing a very large blue hat. Her dark hair is parted in the middle over her forehead, and two braids tied with blue ribbons rest on her shoulders. The face well developed, the rest of the picture broadly sketched.

Collections: Robert Kelso Cassatt; to *Mr. and Mrs. Richman Proskauer*, New York.

Exhibitions: Haverford College, 1939 (cat. 16); Philadelphia Museum of Art, 1960; M. Knoedler & Co., New York, 1966 (cat. 37).

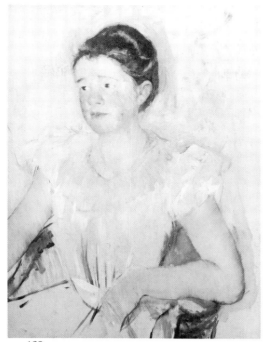

468
Half-length Sketch of Katharine Kelso Cassatt c. 1905
Oil on canvas, 23¾ × 17¼ in., 60.4 × 44 cm.
Unsigned. Mathilde X collection stamp on verso

Description: Half-length view of the artist's mother as a young woman wearing an evening dress with frilly ruffles at the neck and on the shoulders, the waist nipped in. She has dark brown hair and looks to left. Her left arm rests on the arm of a chair.

Note: Durand - Ruel A 1415 - NY 5018; 10499 - LD 13166.

Collections: From the artist to Mathilde Vallet, 1927; Mathilde X sale, Paris, 1927; to Emile Bernheim, Paris; to Durand-Ruel, New York; present location unknown.

Exhibitions: Galerie A.-M. Reitlinger, Paris, 1927 (cat. 79); Durand-Ruel, New York, 1935 (cat. 18); Brooklyn Institute of Arts & Sciences, "Leaders of American Impressionism: Mary Cassatt, Childe Hassam, J. H. Twachtman and J. Alden Weir" (cat. 29), 1937; New Jersey State Museum, Trenton, 1939 (cat. 6); Haverford College, 1939 (cat. 18).

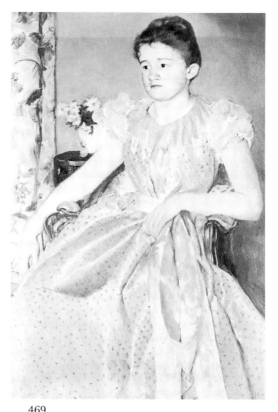

469
Portrait of Katharine Kelso Cassatt c. 1905
Oil on canvas, 39 × 26 in., 99.5 × 66 cm.
Unsigned

Description: A young woman in a white dotted silk evening dress sits in a chair looking to left. Her hair and eyes are dark. Her right arm hangs over one arm of the chair, the left rests on the other. Her dress has ruffles at the round neck, puffed, short sleeves, and a long sash. Behind her is a small table with a vase of flowers on it, and farther left a cretonne curtain.

Note: This is a portrait of the artist's mother as a young girl.

Collections: Katharine Stewart de Spoelberch, Haverford, Pennsylvania.

Exhibitions: Pennsylvania Museum of Art, Philadelphia, 1927; Philadelphia Museum of Art, 1960.

Reproductions: Arts, vol. 11 (June 1927), p. 291.

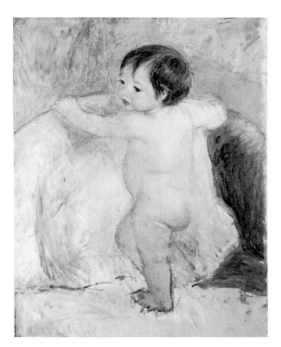

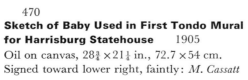

470
Sketch of Baby Used in First Tondo Mural for Harrisburg Statehouse 1905
Oil on canvas, 28¾ × 21¼ in., 72.7 × 54 cm.
Signed toward lower right, faintly: *M. Cassatt*

Description: A nude baby stands alone holding onto the rounded back of a large armchair over which a white sheet is draped. The sheet is shaded in tones of lavender. Background is grayish-blue with tan overlay.

Note: Also called "Bébé debout."

Collections: J. B. Speed Art Museum, Louisville, Kentucky, gift of Mrs. Blakemore Wheeler, 1964, who acquired it in London.

471

Tondo Mural for Harrisburg Statehouse (No. 1) 1905

Oil on canvas, 36½ in. diameter, 93 cm.
Unsigned

Description: A mother, wearing a soft yellow gown with deep décolletage, kneels on the floor beside her nude baby. He has black hair and eyes and his fist is in his mouth. He is seen full length.

Note: Durand-Ruel A6307.

Collections: Mrs. Percy C. Madeira, Berwyn, Pennsylvania.

Exhibitions: Wildenstein, New York, 1947 (cat. 41); Philadelphia Museum of Art, 1960; Parrish Art Museum, Southampton, N.Y., 1967 (cat. 7).

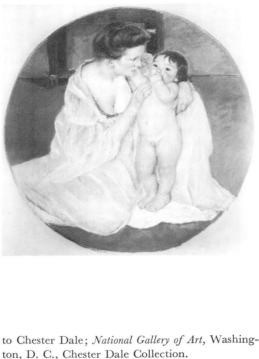

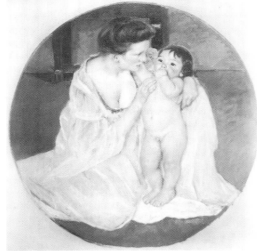

472

Tondo Mural for Harrisburg Statehouse (No. 2) 1905

Oil on canvas, 39½ in. diameter, 100.5 cm.
Signed lower left: *Mary Cassatt*

Description: A little blond girl with straight bobbed hair tied with a bow at left, wearing a pink dress, leans both hands on a crimson cushion covering a chest or bench behind her, and looks at her baby brother seated on her mother's lap. He is nude with dark hair. One leg extends toward left before him. The mother holds his left arm with her left hand. She wears a yellow gown with a long, loose sleeve.

Note: A section (supra-porte) intended for the women's lounge in the Statehouse, Harrisburg, Pennsylvania. Cassatt did not take the commission after completing the two tondos because she had heard that there was much graft involved in the building of the Statehouse. Durand-Ruel 7926-L11717.

Collections: From the artist to J. Howard Whittemore, 1915; Parke-Bernet, New York, Whittemore sale, 19–20 May 1948; *Mr. and Mrs. Nicholas de Koenigsberg*, New York.

Exhibitions: Durand-Ruel, Paris, 1914 (cat. 6); Baltimore Museum of Art, 1941–42 (cat. 47, illus.); Wildenstein, New York, 1947 (cat. 40, illus.).

Reproductions: Baltimore Museum News, vol. 3 (Nov. 1941), pp. 70–71.

473

Mother Wearing a Sunflower on Her Dress
c 1905

Oil on canvas, 36¼ × 29 in., 91 × 72 cm.
Signed lower right corner: *Mary Cassatt*

Description: A mother wears a low-necked gown decorated with a large yellow sunflower over her left breast. Her long, loose sleeve hangs over the green chair arm at right. The nude little blond girl seated on her lap faces to left and looks into a hand mirror which both she and her mother hold. Her full face is reflected in the hand mirror, her mother's profile in a large mirror in the background.

Note: Also called "La femme au tournesol" and "Le miroir."

Collections: Roger-Marx, Paris; Roger-Marx estate sale, Paris, 1914 (cat. 15); Mr. and Mrs. H. O. Havemeyer, New York; American Art Association, New York, Havemeyer sale, 10 April 1930; to Chester Dale; *National Gallery of Art*, Washington, D. C., Chester Dale Collection.

Exhibitions: Durand-Ruel, Paris, 1908 (cat. 6); M. Knoedler & Co., New York, 1915 (cat. 50); Carnegie Institute, Pittsburgh, 1928 (cat. 3).

Reproductions: Gazette des beaux arts, vol. 51 (Oct. 1909), fol. p. 334; *Ladies' Home Journal,* vol. 65 (Jan. 1948), p. 43 (color).

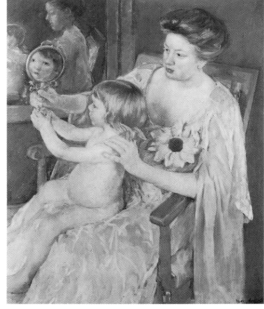

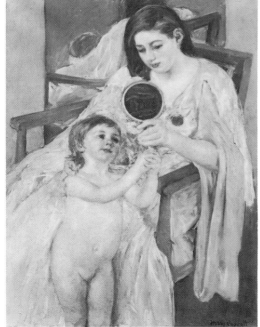

474

Denise and Her Child Holding a Hand Mirror
c. 1905

Oil on canvas, 39½ × 29 in., 100 × 73.5 cm.
Signed lower right: *Mary Cassatt*

Description: A young mother sits before a large mirror in background which reflects interesting angles of a blue-green chair back and arm. Her hair hangs down, parted to left, and she looks down into a hand mirror held by her and her nude child, who stands in front of her. The mother wears a yellow negligée with a sunflower at the breast. The hand mirror has a dark green moiré back.

Note: Also called "The Mirror."

Collections: From the artist to Ambroise Vollard, Paris; to Hirschl & Adler, New York, 1959; to *Theodore E. Cummings*, Beverly Hills, California.

Exhibitions: Virginia Museum of Fine Arts, Richmond, "Tastemakers," 1957.

Reproductions: Selections from the Collection of Hirschl & Adler Galleries, vol. 1, 1959, cat. 11.

475
Daughter and Mother Admiring the Baby
1906
Oil on canvas, 29¼ × 36¼ in., 74.3 × 92 cm.
Signed lower right corner: *Mary Cassatt*

Description: Sara, in a light dress with blond hair hanging down her back, leans her head on her mother's shoulder as she looks at her baby brother seated facing her on their mother's lap. The mother holds him with hands under his arms and smiles at him. She wears a loose gown trimmed in lace.

Note: Painted at Mesnil-Theribus according to Segard. Also called "Maternité," "Caresses maternelles," and "Mother and Two Children." Durand-Ruel 5751-L8370.

Collections: Marcel Bénard sale, Paris, 23–24 Feb. 1931 (cat. 6); to James Stillman; to Dr. Ernest G. Stillman; *Fogg Art Museum*, Cambridge, Massachusetts, gift of Dr. Stillman, 1947.

Exhibitions: Baltimore Museum of Art, 1941–42 (cat. 49); Wildenstein, New York, 1947 (cat. 45, illus.); Carnegie Institute, Pittsburgh, Munson-Williams-Proctor Institute, Utica, N.Y., Virginia Museum of Fine Arts, Richmond, Baltimore Museum of Art, Currier Gallery, Manchester, N.H., "American Classics of the 19th Century" (cat. 74, illus.), 1957.

Reproductions: Achille Segard, 1913, fol. p. 120; Rilla Evelyn Jackman, *American Arts*, Chicago, 1928, pl. 73, fol. p. 168.

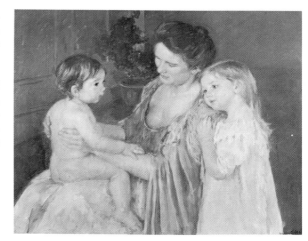

476
Study for "The Bare Back" c. 1906
Pastel on tan paper, 28½ × 22 in., 72.4 × 56 cm.
Unsigned

Description: A nude child with straight red hair rests her head on her seated mother's bare shoulder and embraces her, one hand resting on the mother's back, the other on her right shoulder. The mother, with dark auburn hair, is seen from the rear, her bare back showing above blue and white drapery. The background is variegated greens with some orange strokes.

Collections: Clarica and Fred Davidson, England; Jack O'Hana, London; sold Sotheby & Co., London, 1 Dec. 1965 (lot 64); *Mrs. Prince Littler*, Sussex, England.

Reproductions: Burlington Magazine, vol. 107 (Nov. 1965), p. xv; *International Art Market*, vol. 6 (March 1966), p. 16.

477
The Bare Back c. 1906
Oil on canvas, 36 × 29 in., 92 × 74 cm.
Signed lower right: *Mary Cassatt*

Description: A nude child with straight red hair rests her head on her seated mother's bare shoulder and embraces her, one hand resting on the mother's back, the other on her right shoulder. The mother, with dark auburn hair, is seen from the rear, her bare back showing above blue and white drapery. The background is in various shades of green with some orange strokes.

Note: Comparison of the oil and pastel versions of this subject is of special interest. The color is harsher in the pastel and the forms less well articulated.

Collections: Private collection (bought from Bernheim-Jeune), Paris.

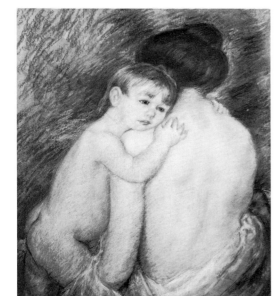

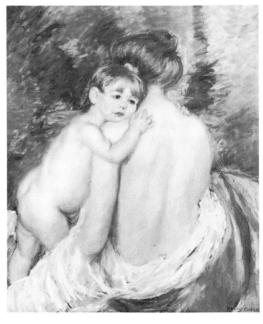

478
Portrait Head of a Frenchwoman c.1906
Pastel on canvas, 15 × 14 in., 38 × 35.5 cm.
Signed lower right: *Mary Cassatt*

Description: Head only of a blue-eyed and pink cheeked young woman with hair in a pompadour. A sketch for the pastel portrait of her with her son (BrCR 479).

Collections: Marie Sterner Gallery, New York; to Dr. and Mrs. T. Edward Hanley, Bradford, Pennsylvania; American Art Association, New York, sale no. 4328 (cat. 22), 6 May 1937; to the Milch Gallery, New York; to Chester Dale; to *Mrs. Chester Dale*, Southampton, New York.

Exhibitions: Parrish Art Museum, Southampton, N.Y., 1967 (cat. 21).

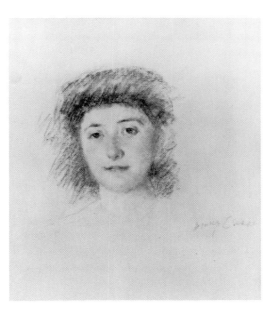

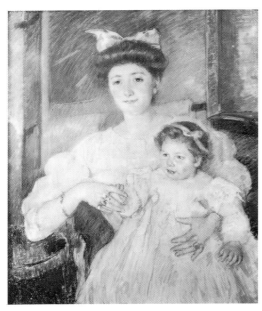

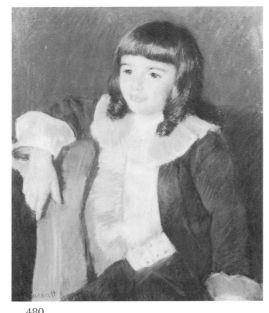

479
Portrait of a Frenchwoman and Her Son
c. 1906
Pastel, 33 × 26⅜ in., 84 × 67 cm.
Signed upper left: *Mary Cassatt*

Description: A woman seated in an armchair leans her right wrist on the arm while she holds her child's right hand in her fingers. She wears a pompadour and above it a stiff ribbon bow. The child wears a ribbon bandeau in his short curls and looks to left while his mother looks at the spectator.

Note: Durand-Ruel Ph6259.

Collections: Private collection, Paris.

Exhibitions: Durand-Ruel, Paris, 1908 (cat. 26); Centre Culturel Américain, Paris, 1959–60 (cat. 11).

Reproductions: Achille Segard, 1913, fol. p. 136.

480
Portrait of Pierre c. 1906
Pastel on paper, 22 × 18 in., 56 × 46 cm.
Signed lower left: *Mary Cassatt*

Description: A little boy with long, dark curls sits on a settee with his right arm resting on its high end. He wears a dark red velvet suit with a wide ruffled collar and cuffs of white material. A blouse under his suit shows a ruffle down the front. Dark background.

Collections: Private collection, Paris.

481
Little Boy in Blue (No. 1) c. 1906
Pastel on paper, 23¾ × 19¾ in., 60.3 × 50.2 cm.
Signed lower right: *Mary Cassatt*

Description: A little boy with dark curls and wearing a light blue suit looks off to left. His hands are folded in his lap but are only slightly indicated. His belt is dark blue. The background is dark green.

Note: Durand-Ruel A7925.

Collections: Durand-Ruel, New York; Effie Seachrist, Kansas City; Mrs. L. L. Marcell, Shawnee Mission, Kansas; *Louis Marcel Davis,* Shawnee Mission.

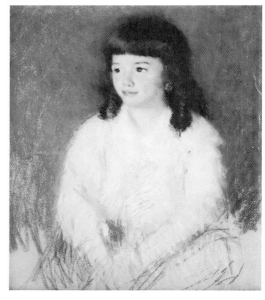

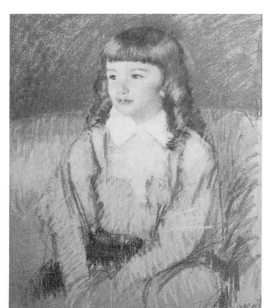

482
Little Boy in Blue (No. 2) c. 1906
Pastel on paper, 20 × 16 in., 50.8 × 40.7 cm.
Signed lower right: *Mary Cassatt*

Description: A little boy with auburn curls wears a blue suit somewhat darker than in the other version (BrCR 481). The contrast with his white collar is greater. The dark belt is more emphatic. The background is divided, with the upper section darker.

Note: Also called "Jeune garçon au col blanc" (by Durand-Ruel) and "Yvonne" (by Andover). Durand-Ruel 7925-L10572.

Collections: Addison Gallery of American Art, Phillips Academy, Andover, Massachusetts.

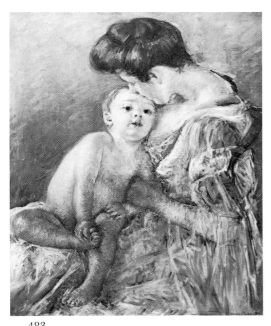

483
Mother Kissing Her Baby on the Forehead While He Holds His Foot c. 1906
Oil on canvas, 32 × 25¾ in., 81 × 65.5 cm.
Signed lower right: *Mary Cassatt*

Description: A baby with reddish-blond hair seated on his mother's lap looks at the spectator while she kisses his forehead. He holds his right foot with his right hand, his leg awkwardly bent at left. The mother's dark brown hair is in a pompadour. Her blue dress is covered with a thin white gauze with lavender shadows. The background is lavender and blue.

Note: Also called "Maternité."

Collections: Present location unknown.

Exhibitions: Marlborough Fine Art Ltd., London, 1957.

Reproductions: Apollo (June 1957), p. vii.

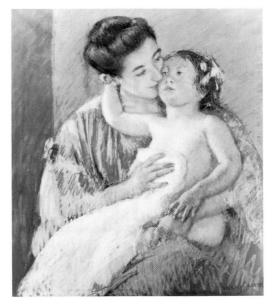

484
Antoinette's Caress c. 1906
Pastel, 28 × 22 in., 71 × 56 cm.
Signed lower right: *Mary Cassatt*

Description: A mother in a jade green negligée holds a nude little girl on her lap and partly covers her with a towel, as though drying her. At the same time she kisses her on the cheek as the child raises her right arm to place it around her mother's neck. Gray background with a darker panel at left.

Note: Related to drypoint Br 209. Durand-Ruel 6601-L9161.

Collections: Mrs. J. Cameron Bradley; Parke-Bernet sale, New York, 10 Dec. 1947; to *Mrs. Houghton P. Metcalf*, Providence, Rhode Island (on loan to the Museum of the Rhode Island School of Design).

485
Woman Looking at a Book c. 1906
Oil on canvas, 25¾ × 21½ in., 65.4 × 54.6 cm.
Signed lower right: *Mary Cassatt*

Description: Half-length of a woman holding a book in both hands and looking down at it. She is seen almost in profile to right. Her dark hair is in a pompadour. Her dress has an intricate border effect.

Note: Also called "Femme lisant." Durand-Ruel 7079-L9702.

Collections: From the artist to Durand-Ruel, Paris, 1911; to Durand-Ruel, New York, 1920; to *private collection*, United States.

Exhibitions: Durand-Ruel, New York, 1920 (cat. 7); Concord (Mass.) Art Association, 8th annual exhibition, 1925 (cat. 8); Durand-Ruel, New York, 1926 (cat. 14); Smith College Museum of Art, 1928 (cat. 8); Carnegie Institute, Pittsburgh, 1928 (cat. 44); McClees Gallery, Philadelphia, 1931 (cat. 19); City Art Museum of St. Louis, 1933–34 (cat. 19).

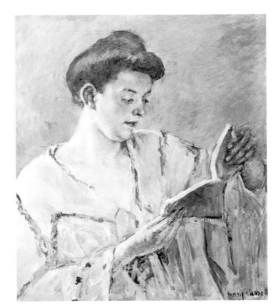

486
Meditation c. 1906
Oil on canvas, 26¾ × 22½ in., 67 × 57 cm.
Signed lower left: *Mary Cassatt*

Description: A woman sits with her right arm on a chair back, holding a piece of her skirt or a handkerchief in both hands. She looks slightly to right, as though thinking of something. Her hair is pompadoured. She wears a gown with a low, square neckline and a sleeve with a scallop above and a ruffle below it.

Note: Durand-Ruel 7096-L9701.

Collections: James Stillman, Paris; to the Metropolitan Museum of Art, New York, 1922, gift of the Stillman family; to the Graham Gallery, New York, 1967.

Exhibitions: Pasadena Art Institute, 1951 (cat. 8); Lakeview Center for Arts and Sciences, Peoria, Ill., "200 Years of American Painting," 1965; Parrish Art Museum, Southampton, N.Y., 1967 (cat. 13).

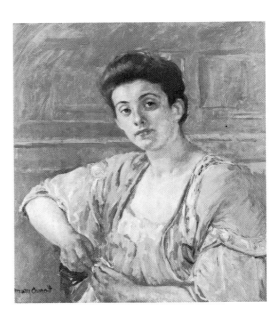

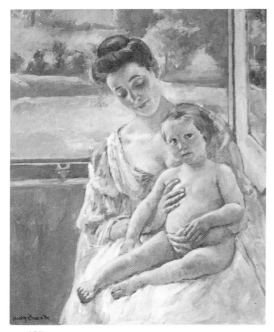

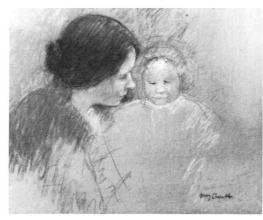

Mother in Profile to Right Looking at Her Child 1906

Pastel and crayon on tan board, 25¼ × 31½ in., 64 × 80 cm.
Signed lower right: *Mary Cassatt*

Description: Head and shoulders of a woman in profile to right looking at her child, seen facing forward with features poorly indicated, before a light green background. The mother's gown is sketched in bluish-green. The figure of the child is outlined in crayon with the face tinted flesh color and the hair red-gold. The mother's hair is very dark brown.

Collections: Parke-Bernet, New York, J. J. Puritz sale (cat. 64), 17 Jan. 1945; to *Mrs. Gardner Cassatt*, Villanova, Pennsylvania.

487

Mother and Her Nude Child in the Conservatory 1906

Oil on canvas, 36⅛ × 28¾ in., 91.7 × 72.5 cm.
Signed lower left corner: *Mary Cassatt*

Description: A nude baby on her mother's lap looks at the spectator, her legs bent toward left, her left hand resting on her mother's. Her mother looks down at her. Behind them through the window is a green lawn with shrubbery and trees. The mother's gown is lavender and her hair auburn.

Note: Painted at Mesnil-Theribus. The model is Renée Chauvet.

Collections: James Stillman, Paris, 1913; Mrs. Frank A. Vanderlip, Scarborough, New York; Charles Lock Galleries, New York, 1954; *Mr. and Mrs. Allan Bronfman*, Montreal, Canada.

Exhibitions: Wildenstein, New York, 1947 (cat. 36, illus.).

Reproductions: Achille Segard, 1913, fol. p. 144.

489

Portrait of Helen Sears 1907

Pastel on paper, 26¼ × 21¾ in., 66.7 × 55.2 cm.
Signed lower left corner: *to H. S./with love/ Mary Cassatt*

Description: A young woman seen in bust-length wears a very large, round hat trimmed with flowers and ribbons. Her left arm rests on a chair back at lower right, and her left hand fondles an ornament which she wears on a narrow gold chain around her neck.

Note: A letter to the author from Mrs. Bradley (formerly Helen Sears), written in 1966, states that she was then 17.

Collections: Mrs. J. Cameron Bradley; to *private collection*, New York.

Exhibitions: M. Knoedler & Co., New York, "Masterpieces by Old and Modern Painters" (cat. 53), 1915.

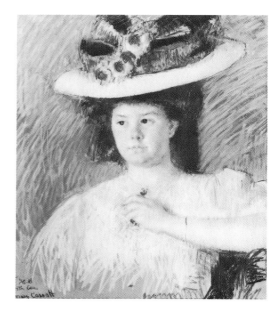

490

Stout Mother Trying to Awaken Her Baby c. 1907

Pastel on paper, 21 × 17 in., 53.3 × 43.2 cm. (sight)
Unsigned. Mathilde X seal on verso

Description: A mother, looking down at her sleeping baby, chucks it under the chin to awaken it. She has auburn hair drawn into a high knot and wears a blue dress with a white vest. The baby's cap is white. Background is yellow-green.

Note: Also called "Femme se penchant sur un bébé."

Collections: From the artist to Mathilde Vallet, 1927; Mathilde X sale, Paris, 1927; Gerard collection, Paris (cat. D.715); to Robert Schmit, Paris, 1967; to Galerie Jean Tiroche, Palm Beach, Florida.

Exhibitions: Galerie A.-M. Reitlinger, Paris, 1927 (cat. 39).

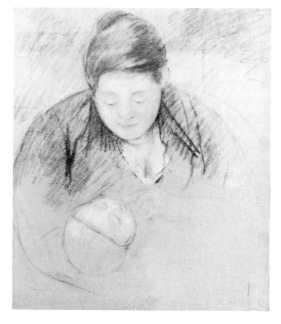

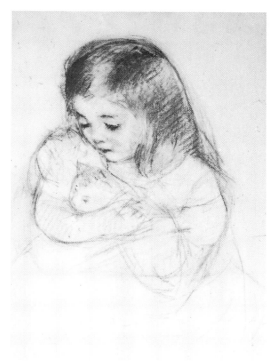

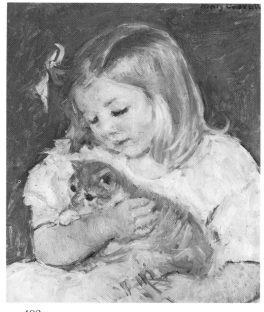

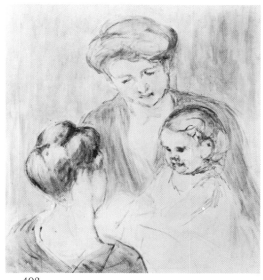

493
Baby Smiling at Two Young Women
c. 1908
Thin oil sketch on linen, $27\frac{1}{2} \times 23\frac{1}{2}$ in.,
69.8 × 59.7 cm.
Signed lower right: *Mary Cassatt*

Description: A blond baby with dark eyes seated on his mother's lap with head, shoulders, and left upper arm developed. His mother looks down at him, her dark hair in a pompadour. Kneeling before them is a dark-haired woman seen from the rear.

Collections: From the artist to Mathilde Vallet, 1927; Mathilde X sale, Paris, 1927; to M. Michel; Parke-Bernet sale, New York, 16 March 1960; to Mr. Savage; present location unknown.

Exhibitions: Galerie A.-M. Reitlinger, Paris, 1927 (cat. 52).

492
Sara Holding a Cat c. 1908
Oil on canvas, 16 × 13 in., 40.6 × 33 cm.
Signed upper right: *Mary Cassatt*

Description: A little girl holds a gray cat in both of her arms and looks down at it. Her blond hair falls onto her shoulders and is caught back at the left by a ribbon bow. The background is dark.

Collections: Julius Stern, Berlin; to Paul Cassirer, Berlin, 1916; M. Knoedler & Co., New York; to Dr. I. G. Oppenheimer, 1947; to *private collection*, San Antonio, Texas.

491
Sketch of "Sara Holding a Cat" c. 1908
Pastel, 19 × 15 in., 48.2 × 38 cm.
Unsigned

Description: Half-length sketch of a little girl in a white dress holding a cat. She has golden hair and looks down toward the cat in her arms. Aside from the flesh tones and pink lines on the arms and hand, the color consists only of her yellow hair with shading of orange. There is also some orange on the head of the cat. The background is light pinkish-tan.

Collections: From the artist to Payson Thompson; American Art Association, New York, Thompson sale, 12 Jan. 1928 (cat. 73); American Art Association, New York, 24 Jan. 1929; to Edward W. McMahon; to *Mr. and Mrs. James S. Collins*, Haverford, Pennsylvania.

494
Two Women Admiring a Child c. 1908
Oil on canvas on board, 28 × 24 in., 70 × 60 cm.
Signed lower right: *Mary Cassatt*

Description: A mother looks down at the child on her lap, turned left. In front of her are the head and shoulders of another woman seen from the rear. Unfinished.

Note: Also called "Baby Smiling at Two Young Women."

Collections: Sold, Sheridan Art Galleries, Chicago, 24 May 1955; Parke-Bernet, New York, Gourgaud et al. sale, 1959; to Mr. L. Garlech; present location unknown.

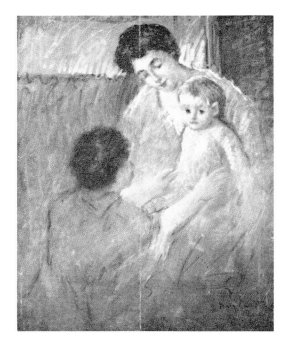

495

Sketch of Mother and Daughter Looking at the Baby c. 1908
Pastel on gray paper, $36\frac{1}{2} \times 29$ in., 92×73 cm.
Signed center right: *To Mr. Thompson/Mary Cassatt*

Description: A baby with short hair and dark eyes is seated on his mother's lap with head, shoulders, and left upper arm developed. His mother looks down at him, her hair in a pompadour. His little sister is barely suggested in profile to right with arm extended to right.

Note: Durand-Ruel A1377-NY5043.

Collections: From the artist to Durand-Ruel, 1908; to Payson Thompson; American Art Association, New York, Thompson sale, 12 Jan. 1928 (cat. 89, illus.); *Randolph-Macon Woman's College*, Louise J. Smith Fund, 1945.

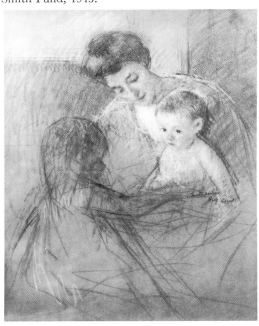

496

Sketch of Mother Jeanne Looking Down at Her Baby c. 1908
Pastel and crayon on tan board, $31\frac{1}{2} \times 25\frac{1}{4}$ in., 80×64 cm.
Signed at lower right: *Mary Cassatt*

Description: A mother with dark pompadoured hair looks down at the child on her lap. This is a study for the oil painting of a mother with an arm around each of her children (BrCR 501). The mother's gown in bluish green is indicated by a few color strokes.

Collections: Cassatt family, Philadelphia; to Annie L. Benjamin; Parke-Bernet, New York, Benjamin sale, 19 Jan. 1939; to J. J. Puritz; Parke-Bernet, New York, Puritz sale, 17 Jan. 1945; present location unknown.

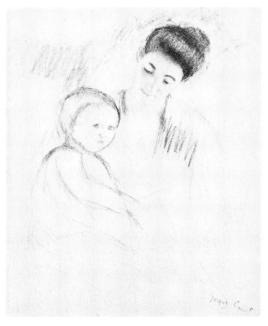

497

Sketch of Mother Jeanne and Her Older Child c. 1908
Oil on canvas, $31\frac{1}{2} \times 25\frac{1}{2}$ in., 80×64.7 cm.
Unsigned

Description: The head of the mother, eyes looking down, hair in a knot on top, is developed with many crisscross brush strokes. The little girl is shown in brush outline only.

Collections: Private collection, Paris.

Exhibitions: Centre Culturel Américain, Paris, 1959–60 (cat. 3).

498

Study of Mother Jeanne's Head, Looking Down c. 1908
Oil on canvas, $15\frac{1}{4} \times 11\frac{3}{4}$ in., 38.7×29.8 cm.
Unsigned. Mathilde X collection stamp on verso

Description: Head and shoulders of a woman looking down with her head bent somewhat to the left. Her hair is drawn up in a pompadour, with bun on top. Her hair is dark against a lighter background.

Note: Also called "Tête de jeune femme." Durand-Ruel 10449-LD13156.

Collections: From the artist to Mathilde Vallet, 1927; Mathilde X sale, Paris, 1927; to Durand-Ruel, Paris; *Miss Sherl M. Fuchsman*, Forest Hills, New York.

Exhibitions: Galerie A.-M. Reitlinger, Paris, 1927 (cat. 47); Durand-Ruel, Paris, 1953 (cat. 7).

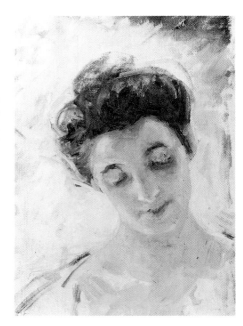

499
Mother Jeanne and Her Older Child
c. 1908

Oil on canvas, 27½ × 23½ in., 69.8 × 59.7 cm.
Unsigned. Mathilde X collection stamp on stretcher

Description: The mother, on the right, is seen in half-length, looking down toward the right. On

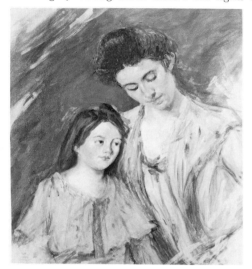

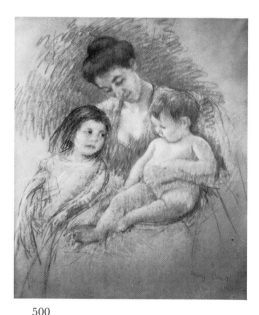

500
Sketch of Mother Jeanne, Embracing Both Her Children c. 1908

Pastel on tan paper, 36½ × 28¾ in., 92.7 × 73 cm.
Signed lower right: *Mary Cassatt*

Description: The mother bends her head to look down at her nude baby seated on her lap with her left arm around him, while her little girl leans against her at the left with her mother's right arm around her. The background and the mother's dress are both in shades of turquoise blue and green. The mother's and girl's hair are both reddish-brown, the baby's lighter. The girl's dress is white. This is a sketch for the oil painting at the White House (BrCR 501).

Note: Durand-Ruel 10094-LD12864.

Collections: Mme. Pierre Gabard, Paris (from a Swiss collection).

the left, leaning her head against the mother's shoulder and arm, is her little girl. There are green reveres to the mother's overdress; her pink underdress has a crimson bow at front. The child has a wide lavender-blue bertha on her dress and a red ribbon in her hair. This is a study, without the baby, for the White House painting (BrCR 501).

Collections: From the artist to Mathilde Vallet, 1927; Mathilde X sale, Paris, 1931; Sotheby & Co. sale, London, 23 June 1965 (lot 100); to Mr. and Mrs. Paul Kantor, Beverly Hills, Cali-

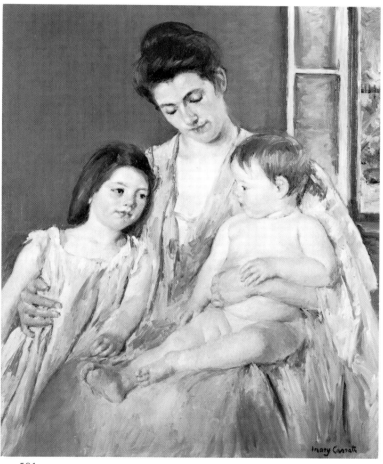

501
Mother Looking Down, Embracing Both of Her Children 1908

Oil on canvas, 36¼ × 28½ in., 92 × 72.5 cm.
Signed lower right: *Mary Cassatt*

Description: A mother sits before an open window at right looking down at the nude baby on her lap. Her right hand shows at the waist of her little girl, who stands at left, and her left arm encircles the baby. The little girl has straight hair hanging down her back, tied with a bow. She leans against her mother and looks at her brother who gazes back at her. The mother's green gown has long, loose sleeves and a deep V-neck. The little girl's dress is blue.

Note: Also called "Jeune mère et ses deux enfants."

Collections: Marcel Bénard, Paris; Bénard estate sale, Paris, 23 Feb. 1931 (cat. 6); Wildenstein, New York; to the *White House*, Washington, D. C., 1966.

Exhibitions: Durand-Ruel, Paris, 1908 (cat. 20); St. Botolph's Club, Boston, 1909 (cat. 11); Cor-

fornia; Parke-Bernet sale, New York, 20 Nov. 1968; to *Mr. L. C. Stein*, Geneva, Switzerland.

Exhibitions: Galerie A.-M. Reitlinger, Paris, 1931 (cat. 8); Galerie Charpentier, Paris, "La Vie Familiale," 1944; Galerie Charpentier, Paris, 1949; Sotheby & Co., London, 1965 (cat. 100) (color); Parke-Bernet, New York, 1968 (cat. 30) (color).

Reproductions: Burlington Magazine, vol. 107 (June 1965), p. xxii (color); *International Art Market*, vol. 5 (Aug.–Sept. 1965), p. 143.

coran Gallery of Art, Washington, D. C., 8th biennial, 1921–22 (cat. 224, illus.); Albright Art Gallery, Buffalo, 1922 (p. 46, illus.); Durand-Ruel, New York, 1924 (cat. 10); Cincinnati Art Museum, 32nd annual, 1925 (cat. 5, illus.); Durand-Ruel, New York, 1926 (cat. 18); Durand-Ruel, New York, 1930 (cat. 3, illus.); The Arts Club, Chicago, 1931 (cat. 5); McClees Gallery, Philadelphia, 1931 (cat. 22); Brooklyn Museum, 1932 (cat. 12); City Art Museum of St. Louis, 1933–34 (cat. 16); Durand-Ruel, New York, 1935 (cat. 16); M. H. De Young Memorial Museum, San Francisco, 1935 (cat. 75, illus.); New Jersey State Museum, Trenton, 1939 (cat. 2).

Reproductions: American Art Annual, vol. 5 (1905–06), fol. p. 109; *Current Literature*, vol. 46 (Feb. 1909), p. 169; *Art & Progress*, vol. 1 (Aug. 1910), p. 278; *Bulletin, Rhode Island School of Design*, vol. 5 (Oct. 1917), p. 29; *Arts*, vol. 10 (Dec. 1926), p. 349; *Art News*, vol. 29 (25 Oct. 1930), p. 6; *International Studio*, vol. 97 (Dec. 1930), p. 131; Forbes Watson, 1932, p. 49; *Art Digest*, vol. 9 (1 March 1935), p. 15; *Gazette des beaux arts*, s6, vol. 69 (Feb. 1967), suppl. p. 100.

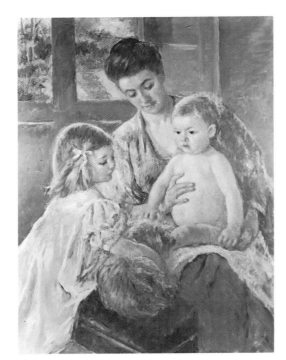

Children Playing with a Dog 1908

Oil on canvas, 39¼ × 28⅝ in., 99.7 × 72.7 cm.
Signed at lower edge toward right: *Mary Cassatt*

Description: A mother looks down at a fluffy gray dog held by her little girl at left, who holds him within her right arm. The dog lies on a crimson covered bench in the foreground. The nude baby looks off to left. The mother's dress is green, the girl's pink.

Note: Also called "Bébé caressant un chien" and "Enfant jouant avec un chien." Durand-Ruel 5760-L8379.

Collections: From the artist to J. Gardner Cassatt; to his daughter, Mrs. Horace Binney Hare; to *Charles W. Hare*, Philadelphia, Pennsylvania.

Exhibitions: St. Botolph's Club, Boston, 1909 (cat. 7); McClees Gallery, Philadelphia, 1931 (cat. 22); Haverford College, 1939 (cat. 6); Philadelphia Museum of Art, 1960; M. Knoedler & Co., New York, 1966 (cat. 40).

Reproductions: Les modes, vol. 4 (Feb. 1904), pp. 4–11.

503
Sketch of Mother Jeanne Nursing Her Baby
c. 1908
Oil on canvas, 33½ × 28 in., 85 × 71 cm.
Signed lower right: *Mary Cassatt*

Description: Three-quarter length sketch of a young mother in a mauve-pink peignoir with pink ruching, her head in profile, looking down at a dimpled, nude infant nursing at her breast, reaching his left hand to her chin. The mother's hair is dark, the baby's light. Background partly filled in with blue-gray.

Note: Also called "Jeune femme allaitant son enfant."

Collections: From the artist to Payson Thompson; American Art Association, New York, Thompson sale, 12 Jan. 1928; to Mrs. Henry Walters; sold Parke-Bernet, New York, 1943; to Dr. B. D. Saklatwalla; to *Mr. and Mrs. John Russell Mitchell Foundation,* Mount Vernon, Illinois, 1946.

Exhibitions: City Art Museum of St. Louis, 1949–50; Mr. and Mrs. John Russell Mitchell Galleries, Southern Illinois University, "American Artists" (pl. 14), 1961.

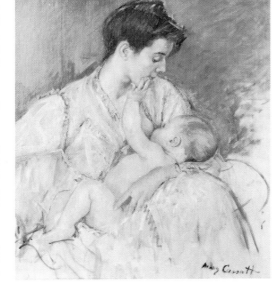

504
Mother Nursing Her Baby c. 1908
Oil on canvas, 39⅝ × 32⅛ in., 100.6 × 81.6 cm.
Signed lower left corner: *Mary Cassatt*

Description: A mother in profile to right looks down at her nude baby who is nursing. The baby lifts his left hand to stroke his mother's chin. His left knee is bent and his right foot is held in his mother's hand. She wears a soft lavender and pink negligée. Behind is a taboret on which is set a green potted plant against a muted pink-brown background.

Note: Art Institute of Chicago title: "Mother and Child." Also called "Young Mother Nursing Her Child," "Mother and Child in Pink and Lilac." Durand-Ruel A6221-L8856.

Collections: Mr. and Mrs. H. O. Havemeyer; Parke-Bernet, New York, Havemeyer sale, 10 April 1930; *Art Institute of Chicago,* gift of Alexander Stewart.

Exhibitions: Durand-Ruel, Paris, 1908 (cat. 22); St. Botolph's Club, Boston, 1909 (cat. 8); M. Knoedler & Co., New York, 1915 (cat. 49); Dallas Art Association, Pennsylvania Museum of Art, Philadelphia, and Carnegie Institute, Pittsburgh, 1928.

Reproductions: Arsène Alexandre, "La collection Havemeyer et Mary Cassatt," *La renaissance,* vol. 13 (Feb. 1930), p. 55.

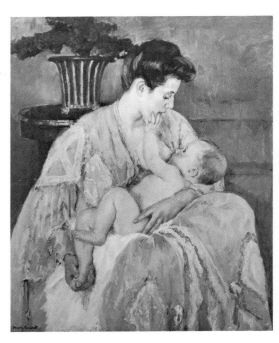

505

Children Playing with a Cat 1908

Oil on canvas, 32 × 39½ in., 81.2 × 100.3 cm.
Signed lower right corner: *Mary Cassatt*

Description: Three-quarter length view of a seated mother seen in profile to left holding her nude baby astride her lap. She wears a yellow dress with orange touches, her dark auburn hair in a pompadour. The baby, with head turned away, touches a sleeping cat with his left hand while his big sister looks at him and holds the cat's tail. She wears a big blue hat with pink and white flowers on top and on either side under the brim. The background is lavender and brown.

Note: Durand-Ruel 6220-L8855.

Collections: From the artist to Durand-Ruel, Paris; Durand-Ruel, New York, 1942; M. Knoedler & Co., New York, 1965; *private collection*, North Carolina.

Exhibitions: Durand-Ruel, Paris, 1908 (cat. 21); National Academy of Design, New York, 84th annual, 1909 (cat. 192); St. Botolph's Club, Boston, 1909 (cat. 2); Carnegie Institute, Pittsburgh, 14th annual, 1910 (cat. 41, illus.); Corcoran Gallery of Art, Washington, D. C., 4th biennial, 1912–13 (cat. 103); Durand-Ruel, New York, 1924 (cat. 14); Durand-Ruel, New York, 1926 (cat. 16); Corcoran Gallery of Art, Washington, D. C., 10th biennial, 1926 (cat. 125); Pennsylvania Museum of Art, Philadelphia, 1927 (cat. 4); Durand-Ruel, New York, 1930 (cat. 5); McClees Gallery, Philadelphia, 1931 (cat. 15); Brooklyn Museum, "Paintings by American Impressionists and Other Artists, 1800–1900" (cat. 13), 1932; City Art Museum of St. Louis, 1933–34 (cat. 15); Durand-Ruel, New York, 1935 (cat. 6); Dallas Museum of Fine Arts, Texas Centennial Exposition, 1936 (cat. 16, illus.); Brooklyn Institute of Arts & Sciences, "Leaders of American Impressionism: Mary Cassatt, Childe Hassam, J. H. Twachtman, and J. Alden Weir" (cat. 30), 1937; Haverford College, 1939 (cat. 12); Baltimore Museum of Art, 1941–42 (cat. 54); Society of the Four Arts, Palm Beach, Florida, "French Impressionist Paintings" (cat. 1), 1947; M. Knoedler & Co., New York, 1966 (cat. 41, illus. cover).

Reproductions: Fine Arts Journal, vol. 23 (July 1910), p. 15; *Craftsman*, vol. 19 (March 1911), p. 543; *Bulletin, Everson Museum of Art*, Syracuse (Oct. 1911); Achille Segard, 1913, fol. p. 128; *Bulletin, Brooklyn Institute of Arts & Sciences*, vol. 26 (23 Jan. 1932), p. 194; *Art Digest*, vol. 16, no. 6 (12 Dec. 1941), p. 8; Margaret Breuning, 1944, p. 40.

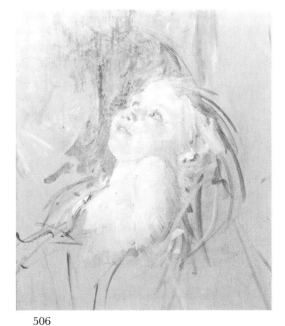

506

Study of the Child for "Mother and Child Smiling at Each Other" 1908

Oil on canvas. Not measured
Unsigned

Description: Head and shoulder of a little blond girl looking up, smiling, with her head thrown back. Her left shoulder and upper arm are shown and long wisps of hair falling down at right.

Collections: Private collection, Maurecourt, France.

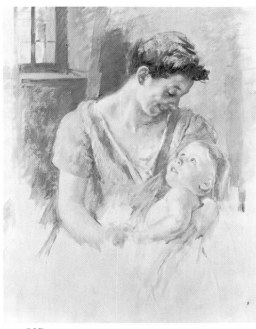

507

Mother and Child Smiling at Each Other (No. 1) 1908

Oil on canvas, 36½ × 29 in., 92.7 × 73.7 cm.
Unsigned

Description: A mother seated before a window smiles down at her child, her dark hair piled up on her head, her face in profile to right. Her nude blond child leans against her. The neck of the mother's gown is in a low V; in the other version (BrCR 508) it is rounded.

Note: This canvas has been cut down; formerly the two figures were seen almost in full length. In that state it was signed at lower right: *Mary Cassatt*.

Collections: From the artist to Ambroise Vollard; to *Chrétien de Gallia*, who inherited it from Vollard.

508

Mother and Child Smiling at Each Other (No. 2) 1908

Oil on canvas, 31¼ × 23¾ in., 79.3 × 60.3 cm.
Signed lower right: *Mary Cassatt*

Description: A mother, seated and wearing a golden-yellow dress, smiles down at her child, her face in profile to right and her dark hair piled up on her head. Her blond child at her knee looks up at her, smiling, her straight hair tied with a small pink bow. The mother's right arm and much of the child's torso are just summarily indicated. Rose-colored background.

Note: This is called unfinished in two of the catalogues mentioned below. Durand-Ruel 10083-LD12862.

Collections: Philadelphia Museum of Art, from the Alexander Simpson, Jr., collection, 1928.

Exhibitions: McClees Gallery, Philadelphia, 1931 (cat. 2); Virginia Museum of Fine Arts, Richmond, 1936 (cat. 68); New Jersey State Museum, Trenton, 1939 (cat. 1); Baltimore Museum of Art, 1941–42 (cat. 53); Philadelphia Museum of Art, 1960.

Reproductions: Bulletin, Art Institute of Chicago, vol. 16 (Sept. 1922), p. 62.

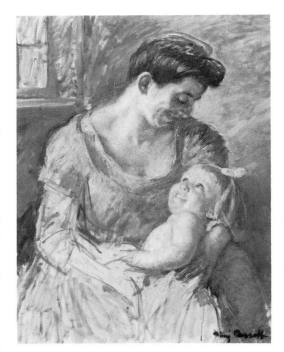

509

Mother and Child with a Rose Scarf 1908

Oil on canvas, 45 × 34½ in., 140.2 × 87.6 cm.
Signed lower right corner: *Mary Cassatt*

Description: A mother sits in an interior with a mahogany console and the lower part of a round mirror behind her. She looks down at her child who looks up at her. Unlike the studies (BrCR 506–08) for this canvas, where they both smile broadly, their smiles here are very slight. They are seen in full length, the child's bare left foot on the mother's pale yellow-green dress. Around her arms is a long rose-colored scarf that hides part of the child's nude body. She has blue eyes and light yellow hair, tied with a pale pink ribbon. The floor is light brown, the paneled wall light bluish-gray. The console has brass feet and a white top. On it is a small blue and white vase in which are purplish-pink and pale pink flowers.

Note: Also called "Femme et enfant avec écharpe rose." Durand-Ruel 6678-L9218.

Collections: John F. Braun, Philadelphia; to Adelaide Milton de Groot; to the *Metropolitan Museum of Art*, New York, Adelaide Milton de Groot collection.

Exhibitions: Buffalo Fine Arts Academy, 1912 (illus.); Carnegie Institute, Pittsburgh, 18th annual exhibition, 1914 (cat. 48); Pan American Exposition, San Francisco, 1915; Pennsylvania Academy of the Fine Arts, Philadelphia, 15th annual Philadelphia watercolor exhibition and 16th annual exhibition of miniatures, 1917; Durand-Ruel, New York, 1920 (cat. 14); Pennsylvania Museum of Art, Philadelphia, 1927; McClees Gallery, Philadelphia, 1931 (cat. 8).

Reproductions: Notes, Fine Arts Academy, Buffalo, vol. 2 (April 1907), p. 172; Eugene Neuhaus, *The Galleries of the Exposition* (Pan American Exposition), San Francisco, 1915, fol. p. 10; *Bulletin, Museum of Art, Detroit*, vol. 13 (April 1919), p. 52; Edith Valerio, 1930, pl. 14; *Pennsylvania Museum of Art Bulletin*, vol. 25 (May 1930), p. 20.

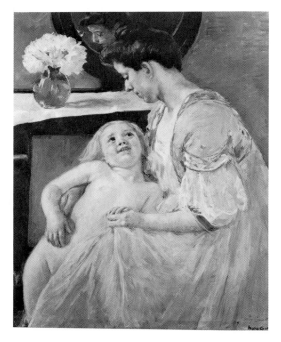

510

The Mauve Dressing Gown 1908

Oil on canvas, 37 × 28¾ in., 94 × 73 cm.
Signed with two signatures, one poorly painted, the other later written above it, lower right corner: *Mary Cassatt*

Description: A woman, wearing a mauve gown with full folds hanging from the shoulders, is in profile left, her dark hair pompadoured and piled on top of her head. Her blond child stands beside her at left, looking up into her face, smiling. On the dressing table behind them is a vase of flowers.

Note: Hirschl & Adler no. 1955 (called "Femme en peignoir mauve et enfant"). Durand-Ruel 6677-L9217.

Collections: Mary T. Cockroft; Hirschl & Adler; to *Mr. and Mrs. Sidney Zlotnick*, Washington, D. C.

Exhibitions: Baltimore Museum of Art, 1941–42 (cat. 58).

Reproductions: Art in America, vol. 46, no. 2 (Summer 1958), p. 100; *Art News Annual*, vol. 18 (1948), p. 98.

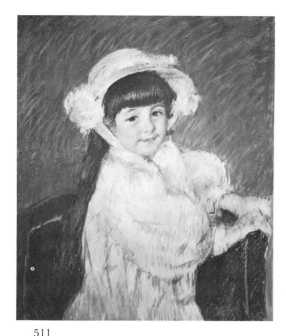

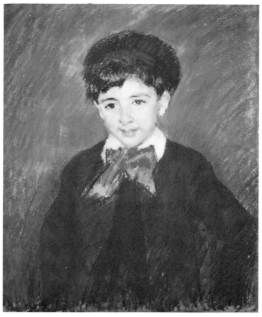

511
Portrait of Adine Kelekian, Age Five 1908
Pastel, 26 × 20¾ in., 66 × 52.7 cm.
Signed lower right, very lightly: *Mary Cassatt*

Description: A little girl smiling and looking at the spectator is seen in half-length facing right with both hands on the arm of a chair which she stands in front of. She wears a straw bonnet with pompons above two ribbons which are tied under her chin. Her long dark hair falls down her back and is cut in bangs across her forehead. Her white dress has large, puffed sleeves. Light green background.

Note: Durand-Ruel A62561.

Collections: Mr. and Mrs. Charles Dikran Kelekian, New York.

Exhibitions: Durand-Ruel, Paris, 1908 (cat. 35).

512
Portrait of Charles Dikran Kelekian,
Age Ten 1908
Pastel, 26 × 20¾ in., 66 × 52.7 cm.
Signed lower right: *Mary Cassatt*

Description: A young boy looking at the spectator is seen in half-length against a light green background. He wears a round navy blue beret back on his head and a dark blue suit with white collar and a red bow tie.

Note: Durand-Ruel A6255.

Collections: Mr. and Mrs. Charles Dikran Kelekian, New York.

Exhibitions: Durand-Ruel, Paris, 1908 (cat. 36).

513
Portrait of Mademoiselle Anne-Marie
Durand-Ruel 1908
Pastel on gray paper, 26 × 22 in., 66 × 56 cm.
Signed lower left: *Mary Cassatt*

Description: A little girl, with long, tight, dark curls hanging far over her shoulders, wears a round hat with white under the brim and flowers and ribbon above. She is seated in a big armchair in half-length, her right hand resting on the arm at left.

Note: Durand-Ruel 6834.

Collections: Anne-Marie Lefèbvre, Paris.

Exhibitions: Durand-Ruel, Paris, 1908 (cat. 42); Durand-Ruel, Paris, 1924 (cat. 35).

514
Ellen Mary Cassatt with a Large Bow in
Her Hair c. 1908
Oil on canvas. Measurements unknown
Signed upper left: *Mary Cassatt*

Description: Head and shoulders of a young girl looking toward right, her dark hair hanging down her back and tied with a large bow at the top of her head.

Note: A study for BrCR 515.

Collections: Milch Galleries, New York; present location unknown.

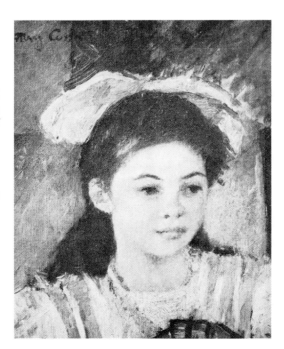

515

Ellen Mary and Eugenia Playing Cards

c. 1908

Oil on canvas, 34½ × 46 in., 87.7 × 116.8 cm.

Unsigned

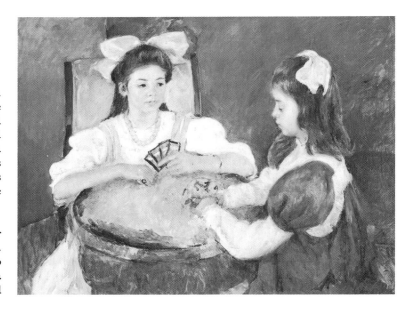

Description: Ellen Mary, with a large blue bow in her hair, sits at left at a round table on which she rests both arms and holds four brightly colored playing cards in her left hand. She looks toward right at Eugenia, seen in profile to left with a big pink bow on top of her hair. Ellen Mary wears a white blouse and a pink jumper. Eugenia's dress is dark blue with white lower sleeves. The background is brown.

Note: The artist wrote to Mrs. H. O. Havemeyer somewhat later: "I am enjoying my young ones. Ellen Mary is really charming and looks so young and pretty in her evening frocks. Eugenia is as tall as I am and of course very thin and unformed, but will no doubt change later."

Collections: From the artist to her brother J. Gardner Cassatt; to his daughter Mrs. Horace Binney Hare; to her son *Charles W. Hare*, Philadelphia, Pennsylvania.

Exhibitions: Pennsylvania Academy of the Fine Arts, Philadelphia, Peale House Gallery, 1955 (cat. 9); Philadelphia Museum of Art, 1960; Parrish Art Museum, Southampton, N.Y., 1967 (cat. 5).

516

Child in a Bonnet Seated in a Victorian Chair c. 1908

Oil on canvas, 16¼ × 13 in., 41 × 33 cm.

Signed lower left: *Mary Cassatt*

Description: Half-length study of a little girl slightly smiling, facing forward, and seated in a round-backed Victorian chair. She wears a poke bonnet tied with long dark ribbons under her chin. Her dress has a wide lace bertha with small points over the shoulders.

Collections: Private collection, Paris.

518

Preparatory Sketch for "Mother and Child in a Boat" (No. 1) c. 1908

Oil on canvas, 14½ × 16¼ in., 37 × 41.5 cm.

Unsigned

Description: A rough sketch of the head of the mother looking down to the left with just a few outlines to indicate the top of her child's head toward lower left. The background is thick greenery.

Collections: Yvon Lambert, Paris; Christie, London, "Barbizon, Impressionist and Modern Drawings, Paintings and Sculpture" (cat. 47, illus.), 5 July 1968; again at Christie, November 1968; present location unknown.

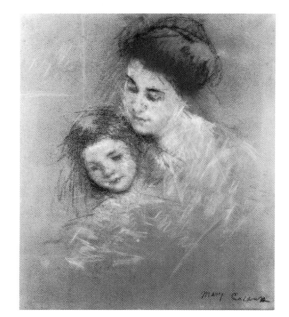

517

Heads of Child and Her Mother for "Mother and Child in a Boat" c. 1908

Pastel on gray paper, 26½ × 22 in., 67.3 × 56 cm.

Signed lower right (poorly): *Mary Cassatt*

Description: A study of a mother's and a daughter's heads, both looking down toward lower left. The mother's chin touches the child's hair. A section at the upper left corner is lined off as though for a window, but this is actually a preparatory study for "Mother and Child in a Boat" (BrCR 524).

Collections: From the artist to Dr. Louis Moinson, Monte Carlo, Monaco; Hammer Galleries, New York, July 1965; William A. Findlay collection, Chicago; to *Mr. and Mrs. David H. Griffin*, Bronxville, New York.

Exhibitions: Hammer Galleries, New York, "Pastels, Watercolors and Drawings" (cat. 13, illus.), 1965.

519

Preparatory Sketch for "Mother and Child in a Boat" (No. 2) c. 1908
Oil on canvas, 12¼ × 15⅜ in., 31 × 39 cm.
Unsigned. Mathilde X wax seal at lower right corner

Description: Head of a dark-haired girl with her hair brushed to left and held by a bow. She smiles and looks down to left. Her mother's head and shoulders, in outline only, also looking down, her cheek resting on the child's head. Trees in background.

Collections: From the artist to Mathilde Vallet, 1927; Mathilde X sale, Paris, 1927; *Mary E. Haverty*, Atlanta, Georgia.

520

Head of Mary: A Sketch for "Mother and Child in a Boat" c. 1908
Oil on canvas, 10 9/16 × 9⅜ in., 27 × 24 cm.
Unsigned

Description: Sketch of the head of a little girl looking forward, her short, bobbed, blond hair parted on the side to right and drawn into a bow at left. Light background of bare canvas.

Note: Also called "Tête de fillette, cheveux blonds." Durand-Ruel 10444-LD13152.

Collections: From the artist to Mathilde Vallet, 1927; Mathilde X sale, Paris, 1927; to Durand-Ruel, Paris; to Durand-Ruel, New York; to *Mr. and Mrs. Thomas Scofield*, Kansas City, Missouri.

Exhibitions: Galerie A.-M. Reitlinger, Paris, 1927 (cat. 16).

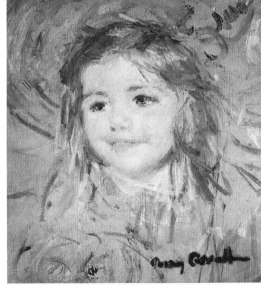

521

Head of Smiling Child: A Study for "Mother and Child in a Boat" c. 1908
Oil on canvas, 13½ × 10½ in., 34.2 × 26.5 cm.
Signed lower right: *Mary Cassatt*

Description: A smiling little girl wears a hat far back on her head, her hair showing under it. She looks to left.

Note: Durand-Ruel 10093-LD12860.

Collections: From the artist to Durand-Ruel, Paris; to *Mr. and Mrs. Joseph Davenport*, Chattanooga, Tennessee.

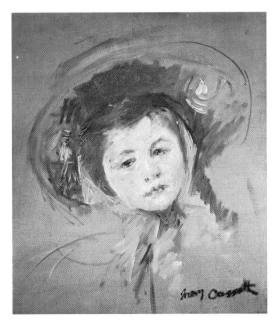

522

Sketch of Child's Head for "Mother and Child in a Boat" 1908
Oil on canvas, 18½ × 15 in., 47 × 38 cm.
Signed lower right (later signature): *Mary Cassatt*

Description: Head of a little girl with a serious expression, looking forward. She wears a round blue hat trimmed with two pink flowers on the underside of the brim. A blue bow is tied under her chin. Background gray (bare canvas).

Note: Durand-Ruel 10088-LD12863.

Collections: Durand-Ruel, New York, 1944; lifetime gift to Mrs. Stewart Huston, Coatesville, Pennsylvania, by Mrs. Margaret Screven Duke; *Telfair Academy of Arts and Sciences, Inc.*, Savannah, Georgia, bequeathed by Mrs. Duke, 1964.

Reproductions: Margaret Breuning, 1944, p. 47 (also in color on dust jacket).

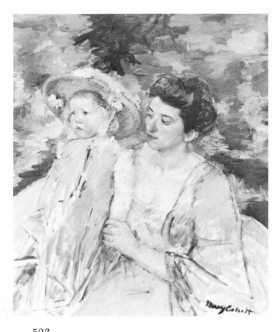

523

Preparatory Sketch for "Mother and Child in a Boat" (No. 3) c. 1908

Oil on canvas, 32 × 25½ in., 81.3 × 64.8 cm.
Signed lower right: *Mary Cassatt*

Description: A mother seated at right, is seen in half-length; her child stands at left. She wears a big round hat with a bow under her chin, the hat trimmed with flowers around crown and under brim. The boat does not show. Background of water with a branch of a tree over child's head.

Note: Also called "En bateau, le bain." Durand-Ruel 10084-LD12856.

Collections: Marlborough Fine Art Ltd., London, 1962; Clifford W. Michel, New York; present location unknown.

Exhibitions: Museum of Modern Art, New York, "Children's Modern Art Festival," 1942; Marlborough Fine Art Ltd., London, 1953 (cat. 5).

Reproductions: Art News, vol. 52 (June 1953), p. 14; *Illustrated London News*, vol. 223 (11 July 1953), p. 73.

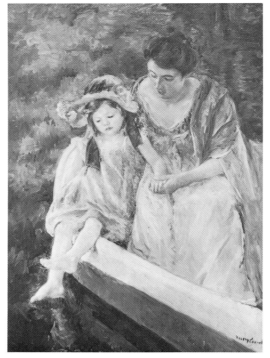

524

Mother and Child in a Boat 1908

Oil on canvas, 45½ × 31¾ in., 115.5 × 80.6 cm.
Signed lower right: *Mary Cassatt*

Description: Sitting in a boat, a mother bends toward a little girl and holds her by the left hand while the child stretches her bare feet over the water. The child wears a blue dress and a big hat with brown streamers; the mother wears a red coat draped over a white dress. The background is dark green.

Note: Also called "Dans la barque." Durand-Ruel 5750-L8369.

Collections: From the artist to James Stillman, Paris, 1913; American Art Association sale, New York, 10 April 1926; *Addison Gallery of American Art*, Phillips Academy, Andover, Massachusetts.

Exhibitions: Durand-Ruel, Paris, 1908 (cat. 2); Durand-Ruel, New York, 1924 (cat. 16) (called "En bateau"); Durand-Ruel, Paris, 1924 (cat. 9); Smith College, Northampton, Mass., 1928 (cat. 7); Carnegie Institute, Pittsburgh, "Survey of American Painting" (cat. 203), 1940; Baltimore Museum of Art, 1941–42 (cat. 56); Wildenstein, New York, 1947 (cat. 47, illus.).

Reproductions: Achille Segard, 1913, fol. p. 160; *Good Housekeeping Magazine*, vol. 58 (Feb. 1914), p. 157; Art News, vol. 29 (9 May 1931), p. 9; *Creative Arts*, vol. 9 (July 1931), p. 13.

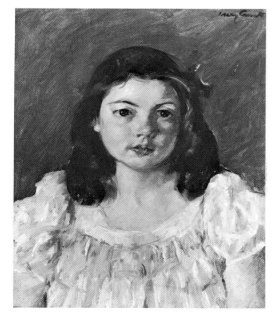

526

Bust of Françoise Looking Forward 1908

Oil on canvas, 18⅛ × 15 in., 46 × 38 cm.
Signed upper right: *Mary Cassatt*

Description: A little girl against a plain green background looks forward, her dark auburn curls over her shoulders and a small red bow at the right on her hair. She wears a smocked, or gathered, low, round-necked white dress with short, puffed sleeves.

Note: Also called "Fillette." Durand-Ruel 6700-L9213.

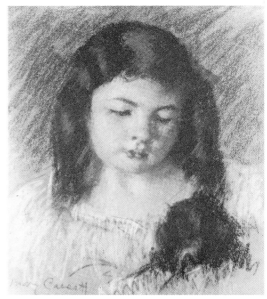

525

Bust of Françoise Looking Down c. 1908

Pastel, 15¾ × 12¾ in., 40 × 32.5 cm.
Signed lower left: *Mary Cassatt*

Description: A little girl, with dark auburn hair falling forward over her shoulders, looks down at the head of her black dog at lower right. She wears a soft pink dress with a round, rather low neck.

Note: Also called "La petite fille en rose."

Collections: Lefevre Gallery, London; *private collection*, England.

Reproductions: The Connoisseur, vol. 143 (June 1959), p. x.

Collections: From the artist to Durand-Ruel, Paris, 1910; to Durand-Ruel, New York, 1920; Parke-Bernet sale, New York, 16 March 1950; to a Swiss collector; to International Galleries, Chicago, 1962; Parke-Bernet sale, New York, 20 Nov. 1968; to Bernard Danenberg Galleries, Inc., New York.

Exhibitions: International Galleries, Chicago, "Collector's Choice" (pl. 1, color illus.), 1965; International Galleries, Chicago, "Mary Cassatt" (cat. 14, color illus.), 1965.

Reproductions: Bernard Danenberg Galleries, Inc., New York, "Recent Acquisitions, Winter 1969" (cat. cover, color).

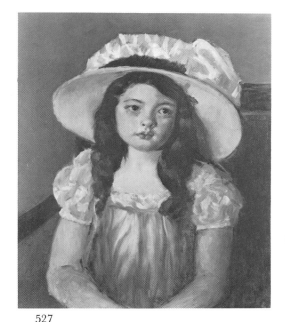

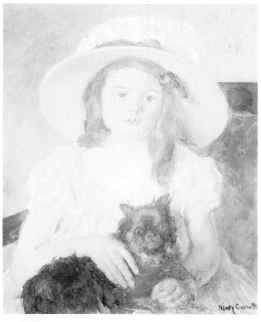

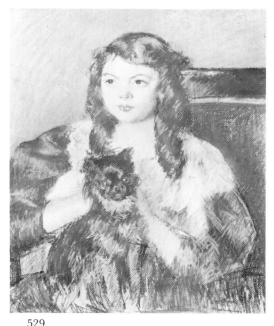

527

Françoise Wearing a Big White Hat c. 1908

Oil on canvas, 24½ × 19¾ in., 62.2 × 50.2 cm.
Signed lower right: *Mary Cassatt*

Description: A little girl with long dark curls hanging over her shoulders sits in an armchair, seen in half-length. She wears a big light hat trimmed with ribbon and a dress with short, puffed sleeves.

Collections: René-Drouet Gallery, Paris; to Chester Tripp, New York; to Wellesley College; to Hirschl & Adler, New York; to Steven Juvelis, Marblehead, Massachusetts, 1967; to *Erickson Educational Foundation*, Baton Rouge, Louisiana, 1967.

Reproductions: Selections from the Collection of Hirschl & Adler Galleries, vol. 8 (1966–67), cat. 6.

528

Françoise Holding a Little Black Dog
c. 1908

Oil on canvas, 24 × 19½ in., 61 × 49.5 cm.
Signed lower right: *Mary Cassatt*

Description: Half-length of little girl holding a little dog who has his paw over her left wrist while her right hand rests on his back. The dog looks at the spectator, the girl off to right. She wears a large light pink hat under which her long dark hair shows, tied with a dark ribbon at right. Her dress is also pink.

Note: Durand-Ruel 6435-L9016.

Collections: From the artist to Durand-Ruel, Paris, 1909; to Durand-Ruel, New York, 1910; present location unknown.

Exhibitions: Smith College Museum of Art, 1928 (cat. 10); McClees Galleries, Philadelphia, 1931 (cat. 11); City Art Museum of St. Louis, 1933 (cat. 18); Arden Gallery, New York, "Portraits of Children in Painting and Sculpture" (cat. 28), 1937.

Reproductions: Arts et les artistes, vol. 12 (Nov. 1910), p. 74; *Current Opinion*, vol. 62 (June 1917), p. 426.

529

**Françoise Holding a Little Dog and
Looking to Left** c. 1908

Pastel on buff paper, 25¼ × 21 in., 64 × 53.3 cm.
Signed lower left: *Mary Cassatt*

Description: A little girl with long dark curls tied with a red flower sits looking left in a chair holding a little dog by his collar as he sits on her lap. Her hands are hidden behind the dog's head. She wears a blue dress with a white yoke. Yellow background.

Note: Durand-Ruel 6383-L8968.

Collections: From the artist to Durand-Ruel, Paris, 1906; to General E. C. Young, 1907; Anderson Gallery sale, New York, 15 April 1926; to *Henry E. Huntington Library and Art Gallery*, San Marino, California.

Exhibitions: Durand-Ruel, New York, 1935 (cat. 3).

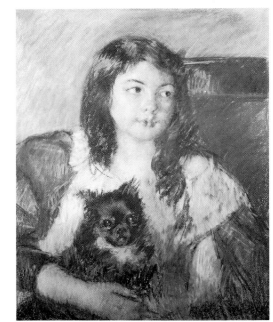

530

**Françoise, Holding a Little Dog,
Looking Far to the Right** 1908

Pastel on paper, 20⅝ × 16½ in., 52.5 × 42 cm. (sight)
Signed lower right: *Mary Cassatt*

Description: A little girl seated in a chair holds her little dog in her right arm as she looks off far to the right. Her long dark curls hang over her shoulders, the curl on the right side longer than that on the left. Her dark blue dress with wide sleeves hangs off her shoulder at right. It has a round white bertha. The background is orange-yellow.

Note: Durand-Ruel A1449-NY5061.

Collections: From the artist to Durand-Ruel, May 1909; to Durand-Ruel, New York, 1910; to Mrs. Ralph Booth, Detroit; to *private collection*, United States.

Exhibitions: Durand-Ruel, New York, 1920 (cat. 1); Durand-Ruel, New York, 1926 (cat. 19); Pennsylvania Museum of Art, Philadelphia, 1927 (cat. 12); City Art Museum of St. Louis, 1933–34 (cat. 17); Durand-Ruel, New York, 1935 (cat. 1); Wildenstein, New York, 1947 (cat. 46, illus.).

Reproductions: Edith Valerio, 1930, pl. 16; Margaret Breuning, 1944, p. 11 (color).

531

**Françoise in a Big Blue Hat Trimmed with
Five Pink Flowers** c. 1908
Pastel, 21 × 16¾ in., 53.4 × 42.6 cm.
Signed lower right: *Mary Cassatt*. Beurdeley collection stamp at lower left

Description: Head and shoulders of little girl with long, stiff auburn curls falling forward over her shoulders. She is turned left and looks to left. Her bright blue hat has a round brim and a fully puffed crown with three pink flowers across the front and one on either side under the brim. Teal blue background. Her dress is lavender pink, streamers or a scarf matching the blue of the hat around her neck and down the front of the dress.

Collections: Y. Beurdeley, Paris; Galerie Georges Petit, Paris, 5th Beurdeley sale (cat. 72, illus.), 2–4 June 1920; *Mr. and Mrs. Norman I. Schafler,* New York.

Exhibitions: Durand-Ruel, Paris, 1924 (cat. 4); Wildenstein, New York, 1947 (cat. 39).

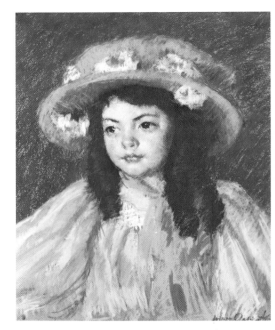

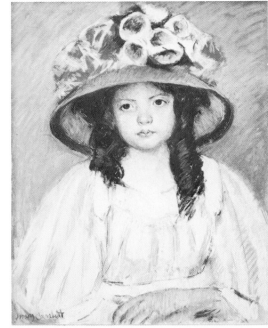

532

**Françoise in a Very Big Hat, Trimmed with
Ribbon Flowers** c. 1908
Pastel on buff paper, 24¾ × 18 in., 63 × 46 cm.
Signed lower left: *Mary Cassatt*

Description: A little girl, wearing a huge hat with large pink ribbon flowers and old gold ribbon on top, looks forward with a serious expression. Her dark curls fall over her shoulders from under the hat. She wears a pink dress with long, puffed sleeves. Her left hand is seen resting along her lap. Green background.

Note: Durand-Ruel 6583-L9132.

Collections: Anderson Gallery sale, New York, 15 April 1926; to *Henry E. Huntington Library and Art Gallery,* San Marino, California.

533

**Sketch for "Françoise in a Round-Backed
Chair, Reading"** c. 1908
Oil on canvas, 29½ × 24½ in., 75 × 62 cm.
Unsigned

Description: Half-length sketch of little girl with dark curls tied with a ribbon at either side and hanging over her shoulders. A large book is indicated at which she looks with lowered eyes. Her dress is a lavender-pink.

Note: Also called "Girl in Pink."

Collections: Elizabeth Arden (Mrs. Graham), New York and Phoenix; to her niece, *Patricia Graham Young,* New York.

534

**Study for "Françoise in a Round-Backed
Chair, Reading"** c. 1908
Oil on canvas, 18⅛ × 15⅛ in., 46 × 38.5 cm.
Signed lower right: *Mary Cassatt*

Description: Head and shoulders of little girl with long dark hair brushed back over her shoulders. She has a patterned band or ruffle bordering her low-necked dress and holds a dark book at which she is looking.

Note: Also called "Fillette dans un fauteuil" and "Fillette devant une fenêtre."

Collections: Sidney Levyne, Baltimore, Maryland; Parke-Bernet sale, New York, 16 March 1950 (cat. 75, illus.); Hirschl & Adler, New York, 1969.

Reproductions: Edith Valerio, 1930, pl. 20; "Collectors' Finds," *selected by Maynard Walker from the Collection of Hirschl & Adler,* 1969.

535

Françoise in a Round-Backed Chair, Reading
1908
Oil on canvas, 28¼ × 23 in., 71.6 × 58.4 cm.
Signed lower right corner: *Mary Cassatt*

Description: A little girl in a round-backed arm-chair rests her right arm on the arm of the chair at left and holds a large blue-green book with both hands. Her dark curls fall forward over her shoulder to right. She wears a soft pink dress with flowing sleeves and a red ribbon in her hair. There is a window behind her through which a lawn and shrubbery can be seen.

Note: Also called "Girl Reading." Durand-Ruel

6582-L9131.

Collections: Mr. and Mrs. H. O. Havemeyer, New York (no. 431, Havemeyer collection catalogue); to their daughter, Mrs. Peter Frelinghuysen; to her son, *Peter H. B. Frelinghuysen, Jr.*, Morristown, New Jersey, and Washington, D.C.

Exhibitions: Carnegie Institute, Pittsburgh, 15th annual exhibition, 1911 (cat. 38); Art Institute of Chicago, 1926; Baltimore Museum of Art, 1941–42 (cat. 61).

Reproductions: Arsène Alexandre, "La collection Havemeyer et Mary Cassatt," *La renaissance*, vol. 13 (Feb. 1930), p. 56.

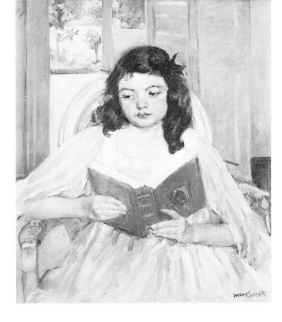

536

Françoise in a Square-Backed Chair, Reading
c. 1908
Pastel on oatmeal paper mounted on linen,
25⅝ × 19¾ in., 65 × 50 cm.
Signed lower right: *Mary Cassatt*

Description: A little girl seen in half-length holds a dark book with both hands on her lap and looks down and off to left, not at the book. Her dark curls hang forward over the shoulders of her blue dress. A window is behind her.

Note: Also called "Fillette en robe bleue." Durand-Ruel 6584-L9133.

Collections: From the artist to Durand-Ruel, 1909; to Helen Sears, Boston, 1910; *Seattle Art Museum*, gift of Mr. and Mrs. Louis Brechemin.

Exhibitions: Art Institute of Chicago, 1926–27 (cat. 7); Carnegie Institute, Pittsburgh, 1928 (cat. 46).

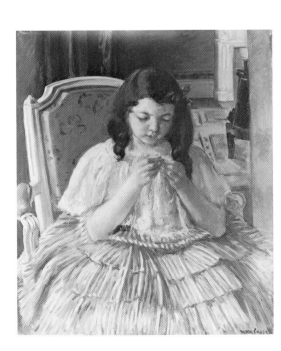

538

Françoise in Green, Sewing 1908
Oil on canvas, 32 × 25½ in., 81.3 × 65 cm.
Signed lower right corner: *Mary Cassatt*

Description: A little girl sits in a French chair sewing. She holds some material with both hands and looks down at it, her dark hair falling over her shoulders and tied with a bow at right. Her soft, light green dress has a very wide skirt spread out across the bottom of the canvas. The interior of a room is visible behind her.

Note: Also called "Young Girl Threading a Needle" and "Jeune fille brodant." Durand-Ruel 6405-L8992.

Collections: From the artist to James Stillman, Paris; *City Art Museum of St. Louis*, anonymous gift through the Metropolitan Museum of Art, New York, 1922.

Exhibitions: City Art Museum of St. Louis, 1933 (cat. 20); Baltimore Museum of Art, 1941–42 (cat. 52); Pasadena Art Institute, 1951 (cat. 7).

Reproductions: Achille Segard, 1913, fol. p. 152; *Good Housekeeping Magazine*, vol. 58 (Feb. 1914), p. 154.

537

Sketch for "Françoise in Green, Sewing"
1908
Oil on canvas, 21½ × 17½ in., 54.6 × 44.5 cm.
Signed lower right: *Mary Cassatt*

Description: A little girl sits on a couch threading a needle. She looks down as she does it, her dark hair falling forward over her shoulders. She wears a light green dress of soft material. A sketch for BrCR 538.

Note: Also called "Young Girl Embroidering." Durand-Ruel 6701-L9214. Hirschl & Adler 4326 (1863-D).

Collections: From the artist to Durand-Ruel, Paris; to Durand-Ruel, New York; to Hirschl & Adler, New York; to John Levy & Dreyfus, New York; Schweitzer Gallery, New York.

Exhibitions: Toledo Museum of Art, M. H. De Young Memorial Museum, San Francisco, Santa Barbara Museum of Art, "Impressionism and Its Influence in American Art" (cat. 7), 1954.

Reproductions: *Good Housekeeping Magazine*, vol. 58 (Feb. 1914), p. 154.

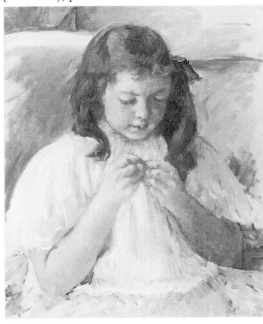

539

**Mother Resting Her Cheek on Her
Daughter's Head** c. 1909
Pastel on board, 29 × 24 in., 73.5 × 61 cm.
Signed lower right: *Mary Cassatt*

Description: Sketch of two heads, the mother's
somewhat higher and to the right of her daughter's.
The mother looks to left, the daughter to right.
Sketchy light shading below both heads suggests
dresses.

Note: Durand-Ruel A1540-NY5292.

Collections: From the artist to Payson Thompson;
American Art Association, New York, Thompson
sale, 12 Jan. 1928 (cat. 91, illus.) (called "Mother
and Daughter"); M. & Ph. Rheims, Paris, Palais
Galliera sale, 27 March 1962, lot 28; *Laura Slatkin*,
New York.

Reproductions: International Art Market, vol. 2 (May
1962), p. 347; *Art in America*, vol. 53 (Aug. 1965),
p. 6.

540

**Head and Shoulders of a Young Girl
Wearing a Hat Peaked in Front** c. 1909
Pastel on paper, 25½ × 21⅛ in., 65 × 54 cm.
Unsigned

Description: A young girl looks off to left. Her dark
curly hair hangs onto her shoulders. She wears a
large hat with a peak in front surmounted by light
ribbon bows. Her blouse has puffed sleeves and a
tucked gimp.

Collections: Jean Mercier, Versailles, France.

541

Child with Large Ears in a Huge Blue Hat
c. 1909
Pastel on paper, 25 × 21 in., 63.5 × 53.3 cm.
Signed lower right center: *Mary Cassatt*

Description: Head of a child wearing a big mush-
room-brimmed hat, trimmed with a large, flat,
dark blue bow. She faces forward, her ears very
prominent under her hat.

Note: Also called "Fillette au chapeau bleu."
Durand-Ruel 7137-L9770.

Collections: From the artist to Durand-Ruel, 1911;
to Mme. Mottart, Paris; Mme. de la Chapelle,
Paris, 1940; Galerie Charpentier sale, Paris, 8
Feb. 1945; present location unknown.

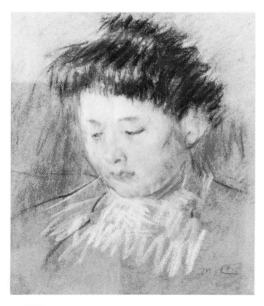

542

Head of Julie, Looking Down c. 1909
Pastel, 16 × 13 in., 40.5 × 33 cm.
Signed lower right: *M. C.*

Description: A young woman looks down toward
left, her eyes just showing under her lowered lids.
Her hair, roughly drawn, suggests a pompadour
with bun above. Her pretty features are well
modeled. Light pastel at her throat suggests a
yoke or jabot.

Note: Also called "Portrait of a Lady."

Collections: Mr. and Mrs. Frederick P. Weissman,
Palm Beach, Florida.

Exhibitions: Corcoran Gallery, Washington, D. C.,
9th biennial, 1924 (no. 113); Joe and Emily Lowe
Art Gallery, University of Miami, Florida,
"Renoir to Picasso 1914" (cat. 15, illus.), 1963.

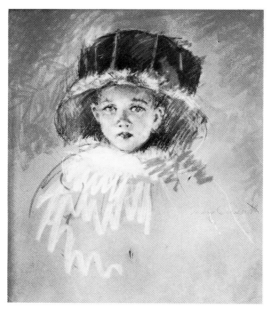

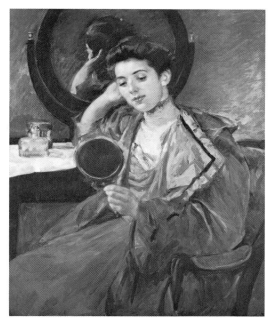

543

Antoinette at Her Dressing Table 1909

Oil on canvas, 36½ × 28½ in., 92.5 × 72.4 cm.
Signed lower right corner: *Mary Cassatt*

Description: A young woman with pompadoured auburn hair smooths her back hair with her right hand as she holds a hand mirror in her left hand and looks into it. The reflection of a part of her head and hand show in the round mirror of her dressing table, before which she is sitting. She wears a light green dress and over it a silk coat of light mulberry color. The wall is also green, the chair mulberry.

Note: Also called "Femme à sa toilette," "At the Dressing Table," and "Jeune femme se mirant auprès de sa table de toilette." Durand-Ruel 6676-L9216.

Collections: From the artist to Durand-Ruel, Paris, 1910; Durand-Ruel, New York; Mrs. Nelson Robinson, New York, 1910; Durand-Ruel, New York, 1912; a Swiss collector, 1948; *Private collection*, Chicago.

Exhibitions: Corcoran Gallery of Art, Washington, D. C., 6th biennial, 1916–17; Pennsylvania Academy of the Fine Arts, Philadelphia, 112th anniversary exhibition, 1917; Durand-Ruel, New York, 1920 (cat. 22); Durand-Ruel, New York, 1924 (cat. 20); Durand-Ruel, New York, 1926 (cat. 8); William Rockhill Nelson Gallery of Art, Kansas City, Mo., "Opening Exhibition," 1933; New Jersey State Museum, Trenton, 1939 (cat. 3); Baltimore Museum of Art, 1941–42 (cat. 57); Wildenstein, New York, 1947 (cat. 48); Marlborough Fine Art Ltd., London, 1953 (cat. 6, illus.); Baltimore Museum of Art, "From El Greco to Pollock: Early and Late Works by European and American Artists" (cat. 50), 1968; Joslyn Art Museum, Omaha, "Mary Cassatt among the Impressionists" (cat. 1, illus.), 1969.

Reproductions: Arts and Decoration, vol. 3, no. 8 (June 1913), p. 295; Achille Segard, 1913, fol. p. 168; *L'art et les artistes*, vol. 12 (Nov. 1919), pp. 69–75; Edith Valerio, 1930, pl. 30.

544

Sketch for "Denise at Her Dressing Table"
c. 1909

Oil on canvas, 20¾ × 16¾ in., 53 × 42.5 cm.
Signed lower right: *Mary Cassatt*

Description: Head and shoulders of a young woman with auburn hair, her right arm bent as though patting the back of her hair. Behind her at left is the curve of a large mirror. She is seen in three-quarter view to left, looking somewhat down.

Note: Also called "Buste de jeune femme."

Collections: Private collection, Paris.

Exhibitions: Chateau de Beaufresne, Mesnil-Theribus, Oise, and Musée-Départemental de l'Oise, Palais-Episcopal, Beauvais, "Hommage à Mary Cassatt" (cat. 2), 1965.

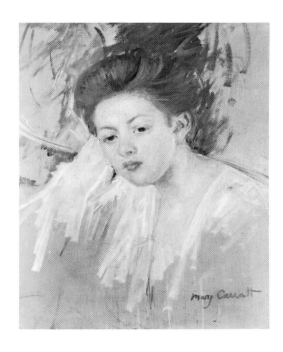

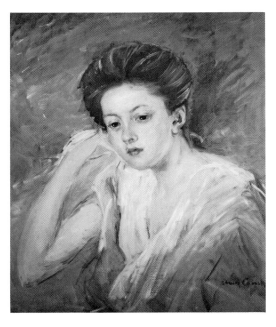

545

Young Girl Leaning on Her Right Hand
c. 1909

Oil on canvas, 24 × 19⅝ in., 61 × 50 cm.
Signed lower right: *Mary Cassatt*

Description: A young woman with pompadoured red hair, her right hand resting on her cheek, is seen just to the waist. She wears a soft yellow gown with a V-neck. Background, with suggestion of round mirror, in light green with sienna streaks.

Note: Durand-Ruel Ph.17131.

Collections: From the artist to Durand-Ruel, Paris; Hôtel Drouot sale, Paris, 4 Jan. 1949 (cat. 23); Galerie Charpentier sale, Paris, 16 June 1959; *Mrs. Samuel E. Johnson*, Chicago, 1961.

Exhibitions: International Galleries, Chicago, "Modern Masters" (cat. 6, illus.), 1961; Ravinia Festival Art Exhibition, Chicago, 1963 (cat. 31, called "Buste de fillette," illus.).

Reproductions: Arts, vol. 10 (Nov. 1926), p. 250.

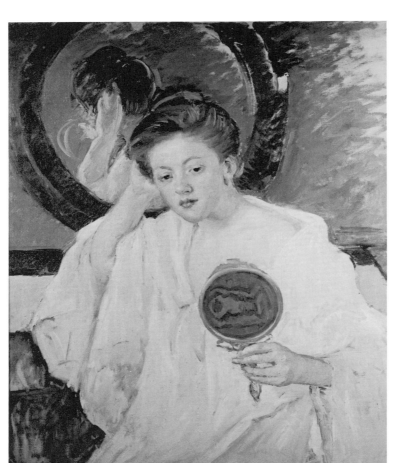

546
Denise at Her Dressing Table c. 1909
Oil on canvas, 32½ × 27 in., 82.5 × 68.5 cm.
Signed lower left corner: *Mary Cassatt*

Description: A young woman with auburn hair sits in front of a dressing table with a large, round, mahogany mirror which shows the reflection of her head and hand. She raises her right hand to touch the back of her hair. She holds a round hand mirror in her left hand. She wears a soft pink-lavender negligée with wide, flowing sleeves. The back of the hand mirror is olive-green moiré.

Collections: *Joseph King*, New York.

Exhibitions: McClees Galleries, Philadelphia, 1931 (cat. 10).

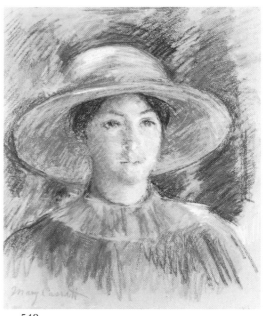

548
Study for "Young Woman in Green, Outdoors in the Sun" c. 1909
Pastel, 21½ × 17 in., 54.6 × 43.2 cm.
Signed lower left: *Mary Cassatt*

Description: Head and shoulders of a young woman facing forward and looking slightly to right. She wears a round straw hat and a green dress with a ruffle around the high round neck. Sunlight strikes the crown of her hat and her left shoulder and is reflected on the side of her face at right.

Note: Also called "Jeune fille au chapeau de paille." Durand-Ruel 10134-L12277.

Collections: M. Heniot, Paris; to Durand-Ruel, Paris, 1924; Mme. de la Chapelle, 1942; Galerie Welz, Salzburg, Austria, 1955; to *Stanley S. Snellenburg*, Philadelphia.

Exhibitions: Durand-Ruel, Paris, 1914 (cat. 13).

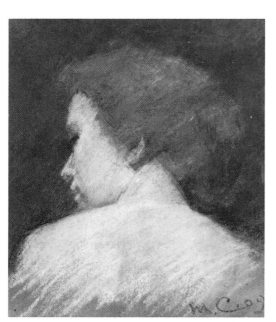

547
Woman with Red Hair 1909
Pastel on gray paper, 11½ × 9 in., 29 × 23 cm.
Signed lower right: *M. C. 09*

Description: Head and shoulders of a woman seen from the rear, looking left. Her profile is only partly visible, the chin lost behind her left shoulder. Her red hair is loosely fixed in a bun at the neck.

Collections: Steven Juvelis; to *Bernard C. Solomon*, Los Angeles.

Exhibitions: A. C. A. American Heritage Gallery, New York, 1967.

549

Young Woman in Green, Outdoors in the Sun
c. 1909

Oil on canvas, 21¹¹⁄₁₆ × 18¼ in., 55.1 × 46.3 cm.
Signed lower right: *Mary Cassatt*

Description: A young woman's head and shoulders facing front, looking to right. She is wearing a light hat with high trimming above and a green dress with a white ruffle at the round neck. There is a section of a window at left and trees in background.

Note: Also called "Below the Veranda." Durand-Ruel 7923-L10583.

Collections: From the artist to Durand-Ruel, Paris; to James Stillman, Paris; to the *Worcester Art Museum,* anonymous gift through the Metropolitan Museum of Art, New York, 1922.

Exhibitions: Durand-Ruel, Paris, 1924 (cat. 25); Symphony Hall, Boston, "Whistler, Cassatt, Sargent," 1954; Parrish Art Museum, Southampton, N.Y., "Important Paintings by American Artists," 1959.

Reproductions: Worcester Art Museum Bulletin, vol. 13 (1922), p. 25; Edith Valerio, 1930, pl. 19.

550

Mother in a Large Hat Holding Her Nude Baby Seen in Back View c. 1909

Oil on canvas, 32 × 26 in., 81 × 66.2 cm.
Signed lower right (poorly); *Mary Cassatt*

Description: A mother in profile to right, wearing a big, round, white hat trimmed with dark blue ribbon and a plum colored dress with short sleeves, holds her baby in both arms, his head on her left shoulder, his arms around her. She has light brown hair and brown eyes. Corner of a house at left, trees in background.

Note: Hirschl & Adler 3170. Durand-Ruel 7907-L11716.

Collections: The Cassatt family; to Jacques Seligmann, Paris, about 1945; to Pedro Vallenilla, Venezuela; Hirschl & Adler, 1961; Coe Kerr Gallery, New York.

Exhibitions: M. Knoedler & Co., New York, "Masterpieces by Old and Modern Painters" (cat. 43), 1915.

Reproductions: Art in America, vol. 49, no. 3 (1961), p. 10; *Selections from the Collection of Hirschl & Adler Galleries,* vol. 3, 1961, cat. 34 (color).

551

Young Mother in a Floppy Hat and Green Dress with Her Child Outdoors c. 1909

Oil on canvas, 29 × 24 in., 73 × 60 cm.
Signed lower right: *Mary Cassatt*

Description: A mother, wearing a floppy white hat with a green crown and a green dress with a white ruffled collar, stands behind her daughter who wears white with a big white bow on her hair. They are seen in half-length, seated before shrubbery.

Note: Also called "Femme tenant un enfant sur ses genoux." Durand-Ruel 7904-L10571.

Collections: Durand-Ruel, Paris; to Ambroise Vollard, Paris; to Martin Fabiani, Paris; to Galerie Pétridès, Paris; to Findlay Gallery, New York; to Pascal Gotterdam; to Leo M. Rogers, New York; Christie & Co. sale, London, 24 June 1966 (cat. 20); *private collection,* Paris.

Reproductions: L'art vivant (June 1929), p. 464; *Apollo,* no. 83 (June 1966), p. xxiv.

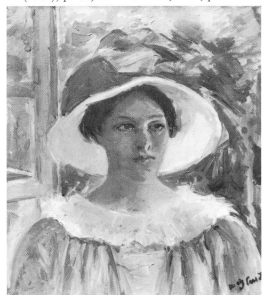

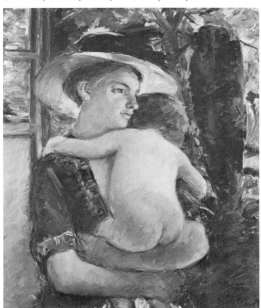

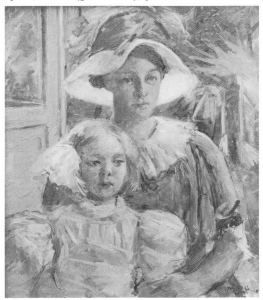

552

Agnès, Age Five c. 1909

Pastel on paper, 25 × 21½ in., 63.3 × 54.5 cm.
Signed lower right: *Mary Cassatt*

Description: A little girl sits at the end of a sofa with a dark wooden frame, resting her right arm on the sofa arm at left. In this preparatory study for the pastel with the dog (BrCR 553), her left arm is positioned to hold the absent dog. Neither of her hands are drawn.

Collections: Private collection, Paris.

Exhibitions: Centre Culturel Américain, Paris, 1959–60 (cat. 4).

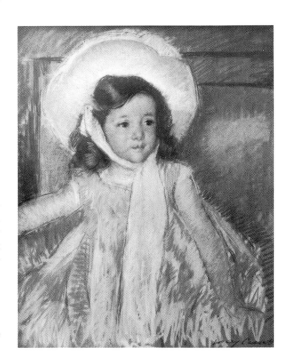

553
Portrait of Agnès and a Dog c. 1909
Pastel on paper, 31½ × 25 in., 80 × 63.3 cm.
Signed lower right: *Mary Cassatt*

Description: Agnès sits at the end of a sofa with her
right arm resting on the dark wooden arm. The
dog lies at the right next to her, his left front paw
in her left hand. She faces forward and looks to
the right, wearing a big bonnet which is tied under
her chin.

Collections: Private collection, Paris.

Exhibitions: Durand-Ruel, Paris, 1908 (cat. 25).

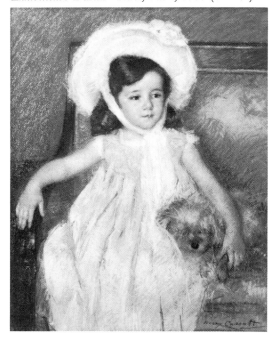

554
**Portrait of Madame O. de S. and Her
Children** c. 1909
Pastel on paper, 35 × 28 in., 88.6 × 71 cm.
Signed lower left: *Mary Cassatt*

Description: Madame O. de S. sits facing forward
with her young son on her lap and her little
daughter leaning against her at the right. She and
her daughter both look at the spectator. The
young boy looks somewhat to right. All three have
dark hair; the little girl has long curls. The boy
wears a white suit with wide sleeves and a sash.
The mother's dress has a low, round neck.

Collections: Private collection, Paris.

Exhibitions: Durand-Ruel, Paris, 1908 (cat. 24);
Centre Culturel Américain, Paris, 1959 (cat. 11).

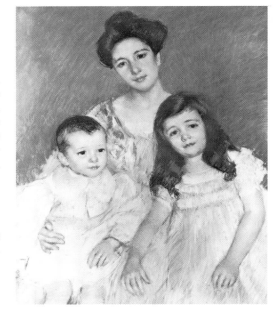

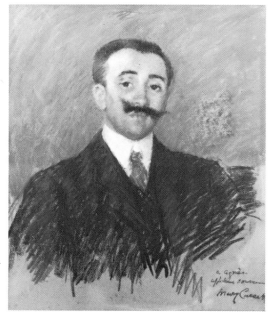

555
Portrait of Monsieur O. de S. c. 1909
Pastel, 26 × 22 in., 66 × 56 cm.
Signed lower right: *Agnès /affectueux souvenirs/
Mary Cassatt*

Description: Portrait of the artist's neighbor at
Mesnil-Theribus, a close friend and one of the last
people to see her alive. He is shown frontally,
observing the spectator, head and shoulders only.
He wears a dark suit, white collar, and neutral tie.
His hair and his pointed moustache are dark.

Collections: Private collection, Paris.

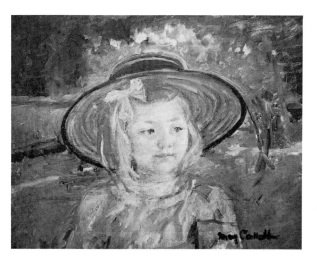

556
**Little Girl in a Stiff, Round Hat, Looking to
Right in a Sunny Garden** c. 1909
Oil on canvas, 15 × 17 in., 38 × 43 cm.
Signed lower right: *Mary Cassatt*

Description: A little girl with straight blond hair
tied with a bow to left under her large, stiff, round
hat bordered in black. She looks to right and is
seen in a sunny garden with blooming flowers and
shrubbery behind her.

Note: Durand-Ruel 10092-LD12865.

Collections: From the artist to Durand-Ruel, 1924;
Robert Lehmann, New York, 1945.

Exhibitions: Durand-Ruel, Paris, 1924 (cat. 17).

557
Mother Kissing Her Child on the Forehead
1909
Oil on canvas, 30½ × 25 in., 77.5 × 63.5 cm.
Signed lower right corner: *Mary Cassatt*

Description: A nude little blond girl sits on her mother's lap facing and looking forward while her mother holds her left hand under the child's chin and kisses her on the forehead. The mother wears a soft lavender gown with a full sleeve. She has dark hair. Background is bluish-gray.

Note: Also called "Baiser maternel." Durand-Ruel 6675-L9215.

Collections: From the artist to James Stillman, Paris, 1910; American Art Association sale, New York, 10 April 1926; present location unknown.

Reproductions: Harper's Bazaar, vol. 45 (Nov. 1911), p. 491; Achille Segard, 1913, fol. p. 184.

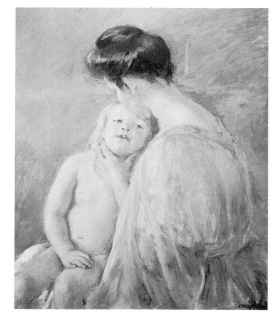

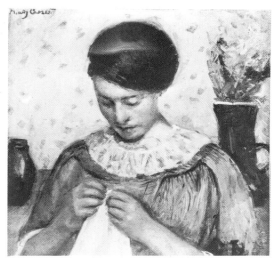

558
Woman Sewing in a Room with Spotted Wallpaper 1909
Oil on canvas, 21 × 21 in., 53.3 × 53.3 cm.
Signed upper left corner: *Mary Cassatt*

Description: A woman with straight dark hair brushed over to the right across her forehead bends her head down over her work. She holds the white material on which she sews with both raised hands. She is seen in half-length and wears a green dress with a wide, white yoke. At the right behind her is a tall vase of flowers, on the left an empty vase. Spotted wallpaper forms the background between them.

Note: Also called "Jeune femme cousant." Durand-Ruel A7922.

Collections: From the artist to Durand-Ruel, Paris, 1910; to Dikran Kelekian; American Art Association, New York, Kelekian sale, 31 Jan. 1922; to J. S. Seligmann, Paris; Seligmann sale, Paris, 18 May 1925 (cat. 24, illus.); to Roger Levy; to Galerie Jean Tiroche, Palm Beach, Florida.

Exhibitions: Durand-Ruel, Paris, 1914 (cat. 4).

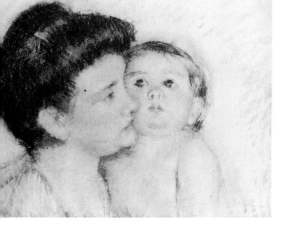

559
Mother in Profile with Baby Cheek to Cheek (No. 1) c. 1909
Pastel on paper, 12¾ × 16 in., 32.3 × 40.6 cm.
Signed lower right: *M. C.*

Description: Similar to the oil sketch (BrCR 560) but with the baby's shoulder and top of arm defined. The baby looks somewhat to left, with his head thrown back enough to show a double chin.

Collections: Mrs. Frederick C. Havemeyer; sold at Trosby, Inc., sale, Palm Beach, Florida, 7–8 Feb. 1967; to *private collection*, Great Neck, New York.

Exhibitions: Trosby, Inc., Palm Beach, Florida, 1967.

Reproductions: Connoisseur, vol. 164 (Jan. 1967), p. vii; *Apollo*, n.s. vol. 85 (Jan. 1967), p. xxv.

560
Mother in Profile with Baby Cheek to Cheek (No. 2) c. 1909
Oil on canvas, 15 × 18½ in., 38 × 47 cm.
Signed lower right: *Mary Cassatt*

Description: The mother's head in profile to right is shown against the baby's head. Her dark brown hair is piled high on her head, the baby's hair just suggested. His eyes are black.

Note: Durand-Ruel 10089-LD12869.

Collections: Durand-Ruel, Paris; to Newhouse Galleries, New York; to *John L. Roper II*, Norfolk, Virginia.

Reproductions: Connoisseur, vol. 156 (Aug. 1964), p. xxxv.

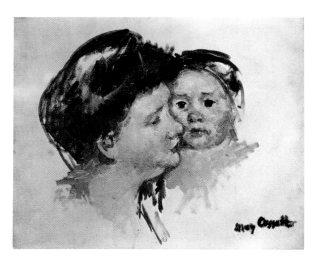

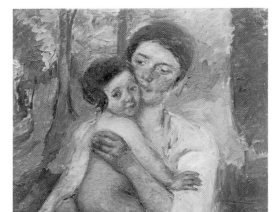

561
Mother Wearing a Pink Dress Holding Her Nude Baby Outdoors c. 1909
Oil on canvas, 32 × 26 in., 81.4 × 66 cm.
Signed lower right: *Mary Cassatt*

Description: A mother seated outdoors holds her nude baby on her right arm, her left hand supporting the baby's back. She faces forward with the baby's cheek against hers. She looks at the spectator, her right arm on the mother's left. The mother's dress is pink. Forest trees in background.

Note: Also called "Femme en robe rose et enfant dans un jardin." Durand-Ruel 7905-L10574.

Collections: From the artist to Durand-Ruel, Paris, 1914; to *M. Poirier*, Paris, 1959.

Exhibitions: Durand-Ruel, Paris, 1914 (cat. 7).

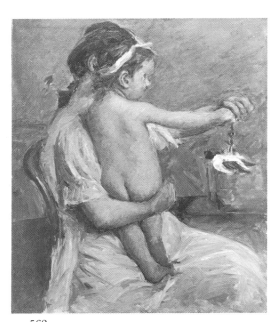

562
Mother Holding a Nude Baby Playing with a Toy Duck 1909
Oil on canvas, 34 × 28⅛ in., 86.4 × 71.5 cm.
Signed lower left: *Mary Cassatt*

Description: Three-quarter length view of a red-haired woman wearing a yellow dress sitting in a chair. She holds her nude baby on her lap, his feet showing as though he were half standing, but she holds him on her right arm. The baby's head hides the mother's face entirely. He extends his arm to hold a black and white duck on a string.

Note: Also called "Mother and Nude Child." Durand-Ruel 7906-L10575.

Collections: *Chauncey Stillman*, Amenia, New York (bequeathed by his sister, Mrs. Langbourne M. Williams, on loan to his brother-in-law, Langbourne M. Williams, New York).

Exhibitions: Baltimore Museum of Art, 1941–42 (cat. 50).

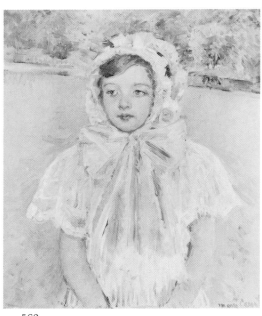

563
Girl in a Bonnet Tied with a Large Pink Bow 1909
Oil on canvas, 26¼ × 21¾ in., 66.7 × 55.2 cm.
Signed lower right: *Mary Cassatt*

Description: A frontal view of a girl standing outdoors in a field with a bank of trees beyond. She looks slightly to left and wears a close-fitting bonnet with ruffles around it, tied with a large pink bow under her chin.

Note: Durand-Ruel 6877-L9442.

Collections: From the artist to James Stillman, Paris; to his sister, Bessie G. Stillman, New York; bequeathed to Chauncey Stillman and his sister, the late Mrs. Langbourne Williams, 1935; *Chauncey Stillman*, Amenia, New York.

Reproductions: International Studio, vol. 55 (June 1915), p. cxxi.

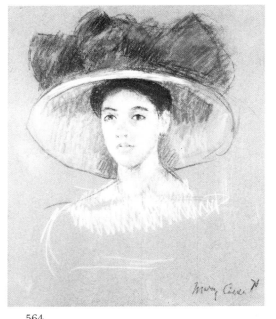

564
Dora in a Large Round Blue Hat c. 1909
Pastel, 28¼ × 23¼ in., 71.7 × 59 cm.
Signed lower right: *Mary Cassatt*

Description: A young woman looks forward, her head and neck modeled in light pastel, her black hair forming a strong contrast. Her large hat extends to the end of her shoulders. It is trimmed with dark blue bows which reach almost as far as the brim, the underside of which is greenish-blue.

Note: Durand-Ruel 10080-LD12868.

Collections: From the artist to Durand-Ruel, Paris; to Durand-Ruel, New York; to Marlborough Fine Art Ltd., London; to *Mr. and Mrs. David Meltzer*, Toronto, Canada.

Exhibitions: Corcoran Gallery of Art, Washington, D. C., 7th Biennial, 1919–20 (cat., 109); Marlborough Fine Art Ltd., London, 1953 (cat. 14).

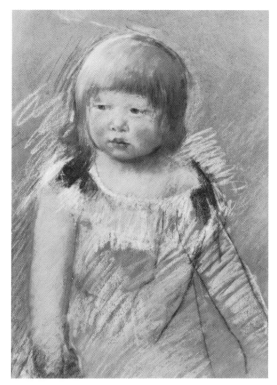

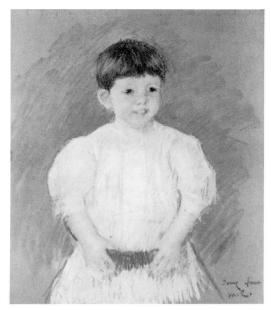

Sketch of Tony 1910
Pastel, 27 × 23 in., 68.5 × 58.4 cm.
Signed lower right: *Tony from/M. C.*

Description: A little boy stands smiling with both hands tucked in his belt. He is seen frontally and looks to right. He wears a white suit with half-length puffed sleeves. His hair is cut short with bangs.

Note: This was a one-hour sketch done at Mesnil-Theribus.

Collections: Anthony D. Cassatt, New York.

Exhibitions: Haverford College, 1939 (cat. 21); Philadelphia Museum of Art, 1960.

565
Child with Bangs in a Blue Dress c. 1910
Pastel, 21½ × 15 in., 54.5 × 38 cm.
Signed lower right:/*M. C.*

Description: Half-length study of a chubby, rosy-cheeked child with fair hair cut in bangs straight across her forehead. She wears a light blue dress with a round low neck and no sleeves and a dark blue bow at each shoulder.

Collections: From the artist to Payson Thompson; American Art Association, New York, Thompson sale, 12 Jan. 1928 (cat. 76, illus.); to Sears Academy of Fine Arts, Elgin, Illinois; to Hirschl & Adler, 1968; to *Jules Zessman,* New York.

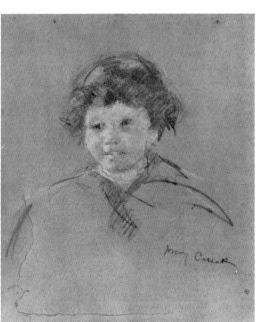

567
Sketch of Alexander J. Cassatt c. 1910
Pastel on tan paper, 21 × 16⅞ in.,
53.4 × 43 cm. (sight).
Signed toward lower right: *Mary Cassatt*

Description: Head and shoulders of Alexander as a boy. His thick curly hair is reddish-blond with golden highlights. He wears a red tie. His eyes look somewhat to left and are dark blue.

Collections: Alexander J. Cassatt, Cecilton, Maryland.

Exhibitions: Philadelphia Museum of Art, 1960.

568
Master Alexander J. Cassatt 1910
Pastel, 26 × 21½ in., 66 × 54.6 cm.
Signed lower right: *A. J. C. jr. from/Mary Cassatt*

Description: Three-quarter length portrait of a boy holding a cat in his arms. He has curly, reddish-blond hair. He looks somewhat to left. He wears a white sailor suit with red collar and tie. The cat's forepaws hang over the boy's left arm.

Note: Durand-Ruel A6603.

Collections: Alexander J. Cassatt, Cecilton, Maryland.

Exhibitions: M. Knoedler & Co., New York, 1966 (cat. 42).

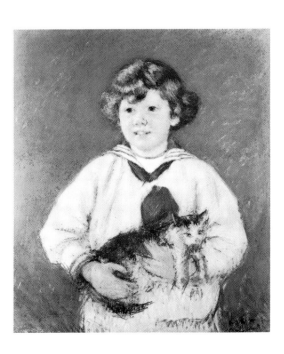

569
Portrait Sketch of Mrs. Algernon Curtis in Japanese Costume 1910
Pastel, 24 × 20 in., 61 × 51 cm.
Signed lower right: *Mary Cassatt*

Description: Half-length view of Mrs. Curtis wearing a Japanese kimono with one large-petaled flower embroidered on the front above a plain obi. Her hair is parted in the middle and rolled back. Behind her hangs a Japanese kakemono on the wall. She looks off to the right.

Note: Executed between 14 January and 1 March 1910 on Miss Cassatt's last trip to the United States.

Collections: From Mrs. Curtis to her relative, Mrs. Warren Blaker, Philadelphia; Hirschl & Adler, 1964; Novick-List Gallery, New York, 1965; A. C. A. Heritage Gallery, New York; to *Mrs. Howard Weingrow*, Old Westbury, New York.

570
Portrait of Charles D. Kelekian 1910
Pastel on tan paper, 26 × 20½ in., 66 × 52 cm.
Signed lower right: *Mary Cassatt*

Description: Half-length portrait of a boy wearing a dark green felt hat. He faces forward and looks at the spectator. His jacket is gray, his tie darker gray, and his shirt white. His hair is black, his eyes dark. The background is a blue gray.

Collections: Mr. and Mrs. Charles D. Kelekian, New York.

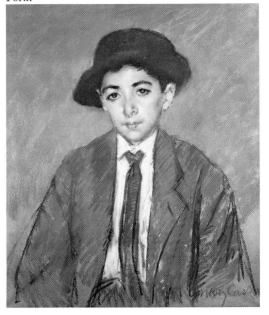

571
Augusta with Her Forefinger on Her Cheek 1910
Oil on canvas, 26⅝ × 22½ in., 67.6 × 57 cm.
Signed lower left corner: *Mary Cassatt*

Description: A young woman with pompadoured dark hair has her right arm raised to touch her cheek at left with her forefinger. She wears a gown with a white pattern on the upper sleeves and a white ruffle at the low V-neck.

Note: Also called "Femme appuyée sur la main droite." Durand-Ruel 6900-L9459.

Collections: From the artist to Durand-Ruel; to James Stillman, 1914; Cleveland Museum of Art, anonymous gift through the Metropolitan Museum of Art, New York, 1922; Hirschl & Adler, 1969.

Exhibitions: Carnegie Institute International, Pittsburgh, 1926; Art Institute of Chicago, 1927 (cat. 33); Carnegie Institute, Pittsburgh, 1928 (cat. 43); Municipal Art Gallery, Davenport, Iowa, 1939; Munson-Williams-Proctor Institute, Utica, N.Y., 1953.

Reproductions: Bulletin of the Cleveland Museum, vol. 9, no. 7 (July 1922), p. 113 and front cover; *The Arts*, vol. 10, no. 5 (Nov. 1926), p. 250; *Art Digest*, vol. 27 (1 Jan. 1953), p. 13.

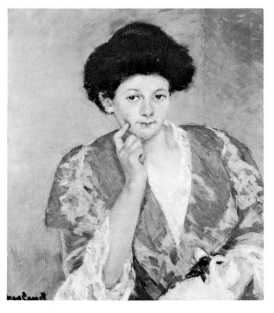

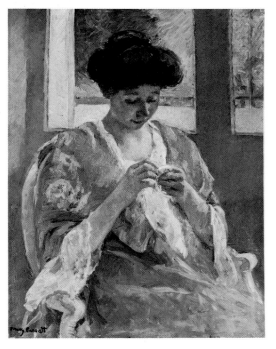

572
Augusta Sewing Before a Window 1910
Oil on canvas, 31¾ × 23¾ in., 80.6 × 60.3 cm.
Signed lower left: *Mary Cassatt*

Description: A young woman sits before a large window, her pompadoured dark hair silhouetted against the greenery outside. Both hands hold her sewing before her as she looks down at it. She wears a blue dress, with a wide collar, decorated with white lace.

Note: Also called "Woman Sewing." Durand-Ruel 6899-L9458.

Collections: From the artist to James Stillman, Paris; *Metropolitan Museum of Art*, New York, anonymous gift, 1922.

Exhibitions: Kalamazoo Art Center, Kalamazoo, Mich., "Paintings by American Masters," 1966.

573
Study of Daughter's Head for "Augusta Reading to Her Daughter" c. 1910
Oil on canvas, 18¼ × 15 in., 46.3 × 38 cm.
Signed lower right: *Mary Cassatt*

Description: A girl sits on a slatted bench looking to right. Her light hair is tied back by two bows. She wears a dress with a shoulder ruffle. Dark water in the background.

Note: Also called "Fillette sur un banc dans un jardin" and "Tête de fillette." Durand-Ruel 10091-LD12867.

Collections: From the artist to Durand-Ruel, 1924; Durand-Ruel, New York, 1924; to Marlborough Fine Art Ltd., London, 1953; present location unknown.

Exhibitions: Durand-Ruel, Paris, 1924 (cat. 13); Durand-Ruel, New York, 1924 (cat. 24); Marlborough Fine Art Ltd., London, 1953 (cat. 4).

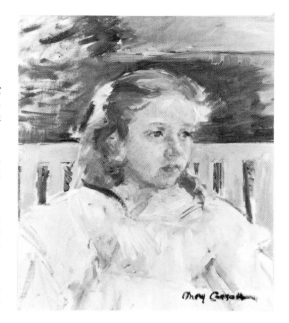

575
Baby John with His Mother c. 1910
Pastel, 11½ × 19¾ in., 29.2 × 50.2 cm.
Signed lower left: *Mary Cassatt*

Description: Head and shoulders of a mother looking at her baby who looks off to left, his blond hair brushed back over his ears. Her dark hair is arranged in a pompadour. Behind her is the top of a dark wooden chair. Her dress is green, the background is blue.

Note: Durand-Ruel 7027-L9634 and 6771.

Collections: From the artist to James Stillman, Paris; *Metropolitan Museum of Art*, New York, anonymous gift, 1922.

Reproductions: American Artist, vol. 23 (March 1959), p. 35.

574
Augusta Reading to Her Daughter 1910
Oil on canvas, 45½ × 35 in., 116 × 89 cm.
Signed lower left corner: *Mary Cassatt*

Description: A mother sits at the end of a slatted bench before a pond with trees beyond, reading to her daughter. The book held in both of her hands is just above the head of the girl, who rests her head on her right hand, her left arm extended as she reclines on the bench.

Note: Also called "Mère et enfant dans un parc" and "La lecteur au parc." Durand-Ruel 6848-L9399.

Collections: From the artist to James Stillman, Paris; to the Walker Art Center, Minneapolis, anonymous gift through the Metropolitan Museum of Art, New York, 1922; to Sotheby & Co., London, sale of impressionist and modern paintings, drawings, and sculpture, 17 July 1957 (lot 171); to *Mrs. Arnold Kirkeby*, Los Angeles.

Exhibitions: Walker Art Center, Minneapolis, 1948; Minneapolis Art Institute, 1950; Women's City Club, St. Paul, 1951.

Reproductions: Harper's Bazaar, vol. 45 (Nov. 1911), p. 491; Achille Segard, 1913, fol. p. 176.

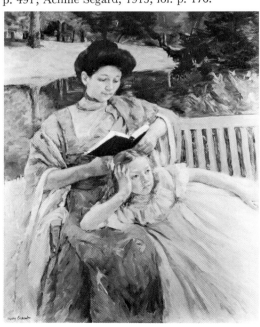

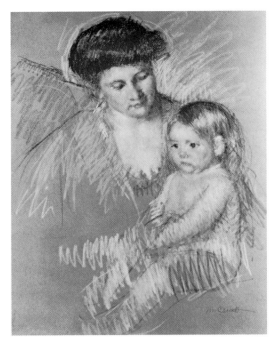

576
Baby John on His Mother's Lap c. 1910
Pastel on tan paper, 31 × 23½ in., 78.7 × 59.6 cm.
Signed lower right in pencil: *M. Cassatt*

Description: Half-length view of a mother looking down at her baby who looks off to left. He is seen in full figure with legs sketched summarily. His hair is brushed back over his ear; hers is in a pompadour.

Collections: Jacques Dubourg, Paris; Arthur Tooth & Sons, London; to Howard Young Gallery, New York; to the *Fisher Governor Foundation*, Marshalltown, Iowa.

Exhibitions: Howard Young Gallery, New York, 1959; Joslyn Art Museum, Omaha, "Mary Cassatt among the Impressionists" (cat. 12, illus.), 1969.

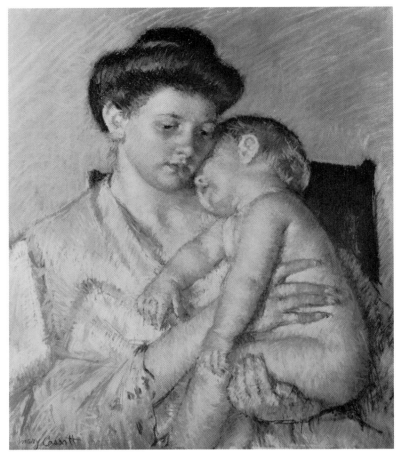

577
Sleepy Baby 1910
Pastel, 25¼ × 21 in., 64 × 53.3 cm.
Signed lower left: *Mary Cassatt*

Description: A mother holds her nude baby on her arm with her right hand holding his side. His head rests on her left shoulder so that his eyes are hidden under her cheek. She looks down toward lower right. The background is blue.

Note: Durand-Ruel 6772-L9325.

Collections: Durand-Ruel, Paris; Durand-Ruel, New York; M. Knoedler & Co., New York; to *Dallas Museum of Fine Arts*, Munger Purchase Fund, 1952.

Exhibitions: M. Knoedler & Co., New York, 1915 (cat. 57).

Reproductions: World Today, vol. 2 (Jan. 1912), p. 1660; *Good Housekeeping Magazine*, vol. 58 (Feb. 1914), p. 158.

578
Baby John Asleep, Sucking His Thumb
c. 1910
Pastel, 26 × 21⅞ in., 66 × 55.5 cm.
Signed lower right: *Mary Cassatt*

Description: A mother holds her nude baby on her left arm with her right hand holding his side. His head rests on her left shoulder so that his eyes are hidden under her cheek. He sucks his right thumb. Her left hand is partly covered by the blanket under him. She wears a blue dress.

Note: Also called "Enfant tétant son pouce."

Collections: Galerie Georges Petit, Paris, Frederic Mallet sale, 20–22 May 1920 (cat. 169); to Francisco Llobet; to his daughter *Ernestina Llobet Llavallol*, Buenos Aires, Argentina.

Exhibitions: Museo Nacional de Bellas Artes, Buenos Aires, "El impresionismo Frances en las colecciones Argentinas" (cat. 16), 1962.

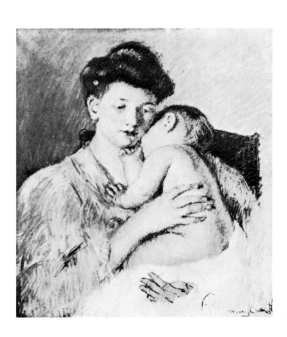

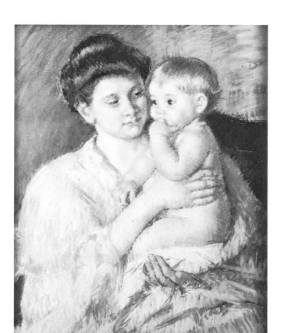

579
Baby John with Forefinger in His Mouth
1910
Pastel on gray paper, 24¾ × 21¼ in., 63 × 54 cm.
Signed lower right: *Mary Cassatt*

Description: Three-quarter length view of a mother holding her baby on her left arm with left hand showing under the folds of a blue blanket held under him. Her right hand holds him under the arm. She looks at him as he gazes to left. Her dress is yellow with a transparent bertha. The background is blue with some green flecks.

Collections: From the artist to Electra Havemeyer Webb, 1910; to *Yale University Art Gallery*, New Haven, Connecticut, gift of J. Watson Webb (B.A. 1907) and Electra Havemeyer Webb, 1943.

Exhibitions: Wildenstein, New York, 1947 (cat. 24, illus.).

580
Two Mothers and Their Nude Children in a Boat 1910
Oil on canvas, 38⅞ × 50¾ in., 98.8 × 129 cm.
Signed lower right corner: *Mary Cassatt*

Description: The mother at left holds her blond child, her left hand on the child's arm, while she looks at another child who is seen from the rear. The child at left extends her legs out of the boat over the water. The child standing at center leans against her mother, who sits in profile to left wearing a bright mauve coat over her light blue dress. The water is brownish-green in the background, except for a small spot of blue at the lower left below the child's feet. The woman at left has auburn hair and wears a yellow gown; the woman at right has black hair. The child seen from the rear wears a pink ribbon around her short, light brown hair.

Note: Also called "Le bain." Durand-Ruel 6847-L9398.

Collections: Musée du Petit Palais, Paris, gift of an anonymous American, 1923.

Exhibitions: Institute Français, Vienna, "Impressionistes et Neo-Impressionistes" (cat. 4), 1949; Art Institute of Chicago and Metropolitan Museum of Art, New York, "Sargent, Whistler and Mary Cassatt" (cat. 27, illus.), 1954; Centre Culturel Américain, Paris, 1959–60 (cat. 5); Chateau de Beaufresne, Mesnil-Theribus, and Musée-Départemental de l'Oise, Palais-Episcopal, Beauvais, "Hommage à Mary Cassatt" (cat. 1), 1965.

Reproductions: Forbes Watson, 1932, p. 47; *Gazette des beaux arts*, s6, vol. 61 (Feb. 1963), supp. p. 43.

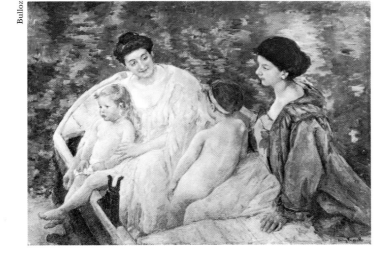

Bulloz

581
Sketch of Head of a Girl in a Hat with a Black Rosette c. 1910
Oil on canvas mounted on board, 9¾ × 13 in., 24.7 × 33 cm.
Unsigned. Mathilde X seal on verso

Description: Head of a little girl looking at spectator, facing forward, her straight blond hair falling over her ears. She wears a big fawn-colored hat with a black velvet rosette at upper right. Leaf green and white background.

Note: Also called "Fillette aux cheveux blonds."

Collections: From the artist to Mathilde Vallet, 1927; Mathilde X sale, Paris, 1927; to Chester Dale; to Dr. B. D. Saklatwalla; Parke-Bernet sale, New York, 1 May 1946 (lot 41); present location unknown.

Exhibitions: Galerie A.-M. Reitlinger, Paris, 1927 (cat. 30).

582
Sketch of a Girl in a Straw Hat Outlined in Black Velvet 1910

Oil on canvas, 19 × 15 in., 48.2 × 38 cm.
Signed lower left: *M. C.*

Description: A little girl looks at the spectator as she faces forward, her straight hair brushed over to the right. The lower brim of her hat is edged in black velvet ribbon which ends in a rosette at right. Her yellow dress has a round neckline and a waistline belted with a green sash. Green foliage in background.

Note: Also called "Young Girl" (by Art Institute of Chicago).

Collections: From the artist to Ambroise Vollard, Paris; from his estate to William A. Findlay, Chicago; to *Art Institute of Chicago*, gift of Mrs. Henry C. Woods.

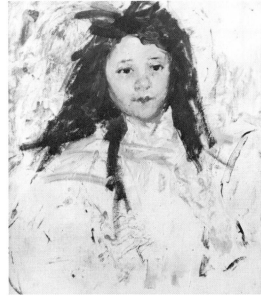

583
Sketch for "Portrait of Agnès, Age Six"
1910

Oil on canvas, 21½ × 18½ in., 54.5 × 47 cm.
Unsigned

Description: Head of a little girl facing forward with long dark hair falling partly over her shoulders and forward, tied with a bow.

Collections: Private collection, Paris.

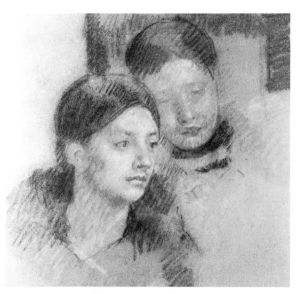

585
Heads of Two Young Women 1910

Pastel on paper, 18 × 18 in., 45.8 × 45.8 cm.
Unsigned. Mathilde X wax seal on verso

Description: The head of the young woman on the left is carried somewhat further than the one above and to the right, whose eyes are very slightly indicated. Both have dark hair, simply arranged.

Note: Also called "Deux jeunes femmes." Durand-Ruel 10448-LD13151. Hirschl & Adler 3602.

Collections: From the artist to Mathilde Vallet, 1927; Mathilde X sale, Paris, 1927; to Durand-Ruel, Paris; to M. & Ph. Rheims, Paris, 27 March 1962; to Hirschl & Adler, New York; present location unknown.

Exhibitions: Galerie A.-M. Reitlinger, Paris, 1927 (cat. 6); Cummer Gallery of Art, Jacksonville, Florida, 1963.

Reproductions: Selections from the Collection of Hirschl & Adler Galleries, vol. 4, 1962–63, cat. 11.

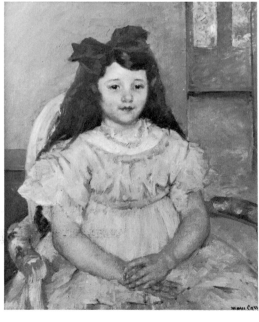

584
Portrait of Agnès, Age Six 1910

Oil on canvas, 29 × 23½ in., 73.7 × 59.7 cm.
Signed lower right: *Mary Cassatt*

Description: Half-length, frontal view of a little girl with long dark hair tied with a big dark ribbon. Her hands are crossed in her lap. She wears a round-necked, high-waisted party dress and sits in a round-backed French chair.

Note: In a letter to Mrs. Havemeyer, written 24 Oct. 1910 at Mesnil-Theribus, Miss Cassatt mentions this portrait: "I am just finishing a little portrait of my neighbor's little girl. He already has one in pastels of her and another with her mother and little brother. He does so love this child who is very pretty and a nice child and begged me to paint her this time. If all sitters were like her it would not be hard."

Collections: Private collection, Paris.

Exhibitions: Centre Culturel Américain, Paris, 1959–60 (cat. 4).

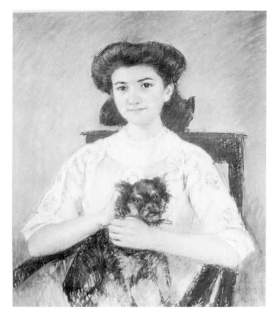

586
Portrait of Marie-Louise Durand-Ruel
1911
Pastel on paper, 30¼ × 25 in., 76.7 × 63.5 cm.
Signed lower right: *Marie Louise/de son amie/*
*Mary Cassatt/**1911***

Description: A young girl sits in a square backed chair holding a toy griffon dog on her lap. Her left hand is at his collar, her right strokes his head. She wears her dark hair in a pompadour, a flat bow at the back of her neck. Her dress has a round neckline and is trimmed on the sleeves with embroidery.

Note: Durand-Ruel 7136.

Collections: Collection d'Alayer, France.

Exhibitions: Durand-Ruel, Paris, 1924 (cat. 26); Marlborough Fine Art Ltd., London, 1953 (cat. 11).

Reproductions: Forbes Watson, 1932, p. 51; *Illustrated London News,* vol. 223 (11 July 1953), p. 73.

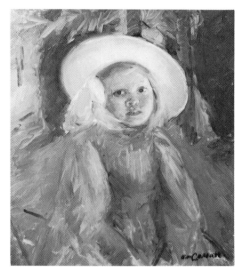

587
Little Girl in a Yellow Hat and
Currant-Colored Dress 1912
Oil on canvas, 25½ × 21 in., 64.7 × 53.3 cm.
Signed lower right: *Mary Cassatt*

Description: Sketch of a little girl in a currant-colored dress and a large yellow hat, with a bow on her hair under the hat. She is turned somewhat to right and looks to left. There are many trees behind her.

Note: Also called "Fillette en robe groseille," "La petite fille au chapeau jaune," and "Fillette habillée en rose." Durand-Ruel 10087-LD12858.

Collections: From the artist to Durand-Ruel, Paris, 1924; Galerie Charpentier sale, Paris, 10–11 June 1958 (cat. 242); Sotheby & Co. sale, London, 12 June 1961 (lot 60); to *Mr. Smythson,* London.

Exhibitions: Durand-Ruel, Paris, 1924 (cat. 11).

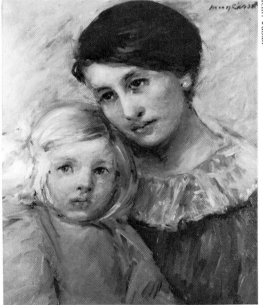

Henri Tabah

589
Mother Resting Her Cheek on Her Daughter's
Blond Head 1913
Oil on canvas, 18 × 15 in., 45.7 × 38 cm.
Signed upper right: *Mary Cassatt*

Description: Heads and shoulders of mother and child. The mother has dark eyes and dark brown hair brushed to right. Her green dress is trimmed with a round, ruffled collar. Her blond child's hair is tied with a blue bow at left. Her dress is pink, her eyes blue. Light ochre background.

Note: Also called "Maternité."

Collections: Findlay Gallery, New York, 1957; Arthur Tooth & Sons, London; André Urban, Paris.

Reproductions: Antiques, vol. 71 (Jan. 1957), p. 10; *Pictures on Exhibit,* vol. 21, no. 2 (Nov. 1957), p. 25.

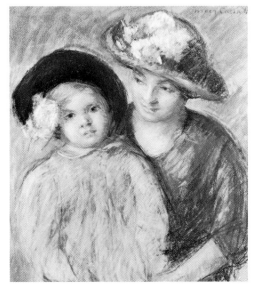

588
Mother in a Flowered Hat and
Her Little Girl in a Dark Hat c. 1913
Pastel, 24¾ × 20½ in., 63 × 52 cm.
Signed upper right: *Mary Cassatt*

Description: Half-length of a mother and child. The mother, at right behind her daughter, looks off to left. She wears a flowered hat with a rolled up brim and a dark dress. The little girl at left wears a round dark hat under which her blond hair is seen parted to the left and tied with a bow. Her dress is plain with a small collar.

Collections: Private collection, France.

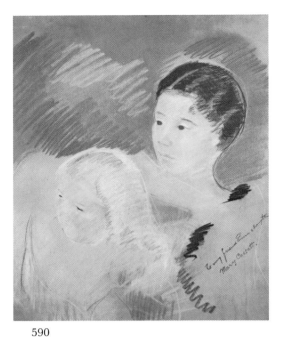

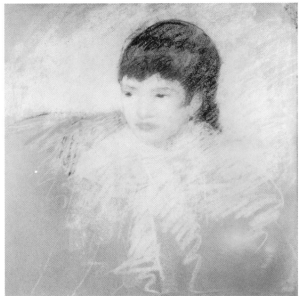

590
Ema and Her Daughter c. 1913
Pastel on buff paper, 21¾ × 18 in., 55.2 × 45.7 cm.
Signed toward lower right: *To my friend Ema and daughter/Mary Cassatt.*

Description: Head and shoulders of a young woman and her blond daughter, both looking down to left. The mother seems to have her hand very slightly indicated at the back of the child's hair, as though tying a bow. The child has an orange scarf about the neck of her blue dress. The mother's short brown hair is parted in the middle, her neck and head outlining a very prominent S line. The background is hatched in olive green.

Collections: Parke-Bernet, New York, Brown, Fried, and Milliken sale (cat. 297), 5 April 1958; Parke-Bernet sale, New York, 13 Dec. 1961 (cat. 53); to *H. W. Golding.*

591
Young Girl with Brown Hair, Looking to Left c. 1913
Pastel on tan paper, 19¾ × 19 in., 50.2 × 48.2 cm.
Unsigned

Description: Head of a young girl with dark hair, looking to left. Her mouth seems to pout. Only the head is clearly articulated. Light background.

Note: Also called "Fillette aux cheveux bruns."

Collections: Edgar Degas; Degas sale, Paris, 1919 (cat. 103); to Mr. Schömeyer; Hôtel Drouot sale, Paris, 29 March 1927; to Hjalmar Gabrielson, Gothenburg; to A. W. Ericsohn, Sweden, 1957; to *Mr. and Mrs. Mark Herschedé*, Cincinnati, Ohio.

592
Child Leaning Against Her Young Mother
c. 1913
Pastel on gray paper, 24½ × 18¼ in., 62.2 × 46.3 cm.
Signed lower left: *Mary Cassatt*

Description: Head and shoulders of young, auburn-haired mother looking down in profile to right. Her child leans against her in frontal view, looking to left. The mother's dress is in shades of blue, the background gray.

Note: Hirschl & Adler 7207-D.

Collections: From the artist to Mary Ann Adler; to Augusta Adler; to Stendhal Gallery, Los Angeles; to Robert Cummings, Montreal; to *Laura Slatkin*, New York.

Reproductions: Art in America, vol. 53 (Aug. 1965), p. 6.

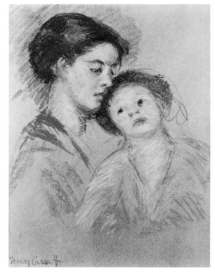

593
Nude Baby on Mother's Lap Resting Her Right Arm on the Back of a Chair 1913
Pastel on paper, 31⅛ × 24 in., 79 × 61 cm.
Signed lower left: *Mary Cassatt*

Description: A mother with smooth dark hair and large dark eyes is seated holding her nude baby on her lap. She holds the baby's upper left arm with her left hand while the baby's right arm rests on the back of the upholstered chair on which his mother sits. Both look slightly to the left.

Note: Also called "Après le bain de bébé." Durand-Ruel A7763-L10436.

Collections: From the artist to James Stillman, Paris; Metropolitan Museum of Art, New York, anonymous gift, 1922; Wildenstein, New York, 1967; Andrew Crispo, New York, 1969; to *Harris J. Klein*, New York.

Exhibitions: Brooklyn Museum, 1937 (cat. 33); Baltimore Museum of Art, 1941–42 (cat. 59); Wildenstein, New York, 1947 (cat. 49).

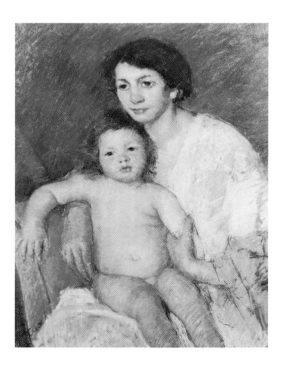

594

Dark-Haired Baby Smiling up at Her Mother
1913
Pastel on paper, 33 × 24 in., 83.8 × 61 cm.
Signed lower left: *Mary Cassatt*

Description: A mother seen in profile to left sits looking down at her nude child who stands leaning against her. The child, with curly reddish-brown hair, looks up at her mother, smiling. The mother's left hand holds the child's left wrist. She wears a blue dress. Green variegated background.

Note: Also called "Bébé souriant à sa mère." Durand-Ruel 7764-L10437.

Collections: From the artist to James Stillman, Paris, 1914; to Durand-Ruel, New York; to Macbeth Galleries, New York; to William J. Johnson; to Thomas J. Watson, New York; to *Westmoreland County Museum of Art*, Greensburg, Pennsylvania, 1968, through the Mary Marchand Woods Purchase Fund.

Exhibitions: California Palace of the Legion of Honor, San Francisco, "Thirty Americans," 1950.

Reproductions: Art News Annual, vol. 18 (1948), p.98.

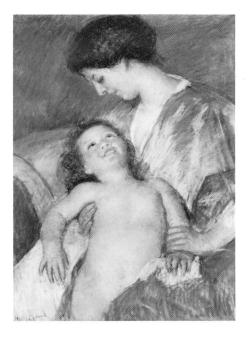

596

Young Girl with Long Brown Hair in a Rose-Red Dress 1913
Pastel on tan paper, 26½ × 19¼ in., 67.3 × 49 cm.
Signed upper left: *Mary Cassatt*

Description: A young girl with long, straight, brown hair gazes slightly to left. She wears a brilliant rose-red dress and light pink ribbons in her hair. Shaded green background.

Note: Also called "Fillette assise en robe rouge." Durand-Ruel A7761-L10439.

Collections: From the artist to Durand-Ruel, 1913; Galerie Marcel Bernheim, Paris; Lock Galleries, New York; Parke-Bernet, New York, Hotchkiss sale, 26 April 1961 (lot 76); to M. Knoedler & Co., New York, 1968; to *Paul Levinger*, Providence, Rhode Island.

Exhibitions: Durand-Ruel, Paris, 1924 (cat. 28); Durand-Ruel, New York, 1924 (cat. 21).

Reproductions: Burlington Magazine (Jan. 1960), p. 44; *Art News*, vol. 60 (April 1961), p. 23.

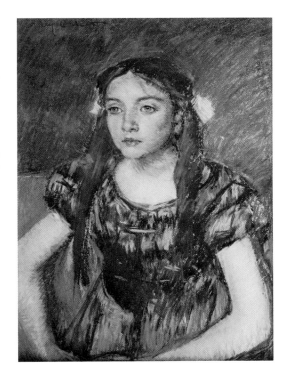

597

Mother and Son on a Chaise Longue, Daughter Leaning over Them 1913
Pastel, 43 × 33½ in., 109.2 × 85 cm.
Signed lower right: *Mary Cassatt*

Description: A mother, with smooth dark hair, in profile left, looks down at her son sprawled on her lap. She wears a fur-trimmed orange gown with a lighter, greenish-white vestee. The little girl behind the chaise longue leans between them, looking at the boy. She has dark hair falling over her shoulder, tied with a bow at left, and wears a brilliant green dress. Shaded background.

Note: Durand-Ruel 10760-L10435.

Collections: Durand-Ruel, Paris, 1913; to Mr. and

595

The Crochet Lesson 1913
Pastel on paper, 30⅛ × 25½ in., 76.5 × 64.8 cm.
Signed lower left: *Mary Cassatt*

Description: A young woman in a light blue blouse helps a young girl in a rose-red dress to crochet. The young woman is behind the girl and places her right hand over the girl's hand. Both look down at their work.

Note: Also called "Jeune fille en corsage bleu et fillette en robe rouge." Durand-Ruel 7762-L10438.

Collections: From the artist to Durand-Ruel, Paris, 1913; Durand-Ruel, New York, 1920; a Swiss collector, 1948–62; International Galleries, Chicago, 1962; Mrs. Charles Laughton, 1962–66; *Melvin and Estelle Gelman*, Washington, D. C., 1966.

Reproductions: Arts, vol. 1 (4 Dec. 1920), p. 33.

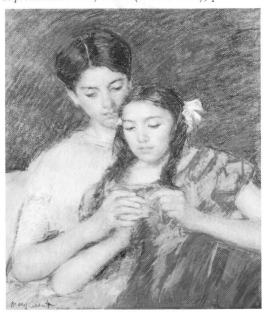

Mrs. H. O. Havemeyer, New York; American Art Association, New York, Havemeyer sale, 1930 (cat. 86, illus.); Mrs. Albert Kahn, Detroit; Wildenstein, New York, 1952; to Walter Chrysler, 1959; to *Memorial Art Gallery*, University of Rochester.

Exhibitions: M. Knoedler & Co., New York, "Masterpieces by Old and Modern Painters" (cat. 42), 1915; Wildenstein, New York, 1947 (cat. 21, illus.); Pasadena Art Institute, 1951 (cat. 2).

Reproductions: Art News, vol. 28, no. 25 (22 March 1930), p. 30; *Pictures on Exhibit* (Nov. 1947), p. 13; *Art Digest*, vol. 26 (15 Oct. 1951), p. 8; *Gazette des beaux arts*, s6, vol. 57 (Feb. 1961), supp. p. 50.

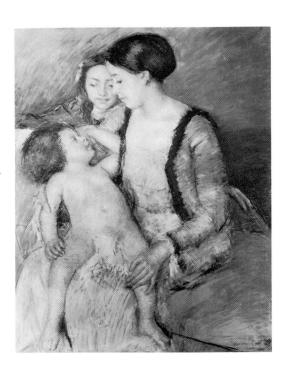

598
Half-Length Figure of a Nude Young Woman
1913

Pastel on paper, 26¾ × 22½ in., 68 × 57 cm.
Signed lower left: *Mary Cassatt*

Description: A young woman with dark hair parted in the middle is seen turned toward left. She is nude and seen to the waist against a dark background.

Note: Also called "Buste de jeune fille" and "Femme nue, buste." Durand-Ruel 7766-L10440.

Collections: From the artist to Durand-Ruel, 1913; present location unknown.

Exhibitions: Durand-Ruel, Paris, 1914 (cat. 19); Durand-Ruel, Paris, 1924 (cat. 8).

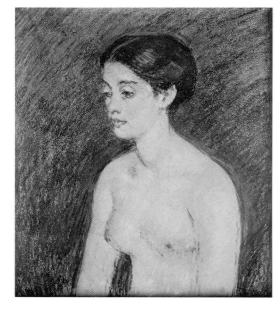

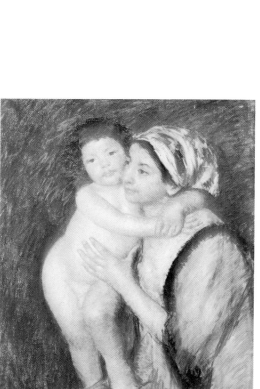

599
Mother Clasping Her Nude Child Seen in Back View 1914

Pastel on paper mounted on canvas, 26⅝ × 22½ in., 67.5 × 57 cm.
Signed lower left: *Mary Cassatt*

Description: Half-length figure of a woman with reddish-brown hair and brown eyes. She is seen in profile to right, her hair drawn back smoothly. She wears a magenta dress with pink and blue flowered trimming. She holds her baby on her left arm and has her right hand on his back. The background is brilliant green-blue.

Note: Executed in Grasse, France, especially for the exhibition at M. Knoedler & Co., New York, 1915. Durand-Ruel 7902-L10570.

Collections: Metropolitan Museum of Art, New York, bequest of Mrs. H. O. Havemeyer.

Exhibitions: M. Knoedler & Co., New York, "Masterpieces by Old and Modern Painters" (cat. 59), 1915; Metropolitan Museum of Art, H. O. Havemeyer Collection Exhibition, 1930 (cat. 138).

Reproductions: Arts and Decoration, vol. 33 (May 1930), p. 55; *American Artist*, vol. 6 (Oct. 1942), p. 20.

600
Mother in Striped Head Scarf Embraced by Her Baby 1914

Pastel on paper mounted on canvas, 32 × 25⅝ in., 81.3 × 65 cm.
Signed lower right: *Mary Cassatt*

Description: A mother is seated holding her nude baby, who stands with his left foot on her lap and embraces her. She wears a white and tan head scarf and a cerise jacket trimmed with dark fur. Background shaded blue and green.

Note: Painted 1913–14 at Grasse, especially for the exhibition at M. Knoedler & Co., New York, 1915. Also called "Maternal Love." Durand-Ruel 7767-L11686.

Collections: Metropolitan Museum of Art, New York, bequest of Mrs. H. O. Havemeyer.

Exhibitions: M. Knoedler & Co., New York, "Masterpieces by Old and Modern Painters" (cat. 58), 1915; Metropolitan Museum of Art, New York, H. O. Havemeyer Collection Exhibition, 1930 (cat. 139).

Reproductions: Arts and Decoration, vol. 33, no. 1 (May 1930), p. 55.

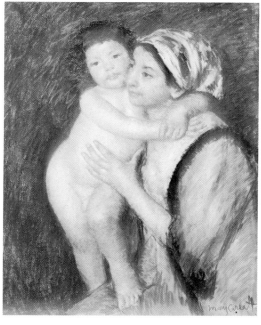

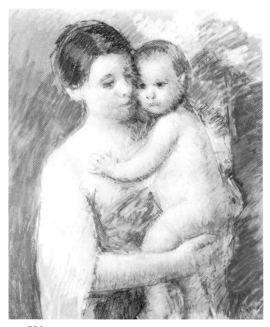

601

Mother Holding Her Nude Baby Whose Left Hand Rests on the Mother's Chest c. 1914
Pastel on paper, 30 × 25½ in., 76.2 × 64.7 cm.
Signed lower right: *Mary Cassatt*

Description: A mother stands holding her nude baby, who leans his head against her face. She is turned toward right and holds him on her right hand. Her hair is auburn and her negligée reddish-brown with a blue pattern. The background is blue and green with a suggestion of bright rose flowers toward upper right.

Note: Also called "Femme vue de face tenant un enfant dans ses bras." Durand-Ruel 8417-L11107.

Collections: Charles E. Slatkin, New York; bought by mother of present owner, 1954; to *Joseph B. Martinson*, New York.

Exhibitions: Durand-Ruel, New York, 1920 (cat. 19); Marlborough Fine Art Ltd., London, 1953 (cat. 17).

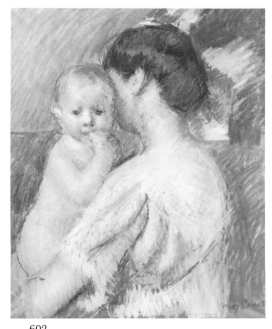

602

Baby Sucking His Finger while Held by His Mother c. 1914
Pastel on paper, 26¼ × 22½ in., 66.7 × 57 cm.
Signed lower right: *Mary Cassatt*

Description: Half-length view of a mother holding her nude baby, who sucks his finger and looks to left. Her face is hidden by his head. Her dark hair is seen against a lighter background with a branch of a tree at the upper right corner.

Note: Durand-Ruel 8418-L11108.

Collections: From the artist to Durand-Ruel, Paris, 1917; to Durand-Ruel, New York, 1917; present location unknown.

Exhibitions: Marlborough Fine Art Ltd., London, 1953 (no. 15).

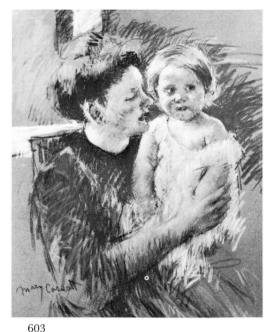

603

Mother in Purple Holding Her Child c. 1914
Pastel on tan paper, 28 × 22 in., 71 × 56 cm.
Signed lower left: *Mary Cassatt*

Description: A mother with pompadoured reddish hair, wearing a deep purple dress, holds her blond child on her left arm and with her right hand holds his left arm. The baby looks off to right. The mother's face is in profile to right.

Collections: Findlay Gallery, New York, 1965; to *Daniel C. Gainey*, Owatonna, Minnesota.

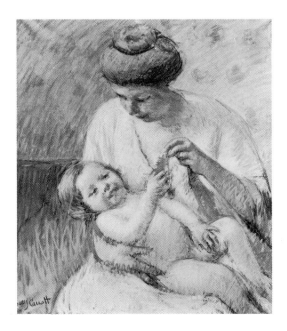

604

Baby Lying on His Mother's Lap Reaching to Hold a Scarf c. 1914
Pastel on brown paper, 29½ × 24½ in., 75 × 62.2 cm.
Signed lower left: *Mary Cassatt*

Description: A young mother, wearing a bluish-white dress, is seated gazing thoughtfully down at the nude child recumbent on her lap. The mother's face is foreshortened. The blond infant smiles and plays with the end of a flame-red scarf held in his mother's right hand. Patterned golden-yellow wallpaper in the background with accents of rose, deep blue, and green.

Note: Durand-Ruel 7903-L10573.

Collections: From the artist to Durand-Ruel, Paris, 1914; Arthur G. Altschul, New York; Parke-Bernet sale, New York, 25 Jan. 1961; to *Mr. and Mrs. Philip D. Sang.*

Exhibitions: M. Knoedler & Co., New York, "Masterpieces by Old and Modern Painters" (cat. 54), 1915; L'Union des Femmes Peintres, Paris, 1947.

605
Sketch of a Mother with Left Hand over Child's Right Hand 1914
Pastel on gray paper, 18 × 16 in., 45.7 × 40.7 cm.
Signed lower right: *M. C.*

Description: Head of a mother in profile left with her little girl's face touching hers. Both look left. The child's arm hangs down at left, but there is no indication of the mother's arm or hand.

Collections: James W. Alsdorf, Chicago; to *Mrs. Sherman Sexton*, Chicago.

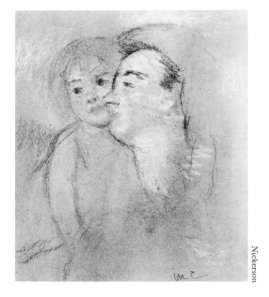

Nickerson

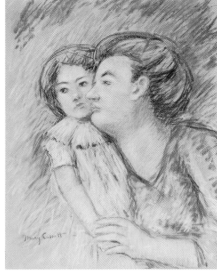

606
Mother in Profile Left with Her Left Hand over the Right Hand of Her Child 1914
Pastel on paper, 23 × 17 in., 58.4 × 43.2 cm.
Signed toward lower left: *Mary Cassatt*

Description: Half-length of a mother seen in profile left, her face against that of her little girl, who looks left. The mother's left hand covers the child's right. The child wears a short-sleeved pink dress with a ruffled collar. The mother's dress is pale green. Shaded blue background.

Collections: American Art Association, New York, O'Reilly-Adams & Schumann sale, 23 Jan. 1936 ("property of a Boston private collector"); Victor Spark, 1952; the *Clowes Fund, Inc.*, Indianapolis, Indiana.

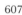

607
Mother about to Kiss Her Baby c. 1914
Pastel on paper, 28 × 23⅝ in., 71 × 60 cm.
Signed lower right: *Mary Cassatt*

Description: A mother holds a nude baby on her lap, her right hand under the baby's right arm, her left holding the baby's right leg at the knee. The brunette baby looks at the spectator. The mother looks down at the baby and is about to kiss her on the cheek.

Collections: Private collection, Paris; to E. V. Thaw & Co., Inc., and Stephen Hahn Gallery, New York.

608
Young Woman in a Small Winged Hat Holding a Cat c. 1914
Pastel on paper, 25½ × 21¼ in., 64.7 × 54 cm.
Signed lower left: *Mary Cassatt*

Description: Half-length of a young woman facing forward wearing a small kelly green felt hat trimmed with the wings of a bird. She looks to left. Her green jumper over a white blouse forms a background for a gray cat with a white face. Tan and brown background flecked with olive green.

Note: Also called "Jeune femme à la toque." Durand-Ruel 8416-L11106.

Collections: From the artist to Durand-Ruel, Paris, 1917; to Durand-Ruel, New York, 1917; Galerie Charpentier sale, Paris, 1–2 April 1954 (cat. 62); to Wildenstein, New York; to *Mr. and Mrs. Ira Kirshbaum*, Beverly Hills, California.

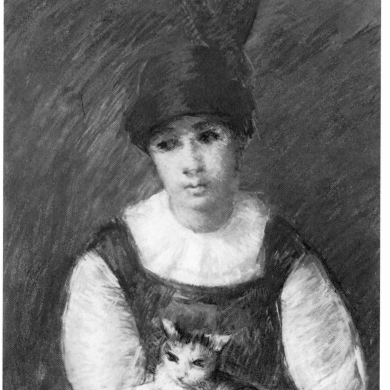

609

Half-Length of a Nude Boy c. 1914

Pastel on gray paper, 22 × 19 in., 56 × 48.2 cm.
Unsigned. Mathilde X collection stamp at lower
right corner

Description: Sketch of a nude boy in half-length
looking to right with only a slight suggestion of
upper arms. He has short dark hair. The back-
ground is yellow green and kelly green.

Collections: From the artist to Mathilde Vallet,
1927; Mathilde X sale, Paris, 1931; E. & A.
Silberman Galleries, New York; to *Washington
County Museum of Fine Arts,* Hagerstown, Maryland,
gift of Mrs. William H. Singer, Jr., 1956.

Exhibitions: Galerie A.-M. Reitlinger, Paris, 1931
(cat. 16, illus.).

610

**Slight Sketch of a Woman Looking Down
to Left** c. 1914

Pastel on paper, 25½ × 17½ in., 64.7 × 44.4 cm.
Signed lower right: *Mary Cassatt*

Description: Head of a woman with dark hair
pulled down over her ears, parted in the middle.
She has a very fat chin and looks down to left.

Note: Also called "Tête de jeune femme." Durand-
Ruel 10382-L11747.

Collections: Durand-Ruel, Paris; present location
unknown.

Exhibitions: Marlborough Fine Art Ltd., London,
1953 (cat. 7).

611

**Mother Seated with Baby Standing Next to
Her in a Landscape** c. 1914

Oil on canvas, 19⅝ × 18 in., 50 × 45.7 cm.
Unsigned. Mathilde X collection stamp on verso

Description: A very mediocre sketch of a nude baby
standing next to his mother, who wears a white
dressing gown.

Note: Called "Bébé nu debout et garçon assis en
peignoir blanc," a misnomer in my opinion.
Also called "Femme et fillette dans un paysage."

Collections: From the artist to Mathilde Vallet,
1927; Mathilde X sales, Paris, 1927 and 1931; to
M. Lorenceau, Paris; present location unknown.

Exhibitions: Galerie A.-M. Reitlinger, Paris, 1927
(cat. 48); Galerie A.-M. Reitlinger, Paris, 1931
(cat. 1, illus.).

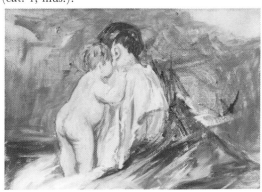

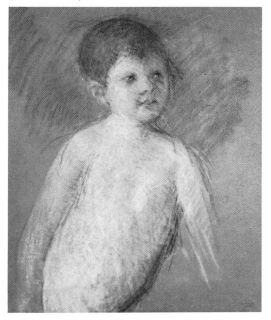

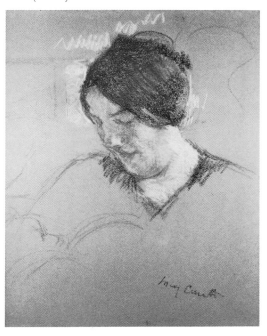

612

**Slight Sketch of Back View of Mother and
Baby** c. 1914

Pastel on paper, 18 × 15 in., 45.7 × 38 cm.
Unsigned

Description: Half-length of a mother seen from the
rear with head turned away, eye and tip of nose
showing. The baby stands next to her with his
right arm on her left shoulder.

Note: Durand-Ruel 10095-L12239.

Collections: From the artist to Durand-Ruel, Paris,
1924; to Durand-Ruel, New York; to *Mme. de la
Chapelle,* 1941.

Exhibitions: McClees Galleries, Philadelphia, 1931
(cat. 14).

613 †

Nude Little Girl Standing (No. 1) c. 1914

Pastel on paper, 16½ × 13½ in., 42 × 34.3 cm.
Unsigned

Description: An impressionistic study of a nude
young child, her head inclined back and pre-
sumably resting upon her left hand, her eyes
gazing upwards. Her disordered chestnut hair
frames her rosy-complexioned face. Vague blue
background.

Collections: From the artist to Payson Thompson;
American Art Association, New York, Thompson
sale, 12 Jan. 1928 (cat. 72); present location
unknown.

614 †

Nude Little Girl Standing (No. 2) c. 1914

Pastel on paper, 21 × 16½ in., 53.3 × 42 cm.
Signed lower right: *Mary Cassatt*

Description: A three-quarter length figure of a
nude child resting her weight upon her left arm,
her right hand raised to her chin. She has red hair.

Collections: From the artist to Payson Thompson;
American Art Association, New York, Thompson
sale, 12 Jan. 1928 (cat. 78); present location
unknown.

Watercolors

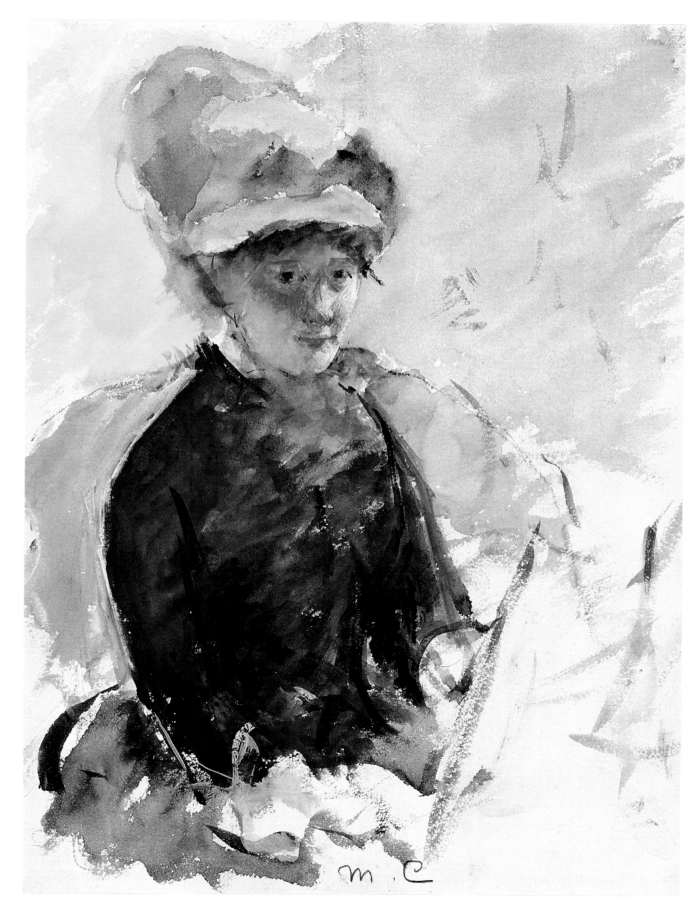

Self-Portrait, c. 1880. BrCR 618.

615
Little Boy with Bandage over His Eye
c. 1873
Watercolor on paper, 5½ × 9 in. (sight), 14 × 23 cm.
Signed toward lower center: *Mary Cassatt*

Description: A little boy is seated on a straight wooden chair, his head bent down disconsolately, his eyes closed and a dark bandage tied around his head and down over his right eye. His hands are folded over his stomach. He wears a dark coat and high shoes. His feet rest on the rung of the chair.

Collections: Mrs. Morris Kaplan, Bryn Mawr, Pennsylvania.

616
Profile of an Italian Woman c. 1873
Watercolor on paper, 10 × 8 in., 25.4 × 20.4 cm.
Unsigned

Description: An interesting looking Italian woman with a long, straight nose in profile to left. Her dark hair is piled high on her head with bangs over her forehead. Her V-necked blouse is red with a white collar and her skirt is blue.

Collections: Mr. and Mrs. Jules Zessman, New York.

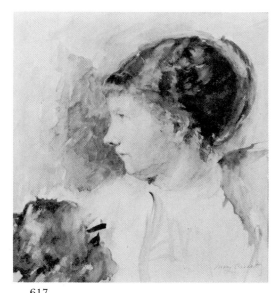

617
Profile of Lydia c. 1879
Watercolor on paper, 16½ × 15⅜ in., 42 × 39 cm.
Signed lower right: *Mary Cassatt*

Description: Head and shoulders of Lydia in profile to left. Her dark hair is waved with a long bun at the back. She wears a white blouse with a high neck. There is a dark spot at lower left which may indicate a bouquet.

Collections: Private collection, Paris.

618
Self-Portrait c. 1880
Watercolor on paper, 13 × 9½ in., 33 × 24 cm.
Signed low center: *M. C.*

Description: Half-length of the artist seated looking at the spectator. She wears a dark costume and a high bonnet tied under the chin with a large bow. At the lower right is a diagonal line representing a drawing or painting board.

Collections: Lucile Manguin, Paris; Galerie de Paris sale, 1963; to *A. P. Bersohn,* New York.

Exhibitions: Musée National D'Art Moderne, Paris, "De l'impressionisme à nos jours" (cat. 22), 1958.

Color plate, page 219.

619
Portrait of a Little Girl with Curly Hair
c. 1880
Watercolor on paper, $13\frac{3}{4} \times 12\frac{1}{4}$ in., 35×31 cm.
Signed lower right: *Mary Cassatt*

Description: Head and shoulders of a little girl turned slightly left observing the spectator. Her curly hair is low on her forehead and covers her ears. She wears a dress cut with a square neckline and short sleeves.

Collections: Private collection, Paris.

Exhibitions: Galerie Charpentier, Paris, 1959 (cat. 3).

620
Robert Sketching Outdoors c. 1882
Watercolor on paper, $9 \times 12\frac{1}{4}$ in., 23×31 cm.
Signed lower right: *Mary Cassatt*

Description: A pale sketch of a boy seated and turned to the right, his right leg crossed over the left, a dark shoe showing. He wears a light suit with high white collar and dark tie.

Collections: Brooklyn Museum, Babbott gift, 1920.

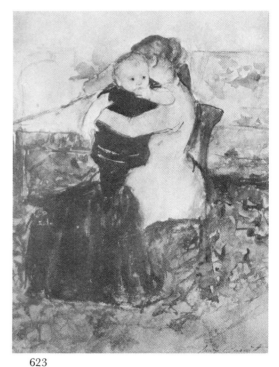

621
Mrs. Robert Moore Riddle c. 1883
Watercolor on paper, $1\frac{1}{2} \times 1\frac{1}{2}$ in., 3.8×3.8 cm.
Unsigned

Description: The head only of Mrs. Riddle, a sketch for the portrait entitled "Lady at the Tea Table" (BrCR 139), now in the Metropolitan Museum of Art. The pose is similar, with the head turned toward right. The hair is drawn down smoothly over her ear. There is just a suggestion of the lace cap tied under her chin. The face is somewhat narrower than in the painting.

Collections: Mrs. George A. Robbins (a granddaughter of Mrs. Riddle), Ambler, Pennsylvania.

622
Baby in a Dark Blue Suit, Looking over Mother's Shoulder (No. 1) 1890
Watercolor on paper. Not measured.
Signed lower right: *M. C.*

Description: Full-length view of a mother seated in a straight chair holding her baby standing on her lap. She wears a light-colored, long, fitted dress with a dark skirt. The baby, in a dark costume, has his left hand up to his mouth.

Note: This and the second version are both studies for BrCR 153.

Collections: Private collection, Paris.

623
Baby in a Dark Blue Suit, Looking over Mother's Shoulder (No. 2) 1890
Watercolor on paper, 13×10 in., 33×25.5 cm.
Signed at lower right, in ink: *Mary Cassatt*

Description: Full-length view of a mother seated on a straight chair holding her baby standing on her lap. She wears a light-colored, long, fitted dress with a dark skirt. The baby, in a dark blue costume, has his left hand up to his mouth.

Note: This is a study for BrCR 153.

Collections: John Quinn, New York; Hôtel Drouot, Paris, Quinn sale, 28 Oct. 1926; present location unknown.

Exhibitions: Armory Show, New York, 1913–14.

624
Head of a Blond Baby, Looking Down
c. 1890
Watercolor on white paper, 7 × 10 in.,
17.8 × 25.4 cm.
Signed lower right: *Mary Cassatt*

Description: A delicately colored drawing of the
head of a blond baby boy, looking down toward
his hands (not drawn). His hair curls above his
forehead. His eyelashes are dark.

Note: Durand-Ruel A1439-NY513.

Collections: From the artist to Albert E. McVitty,
Princeton, New Jersey; private collection, New
York.

Sketch of Vernon Lee Wearing Pince-Nez
1895
Watercolor on tan paper, 9½ × 6¾ in., 24 × 17.2 cm.
Signed lower right: *Mary Cassatt*

Description: Head and shoulders of a woman wear-
ing pince-nez and long earrings. She has a red
ornament in her hair. Her blouse is gray-blue
with red stripes.

Note: The English writer, Violet Padgett, known
as Vernon Lee, visited Miss Cassatt at Mesnil-
Theribus in July 1895 and then wrote to a
friend: "I liked immensely being at Mesnil. . . .
Miss Cassatt is very nice, simple, an odd
mixture of a self-recognizing artist, with
passionate appreciation in literature, and the
almost childish garrulous American provincial"
(Frederick A. Sweet, 1966, pp. 143–44). Durand-
Ruel A1438-NY514.

Collections: From Durand-Ruel to *Mr. and Mrs.
Benjamin Sonnenberg*, New York.

626
Mother Holding Her Baby (No. 1) c. 1899
Watercolor on paper, 6½ × 6¼ in., 16.5 × 16 cm.
Signed lower right: *Mary Cassatt*

Description: A slight sketch of a baby's head with
eyes observing the spectator. Just the top of the
mother's dark hair is indicated. Some pencil
outlines to suggest the baby's back and arm and
the mother's back.

Note: Durand-Ruel A1303-NY3853.

Collections: Present location unknown.

627
Mother Holding Her Baby (No. 2) c. 1899
Watercolor on paper, 9 × 7 in., 23 × 17.8 cm.
Signed lower right: *Mary Cassatt*

Description: Pose of a mother in profile left with a
baby's head on her shoulder. Sketched summarily
against a shaded background. The mother's dress
is dark.

Note: Durand-Ruel A1302-NY3851.

Collections: Durand-Ruel, Paris; Sotheby & Co.,
London, 1967.

628
Mother Holding Her Baby (No. 3) c. 1899
Watercolor on paper, 7½ × 6⅝ in., 19 × 17 cm.
Signed toward lower right: *Mary Cassatt*

Description: A baby's head rests on his mother's
shoulder hiding the lower part of her profile to
left. The mother's dark hair is arranged in a bun.

Note: Durand-Ruel A1289-NY3852.

Collections: Present location unknown.

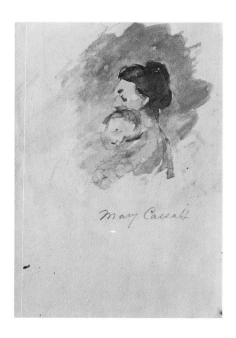

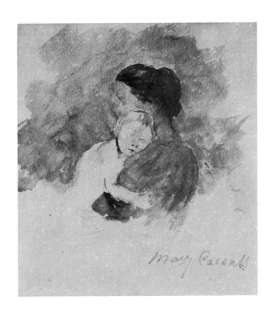

629
Mother Holding Her Baby (No. 4) c. 1899
Watercolor on paper, 7½ × 6⅝ in., 19 × 17 cm.
Signed lower right: *Mary Cassatt*

Description: A baby looks at the spectator as he rests his head on his mother's shoulder and his right arm on her left upper arm. His head hides the lower part of her face. Her hair and dress are both dark.

Note: Durand-Ruel A1290-NY 3850.

Collections: Sotheby & Co., London, 27 April 1967 (cat. 386); to *O. Adler*, London.

630
Mother Holding Her Baby (No. 5) c. 1899
Watercolor on white paper, 10 × 6⅞ in., 25.5 × 17.5 cm.
Unsigned. Mathilde X collection stamp at lower right.

Description: A mother, holding her baby aloft, is in profile to left. The gray-eyed baby is seen frontally. The mother's hair is brown, the edge of her dress blue.

Note: Also called "Femme et enfant." Durand-Ruel 19862B-13930.

Collections: From the artist to Mathilde Vallet, 1927; Mathilde X sale, Paris, 1931; to Durand-Ruel, Paris; present location unknown.

Exhibitions: Galerie A.-M. Reitlinger, Paris, 1931 (cat. 40).

631
Head of a Woman Seated, Reading, Profile Right c. 1906
Watercolor on white paper, 13¾ × 16½ in., 35 × 42 cm.
Unsigned. Mathilde X collection stamp at lower right.

Description: A woman seated in profile right with eyes lowered, reading a newspaper. Beyond her is a green landscape. Her head is in shadow. She has brown hair.

Note: Also called "Tête de femme, fond de verdure." Durand-Ruel 19856B-13928.

Collections: From the artist to Mathilde Vallet, 1927; Mathilde X sale, Paris, 1931; Durand-Ruel, Paris, 1966.

Exhibitions: Galerie A.-M. Reitlinger, Paris, 1931 (cat. 35).

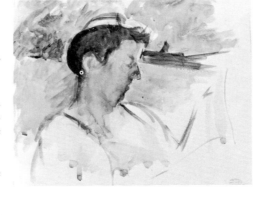

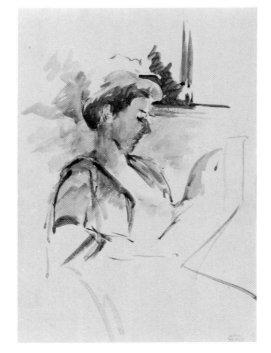

632
Profile Right: Woman Reading a Newspaper
c. 1906
Watercolor on paper, 16½ × 13¾ in., 42 × 35 cm.
Unsigned. Mathilde X collection stamp at lower right.

Description: A woman seated outdoors. Lawn and trees beyond. Touches of rose on her gown outlined in blue.

Note: Also called "Femme assise les yeux baissés (fond paysage)." Durand-Ruel 19852B-13924.

Collections: From the artist to Mathilde Vallet, 1927; Mathilde X sale, Paris, 1931; Durand-Ruel, Paris, 1966.

Exhibitions: Galerie A.-M. Reitlinger, Paris, 1931 (cat. 29).

633
Woman in the Garden Reading a Newspaper
c. 1906
Watercolor on paper, 16½ × 12½ in., 41.9 × 31.7 cm.
Signed toward lower left: *Mary Cassatt*

Description: Head and shoulders of a woman seated on a lawn with trees beyond. She is seen in profile right. Her head and the background are well developed. Her pose as she reads the newspaper is only slightly indicated in the lower half of the picture. Her dark hair is simply arranged.

Note: Durand-Ruel A1301-NY3844.

Collections: Marlborough Fine Art Ltd., London; to *J. D. Kelly*, Glasgow, Scotland.

Exhibitions: Marlborough Fine Art Ltd., London, 1953 (cat. 22).

634
Profile of Seated Woman Sewing c. 1906
Watercolor on white paper, 15¾ × 11¾ in., 40 × 30 cm.
Unsigned. Mathilde X collection stamp at lower right.

Description: A woman seated in profile right. Her head is in dark shadow. There are trees behind her. She looks as though she were sitting near a doorway. Upright lines are behind her.

Note: Also called "Femme assise, travaillant." Durand-Ruel, 19858c-19939.

Collections: From the artist to Mathilde Vallet, 1927; Mathilde X sale, Paris, 1931; Durand-Ruel, Paris, 1966.

Exhibitions: Galerie A.-M. Reitlinger, Paris, 1931 (cat. 50).

635
Mother and Child in a Landscape with a Friend Admiring the Baby c. 1906
Watercolor on paper, 19¼ × 13⅜ in., 49 × 34 cm.
Unsigned. Mathilde X collection stamp at lower right.

Description: In the lower half of the page the auburn-haired mother sits holding her child— no features indicated. There is a figure at left before them with back turned. A curving path winds to right. Dark pine trees beyond and much green grass.

Note: Also called "Femme et enfants dans un paysage." Durand-Ruel 19852A-13941.

Collections: From the artist to Mathilde Vallet, 1927; Mathilde X sale, Paris, 1931; Durand-Ruel, 1966.

Exhibitions: Galerie A.-M. Reitlinger, Paris, 1931 (cat. 52).

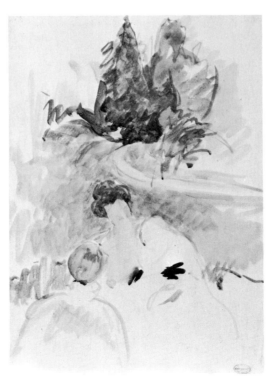

636
Mother Holding up Her Nude Child in a Landscape c. 1906
Watercolor on paper, 16½ × 11¾ in., 42 × 30 cm.
Signed lower right: *Mary Cassatt*

Description: A mother and her nude child are seen before a broad landscape. The mother's face is in shadow. She holds her child standing on her lap. His body is shown only to the waist.

Note: Durand-Ruel 1941-L10598.

Collections: From the artist to Durand-Ruel, Paris, 1914; to Mr. Y. Beurdeley, Paris, 1914; Hôtel Drouot, Paris, 3rd Beurdeley sale, 30 Nov. and 1–2 Dec. 1920 (cat. 80); present location unknown.

Exhibitions: Durand-Ruel, Paris, 1914 (cat. 37).

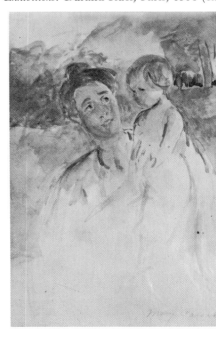

637

Sketch of Mother Jeanne's Head Looking to Left c. 1908

Watercolor on paper, 15¾ × 11½ in., 40 × 29.3 cm.
Signed toward lower right: *Mary Cassatt*

Description: Head only of a woman with pompadoured hair looking to left.

Note: Durand-Ruel A1300-NY3848.

Collections: From the artist to Durand-Ruel, 1914; to Durand-Ruel, New York, 1920; *J. S. R. Byers, Esq.*, England.

Exhibitions: Marlborough Fine Art Ltd., London, 1953 (cat. 19); Belfast Museum, Northern Ireland, "Pictures from Ulster Houses" (cat. 236), 1961.

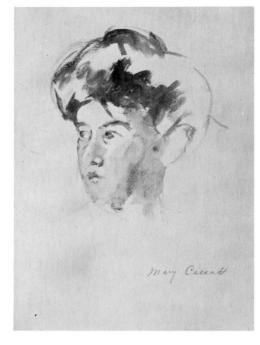

638

Sketch of Mother Jeanne's Head Looking Down (No. 1) c. 1908

Watercolor on paper, 17¼ × 13¾ in., 43.8 × 35 cm.
Signed lower right: *Mary Cassatt*

Description: Head only, almost in profile to right, with pompadoured hair. One dark eye shows, the other is barely indicated.

Note: Durand-Ruel A1294-NY3838.

Collections: From the artist to Durand-Ruel, 1914; to Durand-Ruel, New York, 1915; private Swiss collection; International Galleries, Chicago; to *Mr. and Mrs. Paul W. Hoffmann*, Oak Brook, Illinois.

Exhibitions: Marlborough Fine Art Ltd., London, 1953 (cat. 21).

639

Sketch of Mother Jeanne's Head Looking Down (No. 2) c. 1908

Watercolor on paper, 17¾ × 12⅝ in., 45 × 32 cm.
Signed at right: *Mary Cassatt*

Description: Head of woman wearing her dark hair in a pompadour with a bun on top of her head. She looks down and is seen in three-quarter view to right. The side of her face to right has a dark shadow. It does not extend as far onto her shoulder as in other versions.

Note: Durand-Ruel 7942-L10590.

Collections: Present location unknown.

Exhibitions: Whitney Museum of American Art, New York, "A History of American Watercolor Painting," 1942; Marlborough Fine Art Ltd., London, 1953 (cat. 20).

640

Sketch of Mother Jeanne's Head Looking Down (No. 3) c. 1908

Watercolor on paper, 19¼ × 13¼ in., 49.5 × 34 cm.
Signed toward lower right: *Mary Cassatt*

Description: Head of a woman wearing her dark hair in a pompadour with a bun on top of her head. She is seen in three-quarter view looking down to the right. One side of her face has a lighter shadow than the one that extends onto her shoulder.

Note: Durand-Ruel 7935-L10591.

Collections: From the artist to Durand-Ruel, Paris, 1914; to Durand-Ruel, New York, 1946; private Swiss collection, 1948; International Galleries, Chicago, 1962; to *Mrs. Henry B. Walker, Jr.*, Evansville, Indiana, 1964.

Exhibitions: International Galleries, Chicago, "Mary Cassatt, Retrospective Exhibition" (cat. 13, illus.), 1965.

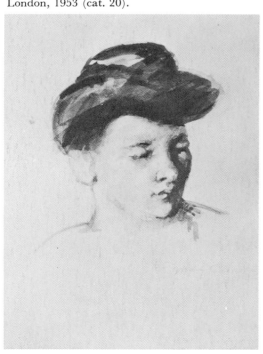

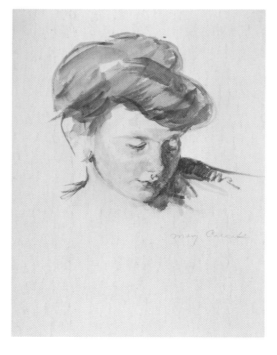

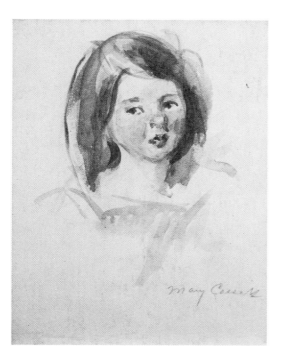

Sketch of Mother Jeanne Looking Down at Her Little Girl (No. 1) c. 1908
Watercolor on paper, 10½ × 8½ in., 26.7 × 21.6 cm.
Signed lower right: *Mary Cassatt*

Description: Slight sketch with the mother's head and torso just indicated and the little girl's head more developed. The mother's head bends over to the right; the child, with her dark hair tied with a bow, looks at the spectator.

Note: Durand-Ruel NY 3849.

Collections: Present location unknown.

641

Sketch of Mother Jeanne's Little Girl
c. 1908
Watercolor on paper, 12⅛ × 9 in., 30.8 × 23 cm.
Signed lower right: *Mary Cassatt*

Description: This is a study of the head of the little girl in the painting "Mother Looking Down, Embracing Both of Her Children" (BrCR 501). Here the little girl is turned somewhat to right but looks to left. Her long hair is parted on the side and tied with a bow.

Note: Durand-Ruel 7940-L10595.

Collections: Durand-Ruel, Paris; present location unknown.

643

Sketch of Mother Jeanne Looking Down at Her Little Girl (No. 2) c. 1908
Watercolor on paper, 17¼ × 11⅜ in., 43.8 × 29 cm.
Signed lower right: *Mary Cassatt*

Description: This sketch develops the two heads of mother and child with much shading. There is no indication of arms or general pose. The mother's head bends to right; the little girl looks at the spectator.

Note: Durand-Ruel 7933-L10593.

Collections: From the artist to Durand-Ruel, 1914; to Durand-Ruel, New York, 1920; Hôtel Drouot sale, Paris, 10 March 1933; present location unknown.

644

Sketch of Mother Jeanne Looking Down at Her Little Girl (No. 3) c. 1908
Watercolor on paper, 17¼ × 11⅜ in., 43.8 × 29 cm.
Signed lower right: *Mary Cassatt*

Description: Half-length sketch with both figures somewhat developed. The little girl's arm shown is at left. Some shading in background.

Note: Durand-Ruel 7939-L10596.

Collections: From the artist to Durand-Ruel, 1914; to M. Caressa, 1917; present location unknown.

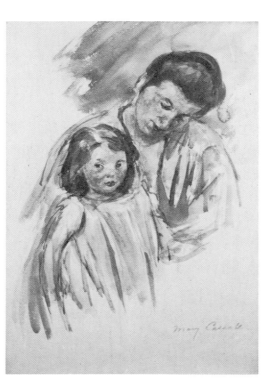

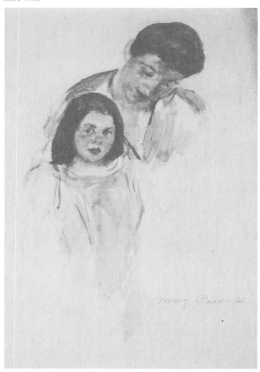

645
Sketch of Mother Jeanne Looking Down, with Her Two Children (No. 1) c. 1908
Watercolor on paper, 17¼ × 11⅜ in., 43.8 × 29 cm. Unsigned. Mathilde X collection stamp at lower right.

Description: A study for the painting "Mother Looking Down, Embracing Both of Her Children" (BrCR 501). The little girl's head is detailed, with dark hair and shading on her face. The mother and baby are outlined as to pose only.

Note: Also called "Tête de fillette, tête de femme et enfant nu, esquissé."

Collections: From the artist to Mathilde Vallet, 1927; Mathilde X sale, Paris, 1931; present location unknown.

Exhibitions: Galerie A.-M. Reitlinger, Paris, 1931 (cat. 55, illus.).

646
Sketch of Mother Jeanne Looking Down, with Her Two Children (No. 2) c. 1908
Watercolor on paper, 17¼ × 11⅜ in., 43.8 × 29 cm. Signed lower right: *Mary Cassatt*

Description: A study for BrCR 501. The baby's face is not quite in profile. Only the head of the little girl is developed.

Note: Durand-Ruel 7934-D10597.

Collections: From the artist to Durand-Ruel, 1914; to M. Mancini, 1917; present location unknown.

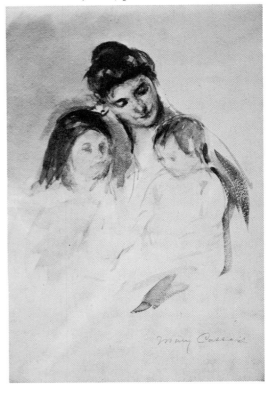

647
Baby Asleep on Mother's Shoulder c. 1908
Watercolor on white paper, 7⅜ × 7⅜ in., 19 × 19 cm. Unsigned. Mathilde X collection stamp at lower right.

Description: Shaded sketch of a baby's head with only a few lines to suggest the mother's head and shoulder. Mostly in tones of gray with some pink.

Note: Also called "Etude d'enfant." Durand-Ruel 19863B-13931.

Collections: From the artist to Mathilde Vallet, 1927; Mathilde X sale, Paris, 1931; Durand-Ruel, 1966.

Exhibitions: Galerie A.-M. Reitlinger, Paris, 1931 (cat. 41).

648
Mother Looking Down at Her Sleeping Child c. 1908
Watercolor on paper, 13⅜ × 11⅜ in., 34 × 29 cm. Unsigned. Mathilde X collection stamp at lower right.

Description: Summary sketch of the head and shoulders of a mother in profile right looking down at her sleeping baby.

Note: Also called "Etude de femme et d'enfant." Durand-Ruel 19851A-13923.

Collections: From the artist to Mathilde Vallet, 1927; Mathilde X sale, Paris, 1931; Durand-Ruel, Paris, 1966.

Exhibitions: Galerie A.-M. Reitlinger, Paris, 1931 (cat. 26)

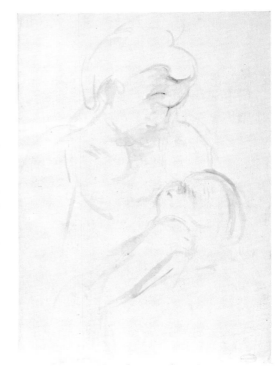

649

Sketch of Pose Related to "Mother and Child Smiling at Each Other" c. 1908
Watercolor on paper, 12½ × 9 in., 31.5 × 23 cm.
Signed lower left: *Mary Cassatt*

Description: A nude child stands to right of her mother who looks down at her. The child leans against her and is seen in full-length with her left leg somewhat forward, her foot not showing.

Note: Related to BrCR 507 and 508. Durand-Ruel A1296-NY3842.

Collections: O'Hana Gallery, London, 1967.

651

Sketch for "Mother and Child Smiling at Each Other" (No. 2) c. 1908
Watercolor on paper, 13 × 9½ in., 33 × 24 cm.
Signed lower right: *M. C.*

Description: A nude baby stands before his mother who bends over to look at him as he bends back his head and looks up. The mother's left hand supports him under his left arm. His right arm is bent as he touches his shoulder.

Note: Related to BrCR 507 and 508.

Collections: Galerie Motte sale, Geneva, 22–23 May 1964 (cat. 229, illus.); to O'Hana Gallery, London.

650

Sketch for "Mother and Child Smiling at Each Other" (No. 1) c. 1908
Watercolor on paper, 17¼ × 11⅜ in., 44 × 29 cm.
Unsigned. Mathilde X collection stamp at lower right.

Description: A mother in profile looks down at a nude child standing before her. The child seems to have both arms raised with hands behind his head.

Note: Related to BrCR 507 and 508. Also called "Femme et enfant, esquisse." Durand-Ruel 11675-L15560.

Collections: From the artist to Mathilde Vallet, 1927; Mathilde X sale, Paris, 1931; to Durand-Ruel, Paris; present location unknown.

Exhibitions: Galerie A.-M. Reitlinger, Paris, 1931 (cat. 45).

652

Head of a Child—Françoise (No. 1) c. 1908
Watercolor on white paper, 12¼ × 9¾ in., 31 × 25 cm.
Unsigned. Mathilde X collection stamp at lower right.

Description: Slight sketch of head only with brown hair shaded darker at right. The eyes look down, with eyebrows accented.

Note: Also called "Etude d'enfant" and "Etude de tête d'enfant." Durand-Ruel 19859A-13940.

Collections: From the artist to Mathilde Vallet, 1927; Mathilde X sale, Paris, 1931; to Durand-Ruel, Paris; present location unknown.

Exhibitions: Galerie A.-M. Reitlinger, Paris, 1927 (cat. 90); Galerie A.-M. Reitlinger, Paris, 1931 (cat. 51).

653

Head of a Child—Françoise (No. 2) c. 1908
Watercolor on white paper, 12 × 9½ in.,
30.5 × 24 cm.
Unsigned. Mathilde X collection stamp at lower right.

Description: Slight sketch of head only with reddish hair shaded darker at right and with one dark vertical stroke at right. The eyes look down (more color than in No. 1). Eyebrows are accented.

Note: Also called "Tête, étude." Durand-Ruel Ph 19859B-13938.

Collections: From the artist to Mathilde Vallet, 1927; Mathilde X sale, Paris, 1931; Durand-Ruel, Paris, 1966.

Exhibitions: Galerie A.-M. Reitlinger, Paris, 1931 (cat. 49).

654

Head of a Child—Françoise (No. 3) c. 1908
Watercolor on paper, 10¼ × 9½ in., 26 × 24 cm.
Unsigned

Description: A little girl with dark hair looks down. Her head is turned somewhat to left. Her mouth is small. Her hair, parted on the far side has many loose strands toward left.

Note: Also called "Étude de tête d'enfant."

Collections: From the artist to Mathilde Vallet, 1927; Mathilde X sale, Paris, 1927; Hugo Dreyfuss, New York; *Samuel H. Nowak*, Philadelphia.

Exhibitions: Galerie A.-M. Reitlinger, Paris, 1927 (cat. 91).

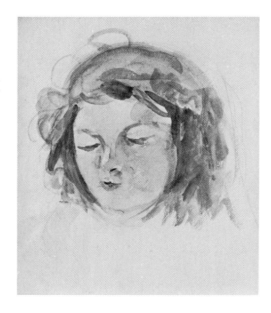

655

Head of Françoise Turned Somewhat Left
1908
Watercolor on paper, 13¼ × 9¼ in., 33.5 × 23.5 cm.
Signed center right: *M. C.*

Description: Head and shoulders of Françoise in a dark blue dress. Her dark hair is parted on the far side and drawn across her forehead. It hangs down with a curl forward on either side. The top of her dark dress makes a double S curve across her chest.

Note: Also called "Portrait d'une jeune fille."

Collections: From the artist to Ambroise Vollard; Galerie Charpentier sale, Paris, 21 June 1960; present location unknown.

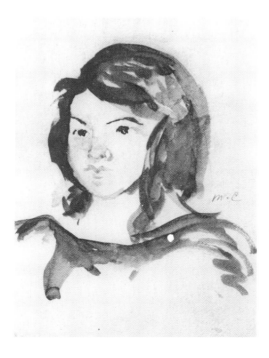

656 †

Study of Françoise's Head c. 1908
Watercolor on paper, 12¾ × 10¾ in., 32.5 × 27.5 cm.
Unsigned

Description: Head in three-quarter view with downcast eyes and an impression of curly chestnut hair.

Collections: From the artist to Mathilde Vallet, 1927; Mathilde X sale, Paris, 1927; to Payson Thompson; American Art Association, New York, Thompson sale, 12 Jan. 1928 (cat. 71); present location unknown.

Exhibitions: Galerie A.-M. Reitlinger, Paris, 1927 (cat. 43).

657

Head of Françoise Looking Down (No. 1)
c. 1908
Watercolor on paper, 9¾ × 8⅜ in., 25 × 21.3 cm.
Unsigned

Description: A little girl's head is seen frontally looking down. Her dark hair falls forward over her shoulders. Side of face at right in shadow.

Note: A study for BrCR 538. Durand-Ruel 10443-LD13155.

Collections: Present location unknown.

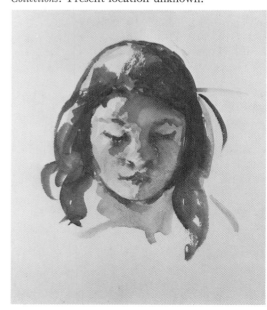

658
Head of Françoise Looking Down (No. 2)

c. 1908

Watercolor on paper, 11 × 9½ in., 28 × 24 cm.
Signed toward lower right: *Mary Cassatt*

Description: The little girl's head is bent slightly to left as she looks down. Her dark hair hangs forward over her shoulders. The left side curls more than the right.

Note: A study for BrCR 538. Durand-Ruel A1287-NY3835.

Collections: Hôtel Drouot sale, Paris, 30 Nov. 1942 (cat. 3); present location unknown.

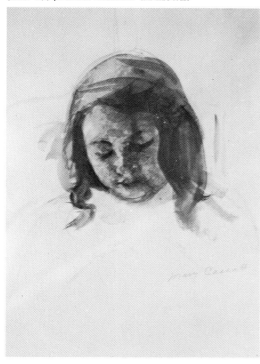

660
Françoise Sewing (No. 2) 1908

Watercolor on paper, 19¼ × 13¼ in., 49 × 34 cm.
Signed lower right: *Mary Cassatt*

Description: A sketch for BrCR 538, but with a different costume. Here the little girl wears a dress with dark blue sleeves over which she wears a white pinafore. She wears a bow on her hair and has no curl over her forehead.

Note: Also called "Étude d'enfant." Durand-Ruel 7936-L10589.

Collections: From the artist to Durand-Ruel, 1914; to Mancini, 1917; Hôtel Drouot sale, Paris, 25 Oct. 1950 (cat. 12); Galerie Charpentier sale, Paris, 13 June 1958 (cat. 5); present location unknown.

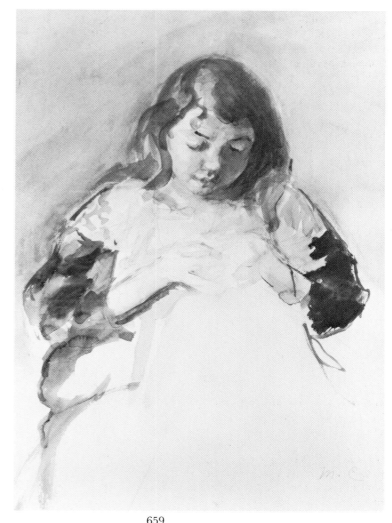

659
Françoise Sewing (No. 1) 1908

Watercolor on paper, 15¾ × 11⅜ in., 40 × 29 cm.
Signed lower right: *M. C.*

Description: A little girl holds a large piece of white material before her with both hands as though sewing it. Her dark brown hair is parted with one short curl falling over her forehead. Her dress has a wide lace yoke or bertha and dark, delft blue sleeves.

Note: Related to BrCR 538. Also called "La petite fille en bleu."

Collections: Parke-Bernet sale, New York, 20 Oct. 1966 (lot 90); to *Joseph H. Hirshhorn collection*, New York.

Exhibitions: Galerie Charpentier, Paris, "L'Enfance," 1949.

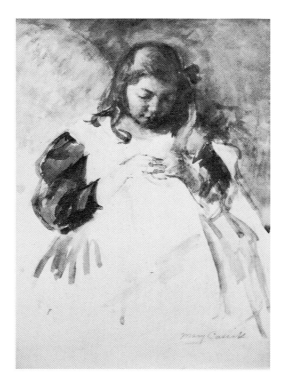

661

Study for "Françoise Wearing a Big White Hat" (No. 1) c. 1908

Watercolor on paper, 17 × 13½ in., 43 × 34 cm.
Signed toward lower right: *Mary Cassatt*

Description: Head only of a little girl with dark hair falling onto her shoulders. One lock of hair curls over her forehead. Outline of a large hat is just indicated. Mostly warm brown and red, with some bluish-gray in hair and for outline of the hat.

Note: A study for BrCR 527. Durand-Ruel A1292-NY3834.

Collections: Chester H. Johnson Gallery, Chicago; to *Marion Koogler McNay Art Institute*, San Antonio, Texas.

Exhibitions: Marion Koogler McNay Art Institute, "American Artists in San Antonio Collections" (cat. 4), 1958.

662

Study for "Françoise Wearing a Big White Hat" (No. 2) c. 1908

Watercolor on paper, 17 × 13½ in., 43 × 34.3 cm.
Signed lower right: *Mary Cassatt*

Description: Head only of a little girl with dark hair falling onto her shoulders. Here her hair is brushed toward right (with no curl). Outline of a large hat clearly shown.

Note: A study for BrCR 527. Durand-Ruel A1285-NY3833.

Collections: Present location unknown.

663

Head of a Little Girl: Study for "Mother and Child in a Boat" c. 1908

Watercolor on paper, 17¾ × 12¾ in., 45.2 × 32.5 cm.
Signed at right, center: *Mary Cassatt*

Description: A little blond girl with full mouth and fat cheeks looks at the spectator. She is turned toward left. Head and shoulders only. Shading to left in background.

Note: A study for BrCR 524. Durand-Ruel A1295-NY3840.

Collections: Edward W. McMahon; American Art Association, New York, McMahon sale, 24 Jan. 1929 (cat. 18); to *Fine Arts Gallery of San Diego*, California.

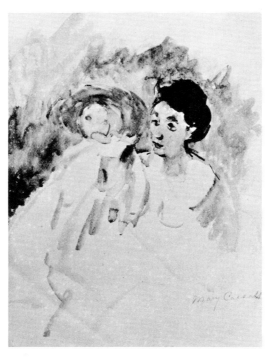

664

Study for "Mother and Child in a Boat" c. 1908

Watercolor on paper, measurements unknown
Signed lower right: *Mary Cassatt*

Description: The mother's head and bust are well developed. She wears a dress with deep décolletage and has very dark hair. The child at left wears a big round hat—just indicated—with no features developed.

Note: A study for BrCR 524. Durand-Ruel A1299-NY3847.

Collections: Present location unknown.

665

Sketch of Dark-Haired Mother with Her Baby at Left c. 1908

Watercolor on paper, 16⅞ × 13¼ in., 43 × 33.5 cm.
Signed lower right: *Mary Cassatt*

Description: The mother's head is seen frontally with dark hair in a bun on top of her head. The baby is barely indicated, with one long curl of hair coming forward. His head is in profile right.

Note: Durand-Ruel A1293-NY3837.

Collections: From the artist to Durand-Ruel, Paris, 1914; in a Swiss collection, 1948; to International Galleries, Chicago, 1962; to *Mr. and Mrs. Maurice Fulton*, Glencoe, Illinois, 1964.

Exhibitions: International Galleries, Chicago, "Mary Cassatt, Retrospective Exhibition" (cat. 15, illus.), 1965.

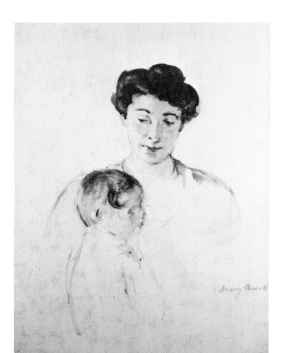

666

Sketch of Mother Jeanne Looking Down, with Her Baby (No. 1) c. 1908

Watercolor on paper, 9⅛ × 11⅜ in., 23.2 × 29 cm.
Unsigned. Mathilde X wax seal on back of frame.

Description: Slight sketch of the head and shoulders of a mother looking toward left. Her hair is pompadoured with a knot on top. Her dress has a square cut neck. The head (only) of her baby at lower right is quite finished with bobbed hair. The baby looks to left in three-quarter view.

Note: A study for BrCR 501.

Collections: From the artist to Mathilde Vallet, 1927; Albert E. McVitty collection; Parke Bernet, New York, McVitty estate sale, 15 Dec. 1949; to *Mrs. Alvin J. Walker*, Montreal, Canada.

Exhibitions: Baltimore Museum of Art, 1936 (cat. 7) (called "Femme et enfant: têtes").

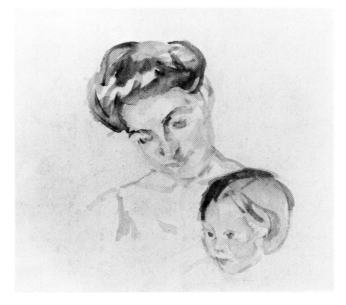

667

Sketch of Mother Jeanne Looking Down, with Her Baby (No. 2) c. 1908

Watercolor on paper, 17¼ × 11⅜ in., 44 × 29 cm.
Signed lower right: *Mary Cassatt*

Description: In this sketch the little girl at left does not appear and the baby's face is not quite in profile. The baby's hand rests on the mother's arm as in painting.

Note: A study for BrCR 501. Durand-Ruel 7938-L10592.

Collections: Mrs. Spira, Vincennes, France; to Gregory Jan Johnson, Paris; to *Dr. Americo Ramos*, Kansas City.

Reproductions: Burlington Magazine, vol. 109 (June 1967), p. xv.

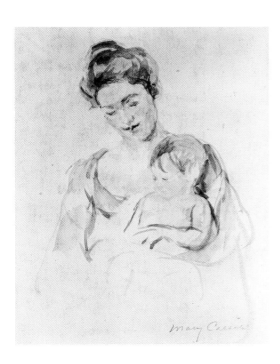

668
Sketch of Mother Jeanne Looking Down, with Her Baby (No. 3) c. 1908
Watercolor on paper, 19⅝ × 13¼ in., 50 × 33.6 cm.
Signed lower right: *Mary Cassatt*

Description: The mother's head and shoulders, with top of the baby's head indicated, and a window behind her to left. She wears a pompadour. There is a dark block of color at lower right.

Note: A study for BrCR 501. Durand-Ruel 7937-L10599.

Collections: Durand-Ruel, New York; Hôtel Drouot sale, Paris, 8 Dec. 1944 (cat. 3); to *Mr. and Mrs. Gerald Bronfman*, Montreal, Canada.

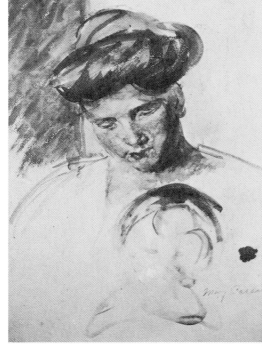

669
Sketch of Little Girl's Head c. 1909
Watercolor on paper, 7 1/16 × 5½ in., 18 × 14 cm.
Signed lower left: *M. C.*

Description: Head of a little girl with big round eyes looking at the spectator. Her blond hair is parted on the side. There is a suggestion of a wide, ruffled yoke covering her shoulders. This is a broadly treated brush drawing.

Collections: Present location unknown.

670
Sketch of Little Girl Seated on the Grass by a River c. 1909
Watercolor on paper, 6¼ × 9 in., 16 × 23 cm.
Unsigned. Mathilde X collection stamp at lower right corner.

Description: Slight sketch of a small child seated on the grass with her legs stretched out in front of her. Her dress has a wide, white ruffle at the neck and is rose-colored.

Note: Also called "Fillette robe rose au bord d'une rivière."

Collections: From the artist to Mathilde Vallet, 1927; Mathilde X sale, Paris, 1931; *Mrs. Maison*, London.

Exhibitions: Galerie A.-M. Reitlinger, Paris, 1931 (cat. 31).

671
Young Girl's Head c. 1910
Watercolor and crayon, 20 × 17¾ in., 51.8 × 45 cm.
Signed upper right: *Mary Cassatt*

Description: The girl's face is softly shaded in watercolor; the hair and shoulder are sketched in crayon. She looks at the spectator.

Collections: Present location unknown.

672
Head of a Woman in a Black Blouse c. 1910
Watercolor on white paper, 9 × 9 in., 23 × 23 cm.
Unsigned. Mathilde X collection stamp at lower
right.

Description: Sketch of a woman's head in profile
right. Her hair is blond and pompadoured with
a knot on top. The neck and shoulder portion of
her blouse are black.

Note: Also called "Tête de femme du corsage
noir."

Collections: From the artist to Mathilde Vallet,
1927; Mathilde X sale, Paris, 1931; private
collection, Paris.

Exhibitions: Galerie A.-M. Reitlinger, Paris, 1931
(cat. 38).

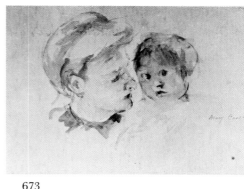

673
Sketch of Baby and His Mother c. 1910
Watercolor on paper, 20 × 12¼ in., 51 × 31 cm.
Signed at right: *Mary Cassatt*

Description: The baby's head is developed as he
looks at the spectator. His mother, in profile right,
looks at him. Her pompadoured hair is light. The
round, high neck of her dress is dark.

Note: Durand-Ruel A1288-NY3836.

Collections: Durand-Ruel, 1966.

674
Baby John and His Mother: Two Heads
c. 1910
Watercolor on paper, 18⅞ × 14⅝ in., 48 × 37 cm.
Signed toward lower right: *Mary Cassatt*

Description: Head and shoulders of a mother and
her baby. She wears a pompadour and is turned
toward right with her cheek against that of her
son. He looks at the spectator, his left arm
suggested resting on his mother's chest. His short
hair brushed to right shows his ear.

Note: A. E. Gallatin wrote in 1922 in *American
Watercolorists*, "Mary Cassatt is not represented
in any public galleries in the country in
watercolor." Durand-Ruel A1286-NY3839.

Collections: Durand-Ruel, New York, 1922–42;
present location unknown.

Exhibitions: Philadelphia Museum of Art, "15th
Annual Watercolor Show" (cat. 581), 1917;
McClees Galleries, Philadelphia, 1931 (cat. 9);
Baltimore Museum of Art, 1941–42 (cat. 64).

Reproductions: A. E. Gallatin, *American Water-
colorists*, New York, 1922, pl. 29.

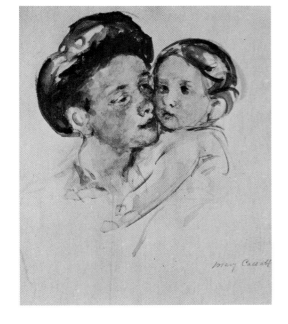

675
Slight Sketch of a River Landscape c. 1910
Watercolor on paper, 13⅜ × 19¼ in., 34 × 49 cm.
Unsigned. Mathilde X collection stamp at lower
right.

Description: Trees reflected in water seen from a
distance.

Note: Also called "Paysage, esquisse." Durand-
Ruel 19853A-13936.

Collections: From the artist to Mathilde Vallet,
1927; Mathilde X sale, Paris, 1931; Durand-
Ruel, 1966.

Exhibitions: Galerie A.-M. Reitlinger, Paris, 1931
(cat. 47).

676
Augusta's Daughter and a Friend Seated Near a River Bank c. 1910
Watercolor on white paper, 19¼ × 13⅜ in., 49 × 34 cm.
Unsigned. Mathilde X collection stamp at lower right.

Description: Augusta's daughter sits on a wooden bench with her back to the river and its sharp reflections of trees beyond. She is talking to a younger child seen in profile left.

Note: Also called "Two Girls Seated" and "Deux fillettes au bord d'un rivière." The younger child is Miss Cassatt's grandniece, now Mrs. John B. Thayer.

Collections: From the artist to Mathilde Vallet, 1927; Mathilde X sale, Paris, 1931; *Baltimore Museum of Art*, Cone Collection.

Exhibitions: Galerie A.-M. Reitlinger, Paris, 1931 (cat. 53, illus.); Baltimore Museum of Art, 1936 (cat. 8); Baltimore Museum of Art, 1941–42 (cat. 65); Pennsylvania Academy of the Fine Arts, Peale House Gallery (cat. 33), 1955; Baltimore Museum of Art, "Manet, Degas, Berthe Morisot and Mary Cassatt" (cat. 113), 1962.

677
Augusta and Her Daughter Seated Near a River Bank c. 1910
Watercolor on paper, 18½ × 13½ in., 47 × 34.2 cm.
Unsigned. Mathilde X collection stamp at lower right.

Description: Augusta in profile right is seated at left before a river landscape with a reflection of trees beyond. The head of her daughter is lightly sketched at right.

Note: Also called "Two Women in a Garden" (Los Angeles County Museum of Art). Durand-Ruel 13926-19851A.

Collections: From the artist to Mathilde Vallet, 1927; Mathilde X sale, Paris, 1931; *Los Angeles County Museum of Art*, Mr. and Mrs. Preston Harrison Collection.

Exhibitions: Galerie A.-M. Reitlinger, Paris, 1931 (cat. 33) (called "Femme, la tête penchée et tête d'enfant esquissée").

678
Mother, Child, and Hovering Figure c. 1910
Watercolor on paper, 18½ × 12¾ in., 47 × 32.4 cm.
Unsigned. Mathilde X collection stamp at lower right.

Description: Slight sketch of a mother seated, turned left looking at child farther left. Above the mother's head at the upper right corner is another figure best seen when page is turned on its right side.

Note: These may be sketches connected with the Musée du Petit Palais painting "Two Mothers and Their Nude Children in a Boat" (BrCR 580).

Collections: From the artist to Mathilde Vallet, 1927; *Canton Art Institute*, Canton, Ohio.

679
Slight Sketch for "Two Mothers and Their Nude Children in a Boat" c. 1910
Watercolor on paper, 13⅜ × 19¼ in., 34 × 49 cm.
Unsigned. Mathilde X collection stamp at lower right.

Description: Two dark-haired women with a child slightly indicated between them. The woman at right has purple hair, the one at left crimson. Bright shades of green above the head of the right-hand figure.

Note: A study for BrCR 580. Also called "Femmes et enfant dans la barque."

Collections: From the artist to Mathilde Vallet, 1927; Mathilde X sale, Paris, 1931; present location unknown.

Exhibitions: Galerie A.-M. Reitlinger, Paris, 1931 (cat. 42).

680
Sketch for "Two Mothers and Their Nude Children in a Boat" (No. 1) 1910

Watercolor on paper, 13⅜ × 18⅞ in., 34 × 48 cm. Unsigned. Mathilde X collection stamp at lower right.

Description: Against a dark blue background the figures of two women and one child are summarily suggested. The woman at right is seen in profile left, her dark hair darker than the background. The woman at the left also has dark hair and dark eyebrows. The child between them is scarcely recognizable, with no details.

Note: A study for BrCR 580. Also called "Dans la barque" and "Promenade en barque."

Collections: From the artist to Mathilde Vallet, 1927; Mathilde X sale, Paris, 1931; *Mme. Roger Hauert*, Paris.

Exhibitions: Galerie A.-M. Reitlinger, Paris, 1931 (cat. 28); Musée National d'Art Moderne, Paris, "De l'impressionisme à nos jours" (cat. 23), 1958; Centre Culturel Américain, Paris, 1959–60 (cat. 6, illus.); Musée Departement de l'Oise, Beauvais, "Hommage à Mary Cassatt" (cat. 3), 1965.

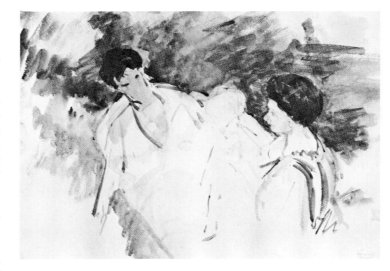

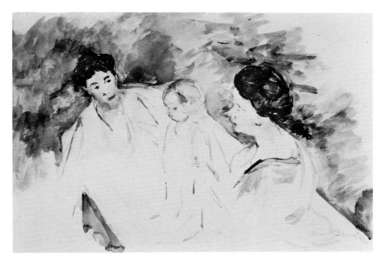

681
Sketch for "Two Mothers and Their Nude Children in a Boat" (No. 2) c. 1910

Watercolor on paper, 13½ × 19¼ in., 34.2 × 49 cm. Signed in pencil at lower right: *Mary Cassatt*

Description: Sketch with indication of three figures, more developed than the other version. The woman at left has eyes and nose and the child also has features. Background in varying shades of green.

Collections: Present location unknown.

Exhibitions: McClees Galleries, Philadelphia, 1931 (cat. 18).

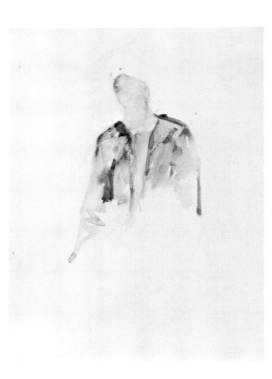

682
Slight Sketch of a Nubian in a Blue Robe
1911

Watercolor on paper, 15¾ × 11¾ in., 40 × 30 cm. Unsigned. Mathilde X collection stamp at lower right.

Description: This is a color note with face, neck, and blue blouse barely indicated. There is a suggestion of a white turban and dark skin on face and neck.

Note: This may be a Nubian sketched when the artist went to Egypt with her brother Gardner and his family in 1911. She then wrote to Mrs. Havemeyer: "I have not even been able to do my Nubian in watercolors. The weather has been so windy and no awning possible as the winds are contrary." Also called "Femme, corsage bleu." Durand-Ruel 19854A-13933.

Collections: From the artist to Mathilde Vallet, 1927; Mathilde X sale, Paris, 1931; Durand-Ruel, Paris, 1966.

Exhibitions: Galerie A.-M. Reitlinger, Paris, 1931 (cat. 44).

683
Study of a Mother's Head 1913
Watercolor on paper, 17¼ × 11¾ in., 43.8 × 29.8 cm.
Signed lower left: *Mary Cassatt*

Description: Head of woman with dark hair parted
on the side toward left and drawn over to cover
part of her ear at right. She looks somewhat to
left. Her face is thinner than in the pastel for
which this is a study (BrCR 593), and is turned
more to left.

Note: Durand-Ruel A1297-NY3843.

Collections: Mr. and Mrs. Benjamin Sonnenberg, New
York.

Exhibitions: Durand-Ruel, Paris, 1953 (cat. 19);
Marlborough Fine Art Ltd., London, 1953
(cat. 20).

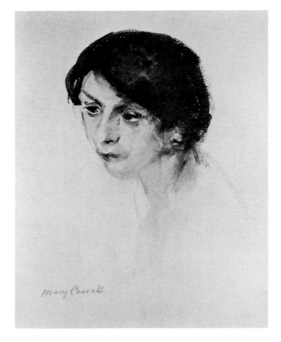

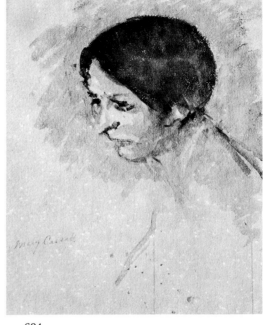

684
Study of a Mother's Head Almost in Profile
c. 1914
Watercolor on paper, 17⅛ × 11¾ in., 43.5 × 29.7 cm.
Signed lower left: *Mary Cassatt*

Description: Head of a woman with hair parted to
left and smoothed down over her forehead
covering half of her ear. She is almost in profile
but both eyes show, looking down to left.

Note: Related to BrCR 600. Durand-Ruel
A1298-NY3845.

Collections: Durand-Ruel, Paris; *Mr. and Mrs.
Benjamin Sonnenberg*, New York.

685
**Sketch for "Young Woman in a Small
Winged Hat Holding a Cat"** c. 1914
Watercolor on paper, 18½ × 13 in., 47 × 33 cm.
Unsigned. Mathilde X collection stamp at lower
right.

Description: A sketch for the pastel (BrCR 608).
The woman is seen frontally, with a green
feathered hat, before a golden-yellow shaded
background.

Note: Also called "Femme au chapeau vert" and
"Le chapeau vert." Durand-Ruel 13922.

Collections: From the artist to Mathilde Vallet,
1927; Mathilde X sale, Paris, 1931; Hôtel Drouot
sale, Paris, 20–21 April 1932 (cat. 4); Parke-
Bernet sale, New York, 5 March 1952 (cat. 5);
Parke-Bernet sale, New York, 29 Jan. 1964
(cat. 11, illus.); Andrew Crispo, New York, 1968;
to Paul Bianchini and the Niveau Gallery, New
York, 1969.

Exhibitions: Galerie A.-M. Reitlinger, Paris, 1931
(cat. 24).

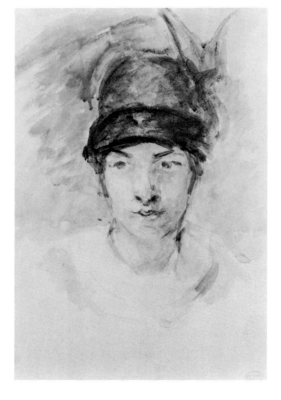

686
Study of a Nude Child c. 1914
Watercolor on paper, 19 × 13 in., 48 × 33 cm.
Unsigned. Mathilde X collection stamp at lower
right.

Note: Also called "Étude d'enfant nu."

Collections: From the artist to Mathilde Vallet,
1927; Mathilde X sale, Paris, 1931; Mrs. William
R. Weber, New York; to H. G. Burman, Paris;
to *Mrs. E. Wilder*, New York.

Exhibitions: Galerie A.-M. Reitlinger, Paris, 1931
(cat. 30).

687
Nude Boy Standing by His Mother c. 1914

Watercolor on white paper, 19 × 13 in., 48 × 33 cm.
(sight).
Signed lower right: *Mary Cassatt*

Description: A nude little boy with auburn hair
looks up at his mother who sits behind him. She
has very dark hair. His two arms extend toward
right as he leans his hands on a low table.

Collections: Milton M. Gottesman, Washington, D.C.

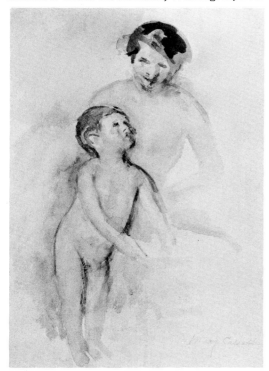

688
Nude Boy Standing Turned Right c. 1914

Watercolor on paper, 19¼ × 13⅜ in., 49 × 34 cm.
(sight).
Unsigned. Mathilde X collection stamp at lower
right.

Description: A nude boy stands with his left arm
extended, his right at his side. He looks toward
the right. His right foot is before the left. A study
rendered in tones of red and sienna.

Note: Also called "Étude d'enfant nu." Durand-
Ruel 19846A.

Collections: From the artist to Mathilde Vallet,
1927; Mathilde X sale, Paris, 1931; Durand-Ruel
Paris, 1966.

Exhibitions: Galerie A.-M. Reitlinger, Paris, 1931
(cat. 54, illus.).

689
Nude Boy Standing Turned Left c. 1914

Watercolor on paper, 19¼ × 13⅜ in., 49 × 34 cm.
Unsigned. Mathilde X collection stamp at lower
right.

Description: A nude boy stands with his left arm
close to his side, seen in full length. The right
arm is unfinished. Developed in tones of red and
ochre and sienna with shadows in blue.

Note: Durand-Ruel 19846B, 13925.

Collections: From the artist to Mathilde Vallet,
1927; Durand-Ruel, Paris, 1966.

Drawings

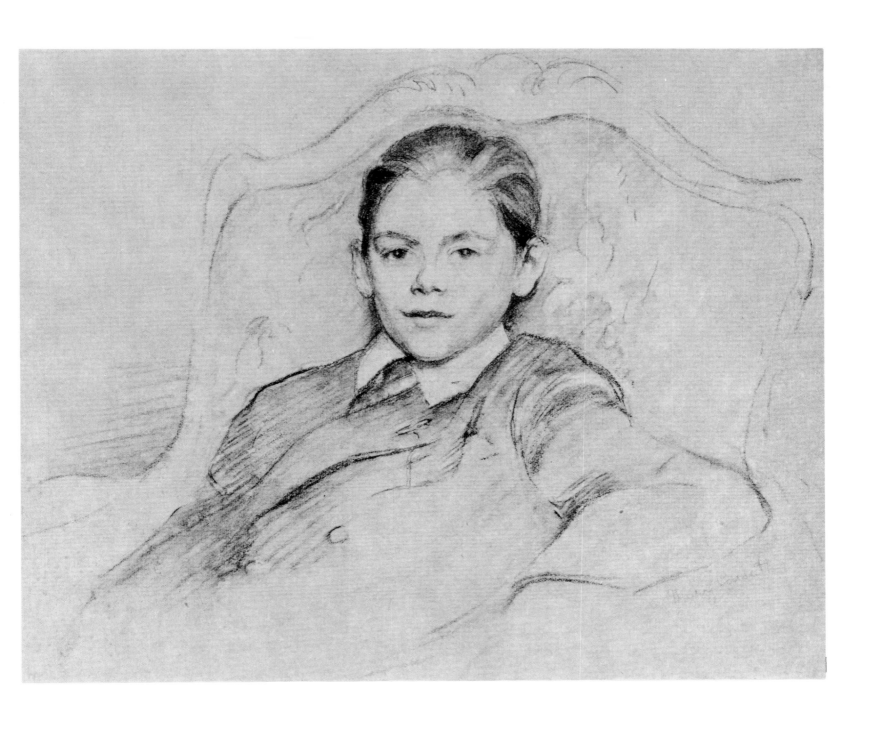

Portrait of Herbert Jacoby, c. 1905. BrCR 914.

690
Woman Seated on Shipboard c. 1866

Pencil on tan paper, 9¼ × 6⅜ in., 23.5 × 16.3 cm. (sight).

Signed toward lower right with monogram: 蘇 [3 indecipherable lines]/*Nov. 23*

Description: A woman with a veil tied over her hair seated on the deck of a ship with railing at an angle beyond. She looks down at something on her lap.

Collections: Mr. Francis Shields Woods, Kinderbrook, New York.

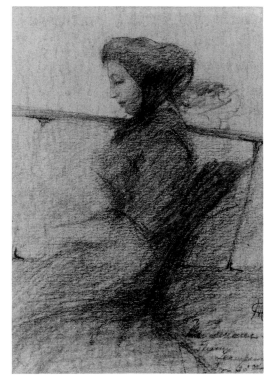

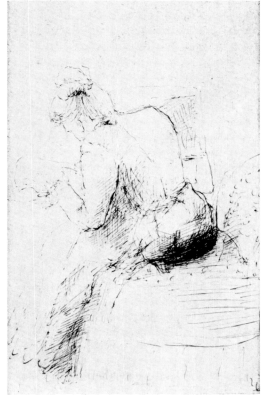

691
Aunt Lou 1867

Pen-and-ink drawing on paper, 7 × 4½ in., 17.8 × 11.5 cm.

Unsigned

Description: Aunt Lou, the subject, is seen from the rear in full length, seated. She leans forward as she writes on a sheet of paper held by her left hand. She wears a blouse with puffed sleeves and a long skirt. Her hair is piled high on her head in a large bun.

Note: "Aunt Lou" was Miss Wight, a life-long friend of Miss Cassatt who lived most of her adult life in Europe.

Collections: The nephew of the sitter, Edmond Rush Duer; to Mrs. Rockwell Gardiner; to Kennedy Galleries, New York; to *David Morgan Yerzy,* New York.

692
Woman Kneeling before Two Little Children
c. 1869

Soft pencil drawing on white paper, 6⅛ × 9 in., 15.5 × 23 cm.

Unsigned. Inscribed in pencil at upper left: *18 rue des | 3 Frères.* Mathilde X collection stamp at lower left.

Description: Shaded figure of a kneeling woman at left with silhouettes of two children toward right.

Note: Also called "Femme accroupie près de deux bébés." Durand-Ruel 19858B-13972.

Collections: From the artist to Mathilde Vallet, 1927; Mathilde X sale, Paris, 1931; Durand-Ruel, 1966.

Exhibitions: Galerie A.-M. Reitlinger, Paris, 1931 (cat. 113).

693
A Woman Setting the Table c. 1869

Pencil on white paper, 6⅝ × 4¾ in., 17 × 12 cm.

Unsigned. Mathilde X collection stamp at lower right.

Description: A woman with face and front of figure in shadow carries plates to the table. One in her right hand she sets on the table, the round curve of which fills the lower right quarter of the page.

Note: Also called "Femme debout mettant le couvert." Durand-Ruel 19862C-13976.

Collections: From the artist to Mathilde Vallet, 1927; Mathilde X sale, Paris, 1931; Durand-Ruel, 1966.

Exhibitions: Galerie A.-M. Reitlinger, Paris, 1931 (cat. 120).

694
Little Girl Holding Up Her Baby Brother
c. 1869
Mixed media, $23\frac{1}{2} \times 19\frac{1}{2}$ in., 59.7×49.5 cm.
Signed lower right: *Mary Cassatt*

Description: A little girl in profile to left is seated at lower right holding up her little baby brother. He is at left, standing looking at the spectator, his little white cap tilted to the side, one bare foot and both hands showing. The girl has long dark hair falling back over her shoulders.

Collections: Mr. and Mrs. Roger Tuteur, New York.

695
Head of Mr. Robert S. Cassatt c. 1871
Pencil on white paper, $9 \times 6\frac{1}{4}$ in., 23×16 cm.
Unsigned. Mathilde X collection stamp at lower left.

Description: Head and shoulders of the artist's father in profile to right. His hair is parted on the right side and brushed over. His mustache seems dark. His eyes are small.

Note: Also called "Tête d'homme profil." Durand-Ruel 19859C-13957.

Collections: From the artist to Mathilde Vallet, 1927; Mathilde X sale, Paris, 1931; Durand-Ruel, 1966.

Exhibitions: Galerie A.-M. Reitlinger, Paris, 1931 (cat. 85).

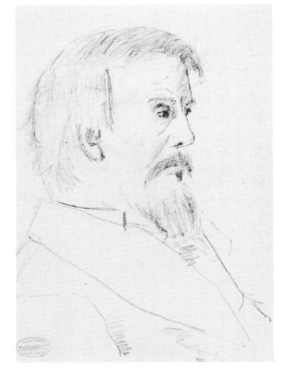

696
Child in a Beret c. 1871
Blue crayon on rough paper, $4\frac{3}{4} \times 6\frac{3}{4}$ in.,
12×17 cm.
Unsigned. Mathilde X collection stamp at lower right.

Description: Summary sketch of a child's head, facing forward, no shading, no indication of pose.

Collections: From the artist to Mathilde Vallet, 1927; Mathilde X sale, Paris, 1931; Wildenstein & Co., New York; present location unknown.

Exhibitions: Galerie A.-M. Reitlinger, Paris, 1931 (cat. 65) (called "L'enfant au beret").

697
Italian Girl: Head and Shoulders 1872
Pencil on paper, $9 \times 6\frac{3}{4}$ in., 23×17 cm.
Unsigned. Mathilde X collection stamp on verso.

Description: A young girl bends her head to right as she observes the spectator. She wears a V-necked blouse and a scarf on her head that reaches her left shoulder.

Note: This may be the same model as in "The Mandolin Player" (BrCR 17) of the same year. The recto stamp of André Pacitti, appraiser, appears at lower right of photo.

Collections: From the artist to Mathilde Vallet, Paris, 1927; present location unknown.

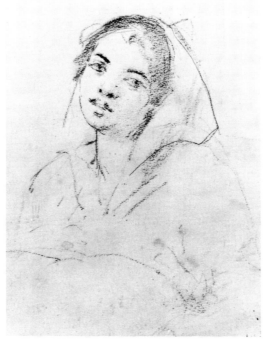

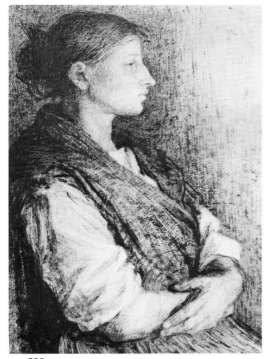

698
Italian Peasant Woman in Profile c. 1872
Sepia chalk with some color nuances, $17\frac{5}{8} \times 12\frac{1}{2}$ in.,
44.7×31.7 cm.
Signed upper right: *M. C.*

Description: Half-length study of a peasant woman
seen in profile to right. Her arms are folded at
her waist, the left hand showing. She wears a
white blouse over which is a dark shawl. Her hair
is drawn back into an untidy bun at the back.

Collections: Augustus Pollack, San Francisco; to
Willem Willemson, Amsterdam, Holland.

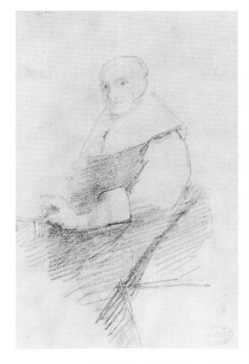

699
**Sketch of a Woman after a 17th-Century
Dutch Painting** c. 1873
Crayon on paper, $8\frac{1}{4} \times 5\frac{1}{4}$ in., 21×13.3 cm. (sight).
Unsigned. Mathilde X collection stamp at lower
right.

Description: Seated figure of a Dutch woman with
large collar and cuffs and tight-fitting cap hiding
her hair. Shaded dress.

Note: In the *Reitlinger sale catalogue* of 1931 there
are five items entitled "copie"; this is one of
them.

Collections: From the artist to Mathilde Vallet,
Paris, 1927; Mathilde X sale, Paris, 1931;
Wildenstein, New York; present location un-
known.

Exhibitions: Galerie A.-M. Reitlinger, Paris, 1931
(cat. 83).

700
Man in a Ruff c. 1873
Pencil on white paper, $8\frac{1}{4} \times 5\frac{1}{4}$ in., 21×13.3 cm.
Unsigned. Mathilde X collection stamp at lower
right.

Description: Head only of a man, possibly sketched
from a Frans Hals' painting.

Note: Also called "Tête de femme" and "copie."
Durand-Ruel 19857D.

Collections: From the artist to Mathilde Vallet,
1927; Mathilde X sale, Paris, 1931; Durand-Ruel,
Paris, 1966.

Exhibitions: Galerie A.-M. Reitlinger, Paris, 1931
(cat. 84).

701
**Man in a Big Ruff, after a 17th-Century
Dutch Painting** c. 1873
Crayon on paper, $8\frac{1}{4} \times 5\frac{1}{4}$ in., 21×13.3 cm. (sight).
Unsigned. Mathilde X collection stamp in lower
left corner.

Description: Three-quarter length sketch of a man
in a big ruff turned to right, looking over his
right shoulder at the spectator, his right hand on
his hip, his left extended. He is bareheaded.

Collections: From the artist to Mathilde Vallet,
1927; Mathilde X sale, Paris, 1931; Wildenstein,
New York; present location unknown.

Exhibitions: Galerie A.-M. Reitlinger, Paris, 1931
(cat. 88) (called "copie"); Phoenix Art Museum,
"Collector's Choice" (cat. 8), 1960.

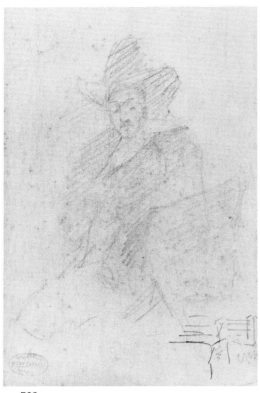

702

Sketch of a Cavalier, Study after a Dutch Portrait c. 1873

Crayon on paper, $8\frac{1}{4} \times 5\frac{1}{4}$ in., 21 × 13.3 cm. (sight). Unsigned. Mathilde X collection stamp at lower left.

Description: Three-quarter length sketch of a cavalier in a high, broad-brimmed hat. He looks at the spectator and is turned somewhat to left. Hat and costume are shaded.

Collections: From the artist to Mathilde Vallet, 1927; Mathilde X sale, Paris, 1931; Wildenstein, New York; *private collection*, United States.

Exhibitions: Galerie A.-M. Reitlinger, Paris, 1931 (cat. 94) (called "copie"); Phoenix Art Museum, "Collector's Choice" (no. 7), 1960.

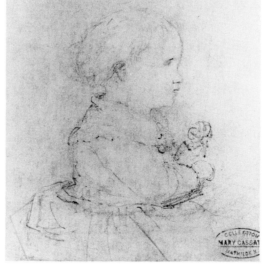

703

A Medieval Head in a Helmet c. 1873

Crayon on paper, $8\frac{1}{4} \times 5\frac{1}{4}$ in., 21 × 13.3 cm. (sight). Unsigned. Inscribed at top: *Sandy at Broek.* Mathilde X collection stamp at lower left corner.

Description: A man's head in a strange helmet with two square ornaments, one on either side above his temples.

Collections: From the artist to Mathilde Vallet, 1927; Mathilde X sale, Paris, 1931; Wildenstein, New York; present location unknown.

Exhibitions: Galerie A.-M. Reitlinger, Paris, 1931 (cat. 89) (called "copie").

704

Half-length Profile of a Baby Holding a Doll c. 1876

Pencil on paper, $4\frac{1}{2} \times 4$ in., 11.5 × 10.2 cm. Unsigned. Mathilde X collection stamp at lower right corner.

Description: A blond baby is seen seated in profile right. Her short hair curls slightly showing her ear. Her dress has a ruffled fichu, long sleeves, and a full skirt. In her hand she holds a doll, slightly indicated.

Collections: From the artist to Mathilde Vallet, 1927; *Mr. and Mrs. Benjamin Sonnenberg*, New York.

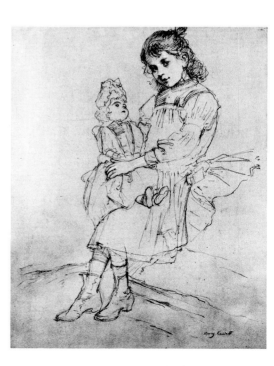

705

Little Girl Holding a Doll c. 1876

Black crayon on paper, 12 × 9 in., 30.5 × 23 cm. Signed lower right: *Mary Cassatt*

Description: A little girl seated on a bank holds a large doll on her lap. She looks at the spectator, the right side of her face shaded. Her curly hair is caught up in a bow at top of her head. She wears high boots and a full-skirted pinafore over a long-sleeved, high-necked blouse and skirt.

Collections: Dorothy Brown, Malibu, California.

Exhibitions: Santa Barbara Museum of Art, 1961; University of Michigan, Ann Arbor, "A Generation of Draughtsmen," 1963.

706

Drawing for "Standing Nude" c. 1878
Pencil on paper, 11 × 7⅛ in., 28 × 18.2 cm.
Signed lower left: *M. C.*

Description: A nude woman stands with her back
showing but turned somewhat toward the left.
Her head is bent as she dries the back of her
neck with a towel. At the right is the tub. This
drawing was used for the soft-ground and aquatint
print (Br 8).

Collections: H.M.P., Paris.

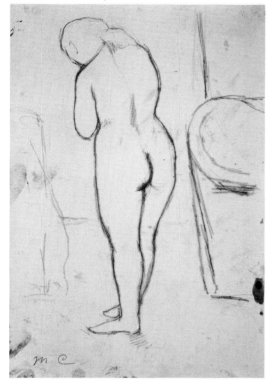

707

**Page of Studies with Sketch for "Portrait of
Madame X Dressed for the Matinée"**
c. 1878
Pen and pencil on paper, 5¼ × 8½ in., 13.5 × 21.5 cm
(sight).
Unsigned. Mathilde X collection stamp at lower
left.

Description: At right a sketch for the painting of
Mme. X (BrCR 54), showing a suggestion of her
seated figure in outline, wearing a hat with high
trimming. At center is the start of a profile of
Mrs. R. S. Cassatt.

Note: Also called "Tête de femme en chapeau."
Durand-Ruel 13963.

Collections: From the artist to Mathilde Vallet,
Paris, 1927; Mathilde X sale, Paris, 1931; to
Durand-Ruel, Paris; *Mrs. Daniel J. Terra,* Kenil-
worth, Illinois.

Exhibitions: Galerie A.-M. Reitlinger, Paris, 1931
(cat. 97).

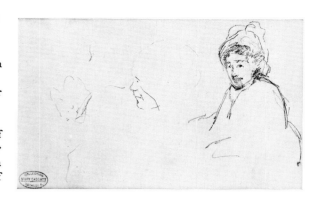

708

**Sketch for "Portrait of Madame X Dressed
for the Matinée"** c. 1878
Soft pencil on paper, 8¼ × 5¼ in., 21 × 13.3 cm.
(sight).
Unsigned. Mathilde X collection stamp at lower
right.

Description: Soft pencil or crayon of a head with
a suggestion of a hat with high trimming. Three-
quarter view to left. She looks at the spectator
and smiles. Shading in left background.

Note: Also called "Tête de femme de trois quart."
Sketch for BrCR 54. Durand-Ruel A1654-
NY9322-13958.

Collections: From the artist to Mathilde Vallet,
1927; Mathilde X sale, Paris, 1931; to Durand-
Ruel, Paris; present location unknown.

Exhibitions: Galerie A.-M. Reitlinger, Paris, 1931
(cat. 87).

709

Sketch for "Woman Driving in a Victoria"
c. 1879
Pencil on paper, 4¼ × 4¼ in., 10.7 × 10.7 cm.
Signed lower right: *Mary Cassatt*

Description: Head and shoulders of a young woman
in profile to right. She wears a poke bonnet tied
under her chin. Her blond hair shows in bangs
over her forehead and as a knot at the nape of
her neck.

Note: Sketch for Br 13.

Collections: Present location unknown.

710
Drawing for "Woman Driving in a Victoria"
c. 1879
Pencil on white paper, 5⅝ × 6¼ in., 13.2 × 16 cm.
(sight).
Unsigned

Description: A young woman seated facing left is seen almost in profile, wearing a poke bonnet. Her hands are folded in her lap. The long lines of the victoria extend almost to left edge of paper.

Note: A preparatory drawing for a soft-ground and aquatint print, but there are many more lines used than in the print (Br 13).

Collections: Durand-Ruel, New York; International Galleries, Chicago; to *Margo Johnson*, Chicago, Illinois.

Exhibitions: Baltimore Museum of Art, 1936 (cat. 18); International Galleries, Chicago, "Mary Cassatt Retrospective Exhibition" (cat. 2, illus.), 1965.

711
Drawing for "The Umbrella" 1879
Pencil on paper, 12¼ × 8½ in., 31 × 21.7 cm.
Signed lower left: *M. C.*

Description: A young woman sits forward in an armchair holding a furled umbrella in her right hand. She wears a little bonnet tied under her chin with a dark bow, a dark full skirt, and a lighter ruffled short cape.

Note: A preparatory drawing used for the soft-ground and aquatint print (Br 5).

Collections: H.M.P., Paris.

712
Drawing for "Waiting" c. 1879
Pencil on white paper, 8⅞ × 6 in., 22.5 × 15.2 cm.
(sight).
Signed under mat opening at lower right: *Mary Cassatt*

Description: A young woman sits in an upholstered armchair, wearing a dark poke bonnet with black ends tied at her throat in a bow. She looks toward lower left and holds a book in her left hand. A curtain is shown at left.

Note: The preparatory drawing for the soft-ground and aquatint print (Br 11).

Collections: Durand-Ruel, New York; present location unknown.

Exhibitions: Baltimore Museum of Art, 1936 (cat. 16) (called "Woman Wearing a Black Bonnet Seated in an Arm Chair Looking out of a Window").

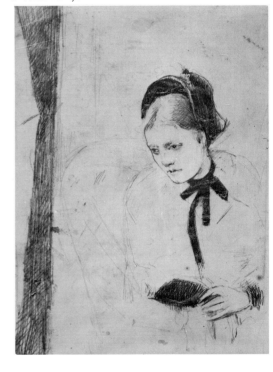

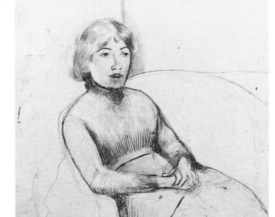

713
Drawing for "The Corner of the Sofa (No. 1)" c. 1879
Pencil on paper over soft ground, 11 × 8¼ in., 28 × 31 cm.
Signed on verso at lower right: *Mary Cassatt*

Description: A young woman wearing a high-necked dress sits at the end of a big armchair or sofa, her hands folded in her lap, looking off to the right. Her hair is parted and drawn over her ears with a curl in the middle of her forehead. This is a preparatory drawing used for the print (Br 14).

Collections: Durand-Ruel, New York; International Galleries, Chicago; to the *Art Institute of Chicago*.

Exhibitions: Baltimore Museum of Art, 1936 (cat. 20); International Galleries, Chicago, "Mary Cassatt Retrospective Exhibition" (cat. 3, illus.), 1965.

714
Drawing for "At the Dressing Table"
c. 1880
Pencil and ink drawing on paper folded to
13 × 8½ in., 33 × 21.6 cm.
Signed lower left: *M.C.*

Description: A young lady in an evening gown with
bustle and train sits in a straight chair before her
dressing table. There are two left arms drawn.

Note: The raised arm was chosen for the soft-
ground and aquatint print (Br 10), for which
this is the preparatory drawing.

Collections: H.M.P., Paris.

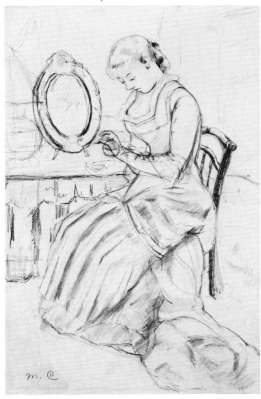

715
Sketch of a Woman in a Box at the Theatre
c. 1880
Pencil on greenish tan paper, 6⅜ × 9⅛ in.,
16.2 × 23.2 cm.
Unsigned. Mathilde X collection stamp at lower
right.

Description: Head and shoulders of a young
woman wearing a high toque. She is reflected in
a mirror along with a row of loges in the back-
ground. Her face is in shadow and her reflection

is darker still.

Note: Durand-Ruel 19860C-13954 (called "Fillette
dessin hachuré").

Collections: From the artist to Mathilde Vallet,
1927; Mathilde X sale, Paris, 1931; Durand-Ruel,
Paris, 1966.

Exhibitions: Galerie A.-M. Reitlinger, Paris, 1931
(cat. 80).

716
Drawing for "In the Opera Box (No. 1)"
c. 1880
Pencil on paper, 8⅝ × 7⅞ in., 22 × 20 cm.
Signed lower right: *Mary Cassatt*

Description: A young woman, holding an open fan,
sits looking to right. There is shading on her face,
hair, and right arm. Every line corresponds to
those of the aquatint and soft-ground print
(Br 20), which is dated c. 1880.

Note: Also called "Femme à l'éventail." Durand-
Ruel 7950-L10475.

Collections: Durand-Ruel, Paris; to Durand-Ruel,
New York; *Metropolitan Museum of Art,* New York.

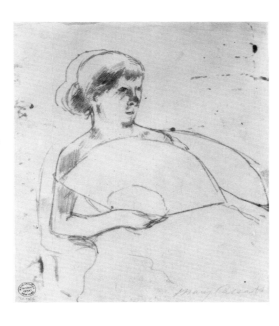

717
**Verso of Drawing for "In the Opera Box
(No. 1)"** c. 1880
Soft ground, 8½ × 8½ in., 21.4 × 21.4 cm.
Unsigned

Description: This verso of the drawing shows the
soft-ground lines which were lifted from the plate
when the drawing was pressed over it.

Collections: Durand-Ruel, Paris; to Durand-Ruel,
New York; *Metropolitan Museum of Art,* New York.

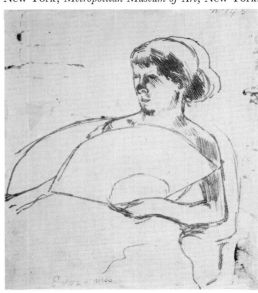

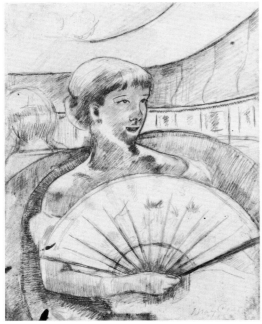

718
Drawing for "In the Opera Box (No. 3)"
1880
Pencil on paper, $8\frac{5}{16} \times 6\frac{5}{8}$ in., 21.2×16 cm.
Signed lower right: *Mary Cassatt*

Description: A young woman holding an open fan sits looking to right. There is much shading on her face, hair, neck and arm, also on the upholstered chair. The lines conform to those on the soft-ground and aquatint print (Br 22).

Collections: National Gallery of Art, Washington, D.C., Rosenwald Collection.

719
Sketch for "A Woman in Black at the Opera" (No. 1) c. 1880
Soft pencil on paper, 4×6 in., 10.2×15.3 cm. Unsigned. Monogram stamp toward lower left in blue ink: 鈺. Inscription at upper left in artist's hand.

Description: The drawing on a larger page is enclosed in a rectangle; the figure, shaded, is at the right. Tiers of boxes at left. The face is toned lightly as are the opera glasses.

Note: On the back of the drawing in pencil is "No. 36 à la vente." A sketch for BrCR 73.

Collections: Museum of Fine Arts, Boston, gift of Dr. Hans Schaeffer, 1955.

720
Sketch for "A Woman in Black at the Opera" (No. 2) c. 1880
Soft pencil on paper, 4×7 in., 10.2×17.8 cm. Unsigned. Mathilde X collection stamp at lower right corner.

Description: A quick, shaded sketch to place the very dark opera glasses. Tiers of boxes indicated horizontally.

Note: A sketch for BrCR 73.

Collections: From the artist to Mathilde Vallet, 1927; Vincent Price, Los Angeles, California; to *Museum of Fine Arts*, Boston.

721
Sketch for "A Woman in Black at the Opera" (No. 3) c. 1880
Soft pencil on paper, $3\frac{3}{4} \times 5\frac{1}{2}$ in., 9.5×14 cm. Unsigned. Mathilde X collection stamp at lower left.

Description: Head and shoulders of a woman in black with a black bonnet looking to left through opera glasses. Tiers of loges curve to left.

Note: Also called "Au théâtre." A sketch for BrCR 73. Durand-Ruel A1655-NY9324-13995.

Collections: From the artist to Mathilde Vallet, 1927; Mathilde X sale, Paris, 1931; to Durand-Ruel, Paris; to Durand-Ruel, New York; to H. Bittner & Co., New York, 1951; *M. and Mme. Adolphe Stein*, France, 1968.

Exhibitions: Galerie A.-M. Reitlinger, Paris, 1931 (cat. 165, illus.).

722
Sketches at the Opera c. 1880
Pencil on white paper, 3¾ × 5½ in., 9.5 × 14 cm.
Unsigned. Mathilde X collection stamp at lower
left corner.

Description: At lower right is a sketch for "A
Woman in Black at the Opera" (BrCR 73).
Above and to the left are sketches with four other
figures in two loges.

Note: Also called "Au théâtre, croquis." Durand-
Ruel 19863A-13945.

Collections: From the artist to Mathilde Vallet,
1927; Mathilde X sale, Paris, 1931; Durand-Ruel,
Paris, 1966.

Exhibitions: Galerie A.-M. Reitlinger, Paris, 1931
(cat. 67).

723
Four Sketches at the Opera c. 1880
Pencil on white paper, 3¾ × 5½ in., 9.5 × 14 cm.
Unsigned. Mathilde X collection stamp at lower
right.

Description: Four sketches, the upper two more
developed with two figures in each box. Below
two single figures.

Note: Also called "Au théâtre" and "Une loge au
théâtre." Durand-Ruel 19862D-13997.

Collections: From the artist to Mathilde Vallet,
1927; Mathilde X sale, Paris, 1931; Durand-Ruel,
Paris, 1966.

Exhibitions: Galerie A.-M. Reitlinger, Paris, 1931
(cat. 171).

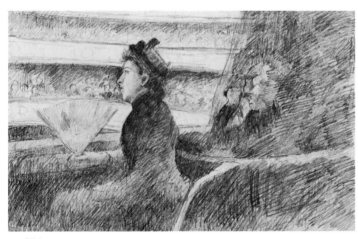

724
**Drawing for "Lady in Black, in a Loge,
Facing Left"** c. 1880
Soft pencil and crayon on paper, 7¾ × 11½ in.,
19.7 × 29.2 cm.
Signed lower left: *M. C.*

Description: A lady in a black hat and gown sits
facing left in a loge, holding a half-open fan in her
right hand. Behind her, at right, is the profile of
a person observing the audience with opera
glasses. Crowded loges in background.

Note: This drawing was used for the soft-ground
and aquatint print (Br 24), where it appears in
reverse.

Collections: H. M. P., Paris.

725
**Drawing for "Lady in Black, in a Loge,
Facing Right"** c. 1880
Soft pencil and crayon on paper, folded to
7¼ × 10¼ in., 18.5 × 26 cm.
Signed lower left: *M. C.*

Description: A lady in a large hat and a dress with
leg-o'-mutton sleeves sits in a loge. She is seen in
lost profile looking at the loges across the theatre.

Note: This drawing was used for the soft-ground
and aquatint print (Br 25), where it appears in
reverse.

Collections: H.M.P., Paris.

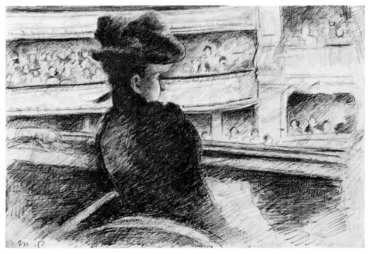

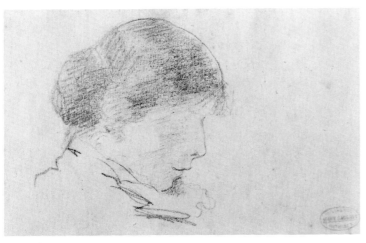

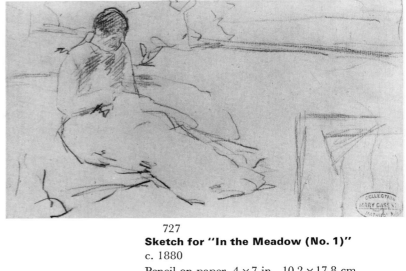

726
Profile Head of a Young Woman c. 1880
Black chalk on buff paper, 5 × 7½ in., 12.7 × 19 cm.
Unsigned. Mathilde X collection stamp at lower
right.

Description: Profile head of a young woman with
her dark hair in a bun at the back and bangs over
her forehead. No eye indicated. Her blouse is
suggested with a high collar and a ruffled jabot
under her chin.

Collections: From the artist to Mathilde Vallet,
1927; Christie & Co. sale, London, 17 July 1962
(lot 154); to Bernard Black Gallery, New York.

Exhibitions: Columbus (Ga.) Museum of Arts and
Crafts, Inc., "American Drawings and Water-
colors" (cat. 6), 1963.

727
Sketch for "In the Meadow (No. 1)"
c. 1880
Pencil on paper, 4 × 7 in., 10.2 × 17.8 cm.
Unsigned. Mathilde X collection stamp at lower
right corner.

Description: A woman sewing is seated on the
grass, her long skirt extending off to right as she
looks down at her work. Suggestion of a landscape
behind her with an angled fence at right lower
corner.

Note: Preparatory drawing for BrCR 92.

Collections: From the artist to Mathilde Vallet,
1927–31; *Vincent Price*, California.

728
Sketch of Elsie's Head c. 1880
Pencil on gray wove paper, 4 × 6¼ in., 10.2 × 16 cm.
Unsigned

Description: The upper part of Elsie's head is seen
between two other people.

Note: A study for the youngest child in the painting
"Mrs. Cassatt Reading to Her Grandchildren"
(BrCR 77).

Collections: *Allen Memorial Art Museum*, Oberlin
College, anonymous gift.

Exhibitions: Joslyn Art Museum, Omaha,
Nebraska, "Mary Cassatt among the Impression-
ists" (cat. 5, illus.), 1969.

729
Portrait Sketch of a Friend c. 1880
Soft pencil and crayon on paper, 8⅜ × 5⅜ in.,
21.4 × 13.5 cm.
Unsigned. Mathilde X collection stamp at lower
left corner.

Description: A woman's head and shoulders in
three-quarter view looking off to left. Her wavy
hair is rather light. She has an earring in her ear
and wears a dark blouse with a loose collar, high
in back.

Note: Also called "Portrait de femme, buste."

Collections: From the artist to Mathilde Vallet,
1927; Mathilde X sale, Paris, 1931; *Baltimore
Museum of Art*, Cone Collection.

Exhibitions: Galerie A.-M. Reitlinger, Paris, 1931
(cat. 134); Baltimore Museum of Art, 1941–42
(cat. 67); Baltimore Museum of Art, "Manet,
Degas, Berthe Morisot and Mary Cassatt"
(cat. 121), 1962.

730
Drawing for "The Chess Game" c. 1880
Pencil on paper, 7¼ × 10¼ in., 18.5 × 26 cm.
Signed lower right: *Mary Cassatt*

Description: The artist's mother sits at the left, wrapped in a shawl, the chessboard before her. Her grandson Robert sits at the right, wearing a dark Eton suit. Both of his hands are on the board. He sits in a large upholstered chair; another is outlined in the rear center.

Note: A preparatory drawing used for the soft-ground etching (Br 61).

Collections: Mrs. Cass Canfield, New York.

Exhibitions: Marlborough Fine Art Ltd., London, 1961.

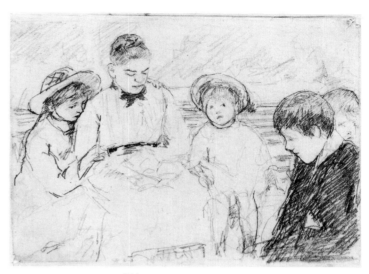

731
Mathilde Reading to the Children c. 1880
Pencil on paper, 5 × 6½ in., 12.7 × 16.5 cm.
Unsigned

Description: Mathilde sits toward left center with the children around her. They are the artist's nephew and her two nieces. Both little girls are wearing hats. Robert is in profile at the right. Behind him the head of a fourth child appears.

Note: This is a preparatory drawing for the soft-ground and aquatint print (Br 60, mistakenly entitled "Mrs. Cassatt Reading to Her Grandchildren [No. 3]").

Collections: From the artist to her brother Alexander; to his son Edward; to his daughter, *Mrs. John B. Thayer*, Rosemont, Pennsylvania.

732
Two Little Girls Playing in a Sandbox
c. 1880
Pencil on paper, 7¾ × 6 in., 19.7 × 15.2 cm.
Signed lower right: *M. C.*

Description: Two little girls in pinafores and high shoes lean over a sandbox while playing. The larger one toward left is seen from the rear; the smaller, with dark hair, looks down toward left.

Note: This drawing was used for a soft-ground print of which no examples are known to date.

Collections: Robert Hartshorne, New York; present location unknown.

Reproductions: Adelyn D. Breeskin, *The Graphic Work of Mary Cassatt*, New York, 1948, Cat. IV (Supplement).

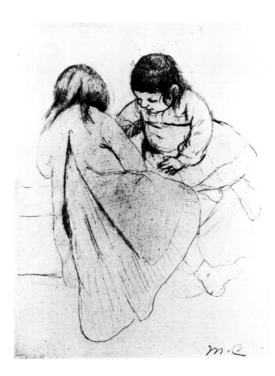

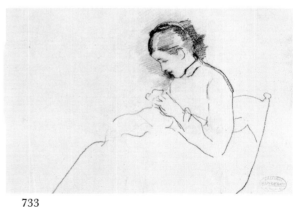

733
Woman Seated Holding a Dog c. 1881
Pencil on paper, 6 × 9 in., 15.6 × 23 cm. (sight)
Unsigned. Mathilde X collection stamp at lower right.

Description: A woman seen in profile left is seated on a chair. She looks down and holds the head of a little dog on her lap, her left hand scratching his head. The dog is rather indistinct.

Note: Durand-Ruel A1663-NY9321, 13981.

Collections: From the artist to Mathilde Vallet, 1927; Mathilde X sale, Paris, 1931; to Durand-Ruel, Paris; present location unknown.

Exhibitions: Galerie A.-M. Reitlinger, Paris, 1931 (cat. 131).

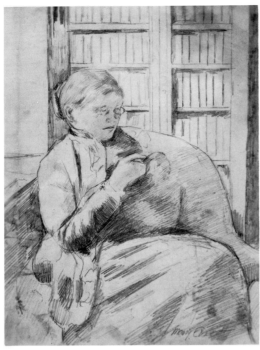

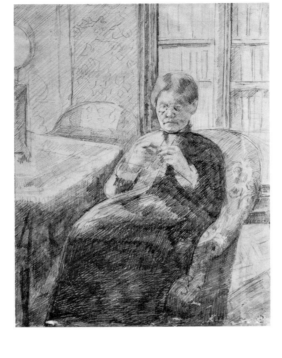

Drawing for "Knitting in the Glow of a Lamp" c. 1881

Pencil on paper, $11\frac{1}{2} \times 8\frac{3}{4}$ in., 29.2×22.2 cm.
Signed lower right, but obscured by holes in the paper.

Description: The artist's mother is seated in an upholstered armchair facing somewhat to left. She wears pince-nez and her hair is parted in the middle. Her dress is dark. To the left of her is a table on which stands a lamp, only half visible. A bookcase is in background to right.

Note: A preparatory drawing for the soft-ground and aquatint print (Br 31).

Collections: August F. Jaccaci, New York; *Metropolitan Museum of Art*, gift of Mrs. Joseph du Vivier, 1954.

734
Drawing for "Knitting in the Library"
c. 1881
Pencil on paper, $11 \times 8\frac{5}{8}$ in., 28×22 cm.
Signed toward lower right: *Mary Cassatt*

Description: The artist's mother is seated in an upholstered chair facing toward right, knitting. She wears pince-nez. Behind her is a large bookcase and to the left a window.

Note: A preparatory drawing for the soft-ground and aquatint print (Br 30).

Collections: Cleveland Museum of Art, bequest of Charles T. Brooks.

736
Lydia Reading c. 1881
Pencil and watercolor on paper, $7\frac{1}{4} \times 5$ in., 18.5×12.7 cm.
Signed upper right: *M. C.*

Description: Lydia sits in a big, patterned upholstered chair, wearing a dark dress and holding up a book in her right hand. Her left hand rests on her lap. Part of a window drapery at left and behind her a curtained window.

Note: A preparatory drawing for the soft-ground and aquatint print entitled "Lydia Reading, Turned Toward Right" (Br 63).

Collections: Peter Deitsch, New York, 1962.

Exhibitions: Baltimore Museum of Art, "Manet, Degas, Berthe Morisot and Mary Cassatt" (cat. 120), 1962.

737
Drawing for "The Round-Backed Armchair"
c. 1881
Soft pencil and ink on paper, $11 \times 7\frac{3}{8}$ in., 28×18.8 cm.
Signed lower left: *M. C.*

Description: A portly woman sits in a large upholstered armchair with a curved back to it. Her hands are folded one over the other on her lap.

Note: This drawing was used for the soft-ground and aquatint print (Br 36).

Collections: H.M.P., Paris.

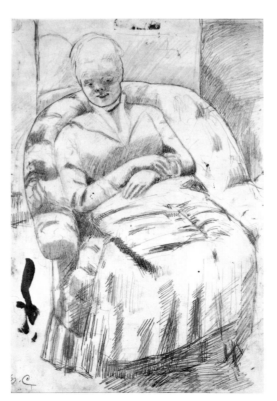

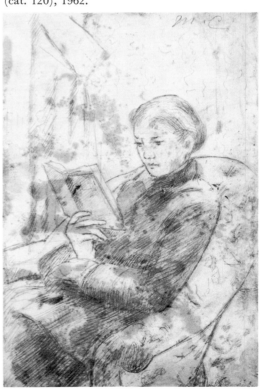

738
Drawing for "Dressing by a Window"
c. 1881
Pencil on paper, 9⅝ × 6½ in., 24.5 × 16.5 cm.
Signed lower left: *M. C.*

Description: A young girl sits at right in an up-
holstered chair pulling on a stocking with both
hands. She is seen in lost profile, wearing a low-
necked nightgown. Her hair is tucked up onto
her head.

Note: A preparatory drawing used for the soft-
ground and aquatint print (Br 35).

Collections: H. M. P., Paris.

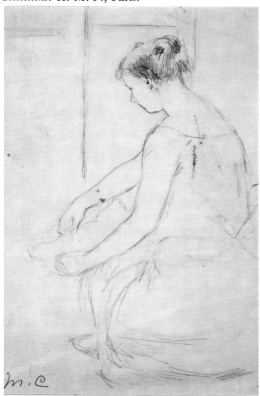

739
Drawing for "Sombre Figure" c. 1881
Pencil on white paper, 10 3/16 × 7¼ in.,
26 × 18.5 cm.
Signed lower right: *Mary Cassatt*

Description: A blond woman with hair in a bun
on top of her head, wearing a dark, fitted dress
with white at the neck, sits in a chair facing to
left. She is seen almost in profile and has her
hands in her lap. Four vertical lines in background.

Note: This is a preliminary drawing for a soft-
ground print (Br 32).

Collections: Baltimore Museum of Art, bequest of
Wilmer Hoffman, 1955.

Exhibitions: Baltimore Museum of Art, "Manet,
Degas, Berthe Morisot and Mary Cassatt"
(cat. 119), 1962.

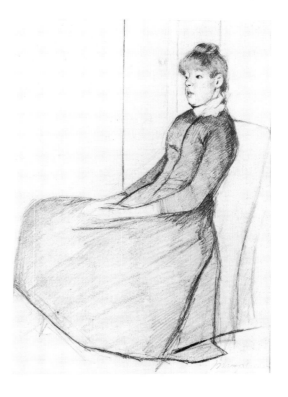

740
Slight Sketch for "Afternoon Walk" c. 1881
Pencil on paper, 9¾ × 5½ in., 24.7 × 14 cm. (sight)
Unsigned. Mathilde X collection stamp at lower
right.

Description: Three-quarter length view of a woman
wearing a tilted small hat, with one arm over her
stomach, the other indicated as possibly touching
her chest.

Note: A sketch for BrCR 741.

Collections: Wildenstein, New York; to *Phoenix Art
Museum*, gift of Dr. F. M. Hinkhouse, 1965.

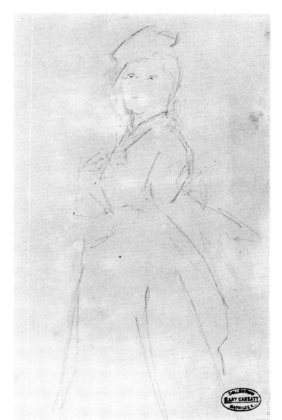

741
Afternoon Walk c. 1881
Pencil and crayon on paper, 10¼ × 6¾ in.,
26 × 17.2 cm.
Unsigned. Mathilde X collection stamp at lower
right.

Description: Full-length study of a woman in an
elaborate costume of hat and gown, walking to
left. There is a bustle effect at the back of the
skirt, which is drawn up to the waist in folds.

Note: Inscribed on back: "Collection Mary
Cassatt, Mathilde X—PHA 1660." Also called
"Portrait de femme en pied avec un chapeau."
This has erroneously been called "Portrait of
Miss Cassatt." Durand-Ruel A1660-NY9317,
13967.

Collections: From the artist to Mathilde Vallet,
1927; Mathilde X sale, Paris, 1931; the Block
estate; to Sessler, Philadelphia; to *David Morgan
Yerzy*, New York.

Exhibitions: Galerie A.-M. Reitlinger, Paris, 1931
(cat. 102).

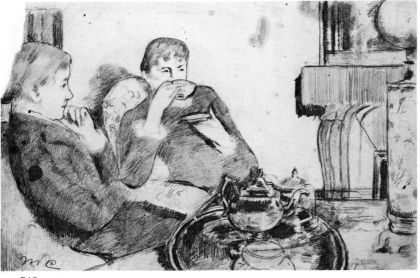

742
Drawing for "Lydia and Her Mother at Tea"
c. 1881
Soft pencil and crayon on paper, $11\frac{1}{8} \times 7\frac{1}{4}$ in.,
28.3×18.5 cm. (torn at upper left corner)
Signed lower left: *M. C.*

Description: The artist's sister is seen in profile at
extreme left with her hand at her chin. Her
mother, closer to center, holds her tea cup up to
her mouth. In right center foreground is a circular
tray with the tea service.

Note: This is a preparatory drawing for the soft-
ground and aquatint print (Br 69). "Five
O'Clock Tea" (BrCR 78) is a painting of the
same composition in reverse.

Collections: H.M.P., Paris.

743
Child with Her Right Hand Held to Her Ear
c. 1881
Pencil on tan paper, $16\frac{1}{2} \times 19\frac{1}{2}$ in., 42×49.5 cm.
Unsigned. Mathilde X collection stamp at lower
left.

Description: Summary sketch of a little girl looking
off to the right and holding her ear.

Note: Also called "Enfant, le bras levé." This
may be a sketch for the child in one of the oil
paintings of "Susan Comforting the Baby" of
1881 (BrCR 111 and 112). Durand-Ruel
19850B-13992.

Collections: From the artist to Mathilde Vallet,
1927; Mathilde X sale, Paris, 1931; Durand-Ruel,
Paris, 1966.

Exhibitions: Galerie A.-M. Reitlinger, Paris, 1931
(cat. 152).

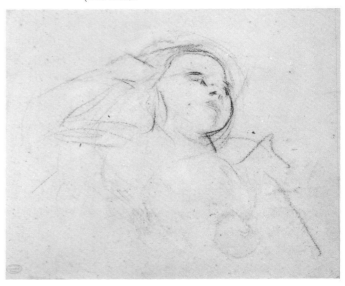

744
Study of a Man in a High Hat c. 1881
Soft pencil on paper, $8\frac{1}{4} \times 5\frac{1}{4}$ in., 21×13.4 cm.
(sight)
Unsigned. Mathilde X collection stamp at lower
left.

Description: Full-length sketch of a man seen in
profile to left with an umbrella under his arm,
holding a paper. He wears a high hat and long
overcoat, both shaded dark. Suggestion of shop
surroundings.

Note: Also called "Étude d'homme en chapeau
haut de forme." Durand-Ruel A1664-NY9314,
13984.

Collections: From the artist to Mathilde Vallet,
1927; Mathilde X sale, Paris, 1931; Durand-Ruel,
Paris; present location unknown.

Exhibitions: Galerie A.-M. Reitlinger, Paris, 1931
(cat. 137).

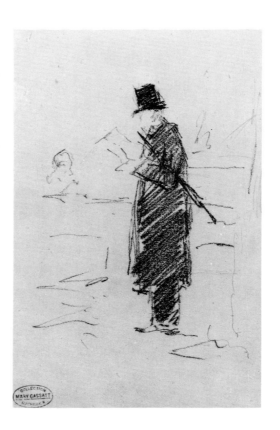

745

Man in a Bowler Hat c. 1881

Black pencil on paper, 8¾ × 6¼ in., 22.2 × 16 cm.
Unsigned. Mathilde X collection stamp at lower
right.

Description: A man in a bowler hat is seated at
right sketching. He is in profile with straight hair
detailed. An indication of full-length pose with
right leg crossed over left to support sketching pad
held on his lap.

Note: Also called "L'homme au chapeau melon."
Durand-Ruel 11289-L13783.

Collections: From the artist to Mathilde Vallet,
1927; Mathilde X sale, Paris, 1931; Durand-Ruel,
Paris; present location unknown.

Exhibitions: Galerie A.-M. Reitlinger, Paris, 1931
(cat. 61).

746

Head of a Man, Profile Right c. 1881

Pencil on paper, 6¾ × 6⅜ in., 17.2 × 16.2 cm. (sight)
Unsigned. Mathilde X collection stamp at lower
right.

Description: Profile of a man with quite a long
nose.

Note: Also called "Portrait d'homme."

Collections: From the artist to Mathilde Vallet,
1927; Mathilde X sale, Paris, 1931; Wildenstein,
New York; present location unknown.

Exhibitions: Galerie A.-M. Reitlinger, Paris, 1931
(cat. 60).

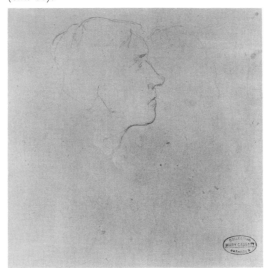

747

Susan Seated, Profile Left c. 1881

Pencil on white paper, 9 × 6 in., 23 × 16 cm.
Unsigned. Mathilde X collection stamp at lower
right.

Description: Susan sits on a straight chair with her
left hand (not indicated) in her lap. She looks to
left and is seen almost in profile. A summary
sketch.

Note: Also called "Femme assise de profil."
Durand-Ruel 19861A-13962.

Collections: From the artist to Mathilde Vallet,
1927; Mathilde X sale, Paris, 1931; Durand-Ruel,
Paris, 1966.

Exhibitions: Galerie A.-M. Reitlinger, Paris, 1931
(cat. 96).

748

Drawing for "Under the Lamp" c. 1881

Pencil on white paper, 8 × 8¾ in., 20.3 × 22.3 cm.
Signed lower left (cut off in photograph): *Mary
Cassatt*

Description: Lydia and Mrs. Cassatt are seen behind
a table on which stands a tall oil lamp. Mrs.
Cassatt sits reading at left, Lydia sewing at right.

Note: A preparatory drawing for the soft-ground
and aquatint print (Br 71).

Collections: Mr. Samuel H. Nowak, Philadelphia.

Exhibitions: Cooper Union Museum, New York,
National Collection of Fine Arts, Washington,
D.C., Museum of Fine Arts, Boston, Philadelphia
Museum of Art, Cincinnati Art Museum, Herron
Museum of Art, Indianapolis, and University of
California Art Galleries, Los Angeles, "The
Graphic Art of Mary Cassatt" (cat. 17, illus.),
1967–68.

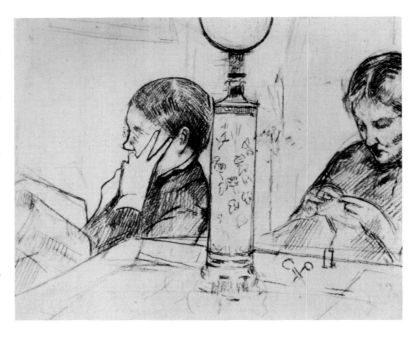

749

Profile Sketch of Mrs. Cassatt, without Her Glasses c. 1881

Black pencil on paper, 8¼ × 5⅛ in., 23 × 13 cm. Unsigned. Mathilde X collection stamp at lower left.

Description: Profile view of Miss Cassatt's mother, without her glasses, seated facing to right. A diagonal line at right may suggest a book or newspaper at which she looks. An uneven vertical line at left with shading.

Note: This is a sketch for the soft-ground and aquatint print (Br 75). Durand-Ruel 11287-L.13781.

Collections: From the artist to Mathilde Vallet, 1927–31; to Durand-Ruel, Paris; present location unknown.

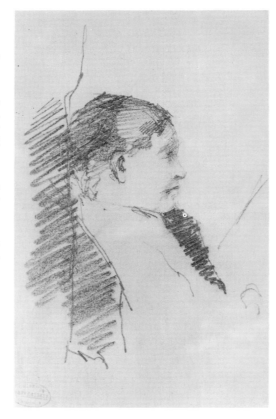

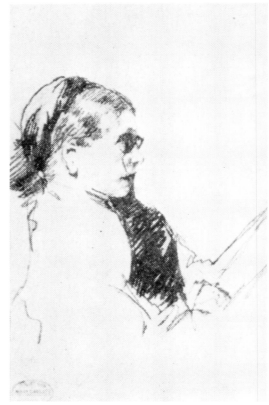

750

Profile of Mrs. Cassatt Reading, with Glasses c. 1881

Pencil on paper, 8¼ × 5¼ in., 21 × 13.5 cm. Unsigned. Mathilde X collection stamp at lower left corner.

Description: Mrs. Cassatt seen in profile right, wearing pince-nez. Her dress is dark. The sleeve is undeveloped. Her hair is waved.

Note: Also called "Femme lisant."

Collections: From the artist to Mathilde Vallet, 1927; Mathilde X sale, Paris, 1931; present location unknown.

Exhibitions: Galerie A.-M. Reitlinger, Paris, 1931 (cat. 161, illus.).

751

Three-Quarter View of Mrs. Cassatt, Turned Left, Wearing Glasses c. 1881

Soft pencil on paper, 6¼ × 9 in., 16 × 23 cm. Unsigned. Mathilde X collection stamp at lower right corner.

Description: Mrs. Cassatt seen in three-quarter view to left, wearing pince-nez. At the right are three horizontal lines probably indicating bookshelves in the library. She looks down.

Collections: From the artist to Mathilde Vallet, 1927; Mathilde X sale, Paris, 1931; *Mr. and Mrs. J. Robert Maguire*, Shoreham, Vermont (a grandniece of Miss Cassatt).

Exhibitions: Galerie A.-M. Reitlinger, Paris, 1931 (cat. 64) (called "Portrait de femme au lorgnon"); Philadelphia Museum of Art, 1960.

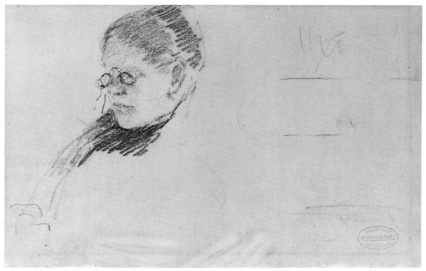

752
Profile View of Mr. Cassatt c. 1881
Pencil on paper, $8\frac{7}{8} \times 5\frac{1}{2}$ in., 22.6 × 14 cm.
Unsigned. Mathilde X collection stamp at lower right.

Description: The artist's father is seen in profile left wearing spectacles, leaning back in an armchair, and reading while holding a book in front of him.

Note: Also called "Homme âgé lisant." A study for the soft-ground and aquatint print (Br 74).

Collections: From the artist to Mathilde Vallet, 1927; Mathilde X sale, Paris, 1931; *Art Institute of Chicago.*

Exhibitions: Galerie A.-M. Reitlinger, Paris, 1931 (cat. 64, illus.).

755
Drawing for "Two Ladies in a Loge, Facing Left" c. 1882
Pencil on paper, $11\frac{3}{4} \times 9\frac{1}{8}$ in., 29.8 × 23.2 cm.
Signed lower left: *M. C.*

Description: The lady at left is seen in profile right, the other in three-quarter view to right. The lady at left holds her clasped hands in her lap.

Note: A preparatory drawing used for the soft-ground and aquatint print (Br 17).

Collections: H.M.P., Paris.

753
Three-Quarter View of Mr. Cassatt, Turned Left, Wearing Glasses c. 1881
Soft pencil on paper, $3\frac{15}{16} \times 6\frac{5}{16}$ in., 10 × 16 cm.
Unsigned. Mathilde X collection stamp at lower right.

Description: Mr. Cassatt sits in a round-backed upholstered chair, reading. The ribbon of his pince-nez is silhouetted at left. His white hair, mustache, and goatee are delicately suggested. At extreme lower right is the top of a table.

Collections: From the artist to Mathilde Vallet, 1927; Mathilde X sale, Paris, 1931; *Mr. and Mrs. J. Robert Maguire*, Shoreham, Vermont (a grandniece of Miss Cassatt).

Exhibitions: Galerie A.-M. Reitlinger, Paris, 1931 (cat. 118) (called "Portrait d'homme au lorgnon"); Philadelphia Museum of Art, 1960.

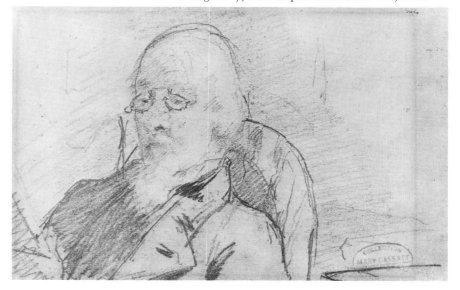

754 †
A Woman in Evening Dress Holding a Large Bouquet c. 1882
Pencil on white paper, $9\frac{1}{2} \times 6\frac{1}{2}$ in., 24.2 × 16.5 cm. (sight)
Signed lower right: *Mary Cassatt*

Description: A woman in a low-necked evening gown sits forward, holding a bouquet in her lap with both hands. She looks to left.

Note: A preparatory drawing for the soft-ground and aquatint print (Br 19).

Collections: Durand-Ruel, New York; present location unknown.

Exhibitions: Baltimore Museum of Art, 1936 (cat. 19).

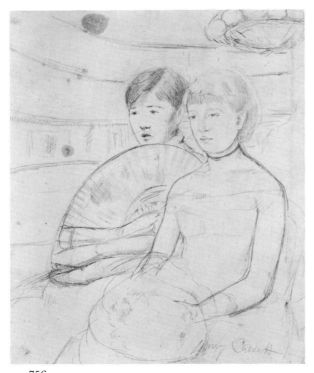

756
In the Loge 1882
Pencil with traces of color on paper, $11\frac{1}{8} \times 8\frac{5}{8}$ in.,
28.2 × 22 cm.
Signed lower right: *Mary Cassatt*

Description: Two young ladies are seated in a loge.
The one at right, a blond, holds a bouquet; the
one at left, a brunette, holds a large green fan
which covers a part of her face. Line of loges in
the background.

Note: This is a sketch for the painting "Two
Young Ladies in a Loge" (BrCR 121).

Collections: Robert Hartshorne, New York; Sessler,
Philadelphia; Chester Dale, New York; *National
Gallery of Art*, Washington, D.C., Chester Dale
Collection.

Exhibitions: Baltimore Museum of Art, 1936
(cat. 10).

757
Head of Robert, Aged Nine c. 1882
Pencil on white laid paper, $6\frac{5}{8} \times 10\frac{5}{8}$ in.,
17 × 27 cm.
Unsigned. Mathilde X collection stamp at lower
left.

Description: A sketch of Robert Cassatt looking
off to right. Head only.

Note: Also called (wrongly) "Tête de fillette."
Durand-Ruel 19861D-13952.

Collections: From the artist to Mathilde Vallet,
1927; Mathilde X sale, Paris, 1931; Durand-Ruel,
Paris, 1966.

Exhibitions: Galerie A.-M. Reitlinger, Paris, 1931
(cat. 76).

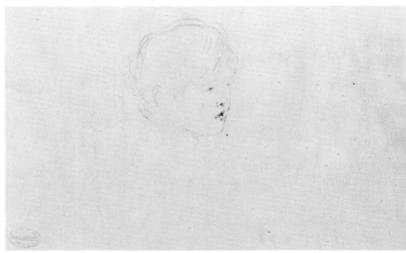

758
Head of Robert with Parted Bangs c. 1882
Pencil on paper, $5\frac{1}{4} \times 8\frac{1}{4}$ in., 13.5 × 21 cm.
Unsigned. Mathilde X collection stamp at lower
left.

Description: Robert looks down, facing forward,
his bangs parted in two places. He wears an Eton
collar and a bow tie.

Note: Also called "Petit garçon au col rabattu."

Collections: From the artist to Mathilde Vallet,
1927; Mathilde X sale, Paris, 1931; present
location unknown.

Exhibitions: Galerie A.-M. Reitlinger, Paris, 1931
(cat. 163, illus.).

Robert with Head Bowed c. 1882

Pencil on paper, 3⅞ × 6 in., 9.8 × 15.2 cm. (sight)
Unsigned. Mathilde X collection stamp at lower
left.

Description: Profile of Robert's head bowed down
to left, possibly a study for the print "The Chess
Game" (Br 61).

Note: Also called "Little Boy's Head in Profile"
and "Jeune garçon, tête baissée."

Collections: From the artist to Mathilde Vallet,
1927; Mathilde X sale, Paris, 1931; Wildenstein,
New York; *private collection*, United States.

Exhibitions: Galerie A.-M. Reitlinger, Paris, 1931
(cat. 168).

760

Robert and His Sailboat c. 1882

Pencil on paper, 8 × 5¼ in., 20.3 × 13.3 cm.
Signed lower right: *Mary Cassatt*

Description: Robert sits on the floor and holds the
mast of a toy sailboat before him toward right.
His right leg extends diagonally toward lower
left.

Note: This is a drawing for a soft-ground print, no
examples of which are known to date.

Collections: Durand-Ruel, Paris; Durand-Ruel,
New York; present location unknown.

Reproductions: Adelyn D. Breeskin, *The Graphic
Work of Mary Cassatt*, New York, 1948, Cat. II
(Supplement).

761

Susan on a Balcony Holding a Dog c. 1883

Pencil on paper, 12 1/16 × 9⅞ in., 30.6 × 25 cm.
Signed lower left: *M. C.*

Description: A young woman seated on a balcony
looks to left. She wears a large bonnet tied under
her chin and a tight-fitting patterned gown with
half-length sleeves and holds a small dog on her
lap. Behind her beyond the iron railing of the
balcony are seen the rooftops of Paris.

Note: This is a preparatory drawing for the soft-
ground and aquatint print "On the Balcony"
(Br 120).

Collections: H.M.P., Paris, 1953; to Lessing
Rosenwald, Jenkintown, Pennsylvania; to the
National Gallery of Art, Washington, D.C., Rosen-
wald Collection.

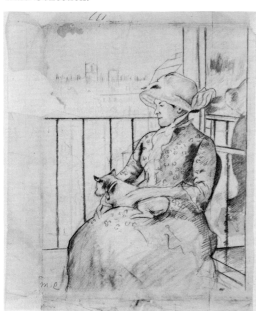

762

**Portrait Sketch of Alexander J. Cassatt
(No. 1)** c. 1883

Pencil on paper, 8¼ × 5⅝ in., 21 × 14.3 cm.
Unsigned. Mathilde X collection stamp at lower
left corner.

Description: Head and shoulders of Miss Cassatt's
brother Aleck, looking off to right.

Note: This is a study for the 1883 oil portrait
(BrCR 126). Also called "Portrait d'homme."

Collections: From the artist to Mathilde Vallet,
1927; Mathilde X sale, Paris, 1931; *William
Rockhill Nelson Gallery and Atkins Museum of Fine
Arts*, Kansas City, Missouri, gift of Mr. and Mrs.
Thomas K. Baker.

Exhibitions: Galerie A.-M. Reitlinger, Paris, 1931
(cat. 60).

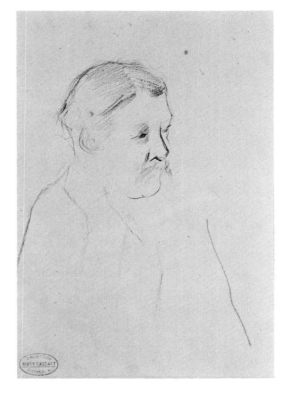

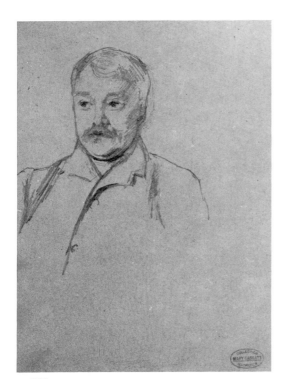

763
Portrait Sketch of Alexander J. Cassatt (No. 2) c. 1883

Pencil on blue paper, 9 × 6¼ in., 23 × 16 cm.
Unsigned. Mathilde X collection stamp at lower right.

Description: Head and shoulders of the artist's brother, seen frontally, looking off to left. His eyes are dark, his mustache and hair, parted on the side, are lighter. His jacket with lapels buttoned high has two buttons indicated.

Note: Also called "Tête d'homme de face." Durand-Ruel 19857B.

Collections: From the artist to Mathilde Vallet, 1927; Mathilde X sale, Paris, 1931; Durand-Ruel, Paris, 1966.

Exhibitions: Galerie A.-M. Reitlinger, Paris, 1931 (cat. 128).

765
Sketch of Mrs. Alexander Cassatt at Her Tapestry Loom c. 1883

Pencil on paper, 9 × 6¼ in., 23 × 16 cm. (sight)
Unsigned. Mathilde X collection stamp at lower right.

Description: A woman sits before a loom seen facing toward left and looking left. She wears a tight-fitting blouse with lapels and long, tight sleeves.

Note: Also called "Femme brodant" and "Femme brodant au métier." This is a study for the pastel portrait (BrCR 127). Durand-Ruel A1656-NY 9320.

Collections: From the artist to Mathilde Vallet, 1927; Mathilde X sale, Paris, 1931; Durand-Ruel, Paris; present location unknown.

Exhibitions: Galerie A.-M. Reitlinger, Paris, 1931 (cat. 138).

764
Sketch of a Boy in a Boat c. 1883

Pencil on paper, 4⅞ × 7½ in., 12.5 × 19 cm. (sight)
Unsigned. Mathilde X collection stamp at lower left.

Description: Head and shoulders of a boy wearing a round beret. He looks off to right. A few diagonal lines are the only indication of a boat and his figure is very vague.

Note: Also called "Dans la barque—esquisse." Durand-Ruel A1657-NY9313-13946.

Collections: From the artist to Mathilde Vallet, 1927; Mathilde X sale, Paris, 1931; Durand-Ruel, Paris; present location unknown.

Exhibitions: Galerie A.-M. Reitlinger, Paris, 1931 (cat. 70).

766

Sketch of Alexander J. Cassatt and His Son Robert c. 1883

Pencil on paper, not measured
Unsigned. Mathilde X collection stamp at lower right.

Description: Heads and shoulders of the artist's brother and his son both looking left. The child's head at the right covers the side of his father's head but allows the features to be seen. There is foxing over the entire page.

Note: Also called "Portraits: deux têtes."

Collections: From the artist to Mathilde Vallet, 1927; Mathilde X sale, Paris, 1931; *Mr. and Mrs. J. West Frazier, Jr.*, Philadelphia, Pennsylvania.

Exhibitions: Galerie A.-M. Reitlinger, Paris, 1931 (cat. 139).

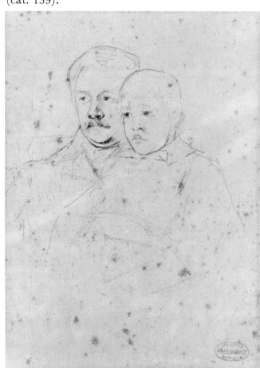

767

Sketch of a Woman Seated in a Folding Chair in a Garden c. 1883

Pencil on paper, $9\frac{1}{8} \times 6\frac{3}{8}$ in., 23.2 × 16.2 cm.
Unsigned. Mathilde X collection stamp at lower right.

Description: A woman seated on a folding chair is seen from the rear. She looks off to left with no features showing. Beyond her is an allée of trees.

Note: Also called "Femme assise sur un fauteuil pliant dans un jardin." Durand-Ruel A1661-NY9318-13977.

Collections: From the artist to Mathilde Vallet, 1927; Mathilde X sale, Paris, 1931; Durand-Ruel, Paris; present location unknown.

Exhibitions: Galerie A.-M. Reitlinger, Paris, 1931 (cat. 121).

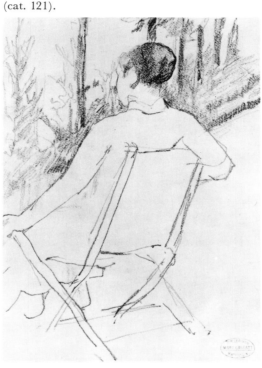

768

Sewing by Lamplight c. 1883

Soft pencil on paper, $7\frac{7}{8} \times 6$ in., 20 × 15.2 cm.
Signed lower left: *M. C.*

Description: A maid and a nurse sit facing each other beside a lamp, of which only a part of the shade is seen. The head of the nurse at the right hides the rest of it. She wears a dark dress with a big white apron. The maid at the left holds the material being sewed with her right hand while her left is raised to the far side of her face.

Note: This is a preparatory drawing for a soft-ground print of which only one impression is known (not in Br), also in the collection of H.M.P.

Collections: H.M.P., Paris.

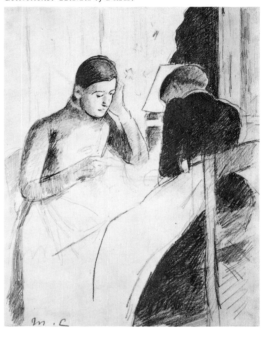

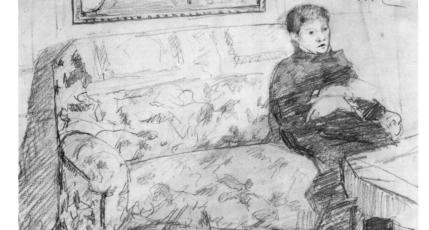

769

Drawing for "Interior: On the Sofa" c. 1883

Pencil on paper, $5\frac{9}{16} \times 8\frac{9}{16}$ in., 14.2 × 21.8 cm.
Signed upper right: *M. C.*

Description: A woman in a dark dress is seated at the right end of a sofa which is upholstered in a patterned material. She holds a letter in her hand and looks toward right. The bottom of a picture shows above the sofa, the end of a table before the figure at right.

Note: A preparatory drawing for the soft-ground and aquatint print (Br 76).

Collections: M. Suzor, Paris; O. Wertheimer, Paris; International Galleries, Chicago.

Exhibitions: Galerie Bernheim-Jeune, Paris, "Cent Cinquante Ans de Dessin 1800–1950" (cat. 16), 1952–53; Musée Département de l'Oise, Beauvais, "Hommage à Mary Cassatt" (cat. 5), 1965; International Galleries, Chicago (cat. 1), 1965.

770

Mrs. Cassatt Tatting, Seated before a Screen
c. 1883
Black crayon on paper, 7½ × 5½ in., 19 × 14 cm.
Unsigned

Description: The artist's mother, seen in three-quarter view, sits in an armchair wearing a dark dress with a white shawl over her shoulders. Behind her is a small table and a high French screen with glass insets. She wears pince-nez.

Note: This drawing was used for a soft-ground print of which no examples are known to date.

Collections: Present location unknown.

Reproductions: Adelyn D. Breeskin, *The Graphic Work of Mary Cassatt*, New York, 1948, Cat. III (Supplement).

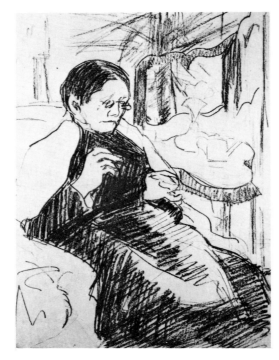

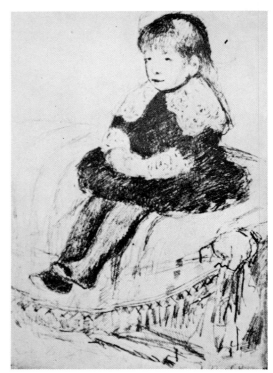

771

Drawing for "Mlle. Luguet Seated on a Couch" c. 1883
Soft pencil on paper, 8½ × 5½ in., 21.7 × 14 cm.
Signed lower right: *M. Cassatt*

Description: A little girl sits demurely on a couch which has an elaborately fringed drapery. She has blond hair with bangs and wears a dark dress with wide lace collar and cuffs, long dark stockings, and dark shoes. She faces and looks to left.

Note: A preparatory drawing for the soft-ground and aquatint print (Br 49).

Collections: Estate of Mrs. Mellon Bruce.

772 †

Drawing for "Mlle. Luguet in a Coat and Hat" c. 1883
Pencil on white paper, 9½ × 7 in., 24.2 × 17.7 cm. (sight)
Signed lower right: *Mary Cassatt*

Description: A little girl stands facing right in lost profile. She wears a very long, fur-trimmed coat and a large round hat tilted back on her head. Her long blond hair hangs down her back.

Note: A preparatory drawing for the soft-ground and aquatint print (Br 48). No photograph available.

Collections: Durand-Ruel, New York; present location unknown.

Exhibitions: Baltimore Museum of Art, 1936 (cat. 15).

773

Head of a Woman, Three-Quarter View to Right c. 1884
Crayon on paper, 5½ × 3¾ in., 14 × 9.5 cm. (sight)
Unsigned. Mathilde X collection stamp at lower right corner.

Description: Slight sketch of a head turned right in three-quarter view and looking to right. Her hair is just outlined. Diagonal lines indicate shoulder and dress.

Note: Also called "Tête de femme."

Collections: From the artist to Mathilde Vallet, 1927; Mathilde X sale, Paris, 1931; Wildenstein, New York; to *private collection*, New York.

Exhibitions: Galerie A.-M. Reitlinger, Paris, 1931 (cat. 166).

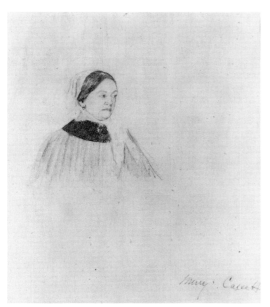

774
Sketch of Mrs. Riddle 1885
Pencil on paper, $9\frac{1}{2} \times 8$ in., 24.2×20.3 cm.
Signed lower right: *Mary Cassatt*

Description: Head and shoulders only. Mrs. Riddle looks off to right wearing a lace scarf on her head, tied under her chin with ends hanging down over the very dark yoke of her gown. Her hair is parted and drawn tightly down. She wears an earring.

Note: A preparatory sketch for the painting "Lady at the Tea Table" (BrCR 139).

Collections: Durand-Ruel, New York; present location unknown.

Exhibitions: Baltimore Museum of Art, 1941–42 (cat. 68).

776
Two Peasant Children on the Grass c. 1886
Soft pencil on paper folded to $9\frac{1}{2} \times 7\frac{1}{2}$ in.,
24.2×19 cm.
Unsigned

Description: A rather homely baby sits at left with a sad looking little girl behind him and to the right. She wears a dark dress with high neck and long sleeves. Her dark hair is straight and falls down on either side of her face. This preparatory drawing for soft ground was evidently never used, since no prints of it are known.

Collections: H.M.P., Paris.

775
Young Girl with Head Bowed, Knitting
c. 1886
Pencil on paper, $8\frac{3}{4} \times 5\frac{1}{2}$ in., 22.2×14 cm. (sight)
Unsigned. Mathilde X collection stamp at lower left.

Description: A young girl bends her head down toward left to look at her knitting held in both hands. Her hair is parted in the middle and is rather untidy.

Note: Also called "Jeune femme, visage baissé." On the verso is a pencil drawing of the head of a child, with no signature, entitled "Child's Head." Durand-Ruel A1665-NY9319-13968.

Collections: From the artist to Mathilde Vallet, 1927; Mathilde X sale, Paris, 1931; Durand-Ruel, Paris, 1938; International Galleries, Chicago; *Carla Johnson*, Chicago, Illinois.

Exhibitions: Galerie A.-M. Reitlinger, Paris, 1931 (cat. 103); International Galleries, Chicago, 1965 (cat. 4).

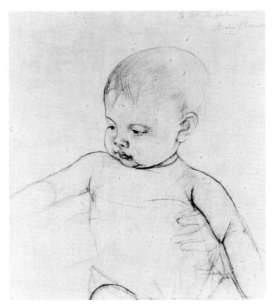

777
Baby of "The Family" Looking Down to Left
c. 1886
Pencil and crayon on paper, $14\frac{3}{8} \times 12\frac{1}{4}$ in.,
36.7×31 cm.
Signed upper right: *To Mr. Keppel/Mary Cassatt*

Description: A handsome baby boy with short hair looks down toward left; his right arm extends toward left. The mother's hand shows under his left arm and, very faintly at upper left, the lower part of her face.

Note: This is a study for "The Family" (BrCR 145) in the **Chrysler Art Museum, Provincetown, Massachusetts.**

Collections: From the artist to Frederic Keppel; to Mr. Allison, senior; to Mrs. Edith Allison; to *Gordon K. Allison*, New York.

778

Sketch of an Elderly Lady c. 1887

Pencil on blue paper, 9 × 6¼ in., 23 × 16 cm.
Unsigned. Mathilde X collection stamp at lower left.

Description: Half-length view of a woman wearing a bonnet tied under the chin and a dark costume. There is a suggestion of her left hand as though holding an umbrella on her lap. She looks off to left.

Note: Also called "Femme assise" and "Femme âgée en chapeau." A study for BrCR 147 or 148. Durand-Ruel 11288-L13782.

Collections: From the artist to Mathilde Vallet, 1927; Mathilde X sale, Paris, 1931; Durand-Ruel, Paris; present location unknown.

Exhibitions: Galerie A.-M. Reitlinger, Paris, 1931 (cat. 104).

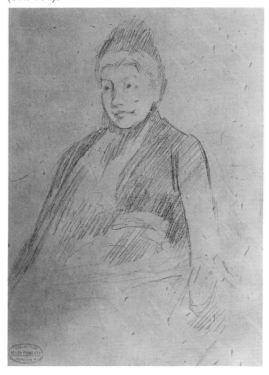

779

Slight Sketch of Mrs. Gardner Cassatt and Her Baby (No. 1) c. 1887

Pencil on white paper, 9 × 6¼ in., 23 × 16 cm.
Unsigned. Mathilde X collection stamp at lower left.

Description: Only the woman's head is somewhat developed with her hair piled high on her head. She looks down and holds her baby in front of her. Only the outline of his head is drawn.

Note: Also called "Portrait de femme." A sketch for the drypoint print (Br 113). Durand-Ruel 19857A-13969.

Collections: From the artist to Mathilde Vallet, 1927; Mathilde X sale, Paris, 1931; Durand-Ruel, Paris, 1966.

Exhibitions: Galerie A.-M. Reitlinger, Paris, 1931 (cat. 105).

780

Slight Sketch of Mrs. Gardner Cassatt and Her Baby (No. 2) c. 1887

Pencil on white paper, 9 × 6¼ in., 23 × 16 cm.
Unsigned. Mathilde X collection stamp at lower left.

Description: Only the woman's head is somewhat developed with her hair piled high on her head. The eyes are detailed. The rest in faint outline.

Note: Also called "Tête de femme et d'enfant, esquisse." A sketch for the drypoint print (Br 112). Durand-Ruel 19860D-13961.

Collections: From the artist to Mathilde Vallet, 1927; Mathilde X sale, Paris, 1931; Durand-Ruel, Paris, 1966.

Exhibitions: Galerie A.-M. Reitlinger, Paris, 1931 (cat. 92).

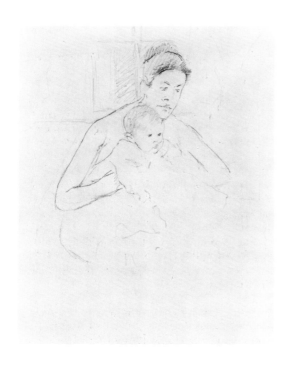

781

Drawing for "Mrs. Gardner Cassatt and Her Baby Seated near a Window" c. 1887

Pencil and crayon on paper, 9⅛ × 6⅜ in., 23.2 × 16.3 cm.
Unsigned

Description: A sketch of Mrs. Gardner Cassatt with her hair piled high in a pompadour, her head bent somewhat forward as she looks down to right. Her body and that of her baby are in outline only.

His head is well detailed. His right arm extends toward lower right, half covering his mother's hand.

Note: This is a sketch for the drypoint (Br 112) of the same subject. In the print the mother's hand extends to right of the baby's arm.

Collections: M. Knoedler & Co., New York, 1965; present location unknown.

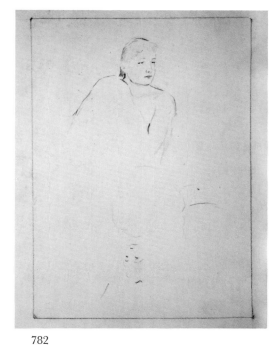

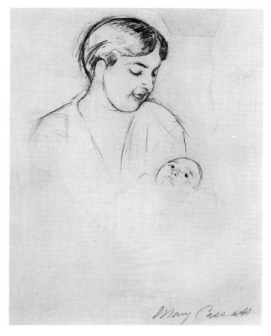

783
Baby Bill Lying on His Mother's Lap (No. 1)
c. 1889

Pencil on paper, 10¼ × 7¾ in., 26 × 19.7 cm.
Signed lower right: *Mary Cassatt*

Description: Head and shoulders of a smiling mother looking down at her baby. Only part of his head with eyes and nose is seen. The mother, with hair parted in the middle, is seen in three-quarter view to right (in the print she is in profile right).

Note: In Durand-Ruel photograph files this is noted as "femme et enfant dessin pr. l'estampe en couleurs du meme motif," but there is no corresponding color print. It is related, however, to a soft-ground with aquatint print (Br 101). Durand-Ruel 7945-L10476.

Collections: From the artist to Durand-Ruel, 1914; to a Swiss collector, 1948; International Galleries, Chicago; to *Geraldine Johnson*, Chicago, Illinois.

782
Sketch for "Young Girl Fixing Her Hair"
c. 1889

Pencil on paper, sheet 11⅞ × 8⅞ in., 30.2 × 22.6 cm.
Unsigned

Description: Head and shoulders of a young girl looking off to right with her two arms (unfinished) raised to hold her hair drawn together as though to braid. Another head started upside down below.

Note: The drawing is related to the drypoint print (Br 100).

Collections: H.M.P., Paris.

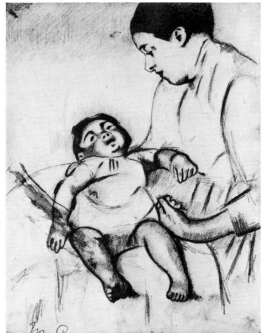

784
Baby Bill Lying on His Mother's Lap (No. 2)
c. 1889

Pencil on paper, 7¼ × 5¾ in., 18.5 × 14.6 cm.
Signed lower left: *M. C.*

Description: A mother in profile left looks down at the baby who lies on her lap. His head is thrown back and he looks off to left.

Note: This is a preparatory drawing used for the soft-ground and aquatint print (Br 101).

Collections: H.M.P., Paris.

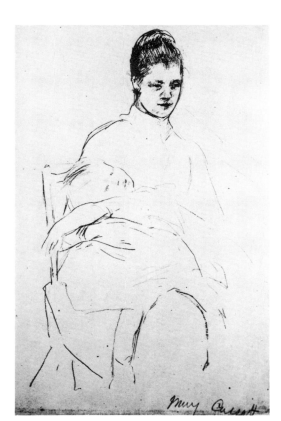

785
The Tired Child c. 1889

Pencil on paper, 7⅞ × 5 9/16 in., 20 × 14.2 cm.
Signed lower right: *Mary Cassatt*

Description: A little girl lies on her mother's lap with her right arm extended to left and her head thrown back, resting against her mother's arm. The mother's face is well developed, the rest of the composition sketched mostly in outline.

Note: This drawing was used for a soft-ground print of which no examples are known to date.

Collections: Durand-Ruel, New York; present location unknown.

Reproductions: Adelyn D. Breeskin, *The Graphic Work of Mary Cassatt*, New York, 1948, Cat. V (Supplement).

786 †
Baby Bill and His Nurse (No. 1) c. 1889

Pencil on white paper, 9⅛ × 6⅝ in., 23.2 × 16.8 cm. (sight)
Unsigned. Mathilde X collection wax seal on back of frame.

Description: A nurse, with dark hair drawn back behind her ear, is seated turned toward right. She holds the baby firmly in both arms. He rests his right hand on her chest as he faces forward and looks to the right.

Note: A preparatory drawing for a soft-ground and aquatint print (Br 109). Also called "Femme et bébé."

Collections: From the artist to Mathilde Vallet, 1927; Mathilde X sale, Paris, 1931; Alfred E. McVitty, Princeton, New Jersey; present location unknown.

Exhibitions: Galerie A.-M. Reitlinger, Paris, 1931 (cat. 73); Baltimore Museum of Art, 1936 (cat. 11); Baltimore Museum of Art, 1941–42 (cat. 69).

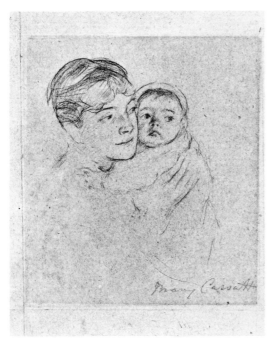

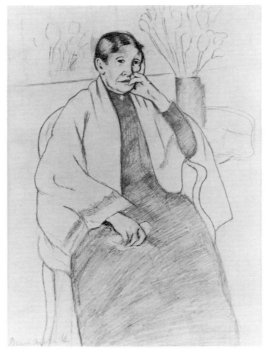

787
Baby Bill and His Nurse (No. 2) c. 1889
Crayon on blue paper, 5½×4 in. on 7⅞×5⅝ in.
paper, 14×10.2 cm. on 19.4×14.2 cm. paper
Signed lower right: *Mary Cassatt*

Description: A baby in a little round cap is held
by his nurse so that their cheeks touch, as both
look to right. The baby's left hand rests on the
nurse's shoulder, and her right hand, shown
under his arm, holds him up.

Note: A preparatory drawing for a soft-ground and
aquatint print (Br 109).

Collections: New York Public Library, S. P. Avery
Collection.

788
**Drawing for "A Portrait of the Artist's
Mother"** c. 1889
Pencil on pinkish-tan paper, 9½×6⅝ in.,
24×16.8 cm. (sight)
Signed lower left: *Mary Cassatt*

Description: Almost full-length figure of Mrs.
Cassatt with her hand on her cheek, seated turned
to right. She wears a dark gown and large white
shawl. Behind her on a table is a tall vase of tulips
which is reflected in a mirror in the background.

Note: This is a preparatory drawing for the soft-
ground and aquatint print (Br 122). BrCR 162
is a painting of similar composition.

Collections: Alexander J. Cassatt, Cecilton, Maryland.

Exhibitions: Haverford College, 1939 (cat. 61).

789
**Sketch of Baby for "Mother Pulling on
Baby's Stocking"** c. 1890
Pencil on paper, 10×8 in., 25.3×20.3 cm.
Signed lower right: *Mary Cassatt*

Description: A detailed sketch of a baby looking
down toward lower left as his mother, sketched
summarily, pulls on his stocking with both hands.
The baby's left hand rests on the mother's left
wrist. His left foot is not drawn.

Note: Sketch for BrCR 790; related to BrCR 190
and to the drypoint Br 129.

Collections: Private collection, Paris.

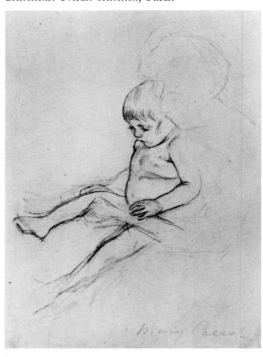

790
Mother Pulling on Baby's Stocking c. 1890
Pencil on paper, 10½×7 13/16 in., 26.7×20.2 cm.
Signed lower right: *Mary Cassatt*

Description: A woman holds her nude baby on her
lap and pulls a stocking onto his right leg, pulling
it up with both hands. Both mother and baby are
turned left. The mother is in profile, the baby in
three-quarter view.

Note: Related to BrCR 190 and to the drypoint
Br 129.

*Collections: Museum of Art, Rhode Island School of
Design*, Providence, gift of Mrs. Gustav Radeke,
1921.

*Reproductions: Bulletin of the Rhode Island School of
Design*, vol. 19 (Oct. 1931), p. 68; Ira Moskowitz,
ed., *Great Drawings of All Time*, vol. 4, New York,
1962, cat. 1014.

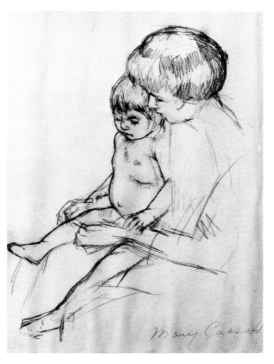

791

Head of a Baby Wearing a Bonnet c. 1890

Pencil on paper, 6¼ × 9 in., 16 × 23 cm.
Unsigned

Description: Head only of a baby wearing a big bonnet with a high crown, looking off to left.

Note: The Mathilde X collection stamp was cut out and pasted on below center toward left.

Collections: From the artist to Mathilde Vallet, 1927; Mathilde X sale, Paris, 1931; Charles E. Slatkin Gallery, New York, 1962; to *Leo Revi,* New York.

Exhibitions: Galerie A.-M. Reitlinger, Paris, 1931 (cat. 109).

792

Baby Wearing a Cap c. 1890

Pencil on paper, 6⅛ × 4½ in., 15.6 × 11.5 cm.
Signed lower right: *Mary Cassatt*

Description: Head and shoulders of a baby sitting up wearing a cap which just about covers his hair and ears. He looks left and is turned so that his farther eye is only in half view. There is very delicate shading over the face.

Collections: Albright-Knox Art Gallery, Buffalo, New York, gift of George F. Goodyear.

793

Slight Sketch of a Woman in a Big Bonnet
c. 1890

Crayon on paper, 6¾ × 9 in., 17.2 × 23 cm. (sight)
Unsigned. Mathilde X collection stamp at lower right.

Description: A woman's face in shadow, seen in profile right under a big bonnet. Her hand is up to her face. She wears a tight-fitting basque.

Collections: From the artist to Mathilde Vallet, 1927; Wildenstein, New York; *private collection,* New York.

794

Sketch of a Woman Seated by a Table
c. 1890

Pencil on white paper, 9 × 6¼ in., 23 × 16 cm.
Unsigned. Mathilde X collection stamp at lower left.

Description: Summary sketch of a woman in evening dress seated by a small table with her left hand resting on it. She looks at the spectator.

Note: Also called 'Femme près d'une table." Durand-Ruel 19861B-13960.

Collections: From the artist to Mathilde Vallet, 1927; Mathilde X sale, Paris, 1931; Durand-Ruel, Paris, 1966.

Exhibitions: Galerie A.-M. Reitlinger, Paris, 1931 (cat. 91).

795

Study for "Hélène of Septeuil" c. 1890

Pencil on paper, 6½ × 6 in., 16.5 × 15.3 cm.
Signed lower right: *Mary Cassatt*

Description: Heads only of mother in profile to right observing her child who looks toward left wearing a big, round hat. Only the faces are detailed.

Note: A study for BrCR 185.

Collections: Durand-Ruel, Paris; present location unknown.

Exhibitions: Marlborough Fine Art Ltd., London, "19th and 20th Century Drawings and Watercolors," 1960.

796

Summary Sketch of a Child and Nurse
c. 1891

Crayon on paper, 5¾ × 9 in., 14.6 × 23 cm. (sight)
Unsigned. Mathilde X collection stamp at lower right.

Description: A nurse at right is seated on a bench. She leans over to hold a little girl with curly hair who stands at left.

Note: Also called "Reclining Woman and Girl" and "Femme assise près d'un enfant debout."

Collections: From the artist to Mathilde Vallet, 1927; Mathilde X sale, Paris, 1931; *private collection*, United States.

Exhibitions: Galerie A.-M. Reitlinger, Paris, 1931 (cat. 119).

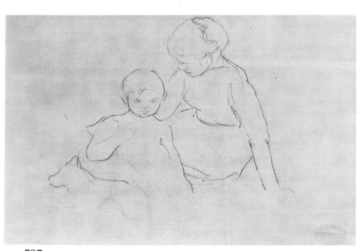

797

Nurse and Young Child on the Grass
c. 1891

Pencil on paper, 6 × 9 in., 15.2 × 22.8 cm.
Unsigned. Mathilde X collection stamp at lower right.

Description: A little girl sits on the grass facing forward and looking down. The young nurse sits somewhat behind her on the right, leaning her weight on her left arm. She looks down at the child.

Note: Also called "Fillette debout devant une dame assise."

Collections: From the artist to Mathilde Vallet, 1927; Mathilde X sale, Paris, 1931; *Telfair Academy of Arts and Sciences*, Savannah, Georgia, bequest of Margaret Screven Duke, 1964.

Exhibitions: Galerie A.-M. Reitlinger, Paris, 1931 (cat. 123).

798

Sketch of Nurse Seated on a Bench, Baby Standing beside Her c. 1891

Pencil on paper, 9 × 6¼ in., 23 × 16 cm.
Unsigned. Mathilde X collection stamp at lower left.

Description: A woman seated on a bench rests her left arm along its back. With her right hand she holds the right hand of a baby standing before her. His other hand is at his mouth.

Note: Also called "Femme assise tenant un bébé nu par la main."

Collections: From the artist to Mathilde Vallet, 1927; Mathilde X sale, Paris, 1931; present location unknown.

Exhibitions: Galerie A.-M. Reitlinger, Paris, 1931 (cat. 158, illus.).

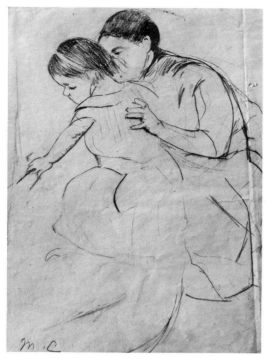

799

Baby with Left Hand Touching a Tub, Held by Her Nurse c. 1891

Pencil on cream paper folded to 10 × 7⅝ in., 25.4 × 19.5 cm.
Signed lower left: *M. C.*

Description: A baby reaches with her left hand to touch the edge of her bathtub and looks down at it. She is held on the lap of her nurse who supports her with her left hand on the baby's back. The nurse's face is half hidden by the baby's straight dark hair.

Note: Light traced outlines on verso.

Collections: H.M.P., Paris.

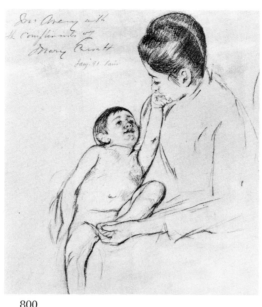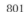

800

The First Caress 1891

Crayon on cream wove paper, 10½ × 7½ in. on 11 × 9 in. paper, 26.8 × 19 cm. on 28 × 23 cm. paper
Signed upper left: *Mr. Avery with/the compliments of/Mary Cassatt/Jany, '91, Paris*

Description: A nude baby lying on his mother's lap looks up at her and reaches with his left hand to stroke her chin. The mother at right looks down at him and holds his left foot in her left hand. Her dark hair is piled high on her head in a twist.

Note: The dateline in the inscription seems to have been added in pencil in another handwriting.

Collections: New York Library, S. P. Avery Collection.

801

Sketch for Color Print "The Bath" (No. 1)
1891

Pencil on paper, 11⅝ × 9⅞ in., 32 × 25 cm.
Signed lower right: *Mary Cassatt*

Description: Sketch of the general pose for the mother, stooping with her left arm extended into tub at right, with the nude baby standing with both arms over her right arm which holds him.

Note: A preparatory drawing for Br 143. Durand-Ruel 7943-L10587.

Collections: Durand-Ruel, Paris; present location unknown.

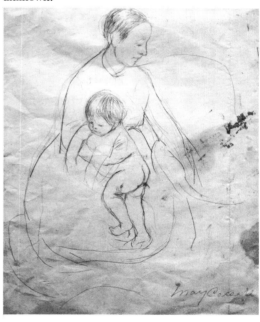

802

Sketch for Color Print "The Bath" (No. 2)
1891

Pencil and black crayon on paper, 12½ × 9¾ in., 31.8 × 24.7 cm. (image), 13 7/16 × 10⅝ in., 34.2 × 27 cm. (page)
Signed lower right: *Mary Cassatt*

Note: A much more detailed working drawing for the color print (Br 143), with most details similar except for the pattern on the mother's dress.

Collections: Durand-Ruel, Paris; to J. Howard Whittemore, Naugatuck, Connecticut, 1921; Parke-Bernet, New York, Whittemore sale, 19 May 1948 (cat. 59); to Lessing Rosenwald, Jenkintown, Pennsylvania; to *National Gallery of Art*, Washington, D.C., Rosenwald Collection.

Exhibitions: Pasadena Art Institute, "Mary Cassatt and Her Parisian Friends" (cat. 9), 1951.

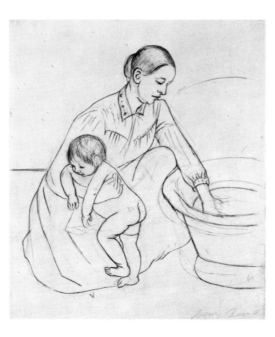

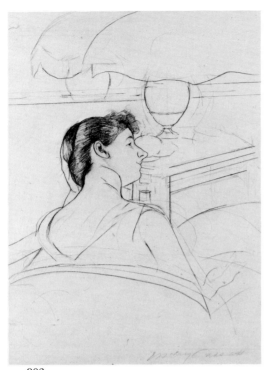

803
Study for "The Lamp" 1891
Pencil and black chalk on paper, $14\frac{1}{4} \times 10$ in., 26.2 × 25.4 cm.
Signed toward lower right: *Mary Cassatt*

Description: Head and shoulders of a woman in profile looking to right. A lamp with a large shade rests on a table in the background.

Note: This sketch was used to put the design onto the plate with soft ground for the color print (Br 144). The outlines are firmly pressed into the paper. Some details are missing. The design is in reverse of the color print. Durand-Ruel 10383-L10468.

Collections: Durand-Ruel, Paris; *Yale University Art Gallery*, bequest of Edith M. K. Wetmore.

804
Drawing for "In the Omnibus" c. 1891
Crayon and pencil on paper, $14\frac{3}{8} \times 10\frac{5}{8}$ in., 36.5 × 27 cm.
Signed toward lower right: *Mary Cassatt*

Description: A man, woman, nurse, and child are seated in an omnibus. The nurse at left looks down at the baby on her lap. The mother, who looks left, holds an umbrella in her left hand. The man is only summarily sketched.

Note: The working drawing for putting the design onto the plate with soft ground for the color print (Br 145). The main outlines are therefore firmly pressed into the paper. The man's figure at right was not used in the color print. Durand-Ruel 7955-L10473.

Collections: Durand-Ruel, Paris; to J. Howard Whittemore, Naugatuck, Connecticut; Parke-Bernet, New York, Whittemore sale, 19 May 1948 (cat. 60, illus.); to Lessing Rosenwald, Jenkintown, Pennsylvania; to *National Gallery of Art*, Washington, D.C., Rosenwald Collection.

Exhibitions: Baltimore Museum of Art, 1941–42 (cat. 73); Baltimore Museum of Art, "Manet, Degas, Berthe Morisot and Mary Cassatt" (cat. 122), 1962.

Reproductions: Arts, vol. 36 (April 1962), p. 32.

805
Drawing for "The Letter" 1891
Pencil and crayon on paper, $13\frac{3}{4} \times 9\frac{1}{16}$ in., 35 × 23.1 cm.
Signed toward lower left: *Mary Cassatt*

Description: A woman sits before a desk holding an envelope up to her mouth with both hands. She looks down at the flat top of the desk. The image is in reverse of the print.

Note: The working drawing for putting the design onto the plate over soft ground for the color print (Br 146). The upright side of the desk is barely indicated and there are no patterns on the dress or background. No letter is on the desk. Durand-Ruel 7952-L10469.

Collections: Durand-Ruel, Paris; *Cleveland Museum of Art*, bequest of Charles T. Brooks.

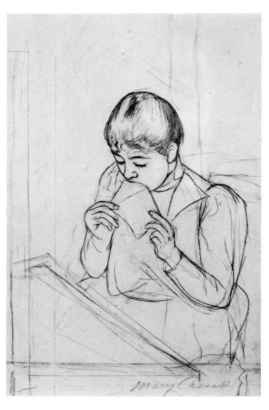

806
Sketch for "The Fitting" and Figure of a Seated Woman c. 1891
Pencil on white paper, $6\frac{3}{4} \times 4\frac{3}{4}$ in., 17.2 × 12 cm.
Unsigned. Mathilde X collection stamp at lower right.

Description: A woman stoops low with her right arm extended, possibly an idea for the foreground figure in the color print "The Fitting" (Br 147). Above, a seated figure, and at right an outline of a head.

Collections: From the artist to Mathilde Vallet, 1927; Stefan Ehrenzweig, New York; present location unknown.

807

Drawing for "The Fitting" 1891

Black crayon on paper, 15⅛ × 10¼ in., 38.4 × 26 cm. (image), 19½ × 12 in., 49.5 × 30.5 cm. (page). Signed lower right: *M. C.*

Description: A woman in an evening gown stands before a mirror while the dressmaker stoops at lower right. She looks down at the dressmaker, one hand posed at her throat.

Note: A preparatory drawing for Br 147.

Collections: National Gallery of Art, Washington, D.C., Rosenwald Collection.

Exhibitions: Baltimore Museum of Art, "Manet, Degas, Berthe Morisot and Mary Cassatt" (cat. 123), 1962.

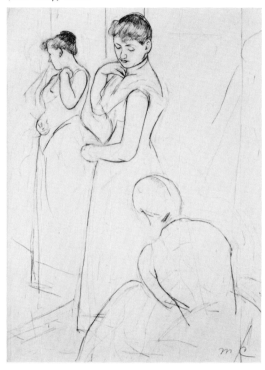

808

Sketch for "Mother's Kiss" 1891

Pencil on paper, measurements unknown Unsigned. Mathilde X collection stamp at lower right corner.

Description: A mother holds her baby, supporting his back with her right hand. The pose is well established, but the heads are far apart instead of together, as in the color print for which it is a study. The baby's left leg is not drawn. The entire composition is in outline only and in reverse of the color print (Br 149).

Collections: From the artist to Mathilde Vallet, 1927; Mathilde X sale, Paris, 1931; *private collection,* England.

Exhibitions: Galerie A.-M. Reitlinger, Paris, 1931 (cat. 150).

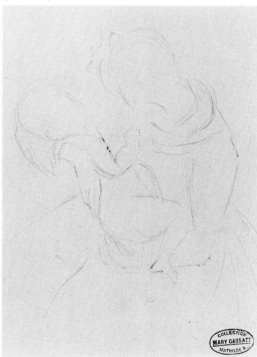

809 †

Working Drawing for "Mother's Kiss"
1891

Pencil on paper, 13¾ × 9 in., 35 × 23 cm. Signed lower right: *Mary Cassatt*

Description: A mother holds her baby close to her as she bends her head down to kiss him. Her right hand supports his back. His right hand holds her collar under his chin. His right leg is bent and his left hangs lower.

Note: A study for Br 149.

Collections: J. Howard Whittemore, Naugatuck, Connecticut; Parke-Bernet, New York, Whittemore estate sale, May 1948 (cat. 151, illus.); present location unknown.

810

Sketch for "Maternal Caress" 1891

Pencil on paper, 14½ × 10½ in., 37 × 26.7 cm. Signed toward lower right: *Mary Cassatt*

Description: A summary sketch of the pose for the color print (Br 150) with the baby's profile well developed but not the pose of his legs. The mother's face is partly covered by the baby's head, as she holds him close and supports his back with her right hand.

Note: Durand-Ruel 7949, L10471.

Collections: Durand-Ruel, Paris; to Richard Davis; to Mr. and Mrs. Daniel Silberberg; to the *Metropolitan Museum of Art,* New York, gift of the Silberbergs, 1964.

Exhibitions: Baltimore Museum of Art, "Manet, Degas, Berthe Morisot and Mary Cassatt" (cat. 124), 1962.

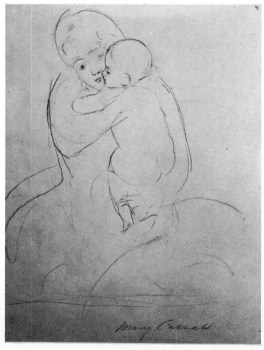

811

Drawing for "Maternal Caress" 1891

Black crayon on paper, 14 × 10½ in., 35.5 × 26.6 cm. Signed lower right: *Mary Cassatt*

Description: A mother holds her nude baby up close to her, his left arm around her neck, as she supports his back with her right hand. Many lines are firmly pressed into the paper for putting the design onto the plate over soft ground, especially those of the pose of the mother and baby. No indication of the bed in the background or the arms of the chair.

Note: Preparatory drawing used for the soft-ground lines of the color print (Br 150). Durand-Ruel 7897-L10551.

Collections: J. Howard Whittemore, Naugatuck, Connecticut; Parke-Bernet, New York, Whittemore estate sale, May 1948 (cat. 150); present location unknown.

Exhibitions: Baltimore Museum of Art, 1941–42 (cat. 72).

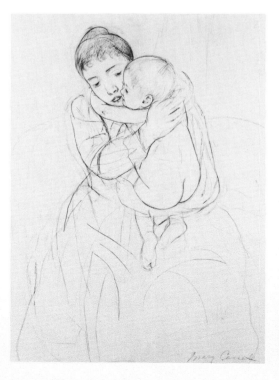

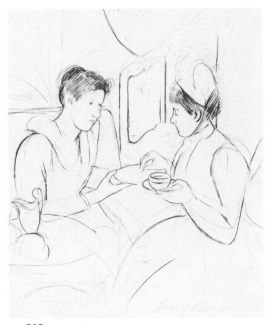

812
Drawing for "Afternoon Tea Party" c. 1891
Pencil on paper, 13½ × 10½ in., 34.4 × 26.8 cm.
Signed lower right: *Mary Cassatt*

Description: A hostess at left offers a cake to her guest, seated at right. The guest wears a small bonnet and holds a tea cup in her right hand. Many lines are pressed firmly into the paper for raising the soft ground from the plate. The guest at the right is not wearing a short cape, which was added later on the plate in aquatint.

Note: A preparatory drawing for Br 151. Durand-Ruel 7946-L10470.

Collections: Durand-Ruel, Paris; *A. Conger Goodyear* and *George Goodyear*, Buffalo, New York.

Exhibitions: Museum of Modern Art, New York, circulating exhibition, "Modern Drawings," 1944–45.

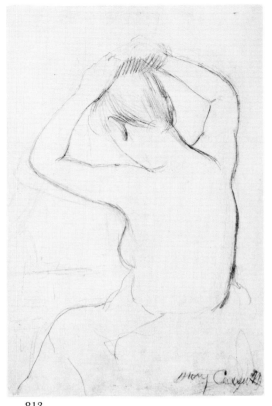

813
Study for "The Coiffure" (No. 1) 1891
Pencil drawing on white paper, 8½ × 5½ in., 21.7 × 14 cm.
Signed lower right: *Mary Cassatt*

Description: Half-length of a seated nude seen from the rear, mostly in outline, with some shading on her hair. Both arms are raised to fix her hair which is piled high. No reflection or indication of a mirror.

Note: A preparatory drawing for Br 152.

Collections: Durand-Ruel, Paris; to Durand-Ruel, New York, until after 1936; to Anthony d'Offay, London; to the *Metropolitan Museum of Art*, New York.

Exhibitions: Baltimore Museum of Art, 1936 (cat. 14); Pasadena Art Institute, "Mary Cassatt and Her Parisian Friends" (cat. 3), 1951.

Reproductions: Adelyn D. Breeskin, *The Graphic Work of Mary Cassatt*, New York, 1948, Cat. VI (Supplement).

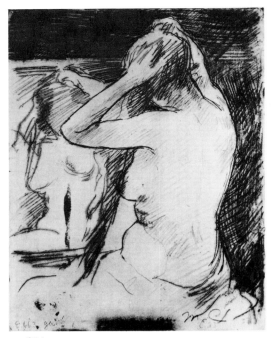

814
Study for "The Coiffure" (No. 2) c. 1891
Pencil and ink on paper, 8¼ × 5¾ in., 21 × 14.6 cm.
Signed lower right: *M. C.*

Description: Half-length study of a nude seen from the rear. Both arms are raised to fix her hair, part of which hangs forward over her left breast. Her reflection is seen in a mirror toward left.

Note: A preparatory drawing for Br 152.

Collections: Durand-Ruel, New York; present location unknown.

Reproductions: Adelyn D. Breeskin, *The Graphic Work of Mary Cassatt*, New York, 1948, cat. VII (Supplement).

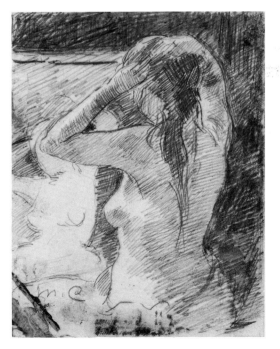

815
Study for "The Coiffure" (No. 3) c. 1891
Pencil on laid paper, 5 13/16 × 4⅜ in., 14.7 × 11.2 cm.
Signed lower left: *M. C.*

Description: Half-length of a nude seen from the rear in shadow. Both arms are raised to fix her hair, part of which hangs down her back. Her reflection is seen in the mirror. There are some traces of green color.

Note: A preparatory drawing for Br 152.

Collections: Henri Petiet, Paris; to Lessing Rosenwald, Jenkintown, Pennsylvania, 1953; to the *National Gallery of Art*, Washington, D.C., Rosenwald Collection.

Exhibitions: Pasadena Art Institute, "Mary Cassatt and Her Parisian Friends" (cat. 10), 1951.

816
Sketch for "The Coiffure" 1891
Pencil on paper, 6 × 5 in., 15.3 × 12.7 cm.
Unsigned. Mathilde X collection stamp at lower right.

Description: Sketch of most of the composition. The figure is turned to right, as in the finished print, with her reflection in the mirror.

Note: A preparatory drawing for Br 152.

Exhibitions: Galerie A.-M. Reitlinger, Paris, 1931 (cat. 132).

Collections: From the artist to Mathilde Vallet, 1927; Mathilde X sale, Paris, 1931; to Anthony d'Offay, London; to *Bob Willoughby*, Pacific Palisades, California, 1967.

819
Study of a Woman's Head c. 1892
Pencil on tan paper folded to 16½ × 11¾ in., 42 × 30 cm.
Unsigned

Description: Head of a woman looking somewhat to left. Her hair is fixed close to her head. She frowns slightly and looks very serious. There is a suggestion of a child's head looking up toward the lower left.

Note: This may be a sketch for one of the women in the center panel of the lost Chicago Exposition mural (BrCR 213).

Collections: H.M.P., Paris.

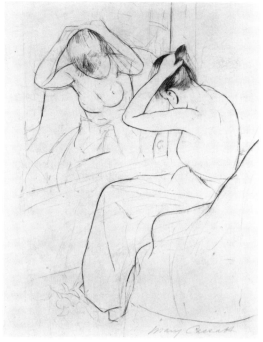

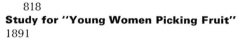

818
Study for "Young Women Picking Fruit"
1891
Lead pencil on paper, 17¼ × 11 in., 44 × 28 cm.
Signed lower right: *Mary Cassatt*

Description: A young woman is seated on a bench at center, facing left, looking up, with her left arm on her hip. To the left of her stands a young woman reaching up with her left arm to pull down a branch. Her right hand rests on the back of the bench.

Note: This is a study for BrCR 197.

Collections: Durand-Ruel, Paris; present location unknown.

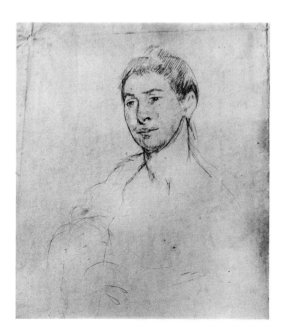

817
Drawing for "The Coiffure" 1891
Black crayon and pencil on paper, 14⅞ × 10¾ in., 37.8 × 27.3 cm. (image), 15¼ × 10⅞ in., 39.3 × 27.7 cm. (page)
Signed toward lower right: *Mary Cassatt*

Description: A woman is seated in an armchair. She is nude above the waist. With both hands she is fixing her hair in a knot on her head. Her reflection is seen in the mirror. Many lines are pressed into the paper for putting the design onto the plate over soft ground. Mirror frame at left not yet defined. No stripes on chair.

Note: A preparatory drawing for the color print (Br 152) but without traces of soft ground on back. Durand-Ruel 7953-L10472.

Collections: Durand-Ruel, Paris; to J. Howard Whittemore; Parke-Bernet, New York, Whittemore estate sale, May 1948; to Lessing Rosenwald, Jenkintown, Pennsylvania; to the *National Gallery of Art*, Washington, D.C., Rosenwald Collection.

Exhibitions: Baltimore Museum of Art, 1941–42 (cat. 74).

Reproductions: Edith Valerio, 1930, pl. 25.

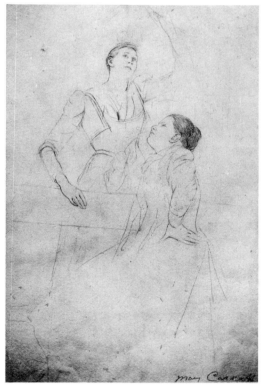

820 †
Sketch for Mural of "Modern Woman"
1892
Pencil on paper, 17¼ × 11⅛ in., 44 × 28.2 cm.
Unsigned

Description: Figures from the central section of the mural.

Collections: Durand-Ruel, New York; present location unknown.

Exhibitions: Baltimore Museum of Art, 1941–42 (cat. 75).

822
Drawing for "Gathering Fruit" 1893
Pencil on paper, 16¾ × 11¾ in., 42.5 × 30 cm.
Signed lower right: *Mary Cassatt*

Description: A young woman stands on a ladder at the right and reaches down with her arm to hand a fruit to a nude baby at left on his mother's arm. Many lines are pressed into the paper firmly for putting the design onto the plate over soft ground. The baby's feet are not finished nor are rungs of ladder and sections of the fruit tree.

Note: A preparatory drawing for the color print (Br 157). Also called "La Cueillette." Durand-Ruel 7956-L10474.

Collections: Durand-Ruel, Paris; present location unknown.

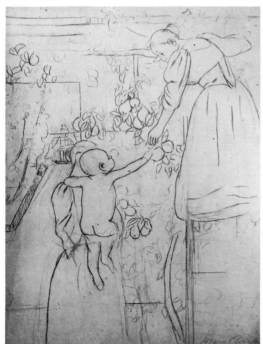

823
Slight Sketch for "Half-Length Drawing of a Woman" c. 1893

Crayon on paper, 8¼ × 7 in., 21 × 18 cm. (sight)
Unsigned. Mathilde X collection stamp at lower right.

Description: Half-length of a woman looking and facing forward with her hands in her lap. Her costume has a long central section from the high neck to the waist.

821
Sketch for "Gathering Fruit" 1893
Crayon on paper, 11¼ × 10 in., 28.7 × 25.5 cm.
Unsigned

Description: A young woman in a patterned dress stands on a ladder (not seen) and reaches down to a nude baby held by his mother. Behind them are espaliered pears. The drawing is colored blue, yellow, green, and purple.

Note: A preparatory drawing for Br 157. The main theme of the color print is established, but the

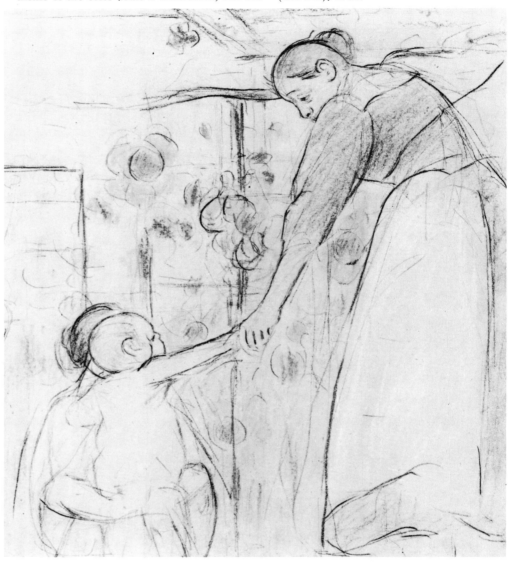

Note: A sketch for BrCR 824. Also called "Femme agée en chapeau."

Collections: From the artist to Mathilde Vallet, 1927; Mathilde X sale, Paris, 1931; Wildenstein, New York; Mr. and Mrs. James A. Vigeveno, California; *Meyer Shapiro*, New York.

Exhibitions: Galerie A.-M. Reitlinger, Paris, 1931 (cat. 140); Pasadena Art Institute, "Mary Cassatt and Her Parisian Friends" (cat. 17), 1951.

lower third of the composition is lacking.

Collections: Christie & Co. sale, London, 16 Dec. 1938 (cat. 118); to Mr. Oettinger, New York; to Victor Spark, 1952; to Winthrop Newman, London; to Louis Macmillan, 1962; to *Mr. and Mrs. Lester F. Avnet*, New York, 1965.

Exhibitions: Baltimore Museum of Art, "Manet, Degas, Berthe Morisot and Mary Cassatt" (cat. 125), 1962.

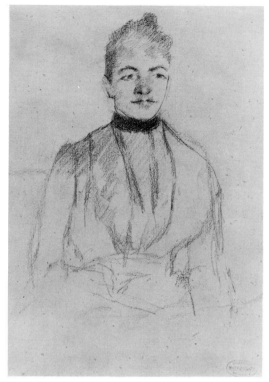

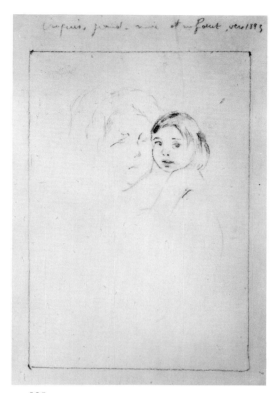

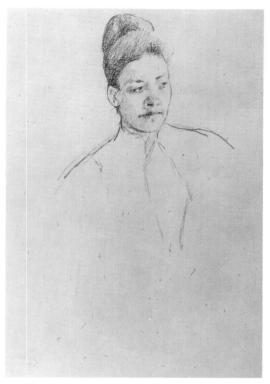

824
Half-Length Drawing of a Woman c. 1893
Pencil on paper, 18 × 14⅛ in., 45.6 × 36 cm.
Unsigned. Mathilde X collection stamp at lower right.

Description: A woman is seated facing frontally, looking slightly to right. Her hair is fixed in a knot on top of her head with soft bangs over her forehead. Her dress has wide lapels on either side of the front yoke. She has a black band around her neck. She is seen in half-length without her hands showing.

Collections: From the artist to Mathilde Vallet, 1927; Mathilde X sale, Paris, 1931; *Los Angeles County Museum of Art*, Mr. and Mrs. William Preston Harrison Collection, 1939.

Exhibitions: Galerie A.-M. Reitlinger, Paris, 1931 (cat. 77); Pasadena Art Institute, "Mary Cassatt and Her Parisian Friends" (cat. 18), 1951.

825
Sketch: Grandmother and Child c. 1893
Pencil drawing on paper, sheet 8⅞ × 5¾ in., 22.7 × 14.6 cm.; within penciled margin, 7³⁄₁₆ × 4¾ in., 18.1 × 12 cm.
Unsigned

Description: A child at right with straight hair brushed over to the side looks at the spectator as she leans her cheek against that of the grandmother, whose features are barely indicated.

Note: This drawing is related to the drypoint (Br 211).

Collections: H.M.P., Paris.

826
Woman from Martinique c. 1893
Black pencil on paper, 8¾ × 6¼ in., 22.3 × 16 cm.
Unsigned. Mathilde X collection stamp at lower left.

Description: Head and shoulders of a woman with dark hair piled high on her head. She looks off to right and wears a blouse with an open yoke. Her face is shaded.

Note: Also called "Martiniquaise" and "Femme créole." Durand-Ruel 11290-L13784.

Collections: From the artist to Mathilde Vallet, 1927; Mathilde X sale, Paris, 1931; to Durand-Ruel, Paris; present location unknown.

Exhibitions: Galerie A.-M. Reitlinger, Paris, 1931 (cat. 110).

827
Sketch for Figure in "The Banjo Lesson"
c. 1894
Pencil on paper, 8¼ × 5¼ in., 21 × 13.3 cm.
Unsigned. Mathilde X collection stamp at lower right corner.

Description: A young woman looks at the spectator. Her wide-sleeved dress tapers to the cuff and her right hand touches either a banjo or the back of a child.

Note: A study for BrCR 238. Also called "Tête de jeune fille, buste esquissé."

Collections: From the artist to Mathilde Vallet, 1927; Mathilde X sale, Paris, 1931; present location unknown.

Exhibitions: Galerie A.-M. Reitlinger, Paris, 1931 (cat. 157, illus.).

828
Sketch for "The Child's Picture Book"
c. 1895
Pencil on tracing paper, 15 × 11 in., 38 × 28 cm.
Unsigned

Description: The book is not shown but both the
mother and baby look down toward left where a
book would be. The mother's hair is drawn tightly
back from center part. The baby's blond hair is
short and curly.

Note: A sketch related to BrCR 243. It is a drawing
for a monotype.

Collections: H.M.P., Paris.

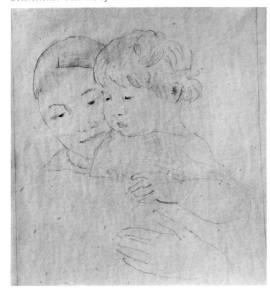

829
**Study for "Portrait of a Smiling Woman in
a Pink Blouse"** c. 1895
Pencil on tan paper, 19⅝ × 12⅜ in., 50 × 31.6 cm.
Signed lower right: *M. C.*

Description: Head of a young woman looking at
the spectator. She wears a pompadour with a few
strands of hair loose at the center of her fore-
head. There is a suggestion of her blouse, which
has a large, loose divided bertha and a brooch
at the neck in front.

Note: A study for BrCR 251.

Collections: H.M.P., Paris.

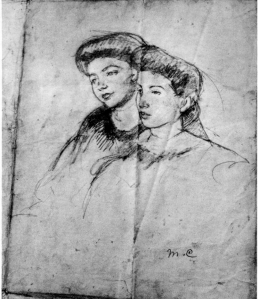

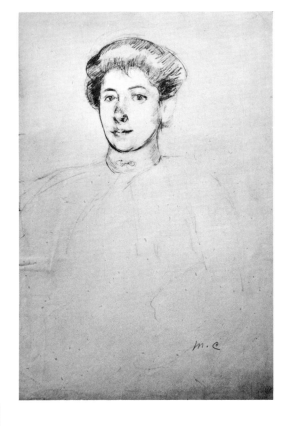

830
**Heads of Two Young Women Looking to
Left** c. 1896
Soft pencil on cream paper folded to 12½ × 9¾ in.,
31.7 × 24.7 cm.
Signed toward lower right: *M. C.*

Description: Heads and shoulders of two young
women both looking to left. Their hair is pom-
padoured. The girl at the right has a long face,
the one on the left a broader face. The latter's
dress with a round neckline is shaded dark.

Note: This may have been used for a soft-ground
print since some lines have been pressed into
the paper, but no such print is known.

Collections: H.M.P., Paris.

831
Two Children, One Sucking Her Thumb
c. 1897
Pencil on paper, 8 × 6 in., 20.3 × 15.2 cm.
Signed lower right and on verso: *Mary Cassatt*

Description: Head of a little girl with her finger in
her mouth. She has short curly hair. An older girl
is barely indicated.

Note: Soft ground on the verso indicates that this
was for a print, but it was evidently never
executed.

Collections: International Galleries, Chicago; to
Dr. Malcolm Boshnack, Coral Gables, Florida.

Exhibitions: Marlborough Fine Art Ltd., London,
1961 (cat. 5, illus.).

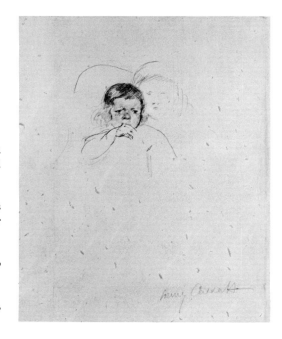

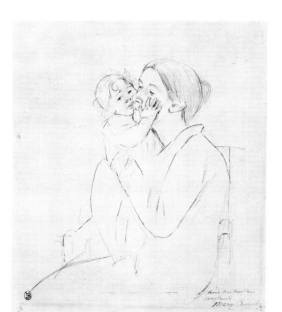

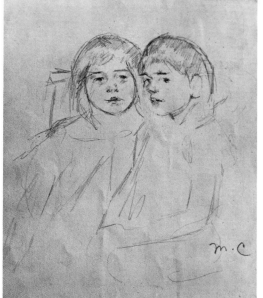

Sketch for "Two Little Girls" c. 1897
Pencil on cream paper folded to $7\frac{3}{4} \times 7$ in.,
19.5×17.8 cm.
Signed lower right: *M. C.*

Description: The little girl at left looks directly at
the spectator; the one at right is seen in three-
quarter view to left. Their bodies are only sum-
marily drawn to the waist.

Note: A preparatory sketch for BrCR 834.

Collections: H.M.P., Paris.

832

**Mother Holding Up a Baby Who Pats Her
Cheek** c. 1897
Pencil on ivory paper, $11\frac{1}{4} \times 9\frac{1}{16}$ in., 28.5×23 cm
Signed at lower right and inscribed: *avec mes
meilleurs/compliments/Mary Cassatt*

Description: A mother seated in three-quarter view
to left holds up her curly-haired blond baby who
pats her mother's cheek with her right hand and
looks at the spectator.

Note: The collection stamp of Y. Beurdeley
(Lugt 421) is at lower left.

Collections: From the artist to Y. Beurdeley, Paris;
to M. Gobin, Paris; the *Fogg Art Museum*, Cam-
bridge, Massachusetts, 1943.

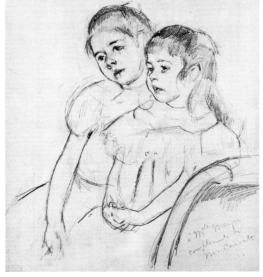

834

Two Little Girls c. 1897
Pencil on paper, $7\frac{1}{2} \times 6\frac{1}{2}$ in., 19×16.5 cm.
Signed: *à Mlle. Mayer/compliments de/M. Cassatt*

Description: Two little girls seated look toward left.
The one at right is brunette with dark eyes. Her
hair is drawn up into a flat bow on top of her
head and hangs down her back. She wears a
round yoked dress with a circular ruffle over her
shoulders. Her hands are folded in her lap. The
other girl has her head tilted to left; her right
arm rests on her lap.

Collections: Dorothy Brown, Malibu, California.

Exhibitions: Pasadena Art Institute, "Mary Cassatt
and Her Parisian Friends" (cat. 16), 1951;
Stanford Galleries, Palo Alto, California, "Exhibi-
tion of the Collection of Dorothy Brown," 1953;
Santa Barbara Museum of Art, "Collection of
Dorothy Brown," 1963.

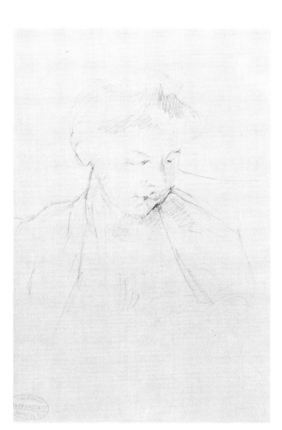

835

**Mother Rose Looking Down at Her Sleeping
Child** c. 1898
Pencil on paper, $13\frac{1}{4} \times 10$ in., 33.5×25.3 cm.
Unsigned. Mathilde X collection stamp at lower
left corner.

Description: Head and shoulders of a mother
looking down toward lower right. Her dress is
open over her chest. Her hair is pompadoured
with a knot on top. She looks down at her sleeping
child (not drawn).

Note: Also called "Jeune femme, les yeux baissés."
Durand-Ruel 19980.

Collections: From the artist to Mathilde Vallet,
1927; Mathilde X sale, Paris, 1931; Durand-Ruel,
1966.

Exhibitions: Galerie A.-M. Reitlinger, Paris, 1931
(cat. 126); Marlborough Fine Art Ltd., London,
1953 (cat. 24).

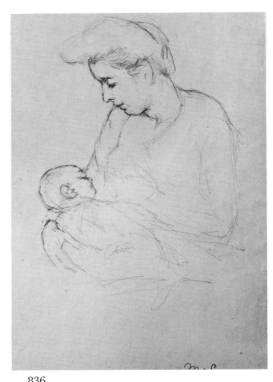

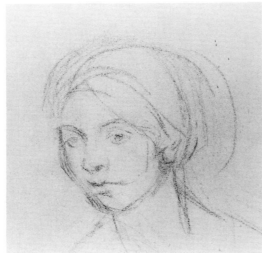

836
Mother Rose Looking Down at Her Baby Asleep after Nursing c. 1900
Pencil on paper, 19¼ × 12⅜ in., 49 × 31.4 cm.
Signed toward lower right: *M. C.*

Description: A mother in profile left looks down at her baby asleep. He rests on her right arm. With her left hand, summarily drawn, she raises her breast from which he has been nursing. Her hair is pompadoured.

Collections: H.M.P., Paris.

837
Head of a Young Woman Turned to Left
c. 1900
Black crayon on tan paper, 12¼ × 12 in.,
31 × 30.5 cm.
Unsigned

Description: Head of a young woman with hair parted on the far side and drawn into a very wide, heavy knot at the back. Her large eyes look somewhat to left.

Collections: From the artist to Mathilde Vallet, 1927; Mathilde X sale, Paris, 1927; M. Simonson, Paris; Schweitzer Gallery, New York, 1958; present location unknown.

Exhibitions: Galerie A.-M. Reitlinger, Paris, 1927 (cat. 24).

Reproductions: Arts Magazine, Oct. 1958.

838
Sketch of Mother Berthe Holding Her Nude Baby c. 1900
Pencil on paper, 7⅝ × 6⅛ in., 19.2 × 15.3 cm.
Unsigned. Mathilde X collection stamp at lower right.

Description: This slight outline sketch is a mirror image of "Mother Berthe Holding Her Nude Baby" (BrCR 319) and is definitely connected with it. It is, however, so faint that one can scarcely see it.

Note: Also called "Femme embrassant un bébé."

Collections: From the artist to Mathilde Vallet, 1927; Mathilde X sale, Paris, 1931; Anthony d'Offay, London; *Bob Willoughby*, Pacific Palisades, California.

Exhibitions: Galerie A.-M. Reitlinger, Paris, 1931 (cat. 143).

839
Sleeping Baby 1901
Crayon and pastel on paper, 7⅛ × 8¾ in.,
18.2 × 22.3 cm.
Signed lower right: *M. C. 1901*

Description: Head of a baby with covers tucked up to his chin, his eyes closed, his head leaning against a pillow. He has curly blond hair and long dark lashes. Pastel only on highlights of nose and cheeks.

Collections: Galerie Bernheim-Jeune, Paris; present location unknown.

840
Nude Child on Mother's Lap c. 1901
Pencil on tan paper, 18¼ × 15¼ in., 46.3 × 38.8. cm.
Unsigned. Mathilde X collection stamp at lower right.

Description: Summary sketch of a child turned toward left and seated on his mother's lap. His left arm is akimbo. Her head is very hazy.

Note: Also called "Enfant assis." Durand-Ruel 19851B-13991.

Collections: From the artist to Mathilde Vallet, 1927; Mathilde X sale, Paris, 1931; Durand-Ruel, Paris, 1966.

Exhibitions: Galerie A.-M. Reitlinger, Paris, 1931 (cat. 151).

841

A Baby on His Mother's Lap c. 1901

Soft pencil on paper, 22½ × 26¼ in., 57.5 × 67 cm.
Unsigned. Mathilde X collection stamp at lower
left corner.

Description: A nude baby in profile right holds
his mother's left hand with his right hand, his
legs extend stiffly to lower right. The mother in
profile left has pompadoured hair. A summary
sketch.

Note: Also called "Femme et bébé." Durand-Ruel
19847-13949.

Collections: From the artist to Mathilde Vallet,
1927; Mathilde X sale, Paris, 1931; Durand-Ruel,
Paris, 1966.

Exhibitions: Galerie A.-M. Reitlinger, Paris, 1931
(cat. 73).

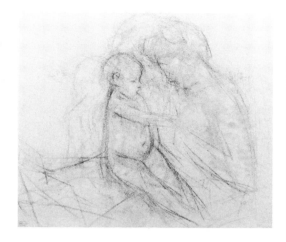

843

Study for "The Picture Book (No. 1)"
c. 1901

Pencil on cream paper, 8¾ × 6 in., 22.4 × 15.2 cm.
Signed lower right: *M. C*

Description: Heads of mother and child both
looking down toward left. Faces and hair of both
are shaded, with delicate modeling of mother's
face especially. The book is not shown.

Note: A study for drypoint Br 176.

Collections: H.M.P., Paris.

842

Head of a Woman Looking Left c. 1901

Crayon touched with white on gray paper,
16 × 12 in., 40.6 × 30.5 cm.
Unsigned

Description: Head of a woman looking left, seen in
three-quarter view. Her hair is drawn up with a
knot on top of her head and a small pompadour.
She has a very serious expression.

Collections: *Dartmouth College*, Hanover, New
Hampshire, gift of Mr. and Mrs. Preston Harrison,
1955.

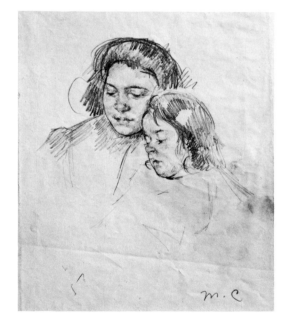

844

Drawing for "The Picture Book (No. 1)"
c. 1901

Pencil on paper folded to 9 × 6 in., 23 × 15.2 cm.,
on page 12 5/16 × 7 13/16 in., 31.3 × 20 cm.
Signed toward lower right: *M.C*

Description: Mother and daughter both look down
toward left at a book indicated by one diagonal
line.

Note: This is related to a drypoint of the same
title (Br 176) and is carried somewhat further
than the other study as to the pose of the
child's arm and her dress.

Collections: *National Gallery of Art*, Washington,
D.C., Rosenwald Collection.

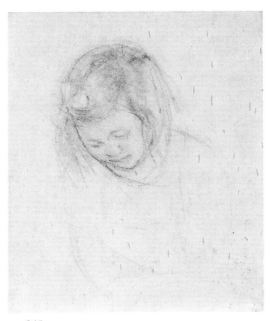

845
Head of Sara Looking Down (No. 1) c. 1901
Pencil on paper, 19¼ × 13¼ in., 49 × 33.5 cm.
Unsigned. Mathilde X collection stamp on verso.

Description: Sara's head and shoulders, with slight indication of arms. She bends her head forward so that her straight hair falls forward over her shoulders. It is parted on the side and held with a bow on left.

Note: Also called "Jeune fille tête baissée." Durand-Ruel 19846B.

Collections: From the artist to Mathilde Vallet, 1927; Mathilde X sale, Paris, 1931; Durand-Ruel, Paris, 1966.

Exhibitions: Galerie A.-M. Reitlinger, Paris, 1931 (cat. 112).

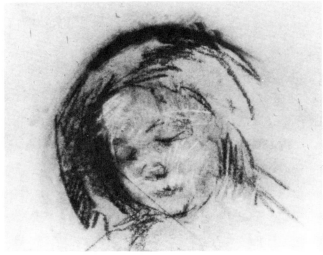

846
Head of Sara Looking Down (No. 2) c. 1901
Colored crayon on paper, 11¼ × 13½ in., 28.5 × 34.5 cm.
Unsigned

Description: A little girl's head only with straight hair hanging down almost to her shoulder at left, parted on the right side.

Collections: Art Institute of Chicago, gift of Carter H. Harrison (sold 1955); present location unknown.

Reproductions: Margaret Breuning, 1944, p. 8.

847
Head of Sara Looking Down (No. 3) c. 1901
Crayon on paper
Unsigned

Description: Head only of little Sara looking down. It is a study for one of the pastels of her with her dog, looking down at the dog. There is diagonal shading on the side of her face and on her hair.

Collections: Musée des Beaux-Arts, Paris, gift of Mme. Jean d'Alayer.

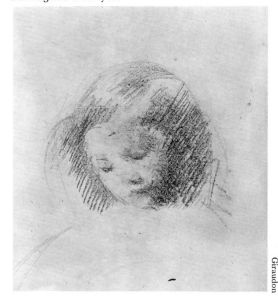

848
Sketch for "Sara . . . Feeding Her Dog" (No. 1) c. 1901
Sanguine on paper, 11⅜ × 8⅝ in., 29 × 22 cm. (sight)
Signed lower right: *Mary Cassatt*. Mathilde X collection stamp at lower right corner

Description: Quick sketch of head and shoulders of a little girl seen in three-quarter view to left, looking down to left. Summary lines of her dress are vague as is a shape to indicate her dog.

Collections: From the artist to Mathilde Vallet, 1927; Mathilde X sale, Paris, 1931; Paul Reinhart Gallery, New York, 1931; to Herman Kristerer, Hackensack, New Jersey; Parke-Bernet sale, New York, 11 April 1962; to *Samuel E. Weir*, London, Ontario, Canada.

Exhibitions: Galerie A.-M. Reitlinger, Paris, 1931 (cat. 108).

849
Sketch for "Sara . . . Feeding Her Dog"
(No. 2) c. 1901
Pencil and crayon on paper, 22 × 16 in.,
56 × 40.7 cm.
Signed lower right: *Mary Cassatt*

Description: Sketch of Sara's head for the pastel of
"Sara, with Bonnet Streamers Loose, Feeding
Her Dog," (BrCR 362), but without the bonnet
or dog. Only her face is developed.

Collections: Private collection, New York; present
location unknown.

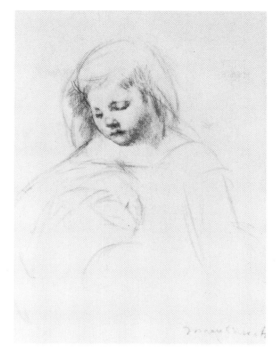

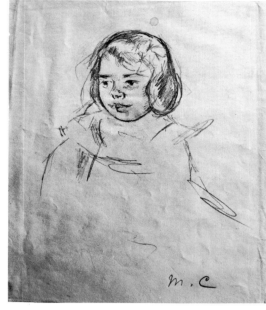

850
Sketch for "Sara Smiling" (No. 1) c. 1901
Pencil on paper folded to $7\frac{1}{2}$ × 6 in., 19 × 15 cm.
Signed lower right: *M. C.*

Description: Head and shoulders of a little girl
looking off to left. She has a bow on her hair
over her left eye. Her dress is summarily suggested
with a bertha extending over the shoulders.

Note: A study for Br 195.

Collections: H.M.P., Paris.

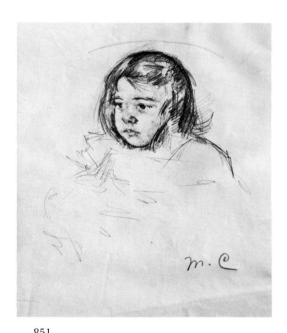

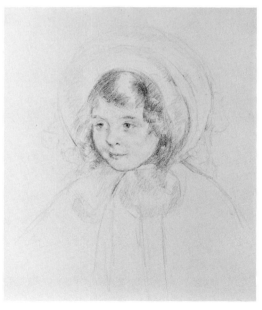

851
Sketch for "Sara Smiling" (No. 2) c. 1901
Pencil on paper folded to $8\frac{3}{4}$ × 6 in., 22.3 × 15.2 cm.
Signed lower right: *M. C*

Description: Head only of a little girl *not* smiling
as she looks off to the left. Her face is well modeled
with sensitive shading. Her hair is drawn over to
the right side with a small bow. A curved line
above her head suggests the top of a chair.

Note: A study for Br 195.

Collections: H.M.P., Paris.

852
**Drawing for "Sara Wearing Her Bonnet and
Coat"** c. 1901
Conté crayon on paper, $17\frac{1}{2}$ × 14 in.,
44.5 × 35.6 cm.
Unsigned

Description: Head and shoulders of a little girl
wearing a large, round bonnet tied under her
chin. She looks to left.

Note: A preparatory drawing for the lithograph
 (Br 198).

Collections: Mrs. Percy C. Madeira, Berwyn, Penn-
sylvania.

Exhibitions: Baltimore Museum of Art, 1941–42
(cat. 79).

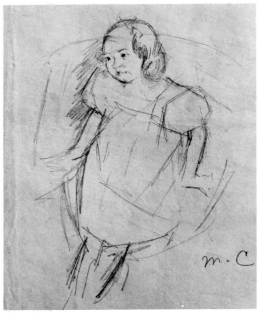

854
Drawing for "Sara, Leaning against an Upholstered Settee" c. 1901
Crayon on paper folded to $9\frac{1}{4} \times 6\frac{3}{4}$ in., 23.5×17 cm.
Signed toward lower right: *M. C*

Description: Half-length view of a little girl in profile to left. Her hair hangs onto her shoulder, and she rests her left hand on the back of an upholstered settee and looks off to the left.

Note: This is the preparatory drawing for Br 196, with very similar effect, carried almost as far.

Collections: H.M.P., Paris.

853
Little Girl in a Party Dress c. 1901
Pencil and crayon on paper folded to $8\frac{3}{4} \times 6$ in., 22.3×15.3 cm.
Signed lower right: *M. C*

Description: A little girl wearing a dress with short, puffed sleeves leans against an upholstered chair, resting both hands on the seat, and looks to left. Her hair curls over her ears.

Collections: H.M.P., Paris.

855
Sketch of Madame Fontveille c. 1902
Pencil on tan paper, $15 \times 10\frac{1}{2}$ in., 38×26.6 cm.
Signed toward lower right: *M. C*

Description: A woman's head and shoulders with head tilted to left. She looks at the spectator and is shown in full face. Her hat is suggested and a shaded area on her shoulder at left suggests a fur piece. The paper is badly creased.

Note: Also called "Tête de femme au chapeau, croquis au crayon." It is related to the drypoint Br 170 and is probably a first sketch for it.

Collections: H.M.P., Paris.

Exhibitions: Marlborough Fine Art Ltd., London, 1953 (cat. 25).

856
Portrait Sketch of Madame Fontveille (No. 1) c. 1902
Pencil on tan paper folded to $16\frac{1}{4} \times 11\frac{1}{2}$ in., 42×29.3 cm.
Signed lower right: *M. C*

Description: A woman sits on a chair with a rounded back, with her hands folded in her lap, wearing a dark hat and a long coat with wide reveres.

Note: Used to transfer the drawing to the plate for the drypoint (Br 170). Blue pencil lines on verso.

Collections: H.M.P., Paris.

859

Study for "The Caress" c. 1902

Pencil on white paper, $11\frac{3}{4} \times 8\frac{1}{2}$ in., 30×21.7 cm. Unsigned. Mathilde X collection stamp at lower left.

Description: The three heads are very sensitively drawn with the pose of the baby suggested. The mother's face is only half delineated.

Note: A study for BrCR 393. Also called "Femme et fillettes s'embrassant." Durand-Ruel 19855A-13983.

Collections: From the artist to Mathilde Vallet, 1927; Mathilde X sale, Paris, 1931; Durand-Ruel, 1966.

Exhibitions: Galerie A.-M. Reitlinger, Paris, 1931 (cat. 136).

860

Sketch of Reine's Head c. 1902

Pencil on light gray paper, $6\frac{1}{8} \times 9\frac{1}{16}$ in., 15.3×23 cm. (sight)
Unsigned. Mathilde X collection stamp at lower left corner.

Description: Head of a young woman with pompadoured hair, with loose ends over her ears. She looks directly at the spectator.

Note: Also called "Tête de femme."

Collections: From the artist to Mathilde Vallet, 1927; Mathilde X sale, Paris, 1931; Theodore Schempp, Paris; to Etta Cone, Baltimore, c. 1944; to the *Baltimore Museum of Art*, Cone Collection.

Exhibitions: Galerie A.-M. Reitlinger, Paris, 1931 (no. 159, illus.); Baltimore Museum of Art, 1936 (cat. 9); Baltimore Museum of Art, 1941–42 (cat. 77); Baltimore Museum of Art, "Manet, Degas, Berthe Morisot and Mary Cassatt" (cat. 126), 1962.

857

Portrait Sketch of Madame Fontveille (No. 2) 1902

Lead pencil on paper, $16 \times 11\frac{1}{4}$ in., 40.7×28.7 cm. Signed lower right: *Mary Cassatt.* Inscribed at upper right corner: *Mme. Ley Fontveille/Ave. d'Eylau 26.*

Description: Three-quarter length view of a woman seated with her left arm resting on the end of an upholstered couch. She wears a wide hat with her pompadoured hair showing under it. A long fur piece is around her shoulders. She looks to left.

Note: Madame Fontveille was a spiritualist medium to whose home Miss Cassatt went in 1902 for some seances. Durand-Ruel 7954-L10584.

Collections: Mr. and Mrs. Leo M. Rogers, New York.

Exhibitions: Baltimore Museum of Art, 1941–42 (no. 76); Marlborough Fine Art Ltd., London, 1953 (cat. 23); Baltimore Museum of Art, "Manet, Degas, Berthe Morisot and Mary Cassatt" (cat. 127), 1962.

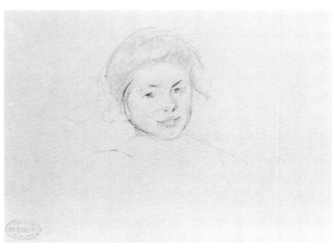

858

Still Life of Bottle and Glass c. 1902

Pencil on gray paper, $7\frac{1}{4} \times 4\frac{3}{4}$ in., 18.5×11 cm. Unsigned. Mathilde X collection stamp at lower right.

Description: A part of a round table or tray with a bottle, glass, cup, etc. Summarily outlined.

Collections: From the artist to Mathilde Vallet, 1927; Stefan Ehrenzweig, Este Gallery, New York, 1965; present location unknown.

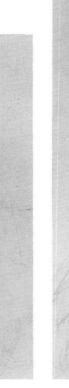

861

Reine Lefebvre Holding a Nude Child on Her Left Arm c. 1902
Pencil on white paper folded to 13½ × 9¼ in.,
34.5 × 23.5 cm.
Unsigned

Description: Reine looks off to left and holds a nude child on her left arm. The blond child presses her left hand against Reine's chest and looks off to left.

Note: Used for transfer to a plate, with blues lines on verso. No examples of a finished print are known. It is related to BrCR 406.

Collections: H.M.P., Paris.

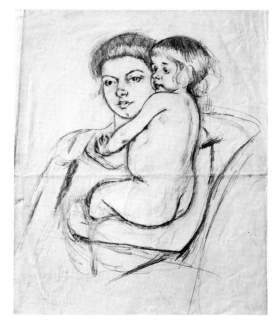

862

Margot Leaning against Reine's Knee (No. 1)
c. 1902
Pencil on cream paper folded to 14⅝ × 10⅜ in.,
37 × 26.4 cm.
Signed below center right: *M. C*

Description: The first of four studies related to "Young Mother Sewing" (BrCR 415). Here the figure of the little girl is more developed than that of the mother, who is seated at right with her left arm resting on the back of a chair.

Collections: H.M.P., Paris.

863

Margot Leaning against Reine's Knee (No. 2)
c. 1902
Pencil on paper folded to 14¾ × 10⅜ in.,
37.3 × 26.3 cm.
Signed lower right: *M. C*

Description: In this sketch attention is focused more on the young woman. Her features are more developed as well as her hair and the neck of her dress. Her body and the figure of the little girl are more sketchily suggested.

Collections: H.M.P., Paris.

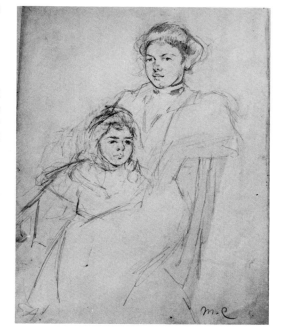

864

Margot Leaning against Reine's Knee (No. 3)
c. 1902
Pencil on cream paper folded to 16¼ × 11½ in.,
41 × 29 cm.
Signed lower right: *M. C*

Description: Here the focus is again on the little girl. Her head is drawn with very dark pencil in quite some detail, whereas Reine's is summarily sketched.

Collections: H.M.P., Paris.

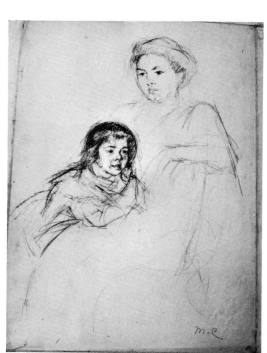

865
Margot Leaning against Reine's Knee (No. 4)
c. 1902
Pencil on paper folded to $15 \times 10\frac{1}{2}$ in.,
38×26.5 cm.
Signed toward lower right: *M. C*

Description: Here for the first time Reine is shown
sewing. She looks down at her sewing held up in
both hands before her. She faces and is turned
left seated on a round-backed chair. Little Margot
looks off to right as she leans against her mother's
lap.

Collections: H.M.P., Paris.

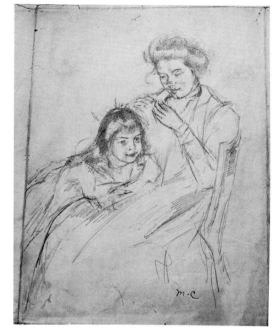

866
**Study for "Portrait of Margot in a Large Red
Bonnet"** c. 1902
Pencil on paper folded to $7\frac{1}{8} \times 5\frac{1}{4}$ in.,
18×13.5 cm.
Signed lower right: *M. C*

Description: The face only of a little girl. She is
seen in three-quarter view to left, her hair parted
on the far side, curling around onto her cheek.

Note: A study for BrCR 425.

Collections: H.M.P., Paris.

867
**Sketch of Louise in a Fluffy Bonnet and Long
Coat** c. 1902
Pencil on cream paper, $12\frac{3}{4} \times 9\frac{7}{8}$ in., 32.5×25 cm.
Signed lower right: *M. C*

Description: A little girl stands looking to left in
three-quarter view. Her face is developed with
shading and there is some shading on her hair,
which is parted on the side to right. The bonnet
and coat with shoulder cape are sketched
summarily in outline.

Collections: H.M.P., Paris.

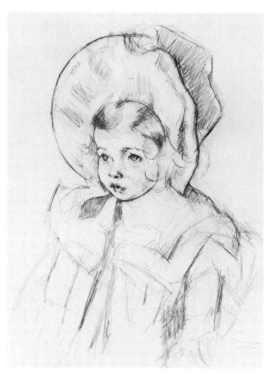

868
**Louise Wearing a Large, High Bonnet and
a Coat** c. 1902
Pencil on paper, 7×5 in., 18×12.7 cm.
Unsigned

Description: Half-length of a little girl in a high
bonnet which ties under her chin and a coat
with a wide, square yoke and ruffle beyond. Her
hair is brushed to the side and curls over her ears.

Collections: From the artist to J. Howard Whitte-
more, Naugatuck, Connecticut; Parke-Bernet,
New York, Whittemore estate sale, 19 May 1948
(cat. 148); present location unknown.

Exhibitions: Baltimore Museum of Art, 1941–42
(cat. 78).

Sketch of Louise in a Big Fluffy Bonnet with Reine c. 1902

Pencil on light tan paper, 8½ × 5¾ in., 21.5 × 14.5 cm.
Unsigned. Mathilde X collection stamp at lower right.

Description: Louise's head is detailed. She wears a big fluffy bonnet with a bunch of daisies on top. Her mother's head, looking from behind and down at her, is barely indicated.

Note: Also called "Fillette au chapeau." Durand-Ruel 19859C-13971.

Collections: From the artist to Mathilde Vallet, 1927; Mathilde X sale, Paris, 1931; Durand-Ruel, Paris, 1966.

Exhibitions: Galerie A.-M. Reitlinger, Paris, 1931 (cat. 107).

870

Sketch of Reine Looking at Louise over Her Left Shoulder c. 1902

Pencil on gray paper, 17⅞ × 18¾ in., 45 × 48 cm.
Unsigned. Mathilde X collection stamp on verso.

Description: The little girl looks off to right, Reine looks at her, their two heads close together. Louise has her hair brushed to the left with a suggestion of a bow. She is not wearing a hat. Her arms show but not her hands.

Note: Also called "Deux têtes" and "Femme et fillette (deux têtes)." Durand-Ruel 19850A.

Collections: From the artist to Mathilde Vallet, 1927; Mathilde X sale, Paris, 1931; Durand-Ruel, Paris, 1966.

Exhibitions: Galerie A.-M. Reitlinger, Paris, 1931 (cat. 148).

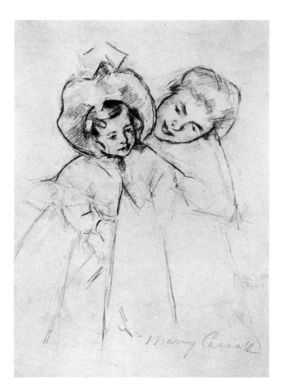

872

Reine Supporting Little Louise Wearing a Large Bonnet c. 1902

Pencil on paper, 8⅝ × 6⅜ in., 22 × 16.3 cm.
Signed lower right: *Mary Cassatt*

Description: Little Louise looks off to the right, wearing a large, high, fluffy bonnet and a coat with a ruffled shoulder-length cape. Reine looks over Louise's left shoulder at her. Their two heads are close together.

Collections: Suzor, Paris; O. Wertheimer, Paris; International Galleries, Chicago; *Drs. Paul and Laura Mesaros*, Steubenville, Ohio.

Exhibitions: Galerie Charpentier, Paris, "L'Enfance," 1949; Musée Département de l'Oise, Beauvais, "Hommage à Mary Cassatt" (cat. 4) (called "Mère et enfant"), 1965.

871

Louise, in a Fluffy Bonnet and a Coat, Held by Reine c. 1902

Pencil on cream paper folded to 8⅝ × 6 in., 22 × 15.3 cm.
Signed lower right: *M. C*

Description: A little girl stands turned somewhat to right and looks to right. She wears a big fluffy bonnet under which her hair, parted on the side, shows as it curls over her ears. Head and shoulders only. Reine's head is seen looking over her left shoulder toward upper right.

Collections: H.M.P., Paris.

873
Margot's Head c. 1902

Pencil on paper, 5¼ × 8¼ in., 13.5 × 21 cm.
Unsigned. Mathilde X collection stamp at lower left.

Description: Head only of dark-haired Margot looking off to right, wearing a large fluffy hat which is only slightly sketched.

Note: Also called "Tête de fillette, chapeau esquissé."

Collections: From the artist to Mathilde Vallet, 1927; Mathilde X sale, Paris, 1931; present location unknown.

Exhibitions: Galerie A.-M. Reitlinger, Paris, 1931 (cat. 162, illus.).

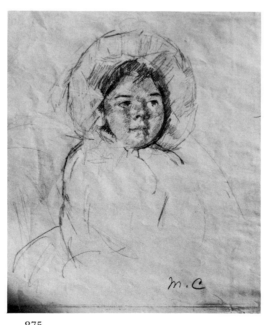

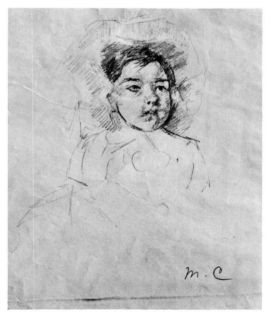

874
Margot in a Ruffled Bonnet (No. 1) c. 1902
Pencil and crayon on paper folded to 7¼ × 6¼ in., 18.5 × 16 cm.
Signed lower right: *M. C*

Description: Head of little Margot looking to right. Her straight, dark hair falls onto her shoulders. Her big bonnet, barely outlined, has a deep ruffle falling down from the brim, used here and in the next five drawings.

Note: Preparatory drawing for the drypoint Br 180.

Collections: H.M.P., Paris.

875
Margot in a Ruffled Bonnet (No. 2) c. 1902
Pencil and crayon on paper folded to 7¼ × 6¼ in., 18.5 × 16 cm.
Signed lower right: *M. C*

Description: Head and shoulders of Margot in her big bonnet tied under her chin so that her hair only shows above and around her forehead. Her face has much shading.

Note: Preparatory drawing for the drypoint Br 180.

Collections: H.M.P., Paris.

876
Margot in a Ruffled Bonnet (No. 3) c. 1902
Pencil and crayon on paper folded to 7¼ × 6¼ in., 18.5 × 16 cm.
Signed lower right: *M. C*

Description: Margot's head is well developed, her face shaded all over, but without as much dark hair showing under her bonnet as in the first sketch. Outline of figure is slightly indicated. The bonnet has an outline of flowers on top.

Note: Preparatory drawing for the drypoint Br 180.

Collections: H.M.P., Paris.

877

Margot in a Ruffled Bonnet (No. 4) c. 1902

Pencil and crayon on paper folded to 7¼ × 6¼ in.,
18.5 × 16 cm.

Signed lower right: *M. C*

Description: Margot sits in an upholstered chair
with a curved side of wood showing at left. An
indication of arms forward but not of hands folded
in her lap. No smile.

Note: Preparatory drawing for the drypoint
Br 180.

Collections: H.M.P., Paris.

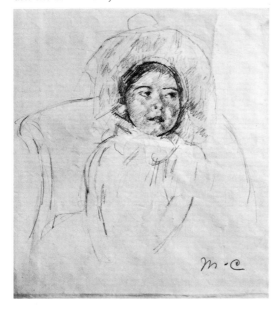

878

Smiling Margot Seated in a Ruffled Bonnet
c. 1902

Pencil and crayon on paper folded to 7¼ × 6¼ in.,
18.5 × 16 cm.

Signed lower right: *M. C*

Description: Margot looks toward the right (in
reverse of the print). She smiles, seated on an
upholstered settee, her hands folded in her lap.

Note: Preparatory drawing for the drypoint
Br 180.

Collections: H.M.P., Paris.

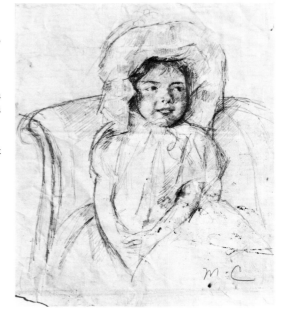

879

**Full-Length View of Margot in a Ruffled
Bonnet** c. 1902

Pencil and crayon on cream paper folded to
13 × 9 in., 33 × 23 cm.

Signed toward lower right: *M. C*

Description: Full-length view of Margot in a light
ruffled bonnet seated on an upholstered settee
looking off to the right, her hands folded in her
lap. Her left leg and shoe are described.

Note: This version was not chosen for the print
(Br 180) but instead the 5th sketch (BrCR 878)
which probably preceded it.

Collections: H.M.P., Paris.

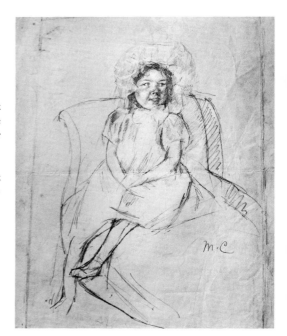

880

**Drawing for "Study of Margot in a Fluffy
Hat"** 1902

Pencil on paper, 9 1/16 × 6½ in., 23 × 16.5 cm.

Signed lower right: *M. C*

Description: Three-quarter length view of Margot
in a ruffled bonnet seated on an upholstered settee
looking off to the right. Her right arm rests on the
back of the settee, her left hand on the seat beside
her. Her face is more rounded than in other
sketches of her.

Note: This is a study for the pastel BrCR 428.

Collections: Wadsworth Atheneum, Hartford, Con-
necticut, bequest of George A. Gay, 1941.

Exhibitions: Detroit Institute of Fine Arts, "Paul
J. Sachs, 70th Birthday Celebration," 1948;
Wadsworth Atheneum, "60 Drawings from the
Wadsworth Atheneum," 1949; Litchfield County
Art Association, Winsted, Connecticut, 1960;
Baltimore Museum of Art, "Manet, Degas, Berthe
Morisot and Mary Cassatt" (cat. 128), 1962;
Huntington Galleries, Huntington, W. Va.,
"Mary Cassatt and Berthe Morisot" (cat. 3),
1962; Parrish Art Museum, Southampton, N.Y.,
1967 (cat. 50) (called "Portrait of a Child").

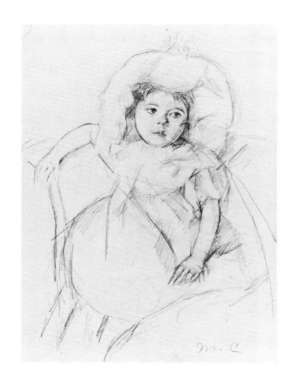

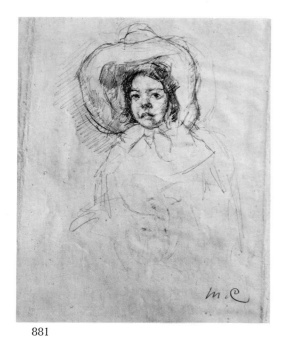

881

Margot in a Floppy Bonnet (No. 1) c. 1902
Pencil and crayon on cream paper folded to
8⅞ ×6¼ in., 22.5 ×15.5 cm.
Signed lower right: *M. C*

Description: Head and shoulders only of Margot
looking at the spectator. Her dark hair outlines
her face. Her large, fluffy bonnet is shaded some-
what. An erased head shows in the lower section
of the paper, upside down.

Note: Preparatory drawing for the drypoint
Br 185.

Collections: H.M.P., Paris.

882

Margot in a Floppy Bonnet (No. 2) c. 1902
Pencil and crayon on cream paper folded to
8¾ ×6⅛ in., 22.3 ×15.3 cm.
Signed lower right: *M. C*

Description: Margot is seen in three-quarter length,
as in the print, with her hand on the seat of a
chair, but the rest of the chair is not yet described.
Her head is not tilted.

Note: Preparatory drawing for the drypoint
Br 185.

Collections: H.M.P., Paris.

883

Margot in a Floppy Bonnet (No. 3) c. 1902
Pencil and crayon on paper folded to 8¾ ×6⅛ in.,
22 ×15.3 cm.
Signed lower right: *M. C*

Description: Margot is seen very much as in the
print but in reverse with her hand resting on the
seat of a French chair. Her head is tilted as in
the print.

Note: Preparatory drawing for the drypoint
Br 185.

Collections: H.M.P., Paris.

884

Sketch of Margot Wearing a Bonnet (No. 1)
c. 1902

Pencil on cream paper, 8 ×6¼ in., 20.5 ×15.6 cm.
Signed lower right: *M. C*

Description: A very rough sketch with general pose
indicated and the line of the stiff, round bonnet
emphasized.

Note: Preparatory drawing for the drypoint
Br 183.

Collections: H.M.P., Paris.

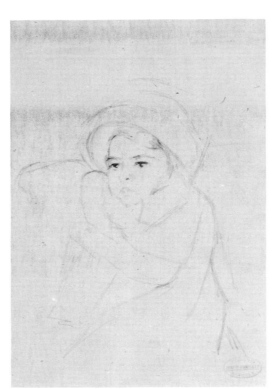

885
Sketch of Margot Wearing a Bonnet (No. 2)
c. 1902
Pencil on white paper, $8\frac{1}{4} \times 5\frac{1}{4}$ in., 21×13.5 cm.
Unsigned. Mathilde X collection stamp at lower right.

Description: Margot's face and bonnet are very large in proportion to the outline of her arms. One arm is placed high against chair back, the left one lower with hands clasped.

Note: Preparatory drawing for the drypoint Br 183. Also called "Fillette au chapeau." Durand-Ruel 19863D.

Collections: From the artist to Mathilde Vallet, 1927; Mathilde X sale, Paris, 1931; Durand-Ruel, Paris, 1966.

Exhibitions: Galerie A.-M. Reitlinger, Paris, 1931 (cat. 59).

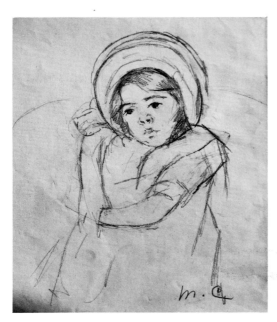

886
Sketch of Margot Wearing a Bonnet (No. 3)
c. 1902
Pencil on cream paper folded to $7\frac{1}{2} \times 6$ in., 19×15.3 cm.
Signed lower right: *M. C*

Description: Margot seated on a sofa looks off to left. The pose of her two arms is indicated but without any detail of hands. Her dark hair is parted to the side under her stiff, round bonnet.

Note: Preparatory drawing for the drypoint Br 183.

Collections: H.M.P., Paris.

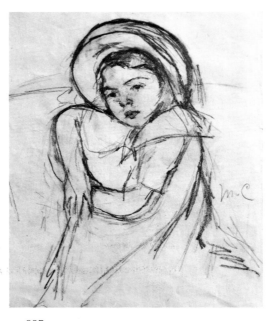

887
Sketch of Margot Wearing a Bonnet (No. 4)
c. 1902
Pencil and crayon on cream paper folded to $7\frac{5}{8} \times 6\frac{1}{16}$ in., 19.5×15.5 cm.
Signed just below center right: *M. C*

Description: A little girl is seated on a sofa with her right arm raised to lean against the sofa back and her right hand clasping her left arm. She looks toward left and wears a stiff, round bonnet.

Note: Preparatory drawing for the drypoint Br 183.

Collections: H.M.P., Paris.

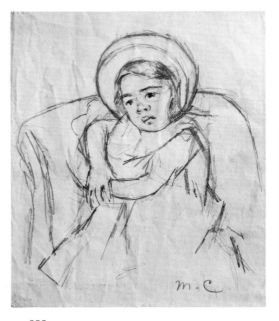

888
Sketch of Margot Wearing a Bonnet (No. 5)
c. 1902
Pencil on cream paper folded to $7\frac{1}{2} \times 6\frac{1}{4}$ in., 19×16 cm.
Signed lower right: *M. C*

Description: A little girl is seated on a sofa with her right hand clasping her left arm. She looks to left. Her hair is parted on the side under her stiff, round bonnet.

Note: Preparatory drawing for the drypoint Br 183.

Collections: H.M.P., Paris.

889

Margot in a Bonnet with a Wavy Brim (No. 1)
c. 1902
Pencil on cream paper folded to 8¾ × 6 in.,
22.3 × 15.3 cm.
Signed toward lower right: *M. C*

Description: A little girl looking to left wears a
stiff, dark bonnet with a wavy brim, tied under her
chin with a dark ribbon. The brim forms **S** curves.

Note: Preparatory drawing for the drypoint
Br. 189.

Collections: H.M.P., Paris.

890

Margot in a Bonnet with a Wavy Brim (No. 2)
c. 1902
Pencil on cream paper folded to 8⅝ × 6 in.,
22 × 15.3 cm.
Signed toward lower right: *M. C*

Description: A little girl seated on a big chair looks
to left. She wears a dark bonnet, the brim of
which forms **S** curves. The hat is tied under her
chin. Her arms, in bare outline, are folded on
her lap. Both face and hat are richly shaded.

Note: Preparatory drawing for the drypoint
Br 189.

Collections: H.M.P., Paris.

891

Margot in a Bonnet with a Wavy Brim (No. 3)
c. 1902
Pencil on cream paper folded to 8⅞ × 6 in.,
22.5 × 15.3 cm.
Signed lower right: *M. C*

Description: Little Margot kneels on a sofa which
is seen from the back and rests her left arm on
the top of it. She wears a dark bonnet, the brim
of which forms **S** curves. She looks off to the left.

Note: Preparatory drawing for the drypoint
Br 189.

Collections: H.M.P., Paris.

892

Simone Wearing a Bonnet with a Wavy Brim
c. 1903
Pencil on paper, 8¾ × 6¾ in., 22.3 × 17 cm.
Signed toward lower right: *Mary Cassatt*

Description: A little girl wearing a dark bonnet
with a wavy brim sits in an armchair, her left arm
resting on the chair arm. She looks off to the
right.

Note: Related to the drypoint Br 188. Also called
"Portrait of Child in a Bonnet."

Collections: August F. Jaccaci, New York; to
the *Metropolitan Museum of Art*, New York, gift of
Mrs. Joseph du Vivier, 1954.

893

Half-length of a Little Girl in a Pinafore
c. 1903
Pencil and crayon on paper folded to 7⅝ × 6⅛ in.,
19.5 × 15.5 cm.
Signed lower right: *M. C*

Description: Half-length view of a little girl who
looks to left wearing a straight simple pinafore.
Her hair is shaded and brushed back over her ear.

Collections: H.M.P., Paris.

894
Sketch of a Little Girl Looking Left c. 1903
Pencil and crayon on paper folded to 7⅝ × 6 in.,
19.5 × 15.3 cm.
Signed lower right: *M. C*

Description: A little girl with a serious expression
and long, unkempt hair looks to the left, seen in
half-length. Her dress is sketched very broadly and
roughly. A few bangs fall over her forehead.

Collections: H.M.P., Paris.

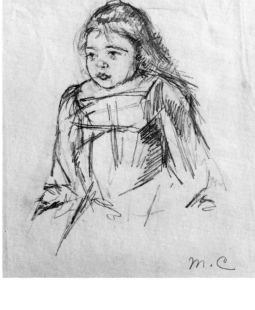

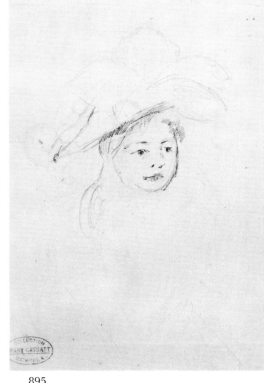

896
Sketch of Simone in a Festive Hat (No. 2)
c. 1903
Soft pencil on cream paper folded to 7 × 4¾ in.,
18 × 12 cm.
Signed lower right: *M. C*

Description: A sketch of a little girl seen in half-
length facing forward and looking somewhat to
right. Her large hat has big loops of ribbon bows
on it and is tied in a large bow under her chin.
Her dark hair hangs down her back. Her hands
clasped before her are barely indicated.

Collections: H.M.P., Paris.

897
Sketch of Simone in a Festive Hat (No. 3)
c. 1903
Pencil on cream paper folded to 7½ × 4¾ in.,
19 × 12 cm.
Signed lower right: *M. C*

Description: The features are here more detailed
and the hat is treated with more care. The pose is
still very summarily suggested.

Collections: H.M.P., Paris.

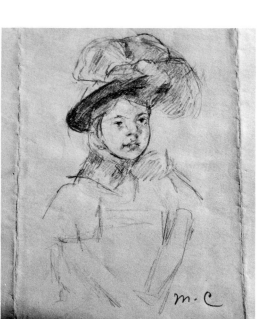

895
Sketch of Simone in a Festive Hat (No. 1)
c. 1903
Pencil and crayon on paper, 6¾ × 5 in.,
17 × 12.5 cm. (sight)
Unsigned. Mathilde X collection stamp at lower
left corner.

Description: Head only of a little girl wearing a
big, elaborate hat piled high with bows. Under
it her long hair falls down over her shoulders.
She looks off to the right.

Note: Also called "Fillette au chapeau de gala."
Durand-Ruel A1658-NY9315; 13975.

Collections: From the artist to Mathilde Vallet,
1927; Mathilde X sale, Paris, 1931; Durand-Ruel,
Paris; Mrs. H. Huddleston Rogers; to her son,
Arturo Peralta-Ramos, New York.

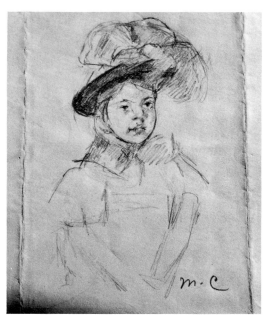

898
Sketch of Simone in a Festive Hat (No. 4)
c. 1903
Pencil on cream paper folded to 7⅛ × 5¼ in.,
18.2 × 13.3 cm.
Signed lower right: *M. C*

Description: The head and hat are treated with
more detail and more variety of shading. The
brim of the hat is very dark and the underside of
it is shown.

Note: Blue outlines show on verso.

Collections: H.M.P., Paris.

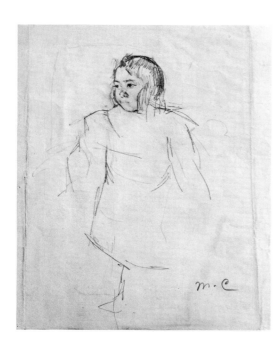

899

Sketch for "Simone Seated with Hands and Feet Crossed" (No. 1) c. 1903

Pencil and crayon on paper folded to $8\frac{3}{4} \times 6\frac{1}{8}$ in., 22×15.5 cm.

Signed lower right: *M. C*

Description: A little girl with dark eyes and rather light hair looks to left. Her full figure is slightly suggested, including the tip of one shoe. Her hair is shaded. The figure is mostly in outline.

Note: Sketch for BrCR 901.

Collections: H.M.P., Paris.

900

Sketch for "Simone Seated with Hands and Feet Crossed" (No. 2) c. 1903

Pencil on paper folded to $8\frac{3}{4} \times 6$ in., 22.3×15.2 cm.

Signed lower right: *M. C*

Description: Little Simone sits in a chair looking to left. Her head is well developed with shading. Her pose is summarily sketched without details of hands together or feet crossed. She holds a book in her hands.

Note: Sketch for BrCR 901.

Collections: H.M.P., Paris.

901

Simone Seated with Hands and Feet Crossed
c. 1903

Pencil on paper, $8\frac{5}{8} \times 6\frac{3}{16}$ in., 22×16 cm.

Signed lower right corner: *M. C*

Description: A little girl sits primly in a chair, looking to left. Her crossed hands rest in her lap and her ankles are also crossed. She wears a dress with a square yoke trimmed with a wide ruffle.

Collections: Cleveland Museum of Art, Leonard C. Hanna, Jr. Collection.

902

Head of Little Girl Leaning on Her Hands
c. 1903

Pencil on cream paper folded to $8\frac{3}{4} \times 6\frac{1}{8}$ in., 22.3×15.5 cm.

Signed lower right: *M. C*

Description: Head of a little girl looking to left. Her features are described. Her shoulders and arms are sketched summarily with an indication of a pose as though she were leaning on her hands extended before her.

Collections: H.M.P., Paris.

903
Full-Length Sketch of a Little Girl Leaning Forward on Her Hands c. 1903
Pencil on cream paper folded to $8\frac{7}{8} \times 6\frac{1}{8}$ in., 22.7 × 15.5 cm.
Signed lower right: *M. C*

Description: A child looks down with eyes lowered as she sits resting both hands before her. Her straight hair is caught in a bow toward right. Her dress has puffed short sleeves.

Collections: H.M.P., Paris.

904
Head of Simone c. 1904
Pencil on white paper, 6 × 9 in., 15.2 × 23 cm.
Unsigned. Mathilde X collection stamp at lower right.

Description: Head only of little girl turned to left and looking left. Her long hair falls onto her shoulders and is caught up at the top of her head. Start of another head at lower left.

Note: Also called "Tête de fillette (une tête esquissée en travers)." Durand-Ruel 19860B-13966.

Collections: From the artist to Mathilde Vallet, 1927; Mathilde X sale, Paris, 1931; Hôtel Drouot sale, Paris, 21 June 1950 (cat. 7); Durand-Ruel, 1966.

Exhibitions: Galerie A.-M. Reitlinger, Paris, 1931 (cat. 100).

905
Simone in a Stiff, Round Bonnet with Hands Clasped before Her c. 1904
Pencil on paper, $7\frac{3}{4} \times 5\frac{3}{8}$ in., 19.5 × 13.5 cm.
Unsigned. Mathilde X collection stamp toward lower right.

Description: A poor sketch of a little girl looking slightly to the left and turned to right in three-quarter view.

Note: Also called "Jeune fille assise."

Collections: From the artist to Mathilde Vallet, 1927; Mathilde X sale, Paris, 1931; Roland, Browse and Delbanco, London; Anthony d'Offay, London; *private collection*, England.

Exhibitions: Galerie A.-M. Reitlinger, Paris, 1931 (cat. 155); Anthony d'Offay, London, 1966 (cat. 13).

906
Slight Sketch of a Child in a Beret c. 1904
Pencil on white paper, 9 × 6¼ in., 23 × 16 cm.
Unsigned. Mathilde X collection stamp at lower right.

Description: Head only of a girl in outline with a high, full beret on the back of her head. Her eyes look somewhat to right.

Note: Also called "Enfant au béret." Durand-Ruel 19861C-13986.

Collections: From the artist to Mathilde Vallet, 1927; Mathilde X sale, Paris, 1931; Durand-Ruel, Paris, 1966.

Exhibitions: Galerie A.-M. Reitlinger, Paris, 1931 (cat. 144).

907
Child in a Beret c. 1904
Pencil on white paper, 6¾ × 4¾ in., 17 × 12 cm.
Unsigned. Mathilde X collection stamp at lower
left corner.

Description: Head and shoulders of little girl
wearing a high, full beret on the back of her head.
Her coat has a deep yoke or cape extending over
her shoulders. She looks left, seen in three-quarter
view.

Note: Also called "Enfant au béret." Durand-Ruel
19862A-13998.

Collections: From the artist to Mathilde Vallet,
1927; Mathilde X sale, Paris, 1931; Durand-Ruel,
Paris, 1966.

Exhibitions: Galerie A.-M. Reitlinger, Paris, 1931
(cat. 172).

910
**Little Simone in a Big Hat Outlined in Black
Ribbon** c. 1904
Pencil on cream paper folded to 13¾ × 8 in.,
34.8 × 20.2 cm.
Signed toward lower right: *M. C*

Description: Head and shoulders of a little girl
wearing a big hat outlined in black ribbon with
a bow at right. Her hair is blond and parted in
the middle. She looks at the spectator.

Collections: H.M.P., Paris.

908
Little Girl Standing before Her Mother
c. 1904
Pencil on white paper, 9 × 6¼ in., 23 × 16 cm.
Unsigned. Mathilde X collection stamp at lower
right.

Description: A little girl with head bent to right
stands before her mother, whose form is indicated
only by her arm and her shoulder, as though
seated with her back to the spectator.

Note: Also called "Enfant la tête appuyée sur son
bras." Durand-Ruel 19858D-13980.

Collections: From the artist to Mathilde Vallet,
1927; Mathilde X sale, Paris, 1931; Durand-Ruel,
Paris, 1966.

Exhibitions: Galerie A.-M. Reitlinger, Paris, 1931
(cat. 129).

909
**Sketch of Simone in a Big Hat beside Her
Mother** c. 1904
Pencil on paper, 9½ × 7 in., 24 × 17.7 cm.
Unsigned

Description: The mother is seated, seen in profile
right. The child stands next to her with her right
hand on the mother's left shoulder. She wears a
large hat and is sketched with no features
developed on her face. In a related painting
(BrCR 450) she is smiling.

*Collections: The Art Museum, Princeton University,
Dan Fellows Platt Collection.*

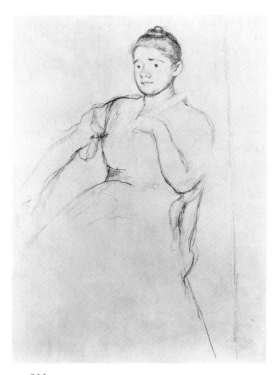

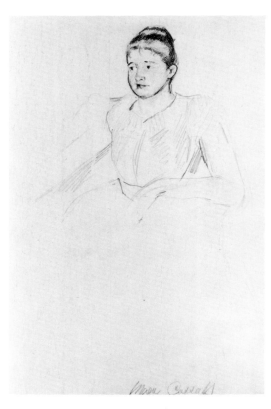

912

Drawing for "Portrait of Katharine Kelso Cassatt" (No. 1) c. 1905
Pencil on paper, 10⅛ × 6¾ in., 25.5 × 17 cm.
Signed toward lower right: *Mary Cassatt*

Description: Half-length sketch with features well developed as well as pose of arms, but before any detail of hands or costume.

Note: This is a study for BrCR 469.

Collections: Marlborough Fine Art Ltd., London, 1966; to *Mr. and Mrs. Benjamin Sonnenberg*, New York.

Exhibitions: Marlborough Fine Art Ltd., London, "Modern Masters' Drawings and Watercolors" (cat. 19), 1966.

911
Sketch of Katharine Kelso Cassatt Seated in an Armchair c. 1905
Pencil on paper, 9¼ × 6¼ in., 23.3 × 15.7 cm.
Unsigned. Mathilde X collection stamp at lower right.

Description: Three-quarter length view of a young woman turned somewhat to left and looking to left. Her right arm rests along the chair arm; her left is raised to touch the closing of her dress at chest height. Her hair is piled in a tight knot on top of her head.

Note: Also called "Femme assise dans un fauteuil."

Collections: From the artist to Mathilde Vallet, 1927; Mathilde X sale, Paris, 1931; Theodore Schempp, Paris; to *Museum of Fine Arts*, Springfield, Massachusetts, 1936.

Exhibitions: Galerie A.-M. Reitlinger, Paris, 1931 (cat. 160, illus.).

Reproductions: Springfield Museum of Fine Arts Bulletin, Vol. 3, No. 9 (June 1937), p. 8.

913

Drawing for "Portrait of Katharine Kelso Cassatt" (No. 2) c. 1905
Pencil on paper, 10 × 6¾ in., 25 × 17 cm.
Signed lower right: *Mary Cassatt* (-*att* is under mat)

Description: Very close to the painting in most respects but without a suggestion of cretonne pattern or curtain at left. Flowers in the vase are only slightly suggested. The subject is the artist's mother as a young girl.

Note: This is a study for BrCR 469.

Collections: De Braux, Philadelphia; present location unknown.

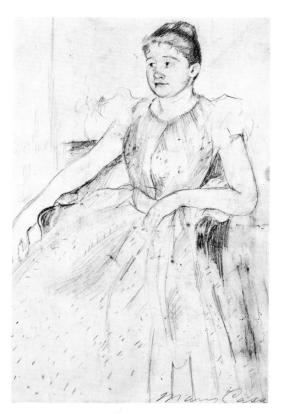

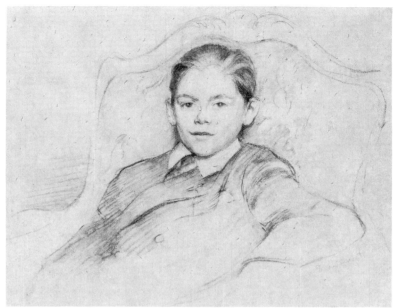

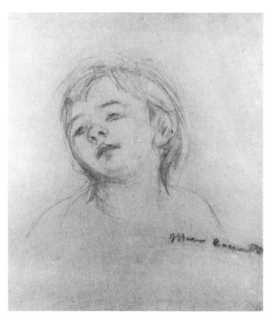

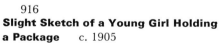

914
Portrait of Herbert Jacoby c. 1905
Pencil and watercolor on rice paper, 8 × 10 in., 20.3 × 25.5 cm.
Signed at right beyond his left forearm: *Mary Cassatt*

Description: Half-length portrait of young Herbert Jacoby seated in a French chair upholstered in a blue-figured damask. He looks at the spectator. His short hair is brushed back from his forehead and behind his ears. He wears a double-breasted suit with a tie and a Buster Brown collar.

Collections: Chapellier Gallery, New York; to *Mrs. Everett D. Reese*, Columbus, Ohio.

Color plate, page 241. Although not visible in the reproduction, a very faint blue may be discerned in areas of the original drawing.

915
Sketch of Denise's Daughter c. 1905
Pencil on tan paper, 15½ × 14 in., 39.4 × 35.5 cm.
Signed lower right: *Mary Cassatt*

Description: Head and shoulders of a little girl with straight blond hair which hangs onto her shoulders. Her head is tilted back somewhat as she looks left in three-quarter view. Her hair falls behind her ear at right.

Collections: From the artist to Albert E. McVitty; to his daughter, *Mrs. Charles H. Taquèy*, Washington, D.C.

916
Slight Sketch of a Young Girl Holding a Package c. 1905
Crayon on paper, 9 × 6¼ in., 23 × 16 cm. (sight)
Unsigned. Mathilde X collection stamp at lower right.

Description: A young girl seen in half-length leans to left resting her right arm on a table. She holds a package in her large right hand. She looks somewhat to right.

Note: Also called "Study of a Boy" and "Femme debout, les mains en avant." Durand-Ruel 13973.

Collections: From the artist to Mathilde Vallet, 1927; Mathilde X sale, Paris, 1931; Wildenstein, New York; *private collection*, United States.

Exhibitions: Galerie A.-M. Reitlinger, Paris, 1931 (cat. 114).

917
Half-Length Sketch of a Girl Looking Down
c. 1905
Pencil on dark tan paper, 9¼ × 7⅞ in., 23.5 × 20 cm.
Unsigned

Description: A summary sketch reinforced with hard pencil to describe features and outline of the head more clearly. Otherwise very faintly sketched.

Note: The paper is foxed.

Collections: Dr. *John F. Simon*, New York.

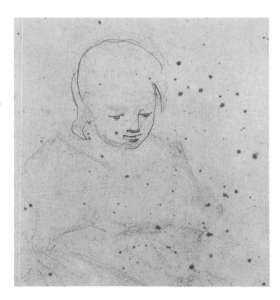

918
Head of a Woman, Profile Left c. 1906

Pencil on white paper, 8¼ × 5¼ in., 21 × 13.3 cm. Unsigned. Mathilde X collection stamp at lower left.

Description: Head of a woman, outline only, looking down to left as though reading. Her hair is pompadoured and in a knot on top of her head.

Note: Also called "Tête de femme, profil." Durand-Ruel 19857C-13955.

Collections: From the artist to Mathilde Vallet, 1927; Mathilde X sale, Paris, 1931; Durand-Ruel, 1966.

Exhibitions: Galerie A.-M. Reitlinger, Paris, 1931 (cat. 81).

919
Nude Little Girl Leaning against Her Mother
c. 1906

Pencil on paper, 15¾ × 11¾ in., 40 × 30 cm. Unsigned. Mathilde X collection stamp at lower left corner.

Description: A little girl is seen in full-length leaning to left as though at her mother's side with an indication of the mother's hand under her left arm. The child looks off toward the left. Feet are not drawn.

Note: Also called "Enfant debout s'appuyant."

Collections: From the artist to Mathilde Vallet, 1927; Mathilde X sale, Paris, 1931; present location unknown.

Exhibitions: Galerie A.-M. Reitlinger, Paris, 1931 (cat. 156, illus.).

920
Young Woman Leaning on Her Elbow
c. 1908

Pencil on white paper, 5 × 7½ in., 12.5 × 19 cm. Unsigned. Mathilde X collection stamp at lower left corner.

Description: Head and shoulders of a young woman in profile left leaning on her elbow with her hand on her right cheek. Her hair is drawn back smoothly into a bun at the back. A very fluffy, full evening gown is barely suggested.

Note: Also called "Femme accoudée" and "Tête de femme, profil." Durand-Ruel 19863C-13947.

Collections: From the artist to Mathilde Vallet, 1927; Mathilde X sale, Paris, 1931; Durand-Ruel, Paris, 1966.

Exhibitions: Galerie A.-M. Reitlinger, Paris, 1931 (cat. 71).

921
Sketch of a Little Girl Standing c. 1908

Pencil on white paper, 8¼ × 5⅜ in., 21 × 13.7 cm. Unsigned. Mathilde X collection stamp at lower right.

Description: A little girl stands with her right arm hanging at her side. She wears a dress with cap sleeves. Her hair hangs onto her shoulders.

Note: A study for BrCR 501. Also called "Fillette." Durand-Ruel 19858A-13987.

Collections: From the artist to Mathilde Vallet, 1927; Mathilde X sale, Paris, 1931; Durand-Ruel, Paris, 1966.

Exhibitions: Galerie A.-M. Reitlinger, Paris, 1931 (cat. 145).

922
Mother Jeanne Holding Her Baby c. 1908
Pencil on white paper, 11¾ × 8½ in., 30 × 21.5 cm.
Unsigned. Mathilde X collection stamp at lower left.

Description: A summary sketch of a mother's head looking down, seen in full face, and her baby's head in outline only.

Note: Also called "Femme tenant son enfant sur les genoux." Durand-Ruel 19855B-13988.

Collections: From the artist to Mathilde Vallet, 1927; Mathilde X sale, Paris, 1931; Durand-Ruel, Paris, 1966.

Exhibitions: Galerie A.-M. Reitlinger, Paris, 1931 (cat. 146).

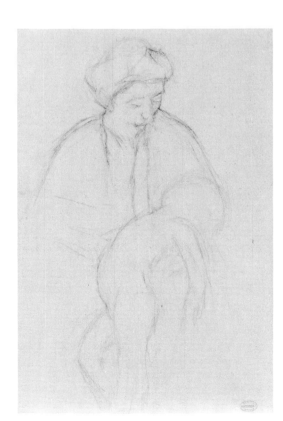

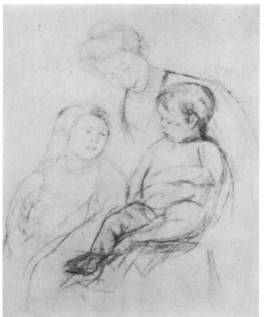

925
Standing Nude Child Reaching up to Caress His Mother c. 1908
Pencil on paper, 19¼ × 13¼ in., 49 × 33.5 cm.
Unsigned. Mathilde X collection stamp at lower right.

Description: A nude child bends far back and reaches up with his right arm to caress his mother's face. He is in profile to left. The mother looks down at him.

Note: Also called "Bébé sur les genoux de sa mère." Durand Ruel 19854B-13994.

Collections: From the artist to Mathilde Vallet, 1927; Mathilde X sale, Paris, 1931; Durand-Ruel, Paris, 1966.

Exhibitions: Galerie A.-M. Reitlinger, Paris, 1931 (cat. 154).

923
Full Sketch for "Mother Looking Down, Embracing both of Her Children" c. 1908
Soft pencil or charcoal on buff paper, 33 × 26 in., 84 × 66 cm.
Unsigned

Description: A mother looks down at her nude baby seated on her lap and clasps him with her left hand while her right arm encircles the waist of her little girl, who leans against her right side and looks at the baby.

Note: A study for BrCR 501.

Collections: Parke-Bernet sale 2326, New York, 27 Jan. 1965 (cat. 57, illus.); present location unknown.

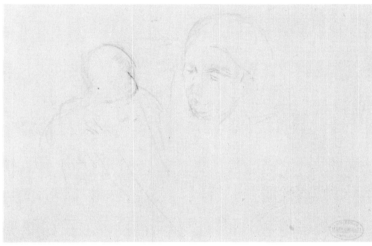

924
Slight Sketch of a Woman and Baby
c. 1908
Pencil on white paper, 6⅛ × 9 in., 15.5 × 23 cm.
Unsigned. Mathilde X collection stamp at lower right.

Description: Outline of a baby held up by his mother whose features are just barely indicated. The baby is at left, the mother at right.

Note: Also called "Femme et bébé, deux têtes." Durand-Ruel 19860A-13944.

Collections: From the artist to Mathilde Vallet, 1927; Mathilde X sale, Paris, 1931; Durand-Ruel, Paris, 1966.

Exhibitions: Galerie A.-M. Reitlinger, Paris, 1931 (cat. 62).

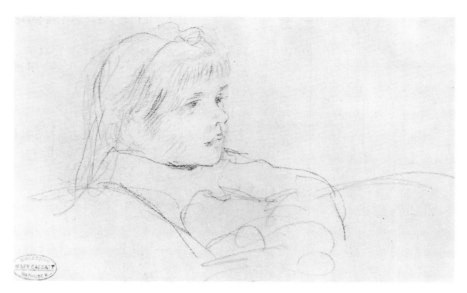

Sketch of Adine Kelekian 1910
Pencil and crayon on paper, 5¼×8⅜ in.,
13.3×21.2 cm.
Unsigned. Mathilde X collection stamp in lower
left corner.

Description: A drawing of a little girl with long
hair and bangs. She looks off to right. Only the
head is developed.

Note: Also called "Tête de fillette." Durand-Ruel
A1659-NY9323.

Collections: From the artist to Mathilde Vallet,
1927; Mathilde X sale, Paris, 1931; Durand-Ruel,
Paris; present location unknown.

Exhibitions: Galerie A.-M. Reitlinger, Paris, 1931
(cat. 124).

927
**Woman in a Plumed Hat Tied under Her
Chin** c. 1910
Lead pencil on paper, 12½×9 in., 31.7×23 cm.
Signed toward lower right: *Mary Cassatt*

Description: Bust-length sketch of a woman in a
large plumed hat tied with a narrow, dark ribbon
under her chin. She wears a pompadour and
looks to left. The round neckline of her dress is
indicated.

Note: Durand-Ruel 10446-LD13163.

Collections: From the artist to Mathilde Vallet,
1927; Mathilde X sale, Paris, 1931; to Durand-
Ruel, New York; present location unknown.

Exhibitions: Galerie A.-M. Reitlinger, Paris, 1927
(cat. 85).

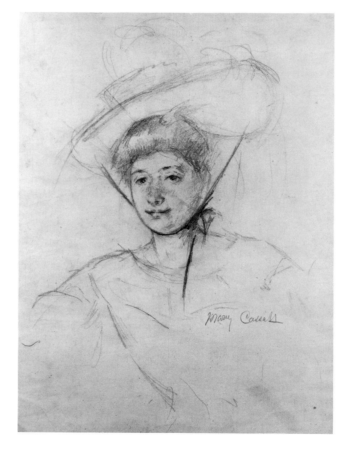

928
**Head of a Woman with Scratches of Shading
over Her Face** c. 1910
Pencil on cream paper folded to 12½×9⅝ in.,
31.6×24.3 cm.
Signed lower right beyond the fold: *M. C.*

Description: Head only of a woman turned some-
what to left. She looks to left. Her hair is drawn
down, half covering her ear, and parted on the
side away from the spectator. There are a number
of scratchy lines over her face which seem not to
belong there.

Collections: H.M.P., Paris.

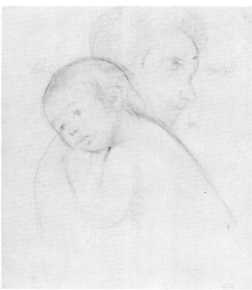

Baby John's Head on His Mother's Shoulder
c. 1910
Pencil on tan paper, 19½ × 16½ in., 49.5 × 42 cm.
Unsigned. Mathilde X collection stamp at lower
right.

Description: Half-length study of a baby resting
his head on his mother's right shoulder. He looks
off slightly to left, his left hand close to his cheek.
His mother is in profile right.

Note: Also called "Étude d'enfant nu" and
"Enfant appuyé sur l'épaule de sa mère."
Durand-Ruel 19846A-13993.

Collections: From the artist to Mathilde Vallet,
1927; Mathilde X sale, Paris, 1931; Durand-Ruel,
Paris, 1966.

Exhibitions: Galerie A.-M. Reitlinger, Paris, 1931
(cat. 153).

929
Woman Half Reclining, Looking Down
c. 1910
Pencil on paper, 8¼ × 5¼ in., 21 × 13.5 cm.
Unsigned. Mathilde X collection stamp at lower
left corner.

Description: Slight outline of the head and
shoulders of a woman. Her shoulders are at a 45°
angle, the left one lower.

Note: Also called "Jeune femme les yeux baissés."
Durand-Ruel 13964.

Collections: From the artist to Mathilde Vallet,
1927; *Bob Willoughby*, Pacific Palisades, California.

Exhibitions: Galerie A.-M. Reitlinger, Paris, 1931
(cat. 98).

931
**Slight Sketch of the Head of a Woman in
a Large Hat** c. 1910
Pencil on paper, 4⅝ × 2⅞ in., 11.6 × 7.5 cm. (sight)
Unsigned. Mathilde X collection stamp at lower
right corner.

Description: Very slight outline sketch of the head
and shoulders of a woman in a large, wide hat.

Collections: From the artist to Mathilde Vallet,
1927; Anthony d'Offay, London; to *Bob
Willoughby*, Pacific Palisades, California.

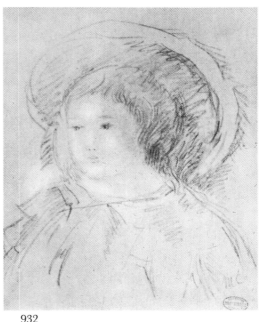

932
**Head and Shoulders of a Little Girl in a Big
Hat** c. 1910
Crayon on gray paper, 11¾ × 9 in., 30 × 23 cm.
Signed lower right above Mathilde X collection
stamp: *M. C.*

Description: The large hat is shaded, also the hair.
The formless face is heightened with white.

Collections: From the artist to Mathilde Vallet,
1927; Mathilde X sale, Paris, 1931; to M. Poyet,
Paris; Parke-Bernet sale, New York, 8 April 1964
(cat. 6, illus.); *Max Bodner*, New York.

Exhibitions: Galerie A.-M. Reitlinger, Paris, 1931
(cat. 65).

933
Slight Outline Sketch of a Girl with Long Hair
c. 1913

Pencil on gray paper, 3¾ × 5⅜ in., 9.5 × 13.7 cm.
(sight)
Unsigned. Mathilde X collection stamp upside
down in lower left corner.

Description: A girl in profile left with features
undescribed but a mass of hair hanging down her
back. Her left arm is bent.

Collections: From the artist to Mathilde Vallet,
1927; Anthony d'Offay, London; to *Bob
Willoughby*, Pacific Palisades, California.

934
**Summary Sketch of a Pose of Mother and
Child** c. 1913

Charcoal, 28 × 21 in., 71 × 53.2 cm.
Unsigned. Mathilde X collection stamp at lower
right corner.

Description: A very summary sketch with little
indication of anything more than round heads
and the mother's shoulders.

Note: Also called "Femme tenant un enfant."
Durand-Ruel 19863D-13970.

Collections: From the artist to Mathilde Vallet,
1927; Mathilde X sale, Paris, 1931; to Durand-
Ruel, Paris; *Maurice Austin*, New York.

Exhibitions: Galerie A.-M. Reitlinger, Paris, 1931
(cat. 106).

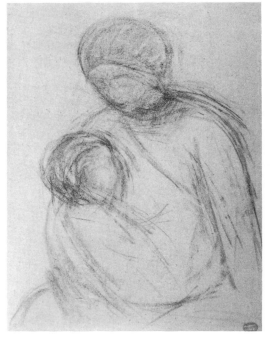

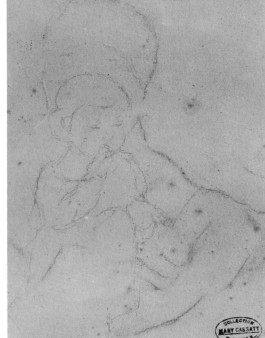

935
**Slight Sketch of a Mother and a Baby with
a Finger in His Mouth** c. 1913

Pencil on paper, 6¾ × 4¾ in., 17.3 × 12 cm. (sight)
Unsigned. Mathilde X collection stamp at lower
right.

Description: A poorly drawn sketch. The baby
looks off to right, his head hiding his mother's
face.

Collections: From the artist to Mathilde Vallet,
1927; Mathilde X sale, Paris, 1931; Wildenstein,
New York; *private collection*, New York.

Exhibitions: Galerie A.-M. Reitlinger, Paris, 1931
(cat. 93).

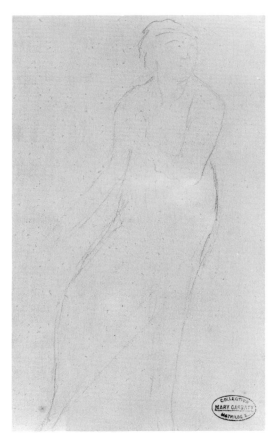

936
**Summary Sketch of a Full-length Figure of
a Woman** c. 1913

Pencil on paper, 8¼ × 5 in., 21 × 12.7 cm. (sight)
Unsigned. Mathilde X collection stamp at lower
right.

Description: A very poor drawing of the full-length
figure of a woman with her head turned to right.
Her left hand is indicated on her chest. Her right
arm is extended to left.

Collections: From the artist to Mathilde Vallet,
1927; Wildenstein, New York; to *private collection*,
New York.

Addenda

937
Roman Girl Smiling c. 1872
Oil on canvas, 23⅝ × 19¾ in., 60 × 50 cm.
Signed upper left corner: *M. S. Cassatt*

Description: Head and shoulders of a smiling young woman with her head thrown back looking over her left shoulder. Her low-cut gown is of a light color. The background is dark.

Collections: Wildenstein & Co., New York; *private collection*, Paris.

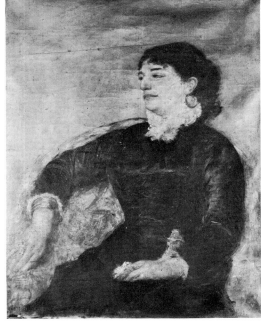

938
Portrait of an Italian Lady c. 1879
Oil on canvas, 31 9/16 × 24⅜ in., 81 × 62 cm.
Signed lower left: *M. S. Cassatt*

Description: A foreign-looking lady wearing large hoop earrings is seated in an armchair upholstered in a rose and white chintz pattern. Her right arm rests on the chair arm, her hand accented by a large diamond ring. She holds a handkerchief in her left hand. Her black long-sleeved gown has white ruffling at the neck and wrists.

Note: This may possibly be a portrait of Mme. Marie Del Sarte, who ran a fashionable boarding school for young ladies which was attended by Louisine Waldron Elder, later Mrs. H. O. Havemeyer, as well as Mary Ellison of Philadelphia.

Collections: Jacques Spiess, Paris.

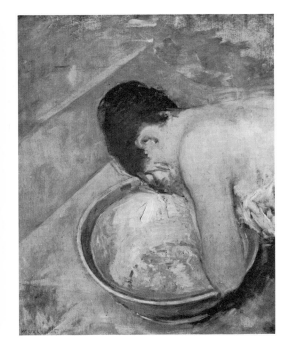

939
Sketch of a Young Woman at Her Toilet
c. 1891
Oil on canvas, not measured
Signed lower left: *Mary Cassatt*

Description: One looks down on the head and shoulders of a semi-nude young woman with dark hair. She washes her face and leans over a wash bowl.

Note: This sketch is related to Br. 148.

Collections: Dr. Mollard, Paris; present location unknown.

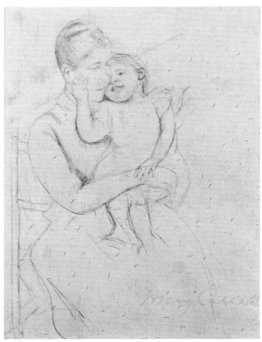

940
Little Girl Patting Her Mother's Cheek
c. 1895
Pencil on paper, 8¼ × 6 in., 21 × 15.2 cm.
Signed lower right: *Mary Cassatt*

Description: Mother seen in three-quarter length is seated in a straight-backed chair. She holds a sleepy little girl in her arms. The child's left hand rests on her mother's right wrist.

Collections: Wilfred H. Stein, Geneva, Switzerland.

941 †
Reine Looking at Margot over Her Left Shoulder c. 1902
Pencil on grey paper, 9 × 6¼ in., 23 × 16 cm.
Unsigned: Mathilde X collection (may have stamp on verso).

Description: Their two heads are close together. Margot looks off to right and Reine looks at Margot. Margot has her hair brushed to the left with suggestion of a bow. Her arms show, but not her hands.

Note: D-R 19850A; "Deux Têtes" and "Femme et enfant, deux têtes esquissées."

Collections: Mathilde Vallet, Paris, 1927–1931; Durand-Ruel, 1966.

Exhibitions: Galerie A.-M. Reitlinger, Paris, 1931 (cat. 86).

942
Margot Leaning Against Reine's Knee (No. 5) c. 1902
Pencil on paper, 15 × 11½ in., 38 × 29.2 cm.
Unsigned

Description: Reine is shown in full face looking down at her sewing which is hidden by Margot's head. The child looks at the spectator. Both heads are developed, the bodies lightly sketched. This is one of five pencil sketches for the painting entitled "Young Mother Sewing" (BrCR 415).

Collections: Dr. Richard Manney, Irvington, New York.

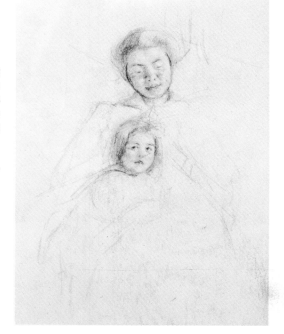

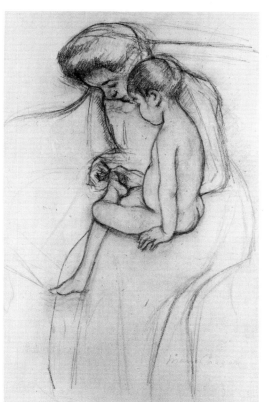

943
First Aid c. 1908
Pencil on paper, 16¾ × 10½ in., 42.5 × 26.6 cm.
Signed lower right: *Mary Cassatt*

Description: Mother seated on a sofa bends forward and looks down to remove a splinter from the foot of her nude child seated on her knee.

Note: A preparatory drawing for Br 203.

Collections: Albert Loeb and Krugier Gallery, New York.

Bibliography

Books

Biddle, George. *An American Artist's Story*. Boston: Little, Brown, 1939.

Bizardel, Yvon. *American Painters in Paris*. New York: Macmillan, 1960.

Borgmeyer, Charles Louis. *The Master Impressionists*. Chicago: Fine Arts Press, 1913.

Breeskin, Adelyn D. *The Graphic Work of Mary Cassatt: A Catalogue Raisonné*. New York: H. Bittner, 1948.

Breuning, Margaret. *Mary Cassatt*. New York: Hyperion Press, 1944.

Carson, Julia M. H. *Mary Cassatt*. New York: David McKay, 1966.

Degas, Edgar. *Degas Letters*. Translated by Marguerite Kay. Edited by Marcel Guerin. New York: Studio Publications, 1948.

———. *Huit sonnets d'Edgar Degas*. Paris: La Jeune Parque, 1946.

Elliott, Maude Howe, editor. *Art and Handicraft in the Woman's Building of the World's Columbian Exposition, Chicago, 1893*. Paris and New York, 1893.

Havemeyer, Louisine W. *An Address Delivered by Mrs. H. O. Havemeyer at the Loan Exhibition* [at M. Knoedler & Co.], *Tuesday, April 6, 1915*.

———. *Sixteen to Sixty: Memoirs of a Collector*. New York: privately printed, 1930.

Lecomte, Georges. *L'art impressioniste d'après la collection privée de M. Durand-Ruel*. Paris, 1892.

Rewald, John. *The History of Impressionism*. New York: Museum of Modern Art, 1961.

Segard, Achille. *Un peintre des enfants et des mères—Mary Cassatt*. Paris: Librarie Ollendorf, Paris, 1913.

Sweet, Frederick A. *Miss Mary Cassatt: Impressionist from Pennsylvania*. Norman: University of Oklahoma Press, 1966.

Valerio, Edith. *Mary Cassatt*. Paris: Crès et Cie., 1930.

Vollard, Ambroise. *Recollections of a Picture Dealer*. Boston: Little, Brown, 1936.

Walton, William. *Art and Architecture, World's Columbian Exposition*. Philadelphia, 1893–1895.

Watson, Forbes. *Mary Cassatt*. American Artists Series. New York: Whitney Museum of American Art, 1932.

Articles

Alexandre, Philippe. "Mary Cassatt—la seule femme qui ait ébloui Degas." *Jours de France*, no. 336 (22 April 1961).

Beurdeley, Yveling Rambaud. "Mary Cassatt." *L'art dans les deux mondes*, no. 1 (22 November 1890).

Biddle, George. "Some Memories of Mary Cassatt." *The Arts*, vol. 10 (August 1926), pp. 107–11.

Brownell, William C. "The Young Painters of America," part 3. *Scribner's Monthly*, vol. 22, no. 3 (July 1881), pp. 321–34.

Cary, Elizabeth Luther. "The Art of Mary Cassatt." *The Scrip*, vol. 1, no. 1 (October 1905), pp. 1–5.

Denoinville, Georges. "Mary Cassatt, peintre des enfants et des mères." *Byblis*, 7th year (winter 1928), pp. 121–23.

Fuller, Sue. "Mary Cassatt's Use of Soft-Ground Etching." *Magazine of Art*, no. 43 (February 1950), pp. 54–57.

Geffroy, Gustave. "Femmes artistes—un peintre de l'enfance—Mary Cassatt." *Les modes*, vol. 4 (February 1904), pp. 4–11.

Grafly, Dorothy. "In Retrospect—Mary Cassatt." *American Magazine of Art*, vol. 18 (June 1927), pp. 305–12.

Havemeyer, Louisine W. "The Cassatt Exhibition." *Pennsylvania Museum of Art Bulletin*, vol. 22, no. 113 (May 1927), pp. 373–82.

Henrotin, Ellen M. "Outsider's View of the Woman's Exhibit." *Cosmopolitan*, vol. 15, no. 5 (September 1893), p. 560.

Hess, Thomas B. "Degas-Cassatt Story." *Art News*, vol. 46 (November 1947), pp. 18–20 ff.

Hoebner, Arthur. "Mary Cassatt." *Century*, vol. 57 (March 1899), pp. 740–41.

Hyslop, F. E., Jr. "Berthe Morisot and Mary Cassatt." *College Art Journal*, vol.13, no. 3. (Spring 1954), pp. 179–84.

Ivins, William M., Jr. "New Exhibition in the Print Galleries: Prints by Mary Cassatt." *Bulletin of the Metropolitan Museum of Art*, vol. 22, no. 1 (January 1927), pp. 8–10.

Johnson, Una E. "Graphic Art of Mary Cassatt." *American Artist*, vol. 9 (November 1945), pp. 18–21.

Leeper, John P. "Mary Cassatt and Her Parisian Friends." *Bulletin of the Pasadena Art Institute*, no. 2 (October 1951), pp. 1–9.

Lostalot, A. de. "L'exposition des oeuvres de Miss Mary Cassatt." *La chronique des arts et de la curiosité*, no. 38–39 (December 1893), p. 299.

Lowe, Jeanette. "The Women Impressionist Masters: Important Unfamiliar Works by Morisot and Cassatt, Exhibition Held at Durand-Ruel." *Art News*, vol. 38 (4 November 1939), p. 9.

McChesney, Clara. "Mary Cassatt and Her Work." *Arts and Decoration*, vol. 3 (June 1913), pp. 265–67.

"Mary Cassatt's Achievement: Its Value to the World of Art." *Craftsman*, vol. 19 (March 1911), pp. 540–46.

"Mary Cassatt Dies in France." *Art News*, vol. 24 (19 June 1926), p. 1.

Mauclair, Camille. "Un peintre de l'enfance, Miss Mary Cassatt." *L'art décoratif*, vol. 8, no. 47 (August 1902), pp. 177–85.

Mellerio, André. "Mary Cassatt." *L'art et les artistes*, vol. 12 (November 1910), pp. 69–75.

————. "Exposition Mary Cassatt, Gallery Durand-Ruel, Paris, November–December 1893." Translated by Eleanor B. Caldwell. *Modern Art*, vol. 3, no. 1 (Winter 1895) pp. 4–5.

Pica, Vittorio. "Artisti contemporanei—Berthe Morisot e Mary Cassatt." *Emporium*, vol. 26, no. 3 (January 1907), pp. 11–16.

"Une Retrospective de Mary Cassatt." *Art et Décoration*, vol. 60, suppl. (July 1931), pp. 3–5.

Shapley, John, editor. "Mary Cassatt—Painter and Graver, 1845–1926." *Index of Twentieth Century Artists*, vol. 2, no. 1 (October 1934), pp. 1–8.

———. "Mary Cassatt." *Index of Twentieth Century Artists*, supplementary issue, vol. 2, no. 12 (September 1935), pp. i-ii.

———. "Mary Cassatt." *Index of Twentieth Century Artists*, supplementary issue, vol. 3, nos. 11–12 (August–September 1936), p. iv.

Sweet, Frederick A. "A Chateau in the Country." *Art Quarterly*, vol. 21, no. 2 (Summer 1958), pp. 202–15.

———. "America's Greatest Woman Painter: Mary Cassatt." *Vogue*, vol. 123, no. 3 (15 February 1954), pp. 102–103 ff.

Tabarant, Adolphe. "Les disparus—Miss Mary Cassatt." *Bulletin de la vie artistique*, 7th year (July 1926), pp. 205–206.

Teall, Gardner. "Mother and Child, the Theme as Developed in the Art of Mary Cassatt." *Good Housekeeping*, vol. 50, no. 2 (February 1910), p. 141.

Visson, A. "Exposition Galerie Wildenstein, New York." *Arts*, no. 141 (21 November 1947), p. 8.

Walton, William. "Miss Mary Cassatt." *Scribner's Magazine*, vol. 19, no. 3 (March 1896), pp. 353–61.

Watson, Forbes. "Mary Cassatt." *The Arts*, vol. 10 (July 1926), p. 3.

———. "Philadelphia Pays Tribute to Mary Cassatt." *The Arts*, vol. 11 (June 1927), pp. 289–97.

White, Frank Linstow. "Younger American Women in Art." *Frank Leslie's Popular Monthly*, vol. 36 (November 1893), pp. 538–44.

Index of Owners

Index of Titles and Sitters